Race-ing Art History *is a long overdue and much needed anthology of major texts that mark out the critical debate about race within the domain and discipline of art history. Key scholars address the question via telling case studies which reveal the complexity and challenge of our confrontation as art historians with both the dire history of racisms and the critical creativity of those artists and scholars who name, shame, and contest it in the name of fully encompassing record of human creative practice and understanding. To be welcomed and commended and read carefully and humbly.*

—Griselda Pollock, Professor of the Social and Critical Histories of Art, University of Leeds

This sprawling and dazzling collection makes room for critical race studies to meet art history, for the tracing of race, representation and artists' dilemmas across millennia and continents, for contributors who provocatively disagree with each other, for insiders and for outsiders, and for Kym Pinder's own remarkable contributions. This is a book that I can't wait to share with students and one that has happily made a student of me.

—David R. Roediger, author of *Colored White: Transcending the Racial Past*

Kymberly N. Pinder is Associate Professor of Art History, Theory, and Criticism at the School of the Art Institute of Chicago. She has published on race and American Art in the *Art Bulletin* and *Third Text*. Her most recent work appears in *Dox Thrash: An African American Master Printmaker Rediscovered* (Philadelphia Museum of Art, 2001). She is currently preparing the manuscript *Framing Color: Reading Race in the History of Western Art*.

Race-ing Art History

CRITICAL

READINGS

IN RACE

AND

ART HISTORY

Edited by

KYMBERLY N. PINDER

Routledge
New York London

Published in 2002 by
Routledge
29 West 35th Street
New York, NY 10001

www.routledge-ny.com

Published in Great Britain by
Routledge
11 New Fetter Lane
London EC4P 4EE

www.routledge.com

Routledge is an imprint of the Taylor & Francis Group.

Cataloging-in-Publication Data is available from the Library of Congress.

ISBN 0-415-92760-9 (hb)
ISBN 0-415-92761-7 (pb)

Contents

Part Four

Race-ing Us
White, Beige, Brown, and Black in the Twentieth Century

A discussion guide for *Race-ing Art History* is available at
http://www.routledge-ny.com/pinderguide

Acknowledgments

I would like to first thank James Elkins who set up the meeting with William Germano at which this book was born. The continuing encouragement of both Jim and Bill and the hard work of Bill's assistants, Damian Treffs, Gilad Foss, and last but not least, Sara Brady, definitely enabled this cumbersome project to happen. Those authors and artists with whom I had direct contact must also be thanked for their overwhelming support for this volume, both in words and deeds, such as supplying original art work. A Ford Foundation Postdoctoral Fellowship for Minorities and the Chicago Theory Group also played a role in my work on this book during my academic leave of 2000. I must always thank my parents, Rachel and Howard Pinder, for their constant support throughout all of my pursuits, and lastly, but most importantly, I thank my husband, Mark Caughey.

List of Figures

List of Color Plates

12. Pablo Picasso, *Les Demoiselles d'Avignon*, 1907, oil on canvas. © 2001 Estate of Pablo Picasso / Artists Rights Society (ARS), New York/ADAGP, Paris. The Museum of Modern Art, New York. Acquired through the Lillie P. Bliss Bequest. Photograph © 2001 the Museum of Modern Art, New York.

13. Wilfredo Lam, *The Jungle*, 1942–43, gouache on paper mounted on canvas. © Copyright 2001 Artists Rights Society (ARS), New York/ADAGP, Paris. Museum of Modern Art, New York (Inter-American fund). Photo © copyright 2001 Museum of Modern Art, New York.

14. Sargent Johnson, *Chester*, 1931, terracotta, San Francisco Museum of Modern Art, Bequest of Albert M. Bender. Photo Ben Blackwell.

15. Sargent Johnson, *Forever Free*, 1933, wood with lacquer on cloth, San Francisco Museum of Modern Art, Gift of Mrs. E.D. Lederman. Photo Ben Blackwell.

16. Horace Pippin, *Self-Portrait*, 1941, oil on canvas mounted on cardboard, 14 x 11 in. Albright-Knox Art Gallery, Buffalo, NY (Room of Contemporary Art Fund, 1942).

17. James Luna, *The Artifact Piece,* 1987, installation and performance, Museum of Man, San Diego.

18. Jimmie Durham, *On Loan from the Museum of the American Indian*, 1985, installation.

19. Jean-Michel Basquiat, *Irony of a Negro Policeman*, 1981, oil on canvas. © Copyright 2001 Artists Rights Society (ARS), New York/ADAGP, Paris. Robert Miller Gallery, New York.

20. Chu Kyung, *Hardship*, 1923, oil on canvas. National Museum of Contemporary Art, Korea.

21. Young Kuk, *Mountain (Topography)*, 1959, oil on canvas. National Museum of Contemporary Art, Korea

22. Park Sco-Bo, *Primordialis, No. 1–62,* 1962, oil on canvas. Photo Boo-Moon Kwon.

23. Candice Breitz, *Rainbow Series*, 1996. 154 × 104 cm. Courtesy galleria francesca kaufmann, Milan.

24. Bryon Kim, *Synechdoche*, (1991), Max Protech Gallery, New York.

25. Gabrielle Varella, *Untitled Series* (1999) Collection of the Artist.

26. Bibiana Suárez, *Y tu abula a donde está? (What color is your grandmother?)*, 1991, Collection of the Artist.

27. Bibiana Suárez, *La Blanquita (The White One)*, 1992, Collection of the Artist.

28. Robert Colescott, *Lighting Lipstick*, 1994, Liquitex, acrylic, gel on canvas, 84 × 114 in, G.R. N'Namdi Gallery.

Introduction

Kymberly N. Pinder

It "had a basic African quality; the jungle is in it. It is some of the purest expression I have seen in a long time, and I would give my soul to be as naive as he is." This is how the white American illustrator N. C. Wyeth described the work of his African American contemporary, Horace Pippin, in 1941.[1] This simple quotation, with its admiration mired in terms of racial bias and condescension, encapsulates the complexity of the representation of race in the discipline of art history, a discourse in which terms like "primitive" or "oriental" have been synonymous with "naïve," "uncivilized," and "pure." Art produced by non-Europeans has naturally been compared to Western art and its study, which refers to a binary way of viewing both. Each essay in this collection is a response to this vision, to the "distant mirror" of looking at "the other."

Even though the last decade of the twentieth century was filled with events that have brought issues of race and ethnicity to our front pages and dinner tables, the last century and a half have seen the globally influential effects of the Civil War in the U.S., the colonization of Africa, Asia, and South America, and more recently, the civil disturbances in Los Angeles and the genocidal conflicts in places like Serbia and Rwanda. All of these events have proven the centrality of ethnicity in class warfare and nationalistic struggles in recent memory. These realities and the critical (and not so critical) discourse in academia and the media generated by them have confirmed that both race and ethnicity are more social and political constructs than the results of any biological factors. Therefore, throughout this volume, the terms "race" and "ethnicity" will depend upon the definition considered by each author. For most of the scholars in this text, "race" means a particular people or ethnic group; these scholars also acknowledge that physical differences can be minuscule while the culturally, politically, and socially constructed categories of racial difference are at the core of the issues being examined. Therefore, "race" here will also refer to "ethnicity" in most instances. Each essay explores the significance of the visuality of race in a work of art and what this element indicates about the work's producer, audience, and historical context.

The reassessment of power structures, central to most poststructural literary theory, such as that articulated by Michel Foucault and Jacques Derrida, catapulted multicultural

readings of canonical works in all of the humanities into the mainstream discourse and encouraged the critical consideration of formerly ignored work by women, gays, bisexuals, and people of color. Most of the essays in this volume participate in the branch of this tradition that has dealt the most exclusively with race: postcolonial theory. This collection has used as its models such important volumes as *Feminism and Art History* (1981) and its sequel, *Expanding Discourse* (1992), both edited by Norma Broude and Mary D. Garrard, and in literary and cultural studies, the numerous anthologies of essays on race, such as *"Race," Writing and Difference* (1986), edited by Henry Louis Gates, Jr., and *Class, Race and Gender: An Anthology* (1997), edited by Margaret L. Andersen and Patricia Hill Collins. I should also acknowledge the emerging area of Jewish Studies within the discipline of art history, as seen in such collections as *The Jew in the Text: Modernity and the Construction of Identity* (1995), edited by Linda Nochlin and Tamar Garb, and *Jewish Identity in Modern Art History* (1999), edited by Catherine Soussloff.[2] Moreover, both the *Art Bulletin* and the *Art Journal* have recently published special issues on race and ethnicity.[3]

At the close of the twentieth century, however, suffocated by pop culture soundbites and the conservative backlash against "political correctness," the potential of multicultural studies to effect change beyond superficial diversity awareness within and outside academia has petered out. By gathering these essays of varying viewpoints and complexity together and allowing them to speak to each other, this book hopes to be part of the next generation of critical discussions concerning issues of difference that will invigorate tired debates and advance our understanding of these issues in the next millennium. Two recent anthologies, *Reading the Contemporary: African Art from Theory to the Marketplace* (1999), edited by Olu Oguibe and Okwui Enwezor, and *With Other Eyes: Looking at Race and Gender in Visual Culture,* edited by Lisa Bloom (1999), are the most notable examples of this new brand of scholarship.

Unlike these collections, which focus on Contemporary Art, *Race-ing Art History* uses a broader, more historical lens. It presents a sampling of art historical scholarship addressing issues of race and ethnicity in relation to the, primarily Western, visual culture of the last two thousand years, with an emphasis on the nineteenth and the twentieth centuries. This emphasis on the modern period stems from the propensity of historians of this era to be more open to multicultural issues. David Theo Goldberg goes so far as to argue that modernity's inherent racialized dimension dictates this tendency:

> So the irony of modernity, the liberal paradox comes down to this: As modernism commits itself progressively to idealized principles of liberty, equality, and fraternity, as it increasingly insists upon the moral irrelevance of race, there is a multiplication of racial identities and sets of exclusions they prompt and rationalize, enable and sustain. Race is irrelevant, but all is race.[4]

I should caution that although I have attempted to include essays that address the concerns surrounding a variety of ethnicities, this volume inevitably focuses on race as a black/white issue. This shortsightedness reflects the infancy of this line of inquiry in the discipline of art history, the limitations and prejudices of English-language scholarship, and regrettable omissions due to prohibitive reprinting costs. There are also other biases. Though heavily indebted to Foucault's hegemonic theories, some of these essays fail to

move outside a binary conception of domination, ignoring what he warned against: "One should not assume a massive and primal condition of domination, a binary structure with 'dominators' on one side and 'dominated' on the other, but rather a multiform production of relations of domination. . . . "[5] Some of the essays here are seminal forays into this sticky wicket of race in the visual culture; others are less well known pieces that have quietly continued an evolving discourse begun by their predecessors.

I have organized this collection of essays in both a chronological and thematic order. The first section presents examinations of ethnicity in the fields of ancient and medieval art history. These essays are good examples of how examining race is based upon the historical reality of cross-cultural contacts in both the Roman and Holy Roman Empires. John R. Clarke examines the signifying presence of the Aethiops in the murals of Pompeii. Clarke introduces a major theme of this book, the visibility of race, something Frantz Fanon articulated in his seminal work *Black Skin, White Masks* (1952) as "the racial epidermal schema" of the non-white in a postcolonial world.[6] Clarke's essay points out that we should not allow our twentieth-century racial lens to misinterpret the meaning of the black man on the wall of a public bath. Like many of the essays in this volume, Clarke's piece is a brief example of the type of scholarship he has been producing on racial representation and visual culture. Diane Wolfthal susses out the manifestation of a positive identity for Jewish women in a fourteenth-century manuscript in which misogynist and anti-Semitic impulses are subverted in both word and image. Using very traditional iconological methods, Jean Devisse presents a thorough survey of the image of the black St. Maurice, who was depicted as white until the thirteenth century. Locating this motif in Northern Europe, due to its popularity among Holy Roman Emperors, Devisse looks at every medium from medieval altarpieces to the drawings of such well-known Renaissance artists as Hans Baldung Grien and Matthias Grünewald. Though this essay originally appeared in the groundbreaking, multivolume *The Image of the Black in Western Art* (1976), this author does not fully commit to strong racialized readings of this Christian figure; he even suggests that Maurice's appearance was more on the account of aesthetics, a taste for black and gold decoration, instead of politics in some instances. Despite this hesitation, Devisse still discusses the role of Maurice's ethnicity; like that of the black Queen of Sheba and the black Wise Man, Maurice's race was important to cross-cultural contact during the Crusades and later, as various political leaders sought support in the Mediterranean.

Part Two introduces such expected modernist topics as "Orientalism" and "Primitivism." Essays by Linda Nochlin and Reina Lewis use Edward Said's seminal postcolonial treatise *Orientalism* (1979) as their theoretical base to explore the intersection of gender with European perceptions of the Asian "other." By looking specifically at the Orientalist work by the British artist Henriette Browne, Lewis complements Nochlin's more traditional feminist reading of the paintings of such nineteenth-century French artists as Jean-Léon Gérome and Eugène Delacroix. Using, of course, Laura Mulvey's articulation of the power of the gaze, in this case gazes both within and outside these art works, Lewis asks the question, "What did it mean for a white, European woman to represent these exotic scenes?" Lewis covers all the bases by astutely outlining all of the "Chinese box," so to speak, of patriarchy and racism that problematize this particular painter's Orientalist view; to her critics Browne's often desexualized and domesticated view of the harem was more authentic (and less driven by fantasy) than those of her male counterparts because she could actually

visit one, yet these representations were less valid because the empathetic gender made her evaluation less objective and less "scientific," and therefore, less reliable.

The final edits for this book were performed shortly after the attacks on U.S. soil of September 11th, 2001 and the beginning of the U.S. war in Afghanistan. Currently, the Arab world has become emphatically "other" and alien and this political construction of it has solidified the opposition of the "civilized" West to the "barbaric" Middle East, which was a cornerstone of the imagery by such artists as Gerome, Delacroix, and Browne. In the past few months, the cultural misunderstandings between Westerners and Muslims, highlighted in the contemporary media coverage of current events, give the essays on nineteenth-century Orientalism in this volume a renewed historical significance.

Also included in this section is an essay in which Sander Gilman delves into the sociopolitical significance of the black maid in Edouard Manet's *Olympia* (1863), often considered one of the most important modernist works of the nineteenth century. Gilman helps us understand how a Parisian in 1862–63 would "see" this woman in relationship to the sexual subject of the painting in the context of the public objectification of the African Saartje Baartman, also known as the Hottentot Venus, and the phrenological theories regarding the morality of prostitutes. The black woman's presence beside the well-known courtesan Victorine Meurend also reinforced stereotypes of the hypersexed black. Gilman ends his discussion with an explanation of how the *absence* of the black woman in an equally important modernist work about sexuality, Emile Zola's *Nana* sheds light on ideas of whiteness in the nineteenth century.[7] In another piece, Abigail Solomon-Godeau discusses Paul Gauguin's images of Tahitians and Breton peasants in the context of nineteenth-century, anthropological representations of an exoticized Polynesia (which she points out are still with us in today's tourist trade). Through Gauguin's own writings and those of other art historians, Solomon-Godeau exposes the "mythic speech" that permeates the artist's reception, which has often overlooked his self-proclaimed status as both primitivist artist and sexual outlaw. The confluent relationship of these two states, the artistic and the sexual, are the focus of her essay.

Crossing the Atlantic to the U.S. in the nineteenth century, the following essays introduce the unique racial dynamics created by the slave trade and the genocide of the native populations. J. Gray Sweeney looks at the image of the Native American in the work of such popular cowboy painters as Frederic Remington and Charles M. Russell.[8] Like Solomon-Godeau, Sweeney reminds us that the shallow stereotyping of natives and white cowboys continues today as seen in the "Marlboro Man" and the art by the Cowboy Artists of America, whose membership as of 1992 still consisted exclusively of white males. Michael Hatt explores the representation of blacks in sculpture as expressions of the ambiguous status of black men after the collapse of slavery. He shows how these fine art images and similar ones from popular culture, such as those found in Currier and Ives prints, presented a complex matrix of signs about masculinity, racial fears, and political power.[9] Hatt also places the black male nude, as seen in the mid-century sculpture of John Quincy Adams Ward and Thomas Ball, within the art historical context of the male nude, a spotty tradition fraught with its own contradictions. Hatt's essay is indebted to the work of Albert Boime, who became one of the pioneers in examining race in nineteenth-century art in his 1990 *The Art of Exclusion: Representing Blacks in the Nineteenth Century*. His essay here eventually became a part of his 1990 book; it reveals how the figure of the black man

in John Singleton Copley's *Watson and the Shark* (1778) and Winslow Homer's *Gulf Stream* (1899) signify political and cultural issues relevant to the time these paintings were created. Boime convincingly argues that the prominence in the popular media of such events as the fledgling abolitionist movement in Britain (for the Copley) and the economic plight of blacks in the West Indies and in America (for the Homer) would have been clear subtexts to patrons and viewers of these works.

Part Three includes essays that address the racial dimension of "primitivism" in relation to modernism. Some may consider this dimension to be a *sub*text of the primitivist impulse, but authors like James Clifford, Patricia Leighten, Anna Chave, Cornel West, and bell hooks show us that it is an *explicit* aspect of both the production and reception of the work of such artists as Picasso, Horace Pippin, and Jean-Michel Basquiat. Using the structure of " 'Primitivism' in Twentieth-Century Art: Affinity of the Tribal and the Modern," the groundbreaking exhibition that appeared at the Museum of Modern Art (MOMA) in 1984, Clifford teases out the hegemonic (and paternal) assumptions and biased categorizations that underlie the significance of modernism's "taste for appropriating otherness" to validate and humanize itself.[10] Curators William Rubin and Kirk Varnedoe organized the show around the idea of "affinities" between modern masters' work and "tribal" artworks (namely, sculpture from Africa, Oceania, and Native America); this show was one of the most important catalysts in advancing the twentieth-century discourse regarding "primitivism."[11]

Leighten embraces the political significance of Picasso's artistic appropriations and boldly argues that Picasso's use of forms derived from African sculpture was a political act that proclaimed his sympathies for anticolonialist efforts on that continent. Chave takes such scholars as Rubin, Varnedoe, and Leighten to task in her critical overview of the scholarly reception of *Les Demoiselles d'Avignon*, "considered the site of origin for modernist painting."[12] She outlines how this work became such an icon of modernism and postcolonial discourse.

The African American painter William H. Johnson once said, "Even if I have studied for many years in New York and all over the world, and know more about Scandinavian literature and classical music than my wife [a white native of Denmark] does, I have still been able to preserve the primitive in me."[13] This quotation reflects the complex and conflicted way in which artists of color perceived themselves within a European modernist tradition, epitomized by Picasso's work, that fetishized most of the non-Western cultures it considered "primitive." This label carried with it the burden of colonial oppression and misconceptions. For most artists of the African diaspora, for example, their discovery of African Art and the racial pride it encouraged was through exposure to colonial booty. The African American painter Hale Woodruff's account of his first encounter with African sculpture offers a poignant example:

> Yes it was! And all written up in German, a language I didn't understand! Yet published with beautiful photographs and treated with great seriousness and respect! Plainly sculptures of black people, my people, they were considered very beautiful by these German experts! The whole idea that this could be so was like an explosion to me.[14]

Both Johnson and Woodruff were educated within a Eurocentric academic framework, therefore their only way of understanding the "primitive" in themselves was through its

available Western constructions. Their own work was entangled in the problem of the "distant mirror" or "veil" of negative representation through which colonized peoples have seen themselves, as articulated by such postcolonial writers as W. E. B. DuBois and Frantz Fanon in the twentieth century. With an art historical vocabulary created by Europe, many non-Europeans had to struggle with finding dignity and themselves within a tradition that continued to exclude them as equals. The artist of color had to place him- or herself both within and against the racist paradigms of "primitivism." As Lowery Sims has written, "[T]he agent becomes subsumed by his or her subject[;]" the black artist is known in the Western canon of art history more as a subject than a producer and must, therefore, enter it as subject.[15]

This section on modernism concludes with four essays that show how artists of color have confronted the primitivist legacy of modernism as they created their own artistic identities. Some of these artists ended up being collusive in their own fetishization and dismissal because they could not escape the racialization (and racism) of the modern art tradition à la Picasso. Linsley reveals that Wifredo Lam, an Afro-Asian raised in Cuba and a protégé of Picasso, was well versed in the writers of the radical, postcolonial "Negritude Movement." Though his use of motifs from Afro-Cuban religions like *Voodoo* combined with a Surrealist style were often problematic, he still considered his work visual counterparts, both artistically and politically, to the literary work of authors like Aimé Césaire and Léopold Senghor. Bridging the discussion of European artists' representations of the trope of race and the response of artists of color to this very discourse, Judith Wilson examines, with a rich historical account, how the black sculptor Sargent Johnson responded to these issues within the Afrocentric rhetoric of the Negro Renaissance of the 1920s and '30s. We learn about Johnson's Afro-American Modernism in the context of such black, modernist contemporaries as Elizabeth Prophet and May Howard Jackson. Wilson also offers some insight into Californian art history and the impact of modern art impulses in the Bay Area.

West and hooks discuss how the critical reception of two African American painters a generation apart, Pippin and Basquiat, has been tainted by modernist desires for the "authentic," black naif. Both authors feel that this reception has prevented the serious consideration of each artist's work then and now. Hooks even boldly broaches the issue of subjective audiences and the inability of non-blacks to fully comprehend the work of a black artist, a controversial but relevant topic to the material in this collection.[16] Jean Fisher examines how contemporary Native American artists such as Jimmie Durham, Alan Michelson, and James Luna address the fallacies and realities of their "vanished" culture as represented by many of the cowboy painters discussed in Sweeney's essay in Part Two. The absence and recovery of the indigenous body is the focus of much of this work. Luna's installation of *himself* as an anthropological museum object in *The Artifact Piece* (1987) is one such example discussed.

This collection of essays concludes with a section on art created in the latter half of the twentieth century. Consistent with the globalization of all cultures in the last few decades, the work discussed in these essays addresses the sociopolitical ramifications of the breakdown of racial categorization due to increased interracial and intercultural exchanges. Rasheed Araeen presents the unique position of the "black immigrant artist" and the problems of labeling, displacement, and identity that influence the art these artists create and their critical reception in England. Using his own exhibition, *The Other Story*, as a case in

point, Araeen addresses, what he calls, "the black art" debate and the catch-22 of exhibiting in shows curated by race.

Jae-Ryung Roe's essay reveals the complex web of racial nationalism and modernist impulses that influenced abstract art in Korea. The popularity of abstract or realist art in Korea was often tied to the country's political climate at the time. For example, an abstractionist like Chu Kyung in the 1920s and '30s was considered to be liberated from the foreign influence of realism, brought to Korea through Japanese colonialism, but the opposite was true after 1945. Koreans in Roe's essay negotiated the legacy of Orientalism in constructing their own identities through art.

Speaking to the essays by Gilman, Solomon-Godeau, and Hatt, Enwezor looks at representations of whiteness and blackness as signifiers of nationalism and citizenship in contemporary South African art. Using the work of such black and white artists as Penny Siopis, Santu Mofokeng, and Candice Breitz, he examines how the sociopolitical concept of the "Rainbow Nation," in its aim to recover black subjectivity in all realms, has been antagonistic to whiteness which is essentially represented by Afrikaners, destabilizing certain cultural and racial hegemonic structures. This assault has made the issue of who shall represent the "true" South Africa paramount. For example, Enwezor's discussion of the photomontages of Breitz and their representation of black sexuality reveals an intersection of Freudian and postcolonial theory where the black female body functions as the ultimate "other" in the actualization of both black male and white female identity.

The volume concludes with my essay on the construction of multiethnic identities in both the popular media and by contemporary American artists, such as Lorraine O'Grady, Adrian Piper, Byron Kim, and Paul Solomon. These artists are exemplary of a generation of cultural producers at the end of the twentieth century who feel the burden of race on art history. One cannot fully understand the theoretical and cultural location of *dislocation* in which these artists find themselves without reading some of the previous essays in the volume. Faced with a racialized modern and postmodern tradition at a time in history in which the generational fallout of colonialism, slavery, the Holocaust, and gendered oppression is having global effects, many contemporary art makers cannot deny the simultaneous experience of both dismay and euphoria as we approach a racial "ground zero," so to speak, at the beginning of the new millennium.[17] Placing the work of such artists as Robert Colescott and Kim alongside such popular American icons as Tiger Woods and Sally Hemings, I discuss how these artists problematize how multiracial identity has become a touchstone for the nationalistic desire to eradicate past and future racial conflicts. I also address the implied construction or deconstruction of whiteness in these images.

To some, this essay may appear to bring us full circle to the uses and abuses of the trope of race Clarke delineated in his essay on Roman art in Part One, but, to others, the fresh and complex way in which these contemporary artists approach the conundrum of race and ethnicity conclude on a more optimistic note. Their work acknowledges that multiculturalism is not without its problems and that any binary lens of oppression is increasingly inapplicable and counterproductive. These artists do not believe there will be a utopian "end of race," nor do they consider such a homogenized, "beige" state a good thing, let alone a utopia. Their work serves as an appropriate bookend to the earlier pieces, such as the images of St. Maurice and Manet's *Olympia* addressed in the preceding sections. They leave the reader with both more answers and questions for the discussion of race in art history,

a dialogue I hope will continue as academia and the public at large struggle to create a better language with which to understand race in our visual culture and our lives.

A Note to Teachers

This volume attempts to bring together a variety of essays on race in art history, essays that are sometimes contentious and at other times affirming and revelatory, but are always provocative. That some of the pieces may contradict each other or the views of their editor is, I believe, what makes the collection a useful tool for teaching or for serious contemplation, hopefully both. Many of these essays present views of some of the most canonical artists, such as Pablo Picasso and Edouard Manet, and tackle social and political aspects of their work. Some essays discuss black, Asian, or Latino artists who have been largely ignored. I have attempted to present a mixture of essays by art historians, artists, anthropologists, literary historians, and philosophers that address the Western canon of art history. I have also brought together a variety of prose and rhetorical styles, which provide other points of comparison. Having pedagogical origins, this collection is "user friendly"; one does not have to be an art historian, just a critical thinker, to learn from these essays. Advanced high school students, undergraduates, and graduate students can all benefit from this collection. Because all of the authors view a work of art as a window into the historical and cultural context in which it is created, these essays serve as a springboard for discussions and lesson plans in a variety of classrooms such as those in history, social science, cultural studies, visual studies, media studies, ethnic studies, gender studies, and of course, studio art. Some of these essays address issues of reception and therefore, provide an excellent survey of the scholarship to date of a given artist's work. Teachers should consider the footnotes in each essay to be a bibliography for further reading.

Notes

1. Judith E. Stein, "An American Original" in Judith E. Stein, ed. *I Tell My Heart: The Art of Horace Pippin* (New York: Universe Publishing, 1993), 11.

2. For more on Jewish identity and art, see Richard I. Cohen, *Jewish Icons: Art and Society in Modern Europe*, Berkeley: University of California Press, 1998, and Margaret Olin, *The Nation Without Art: A Study of Modern Discourses on Jewish Art*. Texts and Contexts, ed. Sander Gilman. Lincoln, Nebraska: University of Nebraska Press, Autumn, 2001.

3. Volume 78:4 (December 1996) and volume 57:3 (Fall 1998), respectively.

4. *Racist Culture: Philosophy and the Politics of Meaning* (Cambridge: Blackwell, 1993), 6.

5. *Power/Knowledge: Selected Interviews and Other Writings 1972–1977*, ed. C. Gordon, (Brighton: Harvester Press, 1980), 42.

6. *Black Skin, White Masks* (New York: Grove, 1967 (1952)), 112.

7. Regrettably, this volume does not have an essay devoted solely to representations of whiteness or white ethnicity. The academic discourse on race has just recently produced a plethora of cultural historical examinations of whiteness in the 1990s with such seminal texts as David R. Roediger's *The Wages of Whiteness: Race and the Making of the American Working Class* (1991),

Theodore W. Allen's *The Invention of the White Race* (1997), and Matthew Frye Jacobson's *Whiteness of a Different Color. European Immigrants and the Alchemy of Race* (1998). A good survey of this scholarship is Shelley Fisher Fishkin's "Interrogating 'Whiteness.' complicating 'Blackness': Remapping American Culture" in *American Quarterly*, vol. 47:3 (September 1995), 428–466.

8. For more on how these artists constructed an imperialist and racially complicated view of the West whose legacy we still endure, see the controversial *West as America: Reinterpreting Images of the Frontier, 1820–1920,* ed. William Truettner (Washington, D.C.: Smithsonian Institution Press, 1991), the catalog for the exhibition of the same name, which caused debate and condemnation on the Senate floor, adding to the conservative backlash against federal support for the arts in the 1990s.

9. For more on many of these issues in American nineteenth-century painting, see Peter H. Wood and Karen C. C. Dalton, eds., *Winslow Homer's Images of Blacks: The Civil War and Reconstruction Years* (Austin: University of Texas Press, 1988). See also Albert Boime, *The Art of Exclusion: Representing Blacks in the Nineteenth Century* (Washington, D.C., 1990), and Guy C. McElroy, ed. *Facing History: The Black Image in American Art, 1710–1940* (San Francisco: Bedford Arts, 1990).

10. See page in text.

11. Robert Goldwater's *Primitivism in Modern Painting* (New York: Harper, 1938) must be mentioned here also. The MOMA show enabled, decades later, for Goldwater's work to reach a wider audience and influence more scholarship.

12. See page in text.

13. Quoted in Richard J.Powell, *Homecoming: The Art and Life of William H, Johnson* (New York: Rizzoli, 1991), 78; see Powell's article " 'In My Family of Primitiveness and Tradition': William H. Johnson's *Jesus and Three Marys*" in *American Art*, vol. 5:4 (Fall 1991), 21–23. for more on Johnson and the "primitive."

14. Romare Bearden and Harry Henderson, *A History of African American Art and Artists, 1792 to the Present* (New York: Random House, 1993), 203.

15. Sims, "Subject/Subjectivity and Agency in the Art of African Americans," *Art Bulletin*, vol. 76:4 (September 1994), 587. See also Michele Wallace, "Why Are There No Great Black Artists? The Problem of Visuality in African American Culture" in *Black Popular Culture* (Seattle: Bay Press 1992), and my review, "Black Representation in Western Survey Texts," *Art Bulletin,* vol. 81:3, 533–538.

16. This topic relates to the problem of a "black aesthetic" or any aesthetic that is based upon some monolithic cultural criteria or identity. See such collections as *The African Aesthetic: Keeper of the Traditions,* ed. Kariamu Welsh-Asante (Westport: Praeger, 1993) and *African American Visual Aesthetics. A Postmodernist View,* ed. David C. Driskell (Smithsonian Institution Press, 1995).

17. I am not the only art historian to recognize these trends in contemporary art, by any means. The summer that this book went into production, Holland Cotter wrote an article on "beyond multiculturalism" in contemporary art in which he cited a recent exhibition at the Studio Museum in Harlem of work by contemporary African American artists that the curator, Thelma Golden labeled "post-black" and "post-ethnic." For more see Holland Cotter, "Beyond Multiculturalism, Freedom?" *New York Times,* July 29, 2001, section 2:1.

Black Athenas, Semitic Devils, and Black Magi

Reading Race from Antiquity
to the Middle Ages

1

"Just Like Us"

Cultural Constructions of Sexuality and Race in Roman Art

John R. Clarke

One of the greatest difficulties plaguing the study of Roman art is the persistent notion that the Romans were "just like us." This problematic idea forms the premise and subtext of five centuries of classical studies. If the Renaissance had a deep stock in establishing the legitimacy of early capitalist/bourgeois conceptions of the humanist individual through the study of classical texts, it was because the legitimation of princely politics and ethics required a powerful precedent—no less authoritative and powerful than the fabled Roman empire. Renaissance humanists looked to Cicero, Vergil, and Livy for ways to define the early modern state. Subsequent attempts to legitimate the prince, the absolute monarch, colonialism, nineteenth-century nationalism, and—finally and most terrifyingly—German and Italian fascism, always went back to the ancient Romans, to those same text with their histories of emperors and empire, their great lawyers, statesmen, rhetoricians, moralists, and poets.

Late twentieth-century Euro-American culture is in many ways the end product of centuries of adaptation of ancient Roman texts and cultural artifacts to fit the requirements of an increasingly capitalist, bourgeois, and colonial system. If the Romans seem to be in all things so much like "us," it is because "we" have colonized their time in history. (In this essay I use the words "we" and "us" to denote the white, male elite of Euro-American culture—the person I perceive to be the dominant voice in traditional scholarship.) We have appropriated their world to fit the needs of our ideology.

A revolution has occurred in the study of classical texts, one that has challenged those five centuries of scholarship. On one front, feminist scholars have challenged and problematized the sources in their search for that elusive person, the Roman woman.[1] All the texts that have survived, written either by elite white males or by men working for them, construct—that is, make up—women. Both the poet and the jurist put words in their mouths and devise their actions, whether vile or virtuous. One will search in vain for a woman's commentary on the condition of women of any class, although by deconstructing texts scholars have succeeded in extrapolating information about the elite woman: her legal and marital status, social mores, and political power. Harder to track are the nonelite women—the greatest number of them invisible because they are ciphers, both juridically

and socially: these include free nonelite women, former slaves, slaves, foreigners, and out-
casts (*infames*) like prostitutes.

A second route of inquiry has tried to recover the diversity of people in the Roman
empire by applying the models developed in sociology, economics, cultural anthropology,
and geography (including urban studies and population analysis). The picture that has
emerged is that of an empire loosely organized indeed. Once the Romans had conquered
various peoples of the Mediterranean, they tried to rule with the lightest possible touch,
preferring the laissez-faire accommodations of religious syncretism, local rule, and vassal
(puppet) kings to the heavy-handed direct policing that was so expensive to maintain. As
long as a town or province paid its taxes to Rome and maintained a modicum of civil order,
Rome was happy to let indigenous cultures continue. Again, it seems that modern ideolo-
gies have required Roman rule to be more all-encompassing than it was in reality.[2]

If application of the methodologies of feminist scholarship and the social sciences has
begun to expand the tunnel-vision optic of traditional classical studies of Rome, what can
the study of visual representation accomplish? Central to any project using Roman visual
arts to understand ancient Roman people is the realization that whereas texts addressed the
elite, art addressed everybody. From official imperial art to the wall paintings in a Pom-
peian house, Roman art consciously embraced a far broader audience than the texts. My
recent work has focused on two specialized genres of Roman art, images of human love-
making and representations of the black African, in an effort to understand the nonelite
viewer, the female viewer, and even the non-Roman viewer.[3] It is from this work that I
would like to draw two illustrations of how contextual readings of visual representations
reveal the great differences between Roman culture and our own.

The typical literature on sexual representation in Roman art presents a variety of imagery
in many media—from wall paintings to ceramics and metalwork—under the rubric of
"erotic" art.[4] Authors then try to tack texts onto photographs of these representations: the
reader sees a photograph of a satyr and maenad copulating on one page, and on the facing
page an excerpt from Ovid's *Art of Love*. Never mind that the painting came from the wall
of a house in Pompeii: that it dates from one hundred years later than Ovid's poem; that
the couple is mythical, not human; and that Ovid was writing poetry for the elite whereas
the viewer of this painting may have been illiterate. Yet with few exceptions studies of
Roman so-called erotic art have assumed that Roman visual representations illustrated texts
and that texts "document" Roman sexuality. Erudite studies of Latin words for sexual posi-
tions claim to find corroboration in wall paintings, lamps, even the coinlike *spintriae*—all
considered without regard to their architectural contexts or dates.[5]

If we turn the tables and begin with the context of visual representations of lovemaking,
surprising results emerge. We begin to understand how what seems to be erotic—by which
I mean an image meant to stimulate a person sexually—had a totally different meaning for
the ancient Roman viewer. A good case in point is the painting (dated A.D. 62–79) cut
from a wall of the House of Caecilius Iucundus at Pompeii (fig. 1.1). Antonio Sogliano,
who excavated this large residence in 1873, deemed it obscene and had it carted off to the
infamous Pornographic Collection of the Naples Archaeological Museum. (To this day this
room, filled with mosaics, wall paintings, and small objects, remains barred to the public.)
Yet consideration of the original location of the picture, along with aspects of its imagery,
indicates that it was the pride of the owner's house: it spelled "status," not "sex."

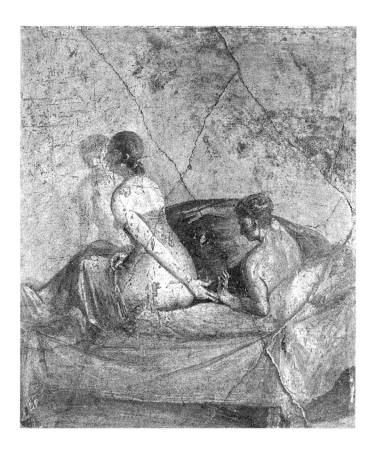

Figure 1.1 Pompeii,
House of Caecilius
Iucundus, peristyle,
Couple on Bed with
Servant. Naples
Archaeological Museum,
inv. 110569
(photo: Michael Larvey).

The owner was a freedman who had enlarged the house to make four dining rooms. The major dining area was the one located on the peristyle; it formed a suite with a luxurious kind of bedroom, one with two niches, immediately to its right. Our "erotic" painting occupied the important space on the peristyle itself between the doorways to these two rooms. Modern scholars, ignoring both the culture of Roman entertainment and the meaning of the picture itself, have assumed that the painting designated the bedroom as a place for a tryst after dining.[6]

We associate bedrooms with sleeping and sexual intimacy; the ancient Romans also used well-appointed bedrooms to entertain guests of a status equal to or higher than their own. The entire Roman house was a place of business; a guest's entrance into a fine cubiculum like this one depended entirely upon his status.[7] This room is not, then, about "privacy"—a concept that does not exist in Roman language or thought—but about high status.

Examination of the painting itself shows that the painter was striving to create an image of upper-class luxury. There is a couple on a richly outfitted bed. The woman holds her hand behind her, whether to conceal her desire to touch the man or to locate him is not clear. He lifts his arm as though in entreaty, but she cannot see this gesture. A nice touch is the way his left hand curves up at the wrist, allowing the artist to show his virtuosity in depicting delicate fingers. The viewer sees these details but the woman does not, allowing the person who looks at this scene of lovemaking to understand the man's entreaty and the

woman's hesitation in a way that the woman—and perhaps her lover also—cannot. In effect, the artist created these nuances of viewing to implicate the viewer as a voyeur. He also included the bedroom servant, the *cubicularius*, to underscore that this was not a poor man's bedroom. He even applied gold to highlight the opulence of fabrics and jewelry. These are all marks of wealth, luxury, and sophistication, similar to the paintings representing lovemaking from the famous villa of the early Augustan period found in Rome under the garden of the Farnesina.[8]

The painting was part of an extensive redecoration campaign with a pointed iconographical program.[9] The adjacent dining room received a refined decorative scheme, including mythological pictures of the Judgment of Paris and Theseus Abandoning Ariadne.[10] Someone entering the cubiculum would have seen relatively large figures at the center of the walls in front to the right and to the left. The room's principal image was a group of Mars and Venus with a figure of Cupid standing in the panel to the right. Bacchus presided over the right wall, on the left wall stood the muse Erato. It seems clear that the artist intended to expand the theme of lovemaking from the human to the divine by associating the vision of aristocratic dalliance in the peristyle panel with an image of passion stirring the quintessential divine lovers, Mars and Venus, in the main panel of the cubiculum. Wine and song, personified by Bacchus and Erato, muse of love poetry, furthered this iconography of amorous pleasures.

This contextual analysis demonstrates that rather than having an erotic function, the painting of lovemaking in the House of Caecilius Iucundus was a sign for the upper-class pretensions of the owner. Like Trimalchio, the wealthy former slave of Petronius's *Satyricon* who delights in explaining his pictures to his (bored) guests,[11] the L. Caecilius Iucundus who dined in this triclinium must have felt a glow of pride when a guest recognized the refinement of his iconographical program, uniting the image of upper-class human lovemaking with the divine pair of Mars and Venus in the cubiculum and the heroic panels of the triclinium. This "erotic" picture was about luxury, not lust.

In an era that advocates study of ethnic, racial, and cultural diversity, it would seem natural to turn to the great melting pot that was ancient Rome to understand how this culture constructed the Other. Again, there is the danger of oversimplification and transference of our Anglo-European culture onto the ancient Romans.[12] Careful contextual study reveals combinations of racial stereotypes and belief systems so different from our own that they simply boggle the late twentieth-century mind.

The excavator who discovered the mosaic of a black bath servant in the 1930s was content to identify him as an ithyphallic pygmy (fig. 1.2).[13] The figure occupies the entryway to the *caldarium* in the House of the Menander. The composition of heraldic strigils framing an ointment jar on a chain fills the outer side of the entryway composition, so that it was the first image that the visitor saw as he or she passed from the dressing room (*apodyterium*) to the *caldarium*. The man carries water vessels (*askoi*), identifying him as a bath attendant: he wears a kind of short kilt that rides above his enormous penis. A laurel wreath crowns his head. Although he is technically macrophallic (i.e., having an unusually large penis) rather than ithyphallic (i.e., with an erect penis), his identification as a pygmy is the more serious error. Images of the pygmy go back to the sixth century B.C.: artists made them short in stature, with large heads in relation to their bodies, the males usually macrophallic.[14] The bath attendant has a different body type. Most important, the artist has differentiated him

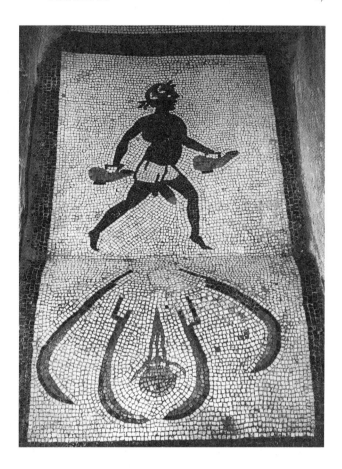

Figure 1.2 Pompeii, House
of the Menander, entryway to
caldarium, Bath Attendant
(photo: Michael Larvey).

from the pygmy by giving him normal proportions. The mosaicist used a saw-tooth con-
figuration of black tesserae to indicate his tightly curled hair. Investigation of comparable
images of black men in Roman art of the period (the mosaic has a firm date of 40–20 B.C.)
establishes that the artist has represented not the mythical pygmy but the real-life Aethiops,
a man from the African continent belonging to a racial and ethnic group attested in con-
temporary texts and visual representations.[15] Since artists made him macrophallic only in
certain sculptures and mosaics, contextual study alone can clarify the meaning of this image.

The bath attendant is poised at the entryway to the hot room of a private bath in a lux-
urious Pompeian house belonging to an elite family. For the ancient Roman, this circum-
stance explains the image: it is a representation with two context- and culture-specific
purposes: to warn the bather of the dangers of the superheated floor of the room he or she
is entering, and to dispel the evil eye through laughter.

The Aethiops is a logical sign to warn the bather about heat because the Romans
believed that the Aethiops's black skin came from being burned by the sun. Because of this
belief, the Aethiops became a metonym for extreme heat.[16] (Similarly, mosaic images of
sandals also appear at the entryways to hot rooms of baths to warn the bather to protect his
or her feet from getting burned.)

More complex and difficult for us to understand is our bath attendant's apotropaic func-
tion. Ancient Romans believed that the envious person (the *phthoneros* or *invidus*) could

cause illness, physical harm, and even death by focusing his or her eye on the person whom he or she envied. Although there were many theories on just how such harm could come to a person without physical contact, most believed that the *invidus* was able to focus this grudging malice through his or her eye; this so-called evil eye emanated particles that sur-rounded and entered its unfortunate victim.[17] A person could encounter the envious evil eye anywhere, but was particularly susceptible in baths and at passageway spaces, such as doorways. People wore amulets on their persons, and artists frequently put symbolic images on floors or walls of dangerous, liminal spaces. These *apotropain* in mosaic and fresco included the representation of the evil eye itself attacked by spears, scorpions, dogs, and the like, as well as images of the erect phallus, sometimes in conjunction with the vagina. In the first instance the image enacts direct aggression against the evil eye; in the second it invokes male and female fertility, the life force, for protection from death.

By making the oversize phallus the attribute of the Aethiops, our mosaic adds yet another apotropaic element: ατοπια or "unbecomingness." The bath servant is "unbecom-ing" and therefore quite funny because he is outside the somatic norms of the Roman elite. Unbecomingness dispelled the evil eye with laughter.[18]

The male Aethiops is not always a comic figure in Roman art: the key to understanding Roman elite attitudes toward him lies in defining what were their norms of ideal male beauty. Briefly, an ideally beautiful man would be of the Caucasian race, of medium stature, with an olive complexion and wavy brown hair. Tall, blond or red-headed Germans were as foreign to this ideal somatotype as the Aethiops.[19] So were men with large penises.[20] It comes as no surprise that our bath attendent makes the perfect *apotropaion*. He is the comic reversal of accepted standards of male beauty, and his large penis makes him doubly effec-tive against the evil eye.

Just as in the case of the seemingly erotic picture, the mosaic of the bath attendant seems hypersexual or "racist" only to the modern viewer who lacks the requisite cultural conditioning and belief systems. Analysis of these images in terms of their contemporary cultural contexts means giving them back the efficacy and power that they held for the ancient viewer. In my opinion it is the art historian's job to empower visual representation by putting objects that have become "orphans" back in their rightful cultural homes.

Whether we have created these orphaned objects by physically removing them from their original settings or simply by photographing them and discussing them in abstract terms (thereby leveling differences of time, place, and culture), as soon as these objects are removed from their original contexts they are no longer part of the culture that created them: they become part of our (or the dominant) culture, expressing our desires, our pre-conceptions, and our prejudices. It is only in this sense that our culture has succeeded in making the ancient Romans "just like us."

Notes

1. For three recent collections of essays, see Nancy Sorkin Rabinowitz and Amy Richlin, eds., *Feminist Theory and the Classics*, New York, 1993, bibl. after each essay and 305–7; Elaine Fantham et al., *Women in the Classical World: Image and Text*, New York, 1994, bibl. after each essay; and

Richard Hawley and Barbara Levick, eds., *Women in Antiquity: New Assessments*, New York, 1995, bibl. 248–64.

2. Peter Garnsey and Richard Saller, *The Roman Empire: Economy, Society and Culture*, Berkeley, 1987, synthesize much of the current revisionist scholarship.

3. See John R. Clarke, "Hypersexual Black Men in Augustan Baths: Ideal Somatotypes and Apotropaic Magic," in Natalie B. Kampen, ed., *Sexuality in Ancient Art*, Cambridge, 1996, 184–98; and idem, *Looking at Lovemaking: Sexuality in Roman Art—Constructums, 100 B.C.–A.D. 250*, Berkeley, forthcoming.

4. This pattern was set up in Jean Marcadé, *Roma Amor: Essay on Erotic Elements in Etruscan and Roman Art*, Geneva, 1965; and idem, *Eros Kalos: Essay on Erotic Elements in Greek Art*, Geneva, 1965. A particularly lamentable recent example of the text/image pastiche is *Eros grec: Amour des dieux et des hommes*, exh. cat., Paris, Grand Palais, Athens, 1989.

5. This approach, pioneered in Gaston Vorberg, *Glossarium Eroticum*, Stuttgart, 1932, continues in Werner Krenkel, "Figurae Veneris," *Wissenschaftliche Zeitschrift der Wilhelm-Pieck-Universität Rostock*, xxxiv, 1985, 50–57.

6. Arnold de Vos, "Casa di Cecilio Giocondo," in *Pompei pitture e mosaici*, III, Rome, 1991, 375.

7. Aristocrats regularly used cubicula for meetings with peers or their social betters. The ancient literature includes five instances of Romans receiving friends *in cubiculo*, three of their conducting business there, and four of emperors holding trials *intra cubiculum*: see Andrew Wallace-Hadrill, *Houses and Society in Pompeii and Herculaneum*, Princeton, NJ, 1995, 17. n. 2.

8. Irene Bragantini and Mariette de Vos, *Le decorazioni della villa romana della Farnesina*. Museo Nazionale Romano, II, pt. 1: *Le pitture*, Rome, 1982, pls. 40, 51, 85, 86, 96, 172.

9. See August Mau. "I scavi di Pompei," *Bullettino dell' Instituto di Corrispondenza Archeologica*, 1876, 149–51, 161–68, 223–32, 241–42 for a description of the now-destroyed or removed paintings.

10. Naples, Archaeological Museum, inv. 115396; see de Vos (as in n. 6), fig. 74; and Mau (as in n. 9). 226.

11. Frescoes greet Trimalchio's guests: a trompe-l'oeil painting of a dog (with the legend CAVE CANEM—"Beware of the Dog") and the story of his life told through allegories of divine intervention (Petron., Sat., 29). Trimalchio interprets the Zodiac in an elaborate dish served to his guests (39); offers a ridiculous iconographical explanation of the imagery in his silver vessels (52); and orders up the iconographical program for his tomb (71).

12. A case of such oversimplification is Frank M. Snowden, Jr., *Before Color Prejudice*, Cambridge, MA, 1983, who argues that there was no "color prejudice" toward blacks in classical antiquity.

13. Ameden Maiuri, *La casa del Menandro e il su Tesoro de Argentena*, Rome. 1933, i. 146.

14. For the iconography of the pygmy in Greek myth. see Veronique Dasen, *Dwarfs in Ancient Egypt and Greece*, Oxford, 1993, 182–91.

15. The most comprehensive coverage is Jean Vercoutter et al., *The Image of the Black in Western Art: 1. From the Pharaohs to the Fall of the Roman Empire*, New York, 1976; see also Frank M. Snowden, Jr., *Blacks in Antiquity*, Cambridge, MA, 1970.

16. For a full discussion of the evidence, in both Greek and Roman authors, for this environmental theory of color, see Snowden (as in n. 15), 2–3, 172–74. See also Jehan Desanges, review of Lloyd Thompson, *Romans and Blacks*, Norman, OK, 1989. *Revue des Etudes Latines*, LXVIII, 1990, 233.

17. M. W. Dickie and Katherine M. D. Dunbabin, "*Invidia rumpantur pectora*: The Iconography of Phthonos: Invidia in Graeco-Roman Art," *Jahrbuch für Antike und Christentum*, XXVI, 1983, 10–11.

18. Doro Levi, "The Evil Eye and the Lucky Hunchback," in *Antioch-on-the-Orontes*, ed. Richard Stillwell, III, Princeton, NJ, 1941, 225. Luca Giuliani, "Der seligen Krüppel: Zur Deutung von

Mißgestalten in der hellenistischen Kleinkunst," *Archaologische Anzeiger*, 1987, 701–21, sees images of physically deformed people less as charms against the evil eye than as vehicles to remind people of their own good fortune and well-being. It is possible that the artist created another reference to the apotropaic phallus, this time within a vagina, in the arrangement of heraldic strigils on either side of the ointment jar on a string that immediately precedes the image of the bath attendant. In a visual pun, the ointment jar becomes the phallus, and the strigils the labia of the vagina. A striking parallel for this representation comes from Sousse in Tunisia, where two public triangles representing vaginas flank a fish-shaped phallus (see UNESCO, *Tunisia: Ancient Mosaics*, New York, 1962, pl. 21): I owe this observation and reference to Anthony Corbeill.

19. Thompson (as in n. 16), 16–17, 35–36.

20. For the Greek aesthetic preference for men with small penises, see Kenneth J. Dover, *Greek Homosexuality*, Cambridge, MA, 1978, 125–35; and Timothy J. McNiven, "The Unheroic Penis: Otherness Exposed," *Source*, xv, no. 1, 1995, 10–16. Roman art and literature corroborate and continue this preference: as late as ca. A.D. 400 an author vilifies the emperor Heliogabalus by elaborating on his taste for men with large penises (Scriptores Historiae Augustae, *Heliogab.*, 8.6, 12.3, 26.5; for different accounts, see Cassius Dio, *Hist. Rom.*, 80.6, 80.14, 80.15.4; and Herodian, *Historia*, 5.3.7, 5.8.1).

2

Imaging the Self

Ritual and Representation
in a Yiddish Book of Customs[1]

Diane Wolfthal

In medieval and early modern Europe, Christians often constructed Jews as a distinct and inferior race. The visual culture served as a primary means for achieving this end. Numerous images show Jews with darker skin, flaming red hair, large hooked noses, and defective bodies.[2] Furthermore, artists frequently contrasted the appearance of Jews with that of Christians, a practice that served to reinforce the idea that Jews and Christians formed two discrete racial categories. Such stereotypes were reinscribed by later art historians. For example, in 1969 James Stubblebine described Giotto's *Betrayal of Christ* as follows:

> Christ . . . stands out because of the fiery magnificence of his head. It is an altogether Olympian cast of face: Giotto has here magnified the noble brow and given Him an even finer, straighter nose than in the other scenes. Judas, on the other hand, is like some lower order of primate, with short brow, deeply inset and dishonest eyes, curved nose, and small chin. His lips are pursed in a mixture of brazen insolence and cowardice. Once again, Giotto has drawn the sharpest possible contrast between two figures and two states of mind.[3]

Yet real Jews were not so easily distinguished. Otherwise why would Christians have found it necessary to mark them with a distinctive badge or hat?[4] A series of recent books has explored the medieval and Renaissance conception of the Jew by relying on the evidence of Christian art.[5] But however valuable these studies are, images made by and for Christians can offer only a partial view of how Europeans visualized Jews. This essay will present another perspective by examining how Jews constructed themselves in a long-neglected *Sefer Minhagim*, or book of religious customs, which was produced in Northern Italy at the turn of the sixteenth century.[6]

The only surviving illustrated Yiddish manuscript, the *Sefer Minhagim* is remarkable in several ways.[7] It is profusely illustrated with extraordinary images, its artist Jewish and its intended audience nonelite. The book of customs raises innumerable issues, but in this essay, I shall explore only a few. First, although the religion of illuminators of Jewish manuscripts cannot usually be determined, in this case evidence overwhelmingly supports the

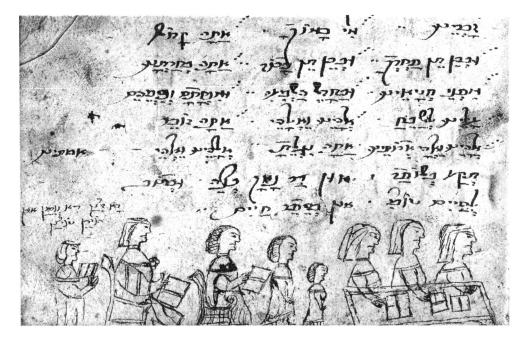

Figure 2.1 Rosh Hashanah (women): Hébreu 586, fol. 43, B55/967. Bibliothèque nationale de France.

conclusion that he, or less likely she, was Jewish.[8] To begin with, except for several figures that were added at a later date,[9] a single artist drew all the images in the manuscript, and these drawings consistently construct the visual narrative so that it proceeds from right to left, paralleling the direction of the Yiddish text. In addition, the images reveal an intimate knowledge of Jewish life. For instance, on folio 8v the artist properly represents the complex gesture of the *birkat kohanim,* or priestly blessing, with hands at shoulder level, fingers pointing downwards, right hand higher than the left, and the two hands brought together to form five openings.[10] Finally, the inscriptions within the miniatures are not only written correctly in Hebrew letters, but with the same handwriting and in the same ink as the captions and text, thus confirming that the scribe was the illustrator.[11] Since the *Sefer Minhagim* presents a rare case of an illuminator of a Jewish manuscript who is known to be Jewish, this essay will explore how one Jewish artist interpreted his own rituals. This essay will begin by comparing the imagery in the *Sefer Minhagim* to that in contemporary Christian books of Jewish customs, in order to demonstrate how the manuscript constructs Jewish ritual from an insider's point of view.

But one Jew cannot speak for all Jews. Rather, the images under discussion visualize the outlook of Jews who lived at a particular time and place, and belonged to a specific socioeconomic class. Traditionally historians of Jewish art have focused on only one type of patron: wealthy and educated men who commissioned luxury manuscripts written in Hebrew. Such works, however, express the viewpoint of only a small group of elite Jews.[12] In contrast, the *Sefer Minhagim* was probably commissioned for someone in the middle rank of Jewish society. Geared for the Yiddish reader, its text is written in the vernacular

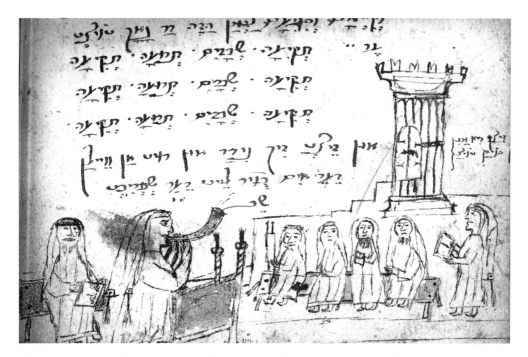

Figure 2.2 Rosh Hashanah (men): Hébreu 586, fol. 42v, B55/266. Bibliothèque nationale de France.

language, with prayers reproduced in the obligatory Aramaic and Hebrew. Furthermore, the manuscript's illustrations are simple line drawings executed on paper in an amateurish style, not luxurious miniatures painted on parchment by a professional artist. For this reason, the second part of this essay will compare the imagery in the *Sefer Minhagim* to that in two other books of customs, which were printed in the same language, for a similar audience, in the same geographical region, but about a century later, in 1593 and 1600.[13] Such a comparison will suggest that Jewish images produced in the ghetto years express a different mood than those from an earlier time. The final section of this essay will explore the striking transformation in the representation of gender that took place over the course of the sixteenth century in Yiddish books of customs and relate that change to the manuscript's patronage and provenance. With its Jewish artist and nonelite audience, the *Sefer Minhagim* opens a new window through which to explore how North Italian Jews around the turn of the sixteenth century imaged themselves and their customs.

The *Sefer Minhagim*, today in the Bibliothèque Nationale in Paris, is richly illustrated on 94 of its 128 folios with pen and wash drawings. Most are line drawings executed in brown ink, but a few show freely added washes of pale red, pink, brown, blue, and green. Although the vast majority depict religious rituals, a minority show nonrepresentational decoration, historical figures, animals, or monstrous creatures. As a rule, the text occupies the center of the folio, with the imagery relegated to the margins (figs. 2.1–2.3). Generally, one or more scenes appear on a single page, but occasionally a single representation spreads over two adjacent folios (figs. 2.1 and 2.2). The drawings may not have been planned from

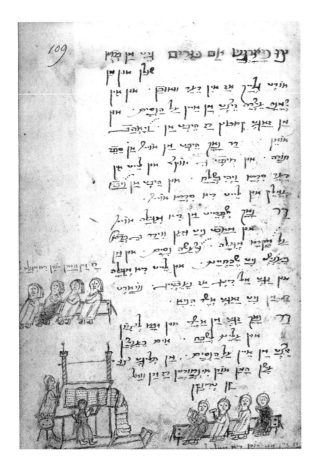

Figure 2.3 Reading the Megillah:
Hébreu 586, fol. 109.
Bibliothèque nationale de France.

the start, since extra space was not reserved for them; the margins with images are just as wide as those without. For this reason, it is unclear whether the drawings were produced concurrently with the text, or only upon its completion.[14] The outer margins of the manuscript have been slightly cropped, and the volume is now tightly bound in a modern binding, making it difficult to view the drawings in the inner margins.

The purpose of the book was to teach the "proper" way to perform Jewish ritual, and generally the drawings in the *Sefer Minhagim* idealize Jewish traditions. They include numerous realistic details, not only the *birkat kohanim*, but also the way the *megillah*, or scroll of Esther, falls in rolls on the floor as it is being read, and the different noisemakers that are used on *Purim*, the Festival of Lots, to deride Haman's name (fig. 2.3). But realistic details should not be taken as a sign of objectivity. For example, the artist shows a range of Jews: young and old, men and women, those with beards who wear ritual garments and hold the Torah, or five books of Moses, and those in revealing tight pants who party on *Purim* (figs. 2.1 and 2.2). But no destitute Jews or badly behaved Jews are included in this idealized picture of Jewish life.[15]

A comparison with contemporary Christian prints of Jewish ritual helps clarify the viewpoint of the imagery in the *Sefer Minhagim*. First, the Christian images, which are often anti-Semitic, contain innumerable inaccuracies. For example, a woodcut in Johannes

Figure 2.4 Pfefferkorn, "Libellus
Judaica Confessione" (Cologne,
1508), 7b. Courtesy of the Library
of the Jewish Theological Semi-
nary of America.

Pfefferkorn's *Libellus de Judaica Confessione* of 1508 incorrectly renders the priestly blessing
and misinterprets the fringes on the *tallit*, or prayer shawl, as a single large tassel (fig. 2.4).[16]
But the Jewish artist not only had an intimate knowledge of these rituals, he was also try-
ing to instruct the reader in their proper performance. For these reasons, he renders Jewish
customs with greater accuracy. Furthermore, whereas the Jewish artist shows a range of
Jews, in Pfefferkorn's print all Jewish men are cleanshaven and wear identical garments,
illustrating a truism of racism, that to outsiders members of a group all look alike.[17]

Most importantly, Christian prints of Jewish ritual denigrate Jews. Some, such as
Thomas Murner's frontispiece of 1512, do this by showing Jews wearing the compulsory
Jewish badge.[18] Others depict the disparaging physical features that comprised the stereo-
type of the Jew.[19] The images in the *Sefer Minhagim*, in contrast, exclude such denigrating
signs. Similarly, although Pfefferkorn's illustrations consistently show Jews blindfolded in
order to indicate that they do not see the truths of Christianity, eyes do see in the drawings
in the Yiddish manuscript: they look intently at the Torah scrolls, read from the *megillah*,
and focus, totally absorbed, on prayer books (figs. 2.1–2.4). In a scene of *Simhat Torah*, a
joyous celebration of the Torah, a man, eager for a small boy to see the open scroll, lifts
him high to gain a clearer view.

Christian prints also denigrate Jewish women by showing them talking during services.
In Pfefferkorn's book, two women turn towards each other as one raises her hand in a
speaking gesture (lower left, fig. 2.4). Chatting during services did occur, but was severely

criticized by Christian and Jew alike, and therefore would have been interpreted nega-
tively.[20] In contrast, images in the *Sefer Minhagim* show women paying close attention to
the religious services. At *Rosh Ha-Shanah* they gaze intently at the blowing of the *shofar*;
on *Purim* they focus on the *bimah*, the lectern where the *megillah* is read (figs. 2.1, 2.3).
The captions confirm their attentiveness. One reads, "Here sit the women and hear the
shofar," the other explains, "These are the women listening to the *megillah*."[21]

Similarly, Christians often constructed circumcision as a bloody ordeal that was a sor-
rowful event for mother and child alike. One nun, Margaretha Ebner, reported a typical
vision in which the Christ Child told her, "Joseph held me [at the circumcision] because
my mother was not able to do it on account of the pain she felt. She cried bitterly, and I
cried and endured much blood."[22] Christian images depict the ritual in a similar manner,
often focusing on the knife held in the hand of the Jewish *mohel*, or circumciser.[23] In con-
trast, in the *Sefer Minhagim*, the circumcision is celebrated joyously; no hint of pain, sor-
row, or blood is introduced.[24] The actual act is not depicted and no knife is shown. Rather,
the only image for the circumcision shows the custom of lying-in. The mother rests in bed
beside her swaddled son, attended to by another woman, while, to the left, food is served
and the wine for the benediction is displayed.

Besides idealizing Jewish customs, this manuscript also differs from its Christian counter-
parts in that Christians do not appear as witnesses or framing figures.[25] For example,
Pfefferkorn's print shows a Christian lighting a lamp during services (fig. 2.4).[26] This man,
with whom the Christian viewer would have identified, is not a neutral figure, since he
holds in his right hand three objects that are rendered as small circles inscribed with a cross.
Some have described these as ordinary pieces of bread, and suggested that they were meant
to ridicule the Jewish fast.[27] It is more likely that they represent hosts, which were often
depicted in this manner. In this scenario, the Christian would be extending his hand towards
the center of the sanctuary to offer the hosts to the Jews. But the Christian print constructs
the Jews as blind, and so unable to accept the offering. In contrast, in scenes of worship and
ritual in the Yiddish manuscript, Christians are irrelevant; they do not appear at all.[28]

But Christians are an implied presence in another group of images in the Yiddish book,
depictions of Jews' oppression. This type of representation, however, does not appear in
Christian books of Jewish rituals. A critical element of many Jewish holidays, including
Purim, Passover, and *Hanukkah*, is the remembrance of past persecution, its association
with present tribulations, and the expression of the belief that as in the past, so in the
future, Jews will be delivered from their enemies. For example, medieval and early modern
Haggadot, the ritual books used at the Passover *Seder*, often include scenes of dogs pursu-
ing hares, which symbolically represent Christians persecuting Jews.[29] Similarly, depictions
of ancient tragedies are often shown as contemporary events.[30] The Yiddish manuscript
remembers past persecutions in a series of images: the prophet Gedaliah is threatened with
execution; Nebuchadnezzar lays siege to Jerusalem; Amalek, the archetypical persecutor of
the Jews, wears an enormous sword;[31] and on *Tishah be'-Av*, men mourn the destruction of
the Temple by sitting on the ground barefoot and reading the Book of Lamentations. Such
scenes recall not only past trauma, but also present ones through their contemporary dress,
furnishings, and weapons. In contrast, Christian books of Jewish ritual consistently omit
all scenes of the persecution of Jews. Recent scholars, most notably Marc Michael Epstein,
have demonstrated how Jews, through their visual culture, negotiated the anti-Semitism

that was rampant in the dominant society, and perhaps there is some sense of that in the scenes of remembrance in the *Sefer Minhagim*.[32] But Marc Saperstein has cautioned that "there was more to Jewish history than a progression of uninterrupted persecution and suffering," and the images in the Yiddish manuscript demonstrate the truth of this assertion.[33] Scenes of Jews' oppression, though present, are kept to a minimum. Of the eighty-six images, only four show such subjects.

All in all, the drawings in the *Sefer Minhagim* construct a celebratory view of Jewish life; the manuscript is filled with scenes of dancing, feasting, and drinking. Men and women dance together at a wedding and on the *Shabbat* following *Tishah be-Av*. Five scenes are devoted to eating, including *Shavuot*, the holiday of first fruits and the giving of the Torah, and *Sukkot*, another harvest holiday, which commemorates the temporary structures in which Jews lived while wandering through the Sinai. In the latter image, the caption refers *only* to eating: "He eats in the *sukkah*," or tabernacle.[34] Additional scenes are devoted to baking *mazzah* and preparing fish. Several folios show drinking. One, for *Purim*, includes four separate drinking vignettes. Another shows a man who holds a wine glass and stands near a large wine vessel, while his companion observes: "Good wine makes me happy."[35] Similarly, the inscription for the *Purim* fool, who holds a wine goblet and huge jug, reads, "The fool is happy on little *Purim*."[36] The manuscript ends with the largest drawing, which covers more than half the page, a scene of dancing, eating, and drinking on *Purim,* whose caption reads: "They celebrate *Purim* and eat and drink and dance."[37]

This celebratory mood is one of the aspects that differentiate the manuscript version of the *Sefer Minhagim* from the later printed Yiddish editions, which were published in Venice in 1593 and 1600.[38] A comparison with these woodcuts will better clarify the artist's viewpoint towards Jewish ritual. For example, unlike the more restrained drawing of *Tishah be-Av* in the manuscript, the woodcuts in the later printed books show men weeping, head in hand, and the temple engulfed in flames. Similarly, although the manuscript lacks an image of dogs chasing a hare,[39] the edition of 1600 repeatedly shows a woodcut of this subject. Furthermore, although no funeral scene appears in the manuscript, this dark theme is included in the edition of 1593. One possible explanation for the more joyous mood in the earlier version is that Italian Jews at the turn of the sixteenth century felt relatively carefree, far from the more severe persecutions of Spain and Germany, and still years before the institution of the ghetto.[40] But it is also clear that the shift in mood between the earlier and later versions of the *Sefer Minhagim* parallels that in Christian culture, which, according to Elliot Horowitz, "tone[d] down popular celebrations" in the post-Tridentine period.[41]

In addition to the more joyful mood, another feature differentiates the earlier manuscript from the later printed books: the rabbi plays a minimal role. In the printed books, he delivers sermons and marries the bride and groom, but in the earlier manuscript, he performs neither of these functions. This aspect also parallels that of post-Tridentine Christianity, which sacralized popular culture and strengthened the role of the priest.[42]

The last feature that distinguishes the manuscript from the later printed versions is the treatment of gender. One problem in discussing this issue is determining the gender of the figures represented in the manuscript. Because the artist's style is naive and untrained,[43] gender must be determined through costume and inscription. Women wear a short head cloth or roll their hair into a net; men cover their heads with a flat-topped hat, a close-

fitting cap, or a *tallit*. Figures with beards and pants are indisputably male, and only women's clothes show a scooped line just above the breasts. Only rarely is the body helpful in determining gender, but the clearly defined breasts of a figure bathing for *Rosh Ha-Shanah* reveal that she is a woman. Finally, the caption often confirms the gender of the figures. The Yiddish words "ער" or "דער" indicate a man, whereas "דיא" may refer to a woman or group of people.[44]

The images of the *Sefer Minhagim* construct an ideal, and part of this ideal is that women are secondary to men. First, men are depicted more frequently. Whereas the vast majority of images (fifty-four) show only men, a tiny minority (seven) depict only women. Second, men occupy the more privileged spaces. Not only do they appear more often in synagogue, but even when women are represented there, they are never permitted near the *bimah*, Torah, and ark, the cabinet where the Torah is stored; these locations are reserved for men. Only men stand at the *bimah* on *Purim*, and only men are seated before the ark and hold the Torah on *Rosh Ha-Shanah* (figs. 2.1–2.3). Although the men face the figure who blows the *shofar*, or ritual ram's horn, the women, relegated to a separate page, see only his back.

Furthermore, men are often constructed as active, whereas women are passive. For example, at *Rosh Ha-Shanah*, a man blows the *shofar* while women listen, and at Purim, only men hold noisemakers; the women's hands are empty (fig. 2.3). Similarly, a man blesses a woman, but not the reverse, and a man lights the menorah, or Hannukah candelabra, while a woman observes. For *Havdalah*, the ceremony that ends *Shabbat*, only men hold the ritual objects and the women are pushed to one side, and for *Pesah*, or Passover, only the men are deemed worthy to collect and destroy the *hamez*, or leavened bread.[45] Furthermore, the captions reinforce the visual message that in synagogue women listen, whereas men speak and act (figs. 2.1, 2.3).

This said, the manuscript nevertheless shows women in a positive light. Although, as we have seen, Christian images denigrate Jewish women by showing them blindfolded, wearing a Jewish badge, or talking during services, the drawings in the *Sefer Minhagim* do not. Even some Jewish manuscripts denigrate Jewish women; several fourteenth- and fifteenth-century Hebrew-language *Haggadot*, the ritual books used at the Passover Seder, or ritual meal, include an image of the husband pointing to his wife to indicate that she is bitter, like the vegetable *maror*.[46] No such motif occurs in the Yiddish manuscript, which idealizes women.

Furthermore, the earlier manuscript shows women participating more fully in rituals than the later Yiddish books. For example, in the manuscript, at Rosh Ha-shanah, the women are down on the main floor, and not hidden by a curtain, screen, or wall (fig. 2.1). Furthermore, they are as large as the men, they occupy the foreground space, each has an open prayer book, and the only child that is depicted is a girl. In contrast, in the edition of 1593, women do not appear in the woodcut for Rosh Ha-Shanah at all. Similarly, in the edition of 1600, women peer down through the upper story windows, distanced from the *shofar*, the *bimah*, the ark, and the holy books that are central to the Jewish service (fig. 2.5). Whereas nine men are depicted in the foreground, several in full figure, only three women are included, all cut off at bust length and relegated to the background. Only one child is shown, a son. For Purim, the earlier manuscript includes images of women drinking, feasting, dancing, and listening to the reading of the *megillah* in synagogue (fig. 2.3). Moreover,

Figure 2.5 "Rosh Ha-Shanah" from Book of Customs, Venice, 1599/1600, Opp.4° 1004, folio 51r. Courtesy Bodleian Library, University of Oxford.

in the latter scene, the women are not isolated from the men on a separate page, but rather included on the same folio and in the same space (fig. 2.3). In contrast, the later printed books show only a group of costumed men for *Purim*.

Similarly, the earlier manuscript lacks a scene of circumcision. Instead, to illustrate the *Berit milah*, the artist shows the lying-in ritual, which focuses on women. Three women appear in this image and all are major characters. The mother lies in her bed beside her son; a second woman attends to her, while a third serves food. Neither the *mohel* nor the male relative who holds the child during the act of circumcision is clearly indicated at all. In contrast, in the edition of 1593 no woman appears in the circumcision scene. In that of 1600, a woman is introduced, but she must stand in the doorway, off to the side, a partial figure, cut off by the frame.

Moreover, the manuscript, which includes many more illustrations than the printed books, shows a greater number of rituals performed only by women. A woman lights the Shabbat lamp, and another, holding a round *mazzah*, embodies Pesah in a list of holidays at the end of the manuscript. Furthermore, only a woman counts the days of *Omer*,[47] only a woman assaults Amalek,[48] only a woman bathes on *Rosh Ha-Shanah*,[49] and only a woman performs *Tashlikh*.[50] In contrast, the later printed books visualize only one rite performed solely by women: the lighting of the Shabbat lamp.

In addition, other drawings show women performing rituals on an equal basis with men. The sheer number of such images and their proportion to the total imagery also constitutes

a major difference from the later printed books. Together women and men bake mazzah and fetch water for Pesah; they become engaged and marry. They share meals on *Pesah,* Shavuot, and Purim. Furthermore, Queen Esther is included, along with Moses and Gedaliah, among the representations of positive figures from the Jewish past.[51] An image, whose inscription reads "they pray" (די אויון), is particularly striking in its similar treatment of the man and the woman, who stand to either side of a lectern, which displays an open book. Nor is this the only drawing to suggest the idea of female literacy. A woman counts the days of *Omer,* which are written in Hebrew, and on *Rosh Ha-Shanah* women hold open books (fig. 2.1).

Another way in which women are shown like men in this manuscript is that they enjoy themselves. As we have seen, they are repeatedly shown eating, drinking, and dancing. Similarly, men as well as women attend to children. For example, it is a man who lifts a small child so he may gain a clearer view of the open Torah on Simhat Torah. Furthermore, more men than women are shown preparing food; thus only men ready the fish for *Rosh Hodesh.*

In summary, most images in the manuscript construct traditional gender roles, but women are consistently portrayed in a positive light, and also appear in a strikingly broad range of roles, in some cases depicted as equal to men, and in a few instances highlighted as the sole performer of a ritual. To what may we attribute these unusual qualities? Shalom Sabar and Howard Adelman have shown that, in contrast to much of Jewish history, contemporary Italian Jewish women strove to participate fully in a wide range of societal roles.[52] Women became writers and used *teffilin,* the phylacteries traditionally worn by men, and a contemporary woman's prayer book, written in Northern Italy in 1480, transformed the morning prayer to read, "Blessed are You . . . who made me a woman and not a man."[53] Sabar also argued that although Sephardic and Northern European images tended to denigrate women and show them in a submissive manner, Italian ones more often elevated women.[54] Certainly the Italian provenance of the manuscript helps to explain the unusual features in the representation of gender.

Another possible explanation is the book's patronage. Could this manuscript have been produced for a woman? Suggestive of a female audience is the positive tone of the images of women, the vernacular language of the text, and the broad range of ritual roles for women.[55] But evidence remains inconclusive on this point. The *Sefer Minhagim* may also represent an early stage of a phenomenon that Chava Weissler demonstrated existed later on, namely, that the less elite a Jewish author was, the higher his view of women.[56] Certainly the image of womanhood constructed in this manuscript would not have been every Jew's ideal. Some Italian rabbis, for example, vociferously opposed mixed dancing and the portrayal of nudity.[57]

Another reason for the unusual representation of gender is the manuscript's date. Long ago, Joan Kelly suggested that women experienced a loss of rights and freedoms over the course of the Renaissance, and evidence has been mounting ever since to support her thesis.[58] Women's legal and economic rights were abridged, the number of women who worked outside the home decreased dramatically, women were increasingly portrayed in a negative light, and conduct books sought to restrict women's behavior.[59] These changes did not apply only to Christian women. Agnes Romer Segal has demonstrated that Yiddish books on women's commandments were stricter at the end of the sixteenth century than at the

beginning.[60] Similarly, the images in the earlier Yiddish manuscript construct a larger and broader role for women than those in the printed books produced almost a century later.

Conclusions

In short, the images in the *Sefer Minhagim* present a radically different view of Jews than those shown in contemporary Christian images of Jewish ritual. The drawings in the Yiddish manuscript remember past persecutions of Jews, idealize Jewish customs, show a range of Jews, and deem Christians irrelevant in scenes of worship. But Jews were part of the larger society, and paralleling Christian culture, when the earlier Yiddish images are compared to later ones, women play a broader role, rabbis participate only minimally, and holidays are constructed not only as solemn rituals, but also as joyous celebrations.

In the past some scholars have interpreted images of Jewish rituals as if they were mirrors of reality that had a "documentary value" or that "document[ed] the rite faithfully."[61] But recent art history has shown that no representation is a passive reflection of reality; all are cultural constructions that have a point of view. For this reason, before we can determine what these images tell us about the practices of past Jews, we must explore their ideological stance. Like Christian art, Jewish illuminations expressed a range of viewpoints. Marc Epstein has demonstrated that some Hebrew manuscripts employ animal symbolism to subvert the anti-Semitic messages of the dominant culture.[62] Conversely, Ruth Mellinkoff has suggested that other Jewish manuscripts incorporate "hate signs."[63] The *Sefer Minhagim* adopts yet another strategy by offering one Jew's ideal of Jewish ritual. But certainly not all Jews would have shared this ideal. Here rabbis play a minor role and pleasure is highlighted. Men and women dance together to the raucous music of the bagpipe, and a naked woman's uncovered hair and breasts are exposed not only to the gaze of the man in the drawing, but also to the viewer's gaze. Such elements, which would have been opposed by the more conservative members of the Jewish community, may well be a manifestation of the nonelite nature of the manuscript's patronage. Rather than expressing an essential, universal Jewish point of view, in this manuscript Jewish identity is multilayered and specific: the class is nonelite, the costumes are Italian, the script is Ashkenazic, and the joyous mood represents but a moment in Jewish history. But this is a moment worth exploring. The *Sefer Minhagim* has been overlooked in large part because its imagery has been deemed of low quality. But if we broaden our definition of the type of object that is worthy of study, we have much to learn.

Notes

1. This essay is based on papers that I presented in 1999 at a symposium at Leeds University and at the annual conference of the Association for Jewish Studies. I wish to thank the organizers of those sessions, Eva Frojmovic and Judith Baskin. I am also grateful to Joel Gereboff, Chava Weissler, and Maurice Wolfthal for their careful reading of preliminary versions of this essay, to Elisheva Baumgarten, Corine Schleif, and Elisheva Carlebach for raising important questions, and

to David S. Areford and Walt Rhinehart for bibliography. I wish to express my thanks to Yael Zirlin of the Centre de Recherche sur les Manuscrits Enluminés, Bibliothèque Nationale de France, Paris, for sharing with me the iconographical index that she is preparing and to Michel Garel of the Bibliothèque Nationale for his kind help. I am especially grateful to Jean Baumgarten for his aid in understanding aspects of the text of the Paris *Sefer Minhagim*. This essay is part of a book that I am writing on *Jewish Ritual, Romance, and Remembrance: Images of Early Yiddish Books*. Grants from the Lucius N. Littauer Foundation, the College of Fine Arts, Arizona State University, and the Memorial Foundation for Jewish Culture made the preparation and publication of this essay possible.

2. See, for example, Ruth Mellinkoff, *Outcasts: Signs of Otherness in Northern European Art of the Late Middle Ages* (Berkeley: University of California Press, 1993), 2 volumes. Jews were commonly shown with such "defects" as pockmarked skin and blind or nearsighted eyes.

3. *Giotto: The Arena Chapel Frescoes*, ed. by James Stubblebine (New York: W. W. Norton, 1969), 86.

4. For the hat, see Benjamin Ravid, "From Yellow to Red: On the Distinguishing Head-Covering of the Jews of Venice," *Jewish History*, VI, 1992, 179–210. For the badge, see note 18.

5. Richard I. Cohen, *Jewish Icons: Art and Society in Modern Europe* (Berkeley: University of California Press, 1998); Sara Lipton, *Images of Intolerance: The Representation of Jews and Judaism in the Bible moralisée* (Berkeley: University of California, 1999); Mellinkoff, *Outcasts*; Heinz Schreckenberg, *The Jews in Christian Art: An Illustrated History* (New York: Continuum, 1996), trans. by John Bowden. See my forthcoming review of Cohen's book in *AJS Review*.

6. Although the patron, scribe, and original owner are unknown, the manuscript shows numerous stylistic connections to Northern Italy. For example, the round towers and crenellations in the scene of *Tashlikh*, the dome over a drum with windows in the ark on folio 99v, and the hose that is attached by laces that form a horizontal row across the thigh in the drawing of Gedaliah are similar to those in illuminations produced in Northern Italy. See Thérèse and Mendel Metzger, *Jewish Life in the Middle Ages: Illuminated Hebrew Manuscripts of the Thirteenth to the Sixteenth Centuries* (Secaucus: Chartwell Books, 1982), figs. 82, 87, and 180. The codex includes a list of death dates at the end of the book. Since the earliest that is recorded is 1503, the manuscript must have been completed in or before that year.

7. For this manuscript, BN Hébr. 586, see Zofia Ameisenowz, "An Illustrated Manual of Rituals from the Late Middle Ages," *Tarbiz*, XXVIII, 1958, 197–200; Jean Baumgarten, "Les Manuscrits Yidich de la Bibliothèque Nationale de Paris," in *The Field of Yiddish: Studies in Language, Folklore, and Literature. Fifth Collection*, ed. by David Goldberg (Evanston and New York: Northwestern University Press and YIVO Institute for Jewish Research, 1993), 127–31 [121–51]; Gabrielle Sed-Rajna and Sonia Fellous, *Les Manuscrits Hébreux enluminés des bibliothèques de France* (Leuven and Paris: Peeters, 1994), 307–10.

8. For medieval and Renaissance artists who are known to be Jewish, none of whom are female, see Franz Landsberger, "Jewish Artists Before the Period of the Emancipation," *Hebrew Union College Annual*, XVI, 1941, 321–414. See also Charles H. F. Avery, "Giuseppe de Levis of Verona—A Bronze Founder and Sculptor of the Late Sixteenth Century," *Connoisseur*, CLXXXI, 1972, 179–88, CLXXXII, 1973, 87–97. For a discussion of the problems in determining whether a particular artist of a Jewish codex is Jewish or Christian, see Marc Michael Epstein, *Dreams of Subversion in Medieval Jewish Art and Literature* (University Park, PA: Pennsylvania State University Press, 1997), 6.

9. The last folio (fol. 125), the figure on the left of folio 117, and the lower fisherman on fol. 113 were added later.

10. In contrast, for an inaccurate depiction of the gesture in a Hebrew manuscript produced in Italy c. 1400, see Metzger and Metzger, *Jewish Life*, 268, fig. 384.

11. This thesis was first proposed by Baumgarten, "Yidich," 130.

12. For the oligarchic structure of Jewish communities in medieval and Renaissance Italy, see Ariel Toaff, *Love, Work, Death: Jewish Life in Medieval Umbria*, trans. by Judith Lansky (London: Littman Library of Jewish Civilization, 1998), 95 and Robert Bonfil, "La sinagoga in Italia," in *Il Centario del Tempio Israelitico di Firenze* (Florence, 1985), 38 [36–44].

13. Note that Christians most probably illustrated the later books, since they contain errors, such as a seven-branched candelabrum for *Hanukkah*.

14. Supporting the idea that the images were added after the text is the fact that although the image and caption generally correspond, they often show a looser connection to the text.

15. For documented cases of rape, adultery, and prostitution within the Italian Jewish community, see Toaff, *Love, Work, and Death*, 11–13. Similarly, *Haggadot* sometimes contain images of the wicked son, see Mendel Metzger, *La Haggada enluminée. I. Étude iconographique et stylistique des manuscrits enluminés et décorés de la haggada du XIIIe au XVIe siècle* (Leiden: Brill, 1973), I, 149–56, pls. XXIX–XXX. The only image in the Paris manuscript that may be critical of Jewish custom is the one for *Rosh Hodesh*, which shows a snake slithering towards two card players. I shall discuss this in a future publication.

16. Although Pfefferkorn's book was published in Germany and the *Sefer Minhagim* is Italian, they form a useful comparison. Italy produced no book of Christian images of Jewish rituals and Pfefferkorn's volume was published within a decade of the manuscript's production. Pfefferkorn's book, published in Latin as well as German, could have been purchased and read in Italy. Italian imagery shows similar anti-Semitic strategies to those employed by Pfefferkorn's illustrator. For anti-Semitism in Italian art, see Kathleen Biddick, "Paper Jews: Inscription/Ethnicity/Ethnography," *Art Bulletin*, LXXVIII, December 1996, 594–9; Mellinkoff, *Outcasts*, II, figs. II.37, II.39, VI.72, IX.2, IX.20, XI.13, XI.15; Hugh Brigstocke and John Somerville, *Italian Paintings from Burghley House* (Alexandria, VA, 1995), 52–53; Anne Derbes, *Picturing the Passion in Late Medieval Italy* (Cambridge: Cambridge University Press, 1996); Dana E. Katz, "Painting and the Politics of Persecution: Representing the Jew in Fifteenth-Century Mantua," *Art History*, XXIII, November 2000, 475–95.

17. For the difficulty in recognizing members of a race other than one's own, see Roy Malpass and Jerome Kravitz, "Recognition for Faces of Own and Other Race," *Journal of Personality and Social Psychology*, XIII, 1969, 330–4 and John C. Brigham et al., "Accuracy of Eyewitness Identifications in a Field Setting," *Journal of Personality and Social Psychology*, XLII, 1982, 673–81.

18. See Schreckenberg, *Jews in Christian Art*, 368, fig. 8. For Italian images of the badge, see David Ruderman, "At the Intersection of Cultures: The Historical Legacy of Italian Jewry," in *Gardens and Ghettos: The Art of Jewish Life in Italy*, ed. by Vivian Mann (Berkeley: University of California Press, 1989), 12–13 [1–23], figs. 9–10; Bezalel Narkiss, *Hebrew Illuminationated Manuscripts* (New York: Leon Amiel, 1969), pl. 59. For additional publications on the Jewish badge, see Cohen, *Icons*, 13.

19. See, for example, note 2, 16, and 23.

20. Diane Wolfthal, "Women's Voice and Women's Community in Erhard Schön's *How Seven Women Complain about Their Worthless Husbands*," in *Attending to Women in the Early Modern Period*, ed. by Adele Seefe and Susan Amussen (Cranburg, NJ and London: Associated University Presses, 1998), 117–43; Howard Adelman, "Rabbis and Reality: Public Activities of Jewish Women in Italy During the Renaissance and Catholic Restoration," *Jewish History*, V, Spring 1991, 31 [27–39]; Mark Saperstein, "Christians and Jews—Some Positive Images," *Harvard Theological Review*, LXXIX, 1986, 242 [236–46].

21. דַז זַיין וְוראַן הוֹרַן דִיא מְגִילַה לַנְ[יען]. דָא זִיצְן דִיא וְוראן און הוֹרַן טוֹיצן.

22. Kirsten M. Christensen, "The Conciliatory Rhetoric of Mysticism in the Correspondence of Heinrich von Nördlingen and Margaretha Ebner," in *Peace and Negotiation: Strategies*

for Co-Existence in the Middle Ages and Renaissance, ed. by Diane Wolfthal (Turnhout: Brepols, 2000), 138.

23. See, for example, New York. Metropolitan Museum of Art, *Gothic and Renaissance Art in Nuremberg 1300-1500* (Munich: Prestel, 1986), 155 cat. no. 30; Schreckenberg, *Jews in Christian Art*, 144–46.

24. Sed-Rajna and Fellous, *Les Manuscrits Hébreux*, 310, claims that the vial on the far left contains blood. I know of no scene of the *Berit milah* that contains such a motif. Instead, it probably holds wine.

25. See the first chapter of Cohen, *Icons*, and my book review in *AJS Review*, forthcoming, for a discussion of Christians as framing figures in scenes of Jewish ritual.

26. For the *Shabbes goy*, see Jacob Katz, *The "Shabbes Goy": A Study in Halakhic Flexibility* (Philadelphia: Jewish Publication Society, 1989).

27. Cohen, *Icons*, 267 n. 33.

28. Similarly, in the Yiddish autobiography of Glikl bas Judah Leib, Jews are central, Christians marginal. See Natalie Zemon Davis, *Women in the Margins: Three Seventeenth Century Lives* (Cambridge: Harvard University Press, 1995), 38.

29. See Epstein, *Subversion*, 16–38, and my review in *Studies in Iconography*, XXI, 2000, 304–07.

30. Diane Wolfthal, "Remembering Amalek and Nebuchadnezzar: Jewish Culture and Symbolic Violence in an Italian Renaissance Yiddish Book of Customs," in *Critical Essays on Art and Warfare*, ed. by Pia Cuneo (Leiden: Brill Academic Publishers, 2001), 181–211.

31. See Wolfthal, "Remembering Amalek."

32. Epstein, *Subversion*.

33. Saperstein, "Christians and Jews," 246.

34. דֶער אִישְׁט אִין דֶער סוּכָּה.

35. גוטר ווֹיִן מאכט ווֹרייליך.

36. In a leap year *Purim* is celebrated in the second month of *Adar*, and *Purim Katan* (Little or Minor Purim) on the fourteenth and fifteenth days of first month of *Adar*. *Purim Katan* involves none of the ritual practices of *Purim*: the *megillah* is not read and food is not distributed to the poor. Rather, it is simply an occasion for rejoicing; see Cecil Roth, "Purim Katan," in *Encyclopaedia Judaica* (Jerusalem: Macmillan, 1971), XIII, 1395.

37. דיא מַכֶן פורים אונ עשֶן אונ טרִנְקֶן אונ טאנצֶן.

38. For these books, see Chone Shmeruk, *The Illustrations in Yiddish Books of the Sixteenth and Seventeenth Centuries: The Texts, the Pictures, and their Audience* (Jerusalem: Akademon Press, 1986) and Chone Shmeruk, "The First Yiddish Printed Books in Italy" *Italia*, 3:1–2 (1982): 112–75 (both in Hebrew).

39. See above for this motif.

40. See Alessandro Guetta, "Les Juifs ashkénazes en Italie; une page d'histoire brève mais importante," in *Mille ans de cultures ashkénazes* (Paris: Liana Levi, 1994), ed. by Jean Baumgarten, pp. 70–75; Moses A. Shulvass, *The History of the Jewish People* (Chicago: Regnery Press, 1985), III. For a discussion of fifteenth-century anti-Semitism and its affect on contemporary Christian art, see Katz, "Painting and the Politics of Persecution," 475–95.

41. Elliot Horowitz, "The Eve of the Circumcision: A Chapter in the History of Jewish Nightlife," in *Essential Papers on Jewish Culture in Renaissance and Baroque Italy*, ed. by David Ruderman (New York: New York University Press, 1992), 556 [554–88] (originally published in 1989).

42. Horowitz, "Eve of Circumcision," 555–6, 563–4.

43. For positive aspects of his amateur status and its relationship to the Yiddish context of the book, see Wolfthal, "Remembering Amalek."

44. The difficulty in determining gender is best exemplified by the figure who performs *Tashlikh* on the High Holy Days. Although some scholars have mistaken the gender of the figure who enacts the ritual (see Ameisenowa, "An Illustrated Manual;" Sed-Rajna and Fellous, *Les Manuscrits Hébreux*, 309, fol. 121r), she is marked as female by her short head cloth, the curved line above her breasts, and the inscription, "She (דיא) does *Tashlikh*."

45. Several contemporary texts argue that due to their laziness women are incapable of performing this task properly, see Adelman, "Rabbis and Reality," 34. Traditionally men were shown performing this task, see Metzger, *La Haggada enluminée*, I, pls. IV–VI.

46. See Narkiss, *Hebrew Illuminated Manuscripts*, pl. 14, fig. 22; Metzger, *La Haggada enluminée*, I, 206–7, figs. 267–8.

47. *Omer* is the seven-week period between *Pesah* and *Shavuot*. Standing on a ground line, the woman holds an open *Omer* calendar, which shows the first and second days. Above, the caption reads, "She blesses *Omer*." At the top, an object labeled "*Omer*" represents another counting aid.

48. For Amalek, see Wolfthal, "Remembering Amalek."

49. In this image, the woman enacts the essential function, whereas the man who approaches, carrying a small vessel of water, serves a secondary, supporting role.

50. The woman stands on a bridge, beneath which flows water. The practice stems from Micah 7:19, where sins are tossed to the bottom of the sea. At least one fish is clearly represented, ready to eat the crumbs that the woman holds in her raised robe.

51. The large, crowned, elegantly dressed woman, labeled "Queen Esther," carries a flower and is accompanied by two women, shown in a smaller scale. This probably refers to the episode in which Esther, in the company of two female attendants, invited Ahasuerus to her banquet, see Emil G. Hirsch and John Dynely Prince, "Esther," in *The Jewish Encyclopedia*, ed. by Isidore Singer (New York: KTAV, 1964) V, 235 [232–37]; Emil G. Hirsch and Carl Siegfried, "Esther, Apocryphal Book of," in *The Jewish Encyclopedia*, V, 240 [237–41].

52. Howard Adelman, "Images of Women in Italian Jewish Literature in the Late Middle Ages," *Proceedings of the Tenth World Congress of Jewish Studies. Division B* (Jerusalem: ha-Igud ha-'Olami le-mada'e ha-Yahadut, 1990), II, 99–106; Shalom Sabar, "Bride, Heroine, and Courtesan: Images of the Jewish Woman in Hebrew Manuscripts of Renaissance Italy," *Proceedings of the Tenth Congress for Jewish Studies. Division D*, II, 67 [63–70].

53. Howard Adelman, "Italian Jewish Women," in *Jewish Women in Historical Perspective*, ed. by Judith Baskin (Detroit: Wayne State University Press, 1991), 139–41 [135–58]; Sabar, "Bride," 68–69.

54. Sabar, "Bride," 63–70.

55. Howard Adelman notes not only the "generally poor state of Hebrew knowledge among Italian Jewish women," but also among Jewish men, see "The Educational and Literary Activities of Jewish Women in Italy during the Renaissance and the Catholic Restoration," in *Shlomo Simonsohn Jubilee Volume*, ed. by D. Carpi et al. (Tel Aviv: Tel Aviv University, 1993), 9–23 (quote from p. 23); Adelman, "Rabbis and Reality," 30–31. Judith Baskin concludes that Jewish women generally knew the vernacular, not Hebrew; see "Some Parallels in the Education of Medieval Jewish and Christian Women," *Jewish History*, V, Spring 1991, 32 [41–51]. For one book that is presumed to have been commissioned for a woman, see Eva Frojmovic, *Hebrew and Judaica from the Cecil Roth Collection* (Leeds: University of Leeds Brotherton Library, 1997), 54, cat. no. 21.

56. Chava Weissler, *Voices of the Matriarchs: Listening to the Prayers of Early Modern Jewish Women* (Boston: Beacon Press, 1998), 16.

57. Sabar, "Bride," 66.

58. Joan Kelly (-Gadol), "Did Women Have a Renaissance?" in *Becoming Visible: Women in European History*, ed. by Renate Bridenthal, Claudia Koonz, and Susan Stuard (Boston: Houghton

Mifflin, 1987), 174–201 (first published in 1976). David Herlihy cites one exception, charismatic female saints; see "Did Women Have a Renaissance?: A Reconsideration," *Medievalia et Humanistica*, n.s. XIII, 1985, 1–22.

59. For a summary of this research, see Diane Wolfthal, *Images of Rape: The "Heroic" Tradition and Its Alternatives* (Cambridge: Cambridge University Press, 1999), 180–81.

60. Agnes Romer Segal, "Yiddish Works on Women's Commandments in the Sixteenth Century," in *Studies in Yiddish Literature and Folklore*, ed. by Chava Turiansky (Jerusalem: Hebrew University, 1986), 47 [37–59].

61. Shmeruk, *Illustrations in Yiddish Books*, 81; Cohen, *Icons*, 60.

62. Epstein, *Subversion*.

63. Ruth Mellinkoff, *Antisemitic Hate Signs in Hebrew Illuminated Manuscripts* (Jerusalem: Center for Jewish Art, 1999).

3

A Sanctified Black: Maurice

Jean Devisse

Editor's note: The excerpt below is taken from "A Sanctified Black: Maurice" by Jean Devisse, originally published in *From the Demonic Threat to the Incarnation of Sainthood*, volume 2, part 1 of *The Image of the Black in Western Art* (© 1979 Menil Foundation). Immediately preceding the excerpt, Devisse recounts the hagiographic history of St. Maurice from the first written accounts of the appearance of his relics in the fourth century to the establishment of his European cult with the founding of the St. Maurice Abbey of Agaunum in France in 515. The popularity of St. Maurice grew and became a particularly German cult in the Carolingian and Ottonian periods, during which rulers like Charlemagne and Otto I exalted him as a military saint. The eastward expansion of their empire made Maurice a key saint invoked against the Slavs. When Magdeburg, a center for the Ottonian Empire, was spared a Slavic attack in 1007, locals believed St. Maurice had interceded on their behalf and the saint became a symbol of German military strength. By the end of the eleventh century, men-at-arms in that city were called *milites mauriciani*, Maurice was invoked at the imperial court at investiture ceremonies for knights, and coins with an effigy of Maurice were minted. Up to this time Maurice had always been depicted as a white man; in 1207 a fire destroyed the cathedral in Magdeburg and a black figure of Maurice was included in the new sculptural program. It is at this crossroads in the saint's representational evolution that the following excerpt from Devisse's essay begins.

A Mutation in the Official Iconography: St. Maurice Becomes a Black Man

The program for the decoration of the Cathedral of Magdeburg, undertaken about 1240–50, included a surprising departure in St. Maurice's iconography: until then represented as white, he became a black man. Nor was this an ephemeral phenomenon. With few exceptions, the saint was portrayed as black until the sixteenth century in Magdeburg, Halle, and Halberstadt. At least we are led to this conclusion by the information now

available to us.[1] The working hypothesis which emerges is that a command from the emperor caused St. Maurice to be depicted as a black in Magdeburg, the city where his relics were enshrined. In this first period the iconography of the black saint was influenced by the fluctuations of imperial power, which waned during the Great Interregnum and rose again, enhanced in strength and prestige, only with Charles IV. Behind the politics of the emperors, the strategy of Magdeburg and its archbishops was active, both city and prelates turning the new iconographic theme to their own advantage, especially in the fifteenth century. Finally, in the sixteenth, Cardinal Albert of Brandenburg took it over. The fact is, however, that before clear, definitive conclusions can be reached in this field, a lengthy, comparative chronological and geographical investigation of all types of representation of St. Maurice, black or white, from the thirteenth to the sixteenth century, will have to be made.

When, after the deposition of Louis IV the Bavarian, Charles of Bohemia[2] became emperor in 1346, he set about gathering to his side the saints recognized as protectors of the imperial power and symbols of the unity of the empire. Maurice was one of them, and Charles had him represented, and distributed his image, as a black: as we see it, this is a proof, albeit a late one, of the imperial choice made a century earlier. If, therefore, in a little more than a hundred years, Maurice, Gregory the Moor at Cologne, and one of the Magi were represented as blacks without any scandal or noticeable disavowal, we conclude that besides the decisions that were made, there must have been a profound sense of acceptance at various levels of the imperial society.

Yet we must point out immediately that at no time did the portrayal of St. Maurice as a black become universal. It belonged to Magdeburg and the regions influenced by that city. This iconography was not welcomed in Trier or Aachen, nor, in its early phase, in Bavaria,[3] nor in France or Italy, although the cult of the saint was at times strong in these areas. Such selective reactions also marked the career of the black Wise Man. But, by way of contrast to the latter case, at present we know of no text that explains the extraordinary innovation that came to light in Magdeburg.

The marvelous sandstone statue in Magdeburg, although fairly often illustrated and described,[4] is dated rather hazily between 1240 and 1250, and art historians throw no light on its origins (fig. 3.1). So far the studies have concentrated mainly on details, particularly on the description of the military costume. Attention has rightly been called to the importance of the sword and to the presence of a banner once held in the right hand (it has now disappeared).[5] But nothing is known about who ordered the statue or who carved it, nor about the circumstances of its execution, perhaps with a black man as model. Yet close attention should be paid to its characteristics, and efforts made to go a little further in identifying it historically. E. Schubert[6] notes similarities between this St. Maurice and a whole group of thirteenth-century statues that are chronologically and stylistically comparable. He sees in the style of the Magdeburg Virgins a northern French influence, perhaps passed on to Magdeburg through Bamberg. He also sees a close relationship between, on one hand, the St. Maurice and the Wise Virgins at Magdeburg, and, on the other, the famous statues in the west choir of Naumburg Cathedral; he leans toward dating the Magdeburg works just before or just after those at Naumburg. It is not easy to agree that the initiative that endowed Magdeburg with a black St. Maurice came from Naumburg itself: his cult was very modest in that little city.[7] As E. Schubert judiciously remarks, this inquiry ends at an impasse, at

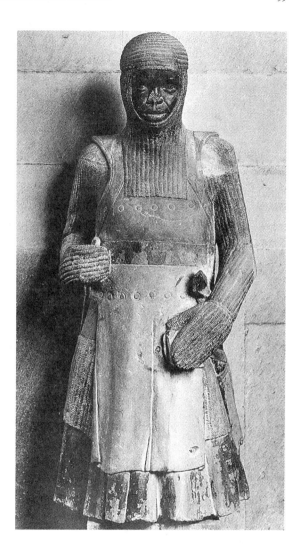

Figure 3.1 Statue of St. Maurice, 1240–50, Magdeburg Cathedral, Magdeburg.

least for the time being. There is good reason to try to push it further given the importance, at all possible levels of analysis, of the advent of the black Maurice.[8]

The theme was to enjoy an almost uninterrupted success for at least three centuries, and for this the archbishops of Magdeburg were largely responsible.[9] But after the Great Interregnum it was another emperor, Charles IV, who revitalized the Maurician cult. His plan was to collect relics of all the saints of importance to the empire and keep them in Prague.[10] In 1354, with the full consent of Rome, he instituted the Feast of the Holy Lance.[11] He had received the famous lance as an insigne of imperial authority, and with it two swords, one attributed to St. Maurice, the other to Charlemagne;[12] and in 1365 an arm of the saint was granted him.[13] At Karlštejn, near Prague, he built a castle,[14] the raison d'être of which was the sumptuous Chapel of the Holy Cross constructed to house the imperial insignia.[15] The walls were covered with panels on which were painted bust-length images of saints, male and female: Maurice was among them.[16] Although in many things Charles of Bohemia followed the example of his uncle, Charles V of France, in this instance he broke with the

French tradition, which always represented Maurice as white;[17] at Karlštejn the Magdeburg model was adopted. To decorate the chapel Charles IV called upon a painter named Theodorik, who may have come from Western Europe but was steeped in local tradition, while for the embellishment of Prague he engaged artists from the court at Avignon. Theodorik organized his studio as a corporation, and it is very hard to distinguish the paintings done by his own hand from those produced by his collaborators and pupils.[18] Each panel is separated from the others by a wide damasked border. There has been disagreement about the attribution of Maurice's panel to Theodorik,[19] but the painting blends in with the whole group in which the stylistic characteristics are easily recognizable: the massive treatment of bodies and faces, the absence of depth and landscape (here an embossed gold background is used instead), the gorgeous fabrics, all differ sharply from any contemporaneous work, even in Prague. Probably painted before 1367,[20] Maurice is a black man characterized not only by color but by the hair and facial traits: he carries the sword, the banner, and the shield with heraldic bearings. So far as we know, this was the first picture of the martyr of Agaunum painted on a panel, and, like the Magdeburg statue, it was a brilliant stroke.

The emperors' favor created an environment in Bohemia that proved lastingly receptive to the representation of Maurice with the features of a black man. A Bohemian martyrology dating from the early years of the fifteenth century[21] shows him, with his companions, as a black, as does an unusual reliquary bust, executed about 1440 and now in Kroměříž, on which the Theban saint wears a ducal headdress.[22] Among the mural paintings in the chapel of the castle at Zvikov, dating from the end of the fifteenth century, we find a black Maurice in armor:[23] this work is approximately contemporaneous with that at Kloster Zinna (about which more later) and their style is very similar. Once again those in power drew attention to Maurice: thereafter he was black. Yet signs of popular acclaim or spontaneous imitation remain rare, and Bohemia[24] does not seem to have made much room for such representations during the fifteenth century. We note the St. Maurice painted about 1420–30 on the wing of an altarpiece, now separated and kept in Quittelsdorf: the somewhat affected posture, the small, delicate head, and the elegantly draped garments suggest fairly close kinship with the Bohemian painting of the early fifteenth century. Considering the modest dimensions of this panel, it might very well have been brought into Thuringia from Bohemia at an unknown date.

Bavaria, once a seat of the Maurician cult, not only failed to adopt this new iconographic type in the fourteenth and fifteenth centuries (as far as our research has shown), but also saw the almost complete disappearance of the saint's name from the calendars and martyrologies of that period.[25]

In Austria, in these same years, a black Maurice, wearing the ducal crown as at Kroměříž, appears among numerous saints on an altarpiece executed in 1447 for the abbey church at Wiener Neustadt.[26] Here we observe the effacement of the religious character from the iconography typical of the thirteenth century in favor of more worldly images; Maurice has left knighthood behind and has been adopted by courtly art.

In Brandenburg we again see the will and influence of Charles IV at work. Twelve saints, one being Maurice, are painted on the back of a wing belonging to the altarpiece formerly on the high altar of the cathedral: the altarpiece portrays the crowning of the Virgin.[27] For the first time, so far as we know, Maurice's shield and gonfalon bear the eagle of the House

of Brandenburg. Almost a century later another altarpiece in the cathedral repeats the same theme,[28] but the place assigned to Maurice is strikingly more modest. Still seen among other saints, popes, bishops, and abbots, he is placed in the background; only his black head and his gonfalon being visible, and the gonfalon bears the cross that was generally attributed to him in Magdeburg. These variations merit attention. Charles IV attached great importance to the old March of Brandenburg, which made contact with the Baltic Sea possible through the Slavic territories then in process of colonization. In 1373 he spent some time in Brandenburg itself: his thought was to remove the bishopric from the province of Magdeburg and to attach it to Prague. At the same time he was taking care to create in Berlin the arrangements that would allow the growth of a center of commercial exchange with the Baltic.[29] The acquisition of the March of Brandenburg followed that of Lusatia and took place simultaneously with the annexation of a section of Mecklenburg; in this way Charles IV extended his territories toward the north. Charles IV ordered a complete description of the lands newly accrued to his crown.[30] He intervened frequently in the affairs of the March and of the bishopric, the bishop of Brandenburg being on bad terms with Charles at the time. The gift, after 1377, of a triptych on which there was an image of St. Maurice with the eagle of Brandenburg, tallied perfectly with the policy of getting the March under the emperor's control. Probably this pressure also explains Maurice's "exile" in the 1465 altarpiece. If these interpretations turn out to be correct, the likelihood is that the first altarpiece was executed before 1378, the year of Charles IV's death. This event was followed in the March by a period of serious disorders, which finally came to an end with the installation of Frederick I of Hohenzollern as margrave in 1411.

Magdeburg did not give up the representation of Maurice with the features of a black.[31] Work on the west façade, begun at the end of the thirteenth century, continued until 1360–70 with the construction of the towers and the architectural part framed in by them. The main portal, and notably the statue of Maurice in the gable under a very high canopy,[32] date from this period. In 1520, the two towers being finished, the central porch was enclosed and transformed into a funerary chapel to house the monumental tomb of Archbishop Ernest of Saxony, to whom we shall return later.

However, before turning to this new phase of the Magdeburg iconography of the black Maurice, we must try to measure the reception the iconography met with. Taken over and used both by the imperial authorities and by the archbishops of Magdeburg, Maurice was so marked a hero that to accept or to reject his representation as a black saint could not possibly be a matter of indifference. The variations in the heraldic bearings accompanying him take on a real significance (we are beginning to suspect) in connection with any effort to estimate the rivalries and the attempts to usurp Maurice's prestige to the detriment of the empire but also to the detriment of Magdeburg. It is therefore rewarding to survey a "geography of acceptances, adaptations, and rejections" starting from the province of Magdeburg, before applying our special attention to what happened in that city at the end of the fifteenth and during the sixteenth century.

The ecclesiastical province of Magdeburg welcomed the black saint in its episcopal sees, monasteries, and humble rural churches. For the moment we shall take note of some few examples.[33] Halle presents us with two stone statues of Maurice in the church dedicated to him.[34] One of them, signed by Conrad von Einbeck and dated 1411, is not very characteristic: the intention to make the saint black is expressed only in the dark color of the face.

The other, a little earlier, shows both in posture and in costume some close similarities to the statue in Jüterbog, about which we shall speak further, and to the stained-glass window in Stendal,[35] in which the saint is standing under a canopy: the pose, the armor, and the shield blazoned with a cross are the same. At Halberstadt, in the church named for him, Maurice is figured on the side of a stall made at the end of the fifteenth century,[36] and a later statue in the cathedral, standing against a pillar,[37] shows him holding a shield on which the two-headed eagle stands out; but it is hard to be sure that this statue has not been more or less restored or transformed several times.

In Lower Saxony, three abbeys still today possess representations of the black Maurice. Medingen—Maurice was its patron saint—has two silver statuettes,[38] the older of which, dated approximately 1470–80, shows the saint in armor, wearing a sort of bandeau around his head and carrying a banner with a cross pattée. Ebstorf has some interesting and diverse fifteenth-century reminders of Maurice.[39] Lastly, at Wienhausen, among other images there is a triptych carved in the second half of the fifteenth century,[40] which has on its left-hand wing three saints in high relief, of which one is Maurice with cape and armor.

In a number of places in Saxony and Thuringia there is an abundance of representations of the black St. Maurice, dating from the end of the fifteenth and the beginning of the sixteenth century.[41] Here we present only a few that have points in common: they are carved polychromed altarpieces with the central panel reserved for a Virgin and Child. At Delitzsch the polyptych dated 1492[42] shows Maurice in the left wing, wearing an ample cape over his armor and without a shield. On the other hand, at Frankenhain,[43] about 1500, he is pictured just to the Virgin's right in the central panel, his head circled with a kind of bandeau as in Medignen. Rottenbach[44] in 1498 and Braunsdorf in 1517[45] offer us a bareheaded, haloed Maurice holding a lance added more recently.

The Magdeburg bracteates, the economic bond between that city and the Baltic merchants, and the efforts made under Charles IV to develop commerce between the empire and the north provide sufficient explanation for the possible expansion of the black Maurice in that direction. However, the thing is not so simple. The "imperial" image of Brandenburg met with resistances, choices, and contradictory interpretations that must be clarified. Yet as early as 1430–40 the church at Teterow housed a black Maurice carrying the gonfalon blazoned with the lance.[46] Teterow, sold by its Slavic owner to a monastery of Premonstratensians, a dependent of Lund, is located on the trade route to the north.[47] During this same period Wismar, on the Baltic, adopted Magdeburg's saint with the cross pattée. The image presented by the "Krämeraltar"[48] in Wismar has little in common with the Teterow image except for the costume: here Maurice's hair hangs in long curls and he wears a kind of turban—which shows how free the artists were, being far removed from the center of Saxony. Still farther north, our search has found black Maurices in Denmark, notably at Roskilde,[49] where the painter's fantasy is expressed both in the pointed shield and in the headdress, in which the feather attached to the bandeau lends an exotic touch to the black-skinned figure. But an overall problem emerges: the relative abundance of representations of the black saint contrasts with the spread of the cult of St. George along the Baltic.[50] A fine statuette of St. Maurice in polychromed wood,[51] dating from the early fifteenth century, once belonged to the treasure of the House of the Black Heads in Riga: the name of this organization probably marks the semantic limits of the "blackness" of Maurice. The latest study to appear on the subject[52] leaves open the possibility that the

name was chosen by the participants without any connection with Maurice, to point up the youth of the members of the brotherhood compared to the old Hansards. If that be the case, in the beginning there would have been no reference to Africans and very little to Maurice, although the Black Heads counted him among their protectors from the time of their foundation in the fifteenth century; but they directed their veneration to St. George. Likely enough the "image of the black"—the real black was so far away!—was freed of all deeply significant correction and used by way of allusion. The seal of the Black Heads in Riga bore the image of a "black Moor's head" with a frontal ribbon.[53] When the city's cathedral was done over, four heads of "black Moors" were put in the stained-glass window given by the Black Heads.[54] In Lübeck the Morum family played on the meaning of their name: their epitaph shows a white Maurice, but the shields with the family's arms have three heads of blacks.[55] The heads figured in the heraldic bearings on the main door of the House of the Black Heads in Riga, the home of the brotherhood, wear the "Moorish bandeau." Below them Maurice is represented following the convention then in use (the sculpted door dates from 1522) at Magdeburg and Halle, as we shall see further on. The saint's banner and shield bear the cross pattée;[56] according to E. Thomson the cross was red on a white ground on the banner, the colors being reversed on the shield.[57] This conventional black Maurice is only a copy of the official iconography widely propagated at the time by authority of Cardinal Albert of Brandenburg. Thus the Baltic area appears, it would seem, as a zone where the models coming from Magdeburg were feebly reproduced, but still more as a place where the image no longer followed the precise conventions to which it was subject in Saxony.

In the Cologne region we come up against another resistance and another limit: the whole area set itself against the pressure from Magdeburg. Cologne, proud of the cult of the Magi, did not share Magdeburg's need to exalt the exotic knight. The city was not hostile to St. Maurice,[58] almost always represented him as white, and, if a historic black hero had to be venerated, preferred Gregory the Moor to the Theban.[59] Gregory made his appearance in Cologne's iconography in the early fourteenth century, notably in the Church of St. Gereon, where his relics were kept, but neither he nor the Holy Moors, whose leader he was, were prominent in the city's devotions. Probably nothing more clearly shows Cologne's independence from Magdeburg than the representation of a white St. Maurice and a black St. Gregory on two wings of the same altarpiece, dated 1520, the work of Anton Woensam.[60]

The Münster area was a zone of contact between separated regions and opposing influences. A "missal" from the priory of Bilzen, produced at the end of the fifteenth century,[61] brings together a remarkable collection of liturgical texts, lessons, and sermons devoted to St. Maurice, some of them by celebrated authors.[62] But in the miniature of his martyrdom,[63] he is represented as white. Black is reserved for the Holy Moors, a group of martyrs connected with Cologne, whom we find in the same manuscript.[64]

Other representations of Maurice convey the same impression of marginality and instability of the theme that we met in the Baltic area: in Fröndenberg a statue[65] recently repainted in accord with the old polychromy gives the saint a dark skin but no other characteristic traits. Thus a veritable cartography takes shape, at least for the fourteenth and fifteenth centuries, showing where the representation of Maurice as a black was accepted and where it was refused, after having been launched in Magdeburg in the mid-thirteenth century, probably upon imperial initiative.

From this point of view it is interesting to explore the reactions in the Alpine and Rhone regions, where the cult of St. Maurice had taken hold before it was annexed by the Ottonians. In general the area west of the Rhine—Flanders, France, Italy—showed total resistance to the adoption of the black Maurice. King René of Anjou's effort to revive the saint's cult in Provence occasioned new representations of Maurice in the south of present-day France during the fifteenth century: he is always white. In a rather unexpected way the House of Savoy adopted the Maurician cult. The origins of the ducal family of Savoy before the year 1000 are still not clear,[66] but by the middle of the eleventh century its power was well established. The center of its possessions was the region called the Bugey in southern Burgundy, but by that time one of its members was abbot of Saint-Maurice at Agaunum and another was bishop of Sion in the Swiss Valais.[67] The cult of St. Maurice, diligently spread abroad by the Savoyards, slowly gained ground in the new duchy,[68] emerging again after being eclipsed as a result of the appropriation of the cult by the empire. Agaunum and Susa minted coins for the dukes of Savoy in the thirteenth century,[69] and in the fourteenth struck the large *mauriziani* which bore the image of the saint:[70] no sample of these seems to have survived. In the fifteenth century St. Maurice was depicted in a Book of Hours made for Louis of Savoy.[71] The saint, who carries a shield with a red cross, is designated as patron and protector of Savoy. He is white, as are his companions.

The foundation in 1434 of the chivalric Order of St. Maurice,[72] the creation of which was granted by Rome to the Duke Amadeus VIII of Savoy, might have advanced the popularity of St. Maurice, but no such thing ensued. The order did not spread beyond Savoy (in 1572 it was decided that the grand master would invariably be chosen from the ducal family[73]), and there is no trace of a black Maurice either in the insignia of the order or in the statues that adorned its basilica in Turin.

A remote area of the Magdeburg province—the area of Jüterbog and Kloster Zinna—furnishes important examples of the transition from the ecclesiastical and imperial iconography, which we have been analyzing, to the pronounced transformations that made their appearance at the end of the fifteenth and during the sixteenth century, mostly due to the initiatives of Cardinal Albert of Brandenburg. We have already noted the interest taken by the archbishops of Magdeburg in Jüterbog and Kloster Zinna in the twelfth and thirteenth centuries; now, in the fourteenth, it was the turn of the Hohenzollerns, the new titularies of the March of Brandenburg,[74] to direct their attention to this far-eastern sector of the March. These margraves freed Brandenburg from the heavy pressure exerted by Charles IV and his successors of the House of Bohemia and developed their policies in full accord with the bishops and with Rome. These "anti-imperial" decisions quickly secured the local predominance of the Hohenzollern family, both on the political level and in church matters—the latter by having its members installed in the episcopal sees.[75] All these facts are fraught with consequences.

In the fourteenth and fifteenth centuries Jüterbog received a certain number of new monuments,[76] among them the Church of St. Nicholas, in which St. Maurice was particularly favored if we judge by the fragments of the altarpiece executed around 1425 for the former high altar. The statue in polychromed wood shows us an already familiar type of Maurice with woolly hair and thick lips; the painted panels now set up as an enclosure for the choir[77] give us more significant information. Here, for the first time, we have a pictorial sequence that places the exotic Theban among the numerous saints whose lives have

been the subject of narrative cycles in art. It was logical to suppose that the baptism of a personage so firm in his faith must itself have been extraordinary, and it was tempting to paint that event although no text related it. This is the old theme of the *Aethiops*, resurgent after a long progress that lies outside the scope of the present inquiry. The refusal to renounce the faith and sacrifice to the gods of pagan Rome is another frequent topic. As they are in many similar fifteenth-century works, the pagan gods are symbolized here by a grotesque devil with bat's wings. The hero's refusal leads to his beheading in the presence of the emperor. It is important for us to emphasize that Maurice is brought before the emperor three times, and that the emperor is a negative personage, treated here in an obviously unfriendly way; moreover, the saint carries the gonfalon marked with the Brandenburg eagle, not with the cross we find most often. As we see them, these details are of great historical interest: the work manifests attachment to the March—to the margraves?—with no more fear of offending Magdeburg than at the time when Charles IV, in our opinion, forced upon the Cathedral of Brandenburg an image of Maurice bearing the eagle. But here there is no question of an imperial command. The personage of the emperor, an iconographic type familiar to the people of the time, is discreetly but firmly brought to trial by repeatedly presenting him as a symbol of evil, whereas the clergy figures only in the scene of the baptism. These clues seem to imply rather strongly the autonomy of the new margraves, an autonomy resting upon the local clergy and upon Rome; and this series of scenes appears to us to be a cautious but effective political manifesto coming from the new masters of the territory.[78] Was it by chance that the "reigning" family of Brandenburg thereafter took possession of the black Maurice to such a degree that the most brilliant period in the saint's iconography coincided with the elevation of a Hohenzollern, Albert, to the archepiscopal throne of Magdeburg?

As was the case in the twelfth century, Kloster Zinna now found its lot closely linked to that of Jüterbog. The guesthouse of the abbey was decorated in the fifteenth century with an important painting in which SS. Andrew, Sebastian, and Maurice are grouped between the Virgin and St. Bernard.[79] When the painting was cleaned in 1958,[80] the image of St. Maurice was uncovered:[81] a knight helmeted and with a halo, his face a reddish brown, he is a more imposing figure than we find in many contemporary works. His heraldic bearings give us food for thought: the gonfalon is marked with the cross pattée (which recalls Magdeburg), but the cross is black on a white ground, following the usage of the Teutonic Knights; the eagle on the shield proclaims that the House of Brandenburg is in charge.

St. Maurice as Cardinal Albert of Brandenburg Pictured Him

Before talking about this great patron of artists and the arts, we shall deal briefly with the important role played by Ernest of Saxony,[82] his immediate predecessor. Ernest, archbishop of Magdeburg from 1476 to 1513, prefigured the renowned humanist Albert of Brandenburg, and in many ways his episcopate prepared Albert's and helps us to understand it. His installation in 1476 was the occasion for a gala performance in which over four thousand horsemen took part. Ernest and his successor already were powerful Renaissance princes; their taste for art and letters inclined them toward theatricality and ostentation, and this in

turn transformed everything around them. The day after his grand "entry" at Magdeburg, Archbishop Ernest presided at a solemn mass in honor of St. Maurice and the Theban Legion, during which the saint's relics were exposed for veneration:[83] so began the new turn the archbishop planned for the Maurician cult. In 1467 his predecessor, pressed for funds needed for the completion, decoration, and maintenance of the cathedral, had set up tighter regulations controlling the veneration of the relics possessed by Magdeburg.[84] It must have been at this time that a new statue of St. Maurice, in alabaster, was executed: the "Negroid" characteristics are barely discernible.[85] All the parish clergy and all priests in charge of chapels were to levy a tax on their people for the purpose of organizing the pilgrimage to Magdeburg, now obligatory. The idea of bringing a whole province together for a great religious demonstration was no doubt a good one, but the methods chosen seem more than questionable. In fact, the travel expenses ate up the best part of the funds collected. In 1491 Archbishop Ernest decided to change the 1467 rules.[86] Thereafter it was the relics that would be brought to where the people were—with the same indulgences as those granted in 1467. The pastors and chaplains would collect the money contributed "spontaneously" by the faithful and send it to Magdeburg in closed sacks bearing their name and the name of the parish.[87] The new procedure must have proved more profitable than the old because Albert of Brandenburg was to make it still more rigorous. This new policy quite certainly explains the proliferation of images of the black Maurice which we shall observe shortly in the parish churches. The liturgy also reflects this renewal of the Maurician cult. B. Opfermann has brought together an impressive sheaf of texts[88] whose root dates from this very time.[89] The Magdeburg Missal, which in part carries over the texts of the ninth and the tenth and eleventh centuries, is the common trunk of a ceremonial which proceeded to spread widely and rapidly.[90]

Ernest of Saxony took further steps to strengthen the prestige of his city's patron saint. In 1511 a "Book of Relics" boldly ranked the city banner, which bore the name of St. Maurice, with the banner of Charlemagne.[91] The archbishop's predilection for Maurice was expressed in concrete form on the tomb which he, while still very much alive, commissioned Peter Vischer the Elder to build for him, and which was completed in its essentials in 1495.[92] Maurice, armed, wearing a halo, and carrying the banner with the cross pattée, figures with St. Stephen on the mitre of the recumbent statue of the deceased and appears again, as a black, in a carving of extraordinary liveliness, on the base of the tomb on the head side, the place of honor.

Magdeburg, however, did not prove entirely amenable to the archbishop's leadership. The taxes imposed in order to implement resistance to the Turks caused friction,[93] and this foreshadowed the troubles later encountered by Albert.

The activities of Ernest of Saxony in the little city of Halle are worthy of still closer attention. Halle was in the salt trade and provided sizable revenues to the archdiocese of Magdeburg. Probably the town had a chapel of St. Maurice as far back as the year 1000. A monastery dedicated to him was founded there, with a school attached, in 1184. In 1200 Albert II built a hospital named for the saint.[94] In 1411 Conrad von Einbeck's statue, already mentioned,[95] was placed in the Church of St. Maurice, and a statue of Maurice was erected on the south side of the town hall.[96] In 1479 Ernest autocratically cut down the rights of the citizens of Halle[97] and, the better to keep the town under surveillance, built a fortress above it. This was only one of the castles built by his order, and this one he named for St.

Maurice: the Moritzburg.[98] There he began to gather together the relics he had bought at high prices; they were to become a miraculous source of revenue for his successor.

Once the monuments were built, Archbishop Ernest's next thought was to decorate them, and for that purpose he commissioned works of art. It is in the Church of St. Maurice that Ernest's taste for magnificence was most sumptuously displayed. In 1507 Hans Baldung Grien painted a triptych for the church, which is now in Berlin.[99] On one of its wings Maurice appears without any conventional characteristic: the type of the black is strongly marked; the beard and moustache accentuate the individuality of the personage, the treatment of the figure being as precise as that of the black King in the Adoration of the Magi, which occupies the central panel; the large, flowing banner bears the eagle, the cross being left to St. George, who appears on the other wing. A huge altarpiece, with an unusually large, delicately carved cornice, today adorns the high altar; its three pairs of painted wings, dated 1511, are the work of Jehner von Orlamünde.[100] Maurice is represented three times. As the church's patron saint he dominates the whole composition in a niche in the cornice with its complex arcatures: there he wears a helmet with chinstrap and carries a shield decorated with an eagle. A second statue of the saint, dated at the end of the fifteenth century,[101] at once vigorous and sensitive in execution, is placed in the central panel: the artist took care to give him a particularly expressive and realistic head, and he holds a shield bearing the cross. We find him again painted on the stationary wing to the right, with the banner bearing the eagle: here the type is much less emphasized. Curiously enough, the first wing on the right shows three companions of St. Maurice, a bit stiff and awkward and treated with a touch of exoticism.

It is very important to reflect upon the heraldic bearings that appear on the banner and shield. In fact, it was not until 1501 that the "historic" standard of St. Maurice, mentioned in the thirteenth century, was described for the first time.[102] It was said, as Sebastian Weynmann informs us, that Charlemagne long ago, and more recently the archbishops of Magdeburg, used the banner in every war, offensive or defensive, against their adversaries: it was of white silk and bore the image of Christ, and it was taken out of safekeeping only on the rarest occasions in order to save it from destruction, so that only a few privileged persons who had seen it could describe it.[103] It would seem that only by a deliberate choice could painters and sculptors have adopted entirely different blazons for St. Maurice.

With Albert of Brandenburg,[104] who succeeded Ernest as archbishop of Magdeburg in 1513, the seminal ideas of the latter were brought to fruition. Historians of art have so admired Albert's role as Maecenas that they have too often overlooked the innocently scandalous side of his way of living. A prince, rich, humanist from his youth, Albert displayed in every field of action a vigor and a taste for life that mark him as a true Renaissance man.

Albert's attention was drawn to Halle more than to Magdeburg, because of the possibilities the smaller city offered to so remarkable an "architect." In 1514 he had some hundred relics transferred from Magdeburg to the Moritzburg to be placed alongside those which Ernest had begun to accumulate there.[105] In 1515 he conceived the idea of a Pan-German pilgrimage to Halle; apparently the pope then granted the authorization to collect fees from the pilgrims. Albert's grand design was to make Halle the leading center of resistance to the Reformation, and he transformed the city to achieve it.

In order to accomplish his purpose he would have to do three things: to show an openness toward humanism, to spread a body of teaching opposed to that of the University of

Wittenberg, and to reestablish the cohesion of the Germanic Christian community. To the first objective corresponded the prelate's display of reverent respect for Erasmus of Rotterdam;[106] to the second, his efforts to launch in Halle a university which could rival Wittenberg;[107] to the third, his intention to "remodel" Halle. The remodeling would begin with the building of a great church, which would be *the* monument to the cardinal's memory and a suitable setting for large-scale exposition of the sacred relics.

The grand idea began to take flesh in 1519. In that year Albert set about putting the canons out of the Collegiate Church of St. Maurice in order to install his own foundation there. Then, having obtained the necessary authorization from Rome,[108] and by agreement with the Dominicans, he ceded the Convent of St. Maurice to them in exchange for theirs, which could more easily be adapted to his uses.[109] Thereupon the Dominican church became a collegiate church dedicated to St. Maurice and St. Mary Magdalene, to whom St. Erasmus was added.[110] Furthermore, the church was entirely renovated in accordance with an exact decorative program.

At that moment, if we follow E. Wind's very appealing hypothesis, the commissions looking toward the ornamentation of the buildings in Halle had already been awarded, and some were partly executed. Wind proposes, on the strength of what seem to be solid arguments, to set the date of the completion of Grünewald's picture, inspired by the Maurice theme, in 1517,[111] and not in 1521, the traditionally accepted date.[112] The painter found himself constrained by a very exact program when the young archbishop commissioned him to work on a subject unheard of until then; viz, the meeting of St. Maurice and St. Erasmus. Erasmus, bishop of Antioch at the close of the third century, could never, of course, have met Maurice; in Germany he was honored in the fourteenth century as one of the Fourteen Auxiliary Saints.[113] Indeed, it was the fact that he had the same name as the Renaissance Erasmus that won him the honor of figuring opposite St. Maurice. E. Wind sees the scene as allegorical: Maurice, patron saint of Magdeburg and Halle, *is welcoming* St. Erasmus,[114] whose features are those of Albert himself.

Grünewald's painting,[115] now in Munich, has been studied time and again from the standpoints of history and art (color plate 1).[116] We are concerned here only with the figure of Maurice. He appears as an Oriental prince; he wears an astounding head covering[117] and traditional armor richly embellished by the painter; lance and banner are left off. In any case, the purpose was not to represent the Maurice of tradition but to show him playing his part in the event itself—the meeting with St. Erasmus—whether this was intended as an allegory signifying acceptance of the latter saint as co-patron of Halle or whether it was meant to commemorate a legendary baptism of Maurice[118] by Erasmus, as L. Grote suggests.[119] Whatever the date of its execution, Albert of Brandenburg thought of this painting as a manifesto. It is interesting to note that in it he had the painter respect the tradition of the black Maurice—probably for purely aesthetic reasons, as we shall see. The realism of the painting would suggest, as it has in other cases, that Grünewald may have sought out a living person as a model.

The silver statue of Maurice cast about 1520 by order of the cardinal did not long survive; it disappeared as early as 1540, since Albert needed the metal for coinage.[120] This statue was probably the one copied in the painting at folio 227ᵛ of the *Liber Ostensionis*, also called the *Hallesche Heiltumsbuch*,[121] an inventory of the reliquaries and precious objects in Halle, drawn up in 1525–27: we shall see more of this. Only minute details distinguish this picture

from the painting on the wing of an altarpiece, dated 1529, in the "Marktkirche" at Halle, the work of an anonymous associate of Cranach:[122] we see the same sumptuously engraved armor and the same huge, plumed hat, while the elegant warrior-prince holds a long, precious sword in his left hand and a huge banner, bearing the Brandenburg eagle, in his right.

From then on this was the usual image, whether used on painted panels, in illumination, or in sculpture. That is how Nikolaus Glockendon pictured Maurice, surrounded by his companions in martyrdom with their helmets gorgeously decorated with white plumes, in a rich missal executed in 1524 for the cardinal, whose taste for luxury and display was rarely indulged so freely.[123] Maurice also appears in two ornamented initials in the same missal,[124] bareheaded or with the plumed hat, as well as in a full-page painting in which, together with Mary Magdalene, he presents the prelate's coat of arms.[125] His image is engraved above Albert's portrait on the silver plaque that adorns the binding. In the Collegiate Church of St. Maurice and St. Mary Magdalene in Halle—now called the "Dom"— there is a statue, recently attributed to Peter Schro[126] and dated 1525, which represents Maurice with the same attributes. We find him again, wearing armor and the broad hat, on two plaques commemorating Albert's dedication of the church in 1523; their purpose was to give future generations visual evidence of the cardinal's generosity and love of display. The larger plaque was carved in Eifel tufa by Peter Schro;[127] it has suffered some damage— notably its upper cornice is gone[128]—but Maurice is intact. Mary Magdalene rests one arm, as does Maurice, on the coat of arms of the House of Brandenburg. The second of these plaques is usually attributed to Loy Hering,[129] author of a carved epitaph in a similar style.[130] Hering gives a simpler version of St. Maurice, presenting him as a young soldier, bareheaded, with definitely kinky hair, holding a large banner.

The map charting the representations of the black St. Maurice in the sixteenth century[131] brings out the importance of the changes that took place by comparison with earlier centuries. The Saxon nucleus was still at the base.[132] In Jüterbog the importance accorded to the Theban saint was such that in 1508 he was represented life-size on the façade of the town hall;[133] the monumental character of the image forced the abandonment of superfluous detail and gave the helmeted warrior (this helmet we have seen only at Kloster Zinna) an undeniably fine bearing. Small churches and monasteries in Saxony welcomed the black Maurice as they had in the preceding period; his representations became more numerous especially between Halle and the Elbe, northwest[134] and south of the city. Probably the influence of the Pan-Germanic pilgrimage also accounts for the presence of many examples of the black Maurice in Lower Saxony (the Lüneburg triptych[135] is a case in point), in Schleswig,[136] and even in the Danish islands. And again, once one gets away from the principal center of the province of Magdeburg, the details of local iconography show vacillations and adaptations; in the castle of Marienburg, for instance,[137] the altarpiece called the "Calenberger Altar" has, on the left wing, a white Maurice whose turban gives him an exotic air, surrounded by his companions, who alone are clearly black.

South Germany, where, as we have seen, the veneration of the Theban had lost ground and the black iconography had made little penetration in the fifteenth century, shows a certain number of examples in the sixteenth.[138] On the wing of an altarpiece executed about 1520 and coming from Schwaigern,[139] Maurice, wearing a hat of more modest proportions than those at Halle, holds a curious shield decorated with three heads of blacks. From Swabia come two painted altarpiece wings, dating from about 1525 and now in

Nuremberg,[140] on which Maurice, bareheaded, holding the shield with the eagle and the banner with the red cross, faces St. George. The church at Limbach, near Pommersfelden, possesses a work of high quality, Hans von Kulmbach's so-called Altarpiece of the Holy Knights ("Ritteraltar"), from the early sixteenth century.[141] Maurice is figured on the stationary wing to the left; his woolly hair and earring accentuate the ethnic type. By the sober style of the armor, the absence of any headgear, and the meditative cast of the face, the painter succeeded in giving his subject an intensity we have seldom found before.

As usual, the liturgy confirms what we learn from works of art. Passau in 1494, Ratisbon in 1510, Constance in about 1485, and Basel about 1486, all revive the cult of St. Maurice. The Ratisbon Missal borrowed directly from the Magdeburg liturgy.[142]

Albert of Brandenburg's policies bore fruit. The plan to initiate a kind of great Pan-German pilgrimage to Halle did in fact awaken a favorable echo among the empire's Catholics;[143] a sumptuous display of riches was centered around it.[144] The cardinal's theatrical exposition of the relics that he and his predecessor had assembled[145] was intended, of course, to stir up the mystical sentiment of a Germany united in the veneration of its saintly protectors, but, paradoxically, it also turned out to be a profitable business enterprise. Luther's violent criticism of the project[146] may have been Albert's reason for waiting to put it into action, which he finally did in 1523.

A breviary dated 1532[147] gives us a clear idea of the theatricality that distinguished the annual pilgrimage, and lets us see how the entire liturgy at Halle was organized around the exposition of the relics.[148] One element stands out immediately in these ceremonies, and that is the marked preference for black vestments, with silver also dominating. Here we see some reason to wonder whether the continued representation of Maurice as a black was not prompted by aesthetic considerations rather than by an ethnic significance inherited from the thirteenth century.

The breviary goes into minute detail on the way the relics were set out for each feast. It is evident that they played a major role in the liturgical ceremonies, which were designed to appeal to the emotions more than to reason. It seems that large tables were erected with an arrangement of steps on top, one table in the center and two others at the sides, each covered with a profusion of rugs and tapestries. Thus every spatial dimension was exploited, with the spoken word to heighten the effect. The relics exposed in the center varied with the saint being venerated and the rank of the feast; the number of relics on display also varied. The pilgrims were also allowed to venerate precious objects called *Plenaria*, which were used in the liturgy: there were twelve of them at Halle. They were not reliquaries but objects in gold and silver plate on which were images of Christ, the Virgin, and the foremost saints.[149] Depending on the solemnity of the feast day, seven, eight, ten, or twelve *Plenaria* were exposed following a strictly determined hierarchical order, table by table and step by step on each table:[150] the twelve were shown only on exceptional occasions.[151] Maurice, we should emphasize, was given very special treatment; indeed, he was the only saint whose feast days, twice every year, brought out the whole group of *Plenaria*. The anniversary of the translation of his head to Halle was more solemnly commemorated than his relics' transfer in the tenth century.[152]

The same breviary describes in detail the ceremonies of the pilgrimage.[153] In September a place close to the church was made ready, decorated with tapestries and lighted with candles and lanterns. At the tenth hour on the first day the bells summoned the pilgrims three

times. A sermon preparing the faithful to venerate the relics was followed by a general confession. Then came the procession, strictly programmed, with alternate singing and playing of trumpets and flutes. The procession first passed[154] before the relics of the saints, the second time before those of Christ, the third before those of the Virgin Mary. The fourth *Gang*, or "passing," involved the veneration of particular saints and the prophets, the fifth, the Apostles and Evangelists, the sixth, martyrs, the seventh, confessors and doctors of the Church, the eighth, virgins, and the ninth and last, the relics of venerable widows and women in religion. After these nine *Gänge* the preacher led the pilgrims in prayers for the Church, the empire, the province of Magdeburg, and the diocese of Halle. Then the list of indulgences was read, and the ceremony ended to the pealing of the bells.

All that precedes has to do with the "noble" aspects of the pilgrimage. What went on on the side is not so rosy. There had been a certain degree of freedom about the event as originally organized, but it quickly became a matter of obligation for the people of the province. The clergy had to herd their flocks together, collect the "alms" that were a requirement of the pilgrimage, and deliver the receipts, in bags sealed with their name before witnesses, to the treasury of the Collegiate Church of Halle. The sale of indulgences was now a custom. The cardinal's need of money never stopped growing, especially after the death of his brother Joachim in 1535. His demands gave rise to coolness, then to hostility, in the citizens of Halle, who in 1534 made their own claim for a tax on the pilgrims!

Conquered by the progress of the Reformation, Albert, in 1540, put an end to the exposition of the precious relics at Halle and ordered most of them transferred to Mainz.[155] This gave Luther the chance for a savage triumph over his adversary. A brochure falsely attributed to Albert of Brandenburg was circulated in Wittenberg in the summer of 1542. The German public was thereby invited to a new pilgrimage center to adore some particularly spectacular relics—including a nice piece of Moses' left horn, three flames from the Burning Bush, three tongues of fire and one egg from the Holy Spirit, one tip from the banner brought back from Hell by Christ, a big curl from the beard of Beelzebub, a feather from the archangel Gabriel's wing, a full pound of the wind that blew past Elijah on Mount Horeb, two long notes sounded by the trumpets at Mount Sinai, thirty clangs of the timbrel played by Moses' sister Miriam, a large, heavy chunk of the shout raised by the children of Israel to bring down the walls of Jericho, five fine strings from David's harp, three of the hairs by which Absalom hung from the oak tree. And the pilgrims were promised the remission of great numbers of sins.[156] The cardinal made no response to this tirade— savage, it is true, but brought on by his own excesses.

It is within this tragicomic framework that we must place the last images of St. Maurice that enter into this study. In order to advance the success of the Halle pilgrimage, the cardinal had ordered the compilation of a catalogue of the reliquaries and the most valuable liturgical objects. This work in printed form appeared in 1520, illustrated with 237 woodcuts by Wolf Traut.[157] A more elaborate manuscript catalogue—the number of reliquaries and sacred objects increased steadily—was compiled between 1525 and 1527. This manuscript, which we cited earlier, is generally known as the *Heiltumsbuch*;[158] originally it included 364 paintings. After the relics were transferred to Mainz, a new handwritten inventory was drawn up in 1540;[159] it did not list all the objects and contained no illustrations.[160]

The Aschaffenburg manuscript alone presents some twenty objects in or on which a black Maurice makes his appearance:[161] his statuette stands on one side of three reliquary

monstrances, with St. Mary Magdalene or St. Ursula on the other side;[162] wearing a ban-
deau, he is sculpted in high relief on a reliquary;[163] he is seen on the wing of a triptych[164]
and in scenes from the life of the Virgin;[165] he adorns the scabbard of a sword, his image,
curiously, being repeated six times;[166] more often, a small erect statuette, in armor and car-
rying the gonfalon and the sword or shield, he stands atop some reliquaries,[167] a fifteenth-
century ciborium,[168] and an unusual drinking horn resting on three bird's feet.[169]

It should be said that in all the above examples Maurice is represented as a more or less
"typed" black, with no originality whatever. With the exception of the fine silver reliquary
statue already referred to,[170] what we find are mostly objects of rich gold or silver plate,
some of them bizarre, intended to stir the imagination; the images of Maurice hold our
interest only by the frequency of their occurrence. Two reliquary busts, however, deserve
closer attention. One of them represents "Fidis," an imaginary sister of Maurice, with
black skin and kinky hair. Her turban and rings contrast with the rich apparel of the
period:[171] the 1520 catalogue already presents her in the same turban and clothing rendered
more sketchily, but there the wood engraving did not allow the blackening of the face—a
banal one at best—whereas the facial traits of the Fidis in the Aschaffenburg manuscript
are delicate and regular. This cannot be said of the features of Maurice on the other reli-
quary bust, which are deliberately "typed."[172] Once again our saint carries the shield with
the eagle, and his headdress is not unlike the one Grünewald gave him; oddly enough, this
headdress is absent in the 1520 catalogue, where Maurice, with strongly marked black fea-
tures, is bareheaded. It may be that the crown in the Aschaffenburg manuscript was added
later, but it is not possible to establish the exact relationship between that picture and
Grünewald's painting. At any rate, in these two reliquary busts we have works that, for all
their ostentatiousness, are powerful and tell us much about the personality of Albert of
Brandenburg.

After the cardinal's demise, the theme that he had caused to be represented more often
than at any other time lost some of its significance, and although its popularity fell off
sharply, it did not completely disappear. In the late sixteenth century the members of the
cathedral chapter of Magdeburg commissioned some large enameled glass goblets, which
form a fairly uniform series: the armorial bearings of aristocratic families figure in the lower
register, and a black St. Maurice in armor, wearing the plumed hat and carrying the banner
with the cross and the shield with the eagle, is represented in the upper band.[173] Could the
goblets have been intended as presents? Were they a new kind of Magdeburg "propaganda,"
like the coins circulated some centuries earlier? St. Maurice appears on them only by allu-
sion to his role as a protector of the city. Inside the city he survived in another way, sur-
prising in view of the Reformation. The new pulpit, erected in the late sixteenth century in
the cathedral, by now a Protestant church, still presents the alabaster images of the saints
so long venerated there, and among them Maurice, identified by a cartouche; his hair is
kinky, and he faithfully carries the banner that protects his city, and a shield decorated with
the two-headed eagle.[174]

Lastly, in the classical period, the black Maurice survived in some few localities situated,
oddly enough, in a horizontal zone going from Münster to Magdeburg:[175] we find a painted
statue, sometimes standing alone,[176] sometimes inserted in a large sculptured group
(baroque altarpiece at Hildesheim[177] and at Langenweddingen,[178] monumental tomb in

Münster Cathedral[179]); Maurice is a black man-at-arms, usually wearing the helmet and cuirass and carrying either the lance or the gonfalon with the cross.

In Magdeburg, from the thirteenth century onward, Maurice was a black saint. Did this amount to an explicit proclamation of the equality of black Africans as men destined to salvation? One might think that this was so in the twelfth and thirteenth centuries, in the midst of the universalist movement in which Otto of Freising took the initiative, when, too, there were manifestations of sympathy that reached the black queen Belakane, mother of a perfect knight.[180] But this perspective did not last. After 1250 the empire abandoned the Hohenstaufens' Mediterranean dreams and became more German than European. Its contacts with the black world remained extremely tenuous at the very time when things were changing in the Mediterranean area. The image of the black Maurice was saved in the empire, but at the cost of concessions to liturgical or aesthetic fashion; as a result, in the sixteenth century the Theban saint was no more than an exotic figure whose black color was in style. Moreover, whether on account of hostility to the empire or because other intellectual trends were developing, the rest of Western Europe showed little or no disposition to adopt the imperial iconographic program. This combination of trends singularly diminishes the historical significance of the beautiful iconography of the black Maurice.

So it is that the empire, which blackened the Queen of Sheba in 1181, St. Maurice around 1250, and one of the Magi-Kings (at least in the texts) in the early thirteenth century, drew no ethnographic or historical conclusion from all this. These images and forms of devotion never became popular or deeply rooted, except perhaps in the case of the Magi, and we note again that one of them was not represented as black before the fourteenth century. The diffusion of the black Maurice, its extent and relatively long continuation notwithstanding, is marked, beginning with the earliest examples, by a progressive withdrawal from the ideas and biblical interpretations that gave rise to his first appearance.

The most cogent reason for this situation is certainly that the entire debate on the theoretical vocation of blacks to salvation and sainthood went on in closed circles. It was first argued in the thirteenth century among high-ranking and highly educated clerks who were concerned only with theological and philosophical speculation; later, the debate was simply transferred to the imperial circle, where the new images appear to have been utilized to the full in order to reinforce the emperor's prestige, to carry on the struggle against pagans, and to loosen the empire's bonds with Rome.

There remains the masterpiece in Magdeburg. The object, admittedly, is an example of the flourishing of thirteenth-century statuary. Its iconographic audacity obviously sprang from a trend of thought devoted not to Africa, but, more fundamentally, to man and the Christian as conceived by the society in which this creation saw the light of day. Yet one would search in vain in medieval art and probably in Western art as a whole for a representation of the African as faithfully and powerfully rendered as this one. Beyond its realism and its historicity this statue, in the plenitude of its expressiveness, embodies the ultimate vocation to offer a blackness through which the light of sanctity might shine. In later times Western Christendom, despite efforts at rapprochement, would betray its inability to convey the personality of the African through a vision as lofty and as true as the one offered by this image of a man transfigured.

Notes

1. A systematic study of the representations of St. Maurice as a black has been inaugurated by the Menil Foundation. The outcome of this research, which is being carried out by Dr. Gude Suckale-Redlefsen and Dr. Robert Suckale of Munich, will be the publication of a catalogue raisonné. In the pages that follow, the iconographic references are taken from the inventory in course of production.

2. It is regrettable that no good monograph on Charles IV is available. Some writers see him as a weakling manipulated by the priests, while others exalt him as a new Frederick II; in other words, practically nothing is known about the motives behind his actions or the importance of his decisions. Further on we shall have occasion to point out that this precise and scrupulous man left no detail to chance.

3. J. J. Morper, "Ein Mauritiuskopf vom Bamberger Dom," *Pantheon* 19 (1937): 18–20, attributes the head of a white warrior to St. Maurice. This attribution, and also the provenance, have recently been questioned by W. Sauerländer in *Bayern: Kunst und Kultur*, Exhibition catalogue, Munich, Münchner Stadtmuseum, 9 June–15 October 1972, 2d ed. (Munich, 1972), pp. 315–16, no. 76. On the other hand, J. J. Morper has drawn up an interesting list of representations of a white, bearded Maurice dating from before the middle of the thirteenth century.

4. D. Schubert, *Van Halberstadt nach Meissen: Bildwerke des 13. Jahrhunderts in Thüringen, Sachsen und Anhalt* (Cologne, 1974), pp. 293–95, no. 115. W. Paatz, "Die Magdeburger Plastik um die Mitte des XIII. Jahrhunderts," *JPKS* 46 (1925): 91–120. Note also that another St. Maurice, shown as a white man and probably executed a few years earlier, also figures in the choir. See Mrusek, *Drei deutsche Dome*, p. 48.

5. E. Wenzel, "St. Mauritius im Dom zu Magdeburg und die Entwicklung des Kriegskleides zur Zeit der Kreuzzüge," *Der Burgwart: Jahrbuch der Vereinigung zur Erhaltung deutscher Burgen* 32 (1931): 36–41.

6. E. Schubert, *Der Magdeburger Dom* (Vienna and Cologne, 1975), pp. 202–6 and pls. 2, 3, 104.

7. In Naumburg in the twelfth century there was a monastery dedicated to St. Maurice of which nothing remains; the present church was rebuilt in the sixteenth century. The inscriptions found in the Naumburg district include no references to St. Maurice; cf. E. Schubert, ed., *Die Inschriften des Landkreises Naumburg an der Saale*, Die deutschen Inschriften, vol. 9, Berliner Reihe, vol. 3 (Berlin and Stuttgart, 1965). Inscriptions in the city itself contain only very rare mentions of Maurice's name, and there is no sign of a special veneration of the saint; cf. idem, *Die Inschriften der Stadt Naumburg an der Saale*, Die deutschen Inschriften, vol. 7, Berliner Reihe, vol. 2 (Berlin and Stuttgart, 1960).

8. The first mention of a standard *(vexillum)* of St. Maurice seems to be one that appeared in 1278; cf. G. Sello, "Dom-Altertümer," *Geschichtsblätter für Stadt und Land Magdeburg* 26 (1891): 139, n. 1. But the saint was mentioned earlier, about 1250, in the Magdeburg calendar of feasts; cf. E. Rosenstock, "Zur Ausbildung des mittelalterlichen Festkalenders," *Archiv für Kulturgeschichte* 10 (1912): 276. I thank Professor R. Folz for his kindness in letting me have these items of information.

9. The maps at the end of the original publication (pp. 270–71) illustrate the wide diffusion of this theme.

10. Prague became an archdiocese in 1344. A university was created there four years later.

11. Bühler, "Die Heilige Lanze," pp. 90–91.

12. Folz, Le Souvenir et la Légende de Charlemagne, p. 453.

13. Bernard de Montmélian, *Saint Maurice et la Légion thébéenne*, vol. I, p. 342.

14. L. Neubert and B. čErný, *Karlštejn* (Prague, 1973); G. Schmidt, "Malerei bis 1450: Tafelmalerei, Wandmalerei, Buchmalerei," in K. M. Swoboda, ed., *Gotik in Böhmen: Geschichte,*

Gesellschaftsgeschichte, Architektur, Plastik und Malerei (Munich, [1969]), pp. 201–4; A. Kutal, *L'art gothique de Bohéme*, trans. M. VanÈk (Prague, 1971), pp. 61–63.

15. Pfitzner, *Kaiser Karl IV*., Bilder aus dem deutschen Leben: Deutsche Könige und Kaiser (Potsdam, 1938), p. 95. Each year the paraphernalia of the coronation were to be put on display there, and the public invited to admire them.

16. V. Dvořáková and D. Menclová, *Karlštejn* (Prague, 1965), pp. 108–9.

17. See, e.g., Paris, Bibliothèque nationale, MS. lat. 1052. *Breviary* of Charles V, decorated in France, second half of the fourteenth century, fol. 513ʳ: Maurice is white and his executioners black.

18. A. Matějček and J. Pešina, *La peinture gothique tchèque, 1350–1450*, trans. J. Delamain and L. DostÁlovÁ (Prague, 1955), esp. pp. 24–28, 62–64; A. Friedl, *Magister Theodoricus: Das Problem seiner malerischen Form*, trans. R. Messer (Prague, 1956); idem, *Počátky Mistra Theodorika* (Prague, 1963).

19. According to Friedl, *Magister Theodoricus*, p. 44, a sort of oil receptacle is seen in the picture and is the painter's real signature.

20. Matějček and Pešina, *La peinture gothique tchèque*, p. 26.

21. Gerona, Museo Diocesano de Gerona, 273. *Martyrology*, Bohemia, about 1402, fol. 94ᵛ: martyrdom of St. Maurice and his companions. Cf. part 2 of this volume, pp. 36–37 and p. 269, nn. 180–82.

22. Kroměříž (Czechoslovakia), Uměéleckohistorické Muzeum, P 11; cf. V. Tomášek, *Obrazárna Kroměřížského Zámku* (Kroměříž, 1964), p. 38, no. P 11.

23. We know this mural painting only through a poor photograph and therefore cannot comment on it.

24. This is not surprising, in view of the promotion of the cult of St. Wenceslas, and also because of the "anti-Slav" character given to Maurice's presence as protector of the Germanic armies in preceding centuries.

25. Lechner, *Mittelalterliche Kirchenfeste*: a fifteenth-century calendar from Freising no longer mentions St. Maurice in September, but at 2 May (p. 110) carries a mention of St. Sigismund, who evidently replaced the other. At Passau the calendar of the St. Nicholas Monastery also introduces the feast of St. Sigismund on 2 May, but keeps that of St. Maurice and his companions on 22 September. At Ratisbon (Regensburg) St. Maurice is no longer celebrated on 22 September, St. Emmeram alone remaining. It seems to us that the cult of St. Maurice was abandoned deliberately in the old Bavarian province, except perhaps at Passau, which was still too close to Niederaltaich to escape its influence. We have been able to establish the fact of this development, but not discover its cause. It may be that quite apart from liturgical and Roman influences, a new political situation affected the changing status of the Maurician cult: from the fourteenth century onward, the House of Savoy accorded great prominence to St. Maurice, and it seems that a new shift in the geography of the cult, this time toward the south, was the result.

26. Vienna, Stefansdom, double-winged altarpiece coming from Wiener Neustadt: Maurice is pictured between two bishops on the reverse of the outer right-hand wing. Here the saint's historiated arms are composite: the party-colored, red-and-white Latin cross brings this Maurice closer to the northern representations than to those of Bohemian inspiration. However, the headdress closely resembles that of the Kroměříž bust and, particularly, that of a polychromed wood statue (about 1470) now in the Church of St. Maurice in Breslau (Wroclaw). For the Wiener Neustadt altarpiece, cf. *österreichische Kunsttopographie*, ed. D. Frey, vol. XXIII, *Geschichte und Beschreibung des St. Stephansdomes in Wien* (Vienna, 1931), pp. 273–81, and *Friedrich III. Kaiserresidenz Wiener Neustadt*, Exhibition catalogue, Wiener Neustadt, St. Peter an der Sperr, 28 May–30 October 1966 (n.p., n.d.), pp. 401–3, no. 234.

27. Brandenburg, cathedral, choir: carved and painted altarpiece, about 1370–80; cf. *Die Kunstdenkmäler der Provinz Brandenburg*, vol. II, pt. 3, *Die Kunstdenkmäler von Stadt und Dom Bran-*

denburg (Berlin, 1912), pp. 271–73; R. Nissen, "Die Plastik in Brandenburg a. H. von ca. 1350 bis ca. 1450," *Jahrbuch für Kunstwissenschaft* (1929): 61–99.

28. Brandenburg, cathedral: painted altarpiece, dated 1465; cf. *Die Kunstdenkmäler der Provinz Brandenburg*, vol. II, pt. 3, *Stadt und Dom Brandenburg*, p. 273; J. Fait, "Die Baugeschichte des Domes und seine Kunstschätze," in J. Henkys, ed., *800 Jahre Dom zu Brandenburg: Im Auftrage des Domkapitels Brandenburg* (Berlin, 1965), pp. 45–46.

29. L. Köhler, *Dietrich von der Schulenburg. Bischof von Brandenburg (1365–1393)* (Halle, 1911), pp. 34 ff. On Charles IV's relations with the Hansa, cf. Dollinger, *La Hanse*, pp. 140–44. Charles IV was the only emperor who was really interested in the trade with the north and the Hansa; he had a "northern policy" after acquiring the Marches of Brandenburg and Lusatia.

30. E. Fidicin, Kaiser Karl's IV Landbuch der Mark Brandenburg (Berlin, 1856); C. Brinkmann, Die Entstehung des Märkischen Landbuchs Kaiser Karls IV (Berlin, 1908).

31. True, a very fine alabaster statue made in 1467 represents him with the features of a white man; cf. J. Braun, *Tracht und Attribute der Heiligen in der deutschen Kunst* (Stuttgart, 1943), col. 530, fig. 284. In this case, the nature and quality of the material probably dictated such a return to the old conceptions.

32. E. Schubert, *Der Magdeburger Dom*, p. 36 and pl. 35.

33. The investigation in progress reveals the multiplication of paintings on wood in the early sixteenth century around Halle and Leipzig.

34. Halle, Moritzkirche: statue executed by Conrad von Einbeck and dated 1411 (the polychromy is recent, and the features are not very "Negroid"); the other statue was done a little earlier by an unknown artist. Cf. G. Schönermark, *Die Stadt Halle und der Saalkreis*, Beschreibende Darstellung der älteren Bau- und Kunstdenkmäler der Provinz Sachsen und angrenzender Gebiete, n.s., vol. I (Halle, 1886), p. 111; B. Meier, "Die Skulpturen am Chor der Moritzkirche in Halle a.d.S.," *Thüringisch-Sächsische Zeitschrift für Geschichte und Kunst* 3 (1913): 50–56.

35. Stendal, cathedral, stained-glass window located in the north side of the choir, executed about 1430–40.

36. Halberstadt, Moritzkirche: side of a stall, about 1470–80; cf. O. Doering, *Die Kreise Halberstadt Land und Stadt*, Beschreibende Darstellung der älteren Bau- und Kunstdenkmäler der Provinz Sachsen, no. 23 (Halle, 1902), pp. 384–85.

37. Halberstadt, cathedral: statue standing against a pillar on the north side of the central nave, dated 1513 (gift of Sebastian von Ploto). Maurice's shield shows the eagle of Albert of Brandenburg, and the bracket on which the statue stands is decorated with two Negro heads. Cf. ibid., p. 264; J. Flemming, E. Lehmann, and E. Schubert, *Dom und Domschatz zu Halberstadt* (Vienna and Cologne, 1974), pp. 51–52 and pl. 101.

38. Medingen, abbey: silver statuette of St. Maurice which, according to the abbess, Dame von Bülow, came from Magdeburg; another, more recent statuette (about 1506) by Hermen Worm, who also made an abbatial crozier with St. Maurice and the Virgin and Child back to back in the volute.

39. Ebstorf, abbey: pyx in gilded silver with a St. Maurice atop the cover; fragment of an altarpiece, now in very bad condition, in which Maurice's blackness is still visible, burse embroidered with the image of the black saint.

40. Wienhausen, abbey, chapter room: triptych in polychromed and gilded wood, about 1450–1500, with SS. Antony, Maurice, and James on the left wing; cf. *Die Kunstdenkmale des Landes Niedersachsen*, vol. XXXIV, *Die Kunstdenkmale des Landkreises Celle im Regierungsbezirk Lüneburg: Textband* (Hannover, 1970), p. 121; H. G. Gmelin, *Spätgotische Tafelmalerei in Niedersachsen und Bremen* (Munich and Berlin, 1974), pp. 377–78, no. 119. Another triptych, in the nun's choir, presents eight saints, including a black Maurice, on its painted predella. The black

Maurice appears again, with shield and standard marked with a cross, on a separate altarpiece fragment, which was added later above this same altarpiece; cf. idem, *Spätgotische Tafelmalerei*, pp. 457–66, no. 152.

41. Refer to the map (see *infra*, p. 270) of the representations of the black St. Maurice at the present stage of the research. The catalogue raisonné now being prepared will give the full list.

42. Delitzsch, Church of SS. Peter and Paul: carved altarpiece, left wing: St. Maurice and a deacon; cf. G. Schönermark, *Kreis Delitzsch*, Beschreibende Darstellung der älteren Bau- und Kunstdenkmäler der Provinz Sachsen und angrenzender Gebiete, no. 16 (Halle, 1892), pp. 37–38.

43. Frankenhain, church: carved altarpiece, central panel: Virgin and Child between St. Maurice and St. Sebastian; cf. R. Steche, *Amtshauptmannschaft Borna*, Beschreibende Darstellung der älteren Bau- und Kunstdenkmäler des Königreichs Sachsen, no. 15 (Dresden, 1891), p. 83.

44. Rottenbach, church: altarpiece from the studio of Valentin Lendenstreich, central panel: Virgin and Child flanked, on the right, by St. Catherine and St. Maurice; cf. *Bau- und Kunst-denkmäler Thüringens*, ed. P. Lehfeldt, vol. I, *Fürstenthum Schwarzburg-Rudolstadt* (Jena, 1894), p. 213; G. Voss, *Die Thüringer Holzschnitzkunst des Mittelalters insbesondere die Werke der Saalfelder Bildschnitzschule*, Heimatbilder der Vergangenheit aus Saalfeld und Umgegend, no. 1 (Magdeburg, 1911), pp. 20–21.

45. Braunsdorf, church: carved altarpiece, right wing: St. Maurice; cf. R. Steche, *Amtshauptmannschaft Chemnitz*, Beschreibende Darstellung der älteren Bau- und Kunstdenkmäler des Königreichs Sachsen, no. 7 (Dresden, 1886), p. 6; W. Hentschel, "Ergänzung des spätgotischen Schnitzaltars von Bräunsdorf," *Deutsche Kunst und Denkmalpflege* 1–2 (1940–41): 195–96.

46. Teterow, church: carved altarpiece, lower register of left wing: black St. Maurice, half length; cf. *Die Kunst- und Geschichts-Denkmäler des Grossherzogthums Mecklenburg-Schwerin*, vol. V, *Die Amtsgerichtsbezirke Teterow, Malchin, Stavenhagen, Penzlin, Waren, Malchow und Röbel.*, 2d ed. (Schwerin i. Mecklenburg, 1902), pp. 11–12.

47. H. Ludat, Deutsch-slawische Frühzeit und modernes polnisches Geschichtsbewusstsein (Cologne and Vienna, 1969), p. 56.

48. Wismar, Nikolaikirche: carved altarpiece (Krämeraltar), central panel: Virgin and Child between St. Michael and St. Maurice; cf. *Die Kunst- und Geschichts-Denkmäler des Grossherzogthums Mecklenburg-Schwerin*, vol. II, *Die Amtsgerichtsbezirke Wismar, Grevesmühlen, Rehna, Gadebusch und Schwerin*, 2d ed. (Schwerin i. Mecklenburg, 1899), p. 37; K. H. Clasen, *Der Meister der Schönen Madonnen: Herkunft, Entfaltung und Umkreis* (Berlin and New York, 1974), p. 98.

49. Roskilde, Domkirke, chapel called Chapel of Christian I or of the Three Magi; cf. *Danmarks Kirker udgivet af Nationalmuseet*, vol. III, *København Amt*, ed. E. Moltke and E. Møller (Copenhagen, 1951), pp. 326–32 and p. 327, fig. 262.

50. See Dollinger, *La Hanse*, pp. 341–42.

51. Originally in Riga, House of the Black Heads; cf. W. Neumann, *Werke Mittelalterlicher Holzplastik und Malerei in Livland und Estland* (Lübeck, 1892). At the moment we do not know what finally became of this statue.

52. E. Thomson, *Die Compagnie der Schwarzhäupter zu Riga und ihr Silberschatz*, Schriftenreihe Nordost-Archiv, vol. 6 (Lüneburg, 1974).

53. Ibid., p. 6.

54. Ibid., p. 15.

55. Lübeck, cathedral, mural painting: epitaph of the Morum family, early fifteenth century.

56. W. Neumann, Das Mittelalterliche Riga: Ein Beitrag zur Geschichte der norddeutschen Baukunst (Berlin, 1892), pp. 54–56 and pls. XXV–XXVI.

57. Thomson, Die Compagnie der Schwarzhäupter zu Riga, p. 27.

58. As late as the seventeenth century an altar was dedicated to St. Maurice in the crypt of the cathedral at Cologne; cf. *Die Kunstdenkmäler der Rheinprovinz*, ed. P. Clemen, vol. VII, fasc. I,

Die Kunstdenkmäler der Stadt Köln, vol. II, fasc. I, *Die Kirchlichen Denkmäler der Stadt Köln,* ed. H. Rahtgens (Düsseldorf, 1911), p. 64. Maurice is not black; only one Theban soldier—is it Gregory?—has the features of a black.

59. For references concerning the iconography of St. Gregory the Moor, see part 2 of *The Image of the Black in Western Art* (Harvard, 1979), p. 38 and 270, nn. 190–94.

60. Munich, Bayerische Staatsgemäldesammlungen, Alte Pinakothek, 1474, 1475. Anton Woensam, two wings from an altarpiece, from Cologne, Church of St. Gereon; cf. G. Goldberg and G. Scheffler, *Altdeutsche Gemälde: Köln und Nordwestdeutschland,* Bayerische Staatsgemäldesammlungen, Alte Pinakothek/München: Gemäldekataloge, vol. 14 (Munich, 1972), *Textband,* pp. 506–14; *Tafelband,* pls. 155–56.

61. Brussels, Bibliothèque Royale Albert Ier, MS. 9786-90. *Missal* of the priory of Bilzen (Limburg); cf. J. van den Gheyn, *Catalogue des manuscrits de la Bibliothèque Royale de Belgique,* vol. I, *Ecriture sainte et Liturgie* (Brussels, 1901), pp. 257–64, no. 435.

62. On the subject of Maurice and his companions, we have found the following in the catalogue cited *supra,* n. 224: eight liturgical texts, twenty-eight readings of different types and levels (one by Albertus Magnus), twelve poems, three hymns, two prayers (one by Albertus Magnus), one sequence, and one martyrology.

63. Brussels, Bibliothèque Royale Albert Ier, MS. 9786–90, fol. 15r: martyrdom of the Theban Legion. The miniature on this folio, closely connected with the text, unquestionably represents whites as the victims.

64. Ibid., fol. 99r: martyrdom of the Holy Moors. The identification of the scene is the one given by Gheyn, *Catalogue des manuscrits,* vol. I, p. 260. The context relates the Holy Moors to the Theban martyrs, but in no way confuses them.

65. Fröndenberg, collegiate church: polychromed and gilded wood statue, about 1400; cf. R. Fritz, *Fresken, Altäre, Skulpturen: Kunstschätze aus dem Kreis Unna* (Cologne and Berlin, 1970), pp. 76–77.

66. G. de Manteyer, *Les origines de la Maison de Savoie en Bourgogne (910–1060)* (Rome, 1899); further information in F. Hayward, *Histoire de la Maison de Savoie,* vol. I, *1000–1553* (Paris, 1941), and vol. II, *1553–1796* (1943).

67. Manteyer, Les origines de la Maison de Savoie, pp. 525–26.

68. In the departments of Saône-et-Loire and Ain, in Savoy, and in the canton of Valais, there are villages named for St. Maurice and churches dedicated to him. Without giving exact chronological references, G. de Manteyer enumerates at least fifteen such churches (ibid., pp. 380–81).

69. D. Promis, *Monete dei Reali di Savoia,* 2 vols. (Turin, 1841).

70. ". . . a parte pile infra circulum medium unum militem armatum armis et ad imaginem sancti Mauritii appodiantem se ad ensem. . . ." (ibid., vol. I, p. 93).

71. F. Mugnier, *Les manuscrits à miniatures de la Maison de Savoie* (Moutiers-Tarentaise, 1894). The manuscript is in Paris, Bibliothèque nationale, MS. lat. 9473 Réserve (between 1440 and 1445). The relevant illustrations are at fol. 180* scenes in addition to the central figure, which embellish the *Vita* as freely as those in Jüterbog. One or two of these scenes probably allude to the organization of the Order of the Knights of St. Maurice, granted by Pope Eugenius IV to Duke Amadeus VIII of Savoy in 1434; cf. idem, *Les manuscrits à miniatures,* p. 94.

72. On this occasion Amadeus VIII withdrew from the world with five of his counselors, forming the first group of the Knights of St. Maurice.

73. L'Ordine dei Santi Maurizio e Lazzaro (Milan, 1966), p. 12.

74. In 1420 an attack on the region by the Pomeranians was repulsed, but was resumed in 1425.

75. B. Hennig, Die Kirchenpolitik der älteren Hohenzollern in der Mark Brandenburg und die päpstlichen Privilegien des Jahres 1447: Kapitel IV: Besetzung der Bistümer Brandenburg, Havelberg und Lebus (Leipzig, 1906).

76. A town hall was built in 1380 and reconstructed between 1450 and 1506. The first mention of a Church of St. Nicholas, a dependency of the Cistercian monastery founded by Wichmann in the twelfth century, dates from 1307: important donations were made to this church in 1350 and 1371; cf. *Germania sacra*, fasc. I, *Die Bistümer der Kirchenprovinz Magdeburg*, vol. III, *Das Bistum Brandenburg*, pt. 2, pp. 321–60. A Franciscan church was built toward the end of the fifteenth century.

77. Jüterbog, Church of St. Nicholas: fragment of the altarpiece of the old high altar (about 1425), reverse of the painted exterior wing: life and martyrdom of St. Maurice. Reading from bottom left to top right, following the conventions adopted for stained-glass windows and ivories in the Middle Ages, we see the saint's baptism, appearance before the emperor, refusal to renounce the Christian faith and to sacrifice to idols, and his martyrdom. Cf. C. Giese, "Zur Rekonstruktion des chemaligen Hochaltares der Nikolai-Kirche in Jüterbog," *Die Denkmalpflege: Zeitschrift für Denkmalpflege und Heimatschutz* (1931): 190–92; H. Bethe, "Ein niedersächsischer Altar um 1430," *Zeitschrift für bildende Kunst* 65 (1931–32): 22–24.

78. Characteristic of the last decades of the fourteenth century and the early years of the fifteenth in Germany were a new, serious, and lasting weakening of the imperial power, and the divergence, which continually grew deeper, between the northern and the southern area of that part of Europe. The disturbances that beset Bohemia, southern Germany, and Hungary had no counterparts in the north. Brandenburg stood somewhat outside of the general course of events; hence, it is not unreasonable to see a degree of originality and a discreet, anti-imperial aloofness in Hohenzollern policy.

79. Kloster Zinna, former Fürstenhaus, second floor, north wall.

80. L. Achilles, ed., Zehn Jahre Denkmalpflege in der Deutschen Demokratischen Republik (Leipzig, 1959), p. 213.

81. A letter from Mrs. G. Fink, curator of the Kreis-Heimatmuseum in Jüterbog, dated 21 August 1969, informs us that the painting, now carefully restored, had for several centuries been covered with layers of paint and varnish which preserved its original colors. Maurice's face is reddish brown; his standard is white with a black cross (also the cross of the Teutonic Order); on the shield is a black eagle on a white ground.

82. A prominent personage in his own right, Ernest of Saxony was elected archbishop at the age of eleven but was not consecrated until he was twenty-five years old.

83. F. W. Hoffmann, *Geschichte der Stadt Magdeburg*, rev. G. Hertel and F. Hülsse (Magdeburg, 1885), vol. 1, p. 252. As we know, the exposition of the relics was already traditional in the thirteenth century. Albert of Brandenburg later broadened its scope.

84. A. Schmidt, "Der Magdeburger Dombau und die St. Mauritiusbruderschaft," *Geschichtsblätter für Stadt und Land Magdeburg* 62 (1927): 102 ff.; text of the archbishop's letter, pp. 105–8.

85. Magdeburg, cathedral, Ernstkapelle; provenance, Johanneskapelle.

86. A. Schmidt, "Der Magdeburger Dombau und die St. Mauritiusbruderschaft," p. 102; text of 1491, pp. 109–13.

87. The pastoral letter sets down in detail the methods of collection, counting the money, and preparation of the bags before witnesses.

88. Opfermann, "Das Messformular," in Schrader, *Beiträge zur Geschichte des Erzbistums Magdeburg*, pp. 192–213.

89. Magdeburg Missal, edition of 1486, revised in 1493 and 1503; cf. W. H. J. Weale and H. Bohatta, *Bibliographia liturgica: Catalogus Missalium ritus latini ab anno 1474 impressorum* (London, 1928), pp. 100–101. Opfermann, "Das Messformular," in Schrader, *Beiträge zur Geschichte des Erzbistums Magdeburg*, used manuscripts of Dresden (1493) and Wolfenbüttel (1486), which contain these texts.

90. Although he did not emphasize it particularly, the clarity of B. Opfermann's edition (Opfermann, "Das Messformular," in Schrader, *Beiträge zur Geschichte des Erzbistums Magdeburg*), brings out the relationships among the several liturgical compilations of Halle (1486, 1494, 1500), Fulda (1493), Kassel (fifteenth century), Beuron (1485–1523), Mainz (1507–90), Bautzen (1485–95), and Speyer (1487), in the case of manuscripts studied, and the Missals of Bursfelde (1498) and Brandenburg (1494), at the level of texts cited. The Magdeburg Missal (sec B. Opfermann, "Das Magdeburger Missale des späten Mittelalters," in Schrader, ibid., pp. 276–89, esp. pp. 282–83), definitively fixes, as of the end of the fifteenth century, not only the prayers in honor of St. Maurice, but also the calendar of commemorations at Magdeburg; this text is still in use in our day. The following days are commemorated: 25 February, arrival of the saint's relics; 3 June, feast of St. Erasmus; 22 September—principal feast day, with octave—martyrdom of Maurice and his companions; 28 September, reception of the martyr's head; 10 October, SS. Gereon and Victor and their companions; 16 October, SS. Gall and Lupus, and St. Sigismund, confessor of the faith; 19 October, the Moorish martyrs.

91. Folz, *Le Souvenir et la Légende de Charlemagne*, p. 513, n. 113.

92. Magdeburg, cathedral, Ernstkapelle: bronze funerary monument of Archbishop Ernest of Saxony (died 1513) by Peter Vischer the Elder; the statuette of St. Maurice, beneath a multifoil arcature, is the only figure on the head side of the base of the tomb; cf. E. Schubert, *Der Magdeburger Dom*, pp. 211–12 and pls. 147–52.

93. Other difficulties arose when the people of the city were called upon to make contributions for the towers of the cathedral; cf. A. Schmidt, "Der Magdeburg Dombau und die St. Mauritiusbruderschaft," pp. 100–113.

94. E. Neuss, ed., *Das alte Halle: Aus den Schriften von Siegmar von Schultze-Galléra* (Leipzig, 1965), p. 31.

95. Ibid., p. 30 and see *supra*, p. 174 and n. 197.

96. The statue is now in Halle, Staatliche Galerie Moritzburg; see R. Hünicken, Halle in der mitteldeutschen Plastik und Architektur der Spätgotik und Frührenaissance, 1450–1550 (Halle, 1936), p. 14; E. Neuss, Kunstwerke des gotischen Gewölbes in der Moritzburg zu Halle (Halle, 1955), p. 15.

97. Hoffmann, *Geschichte der Stadt. Magdeburg*, vol. I, pp. 255 ff.

98. Ernest of Saxony endowed the Moritzburg, after 1503 the residence of the archbishops of Magdeburg in Halle, with a chapel dedicated to St. Maurice in 1509. The residence was badly damaged in the seventeenth century.

99. Berlin (GFR), Staatliche Museen, Gemäldegalerie, 603 A. Triptych, right wing: St. Maurice (reverse: St. Agnes). Cf. *Staatliche Museen Berlin: Verzeichnis der Ausgestellten Gemälde des 13. bis 18. Jahrhunderts im Museum Dahlem* (Berlin, 1962), p. 10, no. 603 A; K. Oettinger and K.-A. Knappe, *Hans Baldung Grien und Albrecht Dürer in Nürnberg* (Nuremberg, 1963), pp. 119–20, pls. 6, 8–15, and c. pls. IV, V.

100. Halle, Moritzkirche, large altarpiece from the high altar, with triple wings dated 1511; cf. Schönermark, *Die Stadt Halle und der Saalkreis*, pp. 139–50.

101. We owe the fixing of these dates to information furnished by Gude and Robert Suckale.

102. Sebastian Weynmann, *Libellus de sanctis reliquiis*, quoted in Sello, "Dom Altertümer," p. 138. I also owe my acquaintance with this text to the kindness of R. Folz.

103. "Et referunt, qui prospexerunt, de serico albo factum esse, ymaginem Christi salvatoris . . . in se habere" (ibid., p. 139).

104. Albert, younger brother of Prince Elector Joachim I of Brandenburg, was elected archbishop of Magdeburg at the age of twenty-three. In 1513 he was entrusted with the administration of the diocese of Halberstadt; in 1514 he became administrator of the archdiocese of Mainz and

the diocese of Erfurt, prince elector, and primate of Germania; in 1518, when he was twenty-eight, Leo X made him a cardinal. His election, however, cost 24,000 florins, which his brother had to borrow from the Fuggers, and Albert's need of money continued to grow.

105. G. von Térey, Cardinal Albrecht von Brandenburg und das Halle'sche Heiligthumsbuch von 1520: Eine kunsthistorische Studie (Strassburg, 1892), p. 9.

106. The very valuable essay by E. Wind, "Studies in Allegorical Portraiture–I (2): Albrecht von Brandenburg as St. Erasmus," *Journal of the Warburg Institute* 1 (1937–38): 142–62, provides a harvest of new and essential information on this subject. It is his opinion—and his demonstration is convincing—that the introduction of the cult of St. Erasmus at Halle, decided upon by Albert, was intended to attract the good will of the Rotterdam scholar and the humanistic public.

107. P. Wolters, "Ein Beitrag zur Geschichte des Neuen Stiftes zu Halle (1519–1541)," *Neue Mittheilungen aus dem Gebiete historischantiquarischer Forschungen* 15 (1882): 7–41, esp. pp. 7–8. See also A. Wolters, *Der Abgott zu Halle, 1521–1542* (Bonn, 1877), p. 21.

108. P. Redlich, Cardinal Albrecht von Brandenburg und das Neue Stift zu Halle, 1520–1541: Eine kirchenkunstgeschichtliche Studie (Mainz, 1900), p. 15.

109. P. Wolters, "Ein Beitrag zur Geschichte des Neuen Stiftes zu Halle," p. 7.

110. Before 1520 Erasmus, by decision of the archbishop, became the third patron saint of Halle, along with Maurice and Mary Magdalene. Wind's argument is well buttressed, and one is tempted to accept his interpretation, however much fluttering this may cause in the dovecotes of tradition—the tradition certainly being no better guaranteed than Wind's solution.

111. Wind, "Studies in Allegorical Portraiture," esp. pp. 144–53.

112. W. K. Zülch, *Grünewald: Mathis Gothardt-Heithardt*, 2d ed. rev. (Munich, 1949), p. 51, dates the work as of 1525. Zülch's argument in favor of this date does not strike us as very solid. He states that Grünewald took as the model for his figure of Maurice a silver statue of the saint, cast by order of the cardinal in 1520, but melted down in 1540 when Albert needed the metal for his coinage (idem, *Grünewald*, p. 52). There is no irrefutable proof that it was not the other way around, Grünewald being copied in the 1520 statue.

113. L. Réau, Iconographie de l'art chrétien, vol. III, Iconographie des saints, pt. 1 (1958), pp. 437–38.

114. Wind, "Studies in Allegorical Portraiture," pp. 154–55, shows that the introduction of the cult of St. Erasmus, whose remains were transferred to Halle with great pomp and ceremony in 1516, modified the planning for the iconography in the collegiate church at Halle.

115. Halle painters seem to have had an excellent reputation in the fifteenth century; cf. R. Hünicken, "Grünewald in Halle," *ZFK* 5 (1936): 220. Yet Albert called upon a young painter who was a stranger to the city.

116. Munich, Bayerische Staatsgemäldesammlungen, Alte Pinakothek, 1044; cf. C. A. zu Salm and G. Goldberg, *Altdentsche Malerei*, Alte Pinakothek München, Katalog 2 (Munich, 1963), pp. 93–96 and fig. on p. 269; U. Steinmann, "Der Bilderschmuck der Stiftskirche zu Halle: Cranachs Passionszyklus und Grünewalds Erasmus-Mauritius-Tafel," *Staatliche Museen zu Berlin: Forschungen und Berichte* 11 (1968): 92–104.

117. The crown on the reliquary bust of Maurice, reproduced in the Aschaffenburg manuscript (see *infra*, fig. 167), presents a problem: is it earlier than Grünewald's painting, hence possibly used by him as a model, or vice versa?

118. Note that the theme of the baptism of St. Maurice appeared once in Jüterbog.

119. L. Grote, *Matthias Grünewald (Mathis Gothardt-Neithardt): Die Erasmus-Mauritius-Tafel*, Werkmonographien zur bildenden Kunst in Reclams Universal-Bibliothek, no. 17 (Stuttgart, 1957).

120. Zülch, *Grünewald*, p. 52.

121. Aschaffenburg, Hofbibliothek, MS. 14. *Liber Ostensionis*, fol. 227ᵛ: drawing of a reliquary statue of St. Maurice in the Collegiate Church of St. Maurice and St. Mary Magdalene in Halle.

122. Halle, Marktkirche (Marienkirche): double-winged altarpiece dated 1529, left wing: St. Maurice, attributed to the Master of the Mass of St. Gregory by M. J. Friedländer and J. Rosenberg, *Die Gemälde von Lucas Cranach* (Berlin, 1932), p. 96. A replica of this painting was sold in New York in 1946; see *Old Masters and XIX Century Paintings*, Auction catalogue, New York, Parke-Bernet Galleries, Villarosa sale, 15 May 1946, no. 36B.

123. Aschaffenburg, Hofbibliothek, MS. 10. *Missal* of Cardinal Albert of Brandenburg, fol. 437ᵛ; sec *Aus 1000 Jahren Stift und Stadt Aschaffenburg*, Exhibition catalogue, Aschaffenburg, Museum der Stadt, 15 June–30 September 1957 [Aschaffenburg, 1957], p. 29, no. 93; A. W. Biermann, "Die Miniaturenhandschriften des Kardinals Albrecht von Brandenburg (1514–1545)," *Aachener Kunstblätter* 46 (1975): 15–20, 152–79, and 166, fig. 223.

124. Aschaffenburg, Hofbibliothek, MS. 10, fols. 369ʳ, 381ᵛ; Biermann, "Die Miniaturenhandschriften," pp. 172–73.

125. Aschaffenburg, Hofbibliothek, MS. 10, fol. 7ᵛ; Biermann, "Die Miniaturenhandschriften," p. 157 and p. 156, fig. 198. Note that fol. 32ᵛ of this manuscript presents a full-page painting of the Adoration of the Magi in which the black King occupies a predominant place; idem, "Die Miniaturenhandschriften," p. 157 and p. 158, fig. 202.

126. Halle, Collegiate Church of St. Maurice and St. Mary Magdalene; cf. E. Ruhmer, "Der Meister der Hallischen Dom-Skulpturen," *ZfK* 21 (1958): 209–29 and fig. 4; more recently, I. Lühmann-Schmid, "Peter Schro, ein Mainzer Bildhauer und Backoffenschüler," *MZ* 70 (1975): 1–62, esp. p. 58 and pl. 13.

127. Halle, Collegiate Church of St. Maurice and St. Mary Magdalene: this plaque was long attributed to a pupil or assistant of Backoffen; cf. J. L. Sponsel, "Flötner-Studien," *JPKS* 45 (1924): 133–44 (chap. II: "Die Ausstattung der Stiftskirche in Halle"), 144–63 (chap. III: "Der Hallische Domschatz"). This excellent study has been usefully completed by H. Volkmann, "Die Weihetafeln des Kardinals Albrecht von Brandenburg in der Stiftskirche zu Halle," *Wissenschaftliche Zeitschrift der Martin-Luther-Universität Halle-Wittenberg: Gesellschafts- und Sprachwissenschaftliche Reihe* 12, nos. 9–10 (1963): 757–63. Recently, Lühmann-Schmid, "Peter Schro," pp. 52–55 and pl. 18, attributes the work to Peter Schro.

128. See an attempted restoration in Volkmann, "Die Weihretafeln des Kardinals Albrecht von Brandenburg," p. 761.

129. Ibid., p. 758.

130. Eichstätt, cathedral: epitaph of Canon Bernhard Arzat (died 1525).

131. Cf. the map, p. 271.

132. G. Suckale's research has already located a dozen representations of St. Maurice as a black, and other examples will come to light. This is the largest concentration we have found in any one time and place. The works are related either to the new type of Maurice wearing a large hat, or to older types.

133. Jüterbog, Kreis-Heimatmuseum: statue of St. Maurice, from the façade of the *Rathaus* ("town hall"), dated 1508; see R. Bergau, *Inventar der Bau- und Kunst-Denkmäler in der Provinz Brandenburg* (Berlin, 1885), p. 431. See also G. Dehio, *Handbuch der Deutschen Kunstdenkmäler*, vol. II, *Nordostdeutschland*, 3d ed. (Berlin, 1926), p. 215; in this book the statue is dated as of 1508.

134. There are fewer examples here, but they too show that the diffusion from Halle went in all directions.

135. Lüneburg, Museum für das Fürstentum Lüneburg, H 75. Painted and carved triptych, from the chapel at Gross-Wittfeitzen; right wing (painted), upper register: St. Maurice, surrounded by his companions, carries a gonfalon with the cross pattée and a shield with a giant face. Here we are

out of the zone of the official Magdeburg iconography under Albert, yet the type of the Maurice wearing a hat was kept; cf. H. Busch, *Meister des Nordens: Die Altniederdeutsche Malerei 1450-1550* (Hamburg, 1940), pp. 82–83; Gmelin, *Spätgotische Tafelmalerei*, pp. 165–68, no. 23.

136. Schleswig, cathedral, large altarpiece from the high altar by Hans Brüggemann, completed in 1521, from the abbey church of Bordesholm. A statuette in natural wood representing St. Maurice with "Negroid" features is seen in the predella.

137. Marienburg, castle, Collection of H. R. H. the Prince of Hannover, altarpiece called "Calenberger Altar," attributed by Gmelin, *Spätgotische Tafelmalerei*, pp. 442–48, no. 148, to the Master of the Goslar Sibyls, about 1515; left wing: St. Maurice and his companions. We note, although we cannot pursue it here, that in the central panel of the altarpiece among the women in the lady donor's suite, kneeling at the feet of the Virgin and Child, is a black.

138. Consult the map, p. 271. When the repertory is completed, it will probably increase the number of locations presently inventoried.

139. Wing of an altarpiece now lost, originally from Schwaigern, formerly (before 1926) in Stuttgart, Württembergisches Landesmumuseum, 13254; cf. J. Baum, *Kataloge der Kgl. Altertümersammlung in Stuttgart*, vol. III, *Deutsche Bildwerke des 10. bis 18. Jahrhunderts* (Stuttgart and Berlin, 1917), p. 262, no. 314.

140. Nuremberg, Germanisches Nationalmuseum, Gm. 285/286.

141. Limbach, church, "Ritteraltar" by Hans von Kulmbach; cf. *Meister um Albrecht Dürer*, Exhibition catalogue, Nuremberg, Germanisches Nationalmuseum, 4 July–17 September 1961 (Nuremberg, 1961), p. 110, no. 174, which gives a bibliography on this work.

142. Opfermann, "Das Messformular," pp. 200 ff.

143. On the gifts that flowed into Halle, see Térey, *Cardinal Albrecht von Brandenburg*, pp. 15 ff. In 1520 Leo X awarded the intrepid cardinal the Golden Rose in recognition of his effort to reconquer Germany for Roman Catholicism.

144. Ibid., pp. 7–8. The author establishes, for the years of Ernest of Saxony and Albert, totals of over 100 antependia, over 600 gold and silver objects, more than thirty-two silk and damask flags, and over thirty-five gold-embroidered, silk tapestries—all collected at Halle, without counting any other objects used in worship services.

145. In the early sixteenth century Halle boasted of the fact that it possessed 8,133 relics and forty-two complete bodies. That was a collection unique in Europe and perhaps in all of Christendom; cf. Wind, "Studies in Allegorical Portraiture," p. 145.

146. One could hardly overstress the dialectical and dramatic aspects of the clash between the cardinal and Luther. Once swords were crossed, each of them pushed to excess the logic of his position. It is obvious that this cynical trading on popular credulity in order to obtain money in return for a look at relics and the promised indulgences was not Albert's sole motive. However, it was the weak point in his position, and Luther attacked it savagely on every occasion, first by denouncing the "idolatry" (*Abgötterei*) being organized in Halle (letter of 7 October 1521 to Albert). Luther denounced the cardinal's taking advantage of the pilgrimage to get money and implied that Albert's motive was greed. This conflict of ideas was to divide the German Christian community for hundreds of years; cf. A. Wolters, *Der Abgott zu Halle*.

147. The following paragraphs are based on the excellent study by P. Wolters, "Ein Beitrag zur Geschichte des Neuen Stiftes zu Halle." The breviary is still in Bamberg.

148. Folio 187ʳ of this breviary begins the inventory of the relics exposed at the high points of the liturgical year in the Collegiate Church of St. Maurice and St. Mary Magdalene.

149. Térey, *Cardinal Albrecht von Brandenburg*, pp. 37 ff., describes seven of them. The first, a very old one, presents an image of St. Paul; the second pictures the Last Judgment; the third consists of an ivory crucifix on black silk. The fourth has a gilded cross at the top and bears images of the Virgin, St.

John, St. Benedict, and other saints, plus the Four Evangelists; the fifth represents the Nativity; the sixth includes a bust of Christ and the Four Evangelists; the seventh shows the Annunciation.

150. P. Wolters, "Ein Beitrag zur Geschichte des Neuen Stiftes zu Halle," pp. 17–18.

151. Epiphany, anniversary of the dedication of the Collegiate Church of Halle, the solemn feast of St. Erasmus, Pentecost, nativity of St. John the Baptist, feast of SS. Peter and Paul, Visitation, feast of St. Mary Magdalene, Assumption, feast of St. Maurice, All Saints' Day, Christmas.

152. The anniversary of the translation of St. Maurice's relics was marked by a limited exposition—seven *Plenaria* and no lateral tables. The same arrangement was followed for the feasts of St. Gregory the Great, St. Joseph, St. George, the Coronation of the Virgin, the Invention of the Cross, the anniversary of the transfer of the head of St. Stephen, etc. In every case, the days after the feast itself saw the progressive withdrawal of the relics, again following a strict order. It may be of some interest to reproduce here the notice regarding the anniversary of the arrival in Halle of the head of Maurice; cf. P. Wolters, "Ein Beitrag zur Geschichte des Neuen Stiftes zu Halle," pp. 30–31:

> Adventus capitis sancti Mauritij. Plenaria ut supra [i.e., twelve] Epiphanie domini. Vexillum sancti Mauritij. Das silbern sanct Moritz brustbilde. Der ubergult sargk mit dem Engel. Der ubersilberte Sargk, mit dem B. gezceichnet. [Das silbern Pulpitum.] Der lengelich, vorgult sargk mit dem leyden christi. Der lengelich silbern sargk mit der hystoria der X.ᵐ ritter. Das gross silbern sanct Victors Brustbilde. Der silbern armme mit dem schwert. Das silbern ubergult haupt sanct Gereonis. Die perlen mutter in silber gefasset und ubergult, auff der decken eyn gewapnetter mit eynem schilt. Der silbern sargk mit eyteln sanct Moritz bildern. [Die silberne monstrantz, in dem tabernackel eyn vorgult sanet Augustins bilde.] Den grossen cristallen becher yn silber gefasset, ubergult und mit Perlen getzyrett. Die Greiffes clawe in silber gefasset, ubergult, uff der decke sanct Moritz bilde, *et sanguinem dominj miraculosum.*

153. Ibid., pp. 38 ff.

154. This arrangement explains the use of the word *Gang* for the description of the relics that we will find in the *Heiltumsbuch.*

155. P. Wolters, "Ein Beitrag zur Geschichte des Neuen Stiftes zu Halle," pp. 8–9.

156. A. Wolters, *Der Abgott zu Halle,* pp. 35 ff.

157. An incomplete, unpaged copy of this work is in Nuremberg, Germanisches Nationalmuseum, Post, Inc. K 1603, *Vortzeichnis und zceigung des hochlobwirdigen heiligthums der Stifftikirchen . . . zu Halle;* cf. *Meister um Albrecht Dürer,* p. 219, no. 393. A complete copy is in Stuttgart, Württembergische Landesbibliothek, R 16 Vor I.

158. This work, the so-called *Hallesche Heiltumsbuch* or *Hallesche Heiltum,* is now in Aschaffenburg, Hofbibliothek, MS. 14; see *Aus 1000 Jahren Stift und Stadt Aschaffenburg,* pp. 29–30, no. 96. Several studies of this work have been published. The first task was to find the pages that had been torn out. Térey, *Cardinal Albrecht von Brandenburg,* was the first to make a careful analysis of the contents, but three important drawings and several pages were missing from the manuscript he used. F. Schneider, "Wieder-gewinnung von Miniaturen aus dem Aschaffenburger Prachtcodex des Halleschen Heiligtums, einer Stiftung des Kardinals Albrecht von Brandenburg," *Hohenzollern-Jahrbuch* 1 (1897): 176–86, found some of the missing folios. E. Neeb, "Die letzten dreifehlenden Blätter, vom Aschaffenburger Prachtcodex des Halleschen Heiligtums aus der Zeit des Erzbischoffs Albrecht von Brandenburg," *MZ* 17–19 (1921–24): 35–40, completed the work of showing the original makeup and appearance of the codex. The detailed study is in Redlich, *Cardinal Albrecht von Brandenburg.* The *Heiltumsbuch* was edited by P. M. Halm and R. Berliner, eds., *Das Hallesche Heiltum: Man. Aschaffenb,* 14, Jahresgabe des deutschen Vereins für Kunstwissenschaft, 1931 (Berlin, 1931).

159. H. Bösch, "Die kirchlichen Kleinodien des Kardinals Albrecht, Erzbischofs und Kurfürsten von Mainz, Markgrafen von Brandenburg," *Mitteilungen aus dem germanischen Nationalmuseum* 2 (1887–89): 123–52.

160. We have not been able to do more than outline the study that should be made, comparing the Breviary of 1532 with the available inventories. This would reveal the details of these liturgical spectacles and would enable us to form a concrete idea of the demonstrations of religious feeling in the sixteenth century.

161. In this same manuscript there are also representations of St. Maurice as a white; cf. Halm and Berliner, *Das Hallesche Heiltum*, p. 37, no. 111b and pl. 60 (silver triptych, one wing of which has a St. Maurice), and p. 47, no. 179 and pl. 101b (reliquary in silver and vermeil, on which are several busts, one representing Maurice without "Negroid" features).

162. Aschaffenburg, Hofbibliothek, MS. 14, fols. 110ᵛ, 284ᵛ, 288ᵛ; see Halm and Berliner, *Das Hallesche Heiltum*, p. 35, no. 99 and pl. 58b; p. 52, nos. 221, 225 and pls. 126a, 129.

163. Aschaffenburg, Hofbibliothek, MS. 14, fol. 283ᵛ; see Halm and Berliner, *Das Hallesche Heiltum*, p. 52, no. 220 and pl. 30b.

164. Aschaffenburg, Hofbibliothek, MS. 14, fol. 427ᵛ; see Halm and Berliner, *Das Hallesche Heiltum*, p. 66, no. 339 and pl. 180.

165. Aschaffenburg, Hofbibliothek, MS. 14, fol. 100ᵛ; see Halm and Berliner, *Das Hallesche Heiltum*, p. 34, no. 89 and pl. 45.

166. Aschaffenburg, Hofbibliothek, MS. 14, fol. 292ᵛ; see Halm and Berliner, *Das Hallesche Heiltum*, p. 53, no. 229 and pl. 134a.

167. Aschaffenburg, Hofbibliothek, MS. 14, fol. 94ᵛ; see Halm and Berliner, *Das Hallesche Heiltum*, p. 33, no. 83 and pl. 41a.

168. Aschaffenburg, Hofbibliothek, MS. 14, fol. 335ᵛ; see Halm and Berliner, *Das Hallesche Heiltum*, p. 57, no. 265 and pl. 131b.

169. Aschaffenburg, Hofbibliothek, MS. 14, fol. 291ᵛ; see Halm and Berliner, *Das Hallesche Heiltum*, p. 52, no. 228 and pl. 132.

170. Cf. p. 194 and fig. 150. This large silver statue was in the choir at Halle (Térey, *Cardinal Albrecht von Brandenburg*). A text dating from 1535 seems to allude to it again; cf. Redlich, *Cardinal Albrecht von Brandenburg*, app. 26, p. 112*, vv. 75–78.

171. Aschaffenburg, Hofbibliothek, MS. 14, fol. 376ᵛ; see Halm and Berliner, *Das Hallesche Heiltum*, p. 61, no. 295 and pl. 110a.

172. Aschaffenburg, Hofbibliothek, MS. 14, fol. 228ᵛ; see Halm and Berliner, *Das Hallesche Heiltum*, p. 46, no. 175 and pl. 98.

173. These goblets have been studied by A. von Saldern, *German Enameled Glass: The Edwin J. Beinecke Collection and Related Pieces*, The Corning Museum of Glass Monographs, no. 2 (Corning, 1965), pp. 128–29, 348–52. Here we mention four of them whose dates seem sure (there exist a number of late copies): Cleveland, Cleveland Museum of Art, 48.232 (dated 1568); Corning, The Corning Museum of Glass, 57.3.82 (dated 1593), 57.3.83 (dated 1594); Leipzig, Museum des Kunsthandwerks, 56.56 (dated 1594).

174. Magdeburg, cathedral, pulpit by Christof Kapup, about 1595–97; cf. E. Schobert, *Der Magdeburger Dom*, pp. 215–16 and pl. 131.

175. Refer to Maps, pp. 270–71.

176. Algermissen, Moritzkirche, statue, recently polychromed, which may have been part of an ensemble. Münster, cathedral, statue backed against a pillar, dated 1613.

177. Hildesheim, Moritzstift, large altarpiece of the high altar, late seventeenth to early eighteenth century.

178. Langenweddingen, Church of St. George, monumental altarpiece by Michael Helwig, dated 1710.

179. Münster, cathedral, monumental tomb of Jodocus Droste (died 1594).

180. Cf. *supra*, p. 164.

IMAG(IN)ING RACE IN THE EIGHTEENTH AND NINETEENTH CENTURIES

4

The Imaginary Orient

Linda Nochlin

> What is more European, after all,
> than to be corrupted by the Orient?
> —Richard Howard

What is the rationale behind the recent spate of revisionist or expansionist exhibitions of nineteenth-century art—"The Age of Revolution," "The Second Empire," "The Realist Tradition," "Northern Light," "Women Artists," various shows of academic art, etc.? Is it simply to rediscover overlooked or forgotten works of art? Is it to re-evaluate the material, to create a new and less value-laden canon? These are the kinds of questions that were raised—more or less unintentionally, one suspects—by the recent exhibition and catalogue "Orientalism: The Near East in French Painting 1800–1880."[1]

Above all, the Orientalist exhibition makes us wonder whether there are other questions besides the "normal" art-historical ones that ought to be asked of this material. The organizer of the show, Donald Rosenthal, suggests that there are indeed important issues at stake here, but he deliberately stops short of confronting them. "The unifying characteristic of nineteenth-century Orientalism was its attempt at documentary realism," he declares in the introduction to the catalogue, and then goes on to maintain, quite correctly, that "the flowering of Orientalist painting . . . was closely associated with the apogee of European colonialist expansion in the nineteenth century." Yet, having referred to Edward Said's critical definition of Orientalism in Western literature "as a mode for defining the presumed cultural inferiority of the Islamic Orient . . . part of the vast control mechanism of colonialism, designed to justify and perpetuate European dominance," Rosenthal immediately rejects this analysis; in his own study, "French Orientalist painting will be discussed in terms of its aesthetic quality and historical interest, and *no attempt will be made at a re-evaluation of its political uses.*"[2]

In other words, art-historical business as usual. Having raised the two crucial issues of political domination and ideology, Rosenthal drops them like hot potatoes. Yet surely

most of the pictures in the exhibition—indeed the key notion of Orientalism itself—cannot be confronted without a critical analysis of the particular power structure in which these works came into being. For instance, the degree of realism (or lack of it) in individual Orientalist images can hardly be discussed without some attempt to clarify *whose* reality we are talking about.

What are we to make, for example, of Jean-Léon Gérôme's *Snake Charmer* (fig. 4.1), painted in the late 1860s, now in the Clark Art Institute in Williamstown, Massachusetts? Surely it may most profitably be considered as a visual document of nineteenth-century colonialist ideology, an iconic distillation of the Westerner's notion of the Oriental couched in the language of a would-be transparent naturalism. (No wonder Said used it as the dustjacket for his critical study of the phenomenon of Orientalism!)[3] The title, however, doesn't really tell the complete story; the painting should really be called "The Snake Charmer and His Audience," for we are clearly meant to look at both performer and audience as parts of the same spectacle. We are not, as we so often are in Impressionist works of this period—works like Manet's or Degas's *Café Concerts*, for example, which are set in Paris—invited to identify with the audience. The watchers huddled against the ferociously detailed tiled wall in the background of Gérôme's painting are as resolutely alienated from us as is the act they watch with such childish, trancelike concentration. Our gaze is meant to include both the spectacle and its spectators as objects of picturesque delectation.

Clearly, these black and brown folk are mystified—but then again, so are we. Indeed, the defining mood of the painting is mystery, and it is created by a specific pictorial device. We are permitted only a beguiling rear view of the boy holding the snake. A full frontal view, which would reveal unambiguously both his sex and the fullness of his dangerous performance, is denied us. And the insistent, sexually charged mystery at the center of this painting signifies a more general one: the mystery of the East itself, a standard *topos* of Orientalist ideology.

Despite, or perhaps because of, the insistent richness of the visual diet Gérôme offers—the manifest attractions of the young protagonist's rosy buttocks and muscular thighs; the wrinkles of the venerable snake charmer to his right; the varied delights offered by the picturesque crowd and the alluringly elaborate surfaces of the authentic Turkish tiles, carpet, and basket which serve as decor—we are haunted by certain absences in the painting. These *absences* are so conspicuous that, once we become aware of them, they begin to function as presences, in fact, as signs of a certain kind of conceptual deprivation.

One absence is the absence of history. Time stands still in Gérôme's painting, as it does in all imagery qualified as "picturesque," including nineteenth-century representations of peasants in France itself. Gérôme suggests that this Oriental world is a world without change, a world of timeless, atemporal customs and rituals, untouched by the historical processes that were "afflicting" or "improving" but, at any rate, drastically altering Western societies at the time. Yet these were in fact years of violent and conspicuous change in the Near East as well, changes affected primarily by Western power—technological, military, economic, cultural—and specifically by the very French presence Gérôme so scrupulously avoids.

In the very time when and place where Gérôme's picture was painted, the late 1860s in Constantinople, the government of Napoleon III was taking an active interest (as were the governments of Russia, Austria, and Great Britain) in the efforts of the Ottoman government to reform and modernize itself. "It was necessary to change Muslim habits, to destroy

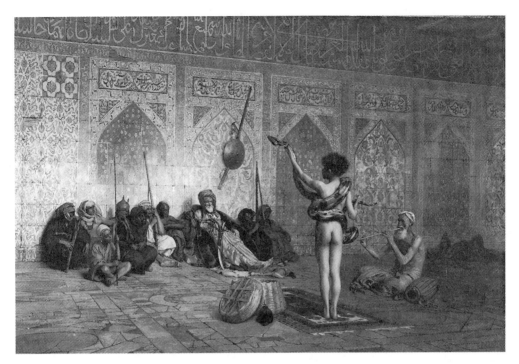

Figure 4.1 Jean-Léon Gérôme, *The Snake Charmer*, c. 1880, oil on canvas, 1955.51. © Copyright Sterling and Francine Clark Art Institute, Williamstown, MA.

the age-old fanaticism which was an obstacle to the fusion of races and to create a modern secular state," declared French historian Edouard Driault in *La Question d'Orient* (1898). "It was necessary to transform . . . the education of both conquerors and subjects, and inculcate in both the unknown spirit of tolerance—a noble task, worthy of the great renown of France," he continued.

In 1863 the Ottoman Bank was founded, with the controlling interest in French hands. In 1867 the French government invited the Sultan to visit Paris and recommended to him a system of secular public education and the undertaking of great public works and communication systems. In 1868 under the joint direction of the Turkish Ministry of Foreign Affairs and the French Ambassador, the Lycée of Galata-Serai was opened, a great secondary school open to Ottoman subjects of every race and creed, where Europeans taught more than 600 boys the French language—"a symbol," Driault maintained, "of the action of France, exerting herself to instruct the peoples of the Orient in her own language the elements of Western civilization." In the same year, a company consisting mainly of French capitalists received a concession for railways to connect present-day Istanbul and Salonica with the existing railways on the Middle Danube.[4]

The absence of a sense of history, of temporal change, in Gérôme's painting is intimately related to another striking absence in the work: that of the telltale presence of Western man. There are never any Europeans in "picturesque" views of the Orient like these. Indeed, it might be said that one of the defining features of Orientalist painting is its

dependence for its very existence on a presence that is always an absence: the Western colonial or touristic presence. *Orientalist painting depicts a world of timeless customs and rituals, untouched by the historical processes that were drastically altering Western society at the time.*

The white man, the Westerner, is of course always implicitly present in Orientalist paintings like the *Snake Charmer*, his is necessarily the controlling gaze, the gaze which brings the Oriental world into being, the gaze for which it is ultimately intended. And this leads us to still another absence. Part of the strategy of an Orientalist painter like Gérôme is to make his viewers forget that there was any "bringing into being" at all, to convince them that works like these were simply "reflections," scientific in their exactitude, of a preexisting Oriental reality.

In his own time Gérôme was held to be dauntingly objective and scientific and was compared in this respect with Realist novelists. As an American critic declared in 1873:

> Gérôme has the reputation of being one of the most studious and conscientiously accurate painters of our time. In a certain sense he may even be called "learned." He believes as firmly as Charles Reade does in the obligation on the part of the artist to be true even in minute matters to the period and locality of a work pretending to historical character. Balzac is said to have made a journey of several hundreds of miles in order to verify certain apparently insignificant facts concerning a locality described in one of his novels. Of Gérôme, it is alleged that he never paints a picture without the most patient and exhaustive preliminary studies of every matter connected with his subject. In the accessories of costume, furniture, etc it is invariably his aim to attain the utmost possible exactness. It is this trait in which some declare an excess, that has caused him to be spoken of as a "scientific picture maker."[5]

The strategies of the "realist" (or perhaps "pseudo-realist," "authenticist," or "naturalist" would be better terms) mystification go hand-in-hand with those on Orientalist mystification. Hence, another absence which constitutes a significant presence in the painting: the absence—that is to say, the *apparent* absence—of art. As Leo Bersani has pointed out in his article on realism and the fear of desire, "The 'seriousness' of realist art is based on the absence of any reminder of the fact that it is really a question of art."[6] No other artist has so inexorably eradicated all traces on the picture plane as Gérôme, denying us any clue to the artwork as a literal flat surface.

If we compare a painting like Gérôme's *Street in Algiers* with its prototype, Delacroix's *Street in Meknes*, we immediately see that Gérôme, in the interest of "artlessness," of innocent Orientalist transparency, goes much farther than Delacroix in supplying picturesque data to the Western observer and in veiling the fact that the image consists of paint on canvas. A "naturalist" or "authenticist" artist like Gérôme tries to make us forget that his art is really art, both by concealing the evidence of his touch, and, at the same time, by insisting on a plethora of authenticating details, especially on what might be called unnecessary ones. These include not merely the "carefully executed Turkish tile patterns" that Richard Ettinghausen pointed out in a recent Gérôme catalogue; not merely the artist's renditions of Arabic inscriptions which, Ettinghausen maintains "can be easily read;"[7] but even the "later repair" on the tile-work, which, functioning at first sight rather like the barometer

on the piano in Flaubert's description of Mme. Aubain's drawing room in "Un coeur simple," creates what Roland Barthes has called "the reality effect" [*l'effet de réel*].[8]

Such details, supposedly there to denote the real directly, are actually there simply to signify its presence in that work as a whole. As Barthes points out the major function of gratuitous, accurate details like these is to announce "we are the real." They are signifiers of the category of the real, there to give credibility to the "realness" of the work as a whole, to authenticate the total visual field as a simple, artless reflection—in this case, of a supposed Oriental reality.

Yet if we look again, we can see that the objectively described repairs in the tiles have still another function, a moralizing one which assumes meaning only within the apparently objectivized context of the scene as a whole. Neglected, ill-repaired architecture functions, in nineteenth-century Orientalist art, as a standard topos for commenting on the corruption of contemporary Islamic society. Kenneth Bendiner has collected striking examples of this device, in both the paintings and the writings of nineteenth-century artists. For instance, British painter David Roberts, documenting his *Holy Land* and *Egypt and Nubia*, wrote from Cairo in 1838 about "splendid cities, once teeming with a busy population and embellished with . . . edifices, the wonder of the world, now deserted and lonely, or reduced by mismanagement and the barbarism of the Moslem creed, to a state as savage as the wild animals by which they are surrounded." At another time, explaining the existence of certain ruins in its environs, he declared that Cairo "contains, I think, more idle people than any town its size in the world."[9]

The vice of idleness was frequently commented upon by Western travelers to Islamic countries in the nineteenth century, and in relation to it, we can observe still another striking absence in the annals of Orientalist art: the absence of scenes of work and industry, despite the fact that some Western observers commented on the Egyptian *fellahin's* long hours of backbreaking labor, and on the ceaseless work of Egyptian women engaged in the fields and in domestic labor.[10]

When Gérôme's painting is seen within this context of supposed Near Eastern idleness and neglect, what might at first appear to be objectively described architectural fact turns out to be *architecture moralisée*. The lesson is subtle, perhaps, but still eminently available, given a context of similar *topoi*: these people—lazy, slothful and childlike, if colorful—have let their own cultural treasures sink into decay. There is a clear allusion here, clothed in the language of objective *reportage*, not merely to the mystery of the East, but to the barbaric insouciance of Moslem peoples, who quite literally charm snakes while Constantinople falls into ruins.

What I am trying to get at, of course, is the obvious truth that in this painting Gérôme is not reflecting a readymade reality but, like all artists, is producing meanings. If I seem to dwell on the issue of authenticating details, it is because not only Gérôme's contemporaries, but some present-day revisionist revivers of Gérôme, and of Orientalist painting in general, insist so strongly on the objectivity and credibility of Gérôme's view of the Near East, using this sort of detail as evidence for their claims.

The fact that Gérôme and other Orientalist "realists" used photographic documentation is often brought in to support claims to the objectivity of the works in question. Indeed, Gérôme seems to have relied on photographs for some of his architectural detail, and crit-

ics in both his own time and in ours compare his work to photography. But of course, there is photography and photography. Photography itself is hardly immune to the blandishments of Orientalism, and even a presumably innocent or neutral view of architecture can be ideologized.

A commercially produced tourist version of the Bab Mansour at Meknes "Orientalizes" the subject, producing the image the tourist would like to remember—picturesque, relatively timeless, the gate itself photographed at a dramatic angle, reemphasized by dramatic contrasts of light and shadow, and further "picturesquified" by the floating cloud which silhouettes it to the left. Plastic variation, architectural values and colorful surface are all played up in the professional shot; at the same time, all evidence of contemporaneity and contradiction—that Meknes is a modern as well as a traditional city, filled with tourists and business-people from East and West; that cars and buses are used as well as donkeys and horses—is suppressed by the "official" photograph. A photo by an amateur, however, foregrounding cars and buses and the swell of empty macadam, subordinates the picturesque and renders the gate itself flat and incoherent. In this snapshot, Orientalism is reduced to the presence of a few weary crenellations to the right. But this image is simply the bad example in the "how-to-take-good-photographs-on-your-trip book" which teaches the novice how to approximate her experience to the official version of visual reality.

But of course, there is Orientalism and Orientalism. If for painters like Gérôme the Near East existed as an actual place to be mystified with effects of realness, for other artists it existed as a project of the imagination, a fantasy space or screen onto which strong desires—erotic, sadistic or both—could be projected with impunity. The Near Eastern setting of Delacroix's *Death of Sardanapalus* (created, it is important to emphasize, before the artist's own trip to North Africa in 1832) does not function as a field of ethnographic exploration. It is, rather, a stage for the playing out, from a suitable distance, of forbidden passions—the artist's own fantasies (need it be said?) as well as those of the doomed Near Eastern monarch.

Delacroix evidently did his Orientalist homework for the painting, probably reading descriptions in Herodotus and Diodorus Sicilis of ancient Oriental debauchery, and dipping into passages in Quintus Curtius on Babylonian orgies, examining an Etruscan fresco or two, perhaps even looking at some Indian miniatures.[11] But it is obvious that a thirst for accuracy was hardly a major impulse behind the creation of this work. Nor, in this version of Orientalism—Romantic, if you will, and created 40 years before Gérôme's—is it Western man's power over the Near East that is at issue, but rather, I believe, contemporary Frenchmen's power over women, a power controlled and mediated by the ideology of the erotic in Delacroix's time.

"In dreams begin responsibilities," a poet once said. Perhaps. Certainly, we are on surer footing asserting that in power begin dreams—dreams of still greater power (in this case, fantasies of men's limitless power to enjoy the bodies of women by destroying them). It would be absurd to reduce Delacroix's complex painting to a mere pictorial projection of the artist's sadistic fantasies under the guise of Orientalism. Yet it is not totally irrelevant to keep in mind that the vivid turbulence of Delacroix's narrative—the story of the ancient Assyrian ruler Sardanapalus, who, upon hearing of his incipient defeat, had all his precious possessions, including his women, destroyed and then went up in flames with them—is

subtended by the more mundane assumption, shared by men of Delacroix's class and time, that they were naturally "entitled" to the bodies of certain women. If the men were artists like Delacroix, it was assumed that they had more or less unlimited access to the bodies of the women who worked for them as models. In other words, Delacroix's private fantasy did not exist in a vacuum, but in a particular social context which granted permission for as well as established the boundaries of certain kinds of behavior.

Within this context, the Orientalizing setting of Delacroix's painting both signifies an extreme state of psychic intensity and formalizes that state through various conventions of representation. But it allows only so much and no more. It is difficult, for example, to imagine a *Death of Cleopatra*, with voluptuous nude male slaves being put to death by women servants, painted by a woman artist of this period.[12]

At the same time he emphasized the sexually provocative aspects of his theme, Delacroix attempted to defuse his overt pictorial expression of men's total domination of women in a variety of ways. He distanced his fears and desires by letting them explode in an Orientalized setting and by filtering them through a Byronic prototype. But at the same time, the motif of a group of naked, beautiful women put to the sword is not taken from ancient versions of the Sardanapalus story, although the lasciviousness of Oriental potentates was a staple of many such accounts.[13] Nor was it Byron's invention but, significantly, Delacroix's own.[14]

The artist participates in the carnage by placing at the blood-red heart of the picture a surrogate self—the recumbent Sardanapalus on his bed. But Sardanapalus holds himself aloof, in the pose of the philosopher, from the sensual tumult which surrounds him; he is an artist-destroyer who is ultimately to be consumed in the flames of his own creation-destruction. His dandyish coolness in the face of sensual provocation of the highest order—what might be called his "Orientalized" remoteness and conventionalized pose—may indeed have helped Delacroix justify to himself his own erotic extremism, the fulfilment of sadistic impulse in the painting. It did not satisfy the contemporary public. Despite the brilliant feat of artistic semisublimation pulled off here, both public and critics were for the most part appalled by the work when it first appeared in the Salon of 1828.[15]

The aloofness of the hero of the piece, its Orientalizing strategies of distancing, its references to the *outré* mores of long-dead Near Eastern oligarchs fooled no one, really. Although criticism was generally directed more against the painting's supposed formal failings, it is obvious that by depicting this type of subject with such obvious sensual relish, such erotic panache and openness, Delacroix had come too close to an overt statement of the most explosive, hence the most carefully repressed, corollary of the ideology of male domination: the connection between sexual possession and murder as an assertion of absolute enjoyment.

The fantasy of absolute possession of women's naked bodies—a fantasy which for men of Delacroix's time was partly based on specific practice in the institution of prostitution or, more specifically, in the case of artists on the availability of studio models for sexual as well as professional services—also lies at the heart of such typical topoi of Orientalist imagery as Gérôme's various *Slave Markets*, like the examples in Williamstown and Cincinnati (color plate 2). These are ostensibly realistic representations of the authentic customs of picturesque Near Easterners. Indeed, Maxime Du Camp, a fellow-traveler in the picturesque byways of the Middle East, remarked of Gérôme's painting (or of one like it): "Gerome's

Slave Market is a fact literally reproduced. . . . People go [to the slave market] to purchase a slave as they do here to the market . . . to buy a turbot."[16]

Obviously, the motivations behind the creation of such Orientalist erotica, and the appetite for it, had little to do with pure ethnography. Artists like Gérôme could dish up the same theme—the display of naked, powerless women to clothed, powerful men—in a variety of guises, that of the Antique slave-market, for instance, or in the subject of Phryne before the Tribunal. What lies behind the production of such popular stimuli to simultaneous lip-licking and tongue-clicking is, of course, the satisfaction that the delicious humiliation of lovely slave girls gives to the moralistic *voyeur*. They are depicted as innocents, trapped against their will in some far-off place, their nakedness more to be pitied than censured; they also display an ingratiating tendency to cover their eyes rather than their seductive bodies.

Why was it that Gérôme's Orientalist assertions of masculine power over feminine nakedness were popular, and appeared frequently in the Salons of the mid-nineteenth century, whereas earlier Delacroix's *Sardanapalus* had been greeted with outrage? Some of the answers have to do with the different historical contexts in which these works originated, but some have to do with the character of the paintings themselves. Gérôme's fantasia on the theme of sexual politics (the Clark Collection *Slave Market*, for example) has been more successfully ideologized than Delacroix's, and this ideologizing is achieved precisely through the work's formal structure. Gérôme's version was more acceptable because he substituted a chilly and remote pseudo-scientific naturalism—small, self-effacing brush strokes; "rational" and convincing spatial effects; in other words, an apparently dispassionate empiricism—for Delacroix's tempestuous self-involvement, his impassioned brushwork, subjectively outpouring perspective, and inventive, sensually self-revelatory dancelike poses. Gérôme's style justified his subject—perhaps not to us, who are cannier readers—but certainly to most of the spectators of his time, by guaranteeing through sober "objectivity" the unassailable Otherness of the characters in his narrative. He is saying in effect: "Don't think that I or any other right-thinking Frenchman would ever be involved in this sort of thing. I am merely taking careful note of the fact that less enlightened races indulge in the trade in naked women—but isn't it arousing!"

Like many other artworks of his time, Gérôme's Orientalist painting managed to body forth two ideological assumptions about power: one about men's power over women; the other about white men's superiority to, hence justifiable control over, inferior, darker races, precisely those who indulge in this sort of regrettably lascivious commerce. Or we might say that something even more complex is involved in Gérôme's strategies vis-à-vis the *homme moyen sensuel*: the (male) viewer was invited sexually to identify with, yet morally to distance himself from, his Oriental counterparts depicted within the objectively inviting yet racially distancing space of the painting.

Manet's *Ball at the Opera* of 1873 may, for the purposes of our analysis, be read as a combative response to and subversion of the ideological assumptions controlling Gérôme's *Slave Market*. Like Gérôme's painting, Manet's work (to borrow a phrase from the German critic Meier-Graefe, who greatly admired it) represents a *Fleschborse*—a flesh-market. Unlike Gérôme, however, Manet represented the marketing of attractive women not in a suitably distanced Near Eastern locale, but behind the galleries of the opera house on the rue Lepeletier. The buyers of female flesh are not Oriental louts but civilized and recogniz-

able Parisians, debonair men about town, Manet's friends and, in some cases, fellow artists, whom he had asked to pose for him. And the flesh in question is not represented *au naturel*, but sauced up in the most charming and provocative fancy-dress costumes. Unlike Gérôme's painting, which had been accepted for the Salon of 1867, Manet's was rejected for that of 1874.

I should like to suggest, however, that the reason for Manet's rejection was not merely the daring close-to-homeness of his representation of the availability of feminine sexuality and male consumption of it. Nor was it merely, as his friend and defender at the time Stéphane Mallarmé suggested, its formal daring—its immediacy, its dash, its deliberate yet casual-looking cut-off view of the spectacle. It was rather the way these two kinds of subversive impulse are made to intersect. Manet's rejection of the myth of stylistic transparency in a painting depicting erotic commercial transactions is precisely what calls into question the underlying assumptions governing Gérôme's Orientalist version of the same theme.

By interrupting the unimpeded flow of the story-line with the margins of his image, Manet frankly reveals the assumptions on which such narratives are premised. The cut-off legs and torso on the balcony are a witty, ironic reference to the actual motivations controlling such gatherings of upper-middle-class men and charming women of the theater: pleasure for the former; profit for the latter. The little legs and torso constitute a witty synecdoche, a substitution of part for whole, a trope *par excellence* of critical realism—a trope indicating the sexual availability of delectable female bodies for willing buyers. By means of a similar synecdoche—the half-Polichinelle to the left, cut off by the left-hand margin of the canvas—Manet suggests the presence of the artist-entrepreneur half-inside, half-outside the world of the painting; at the same time, he further asserts the status of the image as a work of art. By means of a brilliant, deconstructive-realist strategy, Manet has at once made us aware of the artifice of art, as opposed to Gérôme's solemn, pseudo-scientific denial of it with his illusionistic naturalism. At the same time, through the apparently accidentally amputated female legs and torso, Manet foregrounds the nature of the actual transaction taking place in the worldly scene he has chosen to represent.[17]

Despite his insistence on accuracy as the guarantee of veracity, Gérôme himself was not beyond the blandishments of the artful. In his bath scenes, the presence of a Cairene sunken fountain with two-color marble inlay in the foreground and a beautiful silver-inlaid brass basin with its Mamluk coat-of-arms held by a Sudanese servant girl (as well as the inevitable Turkish tiles) indicate a will to ethnographic exactitude (color plate 3). Still, Gérôme makes sure we see his nude subject as art as well as mere reportage. This he does by means of tactful reference to what might be called the "original oriental back-view"—Ingres' *Valpinçon Bather*. The abstract linearism of Ingres is qualified and softened in Gérôme's painting, but is clearly meant to signify the presence of tradition: Gérôme has decked out the products of his flesh-market with the signs of the artistic. His later work often reveals a kind of anxiety or a division—what might be called the Kitsch dilemma—between efforts to maintain the fiction of pure transparency—a so-called photographic realism—and the need to prove that he is more than a mere transcriber, that his work is artistic.

This anxiety is heightened when the subject in question is a female nude—that is to say, when an object of desire is concerned. Gérôme's anxiety about proving his "artistic-ness" at the same time that he panders to the taste for naturalistic bodies and banal fantasy

is revealed most obviously in his various paintings of artists and models, whether the artist in question is Pygmalion or simply Gérôme himself in his studio. In the latter case, he depicts himself surrounded by testimonials to his professional achievement and his responsiveness to the classical tradition. For Gérôme, the classical would seem to be a product that he confects matter-of-factly in his studio. The sign of the artistic—sometimes absorbed into, sometimes in obvious conflict with the fabric of the painting as a whole—is a hallmark of *quality* in the work of art, increasing its value as a product on the art market.

Like the artistic back, the presence of the black servant in Gérôme's Orientalist bath scenes serves what might be called connotative as well as strictly ethnographic purposes. We are of course familiar with the notion that the black servant somehow enhances the pearly beauty of her white mistress—a strategy employed from the time of Ingres, in an Orientalist mood, to that of Manet's *Olympia*, in which the black figure of the maid seems to be an indicator of sexual naughtiness. But in the purest distillations of the Orientalist bath scene—like Gérôme's, or Debat-Ponsan's *The Massage* of 1883—the very passivity of the lovely white figure as opposed to the vigorous activity of the worn, unfeminine ugly black one, suggests that the passive nude beauty is explicitly being prepared for service in the Sultan's bed. This sense of erotic availability is spiced with still more forbidden overtones, for the conjunction of black and white, or dark and light female bodies, whether naked or in the guise of mistress and maid servant, has traditionally signified lesbianism.[18]

Like other artists of his time, Gérôme sought out instances of the picturesque in the religious practices of the natives of the Middle East. This sort of religious ethnographic imagery attempted to create a sleek, harmonious vision of the Islamic world as traditional, pious, and unthreatening, in direct contradiction to the grim realities of history. On the one hand, the cultural and political violence visited on the Islamic peoples of France's own colony, Algeria, by laws like *Senatus Consulte* in the '60s had divided up the communally held lands of the native tribes. On the other hand, specific violence was visited against native religious practices by the French Society of Missionaries in Algeria, when, profiting from widespread famine at the end of 1867, they offered the unfortunate orphans who fell under their power food at the price of conversion. Finally, Algerian tribes reacted with religion-inspired violence to French oppression and colonization; in the Holy War of 1871, 100,000 tribesmen under Bachaga Mohammed Mokrani revolted under the banner of Islamic idealism.[19]

It is probably no coincidence that Gérôme avoided French North Africa as the setting for his mosque paintings, choosing Cairo instead for these religious *tableaux vivants*, in which the worshippers seem as rigid, as rooted in the intricate grounding of tradition and as immobilized as the scrupulously recorded architecture which surrounds them, and echoes their forms. Indeed, taxidermy rather than ethnography seems to be the informing discipline here: these images have something of the sense of specimens stuffed and mounted within settings of irreproachable accuracy and displayed in airless cases. And like the exhibits displayed behind glass in the natural-history museum, these paintings include everything within their boundaries—everything, that is, except a sense of life, the vivifying breath of shared human experience.

What are the functions of the picturesque, of which this sort of religious ethnography is one manifestation? Obviously, in Orientalist imagery of subject peoples' religious practices one of its functions is to mask conflict with the appearance of tranquility. The picturesque

is pursued throughout the nineteenth century like a form of peculiarly elusive wildlife, requiring increasingly skillful tracking as the delicate prey—an endangered species—disappears further and further into the hinterlands, in France as in the Near East. The same society that was engaged in wiping out local customs and traditional practices was also avid to preserve them in the form of records—verbal, in the way of travel accounts or archival materials; musical, in the recording of folk songs; linguistic, in the study of dialects or folk tales; or visual, as here.

Yet surely, the very notion of the picturesque in its nineteenth-century manifestations is premised on the fact of destruction. Only on the brink of destruction, in the course of incipient modification and cultural dilution, are customs, costumes, and religious rituals of the dominated finally seen as picturesque. Reinterpreted as the precious remnants of disappearing ways of life, worth hunting down and preserving, they are finally transformed into subjects of aesthetic delectation in an imagery in which exotic human beings are integrated within a presumably defining and overtly limiting decor. Another important function, then, of the picturesque—Orientalizing in this case—is to certify that the people encapsulated by it, defined by its presence, are irredeemably different from, more backward than, and culturally inferior to those who construct and consume the picturesque product. They are irrevocably "Other."

Orientalism, then, can be viewed under the aegis of the more general category of the picturesque, a category that can encompass a wide variety of visual objects and ideological strategies, extending from regional genre painting down to the photographs of smiling or dancing natives in the *National Geographic*. It is no accident that Gérôme's North African Islamic procession and Jules Breton's or Dagnon-Bouveret's depictions of Breton Catholic ceremonies have a family resemblance. Both represent backward, oppressed peoples sticking to traditional practices. These works are united as well by shared stylistic strategies; the "reality effect" and the strict avoidance of any hint of conceptual identification or shared viewpoint with their subjects, which could, for example, have been suggested by alternative conventions of representation.

How does a work avoid the picturesque? There are, after all, alternatives. Neither Courbet's *Burial at Ornans* nor Gauguin's *Day of the God* fall within the category of the picturesque.

Courbet, for whom the "natives" included his own friends and family, borrowed some of the conventions of popular imagery—conventions signifying the artist's solidarity, indeed identity, with the country people represented. At the same time he enlarged the format and insisted upon the—decidedly nonpicturesque—insertion of contemporary costume. Gauguin, for his part, denied the picturesque by rejecting what he conceived of as the lies of illusionism and the ideology of progress—in resorting to flatness, decorative simplification, and references to "primitive" art—that is to say, by rejecting the signifiers of Western rationalism, progress, and objectivity *in toto*.

Delacroix's relation to the picturesque is central to an understanding of the nature and the limits of nineteenth-century Orientalism. He admired Morocco when he saw it on his trip accompanying the Comte de Mornay's diplomatic mission in 1832, comparing Moroccans to classical senators and feverishly recording every aspect of Moroccan life in his notebooks. Nevertheless, he knew where to draw the line between Them and Us. For him, Morocco was inevitably picturesque. He clearly distinguished between its visual beauty—

including the dignified, un-self-conscious deportment of the natives—which he treasured, and its moral quality, which he deplored. "This is a place," he wrote to his old friend Villot from Tangiers, "completely for painters. Economists and Saint-Simonians would have a lot to criticize here with respect to the rights of man before the law, but the beautiful abounds here."[20] And he distinguished with equal clarity between the picturesqueness of North African people and settings in general, and the weaknesses of the Orientals' own vision of themselves in their art. Speaking of some Persian portraits and drawings, he remarks in the pages of his *Journal* that the sight of them "made me repeat what Voltaire said somewhere—that there are vast countries where taste has never penetrated. . . . There are in these drawings neither perspective nor any feeling for what is truly painting . . . the figures are immobile, the poses stiff, etc."[21]

The violence visited upon North African people by the West was rarely depicted by Orientalist painting; it was, in fact, denied in the painting of religious ethnography. But the violence of Orientals to each other was a favored theme. Strange and exotic punishments, hideous tortures, whether actual or potential, the marvelously scary aftermath of barbaric executions—these are a stock-in-trade of Orientalist art. Even a relatively benign subject like that represented in Léon Bonnat's *Black Barber of Suez* can suggest potential threat through the exaggerated contrast between muscularity and languor, the subtle overtones of Samson and Delilah.

In Henri Regnault's *Execution without Judgment under the Caliphs of Granada* of 1870, we are expected to experience a *frisson* by identifying with the victim, or rather, with his detached head, which (when the painting is correctly hung) comes right above the spectator's eye level (fig. 4.2). We are meant to look up at the gigantic, colorful, and dispassionate executioner as—shudder!—the victim must have only moments ago. It is hard to imagine anyone painting an *Execution by Guillotine under Napoleon III* for the same Salon. Although guillotining was still a public spectacle under the Second Empire and through the beginning of the Third Republic, it would not have been considered an appropriate artistic subject. For guillotining was considered rational punishment, not irrational spectacle—part of the domain of law and reason of the progressive West.

One function of Orientalist paintings like these is, of course, to suggest that *their* law is irrational violence; *our* violence, by contrast, is law. Yet it was precisely the imposition of "rational" Western law by Napoleon III's government on the customary practices of North Africa that tribesmen experienced most deeply as fatal violence. Nor was this violence unintended. The important laws pertaining to landed property in Algeria, imposed on the native population by the French from the 1850s through the mid-'70s—The Cantonment of 1856, the *Senatus Consulte* of 1863, and the Warnier Law of ten years later—were conceived as measures which would lead to the destruction of the fundamental structures of the economy and of the traditional society—measures of legally approved violence, in other words. And they were experienced as such by Algerian natives, who felt their speedy, devastating effects as a savage lopping off of the head of traditional tribal existence, an execution without judgment.

A French army officer, Captain Vaissière, in his study of the Ouled Rechaïch, published in Algiers in 1863, relates that when this group found out that the law of the *Senatus Consulte* was going to be applied to their tribe, they were thrown into consternation, so clearly

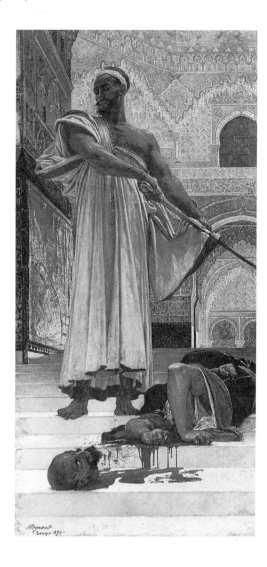

Figure 4.2 Henri Regnault, *Execution without Judgment under the Caliphs of Granada*, 1870, oil on canvas. Musée d'Orsay, Paris (photo Jean Schormans). © Copyright Réunion des Musées Nationaux/Art Resource, New York.

were they aware of the destructive power contained in this measure. "The French defeated us in the plain of Sbikha," declared one old man. "They killed our young men; they forced us to make a war contribution when they occupied our territories. All that was nothing; wounds eventually heal. But the setting up of private property and the authorization given each individual to sell his share of the land [which was what *Senatus Consulte* provided for], this means the death sentence for the tribe, and twenty years after these measures have been carried out, the Ouled Rechaïch will have ceased to exist."[22]

It is not completely accurate to state that the violence inflicted by the West—specifically, by the French in North Africa—was never depicted by the artists of the period—although, strictly speaking, such representations fall under the rubric of "battle painting" rather than the Orientalist genre. "At the origin of the picturesque is war," declared Sartre at the beginning of his analysis of French colonial violence in *Situations V* in 1954. A painting like Horace Vernet's *Capture of the Smala of Abd-el-Kader at Taguin, May 16, 1843*, a vast

panorama exhibited along with six pages of catalogue description in the Salon of 1845, seems a literal illustration of Sartre's contention.[23] This minutely detailed pictorial commemoration of the victory of the Duc d'Aumale's French troops over 30,000 noncombatants—old men, women, children, as well as the treasure and flocks of the native chief, who was leading the rebellion against French military domination at the time—seems fairly clear in its political implications, its motivations fairly transparent.

What is less clear today is the relation of two other works, also in the Salon of 1845, to the politics of violence in North Africa at the time. The Salon of 1845 was the Salon immediately following the crucial Battle of Isly—the climax of French action against the Algerian rebel forces led by Abd-el-Kader and his ally, the Sultan Abd-el-Rahman of Morocco. After the destruction of his *smala* or encampment at Taguin—the very incident depicted by Horace Vernet—Abd-el-Kader was chased from his country and took refuge in Morocco. There he gained the support of the Sultan Abd-el-Rahman—the very sultan that Delacroix had sketched and whose reception he had so minutely described when he had visited Meknes with the Comte de Mornay on a friendly diplomatic mission more than ten years earlier.

Delacroix had originally planned to commemorate the principal event of Mornay's mission by including, in a prominent position, members of the French delegation at the Sultan's reception. Although it exists as a sketch, this version of the painting was never brought to completion, for the event it was supposed to commemorate—Mornay's carefully worked out treaty with the Sultan—failed to lead to the desired *détente* with Morocco. Delacroix's projected painting would no longer have been appropriate or politically tactful. When the defeated Abd-el-Kader sought refuge with the Sultan of Morocco after the defeat at Isly, Moroccan affairs abruptly took a turn for the worse. The French fleet with English, Spanish, and American assistance bombarded Tangiers and Mogador, and Abd-el-Rahman was forced to eject the Algerian leader from his country. The defeated Sultan of Morocco was then forced to negotiate a new treaty that was far more advantageous to the French. Moroccan affairs having become current events, the journal *L'Illustration* asked Delacroix to contribute some North African drawings for its account of the new peace treaty and its background, and he complied.

It is clear, then, why Delacroix took up the subject again for his monumental painting in 1845, but in a new form with different implications, based on a new political reality. In the final version, now in the Museum of Toulouse, it is a vanquished opponent who is represented. He is dignified, surrounded by his entourage, but an entourage that includes the defeated leaders of the fight against the French and as such constitutes a reminder of French prowess. In Delacroix's *Moulay-Abd-el-Rahman, Sultan of Morocco, leaving his palace at Meknes, surrounded by his guard and his principle Officers*, as it was called in the Salon catalogue of 1845, there is no longer any question of mingling the French presence with the Moroccan one.[24]

In the same Salon appeared a painting which is always compared to Delacroix's *Sultan of Morocco*: Théodore Chassériau's equestrian *Portrait of Kalif Ali-Ben Hamet (or Ahmed) followed by his Escort*. Indeed, in the Rochester Orientalism catalogue, Chassériau's painting is described as "inevitably recalling Delacroix's portrait," although more "detailed and portrait-like."[25] But Chassériau's is actually a very different image serving a radically different purpose. It is actually a commissioned porrait: of an Algerian chieftan friendly to the

French, who, with his entourage, was being wined and dined by the French authorities in Paris at the time.[26]

Ali-Ben Ahmed, in short, unlike the uncooperative and defeated Abd-el-Rahman, was a leader who triumphed as a catspaw of the French. The relationship between the two works, then, is much more concrete than some vague bond created by their compositional similarity—they are actually quite different in their structure—or the obfuscating umbrella category of Orientalism. For it is a concrete relationship of opposition or antagonism, political and ideological, that is at issue here. Indeed, if we consider all the other representations of North African subjects in the Salon of 1845—and there were quite a few—merely as examples of Orientalism, we inevitably miss their significance as political documents at a time of particularly active military intervention in North Africa. In other words, in the case of imagery directly related to political, diplomatic, and military affairs in the inspirational territory of Orientalism, the very notion of "Orientalism" itself in the visual arts is simply a category of obfuscation, masking important distinctions under the rubric of the picturesque, supported by the illusion of the real.

How then should we deal with this art? Art historians are, for the most part, reluctant to proceed in anything but the celebratory mode. If Gérôme ostensibly vulgarizes and "naturalizes" a motif by Delacroix, he must be justified in terms of his divergent stylistic motives, his greater sense of accuracy or his affinities with the "tonal control and sense of values of a Terborch or a Pieter de Hooch."[27] In other words, he must be assimilated to the canon. Art historians who, on the other hand, wish to maintain the canon as it is—that is, who assert that the discipline of art history should concern itself only with major masterpieces created by great artists—simply say that Orientalists like Gérôme—that is to say, the vast majority of those producing Orientalist work in the nineteenth century (or who even appeared in the Salons at all)—are simply not worth studying. In the view of such art historians, artists who cannot be included in the category of great art should be ignored as though they had never existed.

Yet it seems to me that both positions—on the one hand, that which sees the exclusion of nineteenth-century academic art from the sacred precincts as the result of some art dealers' machinations or an avant-garde cabal; and on the other, that which sees the wish to include them as a revisionist plot to weaken the quality of high art as a category—are wrong. Both are based on the notion of art history as a positive rather than a critical discipline. Works like Gérôme's, and that of other Orientalists of his ilk, are valuable and well worth investigating not because they share the aesthetic values of great art on a slightly lower level, but because as visual imagery they anticipate and predict the qualities of incipient mass culture. As such, their strategies of concealment lend themselves admirably to the critical methodologies, the deconstructive techniques now employed by the best film historians, or by sociologists of advertising imagery or analysts of visual progaganda, rather than those of mainstream art history. As a fresh visual territory to be investigated by scholars armed with historical and political awareness and analytic sophistication, Orientalism—or rather its deconstruction—offers a challenge to art historians, as do many other similarly obfuscated areas of our discipline.

Notes

1. Organized by Donald A. Rosenthal, the exhibition appeared at the Memorial Art Gallery, University of Rochester [Aug. 27-Oct. 17] and at the Neuberger Museum, S.U.N.Y., Purchase [Nov. 14–Dec. 23]. It was accompanied by a catalogue-book prepared by Rosenthal. This essay is based on a lecture presented in Purchase when the show was on view there.

2. Donald A. Rosenthal, *Orientalism: The Near East in French Painting 1800–1880*, Rochester, 1982, pp. 8–9, italics added.

3. The insights offered by Said's *Orientalism* (New York, 1978) are central to the arguments developed in this study. However, Said's book does not deal with the visual arts at all.

4. Driault, pp. 187ff, cited in George E. Kirk, *A Short History of the Middle East*, New York, 1964, pp. 85–86.

5. J.F.B., "Gérôme, the Painter," *The California Art Gallery*, 1–4, '73, pp. 51–52. I am grateful to William Gerdts for bringing this material to my attention.

6. Leo Bersani, "Le réalisme et la peur du désir," *Littérature et réalité*, ed. G. Genette and T. Todorov, Paris, 1982, p. 59.

7. Richard Ettinghausen in *Jean-Léon Gérôme (1824–1904)*, ex. cat., Dayton Art Institute, 1972, p. 18. Edward Said has pointed out to me in conversation that most of the so-called writing on the back wall of the *Snake Charmer* is in fact unreadable.

8. Roland Barthes, "L'effet de réel," *Littérature et réalité*, pp. 81–90.

9. Cited by Kenneth Bendiner, "The Portrayal of the Middle East in British Painting 1835–1860," Ph.D. Dissertation, Columbia, 1979, pp. 110–111. Bendiner cites many other instances and has assembled visual representations of the theme as well.

10. See, for example, Bayle St. John's *Village Life in Egypt*, originally published in 1852, reprinted 1973, vol. I, pp. 13, 36, and passim.

11. The best general discussion of Delacroix's *Death of Sardanapalus* is Jack Spector's *Delacroix: The Death of Sardanapalus* ("Art in Context" Series), New York, 1974. This study deals with the relationship of the work to Delacroix's psycho-sexuality as well as embedding the painting in the context of its literary and visual sources. The footnotes contain references to additional literature on the painting. For recent discoveries about Delacroix's use of Oriental sources, see D. Rosenthal, "A Mughal portrait copied by Delacroix," *Burlington Magazine*, CXIX, 1977, pp. 505–506 and Lee Johnson, "Towards Delacroix's Oriental Sources," *Burlington Magazine*, CXX, 1978, pp. 144–151.

12. Cabanel's *Cleopatra Testing Poisons on Her Servants* (1887) has been suggested to me by several (male) art historians as coming close to fitting the bill. But of course, the scenario is entirely different in Cabanel's painting. First of all, the male victims are not the sex-objects in the painting; it is their female destroyer who is. And secondly, the painting is, like Delacroix's, by a man, not a woman: again, it is a product of male fantasy, and its sexual *frisson* depends on the male gaze directed upon a female object, just as it does in Delacroix's painting.

13. For a rich and suggestive analysis of this myth in the seventeenth and eighteenth centuries, see Alain Grostrichard, *Structure du Sérail: la fiction du despotisme asiatique dans l'accident classique*, Paris, 1979.

14. This is pointed out by Spector throughout his study, but see especially p. 69.

15. For public reaction to the picture, see Spector, pp. 75–85.

16. Cited in Fanny F. Hering, *Gérôme, His Life and Work*, New York, 1892, p. 117.

17. These issues will be addressed in greater detail in my forthcoming study, "Manet's *Ball at the Opera*: Part and Whole in the Nineteenth Century."

18. For a discussion of lesbian imagery in Orientalist painting, see Rosenthal, *Orientalism*, p. 98.

19. Claude Martin, *Histoire de l'Algérie française, 1830–1962*, Paris, 1963, p. 201.

20. Letter of Feb. 29, 1932, *Corréspondance générale de Eugène Delacroix*, A. Joubin, ed., Paris, 1936, I, pp. 316–317.

21. Entry of March 11, 1950, *Journal de Eugène Delacroix*, A. Joubin, ed., Paris, 1950, I, p. 348.

22. Cited in Pierre Bourdieu, *The Algerians*, trans. A. C. M. Ross, Boston, 1962, pp. 120–121.

23. For an illustration of this work, now in the Musée de Versailles, and an analysis of it from a different viewpoint, see Albert Boime, "New Light on Manet's *Execution of Maximilian*," *Art Quarterly*, XXXVI (Autumn, 1973), fig. 1 and p. 177 and note 9, p. 177.

24. For an extremely thorough account of the genesis of this painting, the various versions of the subject and the political circumstances in which it came into being, see Elie Lambert, *Histoire d'un tableau: "L'Abd el Rahman, Sultan de Maroc" de Delacroix* (Institut des Hautes Etudes Marocaines, no. 14), Paris, 1953, pp. 249–258. Lee Johnson, in a recent article, "Delacroix's Road to the Sultan of Morocco," *Apollo*, CXV (March, 1982), pp. 186–189, demonstrates convincingly that the gate from which the Sultan emerges in the 1845 painting is not, as is usually thought, the Bab Mansour, the principal gate to Meknes, but more likely is a free variation on the Bab Berdaine, which did not figure in the ceremonial occasion.

25. Rosenthal, *Orientalism*, pp. 57–58.

26. For information about Chassériau's portrait and its subject, see Léonce Bénédite. *Théodore Chassériau, sa vie et son oeuvre*, Paris, 1932, I, pp. 234ff, and Marc Sandoz, *Théodore Chassériau, 1819–1856*, Paris, 1974, p. 101.

27. Gerald Ackerman, cited in Rosenthal, *Orientalism*, p. 80. Ackerman's important study of Gérôme should be appearing shortly.

5

"Only women should go to Turkey"

Henriette Browne and the Female Orientalist Gaze

Reina Lewis

How did contemporary viewers respond when a properly respectable lady artist like Henriette Browne started to paint subjects drawn from the popular but morally contentious field of Orientalism? This chapter analyzes responses to Browne's Orientalist paintings in relation to the field of men and women's visual Orientalism.

It is my contention that Browne's Orientalist work offers a feminized vision of the Orient; a choice and treatment of subjects that functions as an extension of the domestic narrative painting for which she was already famous. Her gaze on the Orient is both as woman and as Westerner: the enunciative position from which she paints foregrounds a relation to the Orient that, while it retains a sense of difference, challenges Western assumptions about the inimical otherness of the Orient. This is achieved by portraying points of similarity between the two—the Oriental domestic as analogy for the Occidental domestic. This marks a threat to the conventional assumption of absolute difference that is also a challenge to the West's assumption of absolute superiority. In offering this analysis, I am partially in accord with Billie Melman's work on nineteenth-century British women's written Orientalism. She argues that European women desexualized the harem, domesticating it to reproduce the *haremlik* (the segregated quarters of women and children) as an "image of the middle-class 'home': domestic, feminine and autonomous."[1] I shall be analyzing the transposition of Western concepts of femininity and domesticity in women's Orientalism in the rest of this chapter in order to see the ways in which Browne's work related to what we are now discovering to be the substantial and varied involvement of European women in the cultural codes of Orientalism. Also (and this is where I depart from Melman), I explore what those cultural interventions can tell us about the formation of imperial female subjectivities.[2] It will be argued that like other women travelers Browne retains a sense of difference from the Orient, despite the experience of points of similarity, that is not necessarily registered as pejorative in the totalizing sense characteristic of hegemonic Orientalist discourse. Instead, it is contingent on a gendered set of differentiations whose possibility of a total superiority is compromised by the parallels between Western and Eastern gender relations and by the gender-specific restrictions on women's activities in work, creativity, and politics.

I am drawing on contemporary art criticism to explore the meanings associated with Browne's paintings. The criticism's dispersion of Orientalist "truths" about the harem will be counterposed by an alternative set of knowledges constructed through Western and Oriental women's reports of harem life. Therefore, I shall in fact be reading readings of Browne's images. In so doing I am not making assumptions about their accuracy but analyzing the different discursive strategies that claimed for her the gendered authority associated with women's Orientalism. Thus, I shall be addressing both the critical tendency to read women's work as straightforwardly truthful and the autobiographical claim to an unprejudiced natural vision inherent in women's written accounts of the harem. These both will be regarded as (often conflicting) attempts to establish differently gendered knowledges about the East and West. As such, they will be used to provide an index to the issues at stake in the (female) representation of the harem rather than regarded as a truth of it. Note that while I refer to the harem in the singular, I am not suggesting that there is only one real harem or type of harem or, indeed, assessing how representations relate to the real thing. Rather, I treat the term "harem" as a concept, a set of ideas that had an iconic status in the West at the same time as the word harem also designates the actual (and varied) living arrangements of women in Islamic households.[3] Looking at Browne's Orientalism in this context will allow us to explore how far a white Western woman could accede to the enunciative position of Orientalist discourse; or rather, to unpick the singularity of that positionality and reframe it in relation to the evident, if necessarily partial, access available to a gendered subject like Browne.

Critical Responses to Browne's *Harem Interiors*, 1861

Browne's first Orientalist paintings, the two *Harem Interiors* (*A Visit: Harem Interior, Constantinople* or *The Arrival in the Harem at Constantinople,* 1861, fig. 5.1); and *A Flute Player, Harem Interior, Constantinople,* 1861) were shown at the Paris Salon in 1861 and caused a stir. Interest stemmed less from their artistic merit than from their being known to have been produced by a woman who claimed to have been inside the harem. The reviews dealt in various ways with the contradictory dynamic in which, on one hand, women travelers' different access (real or imagined) to the forbidden territories of the harem appeared to offer a source of reliable information and, on the other, brought back "evidence" that often conflicted with the West's cherished visions of the Orient.[4] This was true of the Orient in general: travelers wrote of the disappointment of coming face to face with landmarks, buildings, and people that bore no relation to the splendor ascribed to them in Western legends.[5] Travel writers like Chateaubriand grappled with the desire to adulterate the truth in order to retain the vision that flourished in Europe. In painting, Ingres used Lady Mary Wortley Montagu's account of her visit to a Turkish bath as a source for his bath scenes, but ignored her insistence that the women's behavior was perfectly proper when he wanted to produce a picture of sex and excess in keeping with Europe's treasured myths. Subsequently, an account like that offered by Browne was likely to be both welcome and contentious since its "authentic" information was a potential challenge to Orientalist conventions. What is not explained by Melman's valuable account of the growing market for women's Orientalism (which was certainly well established by the mid-nineteenth century), is the persistence

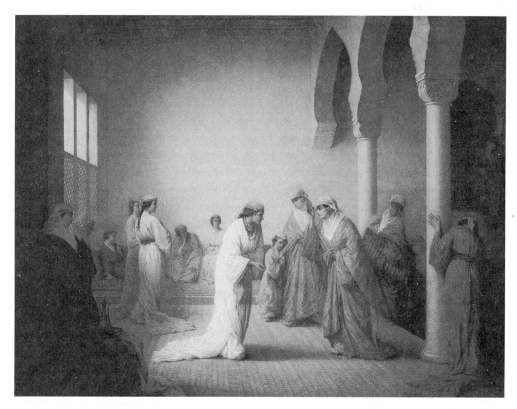

Figure 5.1 Henriette Browne, *The Arrival in the Harem at Constantinople*, 1861. © Copyright Christie's Images, New York.

and longevity of hegemonic Orientalist tropes, even though it seems they were regularly disproved by readily available women's accounts. In what follows, I am concerned to see how the authenticity attributed to Browne's work—and here I agree with Melman that women's work was read as authentic on account of their presumed feminine empathy with their Oriental subjects[6]—was perceived as both a challenge to and potential support for elements of the Orientalist harem fantasy. The different critical strategies adopted in response to her paintings illustrate both the flexibility and the limits of the power/knowledge dialectic of Orientalist discourse.

The interpretations of the painting rely on the artist's presumed presence at the scene. This immediately disrupts the traditions of Western voyeurism outlined by Nochlin.[7] Rather than hide the presence of the Westerner at the scene, the construction of the paintings as testimony foregrounds the presence of the artist: the image would not have been possible if Browne had not been there, even though the figure of the artist is not actually depicted in the painting. Her presence is projected into the scene by a combination of the viewer's allegiance to Orientalist knowledges about the harem (in which a woman's view has a privileged access to a forbidden sight) and the picture's traditional composition (where the viewing position accords with that of the artist) which lends itself to such a reading. Add to this Browne's existing reputation as a naturalistic painter who prioritized study

from life to get her details right (remember the lengths she went to in order to get her hands on a real habit for *The Sisters of Charity*) and we have a painting whose meaning is inextricably linked to its point of production.

Browne's paintings are differently detailed from those of Gérôme. Where his display polished surfaces, opulent sets, and lavish detail, hers are restrained in tone and understated in detail. Her different vision connotes an insider's knowledge rather than obscuring evidence of the artist's presence. This tautologically reinscribes the woman artist as the owner of the gaze that reveals the mysteries of the Orient. Browne does not use an armory of detail and her finish is not that of the seamless, invisible brushwork practiced by Gérôme. Some writers criticize her work as being too sketchy but this is a standard accusation leveled at women artists, and working from black and white photographs I cannot tell if this is an accurate description or unjustified criticism. The actual paintings of Browne's I have seen appear to be quite highly finished and no looser in brushwork than was usual in this period. Her relatively sparse compositions are seen by some as a fault in her technique and by others as proof of the reality of her version of the harem. For her supporters, the scarcity of detail is simultaneously a sign of the painting's veracity (Browne tells it how it is) and a claim to fame for the artist who moves on from outmoded Orientalist conventions. Melman argues that women's Orientalism was seen to bear the mark of a particularly feminine eye for detail—men being inclined to ignore detail in their lofty contemplation of the whole—which was in turn tied back into women's presumed empathetic and experiential knowledge of the Orient. Thus, Browne's detail (though it is not lush it accords with other women's accounts of the *haremlik*) functions as both proof of her having been there and as substantiating her femininity.

Browne's version of the harem disallows some of the genre's expected pleasures; unlike the isolated sexual prison crowded with half-clothed somnolent women and desirable consumer durables, she presents a calm, austere, and social space, marked by relations between the female figures. She activates it as a social realm, its walls regularly penetrated by visitors, friends, and musicians from outside. As such the paintings offer an alternative reading of relations of power, kinship and society in the harem. Her women are dressed and active, in clothes that have a social status and purpose in their wearers' lives instead of merely figuring as decoration or a mismatch of all things vaguely Oriental. There is no sexual intrigue in Browne's harems: the visits and entertainments seem quite above board. The dominant sense of *A Visit* is of an Oriental version of the afternoon visit which so structured European bourgeois society.

Again, we find that the response to Browne's work is split across the French/English divide, but this time in reverse: where the religious and domestic narrative pictures had been hugely successful in Britain but marginal in France, the *Interiors* mark the start of her rising French reputation as an Orientalist but were practically ignored in Britain.

The British art press reviews of the 1861 Salon mention Browne but pay no attention to the Orientalist paintings that were so remarked upon in France. The exhibition of one of them at Gambart's also received scant critical attention. The *Art Journal* noted that the French Gallery's exhibition had popularized French artists and identifies Browne as a "distinguished lady artist [like Rosa Bonheur]" but of the picture it merely mentions that it is "widely differing from the 'Soeurs de Charité' she has recently painted."[8] The *Athenaeum* only records that Browne has sent in "the fruit of a recent tour in her 'Scene in the Seraglio.' "[9]

Does this silence mean that the British reviewers did not like her new work or that they did not see it as anything very different from the genre scenes that they expected from her easel? It is not that Browne is out of favor—in 1862 the *Art Journal* welcomes the publication of an engraving of *The Sisters of Charity* (a sure sign of popular status)—but the new work certainly does not arouse the same excitement as the religious scenes. That fewer British than French critics situate her work in relation to mainstream Orientalism may be accounted for by Orientalism's greater standing in the French art world. Also, Browne's work has a greater affinity with that of Lewis, Britain's leading exponent of Orientalism. In terms of British Orientalism, therefore, her work marks less of a departure than it did in France and was, perhaps, considered less remarkable. (Although, it must be noted, that there was sufficient interest in Britain in women's representation of the harem to sustain the publication of a quantity of women's written accounts: all the written sources I have used were available in English.)

As we shall see in relation to her later Orientalist subjects, the British reception of Browne's work tends to mobilize discourses of ethnography. It is possible that the presentation of the pictures with titles classifying subject and location in much the same way as an ethnographic case study mitigates her potentially illicit venture into the masculine and sexualized field of Orientalism: titles like this include, *A Turkish Scene* (1864, fig. 5.2), *Jeune fille de Rhodes* and *Une école israélite à Tanger* (Salon and Exposition Universelle 1867, Gambart's 1868), *Danseuses en Nubie; Assouan* (Salon 1869), and *Les oranges; Haute Égypte* (Salon 1870).[10]

In France Théophile Gautier gives an enthusiastic reception to Browne's harem scenes. He valorizes the *Interiors* on the grounds that they are the realistic depiction of the eyewitness account only a woman could produce. His rhetoric expands this into a hyperbole asserting that there is no point in men visiting the Orient at all, since so much is hidden from them.

In Constantinople, when our curiosity is allowed to run the streets, enter the houses, it irritates us to be unable to go past the selamlik with our cups of coffee and chibouks, we often say to ourselves "Only women should go to Turkey—what can a man see in this jealous country? White minarets, guilloche[11] fountains, red houses, black cypresses, mangy dogs, hammals with loaded camels . . . or photographs and optical views." Nothing more. For a woman, on the contrary, the odalisque opens itself, the harem has no more mysteries; those faces, doubtless charming, for which the bearded tourist searches in vain . . . she contemplates stripped of their veil, in all the brilliance of their beauty; the feredge [cloak], a domino from Islam's permanent carnival, could not conceal more gracious bodies and splendid costumes.[12]

The dream which we have Mme Browne has truly brought into realization; she has reported a new Orient fresher than those of the *Thousand and One Nights*, to which we must make a comparison.

A Visit shows us at last the interior of a harem by one who has seen it, a thing rare and perhaps unique, because however well male painters often do make odalisques, not one is able to boast of having worked from nature—for architecture, don't go imagining an Alhambra or a fairy palace, but [instead] a very simple room, with some colonettes and white walls decorated with divans—The visitors arrive, the cadine receives them at the

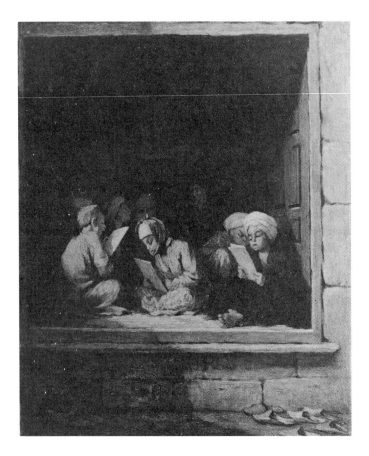

Figure 5.2 Henriette Browne, *A Turkish Scene*, 1864, oil on canvas, Witt Library, Courtauld Institute of Art, London.

top of the stairs, they haven't yet taken off the yashmak and feredge, one is in red, the other in blue, and the transparent muslin of their chinstraps allows one to see that both of them are pretty; they have brought with them a little girl. The harem women, sitting or rather squatting, on the divan, have the air of trying an activity which breaks into their nonchalance in order to celebrate the new arrivals. Their occupations were never very important, one was smelling a flower, and the other, leant against the partition of the wall, smoking a papipos—the cigarette of the Orient—when, as well they know, the narghile is beginning to go out of fashion there.

Nothing is as elegant as these long robes of such delicate colors, which trace the figure and give the body so much grace and svelteness. It makes us hold crinolines in horror! Above these long robes, like flowers on their stems, are poised fresh faces that cannot be imagined by one accustomed to European complexions, because they have never been exposed to the open air.[13]

Gautier's typically detailed descriptions of the paintings emphasize their ethnographic details.

A *Flute Player* initiates us into the diversions of the harem. Draped in white muslin, a young musician plays on a derviche's flute one of those melodies of strange charm which

seizes you as if invisibly, and you recall the memories of airs heard in a previous existence; three women cadines or odalisques are listening leant against the wall in an attitude of ecstatic dreaming. One of the flute player's companions, recognizable by her guzla, teases a tortoise to crawl along on a stool. A third musician watches her do it.[14]

For him, Browne's entry into the female quarters marks out her paintings as real representations of the East as opposed to fantasies.

These two scenes have a character of oriental intimacy which distinguishes them from all the fantasies of "*le turquerie.*" This is really the truth about Turkish women. Mme Browne found, after Decamps, a new way to paint white walls, instead of thickening them, or scratching them, or trowelling, she stuccoes them, so to speak, leaving all the pattern to the figures; the resultant effect is very happy.[15]

Gautier's pointed intervention highlights the importance of the battle over technique between the followers of Decamps and Browne. Considering that the paintings are clearly Orientalist, it is surprising that technical differences aroused such condemnation—the conventions of harem walls *à la* Decamps must have more riding on them than a dispute over how to depict plaster. They signify the very structures of Orientalist discourse. Thus Browne's walls disrupt the codes of viewing critics expect from Orientalist painting. Gautier relates the different way that Browne paints walls to the claims of veracity afforded by her visits to the harem. The plainness of the rooms she depicts may surprise some—"don't go imagining an Alhambra. . . ."—and may dismantle treasured dreams about the harem but Gautier welcomes them as a sign of reality.

He contrasts Browne's intimacy with the Orient to other artists' fantasies, making her paintings function as visual reports. Some may feel that these scenes are too tame and domestic, but Gautier utilizes their claim to reality to give them novelty value and thus promote the paintings. His detailed reading of the content relies on an acknowledgment of the class-, gender-, and nation-specific spaces from which Browne paints. He uses the particularities of her relationship to the harem to construct a critical space in which he can discuss the paintings as mainstream Orientalism (not just as ethnographic portraiture or topography as is the case with other women's amateur and professional Orientalism)[16] without having to contend with the unfeminine immorality associated with the genre. He thus manages to meet the challenge of Browne's desexualized harem and incorporate it within dominant Orientalism by offering a modified fantasy of the harem—if some viewers dislike the paintings it is because they lack the taste to appreciate the real thing. Gautier establishes a relationship between the woman artist and the represented space in keeping with the European linkage of women and the domestic. Thus gender determines Browne's access to the harem (on which rests the paintings' claim to truth) and foregrounds a special relationship to the domestic (on which rests his readings of the paintings as truthful and as womanly). Because of the projection of the idea of women's innate empathy with the domestic, the exotic erotic fantasy harem of Ingres and Gérôme becomes a knowable domestic location. The details of exotic costume and customs become ethnography, albeit picturesque, rather than titillating, lascivious vignettes. The fascination with the harem is amended from one that is overtly sexual to one that is overtly ethnographic, where the

harem's sexual significance is implicit rather than explicit (caught up, for example, in the emphasis on the women's beauty). But for all their affinities, it is important that the Occident not be confused with the Orient. Gautier may praise the feredge over the crinoline, but he maintains enough strategic distance to portray the Orient as inferior to European civilization. (Islam as a "carnival" is spectacular but spiritually worthless, the animals are mangy, the women lazy, etc.)

The review favors the humble details of domestic life available to a woman over the myths of Orientalism available to a man; the key tropes of the Orientalist fantasy (cypresses, minarets, camels, odalisques) and industry (photographs and panoramas) no longer thrill. Instead, the reviewer revels in a new vision of the Orient. Browne's claim to reality is endorsed by the contemporaneity of her details, such as the new fashion for papipos over narghile pipes, which Gautier, with his travel experience, is able to decode. The introduction of fashion, a phenomenon that requires both a concept of time and channels of communication, potentially undermines the image of the harem as an anachronistic prison and emphasizes the temporality of the Orient, in distinction to its traditional representation as timeless and archaic.[17] But the painting displays sufficient traditional tropes to enable the (re)viewer to contain it within the Orientalist myth: Gautier is able to extrapolate the flute melody as a reminder of previous lives in practically the same breath as he remarks on the modernity of the pipes. This contradiction is typical of Gautier's critical approach which is based on connoisseurship and a Romantic immersion in the art object. As such, to be transported (into an evocation of previous lives) was a sign of a painting's success. Gautier's Romantic belief in reincarnation and "intellectual homelands" (his was ancient Egyptian, Delacroix's Anglo-Hindu . . .) worked particularly well in the case of his Orientalist friends because it mapped onto the traditional view of the Orient as the cradle of Western civilization.[18]

Claude Vignon is less than impressed with Browne's harems. Unlike Gautier, she sees no advantage deriving from the artist's gender. In fact Browne, who she previously liked to praise as a masculine and virile artist, is found to have succumbed to the weaknesses of her sex and is demoted to the status of female.

> Madame Browne, whose talent we recognized from the first . . . counts among the three or four best portraitists. . . . The two *Harem Interiors* do not at all indicate a progress of the artist [who showed] . . . for a short while, a totally virile talent. It is feminine painting, a little shallow, a little cold, such at last that, if the *Interiors* were not placed next to the portrait of Baron de S and signed with the same signature, they would not arouse a second glance. Mme Browne owes us more, it is said that she has captured nature in the *Interiors*, [but I think] she was, despite herself, influenced by the harem's enervating atmosphere.[19]

Where Gautier thinks Browne has made a coup by depicting the truth of the harem, as far as Vignon is concerned the artist was betrayed by her own nature. It seems femininity, like blood, will out. Although Vignon criticizes the harem's effects on women, her condemnation of Browne is not couched in the terms of moral repugnance that she directed at Gérôme in that year's *Journal des desmoiselles*.[20] Meanwhile, she continues to praise Browne in the *Journal des desmoiselles*. She does not refer to the disappointing *Interiors* at all, leading me to deduce that the importance of Browne as a role model for the young women readers over-

rides her dislike of the recent work. Gender, which in *Le Correspondent* accounts for Browne's failure, in *Journal des desmoiselles* is the grounds of her success. This example shows how the review's presumed readership impacts on the operation of discourses of gender and art.

Hector de Callias in *L'Artiste* cannot rest easy with Browne's rejection of Decampian conventions. He is impressed with her paintings and accepts their documentary status but wants to retain some of the favorite elements of the Orientalist fantasy. His tone suggests that realism is all very well, but since the fantasy is so well established it is perverse to go against it in case the resultant image is less credible to Western eyes. If Browne equals documentary then what de Callias wants is docudrama!

> She has journeyed in the Orient. Like Lady Montagu, she penetrated into the harems, there she filled her palette with the richest colors and brings back to us interiors peopled with indolent beauties. . . . The harems' white walls are uniform and stucco. We reproach the artist who opposes herself to Decamps' encrusted and engraved walls. One does not dream that such walls would be entirely out of harmony with the general contents of the paintings. . . . [21]

De Callias' fervent championing of Decamps reveals the level of resistance to other versions of the Orient, although his reference to Lady Montagu substantiates the importance of the female eyewitness account.

Olivier Merson is disappointed with Browne's account of the harem. Rather than dispute whether she actually saw what she painted, he minimizes the centrality of the *Interiors* by presenting them as just one version among many. This defuses their challenge to the Orientalist "dream" which, it is implied, continues in reality elsewhere (in the harems of the very rich). While on one hand this seems perfectly reasonable (why should there not be different types and classes of harems, just as there are different types of houses in Europe?), on the other it dilutes the significance of the *Interiors* by refusing their claim to relate to harems as a whole.

> Having been able to clear the threshold of the harems, she [Browne] painted from nature those strange and jealous interiors, . . . This then is the harem. Instead of diamond palaces and rejuvenated Alhambras, marble basins and gushing fountains, sumptuous rugs and naked odalisques rolling about in their pearled costumes, on piles of cushions or mosaics, we see a room that is austere and serious, without ornamentation, with colonnettes and whitewashed walls, a mat unwinding on the flags, a divan dominating all around, and populated with silent women, bored, somnolently graceful, chaste in the muslin of their long robes which outline their fragile and languid bodies. I confess that these pictures disturb our Oriental dreams a little. It is true, if the artist had painted the seraglio of a Grand-Seigneur, perhaps we would have been less disappointed, perhaps we would rediscover the voluptuous setting, that sensual and breathtaking luxury that permeates the stories of *A Thousand and One Nights*.[22]

Merson offers the most telling criticism of Browne's technique. He tells us quite clearly that she has broken the rules of verisimilitude required in the representation of foreign subjects, and so fails to convince.

Now, the painter permits us a technical observation. The inside of the rooms are white-washed. To give this effect, Mme Browne has covered the background with a paste suffi-ciently resistant, and this is for the best. Then, the shaded parts of the figures that must project from this solid background, she has only covered with a wash of color as light as the weave played across toile. This time she is mistaken. In order to free oneself for a foreign plan, it is not enough to give it a more definite location; it is important also that the manner in which it is put is close to natural in the eye of the spectator. This is not a cunning trick of the trade, it is a positive rule whose application we see in all the pictures of the master col-orists. On the contrary, in *The Visit* and *The Flute Player* if I see the shaded tones of people sinking deeper instead of moving away, it is less because of their quality of color than because they were placed there for opposite reasons to the effect they were called upon to express.

It seems that Gérôme had it right all along. Browne's deviation from Orientalist conven-tions (and the review starts with a passage on the particular color opportunities offered by the light of the Orient) is not a matter of interpretation, it is a mistake.

The ease with which Merson and the other critics sum up the characteristics of the Ori-ental dream shows how familiar, and how cherished, it was. Women who reported back on the harem were faced with an audience curious for knowledge but resistant to changes in the accepted knowledges about the East. Of course not all women agreed on what the harem was like. Léon Lagrange in the *Gazette des beaux-arts* plays women off against each other, using the Italian Princess Belgiojoso's travel writings to dispute the authenticity of Browne's image of the harem.[23]

> *The Visit* and *The Flute Player*, which present themselves as revelations of the mysterious life of the harem, do not exceed in value and interest, a woman's travelogue; again the indiscretions of the princess Belgiojoso have a completely different version of the truth. It is possible that in 1860 the young Paris milliners taken to Constantinople by the Crimean War, amused themselves by playing out innocent and insipid entertainments [*berquinades*] in front of Madame Browne which she fixed quickly in her notebook.[24]

Both women's products are trivialized by reducing them to the level of childish amuse-ments like those indulged in by bored milliners. The combination of Parisian milliners, who featured regularly in the list of working-class women suspected of clandestine prosti-tution, and the term "innocent" lends an air of sexual duplicity that reinforces Belgiojoso's "indiscretions" as a more accurate view of the harem.[25] In this case it is implied that Browne was the innocent dupe of the sexually knowing, which undermines her alleged access to the truth. Having thus demolished her claim to serious critical attention he delivers the *coup de grâce* by claiming that only the Parisian obsession with Orientalism protects the canvas from serious critical discussion.

> Madame Belgiojoso peoples harems with massive beauties, that strictly conform to the Mohammedan ideal of the houri type figure, and dressed with the bad taste which char-acterizes this exquisite flower. For us it is impossible to recognize [this] in the luminous pastels that light up the *Interiors* of Mme Browne. . . . The walls too appear naked to us. What! No flashy mirror, no covering from Paris or London, and, similarly with the furni-

ture, no piano, no porcelain clock, likewise no music box. Verisimilitude does not bow in favor of Mme Browne: only the totally Parisian fondness for Turkish subjects protects them from the most serious reproaches that criticism would be within its rights to make of them in the name of art.[26]

Browne's work is characterized as silly and dilettante, a fad of fashion, and thus of no lasting consequence. It is unclear whether the sarcastic reference to the absence of Western goods points to the increased two-way trade between East and West in this period, and is thus an accusation of inauthenticity, or is a sneer at the genre in general for its fondness for interiors crammed with goods. As Kabbani points out, this "catalogue of goods" available to the Western viewer is one of the main pleasures of the Oriental text—a fantasy of ownership that extends to the women pictured in the Oriental interior.[27] The absence of luscious accoutrements in Browne's paintings therefore threatens to disrupt the expected mode of viewing and satisfactions of the Western audience. Although Orientalism is characterized by the European acquisition of Eastern goods, Western products were also sought after in the East. This was particularly the case with clothing. After the dress reforms of the 1830s many rich Turks wore Western dress, but this "inauthentic" clothing was generally edited out by Western artists—even though the display of Western artefacts in rich Ottoman households was often seen by their owners as a sign of progressiveness.[28] Gautier, who approves of the Sultan employing Donizetti's brother as leader of his musical staff, is still somewhat staggered by the Turks' taste for vulgar French clocks or reproduction pictures, all of which are held in high esteem because of their European origin.[29]

Although in many ways the *Interiors* conform to the image of Ottoman houses in Orientalist art (the *mouchearabia*/lattice screened windows, yashmaks and *feredjes*, the coffee pot, the tiled floor, low level seating, arches, and columns) they also differ in that the furnishing is sparse and the room, as Lagrange points out, is bare and simple.[30] This is quite in keeping with Ottoman interiors where space and coolness were maximized by storing furnishings and linens in cupboards when not in use. The dark-skinned woman at the right of the picture is carrying a cushion, such as would be brought out of store for use when guests arrived. This practice contradicts the Western vision of the multitudinous splendors of the Orient that was transposed from their own domestic predilection for interiors crowded with ornament and display. No doubt some visitors to the public areas of Oriental houses were met with an impressive array of luxurious furnishings, but the vision of rooms crammed like an Aladdin's cave full of treasures would disappear when belongings were packed away once the room was vacated.

Several of the architectural and social details of the paintings seem reliable. Charles Newton, curator of the Victoria and Albert Museum's Searight Collection, considers *A Visit* to be a fairly authentic representation of the interior of a wealthy Ottoman household. The stone structure indicates an expensive, large, and probably old house. (Modern houses in nineteenth-century Constantinople were generally built of wood since few people could afford to build in scarce and expensive stone.[31]) The dimensions of the room in *A Visit* suggest that it is the main reception hall of the *haremlik* in a moderately wealthy household. Another possible illustration of the family's wealth is the carpet in *A Flute Player* which, judging by the pattern, may be a Western import. (It is impossible to tell clearly from a black and white photograph.)

These images of domestic detail and social interaction relate more to the English school of Orientalism exemplified by John Frederick Lewis than to French high Orientalist fantasy. Orientalist paintings are caught up in a complex of intertextual relations wherein they invoke each other in a general sense (Europe's knowledge of the Orient being derived from the repetition and authentification of its signs about it) and reference each other specifically. In Merson's review, for example, there is a sense in which he acknowledges that the dream of the Orient challenged by Browne's *Interiors* is a fantasized reality based on representations. As such, an antidote to the disappointment of the *Interiors* can be provided by reactivating the pleasures of *A Thousand and One Nights*. Although Browne deviates from some strands of Orientalism (for example, she does not quote reclining nude odalisques) her realist style quotes enough conventional details of the field to counterbalance such omissions and authenticate the particular image of the harem on offer. The presence of well-rehearsed signs of the Orient, such as the women's yashmaks and curved "Turkish" slippers, gives the paintings a sense of ethnographic verisimilitude. Some critics were able to read this as the detailed representation of an everyday event available only to a female witness. Although some criticize her content and style, for her champions Gautier and Chasrel it is this combination of new and "known" information about the harem that proves their worth.

Chasrel's 1877 retrospective depicts Browne as an important Orientalist and traveler-artist. Entering into recent art world debates about the usefulness of travel for artists, he cites Browne, alongside Gérôme and Fromentine, as one who truly benefits from tours abroad (similar to the inspiration Millet finds at home). This is contrasted to the multitude of talentless artists whose search for ideas on any continent is futile. Browne's presence among such hallowed company is couched in the sugary terms of femininity:

> Without attempting a comparison which would pose as flattery we do not regret the advantages of circumstances which made space for the elegant talent and sensibility [*sympathique*] of [Browne] . . . who has added a new note to the rich and varied scale of Orientalist painting. A feminine note with all the delicacy, all the drama and all the distinction which gives the impression of a woman adding to the essence of art. The addition is but a semi-tone, or even, if you like, a quarter-tone to [our] Oriental gifts, but this quarter-tone belongs to the artist who has had the good fortune to penetrate some of the mysteries of the intimate life of the Orient, and the talent to turn to painting's profit the womanly privileges of discovery she gained. We are reminded of the instant success of *A Visit to the Harem* in the Salon of 1861. If not a revelation, it was at least an amendment which had the mark of direct and personal observation. It was what others had caught fleeting glimpses of, guessed at or simply imagined, Mme Henriette Browne saw it herself, it was part of a privilege; and that she succeeded in communicating to the lay public all the freshness and all the vivacity of this initial impression, is part of her talent.[32]

Browne's talent is relentlessly traced to her gender at the level of both form and of content: Chasrel follows the trend of earlier British reviewers and relates Browne to Millet and the painters of peasants, but he does not base his belief in the authenticity of her representations to the naturalistic style she shares with them. The paintings' credibility rests on the innate femininity of the woman herself:

That which we find pleasing about this talent is . . . the natural distinction and the modesty of the woman . . . [an artist] recognized by her peers and her masters, without her work betraying the infatuation of newly arrived dilettantism.

The touch, without overly precious scrupulousness, [tends] to the delicacy and quality of fine needlework. The accent is precise without any trace of the search for virile energy which too often spoils the most charming qualities. The sentiment is discreet without losing its intensity . . . [her] painting holds itself equidistant from grandeur and from affected winsomeness, from power and from affectation, and finds in the right milieu of its nature the sign of good taste and charm of which any upstart in Art would be incapable.[33]

Although all the critical material on Browne assumes gender to be significant, Chasrel's stress on femininity is the most like the profile in the *English Woman's Journal*. Promoting the genteel femininity of the artist as the crucial measure of her work, he sets up a series of associations with discourses of art and gender in which to position Browne: she is both likened to all things womanly and rescued from the possible pejorative connotations of excessive femininity; her work is delicate but not precious; it is compared to skills relegated to the lesser sphere of craft but rescued from too much diminution by the careful note that the comparison is to "fine" needlework and the heights of accomplishment, not the labor of a common seamstress. Further, it is discreet but not inane.

If Browne is saved from the taints of excessive femininity, she is also protected from the unnatural "search for virile energy" that "too often" ruins women's work. Whereas numerous art critics use virile as a term of praise (Vignon worried that the harem had emasculated Browne's erstwhile virile talent), Chasrel goes to great lengths to absolve Browne from such associations. The language of the review lets the terms of description slide between their apparent object, the art work and the women who produce them. Thus we find that the "charming" women who produce such delicate work are themselves in danger from the taints of virile energy, for "traces" of which the critic carefully searches. The review's problem is how to encompass Browne's achievements within an ideology of art as a male activity without denying her femininity. On one hand her paintings are validated precisely because they come from a woman's sphere, but on the other she and all women artists are in danger of infection by the virility of the art world and the potency of their male counterparts whose achievements (flowing from that very virility) they no doubt might falsely wish to emulate.

The review conceptualizes Browne's Orientalism as a feminine addition to a male field. Chasrel constructs a genealogy of Orientalism in which Browne figures as cousin to the great male Orientalists without compromising her classed gentility.

[S]ince . . . we cited the names [Fromentine, Gérôme, Delacroix] of the leaders of this line of Oriental painting, we could claim a place for her beside them which they would in other circumstances not hesitate to offer her. Mme Henriette Browne is their kinswoman and if the artist had had the time to wait to choose herself a pseudonym she could have restricted herself to the feminization of the first name of one or other of her illustrious colleagues because her painting is a cousin of theirs.[34]

The shifting status of Browne in the "family" of Orientalism attests to the problems of locating a woman artist in this club. In order to facilitate her inclusion in the field of Orientalism,

Chasrel streamlines her oeuvre by de-emphasizing her role as the producer of domestic genre and portraiture which signals a woman artist. Her gender is never disguised (unlike the cross-dressing Rosa Bonheur, there is never any doubt that Browne is a woman) but is modified to produce a version of femininity that fits the concept of Orientalist art. If she figures as too feminine an artist then her status as honorary Orientalist is threatened.

The Female Gaze

While it is easy to accept that the gendered position from which Browne produced fore-grounded certain types of representation, it is harder to ascertain whether this also pro-duced a particular viewing position. Arguably, her harems invite us to see the Orient from a woman's point of view—but how does this gendered view relate to traditional positions of Western superiority? The Orient remains significantly different. For all that the harems have affinities with European drawing rooms, they are quite clearly not the same thing; women wear Oriental dress, loll against cushions, and smoke cigarettes. However, this difference is not necessarily negative. Although reviewers are able to judge these local details as signs of Oriental deficiency (in morals, posture, and work ethic) the paintings do not rule out a less judgmental stance. This is not to suggest that, because she was female, Browne in some proto-feminist manner immediately understood the relations between misogyny at home and exploitation abroad. Rather, that, given the moral implications of subject matter, the socializing act of painting for a woman in Browne's position foregrounded a positionality in relation to the harem that was necessarily less damning and eroticized than that of her male counterparts. It is not necessarily conscious politics on her part but the position from which she paints that leads to the representation of the harem as a space respectable enough to contain the respectable lady artist persona associated with Browne. Unlike Gérôme, as analyzed by Nochlin, Browne's differently detailed technique emphasizes rather than oblit-erates her presence at the scene. By breaking with the voyeuristic viewing position facili-tated by the implied absence of the artist, Browne destabilizes the West's fantasized relationship to the Orient as other. Her sympathetic rendition of the harem theme chal-lenges one set of artistic conventions (Orientalism) but re-affirms another (the codes of feminine art practice).

Although the paintings provide a different Western view of the Orient they are not beyond appropriation—Gautier can still revel in the beauty of the (dressed) women and Vignon can deploy stereotypes of idleness. The interpretations of race and gender that the pictures are made to bear at the point of exhibition circumscribe the radical potential of the female gaze to disrupt imperial ideologies at the point of production. Browne's pictures provide a bridge between the all-female space of the harem and the mixed gender space of the Salon. Both men and women see a female view of a female space (the harem) but within a context subject to critical meanings largely determined by a predominantly male critical community.

Contemporary criticism makes much of the active female spectatorship it associates with the paintings. We can also use twentieth-century theories of the female gaze, devel-oped originally in film theory, to tease out the relationship between the woman artist's look and the viewing positions constructed by her paintings. The ownership of the gaze on screen and between viewer and representation has been of significance to cultural critics

since Laura Mulvey equated being the agent of the look with an active position of power.[35] Arguing that cinematic representation appealed to unconscious scopophilic drives (the fantasy of control through visual mastery), Mulvey produced an explanation of pleasure in which the viewer identifies with the active male protagonist on screen. His actions appear to drive the narrative and control the filmic space, unlike the female figures who are subordinate and passive. Mulvey's later attempt to situate the excluded female viewer (who can only identify sadistically with the male character or passively and masochistically with the female) arrived at an uncomfortable notion of transvestism, wherein she (the viewer) slips between the two polarities of a masculine or feminine identification.[36] Mulvey started a debate about the nature of the female spectator and her pleasure that lasted through the 1980s and extended beyond film to the analyzis of other forms of representation.

Though useful, developments in film theory can never be straightforwardly applied to static visual representations like painting. Some help is offered by the amendments made by television theory, since television, like a visit to an art exhibition, is viewed in circumstances where the social (in the form of interruptions, other people's opinions, and the consciousness of a shared viewing) obviously intervenes (unlike the apparently private viewing experience of the darkened, silent cinema). Lorraine Gamman and Jackie Stacey, working on the woman's gaze in film and television, stress the importance of gazes (and verbal exchanges) *between* female figures.[37] This offers a way of analyzing a desirable viewing position for the female spectator that does not rely on Mulvey's active/passive/transvestite mode of viewing. The active roles of, and relationship between, female protagonists like television detectives Cagney and Lacey differ from the usual cop show format by challenging the traditionally passive status of woman in the narrative and therefore foreground a pleasurable viewing position for women.

Browne's paintings differ from the generic codes of Orientalism by inserting gazes and action between women into a situation that paradigmatically relies on inactive female figures frozen into a static space. Like narrative film, the myth of the harem is activated by the male hero who alone has the power to move the narrative, to be, as Teresa de Lauretis puts it, the agent of transformation.[38] Harem women are traditionally stuck in a freeze-frame awaiting the husband's transforming presence/gaze. Browne, as the only other possible witness/viewer of the harem (symbolically, if not literally), replaces the husband as the transforming agent but, rather than simply climb into his metaphorical shoes and parody a typical harem painting, she sidesteps the myth and socializes rather than sexualizes the harem's petrified space. Browne paints the harem from a position that implies neither a sadistic identification with a male perspective nor a masochistic identification with subordinate female participants (Mulvey's original formulation), nor is she simply transvestite, hopping awkwardly between the two (Mulvey's second position). She paints from a position that *had to be female*, according to the prevailing ideas of artistic production, femininity, and the harem, and that *had to be active*, according to the construction of her as the author of a text predicated on a direct viewing of an unremittingly gendered space. She thus intervenes in the dynamic of active/male and passive/female by being, and being understood to be, a female painting a subject who actively looks at and represents the harem.

The active relationships she represents between the female figures counter the traditional narrative of a male-dominated harem and, like the buddy relationship of Cagney and Lacey, can facilitate a pleasurable viewing position for the women in the audience.

Film theory's stress on narrative (multiple or single) is germane here not only because Browne's audience was accustomed to decoding narratives from paintings but also because to represent the harem in any form was to enter into a longstanding, well-understood narrative about the harem and the East. No representation of the harem stood on its own. As the reviews clearly show, her paintings were seen as part of an ongoing dialogue about the harem with which nearly everyone was familiar, at least in part (whether it was Decamps' paintings, cartoons, *A Thousand and One Nights* or the endless use of the harem as metaphor for slavery, servitude, or sex). The paintings effectively act as another instance in an ongoing story—the painterly equivalent of the reverse shot from the woman's point of view—whose opposite (the numerous and sexualized harem scenes) is well known to the audience.

As representations of a woman's look, the *Interiors* set up a special relationship to the female spectator. They challenge the idea of women as the object, rather than owner, of the gaze by showing female figures who were looked at first by a female spectator and by representing them contrary to the generic codes of passivity. While, as Mary Ann Doane highlights, "woman" was originally conceptualized as the ideal film spectator (a passive consumer), she is generally refused the position of active looking subject in the diegesis.[39] Browne in contrast is conceptualized as doing both: she is imagined as both consumer of the scene (in this case the "actual" scene of the harem, not the represented scene) and agent of its representation. But although this allows the female viewer to stand in the artist's shoes (without resorting to cross-dressing), the distance between the artist/viewer and the subject of the picture is retained. Unlike the pathos of the "woman's" film where weeping, a sign of overidentification with filmic characters, is a sign of the film's success, the *Interiors* cannot risk collapsing the distance between the Western observers and the Eastern observed. The insistence on the difference between women (Occidental and Oriental) effectively marks the female spectator (both Browne and the paintings' audience) as Western and other to the female subjects of the painting.

Theories of the female gaze have deconstructed the earlier tendency to a monolithic female spectator, affirming that the term refers not to any woman who watches a film but to a constructed space of viewing.[40] This textual addressee who does not equal, but whose position may be occupied by, a "real" individual (male/female) is also subject to social differentials (race, sexual orientation, etc.) and an equally, but often differently, differentiated access to critical codes which will give various viewers a different purchase on the text.[41] Browne's demarcation of difference between Oriental and Occidental women is inscribed in the dynamics of the viewing activity rather than overtly played out in the scene itself (unlike the twinning of alternative female personas highlighted in Stacey's analyzis of *Desperately Seeking Susan* for example). Rather than depict herself or another Western woman in the painting as a contrast to the Oriental women, Browne's *Interiors* rely on the traditions of viewing and the codes of Orientalism to assert the difference between audience and subject. By subverting some codes and repeating others, the paintings are able simultaneously to provide points of entry and identification for women viewers and maintain the West's distance from the East. In the final analyzis, the points of similarity and empathy must not override the points of difference. Browne's status as Westerner and artist requires the construction of difference at the same time as her gender allows the construction of an affinity between herself and the women's space. Browne must become not only a seeing but a differentiating agent.[42]

But the spectator who sees through Browne's eyes cannot see everything: there is still something in the harem that denies our inquisitive gaze; something signified by the intense looking activity of the two figures on the steps at the right of the painting. They twist their bodies and turn their backs to us in order to look down at something that is hidden from our view. This visual dynamic within the picture plane undercuts the visual mastery promised by the narrative and disrupts the compositional coherence of the painting. There remains a mystery in the harem that even the female gaze cannot penetrate—or, will not represent for a mixed-gender audience. There is, thus, a tension between the promise of an unimpeded vision offered by the calm, uncluttered, open spaces of the *haremlik* in Browne's painting and the signification of a residual knowledge that remains forbidden. Within the apparently transparent inscription of harem life there lurks a repressed or hidden knowledge that, as with the lesbian subtext of harem and convent imagery, could only be indirectly invoked by an artist with Browne's particularly respectable public profile.

It is evident, despite the scarcity of other examples of Orientalism by women, that women's Orientalism is as heterogeneous as its mainstream equivalent and we must not assume that Browne's version was unchallenged. For all that there are plausible reasons for her to avoid improper subjects, it does not mean that other women artists did the same. (At the same time as Browne and Mary Cassatt were selecting decorous subjects to paint and behaving like nice ladies, Rosa Bonheur was rocketing to fame with her distinctly unfeminine choice of subject and self-presentation.)

We simply cannot tell why some women tried to resolve the contradictions of being a woman artist by conforming to rather than transgressing codes of femininity. It is apparent that Browne, by personality as much as upbringing, was a relatively conservative individual. (Using a pseudonym is indicative here.) What is even more intriguing is how someone like Jerichau-Baumann could still be seen as a respectable person when she exhibited such unfeminine and potentially improper paintings. Browne's work might challenge Orientalist traditions, but it is easy to classify as feminine; yet though Jerichau-Baumann's oeuvre was far more transgressive of gender codes there is no evidence that this ever impacted badly on the artist herself: gendered codes of art and behavior had considerable flexibility. This does not mean that the boundaries were so blurred that they ceased to be meaningful: it was their discursive ability to incorporate, or neutralize, transgressive examples like the work of Jerichau-Baumann that ensured the continued hegemony of dominant definitions of gender.

Reviewers seem to have worked hard to read Jerichau-Baumann's work as feminine. Also, it is evident from the range of work she showed that Jerichau-Baumann regularly presented herself within the parameters expected of women artists. (Her Royal Academy exhibits were predominantly "feminine" genre, the picturesque or portraits.) Presumably, the respectability of her social position (she was, after all, a member of the Copenhagen Royal Academy and married to its president, the eminent Danish sculptor Jens-Adolph Jerichau) also went a long way towards compensating for her more unfeminine works. But the *Art Journal*'s review of her 1871 exhibition at 142 New Bond St (possibly a one-woman show—the only other exhibits appear to have been a few by her husband) demonstrates how difficult it was to maintain critical hegemony.

The paintings of this lady command attention as they are marked by characteristics which are by no means common to woman's work . . . Madame Jerichau moves only in obedi-

ence to the purest strain of academic inspiration . . . she does not yield to fascinations ["tender relations between the sexes," "narratives of affliction"] against which the majority of female artists are not proof. . . . This lady is impelled upwards into the epic vein by her tastes and feelings, and, at the same time, is more pronouncedly ethnographical than perhaps any artist of the day. There is, however, one tie which her woman's heart acknowledges, and that is a love of children; at least we thus read the many studies she has so successfully endowed with the natural graces of childhood. Notwithstanding, however, the element that gives a masculine quality to Madame Jerichau's works . . . she has the power of working up to the utmost refinement of feminine beauty. We instance her portrait of the Queen of Greece . . . *The Favourite of the Hareem*, an oil-picture, declares itself at once a veritable study from Oriental life. All attempts at the improvisation of Hareem beauty by painters and poets have been very wide of the truth, as we learn from this and all other genuine representations of so-called eastern beauty. There are several pictures of eastern women: what is most valuable in them is their indisputable nationality, which is brought forward without any modification or dalliance with conventional prettiness of feature . . . [others afford] evidence of independent thought. . . . There are also one or two female studies of Fellaheen, in which truth and genuine nationality prevail over poet's dreams of matchless houris and peerless Egyptian maids. . . .[43]

As we shall see, ethnographic discourse was often used as a way to validate Orientalist images as scientifically authentic and thus endorse the artist's vision as objective. But in this case, the rigors of objective reality sit uneasily with the definition of feminine art. The reviewer cannot but admire Jerichau-Baumann's depiction of nationality, but would far rather see the conventional prettiness that the artist eschews. Similarly, while he or she is forced to applaud the assertiveness of her independent thought, the reviewer does his or her best to give her oeuvre a feminine complexion by closing with a reaffirmation of her womanly love for children. What interests me here is that her oeuvre *was* mixed and did include paintings which could be received as unproblematically womanly, but that despite this there is something about her Orientalist subjects that creates a problem big enough to destabilize the overall classification of the artist and her work, something that other women Orientalists generally manage to avoid.

That the majority of women's visual representations of the Orient, and of the harem, are morally untroubling could be either because (for those that actually traveled) they never actually saw anything immoral or that they edited it out of their accounts lest it impinge on them as witnesses of the scene.[44] In literary representation, although women writers did have to fend off charges that they were only as moral as their last novel, the conjunction of literary-critical practice and the increasing number of women writers produced a different resolution of the problem of subject than in the visual arts. Here, artists were assumed to have studied what they depicted, in a model if not *in situ*, and were thus tied more closely to the represented scene. For an artist like Browne, who was known for her rigorous study from life, it would have been hard, if not impossible, securely to inscribe such a disassociation from her subject. This obstructed the establishment of a morally essential distance with which a literary author might have had more chance of success. For Western women writers like Emmeline Lott it was relatively easy to disassociate themselves from any immoral acts represented by deploying an imperial distance that presumes the author's and

readers' disapproval of such heathen acts. For Oriental women writing in Europe, where they presumably had to contend with racist assumptions about their own morality, it was imperative that they be dissociated from any misbehavior in the harem. So although the writer Melek-Hanum in *30 Years in the Harem* (1872) describes scenes of debauchery (in the apartments of Nazly-Hanum, the daughter of Mehemet-Ali, the Viceroy of Egypt) she clearly signals her disgust by telling her readers of her prompt departure from the room. The endless assumption of an isomorphic relation between Browne's pictures and her experience of the harem makes the presentation of such a split difficult.

It is clear from the response to Browne's *Interiors* that they upset dominant perceptions of the harem and of the differences between East and West. Linda Nochlin argues that the prerequisite for an art (like Manet's *Olympia*) that transgresses discursive codes is the combination of an alternative practice in both subject and technique.[45] Although the technical differences of Browne's work are not as radical as those of Manet and the French avant-garde, I think that some of the outrage aroused by the *Interiors* can be explained in relation to a similar combination of innovation in style and technique. The changes she makes in the representation of the harem may seem small, but they are not insignificant. The attention devoted to them by critics suggests that the ways which the *Interiors* differ from other (notably French) Orientalist art constitute a challenge to generic codes. (The frequent invocation of Decamps, the symbolic father of Orientalist art, acts as a strong defense mechanism that attests to the seriousness of the threat.)

Rosemary Betterton links challenges to generic codes to the specificity of the female gaze. Writing on Suzanne Valadon, she argues that the conditions under which women view in patriarchy predispose them to look "against the grain" and therefore subvert hegemonic codes of viewing.[46] This "ability to move between and to acknowledge different viewing positions" is determined by the social space occupied by the painter. In Valadon's case, her specific social position (as woman, working-class, model, and artist) leads to a different gaze on and resolution of her chosen subject (the female nude). This manifests itself in a subversion of the nude's generic codes. Browne, unlike Valadon or Manet, was not associated with the avant-garde but her changes to the Orientalist canon can be regarded, and were received, as similarly significant. The censure aroused by her harems is not just because she paints plain walls and austere interiors or because she claims that her subject is the actual truth about the harem, but because of the interaction of the two. While the luscious surface detail of Gérôme substantiates his superior viewing position in relation to the East, the new details and austere surfaces of Browne's work transgress the ideological codes of Orientalist representation.

Her very claim to truth, that was for some the value of her painting, could also be used to downgrade her work and hence minimize its threat. Critical willingness to read the paintings' content from her entry into the harem occludes recognition of her role as active creator of the artefact and allows a discussion of the pictures as if they were transparent recordings of her experiences.[47] The tendency to read the art object as an unmediated representation of an anterior reality is common to critiques of men's and women's work. But in this case it resolves the difference between the fantasy logic of the harem and the observed truth of the woman. The tendency to accuse the paintings of technical deficiencies utilizes a language of formalism that belies its ideological function. One senses in some of the defenses of Decamps the implication that hers may be more authentic but his are more artistic.

If there is a threat in her work it lies in its offer of an alternative discourse on the Orient and in its throwing into question those *"turqueries fantaisistes"* of many successful male practitioners.[48] More than this, it becomes morally disturbing, because the apparently impeccable moral qualities of the scenes witnessed by Browne throw the power relations between the Occident and Orient into question. This is where the different but nearly equal stance of images of the "ordinary" Orient (that we shall see particularly in her treatment of Oriental children) is important. While it is possible to read in Browne's representations a treatment of difference that does not necessarily condemn it, the continued stress on that difference is crucial. It allows the Occident to retain its vision of the separateness of the Orient and therefore to continue to pose itself against it. The ongoing separation of the West and the East mediates any fundamental challenge to the imperial ideology that informs Orientalism. There is room within the discourse for a feminine, and perhaps less virulently xenophobic, version of Orientalism that adapts and amends but does not remove the imperial imperative.

From the Subjective to the Objective: Ethnographic Discourses of Race and Nation

After 1861 Browne continued to exhibit Oriental subjects alongside portraits and the occasional genre piece. But she never returned explicitly to the harem. Her subsequent Oriental subjects were mainly ethnographic types (like *Rhodian Girl*, Salon 1867, Gambart's 1868[49]) and studies of Oriental children—relatively unproblematic topics for a woman artist. In contrast was her painting, *Dancers in Nubia, Assouan* (Salon 1869) which, as a subject that was practically the stock-in-trade image of a sexualized Orient, was a more provocative choice for an artist with so respectable a reputation as Browne.[50]

Rhodian Girl was described by the *Athenaeum* in distinctly ethnographic terms as a "splendid specimen of the almost Nubian-looking women of the ancient island."[51] The fair-skinned European-looking figure in this painting bears no resemblance to a black African Nubian, but the interpretive impact of imperial knowledge allows the review to utilize ethnography as an objective mode in which to read the painting. This type of reading was particularly effective in the case of portraits, since women artists were frequently attributed with the ability to intuit, and thus accurately represent, their subject's character. In the case of the Orientalist portrait like *Rhodian Girl*, it constructs a gaze from West to East that is immutably gendered. The review's reference to Nubia keys into the Nubians' status as an ethnic group of almost mythical beauty—conceptualized as the only beautiful Black Africans.[52] Beauty and race were important components of Orientalist art, although it required considerable juggling to fit a European vision of pale-skinned beauty into an Oriental setting. The surprising number of pale-skinned, blond-haired women represented as odalisques, slaves, and concubines was frequently explained by identifying them as Circassian, an ethnic group of fair-skinned Turks who had long had a reputation as slave traders of their own people.[53]

Black female figures often appear in Orientalist paintings, but are not marked as the overt object of desire; usually the pairing of a light- and dark-skinned woman prioritizes a reading in which the white woman is the object of desire (like Jean-Jules-Antoine Lecomte du Nouy's *The White Slave Girl*, 1888).[54] While the pale Circassians and Georgians could

easily be registered as objects of desire, they could also be seen as objects of pity. Imagined as unwilling victims of Oriental despotism (as typified by the pale nude female slave in Gérôme's *Slave Market*, Plate 21) they could be conceptualized as potentially asexual and, therefore, more moral than Black women who were stereotyped as actively sexual and, consequently, immoral. The pale harem women oscillate between being like and not like European women, i.e. as both the permitted and the forbidden object. Part of the frisson of the white odalisque comes from the projection of the white wife (the licit object) into what amounts to a brothel situation (an illicit site): she is pitied but desired as the fantasy combination of Europe's splitting of female sexuality. This is why the desire to save as well as to savor the harem woman is so significant—it allows the West to view her within a lofty Christian and abolitionist rationale, saves her from taints of the harem, but does not prohibit voyeuristic pleasure in her image.

In contrast to the *Athenaeum's* addition of Blackness to *Rhodian Girl*, the Black figure in *A Visit* is ignored by all but Merson, and he only notices her to comment that a "negress" accompanies the guests. None of the other reviewers pass comment on this figure, but Gautier makes much of the others' fair-skinned beauty, implicitly excluding her from this paean to Oriental beauty. I think *A Visit* deploys racial difference in a manner that is relatively unsexualized for Orientalist painting. The painting marks the Black figure as a servant or slave (the only one carrying a cushion) but does not emphasize her body or make a stereotypical contrast between the figures at all. For all that the represented bodies in the *Interiors* are mostly fair-skinned and elegant, they are clearly not European. Their foreignness is marked by their posture and dress. The critics' frequent references to "indolence," "leaning," and "nonchalance" point out precisely those bodily performances that were frowned upon in Europe and, indeed, impossible for the corseted European female. There, bodily behavior and appearance were perceived to be moral, not just aesthetic, issues. So when Gautier suggests that Eastern dress will bring crinolines into disrepute, we must take it with a pinch of salt. The beauty in the unstructured bodies on display in the *Interiors* is precisely their difference from the women at home. They are similar enough to be desirable and different enough to be exciting.[55]

Like the *Interiors*, Browne's painting *Dancers in Nubia, Assouan* tackles the sexualized image of the Orientalized other straight on. Dancing "girls" were an early and regular feature of the (initially male) tourist itinerary and popular with painters since the subject afforded an opportunity to paint Oriental beauties in poses of abandon and sensual movement. (See for example Gérôme's *Dance of the Almah*, 1863.) Although some visual and written accounts gave them a status within the culture of their own community, dancers increasingly came to be fetishized into an isolated female sign of the Orient's erotic and passionate potential—a good example of the erotic potential of ethnographic detail. Like Gérôme, Browne's painting uses details of costume and musical instruments to authenticate the scene. So how does she negotiate the eroticism associated with the subject without compromising herself? She must have done so with some success, since no less a moralist than Bourniol praises Browne for her chaste treatment of the theme:

> *La Danse des Aimés* though animated, has the merit to be perfectly chaste; the svelte and elegantly formed dancers seemed to me a little too Moorish, that is to say, of a type more savage and primitive [original], than gracious.[56]

The actual title under which the painting was exhibited at the Salon was *Danseuses en Nubie, Assouan*. Just as different ethnicities were extrapolated from the portrait of *Rhodian Girl*, Bourniol redefines Browne's unspecified dancers as Almah. Like "Nubia," "Almah" as a category had a significance beyond its geographical and historical specificity—in this case as a signifier of the sexual display and exchange of women. The Almah were Egyptian dancers noted for their skill in improvised dancing and chanting. By the mid-century the term had come to refer to any female dancer and generally, in the West, carried sexual overtones.[57] In the East, the Almah, in common with other dancers, were often linked with prostitution: in 1834 their practice was restricted to three cities, Qena, Esna, and Assouan.[58] Bourniol uses Assouan as a clue to reinterpret the figures as Almah, thus foregrounding the sexual connotations of the scene, despite the lack of their overt presence in the painting itself. Unlike other representations of dancers, and specifically the Almah, Browne's plays down the image of frenzy and abandon associated with the theme. Like Bourniol, Gautier's account of Moorish dancing emphasizes the dancers' culturally different bodies moving in "perpetual undulations."[59] The sexual availability of the Oriental dancer is encoded in their distinctly non-European (uncorseted) bodies. In Browne's painting this is emphasized by posture, dress, and ornament. But, while her attention to movement and pose emphasizes the unstructured body underneath the clothes, she manages, by breaking generic codes, to minimize the sexualization of the subject.

The painting's geographically precise title, coupled with its circulation as a female-produced artefact, help it to avoid some of the sexual innuendo frequently associated with the subject. Of course, the scientific claims of ethnography often helped rather than prevented the Western objectification and fossilization of Eastern cultures, so I am not suggesting that an ethnographic mode rescues Browne from complicity in imperial power dynamics. But, while the setting clearly signifies Orientalness, the reworking of stereotypical referents for the Oriental dancer invite the viewer to key into the less salacious version of ethnography. Browne's dancers dress and dance as the informed viewer would expect—but she avoids the nudity and overt sexuality that often accompany images of such performances. Many of her viewers would have been familiar with the illustrations from *Lane's Modern Egyptians*, which pictures similarly posed and clothed women in the article on Egyptian dancing girls (*Ghawàzee*, not Almeh). But Browne's figures do not wear revealing *décolleté*.

It is likely that the seated women in Browne's painting are part of the troupe, not the audience, since Muslim women would not be present (especially unveiled) at a mixed performance with male musicians.[60] This means that the audience is placed in the viewer's position, a non-gender-specific viewing position that is an important departure from Browne's treatment of a stereotypically sexualized subject in the harem paintings. Where the *Interiors* present a sight forbidden to men, prioritize a female gaze, and thus contest male fantasies, the construction of *Dancers in Nubia, Assouan* implies a traditional viewing position. *Dancers in Nubia, Assouan* proffers a viewing position open to all (except perhaps Muslim women) and contests male representations of sights that were available to them.[61]

Although critics made much of Browne's privileged, and hence truthful, gaze on the harem, *Dancers in Nubia, Assouan* received little attention. It did not show in Britain and the British press did not pick it out in their Salon reviews. Perhaps it did not have to be taken as seriously and contested as much as the *Interiors* because men could "verify" their rendition of the subject as well as she, once gender had no privilege. Elie Roy, writing in

L'Artiste in 1869, can insinuate that the dancers are fake, the result of dressing up, with far more plausibility than Lagrange's attempt with the milliners' "berquinades" in the case of the *Interiors*: "We find, today without much surprise, but with the greatest of regret, Mme Henriette Browne in the Orientalist camp. Her *Dancers in Nubia* are of a manifest inadequacy of drawing and suggest fancy dress [*déguisement*]."[62]

Browne's pictures of children, the most "feminine" of her Orientalist paintings, get the least comment. Precisely because they are so easily classified as womanly and there was such a bouyant market for pleasing pictures of children, Browne's pictures of Oriental children rarely received more than a passing nod of affirmation. Where individual figures like *Rhodian Girl* could be incorporated into the critical appreciation of her existing portrait practice, the scenes of schools and children could be mapped neatly onto an extended version of women's traditional concerns with education and social welfare. One might suppose that, like the harem scenes, the pictures of children would be seen to clearly project a gendered point of production. However, pictures of Oriental children were a standard part of mainstream Orientalist art and it is hard to distinguish Browne's pictures from those of Decamps, whose numerous vignettes of Oriental children playing at home, school, and in the streets, are not markedly different. No one makes much of the similarity, which is surprising, considering the outrage over her break with Decamps' depiction of the harem. In fact, no one has much to say about Browne's children at all—her reputation as a genre artist was secure by this period so most commentators simply hail the new paintings as more of the same.

Browne's scenes of children include three school scenes: *Egyptian Boys Chanting from the Qur'an* (dated 1869, shown at Gambart's 1870); the Witt Library reproduction entitled *A Turkish Scene* (1864, fig. 5.2); and *Jewish School at Tangiers*[63] (Salon 1865/7). Individual portraits of children intersect with her other ethnographic portrait types, such as *La perruche* (Salon 1875), *The Scribe* (possibly *Un bibliophile*, Salon 1876) and *A Poet: Copts in Upper Egypt* (Salon 1874). These paintings are evidently not diagrammatic illustrations of racial types, but the lack of details about the sitter's identity reinforces the anonymity of the figures and emphasizes the paintings' ethnographic rationale.

The scenes of children in the Orient mirror Browne's pictures of children in Europe. Followers of her career would have been accustomed to expect such paintings from her easel, from the *Catechism* of 1857 to the cutesy *The Children's Room* ten years later. The three Oriental school scenes combine the sentiment of child painting and the excitement of Orientalism. They are ethnographically respectable, with their clear demarcation of religion and region, and bear the markers of the Orient in the prominent display of the children's pointed Turkish slippers, robes, and headdress. But they also tap into the market for the accurate and emotional representation of children—regardless of specific locale. These examples, together with Browne's pictures of European children, provide cameos of "children around the world" that are facilitated rather than impeded by national barriers. On one hand, the universality of children's experience is emphasized (whether Muslim, Jewish, or Christian, they attend religious instruction with varying degrees of diligence), and on the other, the differences believed to exist between the Occident and Orient are endorsed through physiognomy, dress, and posture. The Oriental location and suggestion of poverty are essential to demarcate these children from the rich misses and masters of domestic genre, but it does not rule them out of its range so much as link them to scenes of the

European other, the poor at home and the Orientalized peasantry of Southern Europe. The distinctly classed and nationally coded body of the child in representation can be seen in Sophie Anderson's work, where her rendition of the restrained, winsome, bourgeois girl child in *No Walk Today* (n.d.) registers class and nationality quite differently from the picturesque poverty and happy dishevelment of the Southern European urchin girls of *Guess Again* (RA 1878).

In her paintings Browne makes a clear distinction between Oriental children and Oriental adults. Although certain similarities are suggested between children of different ethnicities, the differences between children and adults are maintained. Given that Orientals and non-Europeans (not to mention European women and the working classes) were often infantilized, this insistence on the adulthood of Oriental grown-ups is important. Her paintings of children bear all the markers of cuteness and sentiment—the overemphasized open mouths of the boys in *Chanting from the Qur'an*, the fretful boredom of students in *The Catechism* and *Jewish School at Tangiers*—which allow the affinities between children to be registered as a property of childhood, while the insistence on generational difference refuses the paternalistic diminution of all Orientals to the status of dependent children. This leaves the adults free to signify the validity and vitality of Oriental culture. The choice of scholars and poets over other popular Oriental subjects like shopkeepers, soldiers, and peasants indicates a willingness to represent the Orient as a place peopled by independent and cultured adults. As we saw with the ethnographic portraiture, the pseudoethnographic verisimilitude of Browne's technique is combined with a gendered reading of the pictures to presuppose an intuitive affinity with the subject of the painting. In an Orientalist context this suggests that the artist, and by implication the viewer, is engaged in a different mode of viewing. For example, Browne's pictures of scribes (*Scribe*, c. 1865, and *A Poet: Copts in Upper Egypt*, 1874) differ from the usual Orientalist stereotype. They are seen in the midst of their trade surrounded by books and papers, sitting upright on chairs, not cross-legged on the floor. Their position and posture flout conventions of representation and suggest dignity and self-possession. In each case the figures are on the viewer's eye level and in *The Scribe* the subject holds us in a clear and forthright gaze. Compare this to the positioning of the figures in Lewis' *The Arab Scribe*, where the brightly dressed scribe and his customers are set below our eye level and become, along with the ornate tiles, part of a richly exotic scene laid out for our perusal.

The Problematic Authority of the Female Orientalist Gaze

As we have seen, critics generally assumed that Browne's gaze on the Orient was different because of her gender. I have assessed how a female gaze on the Orient can destabilize the paradigmatic viewing, and hence power, positions of Orientalist discourse. But we have also seen how the disruptive potential of the gendered gaze has been minimized by appropriation and opposition. Critics who sing the praises of Browne's specific view also confirm that it is not the neutrally authoritative worldview of male artists. The particularity of her gaze, that on the one hand marks its value, is also the grounds of its dismissal as biased and insufficiently detached. John Barrell has traced the pre-eminence of detachment as a mark of authority to the eighteenth-century interest in the classical Republics and the concept of

Public Virtue wherein to qualify for the Republic of Citizens, and hence the Republic of Taste, men must have the ability to be self-governing and to govern others.[64] It was the Public, or Liberal, Man's independence (financially, and so politically and personally) that allowed the detachment needed to make decisions for the greater good without personal motivation. Although by the nineteenth century the concept of the Republic of Taste had been modified to include the newly rich accultured middle classes (previously excluded because of the coarsening effects of mercantile endeavor), the idea of disinterested objectivity lived on in art, politics, and science. The classical exclusion of women, slaves, and subject peoples as unworthy, whether by nature or nurture, from the category of citizenship was incorporated into Enlightenment thinking and lived on in mid-nineteenth-century ideas of femininity and race.

In relation to nineteenth-century Orientalism, woman's gendered inability to accede to the position of the detached scientific observer (the nineteenth-century corollary of the Public Man) compromised her superiority as a Westerner over the Orient. Women Orientalists tended to be positioned as unmediated witnesses, not as scientifically neutral observers. Note how Edward William Lane encouraged Sophia Poole to publish an account of her women-only sights in Egypt as an experiential appendix to his scholarly research.[65] Likewise, Browne, who is praised for her testament about the Orient, is not constructed as the bearer of an independent scientific look but as the transmitter of an experiential and empathetic gaze. There is no suggestion, from even her strongest supporters, that she is learned about the East—only that she is experienced. Experience can be interpreted as good or bad: for Gautier it is an unsurpassable bonus; for Vignon it dilutes her talent.

Any authority accruing to the female gaze is grounded in its presumed (gendered) experience. Although the Romantic cult of the sublime emphasized experience, it was not a mode of engagement that correlated to the axis of female experience. The Romantic immersion in what they took to be the authentic experience of strange lands, ideally led to the loss of their contemporary Western identity in favor of a passionate overidentification with the exotic other. (Like Delacroix's paintings, Gautier's extrapolations of half-remembered previous lives are clear examples of the pathways to fantasy that the Orient offered the Romantics.) For women, the loss of identity involved in a passionate experience of the sublime threatened the boundaries of the proper femininity essential for their reputation. Only women who chose, or could afford, to risk notoriety and social ostracism could tread that path. In a period when an active female sexuality was widely conceptualized as dangerous and aberrant, female artists could only be marginally involved with the ethos and antics of Romantic life.[66] Whereas men could use passion to create art, women, if they were allowed any passion at all, were meant to subsume it into motherhood.

Browne's gendered gaze on the Orient can adopt neither the authority of disinterested science nor the overinvolvement of the sublime. Instead, a position emerges in which is constructed for women a knowledge that is both particular and diminutive. It is a knowledge that has some authority because it is experiential (but that is trivialized because it rests on womanly empathy rather than the clinical detachment of the authoritative scientific gaze) and that is emotional (but petty because its emotions are merely those of feminine sympathy and intuition rather than the grand passion of the Romantics).[67] The very grounds that secure the efficacy of the female gaze also threaten to dismember it: it is caught between the inability to be disinterested and the pitfalls of overidentification. The same

dynamic constrains the construction of the paintings' viewing positions. The female gaze of Browne's paintings needs to produce a viewing position that threatens neither (by an excess of feminine and insufficiently separated identification) the West's superiority over and separation from the Orient nor (by too passionate a response) the female spectator's femininity. While overidentification for men can be rejuvenating, for women, as Vignon points out, it is enervating and not to be recommended. Thus, women, at best, can be endowed with a gaze of partial authority (based on empiricism and sympathy) which leaves unchallenged both the detachment of science and the grand emotions of Romanticism and thus the authority of the male gaze. This is not to deny that Browne's work issued a challenge to the male Orientalist gaze for, as we have seen, such a challenge was keenly felt, but to highlight how this damage was minimized by attributing to her a knowledge that was specific but subordinate.

Emily Apter argues that there is a counter-knowledge within the harem genre itself.[68] She maintains that the sapphic themes of the harem genre are so pronounced as to constitute a veritable "haremization" effect, in which the alleged or assumed sexual relations between harem women construct a challenge to the patriarchal power around which the harem is understood to be organized. Working from the position that the harem functions as thinly disguised version of the Occidental brothel, Apter argues that in order to understand why writers and artists took the trouble to relocate such images in the East, we must assess the harem as a "cultural supplement" that offers something extra, something not available in an Occidental setting. Seen in this light, the latent lesbian libidinal ordering of the harem, far from being an impediment to the paradigmatic male Western viewer's pleasure, actually facilitates his voyeuristic entry. It constitutes a challenge to the phallic interdictory power of the harem that threatens to keep him out. It allows a scopophilic fulfilment of supplementary desires that are suppressed in the Western context: replacing castration anxiety with the multiple identifications of a "more troubling vision of bisexually coded biculturalism" (based on the pleasures of the cultural and gender cross-dressing of the colonial *mise-en-scène*).

The harem and its lesbian subtext thus mirror the ambivalence of colonial discourse itself—simultaneously shoring up and challenging a vision of absolute phallic power. Apter's inference that one of the pleasures of the harem genre is its fantastic promise of disobeying the phallic order shares some ground with Wendy Leeks' argument about Ingres' bathers and harem scenes. Leeks suggests that these paintings constitute a denial of the woman's lack (associated with the onset of the recognition of sexual difference), thus offering the viewer a loss of identity and a return to the *jouissance* of the pre-Oedipal access to the mother's body (before the advent of the third term). Read in this way, Apter's haremization effect would permit an incestuous desire without the threat of castration produced by the recognition of sexual difference. I am somewhat swayed by both these approaches, since they seem to offer between them a possible explanation for the dialectic between phallic power and lesbian codings that suffuses the genre. However, I have some problems with Apter's account which has a problematic relationship to the "real" harem. Like me, she reads women's accounts of the harem for traces of an alternative discourse and notes that they persistently challenge the Orientalist fantasy account, but she sets up women's accounts as evidence, as if they too were not the products of the self-same discourse whose workings she has been analyzing. Similarly, while I am tempted by the possibilities of a

feminist recouping of the harem as an "antiphallic, gynocentric fantasy about the thwarting of colonial mastery," I have to argue that any attempt that tries to reclaim the harem as a site of radical opposition to phallic power *per se* is doomed if it does not recognize that the phallic power that is being challenged by either the harem women's sapphic "*mektoub*"[69] or the Western interloper is an Oriental patriarchy that has already been constituted as impotent. The phallic order that controls the harem is an order that in Orientalist discourse is already understood to be, and continually reproduced as, emasculated and de-legitimate or, at best, barbarically potent (a temporarily pleasurable identification for the Western male viewer that has no evolutionary future). If, as Apter emphasizes, Lacan relies on Orientalism for his metaphor that "the phallus can only play its role as veiled," then the antiphallic challenge offered by the haremization effect is also one step removed—a challenge to an already subaltern phallic order.[70]

It is here that the iconographic links between, and possible visual pleasures of, Browne's images of convents and harems become clearer. Both figure as sequestered communities of women organized around the symbolic or actual power of a male figure, cut off from the male gaze yet understood to be activated by it. As Melman also notes (and this is particularly telling in her sample of writings by evangelical women missionaries), we find within the representation of the convent themes which mirror those fundamental to the cult of the harem: repression, exclusion, despotism, punishment, sadism, exoticism, lesbianism, sexual deviancy, archaism, and rescue.[71]

Just as the women in the harem rely on the bravery of a (Western) man to free them from their prison, so too do the novices in the convent either gaze helplessly out of the window or wait for men to rescue them. Both sets of women are established as passive victims of unjust regimes, rather than as active self-directing subjects formed by the praxis of both power and resistance. The repression of this play of power/s is the unconscious project of many representations of the harem and the convent. The ease with which such meanings were read into Browne's convent scenes, despite her reputation for faithful detail, pre-empted the conflictual dynamic that would greet her harem scenes. The harem paintings were understood as realistic because Henriette Browne, a woman and an artist with a reputation for factual reportage, had really been there, but they were nonetheless interpreted through a grid of Orientalist knowledges about the East and the harem that often overrode the manifest content of the images. Despite her challenge to the stereotypical Orientalist fantasy, Browne's paintings obviously offered a range of alternative visual pleasures. Although she presents images of the Orient couched in realist terms, we can see how, through a variety of responses, critics are able to incorporate (Gautier), provide an alternative "truth" to (Lagrange), or simply ignore (de Callias), her challenge to the Orientalist fantasy, emphasizing the crucial flexibility of discursive definitions of the Orient.

Earlier in this chapter I suggested that we regard Browne's harems as an analogous extension of the European drawing room that offered a safe point of limited identification for female spectators. The question now arises as to whether she really did experience them as such or unconsciously projected onto them the familiar structure of the European domestic. It is a question we cannot answer and one that may not matter—we do not know what Browne observed, only what she painted, and although her representations are backed up by a number of other women's accounts, it is just as possible that they were subject to the same unconscious determinants as she. What we can deduce is that the limited viewing

and painting positions available to women artists contributed in various ways to their particular framing of the Orient. This results in a series of representations of a realm generally conceptualized as innately other that, for all the exceptions like Jerichau-Baumann, display overall a remarkable structural similarity to the familiar European domestic—a similarity that tends to be affirmatively registered, rather than treated as a sexualized contrast as is the case with mainstream and men's Orientalism.[72]

I have found little in women's visual Orientalism that adopts the vigorously critical stance on harem life outlined by Zonana. So, although further investigation may reveal such works, it seems likely that women artists who wished to criticize the gender status quo in Europe involved themselves more directly in the representation of Occidental gender relations.[73] While Browne's (apparent) lack of involvement in proto-feminist politics and cultural formations may explain why her work intervenes in Orientalist conventions without mounting an overt critique of European gender inequalities (though I do think that the presence of an implicit challenge is felt by her critical audience), I am more inclined to regard this difference as a sign of the heterogeneity of women's involvement in Orientalism. That is, that we cannot narrow down to a single strategy the ways in which Western women cultural agents represented the Orient. As Mills points out, the alternative power/knowledge relationship that prompted women Orientalists to represent the Orientalized other as individuals rather than types (what Melman calls the "particularizing" of the harem) is the result of an experience of the Orient that was itself always structured by discourses that positioned women as emotional, empathetic, and personal rather than objective, scientific, and political.[74] Where Mills allows for the always-mediated nature of representation and reading, Melman retains the possibility of an innocent transcription of experience, even if viewing is acknowledged to be culturally determined (women simply "described what they had seen. And seeing is a pre-programmed activity"[75]), that does not allow for the polysemy of the text. It is not just that Orientalism was a heterogeneous, polyglot discourse, but that each individual image was in itself polysemic and contradictory. Thus, the loss of traditional distances between self and other offered by a counter-hegemonic women's Orientalism (empathizing, particularizing, domesticating, familiarizing as it may be) is not an absence of distance but a differently inscribed distance. Although it is likely that the women's accounts I have covered bear a closer resemblance to the experience of harem life than the highly eroticized fantasies of Gérôme, they are nonetheless subject to the fantasy mechanisms associated with Orientalism. We can therefore regard women Orientalists as neither more pure (truthful and non-imperialist) than men, nor as more susceptible to fantasy (the dangerously gullible female tourist), but as agents whose mixture of observation and fantasy about the East is specifically gendered because of the social and psychological restraints on their experience and representation of the Orient.

Notes

1. Billie Melman, *Women's Orients. English Women and the Middle East, Sexuality, Religion and Work 1718–1918*, Basingstoke, Macmillan, 1992, p. 101.

2. Also important here is Zonana's work on "feminist Orientalism." Joyce Zonana, "The Sultan and the Slave: Feminist Orientalism and the Structure of *Jane Eyre*," in *Signs*, vol. 18, no. 3, Spring 1993.

3. The original subtitles of Browne's paintings refer to *intérieur de harem*, which clearly indicates the generic rather than particular (*intérieur d'un harem*) status of the referent.

4. See also Lisa Tickner, "Feminism, Art History and Sexual Difference," in *Genders*, no. 3, Fall 1988.

5. See David Scott, "The Literary Orient," in James Thompson (ed.), *The East Imagined, Experienced, Remembered: Orientalist Nineteenth-Century Painting*, National Gallery of Ireland and National Museums and Galleries of Merseyside, 1988.

6. Thus, women missionaries worked with Oriental women and children, aiming to civilize Oriental men via the feminine sphere, in an Orientalized reproduction of women's moral mission at home. Melman, *Women's Orients*, p. 42.

7. See Chapter 3, "Gender, Genre and Nation: Henriette Browne, the Making of a Woman Orientalist Artist," in *Gendering Orientalism: Race, Femininity and Representation*.

8. The *Art Journal*, May 1862, p. 126.

9. The *Athenaeum*, April 1862, p. 514.

10. The English titles given to these paintings varied slightly but included most, or different versions, of the geographical detail. For example, *Les oranges; Haute Égypte* was shown at Gambart's under the title *Children with Oranges; Nubia*.

11. Guilloche refers to ornamentation that imitates braided ribbons.

12. The Koran requires women to cover their breasts and ornaments, but not faces. The veil was not a religious Islamic ruling, but a social institution based on secular and religious ideas of modesty which impacted most on affluent and urban women. Rural women were far less likely to observe it, since the economic imperative which required their agricultural labor made more than a cursory attempt at observance impossible. See Ian C. Dengler, "Turkish Women in the Ottoman Empire: The Classical Age," in Lois Beck and Nikki Keddie (eds.), *Women in the Muslim World*, Cambridge, MA, Harvard University Press, 1978; Emily Said-Ruete, *Memoirs of an Arabian Princess: Princess Salme bint Said ibn Sultan al-Bu Saidi of Oman and Zanzibar* (1888), London, East-West Publications, 1981, p. 149; Lynn Thornton, *Women as Portrayed in Orientalist Painting*, Paris, Edition ACR, 1985, p. 54.

13. Théophile Gautier, *Abécédaire du salon de 1861*, Paris, Libraire de la Société des Gens de lettres, 1861, pp. 72–7.

14. Gautier, *Abécédaire*, p. 75.

15. Gautier, *Abécédaire*, p. 76.

16. See, for example, the treatment of Eliza Fox Bridell's Algerian scenes as topography when other location shots like Robert's are dealt with as mainstream Orientalism, or Gautier on the Princess Mathilde's *Une Fellah* which is read as a picturesque portrait. Gautier, *Abécédaire*.

17. This phrase about the cigarette also occurs in Gautier's *Constantinople of Today*. It is apparent in this, and other, reviews of Orientalist work that Gautier frequently drew on his Turkish experience to read Orientalist paintings. Some phrases are repeated almost verbatim.

18. See Robert Snell, *Théophile Gautier: A Romantic Critic of the Visual Arts*, Oxford, The Clarendon Press, 1982, pp. 61–4.

19. Claude Vignon, "Une visite au salon de 1861," in *Le Correspondent*, vol. 18, 25 May 1861, pp. 137–60.

20. See note 7.

21. Hector de Callias, "Salon de 1861," in *L'Artiste*, vol. 11, no. 11, 1 June 1861, pp. 241–8.

22. Olivier Merson, *Exposition de 1861: la peinture en France*, Paris, Libraire de la Société des Gens de lettres, 1861, pp. 275–6.

23. Princess Belgiojoso is sometimes referenced as a woman who wrote about travels in the East. The Italian-born princess lived part of her life in Paris and was noted for her nationalism, her literary and political salon, and her frequent *belles-lettres* publications on subjects as diverse as Catholic dogma and travel. Pierre Larrouse, *Grand Dictionnaire universel de xixe siècle*, Paris, 1864–76, p. 491.

24. Léon Lagrange, "Salon de 1861," *Gazette des beaux-arts*, vol. 11, 1 July 1861, pp. 49–73.

25. See Theresa Ann Gronberg, "Femmes de Brasserie," in *Art History*, vol. 7, no. 3, September 1984.

26. Lagrange, "Salon de 1861."

27. Rani Kabbani, *Europe's Myths of Orient*, London, Macmillan, 1986, p. 70.

28. Said-Ruete, *Memoirs*, p. 20.

29. Gautier, *Constantinople of Today* (1953), trans. Robert Howe Gould, London, David Bogne, 1854, pp. 106–7, 187, 203–7.

30. Harvey confirms that the walls of reception rooms were generally painted plain cream with "Turkish" sentences from the Koran as a border. Annie Jane Harvey, *Turkish Harems and Circassian Homes*, London, Hurst and Blackett, 1871, p. 56.

31. Charles Newton (personal communication).

32. T. Chasrel, "Henriette Browne," in *L'Art revue hebdomadaire, illustré*, vol. 2, 1877, pp. 97–103.

33. Chasrel, "Henriette Browne," pp. 97–103.

34. Ibid.

35. Laura Mulvey, "Visual Pleasure and Narrative Cinema," in *Screen*, vol. 16, no. 3, Autumn 1975.

36. Laura Mulvey, "On *Duel in the Sun*: Afterthoughts on Visual Pleasure and Narrative Cinema," in *Framework*, nos. 15–17, 1981.

37. Lorraine Gamman, "Watching the Detectives: The Enigma of the Female Gaze;" Jackie Stacey, "Desperately Seeking Difference," both in Lorraine Gamman and Margaret Marshment (eds.), *The Female Gaze: Women as Viewers of Popular Culture*, London, The Women's Press, 1988.

38. Teresa de Lauretis, "Aesthetic and Feminist Theory: Rethinking Women's Cinema," in Deidre Pribham (ed.), *Female Spectators: Looking at Film and Television*, London, Verso, 1989.

39. See Mary Ann Doane, *The Desire to Desire: The Woman's Film of the 1940s*, Bloomington, Indiana University Press, 1987.

40. See Mary Ann Doane and Janet Bergstrom (eds.), "The Spectatrix," Special Issue *Camera Obscura*, no. 21, 1989.

41. On the specificities of the Black female gaze and its implications for cultural studies see Jaqueline Bobo and Ellen Seiter, "Black Feminism and Media Criticism: *The Women of Brewster Place*," in *Screen*, vol. 32, no. 3, 1991; Jane Gaines, "White Privilege and Looking Relations: Race and Gender in Feminist Film Theory," in *Screen*, vol. 29, no. 4, 1988.

On the interrelationship between (socially determined) critical and spectatorial positionings see Deborah Cherry, *Painting Women: Victorian Women Artists*, London, Routledge, 1993, pp. 115–16.

42. The phrase is adopted from Rosalind Coward, who uses it in relation to sexual difference. Rosalind Coward "Rereading Freud: The Making of the Feminine," in *Spare Rib*, no. 70, 1978.

43. "The Works of Madame Jerichau," in the *Art Journal*, 1871, p. 165.

44. Melman claims that they edited out evidence of Muslim women's oppression in order to preserve the "domesticated" image of the harem as a forum in which to bemoan Western women's oppression. Melman, *Women's Orients*, pp. 308–9.

45. See Nochlin, "Women, Art and Power," in *Women, Art and Power and Other Essays*, London, Thames and Hudson, 1988, pp. 12–13.

46. Rosemary Betterton, "How Do Women Look? The Female Nude in the Work of Suzanne Valadon," in Betterton (ed.), *Looking On: Images of Femininity in the Visual Arts and Media*, London, Pandora, 1987.

47. Melman's emphasis on women Orientalists' tendency to construct intersubjective relationships with Oriental women, operating as "participant observers" rather than as distant onlookers, also runs into the problem of seeing their texts as the straightforward transcription of that experience. While I agree that women were often more inclined to position themselves as participants, this positioning is itself presented to us through a series of textual strategies that simultaneously emphasize the intersubjectivity of the represented encounter and strive to differentiate between the text's Occidental and Oriental subjects. Melman, *Women's Orients*, pp. 62–3.

48. The phrase is from Chasrel.

49. In the Salon catalogue the painting is entitled *Jeune fille de Rhodes* and was exhibited at Gambart's as *A Young Rhodian Girl*.

50. For a more detailed analyzis of these paintings see Reina Lewis, "Women Orientalists: Diversity, Ethnography, Interpretation," in *Women, A Cultural Review*, vol. 6, no. 1, 1995.

51. The *Athenaeum*, April 1868, p. 531.

52. See Sander Gilman, "Black Bodies, White Bodies; Towards an Iconography of Female Sexuality in Late Nineteenth-Century Art, Medicine and Literature," in *Critical Inquiry*, vol. 12, 1985–6.
Nubians were also widely identified in the nineteenth century with the slave trade, as both slaves and slavers.

53. See Thornton, *Women*, p. 183; Bernard Lewis, *Race and Slavery in the Middle East: An Historical Enquiry*, New York, OUP, 1990. See also Said on Lewis' "traditionally" Orientalist attitudes, in Edward W. Said, *Covering Islam: How the Media and the Experts Determine How We See the Rest of the World*, London, Routledge, 1981.

54. Lynne Thornton in her extensively researched volume *Women* reaches the same conclusion. The absence of such images even in her vast sample suggests that Black women were never placed as the acknowledged object of desire, or that if they were we must look to other media for such representations. One possibility in a non-High Art category of Orientalism would be the picture postcard which often verges on the pornographic in its depiction of Oriental women in provocative and semi-clothed poses, and also images of Black and Oriental women in European pornography. See Malek Alloulah, *The Colonial Harem*, Manchester, Manchester University Press, 1987.

55. Kabbani notes that like Munby and his Pre-Raphaelite peers who re-educated, re-moulded and married working-class British women, Lane repeated the process in the Orient, this time purchasing a female slave whom he educated and subsequently married. Kabbani, *Europe's Myths*, p. 79.

56. Bathild Bourniol, "L'Amateur au Salon 1869," In *Revue du monde catholique*, vol. 25, no. 28, 25 May 1869, pp. 516–45.

57. However, Edward Lane in the 1830s had been careful to distinguish between the respectable and educated Almah and other dancers, identified as *Ghawàzee*, who were prepared to perform unveiled in public.

58. See Metin And, *A History of Theatre and Popular Entertainment in Turkey*, Ankara, Forum Yayinlari, 1963–4.

59. Gautier quoted in Thornton, *Women*, p. 136.

60. Women did attend mixed performances in the country, where religious codes were more relaxed, but Assouan is a town.

61. It is possible that by the late 1860s the exiled dancers performed to mixed-gender audiences of Western tourists and that Browne's party attended such a display, or hired dancers for a private performance.

62. Elie Roy, "Salon de 1869," in *L'Artiste*, June 1869, p. 91.

63. Jews function as both a specific and generic Oriental population in Orientalist discourse. Jewish women in particular being so frequently used as unveiled female models that they often serve as an unidentified stand-in for the Oriental Islamic woman. See also Thompson, p. 70. Melman suggests that European women artists, unlike their male counterparts, were able to persuade Muslim women to pose for them. Melman, *Women's Orients*, p. 117.

64. John Barrell, *The Political Theory of Painting from Reynolds to Hazlitt: The Body of the Public*, New Haven, Yale University Press, 1986.

65. Sophia Poole, *The Englishwoman in Egypt, Letters from Cairo, written during a residence there in 1842, 3 and 4 with E. W. Lane Esq. Author of "The Modern Egyptians" by His Sister*, 2 vols. London. Charles Knight and Co., 1844.

66. In contrast, Romanticism in literature did provide a forum in which women writers could encode explorations of fantasy and sexuality. I am unable here to pursue this comparison.

67. See also Sara Mills, *Discourses of Difference: An Analyzis of Women's Travel Writing and Colonialism*, London, Routledge, 1991, p. 99.

68. Emily Apter, "Female Trouble in the Colonial Harem," in *Differences*, vol. 4, no. 1, 1992.

69. "*Mektoub*" is an Arabic term denoting a passive acceptance in the face of destiny. It is taken by Apter as a way to reconceptualize what the West characterizes as harem women's passive docility in response to the tyranny of the harem. She rereads "*mektoub*" as a "kind of fatal, voluptuous, sapphic masochism pegged to an originary self-generating feminine libido." Apter, 'Female Trouble," p. 219.

70. I also wonder if a haremization effect would be possible in a Western setting. One might fruitfully explore the significance of contemporaneous representations of lesbianism in Occidental locations. See also Thaïs-Morgan, "Male Lesbian Bodies: The Construction of Alternative Masculinities in Courbet, Baudelaire, and Swinburne," in *Genders*, no. 15, Winter 1992.

71. Melman also finds that similarities are registered in relation to the communal living arrangements of the convent and the harem, where inhabitants live, sleep, and eat *en masse*. In contrast the bourgeois home was an increasingly divided space. Melman, *Women's Orients*, pp. 158–9.

72. See Kabbani, *Europe's Myths*, on the Oriental interior as transplanted Occidental interior.

73. See, for example, Deborah Cherry on Rebecca Solomons in *Painting Women*.

74. See also Satya P. Mohanty, "The Epistemic Status of Cultural Identity: On *Beloved* and the Postcolonial Condition," in *Cultural Critique*, Spring 1993.

75. Melman, *Women's Orients*, p. 308.

6

The Hottentot and the Prostitute

Toward an Iconography of Female Sexuality

Sander Gilman

One of the classic works of nineteenth-century art records the ideas of both the sexualized woman and the black woman. Edouard Manet's *Olympia*, painted in 1862–63, first shown in the Salon of 1865, documents the merger of these two images (color plate 4). The conventional wisdom concerning Manet's painting states that the model, Victorine Meurend, is "obviously naked rather than conventionally nude,"[1] and that her pose is heavily indebted to such classical models as Titian's 1538 *Venus of Urbino*, Goya's 1800 *Naked Maja*, and Delacroix's 1847 *Odalisque*, as well as to other works by Manet's contemporaries, such as Gustave Courbet.[2] George Needham has shown quite convincingly that Manet was also using a convention of early erotic photography in having the central figure directly confront the observer.[3] The black female attendant, posed by a black model called Laura, has been seen as both a reflex of the classic black servant figure present in the visual arts of the eighteenth century and a representation of Baudelaire's "Vénus noire."[4] Let us juxtapose the *Olympia*, with all its aesthetic and artistic analogies and parallels, to a work by Manet which Georges Bataille, among others, has seen as a modern "genre scene," the *Nana* of 1877 (fig. 6.1).[5] Although Nana is unlike Olympia in being modern, a creature of present-day Paris (according to a contemporary),[6] she is like Olympia in having been perceived as a sexualized female and is so represented. Yet the move from a work with an evident aesthetic provenance, as understood by Manet's contemporaries, to one that was influenced by the former and yet was seen by its contemporaries as "modern" is attended by major shifts in the iconography of the sexualized woman, not the least of which is the seeming disappearance of the black female.

Black Sexuality and Its Iconography

The figure of the black servant is ubiquitous in European art of the eighteenth and nineteenth centuries. Richard Strauss knew this when he had Hugo von Hofmannsthal conclude their conscious evocation of the eighteenth century, *Der Rosenkavalier* (1911), with the mute return of the little black servant to reclaim Sophie's dropped handkerchief.[7] But

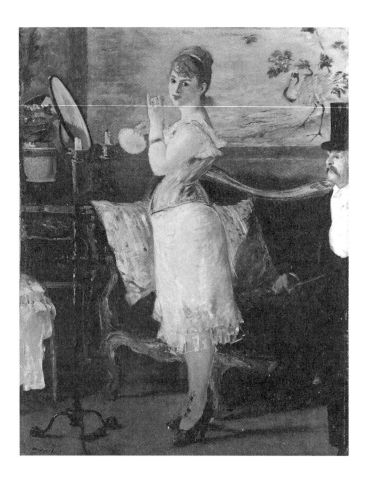

Figure 6.1 Edouard
Manet, *Nana*, 1877, oil
on canvas. © Copyright
Hamburger Kunsthalle
(photo Elke Walford,
Hamburg).

Hofmannsthal was also aware that one of the central functions of the black servant in the
visual arts of the eighteenth and nineteenth centuries was as a maker of the sexualization of
the society in which he or she was found. For the forgotten handkerchief marks the end of
the opera but also the end of the relationship between Octavian, the Knight of the Rose,
and the Marschallin, an illicit sexual relationship that had opened the opera, just as the
figure of the black servant closed it. When one turns to the narrative art of the eighteenth
century, for example to William Hogarth's two great cycles, *A Rake's Progress* (1733–34) and
A Harlot's Progress (1731), it is not surprising that, as in the Strauss opera some two centuries
later, the figures of the black servants mark the presence of illicit sexual activity. And, as in
Hofmannsthal's libretto, the servants and the central figure are of opposite sex. In the sec-
ond plate of *A Harlot's Progress*, we are shown Moll Hackabout as the mistress to a Jewish
merchant, the first stage of her decline. Present is a young black male servant. In the third
stage of Tom Rakewell's collapse, we find him in the notorious brothel, the Rose Tavern in
Covent Garden.[8] The entire picture is full of references to illicit sexual activity, all por-
trayed negatively. Present is a young black female servant.
 The association of the black with concupiscence reaches back into the Middle Ages.
The twelfth-century Jewish traveler Benjamin of Tudela wrote that "at Seba on the river
Pishon . . . is a people . . . who, like animals, eat of the herbs that grow on the banks of the

Nile and in the fields. They go about naked and have not the intelligence of ordinary men. They cohabit with their sisters and anyone they can find, . . . And these are the Black slaves, the sons of Ham."[9] The black, both male and female, becomes by the eighteenth century an icon for deviant sexuality in general, almost always, however, paired with a white figure of the opposite sex. By the nineteenth century, as in the *Olympia*, or more crudely in one of a series of Viennese erotic prints by Franz von Bayros entitled *The Servant*, the central white female figure is associated with a black female in such a way as to imply a similarity between the sexuality of the two. In a contrastive image, Dante Gabriel Rossetti's *The Beloved*, or *The Bride* (1865) associates the unselfconscious innocence of the half-dressed young black serving girl with the sensuality of the "beloved." The association of figures of the same sex stresses the special status of female sexuality. In *The Servant* the hypersexuality of the black child signals the hidden sexuality of the white woman, a sexuality quite manifest in the other plates in the series. The relationship between the sexuality of the black woman and that of the sexualized white woman enters a new dimension when the scientific discourse concerning the nature of black female sexuality is examined.

Buffon, the French naturalist, credited the black with a lascivious, apelike sexual appetite, introducing a commonplace of early travel literature into a pseudoscientific context.[10] He stated that this animal-like sexual appetite went so far as to encourage black women to copulate with apes. The black female thus comes to serve as an icon for black sexuality in general. Buffon's view was based on a confusion of two applications of the "great chain of being" to the nature of the black. In this view, the black's position on the scale of humanity was antithetical to the white's. Such a scale was employed to indicate the innate difference between the races. This polygenetic view was applied to all human characteristics, including sexuality and beauty. The antithesis of European sexual mores and beauty is the black, and the essential black, the lowest exemplum of mankind on the great chain of being, is the Hottentot. It is indeed in the physical appearance of the Hottentot that the central icon for sexual difference between the European and the black was found, a deep physiological difference urged so plausibly on the basis of physical contrast that it gave pause even to early monogenetic theoreticians such as Johann Friedrich Blumenbach.[11]

The labeling of the black female as more primitive, and therefore more sexually intensive, by writers such as Abbé Raynal (1775) would have been dismissed as unscientific by the radical empiricists of late eighteenth- and early nineteenth-century Europe.[12] They would not have accepted generalizations but would have demanded the examination of specific, detailed case studies to evolve a "scientific" paradigm. They required a case study that placed both the sexuality and the beauty of the black in a position antithetical to those of the white. The paradigm had to be rooted in some type of unique and observable physical difference. Such a criterion was found in the distinction drawn between the pathological and the healthy in the medical model. The absorption into that model of polygenetic difference between the races bears out William Bynum's observation that nineteenth-century biology constantly needed to deal with the polygenetic argument.[13]

The writer in whose work this alteration of the mode of discourse, though not the underlying ideology concerning the black female, took place was J. J. Virey. He was the author of the standard study of race published in the early nineteenth century, *Histoire naturelle du genre humain*. He also contributed a major essay (the only one on a specific racial group) to the widely cited *Dictionary of Medical Sciences* (1819).[14] In this essay Virey

summarized his and many of his contemporaries' views on the sexual nature of black females in terms of accepted medical discourse. Their "voluptuousness" is "developed to a degree of lascivity unknown in our climate, for their sexual organs are much more developed than those of whites." Virey elsewhere cites the Hottentot woman as the epitome of this sexual lasciviousness and stresses the consonance between her physiology and her physiognomy (her "hideous form" and her "horribly flattened nose"). His central proof is a discussion of the unique structure of the Hottentot female's sexual parts, the description of which he takes from the anatomical studies of his contemporary Georges Cuvier.[15]

The black female looks different. Her physiognomy, her skin color, the form of her genitalia mark her as inherently different. The nineteenth century perceived the black female as possessing not only a "primitive" sexual appetite, but also the external signs of this temperament, "primitive" genitalia. Eighteenth-century travelers to southern Africa, such as François Levaillant and John Barrow, had described the so-called "Hottentot apron," a hypertrophy of the labia and nymphae caused by manipulation of the genitalia and considered beautiful by the Hottentots and Bushman as well as tribes in Basutoland and Dahomey.[16] In 1815 Saartje Baartman, also called Sarah Bartmann, or Saat-Jee, a twenty-five-year-old Hottentot female who had been exhibited in Europe for over five years as the "Hottentot Venus," died in Paris (fig. 6.2). An autopsy that was performed on her was first written up by Henri Ducrotay de Blainville in 1816 and then, in its most famous version, by Georges Cuvier in 1817.[17] Reprinted at least twice during the next decade, Cuvier's description reflected de Blainville's two intentions: the likening of a female of the "lowest" human species with the highest ape, the orangutan, and the description of the anomalies of the Hottentot's "organ of generation."

Sarah Bartmann had been exhibited not to show her genitalia, but rather to present to the European audience a different anomaly, one that they (and pathologists such as de Blainville and Cuvier) found riveting: her steatopygia, or protruding buttocks, a physical characteristic of Hottentot females which had captured the eye of early travelers. For most Europeans who viewed her, Sarah Bartmann existed only as a collection of sexual parts. Her exhibition during 1810 in a London inflamed by the issue of abolition caused a public scandal, since she was exhibited "to the public in a manner offensive to decency. She . . . does exhibit all the shape and frame of her body as if naked."[18] The state's objection was as much to her lewdness as to her status as an indentured black. In France her presentation was similar. In 1829 a nude Hottentot woman, also called "the Hottentot Venus," was the prize attraction at a ball given by the Duchesse du Barry in Paris. A contemporary print emphasized her physical difference from the observers portrayed.

The audience that had paid to see Sarah Bartmann's buttocks and fantasized about her genitalia could, after her death and dissection, examine both, for Cuvier presented "the Academy the genital organs of this woman prepared in a way so as to allow one to see the nature of the labia."[19] And indeed Sarah Bartmann's sexual parts serve as the central image for the black female throughout the nineteenth century; and the model of de Blainville's and Cuvier's descriptions, which center on the detailed presentation of the sexual parts of the black, dominates medical description of the black during the nineteenth century. To an extent, this reflects the general nineteenth-century understanding of female sexuality as pathological. The female genitalia were of interest in examining the various pathologies that could befall them, but they were also of interest because they came to define the sum

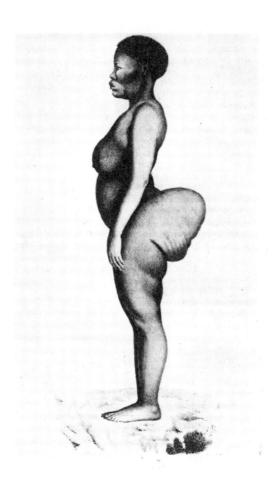

Figure 6.2 Saartje Baartman, the "Hottentot Venus" from Geoffrey Saint-Hilaire and Frédéric Cuvier, Historie naturelle des mammiferes avec des figures originalles, Paris, 1824.

of the female for the nineteenth century. When a specimen was to be preserved for an anatomical museum, more often than not the specimen was seen as a pathological summary of the entire individual. Thus, the skeleton of a giant or a dwarf represented "giantism" or "dwarfism," the head of a criminal, the act of execution which labeled him as "criminal."[20] Sarah Bartmann's genitalia and buttocks summarized her essence for the nineteenth-century observer, as indeed they continue to do for twentieth-century observers, since they are still on display at the Musée de l'Homme in Paris. Thus nineteenth-century autopsies of Hottentot and Bushman females focus on the sexual parts. The tone set by de Blainville in 1816 and Cuvier in 1817 was followed by A. W. Otto in 1824, Johannes Müller in 1834, W. H. Flower and James Murie in 1867, and Luschka, Koch, and Görtz in 1869.[21] Flower, the editor of the *Journal of Anatomy and Physiology*, included his and Murie's "Account of the Dissection of a Bush-woman" in the opening volume of that famed journal. His ideological intent was clear. He wished to provide data "relating to the unity or plurality of mankind." His description begins with a detailed presentation of the form and size of the buttocks and concludes with his portrayal of the "remarkable development of the labia minoria, or nymphae, which is so general a characteristic of the Hottentot and Bushman race." These were "sufficiently well marked to distinguish these parts at once

from those of any of the ordinary varieties of the human species." The polygenetic argument is the ideological basis for all the dissections of these women. If their sexual parts could be shown to be inherently different, this would be a sufficient sign that blacks were a separate (and, needless to say, lower) race, as different from the European as the proverbial orangutan. Similar arguments were made about the nature of all blacks' (not just Hottentots') genitalia, but almost always concerning the female. Edward Turnipseed of South Carolina argued in 1868 that the hymen in black women "is not at the entrance to the vagina, as in the white woman, but from one-and-a-half to two inches from its entrance in the interior." From this he concluded that "this may be one of the anatomical marks of the non-unity of the races."[22] His views were seconded in 1877 by C. H. Fort, who presented another six cases of this seeming anomaly.[23] When one turns to autopsies of black males from approximately the same period, what is striking is the absence of any discussion of the male genitalia. For example, in Sir William Turner's three dissections of male blacks in 1878, 1879, and 1896, no mention is made of the genitalia.[24] The genitalia and buttocks of the black female attracted much greater interest in part because they were seen as evidence of an anomalous sexuality not only in black women but in all women.

By mid-century the image of the genitalia of the Hottentot had acquired various important implications. The central view was that these anomalies were inherent, biological variations rather than adaptations. In Theodor Billroth's standard handbook of gynecology, the "Hottentot apron" is presented in detail in the discussion of errors in development of the female genitalia, an association that was commonplace by 1877. The author, H. Hildebrandt, links this malformation with the overdevelopment of the clitoris, which he sees as leading to those "excesses" which "are called 'lesbian love.'" The concupiscence of the black is thus associated with the sexuality of the lesbian.[25] More so, the deformation of the labia in the Hottentot is accounted a congenital error, and thus incorporated into the disease model. For the model of degeneracy presumes some acquired pathology in one generation which is the direct cause of the stigmata of degeneracy in the next. Surely the best example of this is the idea of congenital syphilis, widely accepted in the nineteenth century and vividly expressed in Ibsen's drama of biological decay, *Ghosts*. Thus the congenital error Hildebrandt sees in the "Hottentot apron" is presupposed to have some direct and explicable etiology, as well as a specific manifestation. While Hildebrandt is silent as to the etiology, his presentation clearly links the Hottentot's genitalia with the ill, the bestial, and the freak (medicine, biology, and pathology).

How is it that both the genitalia, a primary sexual characteristic, and the buttocks, a secondary sexual characteristic, function as the semantic signs of "primitive" sexual appetite and activity? A good point of departure for addressing this question is the fourth volume of Havelock Ellis' *Studies in the Psychology of Sex* (1905), which contains a detailed example of the great chain of being as applied to the perception of the sexualized Other.[26] Ellis believed that there is an absolute, totally objective scale of beauty which ranges from the European to the black. Thus men of the lower races, according to Ellis, admire European women more than their own, and women of lower races attempt to whiten themselves with face powder. Ellis lists the secondary sexual characteristics that comprise this ideal of beauty, rejecting "naked sexual organ[s]" as not "aesthetically beautiful" since it is "fundamentally necessary" that they "retain their primitive characteristics." Only people "in a low state of culture" perceive the "naked sexual organs as objects of attraction." The secondary

sexual characteristics that Ellis then lists as properly attracting admiration among cultured (i.e., not primitive) peoples, the vocabulary of aesthetically pleasing signs, begins with the buttocks. The nineteenth-century fascination with the buttocks as a displacement for the genitalia is thus reworked by Ellis into a higher regard for the beautiful. His discussion of the buttocks ranks the races by size of the female pelvis, a view that began with Willem Vrolik's 1826 claim that a wide pelvis is a sign of racial superiority and was echoed by R. Verneau's 1875 study of the form of the pelvis among the various races.[27] Verneau cited the narrow pelvis of Sarah Bartmann in arguing that the Hottentot's anatomical structure was primitive. While Ellis accepts this ranking, he sees the steatopygia as "a simulation of the large pelvis of the higher races," having a compensatory function like that of face powder. This view places the pelvis in an intermediary role, as both a secondary and a primary sexual sign. Darwin himself, who held similar views as to the objective nature of human beauty, saw the pelvis as a "primary rather than as a secondary character" and the buttocks of the Hottentot as a somewhat comic sign of the black female's primitive, grotesque nature.[28]

When the nineteenth century saw the black female, it saw her in terms of her buttocks, and saw represented by the buttocks all the anomalies of her genitalia. In a mid-century erotic caricature of the Hottentot Venus, she is observed through a telescope by a white male observer, who can see nothing but her buttocks.[29] Again, in an 1899 British pornographic novel set in a mythic antebellum southern United States, the male author indulges his flagellistic fantasy on the buttocks of a number of white women. When he describes the one black, a runaway slave, being whipped, the power of the image of the Hottentot's buttocks captures him: "She would have had a good figure, only that her bottom was out of all proportion. It was too big, but nevertheless it was fairly well shaped, with well-rounded cheeks meeting each other closely, her thighs were large, and she had a sturdy pair of legs, her skin was smooth and of a clear yellow tint."[30] The presence of exaggerated buttocks points to other, hidden sexual traits, both physical and temperamental, of the black female. This association is a powerful one. Indeed, Freud, in his *Three Essays on Sexuality* (1905), echoes the view that female genitalia are more primitive than those of the male.[31] Female sexuality is tied to the image of the buttocks, and the quintessential buttocks are those of the Hottentot.

The influence of this vocabulary on nineteenth-century perception of the sexualized woman can be seen in Edwin Long's 1882 painting, *The Babylonian Marriage Market*. This painting claimed a higher price than any other contemporary work of art sold in nineteenth-century London. It also has a special place in documenting the perception of the sexualized female in terms of the great chain of aesthetic beauty presented by Ellis. For Long's painting is based on a specific text from Herodotus, who described the marriage auction in Babylon in which maidens were sold in order of comeliness. In the painting they are arranged in order of their attractiveness according to Victorian aesthetics. Their physiognomies are clearly portrayed. Their features run from the most European and white (a fact emphasized by the light reflected from the mirror onto the figure at the far left) to the Negroid features (thick lips, broad nose, dark but not black skin) of the figure farthest to the observer's right. The latter figure possesses all of the physical qualities Virey attributes to the black. This is, however, the Victorian scale of acceptable sexualized women within marriage, portrayed from the most to the least attractive, according to contemporary British standards. The only black female present is the servant-slave shown on the auc-

tion block, positioned so as to present her buttocks to the viewer. While there are black males in the audience and thus among the bidders, the function of the only black female is to signify the sexual availability of the sexualized white women. Her position is her sign, and her presence in the painting is thus analogous to that of the black servant, Laura, in Manet's *Olympia*. In Hogarth, the black servants signify the perversities of human sexuality in a corrupt society; in Long's work of the late nineteenth century, on the other hand, the linkage between two female figures, one black and one white, represents the internalization of this perversity in one specific aspect of human society, the sexualized female.

The Iconography of Prostitution

The prostitute is the essential sexualized female in the perception of the nineteenth century. She is perceived as the embodiment of sexuality and of all that is associated with sexuality, disease as well as passion.[32] Within the large and detailed literature concerning prostitution written during the nineteenth century, most of which is devoted to documenting the need for legal controls and draws on the medical model as perceived by public health officials, there is a detailed analysis of the physiognomy and physiology of the prostitute. We can begin with the most widely read early nineteenth-century work on prostitution, the 1836 anthropological study of prostitution in Paris by A. J. B. Parent-Duchatelet.[33] Alain Corbin has shown how Parent-Duchatelet's use of the public health model reduces the prostitute to a source of pollution in much the same class as the sewers of Paris. Parent-Duchatelet believes himself to be providing objective description as he presents his readers with a statistical profile of the physical types of the prostitutes, the nature of their voices, the color of their hair and eyes, their physical anomalies, their characteristics in childbearing, and their sexually transmitted disease. His descriptions range from the detailed to the anecdotal. A discussion of the "embonpoint" of prostitutes begins the litany of their external signs. Prostitutes have a "peculiar plumpness" owing to "the great number of hot baths that the major part of these women take." Or perhaps to their lassitude, rising at ten or eleven in the morning, "leading an animal life." They are fat as prisoners are fat, from simple confinement. As an English commentator noted, "the grossest and stoutest of these women are to be found amongst the lowest and most disgusting classes of prostitutes."[34] These are the Hottentots on the scale of the sexualized female.

When Parent-Duchatelet turned to the sexual parts of the prostitutes, he provided two sets of information that merged to become part of the myth of the physical anthropology of the prostitute. The prostitute's sexual parts are in no way directly affected by their profession. He contradicts the "general opinion . . . that the genital parts in prostitutes must alter, and assume a particular disposition, as the inevitable consequence of their avocation" (42). He cites one case of a woman of fifty-one "who had prostituted herself thirty-six years, but in whom, notwithstanding, the genital parts might have been mistaken for those of a virgin just arrived at puberty" (43). Parent-Duchatelet thus rejected any Lamarckian adaptation, as well as any indication that the prostitute is physically marked as a prostitute. This follows from his view that prostitution is an illness of a society rather than that of an individual or group of individuals. But while he denies that prostitution per se alters the genitalia, he does observe that prostitutes are subject to specific pathologies of their geni-

talia. They are especially prone to tumors "of the great labia . . . which commence with a little pus and tumefy at each menstrual period" (49). He identifies the central pathology of the prostitute in the following manner: "Nothing is more frequent in prostitutes than common abscesses in the thickness of the labia majora" (50). In effect, Parent-Duchatelet's view that there is no adaptation of the sexual organ is overridden by his assertion that the sexual organ is especially prone to labial tumors and abscesses: the resultant image is of the prostitute's genitalia developing, through disease, an altered appearance.

From Parent-Duchatelet's description of the physical appearance of the prostitute—-a catalogue that reappears in most nineteenth-century studies of prostitutes, such as Josef Schrank's study of the prostitutes of Vienna—it is but a small step to the use of such catalogues of stigmata to identify those women who have, as Freud states, "an aptitude for prostitution."[35] The major work of nineteenth-century physical anthropology, public health, and pathology to undertake this was written by Pauline Tarnowsky. Tarnowsky, one of a number of St. Petersburg female physicians in the late nineteenth century, wrote in the tradition of her eponymous colleague V. M. Tarnowsky, who was the author of the standard study of Russian prostitution, a study that appeared in both Russian and German and assumed a central role in late nineteenth-century discussions of the nature of the prostitute.[36] She followed his more general study with a detailed investigation of the physiognomy of the prostitute.[37] Her categories remain those of Parent-Duchatelet. She describes the excessive weight of prostitutes and their hair and eye color, provides measurements of skull size and a catalogue of their family background (as with Parent-Duchatelet, most are the children of alcoholics), and discusses their fecundity (extremely low), as well as the signs of their degeneration. These signs are facial abnormalities: asymmetry of the face, misshapen noses, overdevelopment of the parietal region of the skull, and the so-called "Darwin's ear." All of these signs belong to the lower end of the scale of beauty, the end dominated by the Hottentot. All of the signs point to the "primitive" nature of the prostitute's physiognomy; stigmata such as Darwin's ear (the simplification of the convolutions of the ear shell and the absence of a lobe) are a sign of atavism.

In a later paper, Tarnowsky provided a scale of the appearance of the prostitute in an analysis of the "physiognomy of the Russian prostitute."[38] The upper end of the scale is the "Russian Helen." Here, classical aesthetics are introduced as the measure of the appearance of the sexualized female. A bit further on is one who is "very handsome in spite of her hard expression." Indeed, the first fifteen on her scale "might pass on the street for beauties." But hidden even within these seeming beauties are the stigmata of criminal degeneration: black, thick hair; a strong jaw; a hard, spent glance. Some show the "wild eyes and perturbed countenance along with facial asymmetry" of the insane. Only the scientific observer can see the hidden faults, and thus identify the true prostitute, for the prostitute uses superficial beauty as the bait for her clients. But when they age, their "strong jaws and cheekbones, and their masculine aspect . . . hidden by adipose tissue, emerge, salient angles stand out, and the face grows virile, uglier than a man's; wrinkles deepen into the likeness of scars, and the countenance, once attractive, exhibits the full degenerate type which early grace had concealed." Time changes the physiognomy of the prostitute, just as it does her genitalia, which become more and more diseased as she ages. For Pauline Tarnowsky, the appearance of the prostitute and her sexual identity are preestablished in her heredity. What is most striking is that as she ages, the prostitute begins to appear more and more mannish.

Billroth's *Handbook of Gynecological Diseases* links the Hottentot with the lesbian; here the link is between two other models of sexual deviancy, the prostitute and the lesbian. Both are seen as possessing physical signs that set them apart from the normal.

The paper in which Pauline Tarnowsky undertook her documentation of the appearance of the prostitute is repeated word for word in the major late nineteenth-century study of prostitution and female criminality, *La donna deliquente*, written by Cesare Lombroso together with his son-in-law, Guglielmo Ferrero, and published in 1893.[39] Lombroso accepts all of Tarnowsky's perceptions of the prostitute and articulates one further subtext of central importance, a subtext made apparent by the plates in his book. For two of the plates illustrate the Hottentot's "apron" and steatopygia. Lombroso accepts Parent-Duchatelet's image of the fat prostitute, and sees her as being similar to Hottentots and women living in asylums. The prostitute's labia are throwbacks to the Hottentot, if not the chimpanzee; the prostitute, in short, is an atavistic subclass of woman. Lombroso uses the power of the polygenetic argument applied to the image of the Hottentot to support his views. His text, in its offhand use of the analogy between the Hottentot and the prostitute, simply articulates in images a view that had been present throughout the late nineteenth century. For example, an essay of 1870 by Adrien Charpy, published in the most distinguished French journal of dermatology and syphilology, presented an analysis of the external form of the genitalia of eight hundred prostitutes examined at Lyons.[40] Charpy merged Parent-Duchatelet's two contradictory categories, seeing all of the alterations as either pathological or adaptive. His first category of anomalies is those of the labia, and he begins by commenting on the elongation of the labia majora in prostitutes, comparing this with the apron of the "disgusting" Hottentots. The image comes as naturally to Charpy as it does to Lombroso two decades later. The prostitute is an atavistic form of humanity whose nature can be observed in the form of her genitalia. What Tarnowsky and Lombroso add to this description is a set of other physical indications that can aid in identifying women, however seemingly beautiful, who possess this atavistic nature. And still other signs were quickly found. The French physician L. Julien in 1896 presented clinical material concerning the foot of the prostitute, which Lombroso in commenting on the paper immediately labeled as "prehensile."[41] (Years later, Havelock Ellis would solemnly declare a long second toe and short fifth toe a "beautiful" secondary sexual characteristic in women—-a conclusion consistent with Lombroso's.[42]) Lombroso's coauthor, Guglielmo Ferrero, described prostitution as the rule in primitive societies and placed the Bushman at the extreme end on the scale of primitive lasciviousness. Neither adultery nor virginity has any meaning in such societies, according to Ferrero, and the poverty of their mental universe can be seen in the fact that they have but one word for "girl, woman, or wife."[43] The primitive is the black, and the qualities of blackness, or at least of the black female, are those of the prostitute. The strong currency of this equation is grotesquely evident in a series of case studies on steatopygia in prostitutes by a student of Lombroso's, Abele De Blasio, in which the prostitute is quite literally perceived as the Hottentot (fig. 6.3).[44]

The late nineteenth-century perception of the prostitute merged with that of the black. Aside from the fact that prostitutes and blacks were both seen as outsiders, what does this amalgamation imply? It is a commonplace that the primitive was associated with unbridled sexuality. This hypersexuality was either condemned, as in Jefferson's discussions of the nature of the black in Virginia, or praised, as in the fictional supplement written by Diderot

Figure 6.3 Abele De Blasio, "Steatopygia in an Italian prostitute from Archivo di psichiatria 26" (1905).

to Bougainville's voyages.[45] Historians such as J. J. Bachofen postulated it as the sign of the "Swamp," the earliest stage of human history.[46] Blacks, if both Hegel and Schopenhauer are to be believed, remained at this most primitive stage, and their presence in the contemporary world served as an indicator of how far humanity had come in establishing control over the world and itself. The loss of control was marked by a regression into this dark past, a degeneracy into the primitive expression of emotions, in the form of either madness or unbridled sexuality. Such a loss of control was, of course, viewed as pathological and thus fell into the domain of the medical model.

Medicine, especially as articulated in the public health reforms of the mid and late nineteenth century, was centrally preoccupied with eliminating sexually transmitted disease through the institution of social controls. This was the intent of such writers as Parent-Duchatelet and Tarnowsky. The social controls they wished to institute were well known in the late eighteenth and early nineteenth centuries but in quite a different context. For the laws applying to the control of slaves (such as the 1685 French *code noir* and its American analogues) had placed great emphasis on the control of the slave as sexual object, in terms of permitted and forbidden sexual contacts as well as documentation as to the legal status of the offspring of slaves. The connection made in the late nineteenth century between this earlier model of control and the later model of sexual control advocated by the public health authorities came about through the association of two bits of medical mythology. First, the primary marker of the black is taken to be skin color; second, there is a long history of perceiving this

skin color as the result of some pathology. The favorite theory, which reappears with some frequency in the early nineteenth century, is that the skin color and physiognomy of the black are the result of congenital leprosy.[47] It is not very surprising therefore to read in the late nineteenth century (after social conventions surrounding the abolition of slavery in Great Britain and France, as well as the trauma of the American Civil War, forbade the public association of at least skin color with illness) that syphilis was not introduced into Europe by Columbus' sailors but rather was a form of leprosy that had long been present in Africa and spread into Europe in the Middle Ages.[48] The association of the black and syphilophobia is thus manifest. Black females do not merely represent the sexualized female, they also represent the female as the source of corruption and disease. It is the black female as the emblem of illness who haunts the background of Manet's *Olympia*.

Reading *Nana*

Manet's *Olympia* stands exactly midway between the glorification of the sexualized female and her condemnation. She is the antithesis of the fat prostitute. Indeed, she was perceived as "thin" by her contemporaries, much in the style of the actual prostitutes of the 1860s. But Laura, the black servant, is presented as plump—something that can best be seen in Manet's initial oil sketch of her done in 1862–63. In both the sketch and the final painting her face is emphasized, for it is the physiognomy of the black which points to her own sexuality and to that of the white female, who is presented to the viewer unclothed but with her genitalia demurely covered. The hidden genitalia and the face of the black female both point to the potential for corruption of the male viewer by the white female. This potential is even more evident in a work heavily influenced (according to art historians) by Manet's *Olympia*, his portrait *Nana*. In *Nana* the associations would have been quite clear to the contemporary viewer. First, the model for the painting was Henriette Hauser, called Citron, the mistress of the Prince of Orange. Second, Manet places in the background of the painting a Japanese crane, the French word for which (*grue*) was a slang term for prostitute. The central figure is thus labeled as a sexualized female. Unlike Olympia's classical pose, Nana is not naked but partially clothed, and is shown being admired by a well-dressed man-about-town (a *flaneur*). Manet draws further upon the vocabulary of signs associated by the late nineteenth century with the sexualized female. Fatness is one stigma of the prostitute, and Nana is fulsome rather than thin. This convention became part of the popular image of the sexualized female even while the idealized sexualized female was "thin." Constantin Guys presents an engraving of a fat, reclining prostitute in 1860, and Edgar Degas' *The Madam's Birthday* (1879) shows an entire brothel of fat prostitutes. At the same time, Napoleon III's mistress, Marguerite Bellanger, set a vogue for slenderness.[49] She was described as "below average in size, slight, thin, almost skinny." This is certainly not Nana. Manet places her in a position vis-à-vis the viewer (but not the male observer in the painting) which emphasizes the line of her buttocks, the steatopygia of the prostitute. Second, Nana is placed in such a way that the viewer (but again not the flaneur) can observe her ear. It is, to no one's surprise, Darwin's ear, a sign of the atavistic female. Thus we know where the black servant is hidden in *Nana*. She is hidden within Nana. For even her seeming beauty is but a sign of the black hidden within. All her external stigmata point to the pathology within the sexualized female.

Manet's *Nana* thus provides a further reading of his *Olympia*, a reading that underlines Manet's debt to the pathological model of sexuality present during the late nineteenth century. The black hidden within *Olympia* bursts forth in Pablo Picasso's 1901 version of the painting, in which Olympia is presented as a sexualized black, with broad hips and revealed genitalia, gazing at the nude flaneur bearing her a gift of fruit, much as Laura bears a gift of flowers in Manet's original. But the artist, unlike in the works of Manet, is himself present in the work as a sexualized observer of the sexualized female. Picasso owes part of his reading of *Olympia* to the image of the primitive female as sexual object, as found in the lower-class prostitutes painted by van Gogh and the Tahitian maidens à la Diderot painted by Gauguin. Picasso saw the sexualized female as the visual analogue of the black. Indeed, in his most radical break with the Impressionist tradition, *Les Demoiselles d'Avignon* (1907; see color plate 12), he linked the inmates of a brothel in Barcelona with the black by using the theme of African masks to characterize their appearance. The figure of the male holding a skull in the early version of the painting is the artist as victim. Picasso's parody points toward the importance of seeing Manet's *Nana* in the context of the prevalent medical discourse concerning the sexualized female in the late nineteenth century. For the portrait of Nana is embedded in a complex literary matrix with many signs linking the sexualized female to disease. The figure of Nana first appeared in Emile Zola's 1877 novel *L'assommoir*, in which she is presented as the offspring of the alcoholic couple who are the central figures of the novel.[50] Her heredity assures the reader that she will eventually become a sexualized female, a prostitute, and indeed that identity is inaugurated at the close of the novel when she runs off with an older man, the owner of a button factory. Manet was taken by the figure of Nana (as was the French reading public), and his portrait of her symbolically reflected her sexual encounters presented in the novel.

Zola then decided to build the next novel in his Rougon-Macquart cycle on the figure of Nana as a sexualized female. Thus in Zola's *Nana* the reader is presented with Zola's reading of Manet's portrait of Nana. Indeed, Zola uses the portrait of the flaneur observing the half-dressed Nana as the centerpiece for a scene in the theater in which Nana seduces the simple Count Muffet. Immediately before this scene, Zola presents Nana's first success in the theater (or, as the theater director calls it, his "brothel"). She appears in a revue, unable to sing or dance, and becomes the butt of laughter until in the second act of the review she appears unclothed on stage: "Nana was in the nude: naked with a quiet audacity, certain of the omnipotence of her flesh. She was wrapped in a simple piece of gauze: her rounded shoulders, her Amazon's breasts of which the pink tips stood up rigidly like lances, her broad buttocks which rolled in a voluptuous swaying motion, and her fair, fat hips: her whole body was in evidence, and could be seen under the light tissue with its foamy whiteness."[51] What Zola describes is the sexualized woman, the "primitive" hidden beneath the surface: "All of a sudden in the comely child the woman arose, disturbing, bringing the mad surge of her sex, inviting the unknown element of desire. Nana was still smiling: but it was the smile of a man-eater." Nana's atavistic sexuality, the sexuality of the Amazon, is destructive. The sign of this, her voluptuousness, reappears when she is observed by Muffet in her dressing room, in the scene that Zola found in Manet's painting: "Then calmly, to reach her dressing-table, she walked in her drawers through that group of gentlemen, who made way for her. She had large buttocks, her drawers ballooned, and with breast well forward she bowed to them, giving her delicate smile" (135). Nana's childlike face is but

a mask concealing a disease buried within, the corruption of sexuality. Thus Zola concludes the novel by revealing the horror beneath the mask. Nana dies of the pox. (This is a pun that works in French as well as in English, and that was needed because of the rapidity of decay demanded by the moral implication of Zola's portrait. It would not do to have Nana die slowly over thirty years of tertiary syphilis. Smallpox, with its play on the pox, works quickly and gives the same visual icon of decay.) Nana's death reveals her true nature:

> Nana remained alone, her face looking up in the light from the candle. It was a charnel-house scene, a mass of tissue-fluids and blood, a shovelful of putrid flesh thrown there on a custion. The pustules had invaded the entire face with the pocks touching each other; and, dissolving and subsiding with the greyish look of mud, there seemed to be already an earthy mouldiness on the shapeless muscosity, in which the features were no longer discernible. An eye, the left one, had completely subsided in a soft mass of purulence; the other, half-open, was sinking like a collapsing hole. The nose was still suppurating. A whole reddish crust was peeling off one cheek and invaded the mouth, distorting it into a loathsome grimace. And on that horrible and grotesque mask, the hair, that beautiful head of hair still preserving its blaze of sunlight, flowed down in a golden trickle. Venus was decomposing. It seems as though the virus she had absorbed from the gutters and from the tacitly permitted carrion of humanity, that baneful ferment with which she had poisoned a people, had now risen to her face and putrefied it. (464–65)

The decaying visage is the visible sign of the diseased genitalia through which the sexualized female corrupts an entire nation of warriors and leads them to the collapse at Sedan. The image is an old one; it is *Frau Welt*, Madam World, who masks her corruption, the disease of being a woman, with her beauty. It reappears in the vignette on the title page of the French translation (1840) of the Renaissance poem *Syphilis*.[52] But it is yet more, for Nana begins in death to revert to the blackness of the earth, to assume the horrible grotesque countenance perceived as belonging to the world of the black, the world of the "primitive," the world of disease. Nana is, like Olympia, in the words of Paul Valéry, "pre-eminently unclean."[53] And it is this uncleanness, this disease, which forms the final link between two images of the woman, the black and the prostitute. For, just as the genitalia of the Hottentot were perceived as parallel to the diseased genitalia of the prostitute, so too the powerful idea of corruption links both images. Nana is corrupted and corrupts through sexuality.

Miscegenation is a word from the late nineteenth-century vocabulary of sexuality. It embodies a fear not merely of interracial sexuality, but of its supposed result, the decline of the population. For interracial marriages were seen as exactly parallel to prostitution in their barrenness. If they produced children at all, these children were weak and doomed. Thus Havelock Ellis, enlarging on his view of the objective nature of the beauty of humanity, states that "it is difficult to be sexually attracted to persons who are fundamentally unlike ourselves in racial constitution"[54] and approvingly quotes Abel Hermant:

> Differences of race are irreducible and between two beings who love each other they cannot fail to produce exceptional and instructive reactions. In the first superficial ebullition of love, indeed, nothing notable may be manifested, but in a fairly short time the two lovers, innately hostile, in striving to approach each other strike against an invisible partition which

separates them. Their sensibilities are divergent; everything in each shocks the other; even their anatomical conformation, even the language of their gestures; all is foreign.[55]

It is thus the innate fear of the Other's different anatomy which lies behind the synthesis of images. The Other's pathology is revealed in her anatomy, and the black and the prostitute are both bearers of the stigmata of sexual difference and thus pathology. Zola sees in the sexual corruption of the male the source of political impotence and provides a projection of what is basically a personal fear, the fear of loss of power, onto the world.[56] The "white *man's* burden," his sexuality and its control, is displaced into the need to control the sexuality of the Other, the Other as sexualized female. For the colonial mentality that sees "natives" as needing control easily shifts that concern to the woman, in particular the prostitute caste. Because the need for control was a projection of inner fears, its articulation in visual images was in terms which were the polar opposite of the European male. The progenitors of the vocabulary of images of the sexualized female believed that they were capturing the essence of the Other. Thus when Sigmund Freud, in his essay on lay analysis (1926), discussed the ignorance of contemporary psychology concerning adult female sexuality, he referred to this lack of knowledge as the "dark continent" of psychology, an English phrase with which he tied female sexuality to the image of contemporary colonialism and thus to the exoticism and pathology of the Other.[57] It was Freud's intent to explore this hidden "dark continent" to reveal the hidden truths about female sexuality, just as the anthropologist-explorers, such as Lombroso, were revealing further hidden truths about the nature of the black. Freud continues a discourse that relates images of male discovery to images of the female as the object of discovery. The line from the secrets possessed by the Hottentot Venus to those of twentieth-century psychoanalysis runs reasonably straight.

Notes

1. George Hamilton, *Manet and His Critics* (New Haven: Yale University Press, 1954), pp. 67–68. I am ignoring here the peculiar position of George Mauner, *Manet: Peintre-Philosophe: A Study of the Painter's Themes* (University Park: Pennsylvania University Press, 1975) that "we may conclude that Manet makes no comment at all with this painting, if by comment we understand judgment or criticism" (99).

2. For my discussion of *Olympia* I draw on Theodore Reff, *Manet: Olympia* (London: Allen Lane, 1976), and for my discussion of *Nana*, on Werner Hofmann, *Nana: Mythos and Wirklichkeit* (Cologne: Dumont Schauberg, 1973). Neither of these studies examines the medical analogies. See also E. Lipton, "Manet: A Radicalized Female Imagery," *Artforum* 13 (1975): 48–53.

3. George Needham, "Manet, Olympia and Pornographic Photography," in Thomas Hess and Linda Nochlin, eds., *Woman as Sex Object* (New York: Newsweek, 1972), pp. 81–89.

4. P. Rebeyrol, "Baudelaire et Manet," *Les temps modernes S* (1949): 707–25.

5. Georges Bataille, *Manet*, trans. A. Wainhouse and James Emmons (New York: Skira, 1956), p. 113.

6. Edmund Bazire's 1884 view of Nana is cited by Anne Coffin Hanson, *Manet and the Modern Tradition* (New Haven: Yale University Press, 1977), p. 130.

7. See my *On Blackness without Blacks: Essays on the Image of the Black in Germany* (Boston: G. K. Hall, 1982). On the image of the black see Ladislas Bugner, ed., *L'image du noir dans l'art occidental*

(Paris: Bibliotheque des Arts, 1976 ff.). The fourth volume, not yet published, will cover the post-Renaissance period. In the course of the nineteenth century the female Hottentot becomes the black female *in nuce*, and the prostitute becomes representative of the sexualized woman. Each case represents the creation of a class with very specific qualities. While the number of terms for the various categories of the prostitute expanded substantially during the nineteenth century, all were used to label the sexualized woman. Likewise, while many groups of African blacks were known in the nineteenth century, the Hottentot continued to be treated as the essence of the black, especially the black female. Both concepts fulfilled an iconographic function in the perception and representation of the world. How these two concepts were associated provides a case study for the investigation of patterns of conventions within multiple systems of representation.

8. See the various works on Hogarth by Ronald Paulson as well as R. E. Taggert, "A Tavern Scene: An Evening at the Rose," *Art Quarterly* 19 (1956): 320–23.

9. M. N. Adler, trans., *The Itinerary of Benjamin of Tudela* (London: H. Frowde, 1907), p. 68.

10. See John Herbert Eddy, Jr., "Buffon, Organic Change, and the Races of Man" (diss., University of Oklahoma, 1977), p. 109, as well as Paul Alfred Erickson, "The Origins of Physical Anthropology" (diss., University of Connecticut, 1974), and Werner Krauss, *Zur Anthropologie des 18, Jahrhunderis: Die Friihgeschichte der Menschheit im Blickpunkt der Aufklärung*, ed. Hans Kortum and Christa Gohrisch (Munich: Hanser, 1979). See also George W. Stocking, Jr., *Race, Culture and Evolution: Essays in the History of Anthropology* (Chicago: University of Chicago Press, 1982).

11. Johann Friedrich Blumenbach, *Beyträge zur Naturgeschichte* (Gättingen: Heinrich Dietrich, 1806). Even though a professed "liberal" who strongly argued for a single source for all the races, Blumenbach was puzzled about the seemingly radical difference in the anatomy of the African (read: black woman).

12. Guillaume Thomas Raynal, *Histoire philosophique et politique des éstablissements et du commerce des Européens dans les deux Indes* (Geneva: Chez les libraires associés, 1775), 2:406–7.

13. William F. Bynum, "The Great Chain of Being after Forty Years: An Appraisal," *History of Science 13* (1975): 1–28, and his dissertation, "Time's Noblest Offspring: The Problem of Man in British Natural Historical Sciences" (Cambridge University, 1974).

14. *Dictionnaire des sciences médicales* (Paris: C. L. F. Panckoucke, 1819), 35:398–403.

15. J. J. Virey, *Histoire naturelle du genre humain* (Paris: Crochard, 1824), 2:151. My translation.

16. George M. Gould and Walter L. Pyle, *Anomalies and Curiosities of Medicine* (Philadelphia: W. B. Saunders, 1901), p. 307, and Eugen Hollander, *Askulap und Venus: Eine Kultur- und Sittengeschichte im Spiegel des Arztes* (Berlin: Propyläen, 1928). Much material on the indebtedness of the early pathologists to the reports of travelers to Africa can be found in the accounts of the autopsies presented below. One indication of the power the image of the Hottentot still possessed in the late nineteenth century is to be found in George Eliot's *Daniel Deronda* (1876). On its surface the novel is a hymn to racial harmony and an attack on British middle-class bigotry. Eliot's liberal agenda is nowhere better articulated than in the ironic debate concerning the nature of the black in which the eponymous hero of the novel defends black sexuality (376). This position is attributed to the hero not a half-dozen pages after the authorial voice of the narrator introduced the description of this very figure with the comparison: "And one man differs from another, as we all differ from the Bosjesman" (370). Eliot's comment is quite in keeping with the underlying understanding of race in the novel. For just as Deronda is fated to marry a Jewess and thus avoid the taint of race mixing, so too is the Bushman, a Hottentot equivalent in the nineteenth century, isolated from the rest of humanity. That a polygenetic view of race and liberal ideology can be held simultaneously is evident as far back as Voltaire. But the Jew is here contrasted to the Hottentot, and, as has been seen, it is the Hottentot who serves as the icon of pathologically corrupted sexuality. Can Eliot be drawing a line

between outsiders such as the Jew and the sexualized female in Western society and the Hottentot? The Hottentot comes to serve as the sexualized Other onto whom Eliot projects the opprobrium with which she herself was labeled. For Eliot the Hottentot remains beyond the pale, showing that even in the most Whiggish text the Hottentot remains the essential Other. (George Eliot, *Daniel Deronda*, ed. Barbara Hardy [Harmondsworth: Penguin, 1967.])

17. De Blainville, "Sur une femme de la race hottentote," *Bulletin des Sciences par la société philomatique de Paris* (1816), pp. 183–90. This early version of the autopsy seems to be unknown to William B. Cohen, *The French Encounter with Africans: White Response to Blacks, 1530–1880* (Bloomington: Indiana University Press, 1980) (see esp. pp. 239–45, for his discussion of Cuvier). See also Stephen Jay Gould, "The Hottentot Venus," *Natural History 91* (1982): 20–27.

18. Quoted from the public record by Paul Edwards and James Walvin, eds., *Black Personalities in the Era of the Slave Trade* (London: Macmillan, 1983), pp. 171–83. A print of the 1829 ball in Paris with the nude "Hottentot Venus" is reproduced in Richard Tocliner, ed., *Illustrierie Geschichte der Medizin* (Salzburg: Andreas & Andreas, 1981), 4:1319. (This is a German reworking of Jacques Vie et al., *Histoire de la médecine* (Paris: Albinmichel-Laffont-Tehon, 1979.) On the showing of the "Hottentot Venus" see Percival R. Kirby, "The Hottentot Venus," *Africana Notes and News 6* (1949): 55–62, and his "More about the Hottentot Venus," *Africana Notes and News* 10 (1953): 124–34: Richard D. Altick, *The Shows of London* (Cambridge: Belknap Press of Harvard University, 1978), p. 269; and Bernth Lindfors, "'The Hottentot Venus' and Other African Attractions in Nineteenth-Century England," *Australasian Drama Studies* 1 (1983): 83–104.

19. Georges Cuvier, "Extraits d'observations faites sur le cadavre d'une femme connue à Paris et à Londres sous le nom de Vénus Hottentote," *Memoires du Musée d'histoire naturelle* 3 (1817): 259–74. Reprinted with plates by Geoffrey Saint-Hilaire and Frédéric Cuvier. *Histoire naturelle des mammifères avec des figures originales* (Paris: A. Belin, 1824), 1: 1 ff. The substance of the autopsy is reprinted again by Flourens in the *Journal complémentaire du dictionaire des sciences médicales* 4 (1819): 145–49, and by Jules Cloquet, *Mammel d'anatomie de l'homme descriptive du corps humain* (Paris: Béchet jeune, 1825), plate 278. Cuvier's presentation of the "Hottentot Venus" forms the major signifier for the image of the Hottentot as sexual primitive in the nineteenth century. This view seems never really to disappear from the discussion of difference. See the discussion of the "bushmen" among French anthropologists of the 1970s, especially Claude Rousseau, as presented by Patrick Moreau, "Die neue Religion der Rasse," in Iring Fetscher, ed., *Neokanservative und "Neue Rechte"* (Munich: C. H. Beck, 1983), pp. 139–41.

20. See for example Walker D. Greer, "John Hunter: Order Out of Variety," *Annals of the Royal College of Surgeons of England* 28 (1961): 238–51. See also Barbara J. Babiger, "The *Kunst- und Wunderkanunern: A catalogue raisonné of* Collecting in Germany, France and England, 1565–1750" (diss., University of Pittsburgh, 1970).

21. Adolf Wilhelm Otto, *Seltene Beobachtungen zur Anatomie, Physiologie und Pathologie gehärig* (Breslau: Wilibald Holäafer, 1816), p. 135; Johanues Müller, "Über die äusseren Geschlechtstheile der Buschmänninnen," *Archiv für Anatomie, Physiologie und wissenshafiliche Medizin* (1834), pp. 319–45; W. H. Flower and James Murie, "Account of the Dissection of a Bushwoman," *Journal of Anatomy and Physiology I* (1867): 189–208; Hubert von Luschka, A. Koch, and E. Görtz, "Die äusseren geschlechtstheile eines Buschweibes," *Monatsschrift für Geburtskunde* 32 (1868): 343–50. The popularity of these accounts is attested by their republication (in extract) in *The Anthropological Review* (London), which was aimed at a lay audience (5 [1867]: 316–24, and 8 [1870]: 89–318). These extracts also stress the sexual anomalies described.

22. *Richmond and Louisville Medical Journal*, May 1868, p. 194, cited by Edward Turnipseed, "Some Facts in Regard to the Anatomical Differences between the Negro and White Races," *American Journal of Obstetrics* 10 (1877): 32–33.

23. C. H. Fort, "Some Corroborative Facts in Regard to the Anatomical Difference between the Negro and White Races," *American Journal of Obstetrics* 3 (1877): 258–59. Paul Broca was influenced by similar American material concerning the position of the hymen, which he cited from the *New York City Medical Record* of 15 September 1868 in *Bulletins de la société d'anthropologie de Paris* 4 (1869): 443–44. Broca, like Cuvier before him, supported a polygenetic view of the human races.

24. William Turner, "Notes on the Dissection of a Negro." *Journal of Anatomy and Physiology* 13 (1878): 382–86; "Notes on the Dissection of a Second Negro," 14 (1879): 244–48; "Notes on the Dissection of a Third Negro," 31 (1896): 624–26. This was not merely a British anomaly. Jefferies Wyman reported the dissection of a black male suicide victims in the *Proceedings of the Boston Society of Natural History* on 2 April 1862 and 16 December 1863 and did not refer to the genitalia at all. *The Anthropological Review* 3 (1865): 330–35.

25. H. Hildebrandt, *Die Krankheiten der äusseren weiblichen Genitalien*, in Theodor Billroth, ed., *Handbuch der Frauenkrankheiten III* (Stuttgart: Enke, 1877), pp. 11–12. See also Thomas Power Lowry, ed., *The Classic Clitoris: Historic Contributions to Scientific Sexuality* (Chicago: Nelson-Hall, 1978).

26. Havelock Ellis, *Studies in the Psychology of Sex*, vol. 4. *Sexual Selection in Man* (Philadelphia: F. A. Davis, 1920), pp. 152–85.

27. Willem Vrolik, *Considérations sur la diversité du bassin des differentes races humaines* (Amsterdam: Van der Post, 1826); R. Verneau, *Le bassin dans les sexes et dans les races* (Paris: Bailliére, 1876), pp. 126–29.

28. Charles Darwin, *The Descent of Man and Selection in Relation to Sex* (1871; Princeton: Princeton University Press, 1981), 2: 317 on the pelvis, and 2: 345–46 on the Hottentot.

29. John Grand-Carteret, *Die Erotik in der französischen Karikatur*, trans. Cary von Karwarth and Adolf Neumann (from the manuscript), Gesellschaft Oster-reichischer Bibliophilen XVI (Vienna: C. W. Stern, 1909), p. 195.

30. *The Memories of Dolly Morton: The Story of a Woman's Part in the Struggle to Free the Slaves: An Account of the Whippings, Rapes, and Violences that Preceded the Civil War in America with Curious Anthropological Observations on the Radical Diversities in the Conformation of the Female Bottom and the Way Different Women Endure Chastisement* (Paris: Charles Carrington, 1899), p. 207.

31. Sigmund Freud, *The Standard Edition of the Complete Psychological Works of Sigmund Freud*, trans. James Strachey (London: Hogarth, 1953–74), 7: 186–87, especially the footnote added in 1920 concerning the "genital apparatus" of the female. Translations from other works are mine except where otherwise stated.

32. The best study of the image of the prostitute is Alain Corbin, *Les filles de noce: Misére sexuelle et prostitution aux 19ᶜᵉ et 20ᶜᵉ siècles* (Paris: Aubier, 1978). On the black prostitute see Khalid Kistainy, *The Prostitute in Progressive Literature* (New York: Schocken, 1982), pp. 74–84. On the iconography associated with the pictorial representation of the prostitute in nineteenth-century art see Hess and Nochlin, eds., *Woman as Sex Object*, as well as Linda Nochlin, "Lost and *Found*: Once More the Fallen Woman," *Art Bulletin 60* (1978): 139–53, and Lynda Nead, "Seduction, Prostitution, Suicide: *On the Brink* by Alfred Elmore," *Art History* 5 (1982): 310–22. On the special status of medical representations of female sexuality see the eighteenth-century wax models of female anatomy in the Museo della Specola (Florence), reproductions of which are in Mario Bucci, *Anatomia come arte* (Firenze: Edizione d'arte il Fiorino, 1969), esp. plate 8.

33. A. J. B. Parent-Duchatelet, *De la prostitution dans la ville de Paris* (Paris: J. B. Baillière, 1836), I: 193–244.

34. *On Prostitution in the City of Paris* (London: T. Burgess, 1840), p. 38. It is of interest that it is exactly the passages on the physiognomy and appearance of the prostitute which this anonymous translator presents to an English audience as the essence of Parent-Duchatelet's work.

35. Freud, *Standard Edition*, 7: 191.

36. V. M. Tarnowsky, *Prostitutsíja o abolitsioniszm* (St. Petersburg: n.p., 1888); *Prostitution and Abolitionismus* (Hamburg: Voss, 1890).

37. Pauline Tarnowsky, *Etude anthropométrique sur les prostituées et les voleuses* (Paris: E. Lecrosnier et Bebé, 1889).

38. Pauline Tarnowsky, "Fisiome di prostitute russe," *Archivo di Psichiatria scienze penali ed antropologia criminale* 14 (1893): 141–42.

39. Cesare Lombroso and Guglielmo Ferrero, *La donna delinquente* (Turin: Roux, 1893). On the photographs of the Russian prostitutes, pp. 349-50; on the fat of the prostitute, pp. 361–62; and on the labia of the Hottentots, p. 38.

40. Adrien Charpy, "Des organes génitaux externes chez les prostituées," *Annales des Dermatologie* 3 (1870–71): 271–79.

41. *Congrès international d'anthropologie criminelle* (1896) (Geneva: Georg et Co., 1897), pp. 348–49.

42. Ellis, *The Psychology of Sex*, 4: 164.

43. Guglielmo Ferrero [Guillaume Ferrero], "L'atavisme de la prostitution," *Revue scientifique* (Paris), 1892, pp. 136–41.

44. Abele De Blasio, "Steatopigia in prostitute," *Archivo de psichiatria* 26 (1905): 257–64.

45. Jefferson commented on the heightened sensuality of the black in slavery in his *Notes from Virginia* (1782); Diderot, in his posthumously published fictional *Supplément au voyage de Bougainville* (1796), represented the heightened sexuality of the inhabitants of Tahiti as examples of the nature of sexuality freed from civilization. See the general discussion of this theme in Alexander Thomas and Samuel Sillen, *Racism and Psychiatry* (New York: Brunner/Mazel, 1972), pp. 101ff.

46. On Bachofen's view of primitive sexuality see the Introduction, Chapter 9, and selections by Joseph Campbell to J. J. Bachofen, *Myth, Religion & Mother Right*, trans. Ralph Manheim (Princeton: Princeton University Press, 1973).

47. See Winthrop Jordan, *White over Black: American Attitudes toward the Negro, 1550-1812* (New York: W. W. Norton, 1977), pp. 3–43.

48. Iwan Bloch, *Der Ursprung der Syphilis*, 2 vols. (Jena: Gustav Fischer, 1901–11).

49. Reff, *Manet: Olympia*, pp. 57–58, also p. 118.

50. See Auriant, *La véritable histoire de "Nana"* (Paris: Mercure de France, 1942). See also Demetra Palamari, "The Shark Who Swallowed His Epoch, Family, Nature, and Society in the Novels of Émile Zola," in Virginia Tufte and Barbara Myerhoff, eds., *Changing Images of the Family* (New Haven: Yale University Press, 1978), pp. 155–72, and Robert A. Nye, *Crime, Madness, and Politics in Modern France: The Medical Concept of National Decline* (Princeton: Princeton University Press, 1984).

51. All of the quotations are from Charles Duff's translation of *Nana* (London: Heineman, 1953), here, p. 27. The position described by Zola mirrors Manet's image of Nana. It emphasizes her state of semi-undress (echoing the image of the half-dressed "Hottentot Venus"). In Manet's image she is in addition corseted, and the corset stresses her artificially narrowed waist and the resultant emphasis on the buttocks. Both Manet's and Zola's images recall the bustle that Nana would have worn once dressed. (Nana is, for Zola, a historical character, existing at a very specific time in French history, in the decade leading up to the Franco-Prussian War of 1872.) The bustle (or *tournure*) was the height of fashion between 1865 and 1876 (and again in the mid-1880s). Worn with a tightly laced bodice, the bustle gave the female the look of both the primitive and the erotic while staying safely within the bounds of middle-class fashion. Both the woman wearing the bustle and those who observed her knew that the accessory was artificial but they were also aware of its symbolic implications. The "bum rolls" of the seventeenth century and the "cork rumps" of the eighteenth century had already established a general association. But the bustle of the late nineteenth century, stretching out at the rear of the dress like a shelf, directly echoed the

supposed primitive sexuality of the Hottentot. Thus the dress implied by Nana's state of semi-undress and by her undergarments, in Manet's painting and in Zola's description, also points to the primitive hidden within. See Bryan S. Turner, *The Body and Society: Explorations in Social Theory* (Oxford: Blackwell, 1985).

52. August Barthlemy, trans. *Syphilis: Poème en deux chants* (Paris: Béchet junior et Labé & Bohaire, 1840). This is a translation of a section of Facastorius' Latin poem on the nature and origin of syphilis. The French edition was in print well past mid-century.

53. Cited in Bataille, *Manet*, p. 65.

54. Ellis, *Psychology of Sex*, 4: 176.

55. Abel Hermant, *Confession d'un enfant d'hier*, cited in ibid., n. I.

56. Joachim Hohmann, ed., *Schon auf den ersten Blick: Lesebuch zur Geschichte unserer Beindbilder* (Darmstadt: Luchterhand, 1981).

57. Freud, *Standard Edition*, 25: 212. See also Renate Schleiser, *Konstruktion der Weiblichkeit bei Sigmund Freud* (Frankfurt: Europäische Verlagsanstalt, 1981), pp. 35–39.

7

Going Native

Abigail Solomon-Godeau

The recent Gauguin retrospective on view at the Grand Palais conformed in all its essentials to the familiar form of the blockbuster. The week before its opening, Gauguin was the cover story in mass-media publications such as *Telerama* and *Figaro*. From the moment the show opened, lines routinely stretched from the entrance of the Grand Palais to the metro station; I was told that an average of 7,000 people saw the show each day. The accompanying scholarly apparatus conforms equally to expectations: a seven-pound, 300-franc catalogue produced by a Franco-American equipe, brimming with facts and factoids; a three-day symposium uniting scholars from several countries; corporate sponsorship on both sides of the Atlantic—Olivetti in France, AT&T in the States; and satellite exhibitions of both the graphic work of the Pont Aven school and historical photographs of Polynesia. Also attendant upon the show were disputes, if not polemics, concerned with problems of dating in publications such as *The Print Collector's Newsletter*, and the reissue of numerous older Gauguin monographs.

Consistent with this discursive presentation of the artist and his work—a presentation which, for short, may be designated business as usual—the physical presentation of the exhibition and the catalogue are insistently concerned with a certain inscription of the artist. For example, at various strategic points, the viewer is confronted with over-life-size photographic blow-ups of Gauguin. And departing from the overall stylistic/chronological organization of the show, the very last room is consecrated to a medley of Gauguin's self-portraits, revealing a progression (if that is the right term) from the rather *louche Autoportrait avec chapeau* (1893–94) to the lugubrious *Autoportrait pres de Golgotha* (1896). In other words, there are at least two narratives proposed by this exhibition: one structured around a temporal, formal trajectory (the stylistic evolution and development of the artist's work), and the other around an agonistic and heroicized presentation of the artist's life. The former narrative is produced through curatorial strategies of selection and exclusion; the latter through the interpolation of Gauguin as a biographical subject—for example, the use of text panels chronicling his activities, his travels, his mistresses. These two narratives are unified under the mystic sign of the promethean artist; thus, fully in keeping with the exigencies of a secular hagiography that characterizes

mainstream, culturally dominant approaches to art, the catalogue offers us a full-page photograph of Gauguin's hand.

This shamanlike image is as good a point of entry as any other into the myth of Gauguin, and by extension, into the discourse of artistic primitivism which Gauguin is taken to exemplify. Gauguin's position is here quite central insofar as he is traditionally cast as the founding father of modernist primitivism. I am less concerned here, however, with primitivism as an aesthetic option—a stylistic choice—than with primitivism as a form of mythic speech. Further, it is one of my themes that the critical interrogation of myth is a necessary part of art-historical analysis. Myth, as Roland Barthes famously defined it, is nothing more or less than depoliticized speech—consistent with the classical definition of ideology (a falsification or mystification of actual social and economic relations). But mythic speech is not only about mystification, it is also, and more crucially, a *productive* discourse—a set of beliefs, attitudes, utterances, texts, and artifacts that are themselves constitutive of social reality. Therefore, in examining mythic speech, it is necessary not only to describe its concrete manifestations, but also to carefully attend to its silences, its absences, its omissions. For what is not spoken—what is unspeakable, mystified, or *occulted*—turns always on historical as well as psychic repressions.

Second only to the life of his equally mythologized contemporary Vincent van Gogh, Gauguin's life is the stuff of which potent cultural fantasies are created. And indeed have been. Preeminently, the myth is associated, in both the popular and the art-historical imagination, with Gauguin's ten years spent in Polynesia and—integrally linked—his assumption of the role of savage. Simultaneously, Gauguin's life is also deemed tragic and accursed. A glance through the card catalogue yields some of the following titles: *Oviri: The Writings of a Savage*, *The Noble Savage: A Life of Paul Gauguin*, *Gauguin's Paradise Lost*, *La vie passionée de Paul Gauguin*, *Poètes et peintres maudit*, *Les maudits*, *Gauguin: Peintre maudit*, and—my personal favorite—*Gauguin: Sa vie ardente et misérable*.

Even during his lifetime Gauguin was associated with the flight from, variously, bourgeois life and respectability, the wear and tear of life in the cash nexus, a wife and children, materialism, "civilization." But no less mythically important than the things escaped are the things sought—the earthly paradise, its plentitude, its pleasure, its alluring and compliant female bodies. To admirers of Gauguin during his lifetime and the period immediately after—I refer here to such indispensable and powerful promoters as Albert Aurier, Charles Morice, Daniel de Montfried, and most crucially, Victor Segalen[1]—Gauguin's voyage of life was perceived in both the most literal and gratifyingly symbolic sense as a voyage ever further outward, to the periphery and margins, to what lies outside the parameters of the superego and the polis. On a biographical level, then, Gauguin's life provides the paradigm for primitivism as a white, Western, and preponderantly male quest for an elusive object whose very condition of desirability resides in some form of distance and difference, whether temporal or geographical.

In the myth of Gauguin "the man," we are thus presented with a narrative (until quite recently, one produced exclusively by men) that mobilizes powerful psychological fantasies about difference and otherness, both sexual and racial. On a formal level—or perhaps I should say, on the level of Gauguin the artist—another narrativization is at work. Here, the salient terms concern originality and self-creation, the heroism and pathos of cultural creation, a telos of avant-gardism whose movement is charted stylistically or iconographically.

Common to both the embrace of the primitive—however defined—and the celebration of artistic originality is the belief that both enterprises are animated by the artist's privileged access, be it spiritual, intellectual, or psychological, to that which is primordially internal. Thus, the structural paradox on which Gauguin's brand of primitivism depends is that one leaves home to discover one's real self; the journey out, as writers such as Conrad have insisted, is, in fact, always a journey in; similarly, and from the perspective of a more formally conceived criticism, the artist "recognizes" in the primitive artifact that which was immanent, but inchoate; the object from "out there" enables the expression of what is thought to be "in there." The experience of the primitive or of the primitive artifact is therefore, and among other things, valued as an aid to creation, and to the act of genius located in the artist's exemplary act of recognition.

Is it the historic Gauguin that so perfectly incarnates this mythology, or is it the mythology that so perfectly incarnates Gauguin? Did Gauguin produce this discourse, or did the discourse produce him? From whichever side we tackle this question, it must be said that Gauguin was himself an immensely persuasive purveyor of his own mythology. But the persuasiveness of Gauguin's primitivism—both as self-description and as aesthetic project—attests to the existence of a powerful and continuing cultural investment in its terms, a will to believe to which 100 years of uncritical commentary bears ample witness. Mythic speech cannot be dispelled by the facts it ignores or mystifies—the truth of Brittany, the truth of Polynesia, the truth of Gauguin; rather, it must be examined in its own right. And because myth's instrumentality in the present is of even greater moment, we need to attend to its avatars in the texts of contemporary art history. Thus, while it is fruitless to attempt to locate an origin of primitivist thought, we can at any point along the line attempt to unpack certain of primitivism's constituent elements, notably the dense interweave of racial and sexual fantasies and power—both colonial and patriarchal—that provides its raison d'être and which, moreover, continues to inform its articulation. Insofar as Gauguin is credited with the invention of modernist primitivism in the visual arts, such an investigation needs to reckon both with Gauguin's own production—literary as well as artistic—and with the successive levels and layers of discourse generated around it.

For my purposes here, it is sufficient to begin in 1883, when at the age of 35, Gauguin makes his decisive break with his previous life as a respectable bourgeois and paterfamilias; terminated from the investment firm of Bertin in the wake of the financial crash of 1882, he resolves to become a full-time artist. Three years later he leaves his wife, Mette Gad Gauguin, and his five children in Copenhagen and returns to Paris. Then begins his restless search for "luxe, calme et volupté," a troubled quest for another culture that's purer, closer to origins and—an equally insistent leitmotif—cheaper to live in.

By July 1886, he is installed at Pont Aven, at the Pension Gloanec. It is during this first Breton sojourn that he begins to present himself, quite self-consciously, as a savage. Simultaneously, and in concert with other artists—notably Emile Bernard—he begins to specifically adumbrate the goals and intentions of a primitive art. Brittany is thus presented in Gauguin's correspondence, and in the subsequent art-historical literature, as the initial encounter with cultural Otherness, a revivifying immersion in a more archaic, atavistic, and organic society. Such a view of Brittany is exemplified by Gauguin's often quoted comment, "I love Brittany: there I find the wild and the primitive. When my wooden shoes

ring on this stony soil, I hear the muffled, dull, and mighty tone I am looking for in my painting." Daniel de Montfried, Gauguin's close friend and subsequent memorialist, tied the move to Brittany specifically to Gauguin's ambitions for his art: "He hoped to find a different atmosphere from our exaggeratedly civilized society in what, he thought, was a country with archaic customs. He wanted his works to return to primitive art."[2]

Since the publication of Fred Orton and Griselda Pollock's important essay of 1980, "Les Données Bretonnantes," which significantly does not even appear in the Grand Palais catalogue's bibliography, this conception of Brittany as somehow primitive, severe, and eminently folkloric has been revealed as itself a mythic representation. Indeed, Pollock and Orton's evocation of Pont Aven in the late 1890s suggests nothing so much as Provincetown in the 1950s—an international artists' colony, and a popular site for tourism, coexisting with, and forming the economy of, a relatively prosperous and accessible region whose diversified economy was based on fishing (including canning and export), agriculture, kelp harvesting, and iodine manufacturing.

Far from constituting the living vestiges of an ancient culture, many of the most visually distinctive aspects of Breton society (preeminently the clothing of the women) postdated the French Revolution; they were, in fact, as Orton and Pollock demonstrate, aspects of Breton *modernity*.[3] But from the perspective of an inquiry into the terms of a nascent primitivism, what needs be emphasized is the construction of Brittany as a discursive object; in keeping with analogous constructions such as Orientalism, we might call this construction "Bretonism." Accordingly, the distance between the historical actuality of Brittany in the later 1880s and the synthetist representation of it is not reducible to a distance from or a distortion of an empirical truth, but must be examined as a discursive postulate in its own right. Of what, then, does this postulate consist?

On a formal level, the developments one observes in Gauguin's work of 1886–90, and indeed in the work of the Pont Aven circle as a whole, have little to do with Brittany, whether real or imagined. These years encompass the first two Breton sojourns, punctuated by the 1887 trip to Panama and Martinique, and the crucial encounter with tribal arts and culture at the 1889 Universal Exhibition. Gauguin's jettisoning of phenomenological naturalism with respect to color, atmosphere, and perspective, and his assimilation of, variously, Japonisme, French popular imagery, and Emile Bernard's cloisonnisme, all of which had long since been discursively constituted as the primtive, did not require Brittany for its realization.

On the level of motif, however, Bretonism signals a new interest in religious and mystical iconography—Calvaries, self-portraits as Christ, Magdalens, Temptations, and Falls. To be sure, this subject matter is not separable from the emerging precepts of Symbolism itself, any more than Gauguin's self-portraiture as Christ or magus is separable from his personal monomania and narcissism. In this respect, Synthetism, cloisonnisme, primitivism, and the large framework of Symbolism all represent diverse attempts to negotiate what Pollock and others have termed a crisis in representation—a crisis whose manifestation is linked to a widespread flight from modernity, urbanity, and the social relations of advanced capitalism.

To commentators such as Camille Pissarro, Symbolism was itself a symptom of bourgeois retrenchment in the face of a threatening working class:

The bourgeoisie, frightened, astonished by the immense clamor of the disinherited masses, by the insistent demands of the people, feels that it is necessary to restore to the people their superstitious beliefs. Hence the bustling of religious symbolists, religious socialists, idealist art, occultism, Buddhism, etc., etc.[4]

And he reproached Gauguin for "having sensed this tendency" and, in effect, pandering to it. But from either perspective, it seems clear that Bretonism fulfills a desire for the annihilation of what is deemed insupportable in modernity, which in turn requires that the Brittany of Bretonism be conceived as feudal, rural, static, and spiritual—the Other of contemporary Paris.

Stasis—being outside of time and historical process—is particularly crucial in the primitivizing imagination, insofar as what is required is an imaginary site of psychic return. The "return to origins" that Gauguin claimed as his artistic and spiritual trajectory is emblematized in another frequent quotation: "No more Pegasus, no more Parthenon horses! One has to go back, far back . . . as far as the dada from my childhood, the good old wooden horse."[5] Gauguin's words limn an atavism that is anterior to, and more profound in its implications, than the search for a kind of ethnographic origin in either Brittany or the South Seas.

This atavism has its lineage in Rousseauist thought, in various kinds of temporal exoticism, in certain currents in Romanticism, and—closer to Gauguin's own time—in a new interest in the child and the child's perception. While it might be possible to argue that Gauguin's numerous images of children—Breton girls and adolescents, naked little boys (some of them quite strikingly perverse)—themselves constitute an element of Bretonism, it is also possible that the prevalence of children, like that of unindividuated Breton women, masks something largely absent from the Bretonist vision—namely, adult men and their activities. Why should the character—physiognomic, sartorial, or spiritual—of Breton men be of no interest? While there is no simple answer to this question, I would like to suggest that the absence of men from Bretonism may be structurally similar to the absence of men in the nineteenth-century *discours prostitutionelle*. In other words in the same way that discussions of *proxénétisme* and other forms of male entrepreneurial relations to prostitution are elided, it may well be that what is at work in these discourses is a fantasmatic construction of a purely feminized geography. In this respect, Bretonism thus supplies a vision of an unchanging rural world, populated by obliquely alien, religious women and children, a locus of nature, femininity, and spirituality. And as the Grand Palais catalogue so ingenuously puts it: "In the artistic itinerary of Gaugin, le Pouldu would remain as 'the first of his Tahitis,' his 'French Tahiti.' "[6] And lest we think that Bretonism is a late nineteenth-century phenomenon, here is a description of Breton women written in 1973: "The feminine population of Brittany was both earthy and undifferentiated, the women possessing a shared character which took form in a sort of animal nature, the result of centuries of ritualized response to an established role."[7]

In any event, the appearance of female nudes in Gauguin's work during the first stay in Brittany (the only ambitious female nude anterior to the Brittany work is the "realist" *Suzanne Coussant* of 1881) participates in many of the same structures of desire as does Bretonism itself. Significantly, it was during the Breton period that Gauguin elaborated his peculiar mythology of the feminine—a hodgepodge of Wagnerian citations, fin-de-siècle

Figure 7.1 Paul Gauguin, *The Loss of Virginity*, 1890–91, oil on canvas, Chrysler Museum of Art, Norfolk, VA (Gift of Walter P. Chrysler, Jr.).

idées reçues about woman's nature, Strindbergian misogyny, French belles-lettriste versions of Schopenhauer and so forth and so on. Modern art-historical literature abounds in grotesquely misogynist exegeses of the meanings in Gauguin's representations of women.[8] In terms of my larger argument, it is enough to note that like the putatively archaic, mysterious, and religious Bretonne, the deflowered maiden, the naked Eve and the woman in the waves (all from the Breton period) alike reside in that timeless and universal topos of the masculine imaginary—femininity itself (see fig. 7.1).

Unmistakably, in Gauguin's writing and in his art, the quest for the primitive becomes progressively sexualized, and we must ask if this is a specific or a general phenomenon. From 1889 on, there is an explicit linkage of the natural and Edenic culture of the tropics to the sensual and the carnal—nature's plenitude reflected in the desirability and compliance of "savage women." "The first Eves in Gauguin's Eden," as one art historian refers to them, appear in 1889 (the two versions of *Eve Bretonne, Ondine, Femmes sebaignent*, and, in the following year, *Eve Exotique*). Much psychobiographic ink has been spilled over the fact that the head of the *Eve Exotique* derives from a photograph of Gauguin's mother—Aline Chazal. But if we recall that Eve means mother to begin with, and that, biblically speaking, Eve is the mother of us all, Gauguin's use of his mother's photograph could mean any number of things. Given the ultimate unknowability of an artist's intentions, motivations, and psychic structures, there seems little point in psychoanalyzing the subject through the work. Of far greater importance to my mind is an analysis of the availability and indeed

the self-evidence of the constellation Eve/Mother/Nature/Primitive to the patriarchal imaginary as a cultural and psychic construction.

Again, we are confronted with a form of mythic speech that can by no means be historically relegated to the era of Symbolism. I quote a contemporary art historian:

> What better symbol for this dream of a golden age than the robust and fertile mother of all races? . . . Gauguin's Eve is exotic, and as such she stands for his natural affinity for tropical life. His was more than a passing taste for the sensuality of native women; of mixed origin—his mother had Peruvian as well as Spanish and French blood—he was deeply aware of his atavism, often referring to himself as a pariah and a savage who must return to the savage.[9]

And from another art historian:

> Although Gauguin's imagery clearly emerges out of the nineteenth century tradition of the fatal woman, It rejects the sterility of the relationship. On the contrary, the ceramic [the *Femme noire*] suggests a fruitful outcome to the deadly sexual encounter by representing the *Femme Noire* as full-bellied and almost pregnant: the female uses the male and kills him, but she needs the phallus and its seed to create new life. So the fated collaboration is productive, even though fatal for the male. Gauguin's imagery is basically an organic and natural one.[10]

The leitmotifs that circulate in these citations (chosen fairly randomly, I might add)—strange references to mixed blood, persistent slippages between what Gauguin said or believed or represented and what is taken to be true, the naturalizing of the cultural which, as Barthes reminds us, is the very hallmark of mythic speech—all these suggest that Gauguin's mythologies of the feminine, the primitive, the Other, are disturbingly echoed in current art-historical discourse. Furthermore, insofar as femininity is conventionally linked, when not altogether conflated, with the primitive (a linkage, incidentally, that reaches a delirious crescendo in the fin-de-siècle), is there, we might then ask, a mirror version of this equivalence in which the primitive is conflated with the feminine? Is primitivism, in other words, a gendered discourse?

One way to address this question is by tracking it through Gauguin's own itinerary. By 1889, he had already resolved to make his life anew in Tahiti. Significantly, he had also considered Tonkin and Madagascar; all three were French colonial possessions. Tahiti, the most recent of these, had been annexed as a colony in 1881 (it had been a protectorate until then). Gauguin's primitivism was not free-floating, but followed, as it were, the colonizing path of the tricouleur. From Brittany he wrote to Mette Gauguin the following:

> May the day come soon when I'll be myself in the woods of an ocean island! To live there in ecstasy, calmness and art, With a family, and far from the European struggle for money. There in Tahiti I shall be able to listen to the sweet murmuring music of my heart's beating in the silence of the beautiful tropical nights. I shall be in amorous harmony with the mysterious beings of my environment. Free at last, without money trouble, I'll be able to love, to sing, to die.[11]

In this as in other letters, Gauguin makes very explicit the equation tropics/ecstasy/ amorousness/native. This was mythic speech at the time Gauguin articulated it, and it retains its potency to this day; one has only to glance at a Club Med brochure for Tahiti to appreciate its uninterrupted currency.

Insofar as we are concerned with Polynesia as a complex and overdetermined representation as well as a real place in time and history, we may start by asking what kinds of associations were generated around it in nineteenth-century France. From the moment of their "discovery"—a locution which itself demands analysis—by Captain Samuel Wallis in 1767, the South Sea Islands occupied a distinct position in the European imagination. Renamed La Nouvelle Cythère shortly after by Louis-Antoine Bougainville, Tahiti especially was figured under the sign of Venus: seductive climate, seductive dances, seductive (and compliant) women.

In the expeditionary literature generated by Captain Cook, Wallis, Bougainville, and the countless successive voyagers to the South Seas, the colonial encounter is first and foremost the encounter with the body of the Other. How that alien body is to be perceived, known, mastered, or possessed is played out within a dynamic of knowledge/power relations which admits of no reciprocity. On one level, what is enacted is a violent history of colonial possession and cultural dispossession—real power over real bodies. On another level, this encounter will be endlessly elaborated within a shadow world of representations—a question of imaginary power over imaginary bodies.

In French colonial representation, the nonreciprocity of these power relations is frequently disavowed. One manifestation of this disavowal can be traced through the production of images and texts in which it is the colonized who needs and desires the presence and the body of the colonizer. The attachment of native women—often the tragic passion—for their French lovers becomes a fully established staple of exotic literary production even before the end of the eighteenth century.

The perception of the Maori body—entering European political and representational systems much later than the black or Oriental body—can be seen to both replicate and differ from the earlier models for knowing the Other's body. Like that of the African, the body of the South Sea Islander is potentially—and simultaneously—monstrous and idealized. In the Polynesian context, these bodily dialectics were charted on a spectrum ranging, on the one hand, from cannibalism and tattooing to, on the other, the noble savage (usually given a Grecian physiognomy) and the delightful vahine. It is the fantasmatic dualism of cannibalism and vahine which alerts us to the central homology between the Polynesian body and the African body in European consciousness. For as Christopher Miller has pointed out in relation to Africanist discourse: "The horror of monstrousness and the delight of fulfillment are counterparts of a single discourse, sharing the same conditions of possibility: distance and difference. . . . "[12] The Maori body has its own specificity; it did not conform altogether to the model of the black African body. On the contrary, eighteenth- and nineteenth-century images of the Maori—and they are overwhelmingly of women—work to produce a subject who, if not altogether "white," is certainly not inscribed within the conventional representation schema for "black." This in turn may account for the perpetual problem posed by the "origin" of the Maori. If neither black, white, nor yellow (the overarching racial categories systematized in such summas of racialism as Joseph Gobineau's *Essai sur l'inégalité des races humaines*), the Maori race, along with

its placelessness, was clearly disturbing for nineteenth-century racial theory. In this respect, it would be amusing to think that the "problem" of Maori origins was unconsciously allegorized in Gauguin's *D'où venons-nous, Que sommes-nous, Où allons-nous?*

The Polynesian body had another specific valence which was structured around the perception of its putative androgyny, androgyny here understood in a morphological sense. As Victor Segalen, following countless previous descriptions, specified: "The woman possesses many of the qualities of the young man: a beautiful adolescent [male] comportment which she maintains up to her old age. And diverse animal endowments which she incarnates with grace."[13] Conversely, the young male Maori was consistently ascribed feminine characteristics. This instability in gendering was given explicit expression in the encounter Gauguin described in *Noa Noa* which hinged on his "mastery" of homosexual desire for a young Maori who trekked for him in search of wood to make his carvings.

The logic at work in the literary and iconic production of La Nouvelle Cythère was explicitly structured by the erotic fascination organized around the figure of the young Polynesian woman. "There should be little difficulty," wrote one frigate captain in 1785, "in becoming more closely acquainted with the young girls, and their relations place no obstacles in their way."[14] We may recall too that the mutiny on the Bounty was in part a consequence of the crew's dalliances with the native women. In any case, from the eighteenth century on, it is possible to identify various modalities in which the South Sea Islands are condensed into the figure of the vahine who comes effectively to function as metonym for the tropic paradise *tout court*. Indeed, Maori culture as a whole is massively coded as feminine, and glossed by constant reference to the languor, gentleness, lassitude, and seductiveness of "native life"—an extension of which is the importance in Polynesian culture of bathing, grooming, perfuming, etc. By the time the camera was conscripted to the discursive production of the Maori body (in the early 1860s, a good 20 years before Gauguin's arrival) these conventions of representation were fully established.

In examining popular representational modes—whether graphic or photographic—one can situate them with respect to the high-cultural forms to which they relate as iconographic poor relations. Hence, we move from Rococo *vahines* to "naturalist" or academic representations of unclothed Tahitians in the later nineteenth century, underpinned, as they clearly are, by the lessons of academic painting and its protocols of pose and comportment.

There was, as well, a fully developed literary tradition concerning Tahiti and to a lesser extent the Marquesas, ranging from what are now deemed high-cultural productions such as Herman Melville's *Typee* and *Omoo*, to enormously successful mass-cultural productions such as the *Marriage of Loti* by Pierre Loti (the pen name of Julien Viaud). "Serious" primitivists such as Gauguin and Victor Segalen dismissed books such as the *Marriage of Loti* as sentimental trash—"*proxynètes de divers*," Segalen called them—but to read Segalen's *Les Immemoriaux* or to contemplate Gauguin's strangely joyless and claustral evocations of Tahiti and the Marquesas is to be, in the final instance, not at all far from Loti.

In short, the "availability" of Tahiti and the Marquesas to Gauguin was as much a function of 100 years of prior representation as was its status as French possession, which additionally entitled Gauguin to a 30 percent reduction on his boat ticket and a spurious mission to document native life. Both forms of availability are eloquently symbolized in the 1889 Universal Exhibition whose literal center was composed of simulacra of native

habitations, imported native inhabitants, and tribal objects. William Walton, a British journalist, indicated the scale and ambition of this colonial Disneyland in his "Chefs d'oeuvre de l'Exposition Universelle": "The colonial department includes Cochin Chinese, Senegalese, Annamite, New Caledonian, Pahouin, Gabonese and Javanese villages, inhabitants and all. Very great pains and expense have been taken to make this ethnographic display complete and authentic."[15]

In addition to these villages, there was a model display of 40-odd dwellings constituting a "History of Human Habitation" as well as a display of "The History of Writing" including inscriptions taken from Palenque and Easter Island. The importance of this lexicon of exoticism for Gauguin should not be—but usually is—underestimated. Over a period of several months, Gauguin was frequently within the precincts of the exhibition (the Synthetist exhibition at the Café Volponi ran simultaneously). Thus, the experience of the primitive "framed" within the Pavilion of the Colonies or the History of Human Habitation is analogous to the primitivist discourse "framed" by the imperialism that is its condition of existence and the context of its articulation.

To acknowledge this framing is but a first step in demythifying what it meant for Gauguin to "go native." There is, in short, a darker side to primitivist desire, one implicated in fantasies of imaginary knowledge, power, and rape; and these fantasies, moreover, are sometimes underpinned by real power, by real rape. When Gauguin writes in the margin of the *Noa Noa* manuscript, "I saw plenty of calm-eyed women. I wanted them to be willing to be taken without a word, brutally. In a way [it was a] longing to rape,"[16] we are on the border between the acceptable myth of the primitivist artist as sexual outlaw, and the relations of violence and domination that provide its historic and its psychic armature.

In making an argument of this nature, one can also make reference to the distinction between the Polynesian reality and Gauguin's imaginary reconstruction of it. In 1769, the population of Tahiti was reckoned at about 35,000 persons. By the time of Gauguin's arrival in Papeete in 1891, European diseases had killed off two-thirds of the population. Late nineteenth-century ethnographers speculated that the Maori peoples were destined for extinction. The pre-European culture had been effectively destroyed; Calvinist missionaries had been at work for a century, the Mormon and Catholic missionaries for 50 years. The hideous muumuus worn by Tahitian women were an index of Christianization and Western acculturation. According to Bengt Danielsson, the only Gauguin specialist who diverges from mythic speech, "virtually nothing remained of the ancient Tahitian religion and mythology . . . , regardless of sect, they all attended church—at least once a day. Their Sundays were entirely devoted to churchgoing."[17]

Not only had the indigenous religion been eradicated, but the handicrafts, barkcloth production, art of tattoo, and music had equally succumbed to the interdiction of the missionaries or the penetration of European products. The bright-colored cloth used for clothing, bedding, and curtains that Gauguin depicted was of European design and manufacture.

Gauguin did, of course, indicate his dissatisfaction with Papeete as a provincial town dominated by colonials and demoralized and deracinated *indigènes*. In later years, in the Marquesas, he saw fit to regularly (and publicly) denounce the practice of intermarriage between the resident Chinese and the Polynesians. But the tourist/colonialist lament for the loss of the authentic, primitive culture it seeks to embrace is itself a significant compo-

nent of the primitivist myth. For within this pervasive allegory, as James Clifford points out, "The non-Western world is always vanishing and modernizing. As in Walter Benjamin's allegory of modernity, the tribal world is conceived as a ruin."[18]

In France, Gauguin had imagined Tahiti to be a sensual land of Cockaigne where a bountiful nature provided—effortlessly—for one's needs. This was also what the colonial pamphlets he had read told him. In fact, installed in his house 30 miles from Papeete, Gauguin was almost entirely reliant on the extremely expensive tinned food and biscuits from the Chinese trading store. Bananas and breadfruit, a staple of the Tahitian diet, were gathered by the men once a week on excursions to the highlands. Fishing, which provided the second staple food, was both a collective and a skilled activity. Ensconced in his tropical paradise, and unable to participate in local food-gathering activities, Gauguin subsisted on macaroni and tinned beef and the charity of Tahitian villagers and resident Europeans. Throughout the years in Tahiti and later in the Marquesas, Gauguin's adolescent mistresses were not only his most concrete and ostentatious talisman of going native, they were also, by virtue of their well-provisioned extended families, his meal tickets.

There are, of course, as many ways to go native as there are Westerners who undertake to do so. Gauguin scrupulously constructed an image of himself as having a profound personal affinity for the primitive. The Polynesian titles he gave most of his Tahitian works were intended to represent him to his European market, as well as to his friends, as one who had wholly assimilated the native culture. In fact, and despite his lengthy residence, Gauguin never learned to speak the language, and most of his titles are either colonial pidgin or grammatically incorrect.[19] His last, rather squalid years in the Marquesas included stints as a journalist for a French newspaper and a series of complicated feuds and intrigues with the various religious and political resident colonial factions.

It is against this background that we need to reconsider the text of *Noa Noa*. It has been known for quite a long time that much of the raw material of the text—notably that pertaining to Tahitian religion and mythology—was drawn from Gauguin's earlier *Ancien culte mahorie*, of which substantial portions were copied verbatim from Jacques Antoine Meorenhout's 1837 *Voyages aux iles du grand océan*.[20] Thus, when Gauguin writes in *Noa Noa* that his knowledge of Maori religion was due to "a full course in Tahitian theology" given him by his 13-year-old mistress Teha'amana, he is involved in a double denial; his avoidance of the fact that his own relation to the Maori religion was extremely tenuous, merely the product of a text he had just appropriated, and his refusal to acknowledge that Teha'amana, like most other Tahitians, *had* no relation to her former traditions.

I will return to this paradigmatic plagiarism shortly, but first I want to say a few more words about what we might call Teha'amana's structural use value for the Gauguin myth. Certainly, and at the risk of stating the obvious, it is clear that Teha'amana's function as Gauguin's fictive conduit to the ancient mythologies is entirely overdetermined. No less overdetermined is the grotesque afterlife of Gauguin's successive vahines in the modern art-historical literature. Conscientiously "named," their various tenures with Gauguin methodically charted, their "qualities" and attributes reconstituted on the "evidence" of his paintings and writing, their pregnancies or abortions methodically deduced, what is at work is an undiminished investment in the mythos of what could be termed primitivist reciprocity. This is a form of mythic speech that Gauguin produces effortlessly in the form of the idyll or pastorale, as in the following passage from *Noa Noa*:

I started to work again and my house was an abode of happiness. In the morning, when the sun rose the house was filled with radiance. Teha'amana's face shone like gold, tinge-ing everything with its luster, and the two of us would go out and refresh ourselves in the nearby stream as simply and naturally as in the Garden of Eden, *fenua nave nave*. As time passed, Teha'amana grew ever more compliant and affectionate in our day to day life. Tahitian *noa noa* imbued me absolutely. The hours and the days slipped by unnoticed. I no longer saw any difference between good and evil. All was beautiful and wonderful.[21]

The lyricism of Gauguin's own idealized description of life in Tahiti with its piquant allusions to the breaking of bourgeois norms and strictures—most spectacularly in the vision of a 50-year-old man frolicking with his 13-year-old mistress—is one of the linch-pins of the Gauguin myth. All the more necessary to instate less edifying perspectives on Eden, as in Gauguin's 1897 letter to Armand Seguin:

Just to sit here at the open door, smoking a cigarette and drinking a glass of absinthe, is an unmixed pleasure which I have every day. And then I have a 15-year-old wife [this was one of Teha'amana's successors] who cooks my simple every-day fare and gets down on her back for me whenever I want, all for the modest reward of a frock, worth ten francs a month.[22]

Such oppositions give some notion of the rich range of material available to the Gau-guin demythologizer. More pointedly still, they call attention to one of the particularly revealing aspects of what I may as well now call Gauguinism, namely the continuing desire to both naturalize and make "innocent" the artist's sexual relations with very young girls, as symptomatically expressed in Rene Huyghe's parenthetical assurance in his essay on Gau-guin's *Ancien culte mahorie* that the 13-year-old Tahitian girl is "equivalent to 18 or 20 years in Europe."[23]

Huyghe's anodyne assurance that the female Maori body is *different* from its Western counterpart is paradoxically motivated by the desire to normalize a sexual relationship which in Europe would be considered criminal, let alone immoral. But the paradox is fun-damental, for what is at stake in the erotics of primitivism is the impulse to domesticate, as well as possess. "The *body* of strangeness must not disappear," writes Hélène Cixous in *La Jeune Née*, "but its strength must be tamed, it must be returned to the master."[24] In this respect, the image of the savage and the image of the woman can be seen as similarly struc-tured, not only within Gauguin's work, but as a characteristic feature in the project of rep-resenting the Other's body, be it the woman's or the native's. Both impulses can be recognized in Gauguin's representational practice.

In the Polynesian pictures as in the Breton work, images of men are singularly rare (see color plate 5). Frequently, and in conformity with the already-represented status of the Maori, they are feminized. Nothing suggests that there is anything behind the men's pareros, while Gauguin is one of the first European artists to depict his female nudes with pubic hair. In this regard it is interesting to note that Gauguin's supine nude Breton boy (male nudes appear only in the Breton period) has had his penis strangely elided. But while there is nothing quite comparable to this odd avoidance of masculine genitalia in his images of women, and although they are figured with all the conventional tropes of "natural" fem-ininity—fruits with breasts, flowers and feathers with sex organs—there is nonetheless

something in their wooden stolidity, their massive languor, their zombielike presence that belies the fantasy they are summoned to represent.

What lies behind these ciphers of femininity? By way of approaching this question, I want to reintroduce the issue of Gauguin's plagiarisms. For the scandal of the appropriation of Moerenhout may be seen to have broader implications. Copied for use in *L'Ancien culte mahorie*, it resurfaces in the later *Noa Noa*. Parts of the same text reappear in *Avant et après*. A paragraph from the French colonial office pamphlet touting Tahiti for colonial settlement appears in a letter to Mette Gauguin.

In addition to the appropriation of others' texts, Gauguin tends to constantly recycle his own. Bits and pieces of *The Modern Spirit and Catholicism* surface in letters and articles. In his personal dealings with artists during his years in France, there is another kind of appropriation: Emile Bernard, for example, claimed that Gauguin had in effect "stolen" his Synthetism, and there is no question that Bernard's work comprised a far more developed and theorized Symbolism when the two artists first became friends in Brittany. From 1881 through the '90s, one can readily identify a Pissarroesque Gauguin, a van Goghian Gauguin, a Bernardian Gauguin, a Cézannian Gauguin, a Redonian Gauguin, a Degasian Gauguin and, most enduringly and prevalently, a Puvisian Gauguin. And as for what is called in art history "sources," Gauguin's oeuvre provides a veritable lexicon of copies, quotations, borrowings, and reiterations.

Drawing upon his substantial collection of photographs, engraved reproductions, illustrated books and magazines and other visual references, Gauguin, once he jettisoned Impressionism, drew far more from art than from life. Consider, for example, Gauguin's repeated use of the temple reliefs from Borobudur and wall paintings from Thebes. His borrowings from the Trocadero collections, and from the tribal artifacts displayed at the Universal Exhibition, are obvious. In certain cases, he worked directly from photographs to depict Maori sculptures that he never saw; photographs were often the source of individual figures as well. The Easter Island inscription from the Universal Exhibition appears in *Merahi Metue no Tehamana*. Manet's *Olympia* and Cranach's *Diana* are reworked as *Te arii vahine*. A double portrait of two Tahitian women comes directly from a photograph. Certain of Gauguin's ceramic objects are modeled on Mochican pottery. Woodcuts by Hiroshige provide the motif for a Breton seascape.

For some of Gauguin's contemporaries, this bricolage was the very essence of what they understood to be Gauguin's brand of Symbolism, as in Octave Mirbeau's description of Gauguin's "unsettling and savory mingling of barbarian splendor, Catholic liturgy, Hindu meditation, Gothic imagery, and obscure and subtle symbolism."[25] For less sympathetic observers, such as Pissarro, "All in all . . . it was the art of a sailor, picked up here and there."[26]

All of which suggests that in Gauguin's art the representation of the feminine, the representation of the primitive, and the reciprocal collapse of one into the other, has its analogue in the very process of his artistic production. For what is at issue is less an invention than a reprocessing of already constituted signs. The life of Gauguin, the art of Gauguin, the myth of Gauguin—approached from any side we confront a Borgesian labyrinth of pure textuality. Feminine and primitive, Breton and Maori, are themselves representable only to the extent that they exist as already-written texts, which yet continue to be written. "When myth becomes form," cautioned Barthes, "the meaning leaves its contingency

behind, it empties itself, it becomes impoverished, history evaporates, only the letter remains."[27] In contrast to the recent and elaborate rehabilitation of the primitivizing impulse, Pissarro, closer to the history that the Gauguin myth occludes, always retained his clarity of judgment: "Gauguin," he wrote, "is always poaching on someone's land; nowadays, he's pillaging the savages of Oceania."[28]

Notes

This essay is a slightly altered version of a paper delivered at the conference of the Association of Art Historians, held at the London University Institute of Education, April 6 – 9, 1989.

1. By profession a doctor in the French navy, and by avocation a diarist and writer, Victor Segalen (1878–1919) was an influential producer of toney literary exotica. His first naval tour of duty was in Oceania, and he arrived in Tahiti a few months after Gauguin's death. Subsequently, he purchased many of Gauguin's effects, including manuscripts, art works, photographs, albums, etc. Segalen's essays on Gauguin are anthologized in the posthumous collection *Gauguin dans son dernier décor et autres textes de Tahiti*, Paris, 1975. Upon Segalen's return to France, he wrote his novel *Les Immemoriaux* (1905–6), an imaginary reconstruction of Maori life which he characterized as attempting "to describe the Tahitian people in a fashion equivalent to the way Gauguin saw them." Subsequently, Segalen was posted to China for four years (1909–13), a sojourn that resulted in the novel *Rene Leys*, as well as two collections of essays, *Steles* and *Briques et Tuiles*. His *Essai sur l'exoticisme*, published posthumously, is a meditation on the nature of [Western] exoticism—a desire for the Other.

2. Cited in John Rewald, *Gauguin*, New York, 1938, p. 11.

3. Fred Orton and Griselda Pollock, "Les Données Bretonnantes: La Prairie de la Representation," *Art History*, Sept. 1980, pp. 314, 329.

4. *Camille Pissarro: Letters to His Son Lucien*, ed. John Rewald, New York, 1943, p. 171.

5. Cited in Robert Goldwater, *Primitivism in Modern Painting*, New York, 1938, p. 60.

6. Claire Frèches-Thory, "Gauguin et la Bretagne 1886–1890," *Gauguin* (exhibition catalogue), Paris, Galeries nationels du Grand Palais, 1989, p. 85.

7. Wayne Anderson, *Gauguin's Paradise Lost*, New York, 1971, p. 33.

8. Examples are legion, but Wayne Anderson's book, cited above, is one of the worst offenders. Its central thesis is that Gauguin's work is unified around the theme of the woman's life cycle, wherein the crucial event is the loss of virginity, which, as Anderson has it, may be understood as homologous to the Crucifixion of Christ. Not surprisingly, this theory promotes a fairly delirious level of formal and iconographical analysis.

9. Heri Dorra, "The First Eves in Gauguin's Eden," *Gazette des Beaux Arts*, Mar. 1953, pp. 189–98, p. 197.

10. Vöjtech Jirat-Wasiutynski, "Paul Gauguin's Self-Portraits and the Oviri: The Image of the Artist, Eve, and the Fatal Woman," *The Art Quarterly*, Spring 1979, pp. 172–90, p. 176.

11. *Lettres de Gauguin à sa femme et ses amis*, ed. Maurice Malingue, Paris, 1946, p. 184.

12. Christopher L. Miller, *Blank Darkness: Africanist Discourse in French*, Chicago, 1985, p. 28.

13. Victor Segalen, "Homage à Gauguin," *Gauguin dans son dernier décor*, p. 99 [my translation].

14. C. Skogman, *The Frigate Eugenie's Voyage Around the World*, cited in Bengt Danielsson, *Love in the South Seas*, London, 1954, p. 81.

15. Cited in Christopher Gray, *Sculpture and Ceramics of Paul Gauguin*, Baltimore, 1967, p. 52.

16. Paul Gauguin, *Noa Noa*, ed. and intro, Nicholas Wadley, trans. Jonathan Griffin, London, 1972, p. 23. There are a number of editions of *Noa Noa* in keeping with its complicated production and publication history. Originally planned by Gauguin as a collaboration between himself and Charles Morice, he later declared himself dissatisfied with the literary improvements and narrative reorganization that Morice had imposed. At least three different versions are in print, not counting translations.

17. Bengt Danielsson, *Gauguin in the South Seas*, London, 1965, p. 78.

18. James Clifford, "Histories of the Tribal and the Modern," see pages 217–232 of this volume; originally published in *Art in America*, April 1985, pp. 164–72, p. 178.

19. See in this regard, Bengt Danielsson, "Les titres Tahitiens de Gauguin," *Bulletin de la Société des Études Oceaniennes*, Papeete, nos. 160–61, Sept.–Dec. 1967, pp. 738–43.

20. See Rene Huyghe, "Le clef de Noa Noa," in Paul Gauguin, *Ancien culte mahorie*, Paris, 1951. Gauguin's spelling of *mahorie* is incorrect in any language.

21. Gauguin, *Noa Noa*, p. 37.

22. Letter to Armand Séguin, Jan. 15, 1897. Cited in Danielsson, *Gauguin in the South Seas*, p. 191.

23. Huyghe, "La clef de Noa Noa," p. 4.

24. Cited in Josette Féral, "The Powers of Difference," in *The Future of Difference*, eds. Hester Eisenstein and Alice Jardine, New Jersey, 1980, p. 89.

25. Octave Mirbeau, "Paul Gauguin," *L'Echo de Paris*, Feb. 16, 1891. Reprinted in Mirbeau, *Des artistes*, Paris, 1922, pp. 119–29.

26. *Camille Pissarro*, p. 172.

27. Roland Barthes, "Myth Today," *Mythologies*, ed. and trans. Annette Lavers, New York, 1978, p. 139.

28. *Camille Pissarro*, p. 221.

8

Racism, Nationalism, and Nostalgia

J. Gray Sweeney

This essay is concerned with a white supremacist fantasy of American history that emerged in the late nineteenth century and is perpetuated by an association of contemporary painters known as the Cowboy Artists of America, the CAA. It is a regional art form unique to the western United States. Cowboy art, both of the historical and contemporary type, is premised on nationalistic and conservative values. The ideology embedded in this art still commands powerful allegiances capable of prohibiting the publication of an earlier version of this essay.

The original title of this essay was "Morning of a New Day: The West in Image and Myth." I selected this title for the catalogue introduction I was commissioned to write for the Albuquerque Museum for an exhibition of fifty works from the National Cowboy Hall of Fame Museum in Oklahoma City. No restrictions were placed on the content of my essay, and I was upfront about my revisionist intentions. However, shortly after I submitted the essay and it had been accepted by the Albuquerque Museum, I was informed that the Cowboy Hall of Fame had rejected my essay, claiming that conservative trustees on their board would be upset by my revisionism. The Cowboy Hall's official mission is to perpetuate the "heritage of the Old West." The Hall threatened to withdraw the exhibition from Albuquerque if the essay was not rewritten. I refused to to this, and so withdrew it. It was disheartening when I received the publication with the maudlin title *Adventures West* and saw my catalogue entries had been cut in many cases from four or five pages of typescript to three or four bland sentences. I was grateful, however, to the Albuquerque Museum for paying me for my labor despite censorship for which they were not responsible. Later, it was explained that a "tough" decision had been made to go with the museum's "market" over its educational "mission," because the "gate" would be better served by retitling the publication and putting a cowboy image on the cover.

The purpose of this essay—both in its original, and in its present expanded form—is to interpret the meaning of this art, and to suggest why cowboy painting continues to command a loyal audience more than a century after it first appeared. The values expressed in this art had not been systematically challenged by scholars before my ill-fated essay was written, although the subsequent controversy around the exhibition "The West as America"

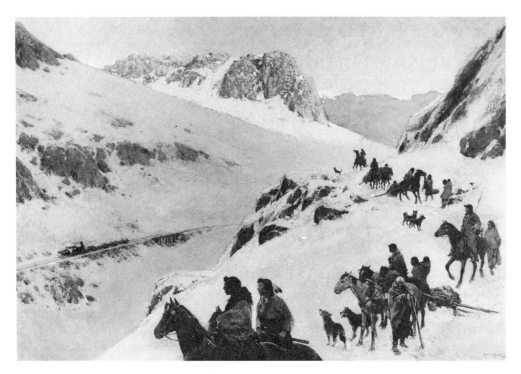

Figure 8.1 Henry Farny, *Morning of a New Day*, 1907, oil on canvas, 98.72.07, National Cowboy Hall of Fame and Western Heritage Center, Oklahoma City, OK.

at the National Museum of American Art amply demonstrates that a revisionist approach to western American art hits a very sore nerve among conservatives. The cultural values exposed here are racism, nationalism, and nostalgia, which threaten the conventional historical notions of pioneers establishing a righteous American Empire in the West. It is an art form implicitly endorsing the suppression of Native Americans who are condemned as "savages" for resisting white expansion into the West, or patronized for their lack of "culture." The cowboy hero—a macho figure of the imagination who has been enshrined in the consciousness of the world as an archetypal protagonist of American history—is the mythic persona fostered in this historical vision of the past as a national morality play.

My selection of Henry Farny's haunting painting *Morning of a New Day* (1907) as the signature image and title for the never-published version of this essay was not a difficult decision (fig. 8.1). It is arguably one of the most complex and aesthetically challenging works from this period, and a painting, I believe, of enduring significance. Henry Farny was born in France, and his artistic training was in the French academic tradition. Although he visited the West often, unlike his contemporaries Farny never painted the cowboy. Farny's oeuvre reveals the mind of an artist who moderated his contemporaries' romantic idealization of the United States suppression of its indigenous peoples. Simultaneously, however, Farny made his living painting these "doomed" natives.[1]

An indication that the values suggested by Farny's image are different from those associated with the work of his better-known contemporaries, Frederic Remington, Charles M.

Russell, and Charles Schreyvogel, is that while their art is endlessly emulated by present-day cowboy artists, Farny's work attracts few imitators. Reasons for this are evident in *Morning of a New Day* with its ambiguous representation of the "fatal environment," as the scholar Richard Slotkin has termed the reality of life for American Indians in his 1985 book of the same title.[2] This "fatal environment"—the genocide of the Native American tribes—was the result the dominant bourgeois group's belief in its self-proclaimed "manifest destiny" to take the West from the Native Americans by military conquest, through technological and entrepreneurial superiority, or if necessary by outright theft.

The primary meaning of Farny's picture is contained in the spare construction of the composition, in the subtle suggestions that can be read from its details, and in the ambiguities of its title. Representing the summation of two decades of meditation on the condition of the Indian, Farny reflects for his white patrons on the loss of a living culture in a work created for an urban, middle-class audience. It is an unusual work because it depicts not only the figures of proud Indian warriors, but also Indian families—cold, tired, and hungry—women, children, and old people. These are subjects which seldom appear in the images of Farny's contemporaries. The scale, placement, and gestures of the figures in a bleak wilderness landscape suggest a desperate struggle for survival against an inevitable historical process. At one level of meaning *Morning of a New Day* stands as a nostalgic lament from within the dominant white culture for the passing of the Native Americans.[3]

On another level, Farny's painting depicts a sentimental encounter between Indians and trains, the "winning of the West," created for the artist's patron, the President of the Baltimore and Ohio Railroad, Melville Ezra Ingalls, of Cincinnati, Ohio, who may have been the first owner of the picture. It plays upon the spectator's sympathy with the plight of the dispossessed Indians at the center of the picture who are marching out of the picture into darkness while the train moves into the light of the "new day." It is not rare to represent Native Americans as proud yet tragically vanquished, but Farny's picture seems to offer an empathetic view of Indian families who appear weary victims of the tireless machine seen on the distant mountainside. With one exception, the old man at right, the Indians are entirely absorbed by the sight of the smoke- and fire-belching engine, he alone gazes directly at the spectator. The technology that accompanied the astonishingly rapid geographic expansion of the American Empire was most clearly symbolized to that age by the railroad, which was presented as an almost divinely ordained assurance of power and prosperity in popular prints by Currier and Ives. *Morning of a New Day* addresses the results of America's colonization of the West—the fulfillment of its sacred "errand into the wilderness"—and the barbarous consequences of this new technology for Native Americans. (I was informed by a staff member at the Albuquerque Museum that the reason Farny's painting could not be used as the signature image for the publication was because "people won't buy a catalogue with cold and hungry Indians on the cover as readily as one with cowboys.")

A selection of images from the censored essay and from other museums of western art by the "big three" nineteenth-century founders of cowboy art, Frederic Remington, Charles M. Russell, and Charles Schreyvogel, discloses the values reinforcing racist attitudes toward Native Americans. It was an attitude concisely captured in the brutal resonance of the popular phrase "the only good Indian is a dead one." Frederic Remington's *A Dash for the Timber* (color plate 6), painted near the beginning of his career in 1889, and his *A Taint in the Wind*, produced toward the end of his life in 1907, are two works epitomizing the artist's

encoding of national attitudes toward Native Americans, and the foregrounding of the artist's heroic alter ego, the cowboy.

In the earlier work, *A Dash for the Timber*, Remington employs a device frequently used by western artists depicting a swarm of "faceless Indians" in hot pursuit of a group of well-dressed cowboy types. In a lecture at Arizona State University, one of the leading scholars of western history contemptuously referred to these figures as "hostile savages," precisely capturing the meaning of Remington's Indian horde. Although it has never been mentioned in the extensive literature on this painting, Remington's formulation of his visual narrative conveniently omits any indication of what these cowboy buckaroos may have done to provoke the Native Americans. More common in the literature on the artist is the assertion that such images are faithful "documents" recording the West as Remington experienced it. Nothing could be further from the truth, for the appearance of authenticity is precisely the effect that the artist sought to create through the careful amassing of accurate details of saddles, clothing, and weapons in his illustrations and large oils. These precisely recorded details were ultimately subordinate to the larger narrative interest that revisionist art historians have finally come to recognize as governing Remington's images.

Remington's later work, after about 1900, is strongly marked by his experimentation with the color and technique of Impressionism and Tonalism, as the artist sought to free himself from the limitations of commercial magazine illustration. *A Taint in the Wind* represents an experiment in these fashionable techniques with its relatively bold impasto and the blue-green tonalist light. In a bid to insert Remington in the pantheon of late nineteenth-century American painting, several recent studies, particularly the exhibition of "masterpieces" that ended its tour at the Metropolitan Museum of Art, have attempted to justify the artist's work purely on a formalist and aesthetic basis, ignoring the problematic meanings of his work.[5]

In *A Taint in the Wind*, on the surface merely another sentimental reflection on the obsolescence of the horse-drawn stagecoach, the racist element subtly asserts itself as the horses rear up in fear. Although never made explicit visually, Remington's title strongly hints that the animals rear because they smell the taint in the wind of lurking Indians and their ponies. Undoubtedly the success of the work with its original audience depended far more on the ideological resonance of its theme than on its painterly qualities. Remington's participation in the dominant racist attitudes of his generation has long been known to scholars of his work, although it has been, until very recently, withheld from the public. In his private letters this attitude that so powerfully informs his art found vengeful expression. "Never will be able to sell a picture to a Jew again," he wrote a friend, "did sell one once. You can't glorify a Jew—coin loving puds—nasty humans." He continued: "I've got some Winchester's, and when the massacring begins [. . .] I can get my share of 'em and what's more I will. Jews—Injuns—Chinamen—Italians—Huns, the rubbish of the earth I hate."[6] To Remington, the crowds of immigrants flooding into America were a "malodorous crowd of anarchistic foreign trash."[7]

A prime example of Remington's racist attitudes, which is seldom discussed, is the profoundly disturbing *The Battle of War Bonnet Creek*. In this picture the soldiers literally stand triumphantly on the bloody corpses of the Indians they have ambushed and massacred. The victory of the dominant civilization over mere "savages" who block "American Progress" is the explicit and unrelieved subject of this grisly image.

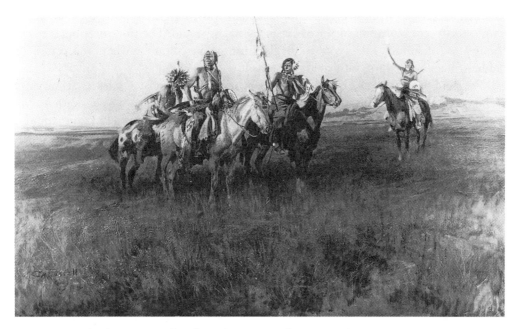

Figure 8.2 Charles M. Russell, *The Red Man's Wireless*, 1916, oil on canvas, 67.07.31, National Cowboy Hall of Fame and Western Heritage Center, Oklahoma City, OK.

Charles M. Russell is the second figure in the traditionally revered canon of western artists, and his paintings suggest some of the same values as those of Remington, preeminently an attitude of racial and cultural superiority of the dominant Anglo-American civilization over the Native Americans. Russell's *The Red Man's Wireless* (fig. 8.2), painted in 1916, is a classic example of how these values are encoded. The work is painted in the high key palette that Russell began to use around 1910 in response to the influence of Impressionism and the brightening of Remington's paintings about the same time. A heavily impastoed foreground, representing plains grass, creates a visual effect indicative of the artist's response to the painterly brush work that increasingly dominated American art after 1900. For this reason alone, the work has long been enshrined at the pinnacle of Russell's oeuvre, as an acknowledged "masterpiece." It was also one of the artist's favorite paintings, hanging in his dining room in his house in Great Falls, Montana. It was my interpretation of this picture that particularly seemed to bring down the ire of the Cowboy Hall of Fame.

With the waning of dogmas of formalism in a post-modernist age, Russell's illustrative technique for representing imagined events may have become more acceptable, but subject matter, and most particularly the attitudes toward the Native Americans implicit in the image, have become increasingly objectionable. Like so many works of the nineteenth century, this painting together with its title, *The Red Man's Wireless*, reveals an attitude of patronizing contempt. It shows the discovery by "red men" of the communications possibility of the simple woman's hand mirror that the mounted figure at right uses to signal to some distant, unseen companion toward whom the central group turns. Many artists earlier in the century, such as John Mix Stanley, and later Remington, depicted communication by smoke signals. Behind all these images is a hint of snide humor, for they assert the

cultural superiority of industrial technology, that is the telegraph, or by the date of this work, the recent invention of the Marconi "Wireless" radio. The title contributes to this smug sense of cultural superiority by the dominant white culture to whom this painting is addressed, and which will ultimately consume it.

The third painter revered by the modern cowboy artists of today is Charles Schreyvogel. Schreyvogel painted about one hundred works in the years from 1900 to his death in 1912, and although he visited the West briefly, his work was executed entirely in his studio in Hoboken, New Jersey, where he frequently posed his "manly" German-American compatriots on the tin roof of his apartment overlooking New York City. One of his main sources of information about Native Americans derived from sketching actors in Buffalo Bill's Wild West Shows when they visited the city. *Nearing the Fort* of 1902 is a characteristic early work that places a triumphant cavalry man in the foreground escorting a band of captured Indians to the unseen stockade or Indian Reservation—a euphemism for what were little better than "death camps." The contrast between the exultant face of the white soldier and the faceless crowd of Indians behind him says it all. In the view of one contemporary critic, Schreyvogel's work preserves "for posterity the story of the conflict for the West [. . .] its spirit even more than its reality."[8] The "reality" of white bourgeois culture attempting to annihilate the spirit of Native American culture is the real subject of these works, as scholars of the "New Western History" have stressed.

Going into Action, a later work executed just before Schreyvogel's death, is surely as improbable an image as anything ever painted or later recorded on motion picture film about Native Americans. It is a patently contrived image, inspired by the popular stereotypes of Indians seen in Buffalo Bill's Wild West Shows. The expression of pure savagery in the face of the chief is repeated, even exaggerated in the angry figure to his left, and reverberates with the terror-struck expression of the horse on which he rides. It seems perfectly comprehensible how such representations of warlike Indians would have met the cultural expectations of Schreyvogel's urban audience in New York City around 1910, whose knowledge of Native Americans came from dime novels and wild west shows. As such the image is disturbingly indicative of a cultural mind-set of the last half of the nineteenth century that approved genocide. One critic of the day put it this way: "Schreyvogel is more than a historian of the Indian. He is giving us an invaluable record of those parlous days of the Western frontier when a handful of brave men blazed the path for civilization and extended the boundaries of empire for a growing nation."[9]

Modern Day Cowboy Art

The fact that contemporary cowboy artists still look to the example of Remington, Russell, and Schreyvogel raises important questions concerning the role of this art form in representing what are primarily conservative and now, more than a century later, even reactionary values. Like the nineteenth-century patron of western art, the admirers of cowboy art are primarily stimulated by the subjects depicted, and in annual exhibitions of cowboy art there is an unvarying uniformity of subjects and realistic techniques. The audience for this art is located almost entirely in the West and the Southwest. Yet there are differences. A century ago, the audience for western art was an urban one predominantly from the

eastern seaboard, and it knew little of the actual West. Today, the main audience for contemporary western art lives amidst the geographical boundaries of the old American frontier—the trans-Mississippi West—and prides itself on being the heir to frontier traditions. The Cowboy Artists exploit this idea of regional identity to the fullest. According to News Release for the 26th Annual Exhibition of the CAA:

> Today, the lives of the frontiersman, the mountainmen and the Indian tribes who originally inhabited the West are splashed in vital colors across the CA's canvases and frozen in time in their sculptures, as are the soldiers and pioneers who subsequently brought civilization west for those who populate the ranches and prairies of the 1990s. Part truth and part myth, these pieces blend authenticity with folklore to create a dichotomy which uniquely reflects the American West of both yesteryear and tomorrow.[10]

Despite its anachronism, the commercial success of contemporary cowboy art is a fascinating if often disturbing manifestation of late twentieth-century American culture.

Nostalgic identification with conservative political values and the heroic myths of the Old West motivates much of this patronage just as it did in the nineteenth century.[11] The modern Westerner is typically a suburbanite working during the week in a large corporate office, but at the weekend he may become a "drugstore cowboy" driving a Ford "Bronco," or cruising the desert landscape in a four-wheel-drive "Ranger," or a Jeep "Cherokee" wagon. As one leading Denver collector put it:

> The fear of inflation caused by Uncle Sam's binge during the Carter years, a nostalgia in Concord [*sic*] Supersonic times for those of the Concord Stagecoach, an attempt to identify with desirable American characteristics perceived as common on the frontier and uncommon today and a widely held belief that our future would be in Reagan's West were a few of the forces behind the uptrend in the Western art market. . . .[12]

Clearly one of the main components of the popularity of contemporary cowboy art is its continued appeal to and astonishing ability to exploit entrenched beliefs in the values of heroic individualism and self-reliance. It should be remembered that much of Remington's, Russell's, and Schreyvogel's work capitalized on popular appreciation of a vanished or rapidly disappearing West where values of unfettered individualism could be reenacted. One of the cowboy artists, Ray Swanson, recently stated in the CAA exhibition catalogue: "I count it a privilege and blessing to have grown up in the West with its majesty, its people, and its opportunities. Through my art, I hope others can see, feel, and appreciate this land. May we all cherish and honor our country."[13] Thus, stereotyped images of western life, the cowboy, the pioneer or settler confronting or battling hostile Indians, who are represented as obstructing the fulfillment of individual or national destiny, are continually repeated.

The credibility of this repetition is sustained by a complex process of marketing contemporary western art as aesthetic experience and as an "authentic" revivification of history. Just as Remington was a master promoter of his work, so too contemporary western art, like most current art forms, is assiduously marketed. Indeed, the CAA employs a professional advertising agency to promote its activities and help stage the annual sales exhibitions. Glossy magazines where every image is reproduced in "living color," such as *Art of*

the West, The Golden West, and *Southwest Art,* are dedicated to cowboy art, and each issue features articles often editorially positioned as "supporting copy" for advertisements promoting the proliferating art dealers and galleries who advertise there.

Specialized organizations have emerged to bring artists together; the most widely known and focused is the Cowboy Artists of America. The CAA is an all male group, founded in 1965. There are no members who are Native Americans or women. Its by-laws state that the purpose of CAA is "to perpetuate the memory and culture of the Old West as typified by the late Frederic Remington and Charles Russell [. . .] and to insure authentic representations of the life of the West as it was and is. . . ."[14] Other organizations, such as the National Association of Western Artists, NAWA, have slightly broader objectives in exhibiting work from their membership. NAWA does include women—or at least one woman has now been elected as a card-carrying member. In 1983 the Cowboy Artists of America opened their own museum in Kerrville, Texas, where visitors "often become enthusiastic collectors."[15] Several art museums in the West, in particular the Phoenix Art Museum in Arizona, host annual exhibitions for these groups, taking a percentage from sales profits for museum operations.[16] In effect, they are active accomplices in promoting and selling this type of art, an unusual practice for an art museum, and something that they consistently decline to do for other contemporary artists.[17]

Historical realism and storytelling are the twin foundations upon which contemporary western art is built. Like Remington, Russell, and Schreyvogel, many of the artists pride themselves on their research into the details of clothing and gear, and the anatomy and movements of horses, and such an exacting fidelity to detail serves the interests of narative.[18] Robert Pummill's *Mules and the Iron Horse* (1991) is an example of this with its attempt at precision rendering of the old stagecoach and locomotive. To these ingredients of "historical authenticity" the artist is free to mix stylistic nuances of Impressionism or Tonalism.

A masculine type of heroism in various forms is usually the order of the day in a "good" cowboy painting when it deals with the earlier history of the West. Here the rag-tag, dirty, and tired figures disclosed by revisionist histories and photography are not to be found. Women and children are seldom the main subject, and the women and children of Native Americans are usually excluded.[19] Instead, an idealized and blatantly romanticized past is called up repeatedly to provide material for the creation of a conscious anachronism. A favorite image is the bronze figure of an "Americanized" Indian, with his face or torso "war painted" the colors of the American flag. Typical of the genre is a recent image by Fred Fellows, *The Indian Agent's Big Medicine* (1990) (fig. 8.3). It plays on the superiority of white technology over primitive Indians. Particularly objectionable in this fantasy is the appearance of nude Indian females running excitedly in clouds of dust raised by the automobile that carries the Indian Agent and the chiefs in their war bonnets. Such exploitative imagery, with its undisguised aspect of racism and sexism, is a doubly cruel irony when one considers the brutal suppression of the Indians, and their continuing marginalization in American society.

Contemporary western painting and sculpture are a genre unique to Texas, Oklahoma, Colorado, Montana, New Mexico, Arizona and, to some extent, Southern California. The economic base for this art is drawn principally from oil, ranching, real estate development, and the financial industry. The collectors often see themselves as "self-made." They deeply believe in the myth that the struggles of self-reliant men working in a "free enterprise" system are the foundation of national greatness and personal wealth and power. Prominent in

Figure 8.3 Fred Fellows, *The Indian Agent's Big Medicine*, 1990, oil on canvas. Exhibited at the 25th Annual Cowboy Artists of America Exhibition, 1990, Phoenix Art Museum, Phoenix, AZ.

the southwestern regions is an automobile-dealer posturing in front of cowboy paintings in a television advertisement, touting his integrity and fair dealing: "You can trust me to sell you your next car," the pitch line runs, "because I have a white hat and good cowboys never lie."

Like so much of the mythology of the "Old West," the image of the cowboy hero is one that has shifted radically in the last decade under the scrutiny of revisionist history. Beginning with the exhibition "The American Cowboy," at the library of Congress in 1983, the revision of the cowboy's heroic image, long a concern to historians, became a sensational public event.[20] It exposed the means by which popular and artistic culture has served to enshrine the cowboy in a veil of myth. Much of the ensuing controversy about the meaning of the West, that has culminated in the attacks on the Smithsonian exhibition "The West as America" and led to the rejection of my text, revolves around the necessary struggle over the meaning of history that is part of a progressive politics. Revisionist history exposes the reactionary function of myth, which has been used to reinforce the status of dominant power groups obsessed with protecting the national "virtue" of the United States. As scholars and curators attempt to present a more complex, critical, and multicultural portrait of the American past, it is to be expected that controversies will occur. A view of the American past that is anything less than heroic and untainted by motives of greed and racism that in fact motivated so much of migration westward during the last century is threatening to conservatives.

What is so amazing about America's fascination with the cowboy is that there has been such an enormous feast on so little food.[21] The fact is that the cowboy had his origin in an economic system that lasted from about 1865 to 1895. The cowboy's trade was created as

part of the burgeoning eastern demand for beef, made possible by refrigeration and rail-roads to transport this product. His existence depended, to a large extent, on the availabil-ity of great expanses of free public land that could be exploited by eastern and British corporations for grazing cattle herds. Although the myth of the cowboy hero represented him as white, in reality he was usually black or brown. He was often a former slave or a vaquero, or a descendent of slaves or vaqueros. The daily reality of the cowboy's life was virtually unending hard work—hot and dry in summer, cold and wet in winter. It is for this reason that images such as Tom Ryan's *Sixty Years in the Saddle* painted in 1967 are rare. A depiction of a tired cowboy with glasses and bad teeth—an "anti-hero"—is not generally a popular subject for cowboy artists.

The mythic image of the cowboy hero was further established in popular dime novels and in Buffalo Bill's Wild West Shows, and elaborated in turn-of-the-century illustrated maga-zines and in the writings of Owen Wister, among others. The popularity of Teddy Roosevelt, "the first cowboy president," and later the cinema, were factors in the spread of the vision of the cowboy as a fantasy hero. Needless to say, the second "cowboy president," Ronald Rea-gan, used his huge public relations apparatus for the ultimate political exploitation of the old myth.[22] Ronald Reagan was inducted into the pantheon of cowboy heroes in a huge media event at the Cowboy Hall of Fame at the same time my essay was pushed aside.

The love affair with the cowboy and the phenomenon of contemporary cowboy art coincided with the apogee of America's romance with the cowboy and Indian in films and on television.[23] Simultaneously, the cowboy image was appropriated by the advertising industry to support a wide range of products; perhaps the most deeply imprinted by mass media being the "Marlboro Man." An early example of the nonchalant smoking cowhand is seen in Phillip Goodwin's 1910 oil entitled *When Things Are Quiet*. Amusingly, this image was seriously proposed for the cover of the catalogue, but I was able to circumvent it when I pointed out that a picture of a smoker might raise the ire of a popular non-smoking coalition in Albuquerque that had recently succeeded in banning smoking from public spaces. In a recent version of Philip Morris's advertisement for Marlboro the reference to Remington's *A Dash for the Timber* is unmistakable. However, Philip Morris refused per-mission to reproduce this image, asserting that: "the suggestion that the advertisement copied a Frederick Remington painting is inaccurate."[24] Not surprisingly, Charles Herbert, the original Marlboro Man, was a carpenter who was discovered by an advertising agency working on a scaffold in Greenwich, Connecticut, in 1957. He had never ridden a horse until he went to work for Philip Morris.

It is certainly no coincidence that along with the established museums like the Thomas Gilcrease Institute of American History and Art in Tulsa, Oklahoma, the Amon Carter Museum in Fort Worth, Texas (formerly the Amon Carter Museum of Western Art), the Buffalo Bill Historical Center in Cody, Wyoming, and the National Cowboy Hall of Fame, several recently established institutions, such as the Stark Museum of Western Art in Orange, Texas, the Museum of Western American Art in Denver, or the Gene Autry Western Her-itage Museum in Los Angeles, have taken as their missions the perpetuation of the myths of the West. Visitors are informed that Native Americans had at best only a tenuous claim on the North American continent, having arrived themselves only a few millennia earlier than the first Europeans. For Bill Foxley, founder and proprietor of the now-defunct Museum of Western Art, the history of the movement West is like: "an oft repeated prayer, a nostalgic

reminder of that which made America great and permanently molded her character."[25] This neo-conservative view of the West discloses a radical divergence with an academic community increasingly at odds with the dominant political culture in the United States.

The troubling question of the true significance of western art for the future remains, and has undoubtedly become more acute now that the Reagan-Bush era has ended. To be sure the "lustrous loads of masterworks" that one collector of historic western art saw as the investment promise of the field has been little diminished. With the sale of paintings by Remington for seven figures, the worldwide appetite for historic western art shows no sign of diminishing, although there has been a weakening in the market for contemporary cowboy art. Of course, one major incentive for producing cowboy art is that historic works by Remington and Russell are now out of reach for mid-level collectors, and this is used to legitimize the derivative work of the cowboy artists who fill an obvious need with their considerably cheaper product.

Despite recession in the contemporary art market, the commercial potential of cowboy art still seems strong, and art dealers continue to assure the public that prices will rise.[26] With market success comes serious scholarly and curatorial attention, and there is at last a new willingness in the academic community to widen the scope of art-historical investigation to include western art, and to consider the powerful ideologies behind its production and consumption. But recent attacks by conservative critics make it abundantly apparent that the supporters of western art are willing to do everything in their power to protect the cherished fantasy of America's "winning of the West" promoted in this art.

Notes

This essay was written following the events described in 1981. I have revised a few errors of fact and made a few editorial changes for clarity and accuracy, otherwise the essay remains as written. The serious study of western art has accelerated dramatically since then, and many useful publications are now available, although there is still no serious, full-scale study of the social and cultural implications of contemporary cowboy painting.

1. The only monograph on Farny is Denny Carter's *Henry Farny* (New York: Watson-Guptill for the Cincinnati Art Museum, 1978).

2. See Richard Slotkin, *The Fatal Environment: The Myth of the Frontier in the Age of Industrialization* (Middletown, CT: Wesleyan University Press, 1985), especially Part V, "The Railroad Frontier, 1850–1860," and Chapter 14, "The New Paternalism: Paupers, Proletarians, and Indians, The 'Peace Policy' in Practice, 1869–1875."

3. It should be noted that there were other intellectuals in the United States during this period who objected to the wanton destruction of Native American tribes and the wholesale confiscation of their lands. The most notable was Helen Hunt Jackson whose classic book, *A Century of Dishonor: A Sketch of the United States Government's Dealings with Some of the Indian Tribes* (Boston: Roberts Brothers, 1885) is a compelling and highly detailed account of the history of US–Indian relations, with extracts from official government reports. In the conclusion Jackson observed: "It makes little difference, however, where one opens the record of history of the Indians; every page and every year has its dark stain. The story of one tribe is the story of all, varied only by differences

of time and place. . . . Colorado is as greedy and unjust in 1880 as was Georgia in 1830, and Ohio in 1795; and the United States Government breaks promises now as deftly as then, and with an added ingenuity from long practice." Quoting from a government report of the late 1860s, Jackson notes, "The history of the Government connections with the Indians is a shameful record of broken treaties and unfulfilled promises. The history of the border white man's connection with the Indians is a sickening record of murder, outrage, robbery, and wrongs committed by the former, as the rule, and occasional savage outbreaks and unspeakable barbarous deeds of retaliation by the latter, as the exception" (pp. 337–9).

4. The identification of Ingalls as the first owner of Farny's picture was made by William H. Truettner in "Reinterpreting Images of Westward Expansion," *Antiques*, vol. 89, no. 3 (March 1991), p. 551. Truettner suggests that Farney's "artistic strategy asserts that technology will inevitably prevail." I would argue that, seen in the larger context of Farny's work, the painting also indicates a deep sense of *regret* at this historical inevitability.

For a general discussion of railroads in American art see, *The Railroad in American Art: Representations of Technological Change*, ed. Susan Danly and Leo Marx (Cambridge, MA: MIT Press, 1988), and especially Kenneth Maddox's essay, "Asher B. Durand's *Progress: The Advance of Civilization and the Vanishing American*." See also David M. Lubin's useful review of this publication, "A Backward Look at Forward Motion," in *American Quarterly*, vol. 41, September 1989, pp. 549–57. Lubin points out that the essays lack a critical theory of representation, noting that, "these visual images represent the world for—on behalf of—those of a certain class or subclass who produce and consume these images" (p. 554).

5. For example, see Michael Shapiro and Peter H. Hassrick, *Frederic Remington: The Masterworks* (New York: Harry Abrams for the Saint Louis Art Museum and Buffalo Bill Historical Center, 1988). For an important alternative view of Remington see Alex Nemerov, " 'Doing the "Old America": The Image of the American West, 1880–1920," in William H. Truettner ed. *The West as America* (National Museum of American Art and Smithsonian Institution Press, 1990), pp. 285–343.

6. Letter to Poultney Bigelow, the editor of *Outing* magazine. Cited in David McCullough, "Remington the Man" in *Frederick Remington: The Masterworks*, exhibition catalogue (New York: Harry N. Abrams, 1988), p. 29.

7. Ibid.

8. Cited in James Horan, *The Life and Times of Charles Schreyvogel* (New York: Crown Publishers, 1969), p. 42.

9. Clarence Richard Linder, "The Romance of a Famous Painter," *Leslie's Weekly*, August 4, 1910, cited in Horan, p. 51.

10. News Release, Cowboy Artists of America 26th Annual Exhibition, pp. 3–4.

11. It is important to stress that the attraction for cowboy western art is strongest in the West and Southwest, and particularly in Texas, Oklahoma, and Arizona. Cowboy art has virtually no market in other regions of the United States or abroad. These states are without doubt among the most conservative in the United States, and the geographical connection with dominant conservative values expresses in the paintings another symptom of their political complexion.

12. William C. Foxley, *Frontier Spirit: Catalogue of the Collection of the Museum of Western American Art* (Denver: The Museum of Western American Art, 1983), p. XIII.

13. *Cowboy Artists of America: 25th Annual Exhibition at the Phoenix Art Museum October 19–November 18, 1990*, no page cited.

14. Cited in, James K. Howard, *Ten Years with the Cowboy Artists of America: A Complete History and Exhibition Record* (Flagstaff, AZ: Northland Press, 1976), p. 7.

15. "A History of the Cowboy Artists of America," *Cowboy Artists of America: 25th Annual Exhibition at the Phoenix Art Museum October 19–November 18, 1990*, no page cited.

16. According to the news release for the 1991 exhibition: "This year the artists will be head-quartered at the Ritz-Carlton Hotel . . . Friday evening will find art aficionados eagerly placing 'intent-to-purchase' slips in the boxes before their favorite pieces during this year's pre-exhibition sale at the Phoenix Art Museum, beginning at 7 p.m. Sharply at 8:00, the revelry is quieted by the lengthy, resonant blare of the horn signalling the end of the viewing period and the beginning of the draw. Through this time-forged tradition, a MAC [Men's Art Council] member stationed before each artist's exhibit then reaches into the 'intent boxes' in front of each work and selects two names who then receive first and second right of refusal. True to the mores of the Old West, this custom allows novice collectors equal opportunity with those who have been collecting cowboy art since the first CAA show at the Cowboy Hall of Fame" (News Release, Cowboy Artists of America 26th Annual Exhibition, pp. 4–5).

17. According to James K. Ballinger, Director of the Phoenix Art Museum: "For the past several years the CAA exhibit has been our most consistently attended show. In fact, over the 17 years the show has been held here at the Phoenix Art Museum, its patrons have proven to not only be the most consistent, but also some of the most enthusiastic. Though new visitors attend every year, the most fascinating thing about it is that we see many of the same faces from points near and far here for this show year after year" (News Release, Cowboy Artists of America 26th Annual Exhibition, p. 6).

18. According to the News Release for the 26th Annual CAA Exhibition: "Today's West aficionados are realists, they demand to be drawn into each piece through realistic points of view such as those depicted in recent movies like 'Dances with Wolves' and 'Son of Morning Star,' and the television mini-series 'Lonesome Dove.'

And this is just what the Cowboy artists offer—art reflecting reality in a school that has become known as Western American Realism.

Though the art lover of the 1990s often chooses jeans fashioned by designer, the traditional Levi had never been more popular—nor prominent in Western American Realism. This bent toward yesteryear's comfort has expanded beyond the pants. Famed designers—such as Ralph Lauren—are now offering full wardrobes patterned after those of the Old West. . . .

Just how do they know what these fabrics and styles were? One of the ways is through the CAs paintings and sculptures. Thus it is that the CAA, once again, leads the movement toward demands for authenticity through true reflections of cowboys and their compatriots of the Old and new West" (pp. 1–2).

19. For a perceptive discussion of the place of women in western art see Corlann Gee Bush, "The Way We Weren't: Images of Women and Men in Cowboy Art," in Susan Armitage and Elizabeth Jameson, eds., *The Women's West* (Norman, OK: University of Oklahoma Press, 1987), pp. 19–34. Bush notes: "[The] sense that women must be protected by white men from the ravages of Indian men is also a favorite theme of cowboy artists. . . . These paintings reinforce the cultural view that Indian men were heathens and savages, a class of 'others' who deserved killing because they threatened white women. Thus, by portraying white men as courageous defenders of virtue, by showing white women as helpless at the hands of ravening savages, this subgenre of cowboy art reveals how inextricably racism is connected to sexism in the American subconscious" (p. 28).

20. Lonn Taylor, "The Open Range Cowboy of the Nineteenth Century," in *The American Cowboy*, exhibition catalogue (Washington, DC: Library of Congress, 1983).

21. Taylor, p. 17. Taylor is citing the historian of Montana, K. Ross Toole, in making this bold assertion.

22. The News Release for the 26th CAA Annual Exhibition proudly notes: "Western artworks can be seen throughout corporate offices across the country, almost every government office—and particularly state capitol buildings—features at least one of these representations of our national heritage. But, one location easily wins out as the one of which they [cowboy artists] are

most proud. Tom Ryan, J. N. Swanson and Melvin Warren each boast the fact that their paintings have graced the walls of the White House. Indeed, American presidents—from Lyndon Johnson to George Bush—have favored Western art" (p. 6).

23. See Jack Weston, *The Real American Cowboy* (New York: Schocken Books, 1985). Weston observes: "The only force strong enough to explain such a powerful appetite for the Western [film] is a profound sense of deprivation and loss by the American people and a mass longing for a better world. We continue to believe that we have been robbed of our community, our freedom, and our natural environment, and we long for a world in which we once enjoyed these benefits and rights. The West offered such a world, and the myth of the West offered a later fantasy world after industrial corporate capitalism completed its conquest of the real West" (p. 210).

24. Letter to the author 25 September 1991, from Susan Strausser, Consumer Affairs, Philip Morris.

25. Foxley, p. XI.

26. One academic apologist for the Cowboy Artists, University of Arizona Professor Sheldon Reich is quoted in the News Release for the 26th Annual CAA Exhibition: "I thought when I first came in contact with the work of the Cowboy Artists of America that their work, while attractive enough, had no real economic value. I have since changed my mind. It has a rather broad audience and the pictures and sculptures do have a rather substantial value. There are even a few stars that garner prices in the six digits, and that's pretty good for any living artist not residing in the art colonies of New York and Los Angeles. In fact, that's good money for any artist" (p. 1).

9

Blacks in Shark-Infested Waters

Visual Encodings of Racism in Copley and Homer

Albert Boime

[The slave trade is a] cruel war against human nature itself, violating its most
sacred rights of life and liberty.

—Thomas Jefferson, a slaveholder[1]

Watson and the Shark, 1778, by John Singleton Copley (1738–1815) and *The Gulf Stream*,
1899, by Winslow Homer (1836–1910) share more than a common depiction of a dramatic
marine subject. The works make assertions about blacks in the West Indies, a crucial leg in
the triangular trade of slaves, the one glorifying them in the guise of the "noble savage,"
the other focusing on their perennial dilemma in a racist world. Together they bracket one
hundred years of American history critical to the status of blacks in the political, social,
and cultural life of the nation, embracing the Revolution, Civil War, Reconstruction, and
de facto segregation. In addition, both pictures were painted by North American artists
from privileged white middle-class backgrounds. Thus, a study of their themes should
reveal significant clues as to how two of the nation's most gifted artists visually transmitted
the attitudes of their peers toward blacks.

Recent studies on Copley's *Watson* attest to the powerful appeal of its thematic com-
plexities and vivid treatment (color plate 7).[2] These studies challenge the traditional view
of the painting as essentially a historical reconstruction of the event that led to young
Brook Watson's (1735–1807) dismemberment by a shark. Irma Jaffe examines the work's
religious symbolism and interprets it as an allegory of resurrection and salvation, while
Roger Stein demonstrates the picture's seminal contribution to a new American seascape
typology forged out of the influence of New England puritanism and the idea of the sub-
lime. Ann Uhry Abrams analyzes the profound links between the work and the War of
Independence, particularly as events of the struggle were recorded in contemporary popu-
lar imagery and satirical prints.

The efforts of these scholars have convincingly grounded the work within the Ameri-
can political, religious, and literary traditions of the late eighteenth century. Yet except for

Stein's essay, none of the modern studies—including Jules Prown's pioneering work on Copley—have paid more than passing attention to what is perhaps the fundamental motif of the composition—the figure of the black man occupying the key location at the top of the visual pyramid. While this essay will argue against Stein's suggestion that Copley depicted this figure as the "democratic equal of the whites," his provocative insights in the closing paragraphs of his study, which insist on the "crucial role" of the black crewman and the "umbilicus" that links him to Watson, open the way for a deeper understanding of the painter's singular triadic relationship of black man, victim, and shark.

Throughout the history of art, this triangular configuration not only established compositional unity, but also denoted social hierarchy and subordination. Almost invariably in traditional representations we find that the summit or apex of the pyramidal design is occupied by royal, religious, or allegorical authority (later supplanted by bourgeois leaders), while plebeians or others lower on the social scale are consigned to the base or terrestrial level. This hierarchical arrangement is especially striking in scenes depicting blacks, who are, almost without exception, located at the bottom of the pyramidal configuration in a humble or servile position. Visually they are literally and figuratively associated with all that is base or inferior in social position. Even when the intention was to express goodwill to blacks, as in the case of Samuel Jennings's abolitionist allegory of *Liberty Displaying the Arts and Sciences*, the artist could not override the dictates of this powerful convention (color plate 8).

The fact that Copley's dignified black man reverses this conventional hierarchical arrangement adds significantly to the unorthodox nature of the picture and aids us in unraveling its thematic and visual complexities. At the same time, a careful examination of Copley's visual pyramid and its relationship to previous formal encodings of hierarchical representation enables us to grasp the later evolution of this encoding in response to the developing history of blacks in American society. Homer, for example, clearly assimilated every iconographical ingredient of Copley's *Watson* in *The Gulf Stream* (color plate 9). Yet in stripping away every figure except the black man—thereby making him the central focus of the triangular design—Homer constructed a new meaning based on his understanding of contemporary race relations. While the total isolation of the figure might not be understood in relationship to a hierarchy in the narrative sense, its relationship to the iconographical tradition tells us much about the social meaning of the image.

Watson represents the incident in 1749 when young Brook Watson was attacked by a shark while swimming in Cuba's Havana Harbor. Nine men, most of them sailors, are crowded in a lifeboat frantically engaged in rescuing the youth. All aboard seem to have their distinct function within the operation: one shouts orders to two others leaning over the side to grasp Watson, one navigates, three others row, and one holds a towline while a harpooner poises his weapon to strike the shark. The dynamic thrust of the harpooner's arm establishes the right-hand slope of the pyramidal composition, with the end of the harpoon serving as a vertex. Just to his right the black man holds the towline, occupying the key location in the design close to the vertex. The base is formed by the helpless, mangled body of Watson and the ferocious shark. Hence, a genuine reversal has taken place here in which the victim, a white man, occupies the lower register and a black man the upper portion. Moreover, the towline that the black man holds reels off down the side of the boat and wraps around Watson's right arm, establishing a direct connection with the white victim and giving the black man a potentially primary role in the rescue operation.

But when we look more closely at the picture, some curious features emerge: the black man is dressed more fashionably than the others, clearly distinguishing him from his fellow sailors; also, he is the only person that does not participate in the vigorous convergence toward Watson. The others struggle to reach the injured youth or work energetically on his behalf, while the black man stands passively holding the rope, seemingly waiting for the others to grasp it at the proper moment. He stretches his free arm out away from the action in an elegant gesture (perhaps to balance himself) that contrasts sharply with the hectic, concentrated movements of his colleagues. Thus, the ambiguity of his position among the other crew members is pronounced, and it is not surprising that critics of the period pointed out this discrepancy and wondered at his curious role within the design.[3] Apparently the majestic black man functions as a servant, waiting to hand the rope to the others when called on to do so; at best he registers a sense of compassion for the hapless Watson.

The picture was painted at the very beginnings of the English abolitionist movement that was spearheaded by the philanthropist Granville Sharpe, whose profound influence on fellow countryman William Wilberforce in the next decade would in turn generate the impulse for a century of international clamor for abolition. A Whig agitator for reform, Sharpe won a court ruling in 1772 that essentially abolished slavery in Great Britain, permitting any slave setting foot on the soil of Great Britain to become automatically free. This ruling occurred ten years after England had practically secured the monopoly on the slave trade.[4] Earlier, England developed an enormous slave smuggling operation, designed to deprive the custom house in Cuba—perhaps the major slave market in the Atlantic world—of duties on imported slaves. A great deal of illicit trading went on between 1740 and 1750, embracing the period of Watson's participation in mercantile affairs in Cuba. By the 1770s the Quakers and other dissidents began speaking out for abolition, and philanthropist David Hartley initiated the first motion on the subject in Parliament in 1776 on the grounds that the "Slave-trade was contrary to the laws of God, and the rights of men."[5] The motion failed, but the Declaration of Independence, proclaimed that same year, also made numerous—albeit indirect—allusions to slavery in connection with George III's colonial policies.

These early stirrings in behalf of the abolitionist cause gave particular meaning to Copley's picture. It was Brook Watson himself, now an immensely wealthy merchant and Tory leader, who commissioned the painting and dictated its subject. At that time, the Tories (staunch supporters of the throne) and Whigs (the opposition supporting American independence and reform) were engaged in bitter controversy over the American Revolution, and the question of repression and slavery became a burning issue, cutting across party lines. Thus, opponents of the Revolution—including the notorious Tories Samuel Johnson and Edmund Burke—who simultaneously wished to present themselves as defenders of liberty, exploited the slave question as a safe outlet for their beliefs. Naturally, as the movement gathered momentum and threatened to make abolition a reality, some of them changed their views.

The historian Samuel Isham asserted that Watson's youth was spent in the slave trade, a claim disputed by Watson's biographer, J. Clarence Webster.[6] Orphaned at an early age, Watson was sent to Boston in the late 1740s in the care of a relative named Levens, who was engaged in some form of smuggling. We know that Levens sent the youth on a regularly scheduled trading voyage to the West Indies. As stated earlier, trading vessels depart-

ing from Boston to the West Indies often traveled by way of the "Middle Passage"—through that part of the Atlantic Ocean between Africa and the West Indies that designated one symbolic leg of the "triangular trade" in slaves. Vessels left Boston harbor carrying rum and other commodities to trade for African slaves and then headed for the West Indies to exchange their human cargo and supplies for sugar and molasses, so essential to the New England economy.[7]

Inevitably, Boston merchants engaged in smuggling in reaction to the harsh trading restrictions imposed on them by the Mother Country. Great Britain intended the Navigation Acts of the seventeenth century to secure certain colonial exports for their exclusive use and to discourage colonial consumption of foreign products. Thus, the options of the colonial merchants for turning a profit were severely circumscribed. Resourceful individuals engaged in illicit trade with Spanish and French colonies in the West Indies to earn credits to pay for British goods and maintain a favorable balance of payments.[8]

West Indian colony planters found the cultivation of sugar cane so profitable that they chose to devote whatever land they owned to its production, neglecting to raise the foodstuffs necessary to feed their families and slaves. The island planters were also in desperate need of timber for building and barrel staves for their sugar and molasses, which Yankee traders were only too happy to supply. They brought to the islands huge cargoes of timber and dried fish—two otherwise unmarketable commodities that New Englanders possessed in great abundance. The islanders bought, at bargain prices, the dried and broken bits of cod unfit for other markets to feed their slaves.

The drive for increased profit prompted Boston merchants such as Levens to augment their fortunes outside the empire, especially if they wished to avoid the onerous duty on foreign molasses obtained from the Spanish and French colonies. Great Britain intended these duties, imposed by the Molasses Act of 1733, to force North Americans to depend on the British islands for their entire supply. By the early 1730s, however, Boston and Newport had established their own rum distilleries, which consumed such vast amounts of cheap molasses that they could not be adequately supplied by the British colonies. Their merchants then engaged in an aggressive smuggling trade that not only included lumber and dried fish but African slaves as well, which they purchased with rum distilled from West Indian molasses.[9] Given the prevalence of illicit trade during this period, it is quite likely that Levens participated in smuggling commodities and slaves. Watson's own lifelong interest in the exporting of dried fish to the islands suggests that he picked up this end of the business from his Boston mentor.

It was during a moment of recreation on one of these trading voyages that Watson was attacked by a shark and lost the lower half of his right leg. After recovering from his ordeal, Watson learned that Levens had gone bankrupt and disappeared. After a series of new adventures, the youth eventually appeared in Nova Scotia as secretary to Lieutenant Colonel Robert Monckton of the British army. Joshua Winslow, Chief Commissary to Monckton's army, so admired the industrious Watson that he hired him for his department. In 1759 Watson returned to London and joined the mercantile company of Joshua Mauger, who had earned a fortune in Halifax both as a provisions agent for the troops and as a distiller and leading smuggler in the province. Watson and Mauger conducted a large trade, chiefly with North America. Watson then entered into a partnership with Robert Rashleigh, exporting goods to the colonies and to the East and West Indies. As he prospered, he

maneuvered for position within the Tory ranks. In 1779 he helped organize the corps of royalist light horse volunteers who aided in the suppression of the Gordon Riots in 1780—an event that involved underclass protest against the economic burden resulting from the American war.

Because Watson traveled regularly to the American colonies on business and vehemently proclaimed himself to be a liberal and a friend of the colonialists, he could secretly serve as a British agent, relaying information to the British government. Copley would have been well aware of Watson's role as spy because their economic interests so closely overlapped. Copley was married to Susanna Clarke, daughter of Boston's leading importer, whose relatives occupied key commercial posts and were dependent on England for their income and status. Of the three Massachusetts firms designated as consignees for the British East India Company, one belonged to Copley's in-laws and the other two to their relatives. One of these companies belonged to Joshua Winslow, Susanna Clarke Copley's uncle, who had hired Watson when he was the Commissary-General to Monckton's army.[10] Winslow's company served as the Boston representative for the London exporting firm of Watson and Rashleigh. During the summer of 1773 Watson met often with Copley's brother-in-law, Jonathan Clarke, as well as the other consignees to coordinate plans for shipping tea to America. This set the stage for the momentous episode known as the Boston Tea Party in 1773, an event that traumatized Susanna Copley's family and forced Copley to move permanently to London.[11] While Copley later insisted on his political neutrality, his economic interests were bound up so closely with the Tories that we must see the definitive break with his homeland as a political act of opposition.

Meanwhile, Watson continued to make his way in the Tory ranks. At the time Copley painted *Watson and the Shark*, there was bitter strife between the Tories and the Whigs. Alderman John Wilkes, the dynamic and controversial leader of the Whig Party, whose followers used as their rallying cry the slogan "Wilkes and Liberty!", had been elected Lord Mayor of London during 1774–1775 and used his prestigious position to advance the colonists' claims. Unlike Watson, Wilkes sided with the rebels and even encouraged their revolt. In this he was constantly at odds with the Tories, especially successful London merchants like Watson, one of Wilkes' favorite targets. Indeed, the mirthful postwar *Criticisms on the Rolliad*, a Whig satire written by Wilkes' partisans, makes Watson and his wooden leg the butt of a witticism that concludes: "The best of workmen, nor the best of wood/ Had scarce supply'd him with a head so good."[12]

Wilkes had long since become the hero of the smugglers and merchants of Boston, who organized the Sons of Liberty opposing the Stamp and Townshend Acts. In 1768 they made a direct bid for his support, writing with such deferential reverence that it is clear they had idolized him for some time. Wilkes maintained a regular correspondence with the group through the early 1770s, Steadfastly proclaiming his friendship for the colonies. As he wrote to William Palfrey, the Secretary of the Boston Sons of Liberty, "The cause of liberty in America as well as here shall always have in me a zealous advocate, and where my little influence extends, it shall be employed in the promotion of it." Palfrey wrote him later that year to reassure him that "the Sons of Freedom will love and honor you, while you persevere in that best of causes." Immediately after the Boston Massacre, the town's Freeholders organized a committee to inform Wilkes of the entire episode and to keep him posted on certain people "plotting the ruin of our Constitution and Liberties."[13]

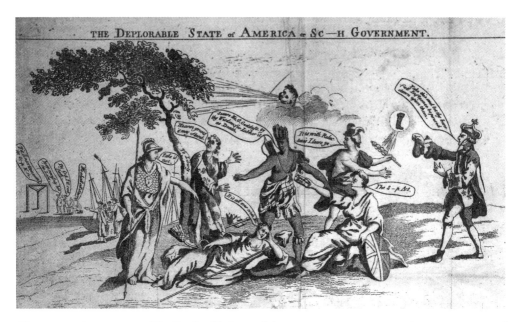

Figure 9.1 Anonymous, *The Deplorable State of America*, 1765, engraving. Library Company of Philadelphia.

Thus, it is not surprising that on both sides of the Atlantic, Tories such as Watson and Copley scapegoated Wilkes as the source of their domestic and foreign problems. Significantly, Copley exhibited this negative attitude toward Wilkes in his work. The painter eliminated a symbolic reference to the liberal leader in a satirical print he created in response to an English engraving attacking the Stamp Act—an image he otherwise picked over generously for ideas (fig. 9.1). The English caricature, *Deplorable State of America*, shows Liberty lying prostrate on the ground, sighing, "It is all over with me," while the staff surmounted by a liberty cap, the popular symbol for Wilkes, falls from her grasp.[14] Copley's version adopted all the symbolic trappings with the exception of the staff and liberty cap, the allusion to Wilkes, and is essentially much more conservative than its predecessor. For the personification of Liberty, Copley substituted a Native American who exclaims, "and canst thou Mother! O have pity this horried box," as Britannia hands Pandora's box (the Stamp Act) to an Indian woman (her "daugher").[15] Although both cartoons oppose the Stamp Act and the collusion of foreign powers in its imposition, the earlier deals with the impact on domestic and internal reform in England itself, while Copley's focuses on the damaging impact on the colonial relations between the Mother Country and its mercantile offspring. The English illustrator agitates generally for internal liberal reform, which naturally embraces the question of liberty for the colonies, but Copley's concern is much more narrowly confined to the status quo.

Because *liberty* and *slavery* were terms bandied about by the American colonial elite to ensure their continued prosperity, the Tories had to establish that they were not tyrants bent on suppressing the colonies' freedom. The question of black servitude arose in this context and cut across party lines; many Whigs supported and profited from slavery, while

die-hard Tories like Samuel Johnson bitterly attacked it. Johnson, in fact, delighted in laying bare the contradiction in the colonists' ideology. He greeted the news of the Declaration of Independence with the announcement, "How is it that we hear the loudest yelps for liberty among the drivers of Negroes?"[16]

The egregious inconsistency of American demands for freedom while at the same time maintaining slavery exposed the colonists to devastating critiques both at home and from abroad. In his *Dialogue Concerning the Slavery of Africans* Samuel Hopkins wrote of the "inconsistence with ourselves, in holding of so many hundreds of thousands of blacks in slavery, who have an equal right to freedom as ourselves, while we are maintaining this struggle for our own and our children's liberty."[17] Even slaves themselves plunged into the debate: In 1777 one group in Massachusetts wrote pointedly "that every principle from which America has acted in the course of her unhappy difficulties with Great-Britain, pleads stronger than a thousand arguments in favor of your humble Petitioners."[18] Thus, strident attacks from British critics joined a growing domestic outcry of black and white indignation over the contradiction between American ideology and practice involving blacks. John Jay commented on this profoundly embarrassing contradiction in the American cause, "To contend for liberty and to deny that blessing to others involves an inconsistency not to be excused."[19]

The colonists' concern for international opinion is reflected in the Pennsylvania Executive Council's suggestion to the Assembly in 1778 that the importation of slaves be prohibited as a first step toward eventual abolition. The council claimed that this move would boost American prestige among Europeans "who are astonished to see a people eager for liberty holding Negroes in Bondage." The same year New Jersey's governor urged the state legislature to provide for eventual abolition on the grounds that slavery violated the principles of Christianity and was especially "odious and disgraceful" for a people pretending to love liberty.[20]

But it was in Massachusetts, where resistance to British authority had been the sharpest and most ideological, that the conflict between revolutionary ideals and slave practice hit home most directly. Clergyman Jeremy Belknap of Boston remarked, "The inconsistency of pleading for our own rights and liberties, whilst we encouraged the subjugation of others, was very apparent; and from that time, both slavery and the slave-trade began to be discountenanced." As the colonial crisis headed for a showdown earlier in the decade, New Englanders grew ever more self-conscious about the contradiction. Abigail Adams wrote to her husband John in 1774 that it was iniquitous to "fight ourselves for what we are daily robbing and plundering from those who have as good a right to freedom as we have."[21]

Participants in Massachusetts town meetings began to link their protests against royal usurpation with pleas that slavery be abolished. In September 1776, two months after the Declaration of Independence (which made no mention of slavery), the State House of Representatives climaxed this swelling chorus of sentiment with the resolution that slavery violated the natural rights of man and was "utterly inconsistent with the avowed principles in which this and other States have carried on their struggle for liberty." Several slaves in Massachusetts collected money among themselves and successfully sued for their freedom; John Adams defended bondsmen in several cases with the argument of the "rights of mankind, which was the fashionable word at that time."[22]

Perhaps a black slave illuminated the gross contradiction most forcefully in a poem published in the New London *Gazette* on 1 May 1772:

Is not all oppression vile?
When you attempt your freedom to defend,
Is reason yours, and partially your friend?
Be not deceiv'd—for reason pleads for all
Who by invasion and oppression fall.
I live a slave, and am inslav'd by those
Who yet pretend with reason to oppose
All schemes oppressive; and the gods invoke
to curse with thunders the invaders yoke.
O mighty God! let conscience seize the mind
Of Inconsistent men, who wish to find
A partial god to vindicate their cause,
And plead their freedom, while they break its laws.[23]

But slavery continued in the Massachusetts Commonwealth long past Copley's comple-
tion of *Watson*, and indeed in the very year of its execution even the status of freedmen
proved troublesome for the colonists. Massachusetts' proposed state constitution—based on
the formula for its militia act of 22 January 1776, which debarred blacks and Native Ameri-
cans from the army—excluded Negroes, mulattos, and Indians from the suffrage, demon-
strating that public sentiment was far from unanimous on the question of political rights for
emancipated slaves.[24] Thus, Tory critics and their colonial sympathizers had no trouble forg-
ing a wedge between their opponents by exploiting the crisis of conscience over colonial
principles and practices. Tory writers taunted the rebels of 1776 with charges of hypocrisy,
and developed strategies for discrediting the colonists' cry of oppression by associating it
with black slavery. In 1776 the theologian Samuel Hopkins observed that the bondage the
colonists complained of was "lighter than a feather" compared with the suffering of blacks.
These arguments were used to neutralize the shibboleth of *Tyranny* on the one hand, and to
demonstrate that the colonists themselves were tyrants on the other. This criticism caused
discontent and unease among a growing number of Americans sensitive to the accusations
of inconsistency in holding slaves while resisting a British plot to enslave the colonies.[25]

The Tory critics contributed to this divisive strategy not only through the printed
medium and by rumor, but through the active recruitment and organization of black slaves
in the colonies. The English promised freedom for every runaway slave that joined their
army and navy. Indeed, Thomas Jefferson's rough draft for the 1776 Declaration of Inde-
pendence included a paragraph—later omitted—condemning George III for instigating
the slaves "to rise in arms among us, and to purchase that liberty of which *He* deprived
them, by murdering the people upon whom he also obtruded them; thus paying off former
crimes committed against the liberties of one people, with crimes which he urges them to
commit against the *lives* of another."[26] This doubletalk offended the Southern delegation
because of its allusion to slavery, and its faulty logic and conspicuous distortion made it
easy to dismiss.

But Jefferson did refer to an actual historical situation, although he reinterpreted it to
suit his own ideological predisposition. In November 1775, Lord John Murray Dunmore,
the governor of Virginia, issued a proclamation at Norfolk offering freedom to slaves who
would join the British army. As an early English historian understood it:

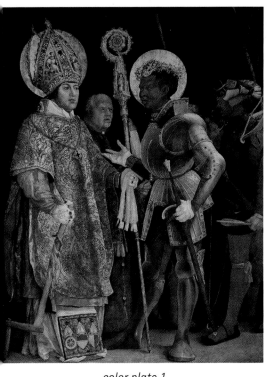

color plate 1

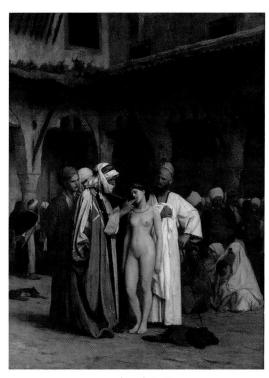

color plate 2

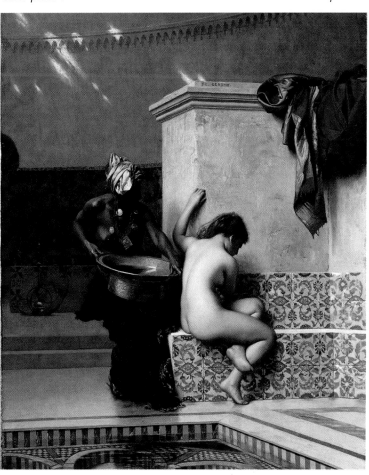

color plate 3

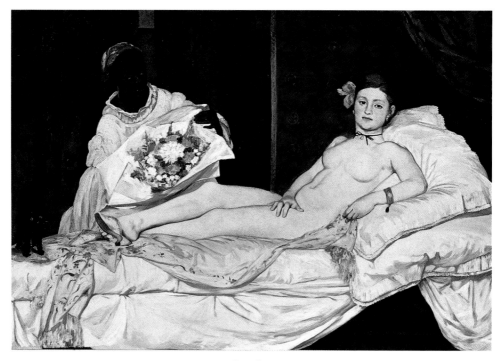

color plate 4

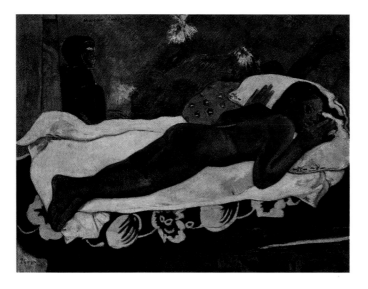

color plate 5
Paul Gauguin,
Spirit of the Dead Watching, 1892

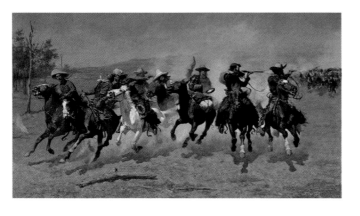

color plate 6

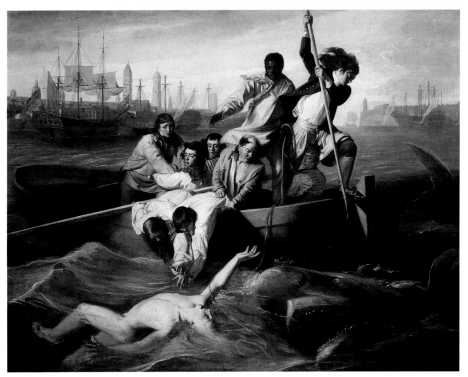

color plate 7

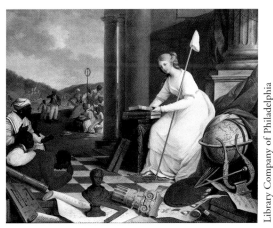

color plate 8

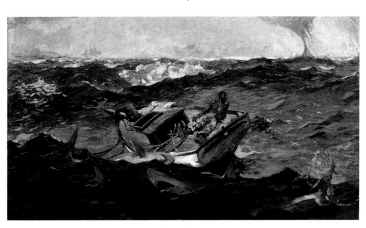

color plate 9

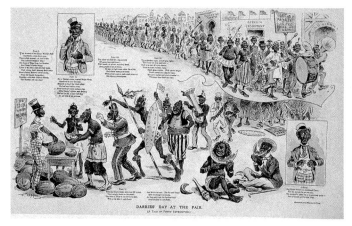

color plate 10

color plate 11

Cover of *"Primitivism" in 20th Century Art: Affinity of the Tribal and the Modern*, volume 1, 1984 (detail of Pablo Picasso's *Girl before a Mirror* and Kwakiutl Mask).

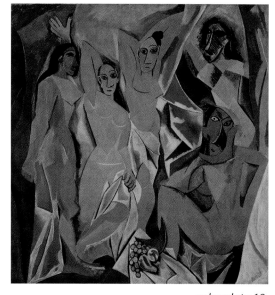

color plate 12
Pablo Picasso,
Les Demoiselles d'Avignon, 1907

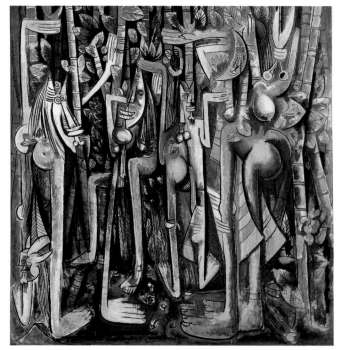

color plate 13
Wilfredo Lam, *The Jungle*, 1942–43

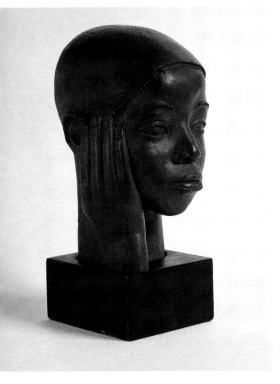

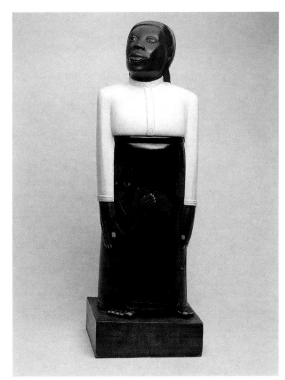

color plate 14

color plate 15

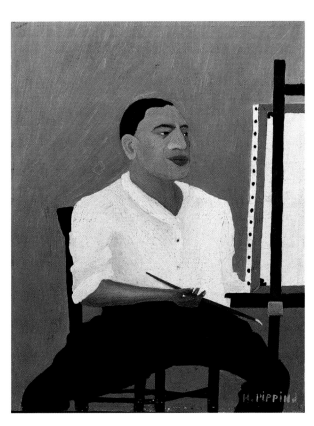

color plate 16
Horace Pippin, *Self-Portrait*, 1941

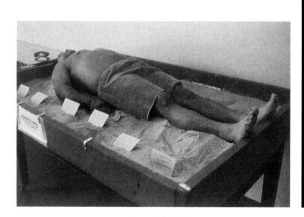

color plate 17

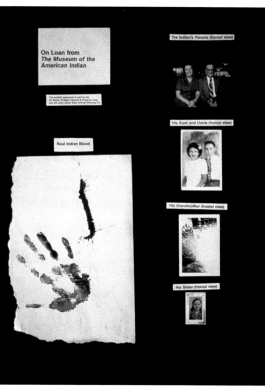

color plate 18

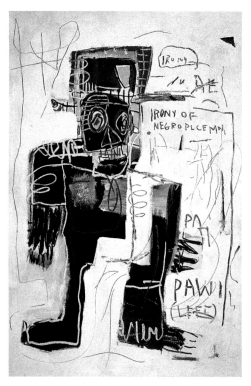

color plate 19

color plate 20

color plate 21

color plate 22

color plate 23

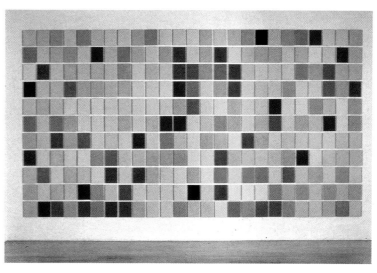

color plate 24

My skin

isn't dark

enough
for you

to think

I've ever
worked hard

in my life.

color plate 25

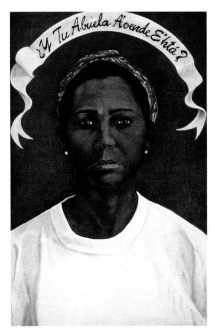

color plate 26

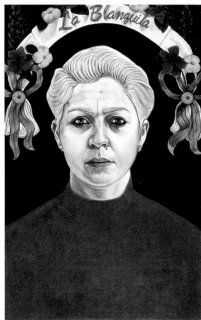

color plate 27

color plate 28

In letters which had been laid before the English Parliament, and published to the whole world, he (Lord Dunmore) had represented the planters as ambitious, selfish men, pursuing their own interest and advancement at the expense of their poorer countrymen, and as being ready to make every sacrifice of honesty and principle, and he said more privately, that, since they were so anxious for liberty,—for more freedom than was consistent with the free institutions of the Mother Country and the charter of the Colony,—that since they were so eager to abolish a fanciful slavery in a dependence on Great Britain, he would try how they liked abolition of real slavery, by setting free all their negroes and indentured servants, who were, in fact, little better than white slaves.

Dunmore's plan miscarried, but its implications had not been lost on the colonists. A large contingent of blacks served under his leadership, and when the colonists finally forced him to set sail for England in 1776 he took these volunteers with them. Their presence in England heightened British accusations of inconsistency between colonial ideals and practice and demonstrated the Mother Country's more liberal attitude toward blacks.[27]

The Tories continued to appeal to slave unrest, feeding rumors of servile insurrection that spread panic among slaveholders in areas like the Hudson Valley. The eruption of civil war and British occupation of the colonies provided blacks with opportunities for escape or for joining ranks with the Tories. In turn, these pressures on the colonists, plus the shortage of manpower on their side, contributed to a shift in sentiment against the slave issue, especially in the North. Various states encouraged the emancipation of slaves for military service, using some slaves as substitutes for their masters. Ultimately, thousands of blacks—both slave and free—fought under Washington's command, and took part in every major battle of the War of Independence. But their participation occurred mainly in response to the British policy of declaring free all slaves who joined their side.

Similarly, Copley's picture demonstrates a Tory attempt to show sympathy for repressed people at the height of Tory antagonism toward the American Revolution. Through the work, both painter and patron sent the message that opposition to the rebellion was not identical with opposition to regulated freedom. In *Watson*, a conservative painter formulated for his conservative client a response to the political attacks of Whig opponents whose own involvement in slavery belied their stated defense of American independence. Watson, moreover, emphasized his close association with the New World, not just as an armchair spectator or tourist, but as someone who had experienced it in the raw. Seemingly, Watson announced: "I know more about this world than smug, self-righteous Whigs. I have been there and I have suffered there." His vision of the New World had not yet been vitiated by trivia such as tea and taxes, and it was regulated humanely by a privileged white minority. Not surprisingly, while the black man in Copley's picture has been treated sympathetically and plays an emblematic role in the general design, Copley presents him mainly as an exotic servant who awaits his master's next move.

The answer to this ambiguity lies in the conservative instincts of patron and client. During the early parliamentary debates over abolition between 1789 and 1792, Alderman Watson reacted in fright to the possibility of immediate abolition. He opposed it on the grounds that it would gravely compromise London trade and thereby bring ruin on the entire nation. He presented a petition from business associates in the West Indies warning of the disastrous economic consequences of abolition and stressed the links between the

slave trade and British commerce in general. For example, Newfoundland sold a vast quantity of "inferior fish" that "was quite unfit for any other market" to West Indian planters for their slaves. Thus, Watson reasoned that destruction of the slave trade would undermine every other branch of English commerce. At one point in his argument, Watson even judged the slave trade "to be merciful and humane." He urged gradual emancipation and "wholesome regulations" as a substitute for abolition.[28]

Painter, playwright, and historian William Dunlap, who studied under Benjamin West when Copley lived in London, commented bitterly on the relationship between Watson and Copley, remarking that once the latter had moved to England he was "no longer an American painter in feeling; and his choice of subjects for historical composition was decided by the circumstances of the time, or by employers." Then, citing the example of *Watson and the Shark*, Dunlap indicted the former "as arrayed with our enemies in opposition to our independence, and with the enemies of God and man in opposition to the abolitionists of the slave-trade in the English house of commons. Before he avowedly joined the standard of Britain, the traitor ingratiated himself with many leading Americans, obtained as much information of their designs as he could, and transmitted it to his chosen masters. In the character of legislator, his argument in support of the trade in human flesh was that it would injure the market for the refuse-fish of the English fisheries to abolish it—these refuse-fish being purchased by the West India planters for their slaves. To immortalize such a man was the pencil of Copley employed."[29]

Watson clearly perceived the slave trade in a somewhat different light when he earlier commissioned Copley to paint the picture in 1778. At this point, as Irma Jaffe has suggested, Watson sought some form of symbolic resurrection and salvation, evident in Copley's inclusion of pictorial sources and biblical allusions.[30] Many New Englanders, with their puritanical upbringing, viewed the troubles of the period as a form of divine retribution for holding human beings in bondage. Samuel Hopkins noted in his *Dialogue Concerning the Slavery of Africans* that "if the slavery in which we hold the blacks, is wrong; it is a very great and public sin; and therefore a sin which God is now testifying against in the calamities he has brought upon us, consequently must be reformed, before we can reasonably expect deliverance, or sincerely ask for it."[31] Deacon Benjamin Colman of Newburyport even went so far as to suggest that God ordained the British authorities to close the port of Boston because the town had been the first to engage in the slave trade.[32]

Copley represented Watson as a victim of divine wrath for his own involvement in slave trading. Watson commissioned the work during the period when Tories and Loyalists chided the colonists for their inconsistent position on freedom and slavery, thus holding himself up as an example and a warning of the impending punishment awaiting Americans unless they abandon their present path. Therefore, Watson prompted Copley to invert the normal hierarchical dependence, turning the social pyramid upside down with himself in the position of victim and the black man in the position of master. It may not be coincidental that the hapless body of Watson closely resembles the prostrate victim at the left in Paul Revere's engraved broadside of the *Bloody Massacre*, which represents the Boston Massacre of 5 March 1770, whose first victim was a black man named Crispus Attucks. A former slave, Attucks led the rebellious colonists against the redcoats. Described as exceptionally tall, Attucks is likely the tall corpse in Revere's illustration resembling the wounded Watson. (Copley certainly knew this engraving, because Revere plagiarized it from a design

by Copley's stepbrother, Henry Pelham, who published his two weeks after Revere's came out; they are almost exact duplicates.) In this sense, Watson replaces the martyred Attucks, who has been resurrected in the form of the black man standing in the boat.

The colonies are shown metaphorically as shark-infested waters—dangerous breeding ground for revolutionary ideas that threaten the youth of the New World. When Copley first learned of the outbreak of war in Boston in 1777, images of blood and gore instantly sprang to his mind. He wrote to his wife that the "ground will be deluged with the blood of its inhabitants before peace will again assume its domain in the country." Two years earlier he wrote his stepbrother that "Ocians [*sic*] of Blood will be shed to humble a people which they never will subdue."[33] Yet in *Watson* it is the British who come to Watson's rescue, delivering him from the jaws of evil. Watson assumes the role of martyr and mediator in the cause of peace, interposing his body between the Old and New Worlds. Watson could fulfill this role because he literally had one foot in the New World and one in the Old.

Both Watson and Copley wished to see America's potential develop in a stable world ruled by the Mother Country, and they perceived the possible loss of America as a tragic event. Watson's severed leg emblematizes this possibility: as Abrams has shown, severed limbs were a common symbol in contemporary illustrations for a dismembered British empire or a disunified state. At the same time, the gruesome bite of the shark had long been associated with the system of slavery indeed, the expression "to be thrown to the sharks" grew out of its grisly practices. Blacks who died en route from Africa to the West Indies or America were thrown overboard, or those who saw their fate as hopeless often jumped overboard, thus serving as shark bait. Occasionally a dead slave was used deliberately as bait, to lure sharks when food was scarce, ironically feeding the sharks to enable the crews to survive. In this cannibalistic cycle, the slavers literally devoured their own slaves like greedy sharks. As Peter H. Wood suggests, this powerful image of the African "caught between the devil and the deep blue sea" provided a cogent stimulus for writers and artists of the day. In 1732 an English travel anthology published one unforgettable description of the shark:

> If a man happens to fall overboard, and these monsters are at hand, they soon make him their prey; and I have often observ'd, that when we threw a dead slave into the sea . . . one shark would bite off a leg, and another an arm, whilst others sunk down with the body.[34]

The links between the severed leg as a metaphor for the dismembered nation and the cruelties of slavery converge at the interposed body of Watson. Copley's representation of Watson reverses the traditional hierarchical relationship of white and black, slave and victim. But Watson still maintains his hold over the black man, who serves him the rope. That is, the black rescuer remains mastered by Watson despite the reversal of black and white. The homologous relationship of Watson and the shark further sustains this association. The eyes and mouths of the attacker and victim are depicted analogously, wide open and jaws agape. Furthermore, the forms enclosing both Watson with his outstretched arm and the shark's head mirror each other like two animated scalene triangles clashing head-on. They comprise in turn a triangular subset of the larger triadic organization. Thus, Watson and the shark are shown to be equivalent entities, and both in fact are under attack in a kind of cyclical visual allegory akin to "Big Fish Eat Little Fish." We recall that Watson connived and intrigued like a shark in his business dealings and in his espionage. In this

sense Watson is hunter and victim simultaneously, and this dialectical relationship should be understood as a pictorial solution to his need to redeem himself—Jonah-like—from his guilty past. Watson reaches upward for aid with his right arm, while his black counterpart reaches downward with his right in a parallel gesture that establishes their need for one another.[35] While the gap is unbridgeable pictorially and in fact, Watson asks for forgiveness and receives it metaphorically from the victims he himself has greedily devoured. Thus, the shark within him his been exorcised, and by extension the shark-infested waters of the colonial appendage are cleared. But the actual hierarchy remains untouched in both New and Old Worlds.

Conceptually, Watson's fate and the black man's freedom are intertwined, with the condemned relegated to the lower register of the composition and the newly emancipated at the top. But this arrangement was an abstract formulation established consciously to counter and expose colonial hypocrisy. Watson, and probably Copley as well, did not wish immediate abolition and certainly not political rights for blacks but only a vague paternalism disguised by the phrase "natural rights of man." On this abstract plane the black man could be permitted to exist as a sign, but his actual participation in the social structure was to be minimized.[36] This concept explains the black man's curious ambiguity in the composition: while occupying the key position in the triangle, he in fact functions as little more than a peg on which to hang the towline. His expression reflects his concern for the fate of the youth, but he does not act. Thinkers as sophisticated as Jefferson gave more credence to the black man's moral sense than to his intelligence, placed more emphasis on his feelings than on his reflections. Given this retrogressive position, it is understandable that in Copley's painting the black man—despite his prominent position—remains an invisible man whose capacity to act in the real world is blocked. In the end, he functions as a decorative adjunct to the composition, as empty of potential action as the rhetorical shallowness of the colonists and the inflated bombast of their Tory critics.

If the black man in Copley's picture embodies an intellectual abstraction of the libertarian viewpoint, Homer's besieged fisherman is an allegory of the black man's victimization at the end of the nineteenth century. *The Gulf Stream* depicts a solitary black man, modeled with a powerful physique, but flat on his back on the deck of a fishing boat damaged by a squall, threatened by sharks on one side and an advancing tropical storm on the other. Alain Locke claims that this work was influential in breaking "artistic stereotypes of the cottonpatch and back-porch tradition," and "began the artistic emancipation of the Negro subject in American art." Indeed, the work remains a testament to Homer's capacity to empathize with marginal groups in modern culture.[37] All his life Homer was attracted to people of color, and he painted them frequently on visits to the southern United States and the West Indies. Like Copley and his in-laws, Homer was a Bostonian whose ancestors had been merchants actively engaged in overseas trade. One seventeenth-century forebear was born in Bristol—a major slave-trading port—and captained a trading vessel that operated out of London. Both Homer's grandfather and father ran an import-export business, while his maternal grandfather was a merchant in the West Indies trade.[38] Homer's attachment to the West Indies and their black inhabitants originated from the family's mercantile contacts but assumed a deeper significance under the impact of the Civil War and Reconstruction. His *Shackled Slave* of around 1863 does not expose the bondsman to the spectator's gaze for either entertainment or compassion, but shows him oblivious of the outside world and suffering alone.[39]

Homer painted *The Gulf Stream* shortly after the Spanish-American War, which made the United States a power in the West Indies. The United States now had to reconcile its institutionalized racism with multiracial societies in Cuba and Puerto Rico. Americans actively discussed the issue of race in the 1890s, and their worries were complicated further by the waves of immigrants then pouring in on the eastern seaboard. Social Darwinism dominated ruling-class thought in this era, and racists exploited it to give a scientific veneer to their assertions. In 1891 Francis A. Walker, a leading Northern economist and a former superintendent of the U.S. Census, used the latest statistics to demonstrate that the black population was increasing at a rate substantially below that of whites and was concentrated in a diminishing area of the deep South. He concluded that blacks were biologically unsuited for all but the most tropical regions of the United States.[40] The 1890 census coincided with the full impact of Darwinism on American thought, and thus the statistical evidence that blacks were failing to hold their own coincided with the thesis of the "survival of the fittest" in the competitive struggle for existence between the contending social groups. As a result, in the 1890s certain influential conservative intellectuals engaged in an unparalleled outburst of racist speculation on the impending disappearance of the American Negro. Confident predictions of black extinction through natural processes came from both reputable and disreputable sources, and those who wished to consign the entire black race to oblivion could scarcely conceal their satisfaction.[41]

In the 1890s Frederick L. Hoffman, a German-born insurance statistician who made a careful study of Negro mortality, released a thoroughgoing and detailed exposition of how and why blacks were losing out in the struggle for existence. His findings had wide influence because they were presented under the prestigious imprint of the American Economic Association and because Hoffman's foreign birth made him supposedly unbiased. Thus, his *Race Traits and Tendencies of the American Negro*, published in 1896, developed into one of the most influential expositions of the race question to appear in the nineteenth century. The book became a precious source of information for anti-Negro writers and had the practical effect of helping to convince most white insurance companies that blacks were an unacceptable actuarial risk. Hoffman presented the case for black degeneracy and impending extinction with thoroughness and with all the callous insensitivity typical of quantified social research in that period. His comparison of the Negro to the Indian as a vanishing race provided solace to white supremacists in the epoch of American imperialism.[42]

At the end of the nineteenth century, blacks, after their short-lived breather during Reconstruction, were relegated to dustheap status by the federal institutions and the vast majority of Americans. Except for brief periods of relief during the populist revolt of the 1890s and the Spanish-American War, the last quarter of the century—particularly the last decade—marked the nadir of blacks' quest for equal rights. Blacks were segregated, systematically deprived of their civil rights, and lynched in increasing numbers. Indeed, eighty-seven blacks perished in this fashion the year Homer painted *The Gulf Stream*. Beginning in 1877, with President Rutherford B. Hayes' withdrawal of the remaining federal troops that had been stationed in South Carolina and Louisiana during the Civil War, the commitment of the nation to giving equal rights to its black citizens had virtually come to an end. A series of indifferent presidents, a conservative Supreme Court, and a pro-business Congress facilitated the consolidation of white supremacy in the South. The sum total of their actions constituted a systematic attempt to neutralize the political power of blacks. The

formation of a new coalition of Republicans and Southern Democrats conspired to defeat major voting legislation for blacks in return for solidarity on economic policies favoring business investments and industrial growth in the North.

At the outset of the 1890s, Henry Cabot Lodge, Republican representative from Massachusetts, introduced a bill on 26 June 1890 for supervision of federal elections in the South. He produced evidence of a widespread conspiracy to deprive blacks of their electoral franchise, citing alarming statistics illustrating that elections in the South did not correspond to the will of the people. The strident debates over the bill were pervaded by the exaggerated accusations of its opponents, who labeled it a "Force Bill." The South and its Northern supporters interjected states' rights rhetoric about how the South could handle the black question on its own without the interference of the federal government. Unfortunately, this coalition saw to it that the bill, which just squeaked by the House, was defeated in the Senate on 26 January 1891.[43]

The biggest blow to black freedom was the legal sanctioning of the "Jim Crow" separation of black and white cultures in 1896. Almost all the United States Supreme Court's relevant decisions from Reconstruction to the end of the century nullified or curtailed any rights that the Reconstruction "Radicals" thought they had written into laws and into the Constitution. But the culmination of this negative development came in 1896 with the Court's ruling on *Plessy v. Ferguson:*

> If the two races are to meet upon terms of social equality, it must be the result of natural affinities, a mutual appreciation of each other's merits and a voluntary consent of individuals. . . . If one race be inferior to the other socially, the Constitution of the United States cannot put them upon the same plane. The distinction between the two races, which was founded in the color of the two races, must always exist so long as white men are distinct from the other color.

Thus, as late as 1896 *Plessy v. Ferguson* incorporated into one of the most unjust rulings of the Court the chromatic distinctions between black and white, on which it sanctioned the doctrine of "separate but equal accommodations."[44]

In addition to the domestic attempt to disenfranchise blacks, growing American imperialism added an international sanction to its discriminatory policy. After the Spanish-American War the United States assumed the role of trustee for "little brown brother" in the Philippines; for white, colored, and black Puerto Ricans; and the role of protector for white, colored, and black Cubans. This attitude momentarily diverted attention from additional denials of constitutional rights to black Americans. American imperialism was justified, however, on racial and moral grounds; for example, one writer urged permanent American intervention in Cuba in 1898 to prevent the domination of the whites by the blacks. Other individuals, however, tried to distinguish the blacks of the newly acquired territories from their domestic counterparts and advised a different approach.[45] The emergence of Social Darwinism and the mad scramble for African colonies facilitated America's acceptance of the inherent inferiority of black peoples. This international discrimination appeared most visibly as illustrations in the satirical magazines burgeoning in the last decade of the century. These mercilessly lampooned blacks and colonialized culture, providing a foundation for a category of popular imagery that persisted deep into the twentieth century (color plate 10).

Ironically, at the outbreak of the Spanish-American War in 1898, black soldiers enlisted once again in the service of their country, helping to liberate Cubans from Spanish domination. Four black regiments fought in the war, and the feelings of temporary solidarity between the races that the war inspired gave blacks a much-needed shot in the arm. But the same year Louisiana passed its notorious Grandfather Clause, which restricted the franchise of black citizens. In Wilmington, South Carolina, two days after the congressional elections, a race riot broke out in which a score of blacks were killed resulting in a mass exodus of blacks from the city.

Blacks were also vilified in Congress. In April 1898, David A. De Armond of Missouri described blacks as being "almost too ignorant to eat, scarcely wise enough to breathe, mere existing human machines." John Sharp Williams of Mississippi gave a classic denunciation of the black race when he declared on 20 December 1898,

> You could ship-wreck 10,000 illiterate white Americans on a desert island, and in three weeks they would have a fairly good government conceived and administered upon fairly democratic lines. You could ship-wreck 10,000 negroes, every one of whom was a graduate of Harvard University, and in less than three years, they would have retrograded governmentally; half of the men would have been killed, and the other half would have two wives apiece.[46]

This fantastic hodge-podge of traditional racist projections again conjures up the white association of blacks and shipwreck in a period when their hopes were indeed dashed against the shoals of a hostile nation.

The metaphorical allusion to disaster at sea was also employed in another sense by the powerful black leader Booker T. Washington. In some ways, Washington's famous Atlanta Compromise Speech on 18 September 1895, gave the declining status of blacks an inadvertent shove. Essentially Washington renounced the drive for social equality, conceding a provisional subordinate political position for Southern blacks until they became educated and gained employable skills. Washington suggested that education and wealth would bring poltical rights, advocating in effect French statesman François Guizot's *"juste milieu"* (golden mean) formula of *"Enrichessez-vous!"* (Get Rich!).

Washington's speech may have been diplomatically astute in a time of racial stress, but black progressives like W. E. B. Du Bois and William Monroe Trotter were outraged by what they considered "the way backward." This factionalization of the black community was disregarded by the reigning white elite, who now elevated Washington as the spokesperson for American blacks. Washington's conciliatory speech stressed the need for blacks to share in the industrial progress signified at the 1895 Cotton States' Exposition, and he used as his self-help analogy the story of "a ship lost at sea for many days" suddenly sighting a friendly vessel. He continued:

> From the mast of the unfortunate vessel was seen a signal: "Water, water; we die of thirst!" The answer from the friendly vessel at once came back: "Cast down your bucket where you are." A second time the signal, "Water, water; send us water!" ran up from the distressed vessel, and was answered: "Cast down your bucket where you are. . . . " The captain of the distressed vessel, at last heeding the injunction, cast down his bucket, and it

came up full of fresh, sparkling water from the mouth of the Amazon River. To those of my race who depend on bettering their condition in a foreign land, or who underestimate the importance of cultivating friendly relations with the Southern white man, who is their next door neighbor, I would say: "Cast down your bucket where you are"—cast it down in making friends in every manly way of the people of all races by whom we are surrounded.[47]

Homer would have carefully followed the events at the Cotton States' International Exposition, including Washington's highly publicized address. He himself had participated in the Atlanta exposition in 1895, which focused on the cotton industry's concern with finding new markets to sustain growth.[48] Homer sent a favorite painting titled *Upland Cotton*, which depicts two black women collecting cotton pods.[49] The work linked blacks and cotton in the southern United States, just as *The Gulf Stream* linked blacks and sugar in the British West Indies. Here Homer reveals his understanding of the relationship of economics to the plight of blacks and to their survival. He would also have been responsive to similes of shipwreck and survival uttered by both friend and foe of black reform in the decade of the 1890s.

When Homer visited the Bahamas in the 1890s, the black majority in the islands was mired in poverty and ignorance from which they could not extricate themselves. Property qualifications denied most of them the vote, and they continued to be ruled by the white minority. The general rate of population increase was less than one percent a year in that period, and in many of the islands it declined. Sponge fishing was the backbone of the Bahamian economy, but the Negro sponge fisherman's lot during the period was decidedly grim. A writer for the Bahamian journal *Freeman* noted the "steady deterioration in the physique of the men and their families as a consequence of the low standard of living which the accursed system imposes upon them."[50]

The author of a travel article in the February 1887 *Century Magazine*, which Homer illustrated with reproductions of watercolors painted during his first trip to the Caribbean in 1885, presented another view of the black man's plight on the islands.[51] The article, a light, frothy piece spotlighting the steamship companies, contained a fascinating subtext on the impact of environmental and hereditary pressures on the islanders. The author began with a historical survey, recalling the indigenous peoples' extinction under the oppressive Spanish yoke. He pointedly asserted that the "light which guided Columbus" turned out to be "an omen of disaster and death." Fourteen years later, he remarked, the entire race had disappeared.[52]

Elsewhere in his text he noted that blacks, who in 1887 comprised four-fifths of the present population, possessed "something of their spirit." Although he referred to a similarity in personality and psychological traits, he returned continually to the idea of social degeneracy and survival. He observed, for example, that blacks suffered disproportionately from consumption—the most prevalent disease on the islands—probably because they spent so much of their time in the water earning their livelihood, and were forced to inhabit impoverished huts. On the other hand, he claimed that interracial marriages were forging a new race and that color prejudice was not a major social problem on the islands. While he waffled on the issue of miscegenation, he quickly declared that the biggest factor in overcoming racial prejudice was wealth. After citing examples of wealthy people of color on the islands, he concluded that prosperity would do for blacks in the United States what it

accomplished for some of the islanders. In this he appealed to Northerners—the same group that received Booker T. Washington's speech with unreserved enthusiasm eight years later—who could blithely ignore the condition of impoverished masses by parading examples of the exceptions.[53]

But perhaps his most revealing comment came in the context of his discussion of sharks as a potential risk in vacationing in tropical waters. He tried to discountenance the stories of maneaters, and at one point declared, "The sharks are not inviting, but there is a tradition that they do not take kindly to black flesh."[54] This rather cryptic comment should be compared to the almost legendary association of blacks and sharks in the literature on slavery, which reveals that the tradition is precisely the opposite of what he claimed. The deliberate irony and ambiguity of his statement sheds light on the racial encoding of his article, for it actually suggests something to the effect that "sharks are as intelligent as whites," and therefore your friends.

When Homer painted *The Gulf Stream* twelve years later, he made use of his illustrations reproduced in the *Century Magazine* article—especially *Fishing for Sharks*—and would have had, because of his travels, a deeper perspective on the environmental and hereditary arguments feeding the virulent anti-black propaganda spewing forth in the 1890s. Once again blacks were beset on all sides by greedy sharks, while the gains and optimism generated by the Reconstruction era had been shipwrecked on the reefs of bigotry. In addition to this explicit allusion to the historical association of sharks and slaves, Homer gives us another in the image of the stalks of sugar cane rising out of the hold of the sloop and trailing down into the water. Peter Wood rightfully calls attention to this generally overlooked element. Sugar cane would have been a common sight aboard fishing craft in the Gulf Stream, "both as a cargo and as a source of nourishment."[55] Yet Homer's conspicuous representation of the stalks, totally out of proportion to the boat and its lone passenger, assumes a symbolic and metonymic connotation in its intimate relationship to the history of slavery in the West Indies. In fact, the reason that slaves were wrenched from their homeland and transplanted to the New World was because of the voracious demand for sugar in European markets. But when Homer painted his picture, this allusion would have taken on yet another level of meaning: America's imperialist ambitions—culminating in the Spanish-American War of 1898—devolved on the Hawaiian Islands, the Philippines, Cuba, and Puerto Rico, all of them rich sugar-producing territories and all of them worked by blacks soon to suffer the discriminatory policies of a racist society.[56]

Thus, Homer's black fisherman is caught in a powerful dilemma, prostrate on a dismasted, drifting sloop, having already been severely buffeted by a violent hurricane. Could it get any worse? Yes, for now he is trapped between hungry sharks on one side and an approaching squall on the other. But having experienced a series of shocks, his reaction to this dilemma is calmly to await his fate. It is a comment on the times that some critics of the period viewed his air of resignation as "sullen laziness" and apathy. But close inspection of the figure reveals that he is very much awake and alert to the dangers; he props himself up tautly on his elbows to survey the perils confronting him.

The figure's transitional state perplexed the critics and made prospective buyers uneasy. Despite the gravity of his situation he betrays no fright and gazes on the perils with the indifference of a human being who has lived through all this before. Nevertheless, the outcome remains in doubt and that is why clients pressed Homer's dealer to learn of the eventual fate

of the picture's protagonist. Homer responded sarcastically, "You can tell these ladies that the unfortunate negro who now is so dazed & parboiled, will be rescued & returned to his friends and home, & ever after live happily."[57] Homer's ironic tone carries with it the masculinized aura of the Victorian male who admired risk-taking situations remote from the realm of "ladies," but it also signifies the opposite of what he stated. What is essential is that the image depicts a situation in *suspension,* when a vulnerable human being is jeopardized on all sides by forces beyond his control. Homer's realism spells out the situation of blacks in contemporary America without supplying the happy ending.

All the ingredients of Copley's picture are present: a boat floundering in a hostile aquatic environment ruled by a malevolent shark, and the centrality of the black man. But if the protagonist's reaction to peril is again passive, he now constitutes both the thematic and compositional focus. Homer's black man is both hero and victim, collapsing the old categories of triangular formalism into a powerfully condensed metaphor of implicit power blocked. The black man is no longer an empty intellectual abstraction, but a force whose actual potential is thwarted by roadblocks set up everywhere to neutralize it. While Copley painted his work during the earliest stage of abolitionist thinking, Homer completed his in the aftermath of the legal recognition of the rights of blacks. Copley's figure stands upright and outside the main action, Homer's lies prostrate and well inside the triangulated danger zone. When the black man was powerless, he could be assigned a prominent theoretical position. When he assumed power, he had to be physically walled off and a color line drawn. Homer's image thus conveys the paradoxical destiny of a freed black people in modern society. For the white Homer, however, the image was progressive insofar as he located the perils outside the locus of black culture. Generally, the opposite was true: the specter of black political influence was invoked to keep the status quo. Triangulation had helped prepare the ground for ghettoization.

Notes

I wish to express gratitude to Gary B. Nash, Bernard Reilly, and Peter H. Wood for their help and suggestions in the formulation of this essay.

1. Thomas Jefferson, from the first draft of the Declaration of Independence. See Thomas Cochran and Wayne Andrews, eds., *Concise Dictionary of American History* (New York: Charles Scribner's Sons, 1967), p. 1.

2. For the main literature on this picture see Jules David Prown, *John Singleton Copley*, 2 vols. (Cambridge, MA: Harvard University Press, 1966), II: 267–74; Irma B. Jaffe, "John Singleton Copley's *Watson and the Shark,*" *American Art Journal* 9 (May 1977): 15–25: Roger B. Stein, "Copley's *Watson and the Shark* and Aesthetics in the 1770s," in *Discoveries and Considerations* (Albany: State University of New York, 1976), pp. 85–130; Ann Uhry Abrams, "Politics, Prints, and John Singleton Copley's *Watson and the Shark,*" *Art Bulletin* 61 (March 1979): 265–76.

3. Prown, *Copley*, pp. 267–68, note 17.

4. This ruling was made possible by the system of licenses, or *asientos,* issued by the Spanish to English firms in return for an obligation to carry a specified number of slaves to particular desti-

nations. See Philip D. Curtin, *The Atlantic Slave Trade: A Census* (Madison: University of Wisconsin Press, 1969), p. 21.

5. Thomas Clarkson, *The History of the Rise, Progress & Accomplishment of the Abolition of the African Slave-Trade, by the British Parliament*, 2 vols. (London: Longman, Hurst, Rees, and Orme, 1808), II: 71.

6. Samuel Isham, *The History of American Painting* (New York: The Macmillan Company, 1927), p. 26; also, John Clarence Webster, *Sir Brook Watson, Friend of the Loyalists* (New Brunswick: Mount Allison University, 1924), p. 24.

7. For New England slave trading see William Edward Burghardt Du Bois, *The Suppression of the African Slave-Trade to the United States 1638–1870* (1896; New York: Russell & Russell, 1965). pp. 27ff; also, Daniel P. Mannix and Malcolm Cowley, *Black Cargoes: A History of the Atlantic Slave Trade 1518–1865* (New York: The Viking Press, 1962), pp. 61, 67–68, 156–57, 159–70.

8. John W. Tyler, *Smugglers & Patriots: Boston Merchants and the Advent of the American Revolution* (Boston: Northeastern University Press, 1986), pp. 8–9.

9. Richard Pares, *Yankees and Creoles: The Trade Between North America and the West Indies Before the American Revolution* (London: Archon Books, 1968), pp. 46, 53–57; and Richard Sheridan, *Sugar and Slavery; An Economic History of the British West Indies 1623–1775* (Baltimore: The Johns Hopkins University Press, 1973), pp. 343–44.

10. John Clarence Webster, *The Journal of Joshua Winslow* (Saint John: Publications of the New Brunswick Museum, 1936), pp. 11, 18.

11. Abrams, "Politics," pp. 267–68.

12. *Criticism on the Rolliad* (London: J. Ridgawy, 1785), p. 134. This quote has come down slightly askew in the Copley literature; the quote here comes from the original source. See Martha Babcock Amory, *The Domestic and Artistic Life of John Singleton Copley, R. A.* (Boston: Houghton, Mifflin and Company, 1882), p. 72.

13. For Wilkes' relationship to the Bostonians see G. M. Elsey, ed., "John Wilkes and William Palfrey," *The Colonial Society of Massachusetts. Transactions 1937–1942* 34 (1941): 411–28; also, Worthington C. Ford, "John Wilkes and Boston," *Massachusetts Historical Society. Proceedings* 47 (January 1914): 190–215.

14. The connection between Wilkes and the staff surmounted by the liberty cap had been established by Hogarth's best-selling print of 1763, which attacked the popular champion of British liberties, and soon the motif was adorning pottery, glassware, medals, and punchbowls. See Neil McKendrick, J. Brewer, and J. H. Plumb, *The Birth of a Consumer Society: The Commercialization of Eighteenth-Century England* (Bloomington: Indiana University Press, 1982), p. 244. For the American version of this motif, see Donald H. Cresswell, *The American Revolution in Drawings and Prints* (Washington, DC: Library of Congress, 1975), p. 257, no. 644; also, Yvonne Korshak, "The Liberty Cap as a Revolutionary Symbol in America and France," *Smithsonian Studies in American Art* 1 (Fall 1987): 54–57.

15. Abrams, "Politics," pp. 269–71.

16. Quoted in R. Fumeaux, *William Wilberfore* (London, 1974), p. 67. Wilkes had long joined the terms liberty and slavery in his rhetoric, thus providing a model for the colonists. See J. Almon, ed., *The Correspondence of the Late John Wilkes,* 5 vols. (New York: Burt Franklin, 1970), IV: 19.

17. Samuel Hopkins, *A Dialogue Concerning the Slavery of Africans* (Norwich, CT: Judah P. Spooner, 1776), p. iii.

18. Benjamin Quarles, *The Negro in the American Revolution* (Chapel Hill: The University of North Carolina Press, 1961), pp. 43–44; also, Winthrop D. Jordan, *White Over Black: American Attitudes Toward the Negro, 1550–1812* (Baltimore: Penguin Books Inc., 1969), pp. 289–92.

19. Leon F. Litwack, *North of Slavery: The Negro in the Free States, 1790–1860* (Chicago: The University of Chicago Press, 1961), p. 7.

20. Ibid.

21. Ibid., p. 9.

22. Ibid., pp. 9–10.

23. Ibid., p. 11.

24. Quarles, *The Negro*, p. 16.

25. Cited in David Brian Davis, *The Problem of Slavery in the Age of Revolution, 1770–1823* (Ithaca, NY: Cornell University Press, 1975), pp. 275–76.

26. Cited in Harry Ploski and Roscoe C. Brown, Jr., *The Negro Almanac* (New York: Bellwether Publishing Company, Inc., 1967). p. 61.

27. Joseph Thomas Wilson, *The Black Phalanx* (New York: Arno Press and *The New York Times*, 1968), pp. 43–46; also, Quarles, *The Negro*, pp. 19–31.

28. Clarkson, *The History*, II: 72–73, 76ff., 81–82, 253–54, 262, 364.

29. William Dunlap, *A History of the Rise and Progress of the Arts of Design in the United States*, 2 vols. (New York: Dover Publications, 1969), I: 117–18. Also, see Henry Theodore Tuckerman, *Book of the Artists: American Artist Life* (New York: J. F. Carr, 1966), pp. 78–79, which is based on Dunlap.

30. Jaffe, *Watson and the Shark*, pp. 18, 20.

31. Hopkins, *Dialogue*, p. 5.

32. Jordan, *White Over Black*, p. 299.

33. Abrams, "Politics," pp. 268, 274.

34. Peter H. Wood, "Waiting in Limbo: A Reconsideration of Winslow Homer's *The Gulf Stream*," in *The Southern Enigma: Essays in Race, Class, and Folk Culture*, W. J. Fraser, Jr. and W. B. Moore, Jr., eds. (Westport, CT: 1983), pp. 85–87.

35. Ironically, many blacks in opposition to American slavery served as British spies, guides, and informers. See Quarles, *The Negro*, pp. 142–46.

36. Actually, blacks served the British army mainly *behind* the lines to release white manpower for combat. Ibid., p. 119.

37. Alain Locke, *Negro Art: Past and Present* (Washington, DC: Associates in Negro Folk Education, 1936), pp. 45–46.

38. For Homer's family background see Gordon Hendricks, *The Life and Work of Winslow Homer* (New York: Harry N. Abrams, 1979), p. 10; and Lloyd Goodrich, *Winslow Homer* (New York: The Whitney Museum of American Art, 1944), pp. 1–2.

39. For Homer's depiction of blacks see Karen Adams, "Black Images in Nineteenth-Century American Painting and Literature: An Iconological Study of Mount, Melville, Homer, and Mark Twain" (Ph.D. diss., Emory University, Atlanta, 1977), pp. 111–53; Michael Quick, "Homer in Virginia," *Los Angeles Country Museum of Art Bulletin* 24 (1978): 61–81; Mary Ann Calo, "Winslow Homer's Visits to Virginia during Reconstruction," *American Art Journal* 12 (Winter 1980): 4–27; and Wood, "Waiting in Limbo," pp. 76–94.

40. George M. Frederickson, *The Black Image in the White Mind* (New York: Harper & Row, 1971), pp. 246–54.

41. We can catch a glimpse of the widespread bias against blacks at the respectable Northern publishing house of Charles Scribner's Sons in the 1880s. Pretending to be scientifically objective, the authors of its popular *Atlas* wrote, "Statistics show little regarding the relative increase of the colored race before and after emancipation, but it is fair to assume, from all the circumstances of the case, that the increase is less now than formerly, a presumption borne out by such statistics as are at hand. When slaves were property, every consideration of self-interest on the part of the

slaveholder prompted him to watch over their health, to encourage child-bearing and to protect and preserve the children. It is not to be supposed for a moment that a careless, improvident race, thrown suddenly upon their own resources, could at once, or within a generation, learn to exercise such care over either their own health, or that of their own children, as they had received when slaves. Wherever mortality statistics are available, there is shown a death rate of the colored population far in excess of that of the whites, a death rate so large throughout the country generally as to overbalance the greater birthrate, as appears by the fact that the increase from 1860 to 1880 was, for the colored, but 48 per cent, while for the whites it was 61 per cent. The conclusion is unavoidable that the colored race cannot hold its own numerically against the white, but must fall farther and farther behind, unless, under conditions of freedom, the race shall develop physical and moral qualities which it has not yet shown." Fletcher W. Hewes and Harry Gannett, *Scribner's Statistical Atlas of the United States Showing by Graphic Methods Their Present Condition and Their Political, Social and Industrial Development* (New York: Charles Scribner's Sons, 1883), p. xlii. Such a maniacal and paranoid array of facts would be laughable were it not for the tragic results of their broadcast.

42. Ibid., p. 249.

43. Rayford Whittingham Logan, *The Betrayal of the Negro from Rutherford B. Hayes to Woodrow Wilson* (New York: Collier Books, 1965), pp. 70–71.

44. Ibid., p. 120.

45. C. M. Pepper, "Cuba in Suspension," *Harper's New Monthly Magazine* 99 (November 1899): 969–70. Henry Cabot Lodge, Representative of Homer's native Massachusetts, stated unequivocally that Cuba's condition was largely owing to the "sinister influence of slavery," which had led "the United States to hold Cuba under the yoke of Spain, because free negroes were not to be permitted to exist upon an island so near their Atlantic Seaboard." See H. C. Lodge, "The Spanish American War: The Unsettled Question," *Harper's New Monthly Magazine* 98 (February 1899): 450–52.

46. Logan, *The Betrayal*, p. 99.

47. The entire text of the speech may be found in Ploski and Brown, *The Negro Almanac*, pp. 100–102.

48. *The Official Catalogue of the Cotton States and International Exposition, Atlanta* (Atlanta: Claflin & Mellichamp, 1895), p. 251; the work is listed as no. 311, "Homer, Winslow, N. A., Upland Cotton (oil)."

49. Calo, "Winslow Homer's Visits," pp. 21–25. Calo notes that contemporary reviews placed heavy emphasis on the cotton plant itself.

50. Michael Craton, *A History of the Bahamas* (London: Collins, 1962), pp. 254ff.

51. W. C. Church, "A Midwinter Resort. With Engravings of Winslow Homer's Water-Color Studies in Nassau," *Century Magazine* 33 (February 1887): 499–506. For Homer's trips to Key West, Cuba, and the Bahamas, see Patti Hannaway, *Winslow Homer in the Tropics* (Richmond, VA: Westover Publishing Company, 1973).

52. Church, "A Midwinter Resort," p. 499.

53. Ibid., pp. 501–502.

54. Ibid., p. 506.

55. Wood, "Waiting in Limbo," pp. 84–85.

56. Worthington C. Ford, "Trade Policy with the Colonies," *Harper's New Monthly Magazine* 99 (July 1899): 294–301; also, Pepper, "Cuba in Suspension," pp. 966–67.

57. Goodrich, *Winslow Homer*, p. 162.

10

"Making a Man of Him"

Masculinity and the Black Body in Mid-Nineteenth-Century American Sculpture

Michael Hatt

Till the blacks were armed, there was no guaranty of their freedom. It was their demeanour under arms that shamed the nation into recognising them as men.[1]

With those words, Thomas Wentworth Higginson ends his book *Army Life in a Black Regiment* of 1870, an account of his experience as the white colonel of a black regiment during the American Civil War. The book, written in praise of his black troops and their displays of courage, loyalty, and discipline, is symptomatic of a shift in perceptions of African American men that followed in the aftermath of the war. This shift was, essentially, a reassessment of the African American's status as man. In this essay I want to explore the ways in which this new definition of the African American, this new means of recognizing him, was not simply a question of reformulating the position of the black in the contemporary hierarchical division between man and animal, but of gendering the black man, of making him masculine.[2] In particular, I want to take the terms that underpin Higginson's summarizing sentence—war, freedom, manhood, recognition—and, by means of an experiment in corporeal analysis, to try to articulate the ways in which the body and its representation are implicated in this set of ideas. The concept of "manliness" in Victorian America was a hazy one, referring to diverse characteristics, which were often incompatible, as well as different types or categories of manhood, such as citizen, economic unit, sexual being, and so on. Debates around manhood did not pay attention to these divisions; differences were effaced by the ostensibly self-evident and unified notion of masculinity. I shall follow the Victorians' lead in not trying to identify specific categories, not least because the question of black masculinity is concerned with a fundamental gender status that is, apparently, prior to more specific formulations, but I hope that it will become evident how unstable definitions of masculinity were, and still are.

Throughout this essay I shall, rather uneasily, use the word "negro" to refer to the nineteenth-century white representation of the black man. The question of terminology is a

difficult one, since one has to take account of both historical labels for ethnic groups, as well as the ways these change as members of those groups engage in debates about self-naming, and the political implications of those names. My response to this is to use "negro" as a kind of meta-representational term, that is, as a representation of the white representation of the black, to use "black" when no specific ethnic group is necessarily referred to, and the rather awkward "African American" when talking specifically about blacks in the United States.

Before and After Masculinity

If one word serves to define a norm of masculinity in mid-nineteenth-century America, it is probably "control." Whatever else manliness might have been, it always connoted a man's power over himself, his appetites and emotions, and over his environment, both geographical and social. Manhood involved self-reliance, the refusal of excess, moderation—virtues which shaped bourgeois home life, sexual relations, religious observance, and professional working life. This is not to say that men in mid-nineteenth-century America were not emotional; in many respects they were emotional in ways which today would be considered overstated, but displays such as passionate friendships between men were clearly defined as stages in a man's life which would serve their purpose and then be discarded.[3] The limits of such emotionalism were carefully set, and, if adhered to, were still compatible with the demand for self-control.

If manliness was a question of control, then the negro could not be considered masculine. His dependence on his owner within the paternalistic bond of slave society, and his lack of control over his circumstances—economic, social, and even sexual—made him a very paradigm of the unmanly. This distinction, however, between the white man and his black dependent was more than the straightforward description of a social and political bond necessary to slavery; it was a distinction that was also discussed in pathological terms. The negro's lack of social control, his inability to determine the external aspects of his existence, was understood as an absence of the self-control that was the fulcrum of white masculinity. His lack of manhood was accepted as a consequence of his natural temperament, weak, cowardly, and stupid. Indeed, it was the pathologization, or naturalizing argument of mid-century racial theory, that both explained and justified the negro's wretched servitude.[4] The negro then, was understood as being inherently incapable of achieving the masculine qualities of courage, morality, conscience, and civility.

The negro was constructed, in the 1850s and early 1860s—and indeed beyond—around the twin tropes of savagery and docility. In his important book *The Slave Community*, John Blassingame points out that whites, particularly in the slaveholding South, were able to characterize slaves as both sub-human savages who needed to be kept in bondage for everyone's safety, and as docile, lazy good-for-nothings who required care, since they were incapable of looking after themselves on account of their mental and physical inertness.[5] Eugene Genovese, similarly, points up this paradox, albeit within a considerably different framework, when he says:

> Theoretically, modern slavery rested [. . .] on the idea of a slave as *instrumentum vocale,*—a chattel, a possession, a thing, a mere extension of his master's will.

But, at the same time:

> Paternalism defined the involuntary labor of the slaves as a legitimate return to their masters for protection and direction. [. . .] Paternalism's insistence upon mutual obligations . . . implicitly recognized the slaves' humanity.[6]

This contradiction is further complicated by the fact that general definitions were palpably inaccurate and unusable at the level where slaveowners had to deal with specific slaves; the complex webs of loathing, bitterness, affections, and resentments made the lived experience of slave society something beyond the grasp of reductive racial theory. It is important, I think, that we ensure that we do not fall into the same trap of providing a coherent and totalizing account of the negro—or indeed of the white who created him—since these contradictions are important clues to the complexity of the issues at stake here; of the conflicting ideological demands that slavery made on whites, and the enormous flexibility of racist ideology in containing these contradictions. Moreover, the wide circulation of these ideas should not lead us to believe that whites actually believed them, or that their beliefs were so easily pigeonholed. The characterization of the negro was also very much to do with the justification of slavery, and the mitigation of white experience and fear of African American resistance.

What is true of both definitions of the negro, and of the diverse modifications of the basic stereotypes, is that they involve an implicit belief in the negro's racial difference in terms of gender. The savage is more animal than human and so clearly cannot be a man, not least because of his excessive sexual nature, lustful and unregulated by socialization; and the socialized negro is denied the essential moral components of masculinity. The negro is always defined against a masculinity that is inseparable from normative white bourgeois identity, a process which might be described, at the risk of replacing characterization with caricature, as a gainsaying. If white is masculine, negro is emasculated; if white is control, negro is excess; if white is eugenic, negro is degeneration; if white is enterprise, negro is laziness; if negro is labor, white is supervision, and so on. In this process, however, the contradiction Blassingame describes is replicated and fractured further into a set of mutually incompatible axioms. For example, the negro is both impotent, since the white represents sexual health, and sexually voracious, since the white represents Christian chastity; he is too stupid to dissimulate, since intellectual guile is white, yet at the same time he is cunning, because honesty is a white characteristic. It is clearly not only definitions of race that are contradictory, but those of masculinity, the ostensibly unified, stable, natural gender role; and like racial theory, it is exactly this combination of the appearance of singularity, while constantly shifting to accommodate new problems and needs, that makes masculinity such a powerful ideological tool.

Of all the guises of the negro, perhaps the most important was Sambo. Sambo was the childlike, docile, and comic creation who best defused the white fear of the African American. Infantalization was a crucial *topos* in the writings of racial ideologues. J. H. van Evrie, a leading racial theorist from the South, wrote that their experience of African Americans:

> leads the people of the South to designate the negro of any age as a "boy"—an expression perfectly correct, in an intellectual sense, as the negro reaches his mental maturity at twelve or thirteen, and viewed from our standpoint is, therefore, always a boy.[7]

It should not go unnoticed that this puerility is not an arrested development. It is a complete process that is indicative of the fact that the negro is constitutionally incapable of acquiring the manliness that comes with maturation.

Infantilization is not only a belief in the Southern states, though. While Southern ideologues may wander round like Blanche DuBois, murmuring "A boy . . . just a boy," it is also widely discussed in the North, and features significantly in much abolitionist discourse. Addressing the American Anti-Slavery Society in New York, for instance, abolitionist Theodore Tilton declared, quite unproblematically:

> Inferior? What is human inferiority? Will you look at a child in his cradle and say, That is an inferior man? No. You wait for his growth—you judge him by his manhood. Will you look upon a race yet in its infancy and say, That is an inferior race? No. The time has not yet come to judge that infant child; the time has not yet come to judge this infant race.[8]

There are important differences between van Evrie and Tilton, of course. Tilton seems to allow the possibility of development. His model of infancy is metaphorical, rather than van Evrie's literal use of the term. Nonetheless, what is important here is that Tilton describes an infant race that has yet to reach manhood, men who are not yet masculine. Both North and South, in spite of the enormous political differences, the negro is dependent, weak, naturally subordinate, and cannot qualify as manly. Both sides of the Mason-Dixon line, Sambo declares the negro's ineligibility for masculine status.[9]

I want to begin assessing the relation of these ideas to visual representations by a brief examination of a popular print, produced and distributed by the fantastically successful company of Currier and Ives: Frances Palmer's *Low Water on the Mississippi*.[10] In the image, an African American family indulges in simple, childish pleasures, their leisure revolving around the banjo, dancing, and dandling babies, favorite pastimes of Sambo. The scene is enacted before a neat and cozy home, complete with picturesque climbing plant and garden plot. Indeed, picturesque seems an apposite term; the quaint, low subject matter, the composition, and the use of stylistic protocols to define marginal groups place Palmer's print squarely in the tradition of the picturesque. This vignette of negro life, which was also issued separately as a print called *The Plantation House*, presents a common iconography of the slave family as idle, docile, and happy. As the date of the print shows, the upheaval of the Civil War made little immediate difference to such representations; the meaning of the iconography simply shifts in its political implications, offering now a nostalgic view of the good old South, and confirming that negroes were better off under slavery.

Low Water on the Mississippi, however, reinforces not only the image of the negro as a child in a general anthropological sense, but also in terms of a specific social relationship with his master. Sambo can be seen to be inextricably bound to the paternalism of slavery and its economic needs. The natural order of white and negro is echoed in the juxtaposition of the slave hut and the big house. Both are located in a stable, ordered society, where the plantation and the steamship signal the successful and increasingly mechanized agricultural economy of the South. The simple black family and the sophisticated whites in their mansion are all thriving in a symbiotic relationship. Sambo's interests are identified with those of his master, his father figure; each figure knows his place in the racial economy.

The relationship of father and son is not that between the negro and his children, but that between master and slave. Why, the South is just fine and dandy; one big happy family.

One further aspect of this vignette that may not be obvious, however, but which needs to be teased out for the purposes of finding a history of African American masculinity, is the importance of the heterosocial nature of their quarters. Social space is an important concept in gender history, not least in nineteenth-century America, where the regulation of space—that is, formal or informal legislation governing who may go where and when—is so carefully monitored. In addressing this perhaps rather insubstantial area of analysis, one needs to mark a fundamental division between the homosocial and the heterosocial; that is, between those spaces which are only open to men and those that are open to both sexes—examples might be the saloon and the home. Of course, these divisions are complicated by questions of class and ethnicity, as well as the rather misleading Victorian notion of separate spheres. But while it is essential to remember that, say, the home was defined as a female and private space, we must not forget that it was, in fact, heterosocial, that the father of the family normally took charge, and that its privacy was regulated in a variety of subtle ways.[11] Masculinity is very much a product of homosocial relations. It is in all-male arenas that masculinity can be displayed, transmitted, learned, and controlled. While the "sissy" spends his leisure time with women, masculine men seek out the homosocial realm for the consolidation of their gender positions.

In contrast to this, the negro inhabits a weak, unmasculine world. The organization of his social space by his owner precludes the possibility of escaping the feminizing influence of women; indeed, every part of the negro man's life, from labor to leisure, is shared with women. It was warfare which, for the first time, offered the African American a homosocial space where he could become unequivocally masculine.

The upheaval of the Civil War may have made little difference to the kinds of work Currier and Ives were pumping out, but, unsurprisingly, it greatly affected definitions of manhood. Soldiering required a reappraisal of the male role both North and South, and masculinity began to assume a far more aggressive and combative aspect. The violence that is implicit in military service would not have sat comfortably with the temperate and highly controlled paradigm of what Charles Rosenberg has termed the Christian Gentleman,[12] but the fact that the war was being fought for a cause provided an ethical mitigation of this problem; indeed, it allowed violence to become not merely permissible within the boundaries of masculinity, but positively desirable. The crucial interconnection here between the physical and the moral was to remain the fulcrum of masculinity for the rest of the century.

The environment of the army camp, and the male relationships it afforded, were identified by many contemporaries, both highbrow thinkers and ordinary soldiers, as significant to their personal sense of manhood. The cause for which they were fighting became inextricable from the development of homosocial relations—this is, of course, a familiar trope in the modern rhetoric of warfare—and masculinity seemed to emerge from the extremes of male contact: friendship and desire on the one hand, fighting and death on the other. In the homosocial military world this masculinity could flourish. Masculinity defined and was defined by the soldier's task, both moral and physical; the soldier's rough and rugged lifestyle; his determination and endurance; and by his physical control—the notion of control was still an essential factor, not least in the military requirement for discipline.

The Civil War provided African Americans with their first point of entry into the realm of the homosocial. In the first instance this contact was as contraband. Slaves began to flee from the South to seek refuge in Union camps. Since they were, in Southern terms, property rather than people, they were technically booty, the spoils of war; hence the use of the term "contrabands" to describe them. Once in the camp, African Americans would serve as cooks, mule teamsters, and would perform other noncombative menial tasks. An extremely important breakthrough came in 1863, when the North raised the first African American regiments; and it may be no coincidence that this was the year in which Lincoln issued the Emancipation Proclamation. The establishment of African American army units was highly controversial.[13] In the North, many whites opposed the move; while in the South, the Confederacy declared that any white officer taken prisoner while leading African American troops would be executed rather than imprisoned. Arguments against the founding of African American regiments were largely motivated by white fear of arming blacks. Not only did it give them a power that might be used to white disadvantage and in the South, the possibility of black insurrection, represented by the specter of African American rebel Nat Turner, was acutely felt, but it was a power that would be inevitably unstable since the negro was, of course, devoid of the necessary self-control. At the same time, though, there was a sense that, regardless of any specific case to be made for or against the raising of African American troops, the fact remained that it was simply not the negro's place to fight. Fighting was man's work, and that meant whites only. The instinctive, irrational negro was misplaced in the masculine institution of warfare.

Nonetheless, as the war dragged on, at great economic and human cost, the need for more recruits, and the availability of African Americans as a potential fighting force—one, moreover, that had a personal interest in fighting—was more persuasive than the rhetoric of racism. But in order for African Americans to become soldiers, the exclusively white nature of masculinity had to be rethought. The negro, if he was to be a soldier, had to be recognized as a man. The rhetoric of race took on a new register. A recruitment poster addressed to African Americans, for example, made this change explicit and capitalized on it:

> [We] must rise up in the dignity of our manhood, and show by our own right arms that we are worthy to be freeman. Our enemies have made the country believe that we are craven cowards, without soul, without manhood, without the spirit of soldiers. We say that we have manhood—now is the time to prove it.[14]

Again and again, this insistence on black manhood structures debates around the arming of African Americans. It is interesting that while this is clearly articulated as black addressing black, the speech takes place in, and is organized by, the white military institution. Accounts of African American soldiering aimed at white audiences tended to reverse the causal connection here; rather than the African American's manhood being made evident by his military position, that position was often expressed as the cause of the African American's manliness. As Henry T. Johns remarks in his memoir *Life with the Forty-Ninth Massachusetts Volunteers*, "Put a United States uniform on his back and the *chattel* is a *man*."[15] The situation is, inevitably, a little more complicated than my example allows. We should note that there is some precedent for this declaration of black manhood, in accounts of African American soldiers in the Revolution, figures such as Crispus Attucks, the first casualty of

the war for independence.[16] Furthermore, while the African American man is now given a position where he can be masculine, the Sambo stereotype does not disappear. It is a notion that appears in much debate in the North in favor of and in praise of African American regiments, including Thomas Wentworth Higginson's book.[17] The African American may be perceived as a good soldier because of his natural obedience and subservience: "Their docility, their habits of unquestioning obedience, pre-eminently fit them for soldiers;"[18] and, of course, they are marvelous at drill on account of their natural sense of rhythm: "In mere drill they must beat the whites; for 'time,' which is so important an item in drilling, is a universal gift to them."[19] Higginson is not as crude as this, but he makes it plain that black masculinity is dependent on a white context; the negro has a capacity for manhood if appropriately disciplined through the white homosocial medium of the army.

The subhuman body of the negro is "liberated" into the disciplined body of the regimented black.[20] Rather than dancing, Sambo is now marching, his every move prescribed by white military protocols; and the consequence of this is that he can now be viewed as brave and principled, even if this is something created by the external constraints of military procedure rather than coming from within, something that is outside rather than inside the body. The longstanding civic ideal of fighting, and even dying, for one's country is something that can form part of African American experience, and, therefore, so must the display of manly virtue. Again, Henry Johns is an instructive correspondent. As he continues to praise the African American soldiers he comes across on his sojourn in the Union camp, in an extraordinary mixture of pro-black and racist sentiment, he asserts the inextricable link between the African American's freedom and his gender; the African American on guard duty "seems to say: 'I am guarding my freedom and my manhood.'"[21] Crucially, though, Johns goes on to explain that black emancipation, "negro equality,"[22] is not a question of political or even social equality. So what does equality for the negro mean? "It means making a man of him."[23] I now want to turn to sculpture produced in the 1860s to explore how art participates in, and is affected by, these redefinitions of the African American man in relation to masculinity; and how, within the field of visual representation, the body provides the focus for the debate.

Viewing the Black Male Nude

It is at this historical moment, as African Americans are nominally freed and allowed to enter gender, that the negro emerges as a subject for public sculpture in America. But this new subject creates a tension between the demands of sculptural practice as legitimated by a centuries-old European tradition and the search for a national art, representative of national ideology. In the 1860s, American sculpture was still in its formative stages, and self-conscious attempts by sculptors and art institutions to initiate a specifically American sculptural history were awkwardly played out in the context of a dependence on Europe, and particularly Italy, for all aspects of production from teaching and stylistic models, to materials, artisanal carvers, and foundries. Sculpted representations of the negro constituted part of the effort to Americanize sculpture. It was not simply that the Emancipation Proclamation of 1863 required concrete public form, but the rendering of momentous events in the nation's history in the form of public monuments could at once both authorize that history,

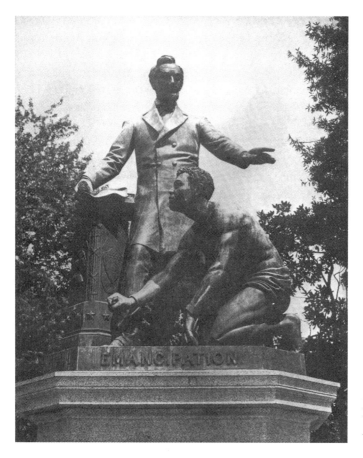

Figure 10.1 Thomas Ball,
Emancipation Group, 1875,
bronze, Lincoln Park,
Washington, DC.

providing the official version, and promote a national air which would be inextricable from
the authority of American history. The struggle to produce an authentic national culture
would actually be inscribed in official history, while providing the means of inscription.

Thomas Ball's *Emancipation Group* (fig. 10.1) is such a work. A large sculptural group, it
represents Lincoln, the national hero, standing over the slave he has just freed. Ball first
modeled it in 1866 in response to Lincoln's assassination; a full-scale version was cast and
erected in Washington, DC, in 1875. It is a tribute to the white man, who is shown enact-
ing his greatest triumph, namely, the abolition of slavery.[24] Indeed, for all Ball's abolitionist
enthusiasm, the *Emancipation Group* does seem to maintain the *status quo* in terms of the
racial economy. The differences between the two figures present a sharp contrast: Lincoln
is standing, clothed, and has a specific identity, while the negro is crouching, naked, and
generic. Such a distinction is, of course, constitutive of the work's narrative content—Lin-
coln, a single figure, frees the entire shackled and unprotected black race—but it also oper-
ates within a paradigm of racial difference implicit in paternalism; that is, a paradigm
where white and black are mapped respectively onto civilized and uncivilized, developed
and undeveloped. A racial hierarchy structures the very composition of the group. The
paternalism of Northern abolitionist sentiment is reproduced visibly in the statue. Black
freedom has to be represented as white power. The iconography of these bodies, and the

connotations of their interaction, goes beyond the apparently simple act of setting free and invokes a set of notions of power, humility, and dependence.

While such a political relationship would no doubt have suited the majority of whites, including many abolitionists, it was far from what African Americans wanted or expected from emancipation. Many African Americans dreamed of a life where they would take the place of their masters and mistresses; a life summed up in the words of a familiar negro song, "Nigger in de saddle, white man on de groun.'"[25] The iconography of erect and crouching figures, on and off de groun', is a central motif in descriptions of racial equilibrium and of African American dreams of power. It might describe quite simply the change in the position of African Americans, as in this quotation from an anonymous African American sergeant:

> The change seems almost miraculous. . . . The very people who, three years ago, crouched at their master's feet, on the accursed soil of Virginia, now march in a victorious column of freedmen, over the same land.[26]

This rising up, expressed in strongly gendered terms, is something that Ball's slave has yet to achieve. But this change in position could also necessitate the repositioning of the white man too, a kind of hydraulic, or world-turned-upside-down model.

Such a change would not only reverse the physical positions of the standing and the kneeling, but would also reformulate conditions of viewing, prescribing differently who may look at whom, and how. The audience for Ball's group joins Lincoln in standing over the African American. Of course, this is not literally the case, since the pedestal of the monument sets the figures above head height, but the standing spectator is offered an identification with the standing Lincoln. This identification is both a straightforward physical one, since the viewer is also standing and, one presumes, clothed, and one that connects the viewer's gaze with that of the hero, creating a spectacular arena around the figure of the negro. The white gaze is a prerequisite for power in this visual economy, as freedom is staged within white representation. An anecdote in Leon F. Litwack's wonderful book *Been in the Storm So Long* gives us a fascinating alternative.

Litwack quotes Chaplain Henry M. Turner of the 1st Regiment of Colored Troops, writing in the *Christian Recorder* on the 17 May 1865. Turner writes:

> I was much amused to see the secesh women watching with the utmost intensity, thousands of our soldiers, in a state of nudity . . . I suppose they desired to see whether these audacious Yankees were really men, made like other men, or if they were a set of varrants. So they thronged the windows, porticos, and yards, in the finest attire imaginable. Our brave boys would disrobe themselves, hang their garments upon their bayonets and through the water they would come, swarm up the street, and seem to say to the feminine gazers Yes, though naked, we are your masters.[27]

There may be a danger of "overreading" that quotation, but it provides an extraordinarily rich source of connections between the issues at stake here. Firstly, the question of spectatorship: the naked, or as Turner puts it, nude male black body is scrutinized by the female gaze "with the utmost intensity." In an age when the represented male nude was a highly

dangerous subject, let alone unclothed flesh and blood bodies, this seems remarkable, particularly in view of the fact that the audience is female. It must be said, of course, that the historical circumstances of the South's defeat in the war are bound to impinge upon the prudish protocols of spectatorship. But there is also a sense of the gaze here being used in defiance of the free African American soldiers, both in its intensity, and given the context of the women's dress, "the finest attire imaginable." The women are refusing to give up their status, performing still the role of the elegant mistress free to stare at the bodies of her negro slaves—a *beau regard* indeed. The insistence on the nude black male body as a legitimate object of the female gaze is a means of refuting political change, of asserting the stability of the racial economy of slavery. The racial difference at the heart of the scene is again displayed in terms of the clothed/unclothed division, but in an extreme form: finery and nudity. The class connotations of this distinction are also unmistakable. The African American soldiers, of course, redefine the power of the gaze; they assume the role of master in spite of their nakedness. The duality of clothed and unclothed, of spectator and spectacle, is reversed. Turner's troops subvert the power constituted in the structure of spectacle; taking off their clothes, they allow themselves to be scrutinized by a hostile gaze, and yet still declare themselves masters, black over white. It should be clear that there is an uneasy closeness between the women and the soldiers, and Lincoln and the freed slave. Ball's free negro, another black male nude, would also be an acceptable object for the female gaze; the visual economy of slavery is to some extent still operative.

Chaplain Turner's remark about the women wanting to see if the African American soldiers were really men also opens out onto a specific and important debate, which is central to the logic of spectatorship. This is the debate about race and the body, and, in respect of this, there are two crucial points to be made. Firstly, racial difference is principally understood through corporeal difference. Anthropometry was the hallmark of much nineteenth-century anthropology,[28] and ethnologists in America reiterate constantly that the negro is not simply a black white-man, but is physically irreducibly different. Signs of inferiority and degeneration are unproblematically read from the negro body in pseudosciences such as craniology, embryology, or niggerology; in Biblical justifications for racism, authorized by Old Testament theology, blackness is the mark of Cain, or the curse of Ham; and in ethnology and anthropology, scientific measurement permits overwhelming evidence of negro inferiority. The negro's position is physically determined. His ugly, misproportioned, expressionless corpus is a natural sign of his inferiority. Not a bone in his body can make him equal, as the House of Representatives was told in 1867:

> The skeleton is unlike in the whole in weight and measurement, and unlike in every bone of it. These differences ought to be conclusive that they cannot and do not belong to the same type.[29]

Moreover, specific details of the racist morphology of the negro body could be used to justify certain forms of discipline. His thick skull means you can hit him on the head with heavy objects; his thick insensitive hide means you can whip him. Even subservience could be read from the body, since the negro leg is naturally bent at the knee.[30] The embodiment of race is pursued to such a degree that the person, and his selfhood, is erased. The negro is reduced to the morphology of the body and no more. Sambo has no will of his own; his

interests are identical with those of his master, and the possibility of black agency disrupting this situation does not arise. Embodiment is, strangely perhaps, a dehumanizing gesture. The body is not measured, probed, and analyzed in order to animate the object of anthropology, but to petrify it in ideological rock.

The second point to be made is that through the second half of the nineteenth century in America, the body increasingly became the medium of masculinity. Masculinity was understood as literally embodied. Manliness, like racial inferiority, could simply be read off the body, and just as the apparent physical defects of the negro signaled a moral absence, so, in the white body, the moral and the muscular were conflated and conceived as mutually reducible. It is this masculine body that sculpture demands, and it is around the issue of ethnicity and the gendered body, and particularly of the male nude, that Turner's troops meet Ball's freed slave, and the high discourse of art meets the low discourse of racism.

The male nude is strangely ambivalent. It is a traditional sign of masculinity, of strength and courage. Classical and classicizing sculpture from Phidias to Thorwaldsen and beyond takes the male nude as a central subject; indeed, it is this tradition that makes nudity heroic. Yet, at the same time, and perhaps in spite of the cultural encoding of the unclothed male body, to be nude is to be vulnerable and exposed. The male nude needs to be supported by traditions of masculine representation, narratives of inviolability, and media that can offer concrete analogues for the inviolability of the heroic flesh. The nude provides these analogues by careful attention to the organization of the body and its surfaces: proportion, physical perfection as ruled by antique or pseudo-antique canons; pose, as a science of balance, the poised, relaxed body *after* exertion; the surface of the body rendered as smooth and as unblemished as new armor. All these present a body that is symbolic of moral perfection. Once again, the fulcrum of the masculine is control. The particular exclusions, such as excessive contrapposto, or the contrivances of pose one might find in Giambologna or Bernini, are not simply an indication of the importance of classical idealization in mid-nineteenth-century America; they also draw our attention to the symbolic and morphological differences of male nudity, and the limitations of discussing the male nude as a homogeneous category. The male nude is all too often taken to be an unproblematic, self-evident category, and one that stands apart from historical problems such as race. The male nude needs to be unsettled; the distinctions that the nude creates, and its location in a larger taxonomy of corporeal morphology, make it clear that there is a tension between any appeal to the generic nude as the unimpeachable icon of aesthetics, and any given nude as a specific representation of the body. In order to understand what is at stake here we need to think of the nude as a set of bodies, a system of corporeal classification that can distinguish the acceptable, controlled body from the excessive and indecent one. The nude is not simply a representation of the body, but a measure of corporeal decorum. This decorum also applies to other bodies; the nude becomes the yardstick not only in art, but within a broader representational field.[31]

The male nude, then, is fraught with problems and divisions. These are only heightened by the introduction of blackness into the equation, and are thus evident in the black bodies of public sculpture. The black male nude illustrates the tension inherent in the male nude to a potentially disruptive degree; while produced within the unifying tradition of sculptural nudes, it simultaneously fractures this tradition, drawing attention to racial division as fundamental to representations of the body. This is not necessarily a problem for

artists in nineteenth-century America, though. Indeed, it can provide the means of assert-
ing black masculine identity without challenging paternalism. Ball's freed slave, for exam-
ple, is idealized, the body shaped in accordance with the classicizing aesthetic imperatives
of his time. The figure also conforms to notions of how the masculine body looks. It is an
unremarkable, idealized male body. On the one hand, this is a breakthrough, given the
slave's blackness. The statue does constitute some kind of challenge to ethnological ortho-
doxy in America, given that it requires the recognition of the black as masculine, and
asserts that recognition through the representation of the body. But on the other, as we
have seen, this masculinized body, within the context of the sculpture's narratives, plays on
the ambivalence of the nude, and creates a nude not of power, but of vulnerability within
a racial hierarchy. Massa is still standing, nigger is still on de groun'. The male nude, then,
is not a simple sign of power, but can be used and contextualized in ways that separate
physical and political power. It can both endorse masculine identity, but keep this distinct
from the social implications of what masculinity permits.

Recognition and the Erotics of Power

> To be sure, they often look magnificently to my gymnasium-trained eye; and I always
> like to observe them when bathing,—such splendid muscular development, set off by
> that smooth coating of adipose tissue which makes them . . . appear even more muscular
> than they are.[32]

Within this complex and somewhat troubling debate around the male nude and the struc-
tures of spectatorship, there is one further problem to be broached: the erotic. The male
nude is also precariously positioned in relation to desire. While nudity is a purification of
nakedness, an ostensible translation of the erotic into the disinterested aesthetic, thus func-
tioning as a defense against desire, the erotic and the aesthetic are not so easily separated,
being, as they are, mutually defining. Moreover, nudity cannot help but be a representa-
tion of nakedness; there is a sense in which it must offer the exposed body for the delecta-
tion of the viewer. It would be easy to overlook the sexual resonances of, say, Higginson's
remarks about the pleasures of watching his black bathing beauties; it would be similarly
easy, and similarly historically mistaken, to predicate an erotic charge in looking that repre-
sents homosexuality, whether latent or not.[33] At this point, I want to take a short, specula-
tive theoretical detour, to try to steer the debate between the Scylla of disavowal and the
Charybdis of anachronism.

 We have seen how black masculinity could be constructed through the male nude, and
how sculptural protocols, the requirement for the body to be cast within specific parame-
ters, prescribe how the black man is to be defined. Sculpture permits the figuration of
black manhood, but its agent, the classicized, black Apollo, cannot stand outside the para-
digm of white paternalist representation. Thus, while black manliness is permitted, it is,
simultaneously, displaced; it is still only definable in relation to white norms. Describing a
similar, though by no means identical problem—that of Indian widow sacrifice under
British imperialism—Gayatri Chakravorty Spivak talks of "an inaccessible blankness cir-
cumscribed by an interpretable text;"[34] that is, the figure of the widow can only be appre-

hended by whites within epistemological structures which actually make apprehension impossible. In the same way, the white interpretations of the black masculine body are radically disjoined from the black man; he is inaccessible. The recognition of black manhood, the striving for an identifiable authenticity, is simply a demonstration that the authentic black man is unrecognizable. Black masculinity is no more than a symptom requiring interpretation. This points towards what makes Spivak's formulation so useful: that she is, of course, describing the unconscious. I want to push this Freudian analogue a little further to explore the possible connections between these structures, to see, in particular, how the black male nude is caught up in the translation of the erotic.

The analysis thus far has concentrated on the decorum of the male nude—its coherence, control, surface, and organization—and the symbolic importance of these factors in the signification of gender and social cohesion. Importantly, such a body, when used for the black, represents a shift from ugliness to beauty. Instead of being marked out as comic or repulsive, the black body is aestheticized. This is an inevitable consequence of the use of antique models, perhaps, but the ramifications should not be dismissed lightly; for not only does this body allow the construction of black masculinity while allaying fears of social disruption, but also establishes the black body as aesthetically alluring, as something to be looked at, not in terms of subordination, but in terms of pleasure. The body signals the containment of power, the maintenance of white supremacy, and beauty. What is it that binds these things together across the surface of the nude?

Central to this nexus is the issue of recognition, a term I take from the work of Jessica Benjamin.[35] Benjamin's work is part of a movement in psychoanalytic theory away from the intrapsychic emphasis of Freud, towards the realm of intersubjectivity, a movement that "reorients the conception of the psychic world from a subject's relations to its object toward a subject meeting another subject."[36] What the theory of intersubjectivity offers is a model of psychic, and in Benjamin's work, specifically erotic, life that is founded not in the tensions of an internal psychosexual development, but on tensions between interacting individuals. Working through intersubjectivity in very subtle ways, Benjamin suggests that "the original erotic component [is] the desire for recognition."[37] Unlike, say, ego psychology, where the self emerges through the process of differentiation, Benjamin's theory predicates the subject as already formed, already differentiated, even in the pre-Oedipal stages of life.[38] The crucial problem of asserting subjectivity, or self-identity, is rather one of recognition and the paradox it poses. To assert its identity, the subject has to be recognized by another; but to be recognized requires that the other also be recognized as a subject. This, in turn, poses a threat to the power of the subject, since it necessitates the sharing of power, the granting of power to the other. Mutual recognition is a necessity, and this operates a tension between sameness—understanding both self and other as subjects in an intersubjective relationship—and difference—differentiating oneself through the other's recognition. Failures to resolve this tension are what, in Benjamin's argument, motivate erotic fantasies of domination and submission, and, extrapolating from specific psychosexual examples, the eroticization of power and violence in a more general sense. Without wishing to dally in the debates about pre-Oedipal sexual development, I think Benjamin's thesis provides an interesting framework for the analysis of the emergence of the black masculine body.[39] I am aware that to move from Thomas Wentworth Higginson's claim that whites are now "recognizing" African Americans as men, to Benjamin's highly theorized

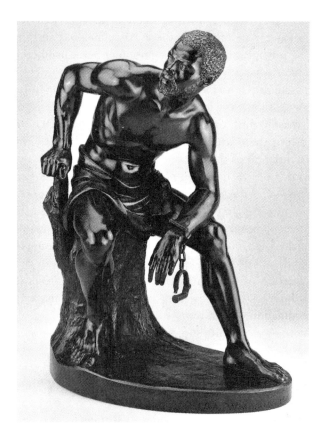

Figure 10.2 John Quincy Adams
Ward, *The Freedman*, 1863,
bronze, Art Institute of Chicago.

psychoanalytic extension of the term is to create a slippage from the historical to the psy-
chic, a movement between apparently unconnected discourses. Nonetheless, I feel that
there is a connection to be traced, and one that might prove illuminating.

The recognition of the African American as a man in nineteenth-century America was a
question of negotiating between sameness and difference, permitting manhood without
disturbing inequalities of power based on ethnicity. The black male nude certainly bears
this structure; indeed, it is the third term of the body beautiful that allows the recognition
to appear complete. Three years before Ball began to model his *Emancipation Group*, in
1863, John Quincy Adams Ward had exhibited *The Freedman* (fig. 10.2) at the National
Academy of Design in New York. It is a single figure—a seated black nude, the shackles
around his wrists broken—and it is an almost allegorical figure, representing African
American liberation, albeit in a rather literal-minded manner. This work and contempo-
rary responses to it, like Ball's *Emancipation Group*, point up the need for sculptors and
viewers to negotiate the tensions between the demands of sculptural practice in relation to
gender, and the demands of white discourse in relation to race; the sameness of masculin-
ity and the difference of race.

Even more than in Ball's statue, the body here is classicized; the model for pose, propor-
tion, and musculature is the *Belvedere Torso*. This physique, the classical ideal with its reso-
nances of perfect masculine virtue, functions like the Emancipation Proclamation itself,

conferring on the negro a new status of freedom, of masculinity, of subjectivity, a status described through the body. The ideal black, of course, is no truer than the body of ethnological thought. Critical reactions to Ward's sculpture unwittingly declare the awkwardness it poses. The *New York Times*, reviewing the Academy's exhibition, wrote enthusiastically:

> It is the full-length figure of a Negro, modeled from select specimens of the race, and shows that the African shares with the European the exalted proportions of the human figure. . . . We know of no American statue which more nearly approaches the classic, either in conception or execution.[40]

Here is proof, then, that black and white bodies are the same; both display the classical proportions central to human beauty and thus its moral concomitants. But the proof of corporeal equivalence between black and white is undercut by an obvious paradox: the single, unified, well-proportioned African body is built up from select specimens. It is modeled from life, and yet it is palpably classicized. Ward becomes a Frankenstein figure building up a recognizable negro, perfecting the black body through the medium of the ideal male nude. This tension between the ideal and the specific, of course, could also apply to other nudes; what is particularly problematic here is the ambiguity as to whether *The Freedman* signifies a general human ideal or only a specific black one.

This incoherence is repeated by James Jackson Jarves in his book *The Art-Idea* of 1867, one of the most important of nineteenth-century American art critical works. Jarves, too, is very enthusiastic about *The Freedman*. It is:

> a genuine inspiration of American history, noble in thought and lofty in sentiment. . . . A naked slave has burst his shackles and, with uplifted face, thanks God for freedom. It symbolizes the African race of America—the birthday of a new people into the ranks of Christian civilization. The negro is true to his type, of naturalistic fidelity of limbs, in form and strength suggesting the colossal, and yet of an ideal beauty, made divine by the divinity of Art.[41]

Jarves tries to accommodate the same problem: is this naturalistic or is it ideal? Is this a true to life and true to type male body, or one perfected by the sculptor and his divine muse? Is this general humanity or specific blackness? The paradox of recognition is mitigated by the hegemony of creativity; art consolidates the power to recognize as greater than the need to be recognized. Again, the paternalist gloss on black identity is brought into play, bounding the sculpture and its meanings, in Jarves' account, ascribing as he does both the black's freedom and his masculine body to divine agency, be it white God or white art. This is confirmed and complicated by the issue of nationality. Is this man American or African? "The African race of America" is an uneasy phrase, endorsing white supremacy—these are the blacks *of* America. The black hole of Africa is made accessible by the interpretability of white America.

The central problem of recognition, the negotiation of sameness and difference, seems to structure the black male nude and the response to it. Jarves' difficulties, for instance, with Ward's *Freedman* are fundamentally an uneasy resolution of the assertion of similarity, the black body as American and ideal, and of difference, the body as African. The body

actually provokes the process of recognition. The articulation of black manhood within the context of white power depended on making the body beautiful—a sameness—but submissive—different. The contradiction is that the heroic body is by its very nature not submissive. What is fascinating is the fact that it is the body, the most important site of the erotic, that is central to the paradox, a connection that Benjamin's theory would suggest is no accident. So it is not simply the aesthetic, but the erotic—which is, after all, the representation of the sexual within the limits of the aesthetic—that channels the paradox away, that cathects it. The glue that binds together power, inequality, and beauty is *desire*.

I do not wish to overemphasize this notion of the erotic in the black male nude; it is, after all, almost impossible to adduce historical evidence for it. Nonetheless, it seems important to be aware of the ways in which desire might intervene in the matrix of race, power, sexuality, and beauty, particularly in view of the centrality of the body to this formation. We need to address the fundamental question of why one man should want to look at another naked man. In problematizing the homosocial gaze, asking what is at stake, and how it is regulated, a theoretical framework is needed that can deal with issues of what can and cannot be said, of blankness and text, of inaccessibility and interpretability. In talking about desire between men in this way, it is important that we avoid the trap of discussing homosexuality. In nineteenth-century America, homosexuality is yet another inaccessible blankness, but one circumscribed by an interpretable text which I would term the homoerotic. By homoerotic I do not mean eroticism within homosexuality: there is a crucial distinction to be made between these. I use the term instead to designate a displacement of desire into a position which both allows and refuses that desire; that is, it is a position which clearly contains the possibility of desire between men, but which, in making that containment evident, actually constructs the possibility of the desire it refutes. Importantly, it provides us with a theoretical model which can articulate a desire between men that can be conceived as something other than an ostensibly self-evident homosexuality.[42]

Given the operation of desire, how is it possible that the pleasure Higginson experiences as he watches his troops bathe can be publicly invoked by sculpture without a slip into indecency? The process of recognition also required that the black body be viewed differently. Under slavery, the black body could be clearly contained by the white gaze as either anthropological curiosity, animal, or chattel; that is, it could be a legitimate object for the spectator in spite of the problematic status of the male body, particularly when unclothed, in the visual realm. After emancipation, a new logic of spectacle was needed, a new codification of the body and its audiences to allow scrutiny and visual discipline of the black, but one which would mitigate the dangerous, potentially erotic allure of gleaming black muscles. While the homoerotic charge of the black form could be effaced or sublimated by rituals of violence, myths of sexual prowess, and dehumanization in pre-War visual economies, the opening of recognition, if Benjamin is to be believed, brought the erotic to the surface. Of course, strategies of containment, of fictions and violence, continued; but these would not deflect the threat posed by the black male nude. So how is this permissible?

It is the very medium of public sculpture that provided the answer. The sculpted body of bronze or marble was an essential means of exposing and classifying the male form without at the same time exposing the flesh, its weaknesses and its pleasures. Time and again, across numerous discourses, the masculine body is discussed in metaphors of stone and metal, described as hard and inviolable, defined as sculpture. While there were still limits to the sculp-

tural representation of the male nude—for example, the penis had to remain hidden and, in general, before the 1880s at least, classical models had to be adhered to—statues were seen to defuse the problem of the erotic. Of course, there is a sense in which it is actually on the body of sculpture that the homoerotic is formed, that male pleasure in a male body becomes a possibility, but as erotic pleasure is given a concrete object, it is defused or displaced by the visual economy of the aesthetic. The impossible object of the homoerotic gaze in nineteenth-century America, the inaccessible blankness, is constructed and occluded by the interpretable text of sculpture. The black body is easily legitimated as a body for the homosocial gaze, as Ball's *Emancipation Group* demonstrates; the black male nude still bears the traces of objectification even within the new category of the masculine black subject. Moreover, this spectacle of the black male nude is staged within the arena of white power. Thomas Wentworth Higginson's eye is "gymnasium-trained;" it has the legitimacy of a homosocial structure and institution that is highly important in the definition of masculinity. This allows an interpretation, a reading of male bodies, that mitigates desire, but one which, at the same time, requires that the possibility of desire be permitted. Again, following Jessica Benjamin, we might assert that the undecidable status of the black, the unresolved tension between sameness and difference, manifests an erotics of power which structures the homosocial gaze.

The Grotesque Body and Class Transgression

The coherent black body, then, is significant of white social coherence,[43] a stable racial economy, and the containment of the homoerotic (or, perhaps, the homoerotic is a containment of homosocial desire across the race divide). It need hardly be said, of course, that while the coherence of the black body was essential to public sculpture, this coherence, and its connection with the granting of masculinity to the black man, is absent in other forms of representation. Indeed, let us not forget that it is *after* emancipation that racism becomes most intense and virulent.[44] The pre-War myths do not disappear, but they are recast in such a way as to allow their use within a changed political and social context. One of the central myths that is recycled to an enormous extent is that of the negro as mimic; the belief that the negro is a gifted and natural mimic whose instinctive facility for imitation is a source of both entertainment and social usefulness. It is this mimetic faculty that allows that training of the negro to fit into white society. This is Theodore Tilton, still droning on at the Cooper Institute:

> We need the negro for his imitative faculty—which . . . not making him a mechanic or inventor, works toward the aesthetic faculties and makes him the true dramatic actor, though banished from the stage.[45]

In other words, a minstrel to provide an entertainment for whites. Josiah Nott's *Instincts of Races*, published originally in the *New Orleans Medical and Surgical Journal* in 1866, proposes a rather different benefit to be gained from this natural mimesis:

> The Negro is imitative, social, easily domesticated, and as long as kept in subordination to a higher race, will ape to a certain extent its manners and customs. But the negro rises only

to a certain part of imitation—his intellect permits no approach to civilization but that of imitation, and, as soon as the race is . . . separated from whites . . . it becomes savage.[46]

After emancipation this idea takes on a new importance. The insistence in some quarters on the African American as an independent subject was contested in more overtly racist representations and writings, by a greater emphasis on imitation. That is, any claim which might be made for African Americans, such as that they can be viewed as masculine, could be countered by the claim that this was simply further proof of the imitative nature of the negro. The imitation now, though, was dangerous. Nott's warning that the negro must be kept in subordination to the white was heard with increasing frequency.

Again, a central motif for the expression of this was the black body; but rather than the coherent and controlled body of the sculptural male nude, the incoherent and grotesque body of the popular print, exemplified by Currier and Ives's *Darktown* series (fig. 10.3). This series of comic prints was the work of Thomas Worth who, although never a regular employee of Currier and Ives in the way that Frances Palmer had been, produced some of the company's most popular and financially successful prints. The *Darktown* comics present African Americans mimicking white activity both in labor and, more often, leisure. The subjects chosen by Worth—firefighting, boating, baseball, hunting—tended to be those that other, serious Currier and Ives prints depicted, and so he had a visual vocabulary at hand to provide the basis for his comic images. Moreover, he had a visual vocabulary that provided a lexicon of gender roles and their representation, and so *Darktown*, in the context of print production as a whole, was able to consolidate a clear distinction between norm and deviance. In these pictures, the free negro is shown taking on the identity, role, or behavior of white Americans; they are aping their ex-masters and -mistresses. But this assumption of roles, and particularly of gendered behavior, is always parodic. The negro is no longer a child, nor is he really masculine; he can only offer a hilarious and humiliating spectacle of pseudo-masculine behavior.

The emancipated negro, as we have seen, has acquired gender. He also has a more apparent class position. This is not to suggest that, under slavery, African Americans did not have a very clearly defined class position, but that as chattels, they could not be considered class subjects by whites and the institution of slavery. From the end of the Civil War, though, class came to feature explicitly in representations of the African American. The consolidation of African Americans as part of the working class is indirectly treated in *Darktown*. Negroes were well-known for being bumptious and uppity, for ostentatious display,[47] for getting ideas above their station. That is exactly what is at stake here: keeping the free African American in his place. The *Darktown* negroes are stepping outside their class position, trying to behave like the bourgeoisie. This aspiration is clearly beyond the stupid, clumsy, and inept characters in the images. As with the negroes' gender, their class status is mere mimicry, a shallow simulacrum.

The style of the *Darktown* series is far more caricature than previous work by Worth or many other Currier and Ives artists. *Darktown* represents an intensification of the implications of ethnological thought from the 1850s and 1860s. The body is the principal medium for this. Those familiar features such as big feet, scrawny gangling limbs, woolly hair, and minstrel style faces with no capacity for any but the most comical and grotesque expressions, are once more the defining characteristics of the black body. Moreover, this body is

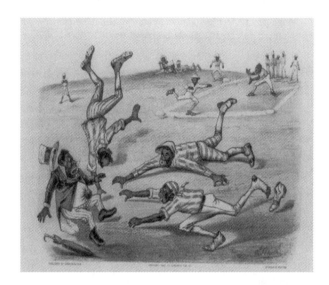

Figure 10.3 Thomas Worth, *A Base Hit!* 1882, engraving, Library of Congress, Washington, DC.

visible proof of the African American's pretension in trying to engage in bourgeois—or even white working-class—leisure. With a body as uncoordinated as this, any attempt to live out his new status as a classed and gendered subject is thwarted. The pictures of the *Darktown* baseball team are a perfect example.

In the last quarter of the century, sport became increasingly popular and was widely encouraged. It was an important way of developing the muscular, moral, masculine body, the athletic physique and fitness that marked out true men. Baseball was no exception to this. Like other team games, it was also championed as providing not only individual discipline, but the discipline of working as a team. The goals of physical and moral health, of homosocial cohesion, and of victory, were those that had previously been established in the discipline of war. All these goals are absent in *Darktown*. The negroes are unfit; their bodies are horrendously and laughably unathletic; and the lack of discipline is all too clear. The elements of sport which define masculinity are missing; they are merely mimicked. Baseball simply does not belong to the negro. The black body, the grotesque sign of class transgression, betrays him. *Darktown* proves Josiah Nott's point, that true acculturation is not possible.

The *Darktown* prints seem to lie squarely in the field of what has come to be known as retrogressionist thought.[48] This is exemplified by Nott's thesis; that, free of civilizing white society and white masters, blacks will inevitably revert to a state of natural savagery. The rise of retrogressionism, although firmly rooted in antebellum fictions, was very much part of a post-emancipation fear of African American retribution, power, and, perhaps worst of all, integration. Retrogressionist arguments tended to be constructed as more sophisticated forms the myth about negro imitativeness; while African Americans may take on the identities of bourgeois teachers, rural workers, preachers, politicians, mechanics and so on, they are, in spite of any ostensible socialization, fundamentally undifferentiable. All are savages. Freedom, of course, was viewed as the cause of their reversion to type.

In this well-received book of 1889, *The Plantation Negro as a Freeman*, Philip A. Bruce wrote:

The blacks are now at liberty to act just as they prefer to act, wholly unhampered by authority. . . . [T]he unrestricted indulgence of their instincts in consequence, however injurious to themselves or destructive to society, has served only to fix these instincts more deeply in their natures. Then, too, emancipation enlarged the scope of these instincts, by increasing the opportunities for their gratification. . . . The whole race is fast reverting to the original physical type, and, therefore, to the original moral. . . . The further development of these traits means the further departure of the negro from the standards of the Anglo-Saxon.[49]

We can recognize only too well the structures of thought underpinning Bruce's argument: the coupling of the physical and the moral; the incipient paternalism; the gendered vocabulary that opposes unmanly gratification and masculine control.

Interestingly, Bruce's book was received by critics North and South as an impartial scientific account. If such an essay represents a cool statement of the retrogressionist position, and an articulation of the basic threat, *Darktown* constitutes a means of defusing the threat. No longer disciplined by the hand of slavery, the inhabitants of *Darktown* act freely; but in doing so they merely ape white society while regressing to their natural state, characterized here by inertness and stupidity. Their racial characteristics make their class status redundant. The negro is something to be mocked, not feared.

What the *Darktown* series seems to postulate is a symbolic connection between the incoherence of the black body and the incoherence of the black social group. This extends the symbiosis of the moral and the corporeal to serve a number of purposes. Firstly, it allays fears of African American political action or physical revolt in the aftermath of slavery. The South, and to some extent the North, was haunted by the fear of African American insurrection, but these gangling grotesques cannot play baseball properly, let alone form a cohesive and effective political organization. Secondly, it provides an answer to the paradox of recognition which bypasses the erotic, and the nexus of desire in black-white relations. The black's apparent subjectivity, his demand for recognition, is a mere extension of his imitative gift. Recognition is not a question of the intersubjective, but is a hollow spectacle where Sambo still plays the ape for a white audience, one-way traffic. Thirdly, and crucially, it shows that the coherent black body is only held in place by paternalism. Disengaged from white control, the body politic and the body corporal degenerate into excess, weakness, and utter degradation. There is a sense in which we should read *Darktown*, not as antithetical to Ball's *Emancipation Group*, but as complementary to it. While there is an obvious distinction between the pro-abolitionist dignified black body of the statue, and the overtly racist negroes of the popular print—a distinction which, I hasten to add, should on no account be ignored—we should also be aware that together the two works demonstrate a more fundamental problem in the representation of racial difference.

In the sculptures by Ball and Ward, the black functions as a symbol of America. The freedman is part of the nation—in Ball's work a symbol of Lincoln, the great white leader, or of racial unity. The consonance here, a consonance defined by the coherent black body, is a product of white models of representation, and what could be whiter than classical antique Apollo? As I hope I have shown, this modeling is deeply indebted to and constitutive of white racist fantasy. *Darktown*, on the other hand, uses the black body in its extreme grotesque definition as a symbol of the coherence of *white* America, of all the white men

who play baseball, the solid social grouping to which the Darktown baseball team provides the foil. The bodies here invoke the moral, muscular bodies of white masculinity, and so are represented in relation to the same corporeal, and therefore moral, ideal as Ball's and Ward's figures. The crucial point I am trying to make here is this: together, these examples show how white racial—or racist—thought actually structures visual representation. Artistic intention may seem obvious—it is very easy to call Worth a racist, and Ball not—but the very languages available, the very cultural sites in question, have been constructed and are constitutive of a racial economy that privileges white over black. While there is an important difference between statue and print, in terms of the different demands of particular media and their respective audiences, they stand as complementary nodes in the cultural matrix; indeed, the different media actually hold each other in place.

Ball and Ward were quite plainly trying to produce what one might term sympathetic images of the African American, but the notion of a sympathetic image is highly problematic: sympathetic to whom, and at what cost? A reading of *The Freedman* or the *Emancipation Group* as unproblematically positive would be to displace the sculpture from its historical location of a fundamentally divisive site. The issue is not simply to find a way of labeling all white representations of blacks as racist—that would be too simplistic, historically and morally. We find ourselves in a situation where the limits of the language of racism become only too apparent. There is a danger that an undeveloped model of "racist representation" will only ever permit more and more images to be labeled; as if cultural analysis were simply a contest to find racism in increasingly obscure places. It would seem more important to disrupt white liberal pieties that allow such labeling to take place so easily.[50] The more important task is one of trying to understand how racism works in the visual field, the purposes it serves, and how art may be implicated in the racial economy. "Representation has not withered away."[51] Spotting racism is not enough; the question is, why is it so difficult to dismantle?

Notes

I am indebted to Lynn Nead for her acute readings of both this essay and an earlier version of it. Thanks also to Andrew Hemingway and Annie Coombes for their helpful comments.

1. Thomas Wentworth Higginson, *Army Life in a Black Regiment* (Boston, 1870), p. 267.

2. This essay only considers masculinity and the male body; in omitting any discussion of the female body I do not intend to suggest that representations of masculine and feminine are not mutually defining, nor would I maintain that much of my argument could not apply, in very broad terms, to the female body.

3. E. Anthony Rotundo, "Romantic Friendship: Male Intimacy and Middle-Class Youth in the Northern United States, 1800–1900," *Journal of Social History*, vol. 23, no. 1, Fall 1988, pp. 1–25. See also Donald Yacovone, "Abolitionists and the 'Language of Fraternal Love,'" in eds. Mark C. Carnes and Clyde Griffen, *Meanings for Manhood: Constructions of Masculinity in Victorian America* (Chicago and London, 1990), pp. 85–95.

4. While the relationship between popular and scientific discourses was by no means completely straightforward, novels, magazine articles, and journalism all drew on racial theory in dis-

cussions of the negro; hence, the slippage here between scientific theory and ideas held across a wider social formation.

5. John W. Blassingame, *The Slave Community: Plantation Life in the Antebellum South*, revised and enlarged edition (New York and Oxford), 1979, p. 230.

6. Eugene D. Genovese, *Roll, Jordan, Roll: The World the Slaves Made* (New York), 2nd edition, 1974, pp. 4–5.

7. J. H. Van Evrie, *White Supremacy and Negro Subordination*, 2nd edition (New York, 1868), p. 220.

8. Theodore Tilton, *The Negro. A Speech at Cooper Institute, New York, May 12* (New York and Boston, 1863), p. 5.

9. On black resistance to the Sambo myth, and attempts to fulfill masculine roles as fathers and husbands, see Genovese, op. cit., pp. 490–4.

10. For details of Palmer's work and career, see C. S. Rubinstein, "The Early Career of Frances Flora Bond Palmer," *American Art Journal*, Fall 1988, pp. 71–88.

11. Margaret Marsh, "Suburban Men and Masculine Domesticity, 1870–1915," in Carnes and Griffen, op. cit., pp. 111–27.

12. Charles E. Rosenberg, "Sexuality, Class, and Role in Nineteenth-Century America", *American Quarterly*, vol. 35, no. 2, May 1973, pp. 131–53.

13. On the history of black soldiers in the Civil War see Dudley Taylor Cornish, *The Sable Army: Negro Troops in the Union Army; 1867–1865* (New York, London, and Toronto), 1956; William Wells Brown, *The Negro in the American Rebellion. His Heroism and His Fidelity* (Boston, 1867); eds. Ira Berlin, Joseph P. Reidy, and Leslie S. Rowland, *Freedom: A Documentary History of Emancipation, 1861–1867. Series II: The Black Military Experience* (Cambridge, 1982).

14. The poster is reproduced in L. Hughes and M. Meltzer, *A Pictorial History of the Negro*, 3rd edition (New York, 1968), p. 173.

15. Henry T. Johns, *Life with the Forty-Ninth Massachusetts Volunteers* (Pittsfield, MA, 1864), p. 151.

16. For example, William Nell, *Colored Patriots of the American Revolution* (Boston, 1855).

17. Higginson, op. cit., pp. 52–3.

18. Johns, op. cit., p. 150.

19. Ibid., p. 150.

20. I am indebted here to a discussion of frameworks for theorizing the body by Arthur W. Frank, in "For a Sociology of the Body: An Analytic Review," in eds. M. Featherstone, M. Hepworth, and Bryan S. Turner. *The Body: Social Process and Cultural Theory* (London, Newbury Park, and New Delhi, 1991), pp. 36–102.

21. Johns. op. cit., p. 152.

22. Ibid., p. 152.

23. Ibid., p. 153.

24. Thomas Ball, *My Threescore Years and Ten* (Boston, 1891), pp. 252–3 and pp. 281–3. For the commission from Moses Kimball for a duplicate for Boston, see p. 290.

25. Leon F. Litwack, *Been in the Storm So Long. The Aftermath of Slavery* (London, 1980), p. 224.

26. *Christian Recorder*, May 28, 1864, quoted in Litwack, op. cit., p. 95.

27. Litwack, op. cit., p. 97.

28. John S. Haller, Jr., *Outcasts from Evolution: Scientific Attitudes of Racial Inferiority, 1859–1900* (Urbana, Chicago, and London, 1971), p. 7.

29. William Mungen, speech in the House of Representatives, July 10, 1869, quoted in Hinton Rowan Helper, *The Negroes in Negroland; the Negroes in America; and Negroes Generally* (New York, 1868), p. 190.

30. On the naturally subservient position of the negro body see Karen Sanchez-Eppler, "Bodily Bonds: The Intersecting Rhetorics of Feminism and Abolitionism," *Representations*, vol. 24, Fall 1988, p. 30.

31. While the male nude is a general type, defining a universal masculinity, it should also be noted that it can be viewed as class specific; the inscription of forms of labor on the working-class body marks it out as ineligible for the representation of essential manhood.

32. Higginson, *Army Life*, p. 55.

33. While my argument rests on historically specific definitions of sexual behavior and identities, I do not wish to subscribe to the radical social constructionist view of homosexuality as historically incoherent before the rise of sexology in the late nineteenth century. This view is, in itself, incoherent; see Hilary Putnam, "Philosophers and Human Understanding," *Realism and Reason: Philosophical Papers*, vol. 3 (Cambridge, 1988), pp. 184–204.

34. Spivak describes her essay "Can the Subaltern Speak?" as an elaboration of this notion in "Three Women's Texts and a Critique of Imperialism," *Critical Inquiry*, vol. 12, Autumn 1985, p. 260, no. 9. "Can the Subaltern Speak?" is to be found in eds. Cary Nelson and Lawrence Grossberg, *Marxism and the Interpretation of Culture* (Basingstoke and London, 1988), pp. 271–313.

35. Jessica Benjamin, *The Bonds of Love: Psychoanalysis, Feminism, and the Problem of Domination* (London, 1988), and "Master and Slave: The Fantasy of Erotic Domination," in eds. A. Snitow, C. Stansell, and S. Thompson, *Desire: The Politics of Sexuality* (London, 1984), pp. 292–311.

36. *Bonds of Love*, p. 20.

37. "Master and Slave," p. 292.

38. *Bonds of Love*, p. 94.

39. Once again, the contradiction of paternalism that Genovese outlines comes to mind. Genovese discusses the use of Freud in the history of American blacks, and mentions his own debt to Freud, in "Towards a Psychology of Slavery: An Assessment of the Contribution of *The Slave Community*," in eds. Al-Tony Gilmore, *Revisiting Blassingame's "The Slave Community": The Scholars Respond* (Westport, CT, and London, 1978), pp. 27–41.

40. Quoted in Lewis I. Sharp. *John Quincy Adams Ward: Dean of American Sculpture* (Newark, London, and Toronto, 1985), p. 154.

41. James Jackson Jarves, *The Art-Idea*, ed. Benjamin Rowland, Jr. (Cambridge, MA, 1960), p. 225.

42. For another solution to the problem of articulating desire between men in nineteenth-century America see Michael Moon's essay "Disseminating Whitman" in eds. Ronald R. Butters, John M. Clum, and Michael Moon, *Displacing Homophobia: Gay Male Perspectives in Literature and Culture* (Durham, NC, and London, 1989), pp. 235–53.

43. The question of the body and the symbolization of the social has been most brilliantly analyzed by Mary Douglas; see, in particular, her *Natural Symbols: Explorations in Cosmology* (London, 1970), and "Do Dogs Laugh? A Cross-Cultural Approach to Body Symbolism," in ed. T. Polhemus, *Social Aspects of the Human Body* (Harmondsworth, 1978), pp. 295–301.

44. Rayford W. Logan, *The Negro in American Life and Thought: The Nadir, 1877–1901* (New York, 1954).

45. Tilton, op. cit., p. 12.

46. Josiah C. Nott, *Instincts of Races* (New Orleans, 1866).

47. For example, see Johns, op. cit., pp. 148–9.

48. Herbert G. Gutman, "A Brief Note on Late-Nineteenth Century Racial Ideology," in *The Black Family in Slavery and Freedom, 1750–1925* (New York, 1976), pp. 531–44.

49. Philip A. Bruce, *The Plantation Negro as a Freeman* (New York and London, 1889), p. 129.

50. This is another important theme in Spivak "Can the Subaltern Speak?", op. cit., and one that recurs in various ways throughout the collection, Gayatri Chakravorty Spivak, *The Post-Colonial Critic: Interviews, Strategies, Dialogues*, ed. Sarah Harasym (London and New York, 1990).

51. Spivak, "Can the Subaltern Speak?", op. cit., p. 308.

MODERNISM AND ITS "PRIMITIVE" LEGACY

11

Histories of the Tribal and the Modern

James Clifford

You do not stand in one place to watch a masquerade.
—An Igbo Saying

During the winter of 1984–85 one could encounter tribal objects in an unusual number of locations around New York City. This chapter surveys a half-dozen, focusing on the most controversial: the major exhibition held at the Museum of Modern Art (MOMA), " 'Primitivism' in 20th Century Art: Affinity of the Tribal and the Modern." The chapter's "ethnographic present" is late December 1984.

The "tribal" objects gathered on West Fifty-third Street have been around. They are travelers—some arriving from folklore and ethnographic museums in Europe, others from art galleries and private collections. They have traveled first class to the Museum of Modern Art, elaborately crated and insured for important sums. Previous accommodations have been less luxurious: some were stolen, others "purchased" for a song by colonial administrators, travelers, anthropologists, missionaries, sailors in African ports. These non-Western objects have been by turns curiosities, ethnographic specimens, major art creations. After 1900 they began to turn up in European flea markets, thereafter moving between avant-garde studios and collectors' apartments. Some came to rest in the unheated basements or "laboratories" of anthropology museums, surrounded by objects made in the same region of the world. Others encountered odd fellow travelers, lighted and labeled in strange display cases. Now on West Fifty-third Street they intermingle with works by European masters—Picasso, Giacometti, Brancusi, and others. A three-dimensional Eskimo mask with twelve arms and a number of holes hangs beside a canvas on which Joan Miró has painted colored shapes. The people in New York look at the two objects and see that they are alike.

Travelers tell different stories in different places, and on West Fifty-third Street an origin story of modernism is featured. Around 1910 Picasso and his cohort suddenly, intuitively

recognize that "primitive" objects are in fact powerful "art." They collect, imitate, and are affected by these objects. Their own work, even when not directly influenced, seems oddly reminiscent of non-Western forms. The modern and the primitive converse across the centuries and continents. At the Museum of Modern Art an exact history is told featuring individual artists and objects, their encounters in specific studios at precise moments. Photographs document the crucial influences of non-Western artifacts on the pioneer modernists. This focused story is surrounded and infused with another—a loose allegory of relationship centering on the word *affinity*. The word is a kinship term, suggesting a deeper or more natural relationship than mere resemblance or juxtaposition. It connotes a common quality or essence joining the tribal to the modern. A Family of Art is brought together, global, diverse, richly inventive, and miraculously unified, for every object displayed on West Fifty-third Street looks modern.

The exhibition at MOMA is historical and didactic. It is complemented by a comprehensive, scholarly catalogue, which includes divergent views of its topic and in which the show's organizers, William Rubin and Kirk Varnedoe, argue at length its underlying premises (Rubin 1984). One of the virtues of an exhibition that blatantly makes a case or tells a story is that it encourages debate and makes possible the suggestion of other stories. Thus in what follows different histories of the tribal and the modern will be proposed in response to the sharply focused history on display at the Museum of Modern Art. But before that history can be seen for what it is, however—a specific story that excludes other stories—the universalizing allegory of affinity must be cleared away.

This allegory, the story of the Modernist Family of Art, is not rigorously argued at MOMA. (That would require some explicit form of either an archetypal or structural analysis.) The allegory is, rather, built into the exhibition's form, featured suggestively in its publicity, left uncontradicted, repetitiously asserted— "Affinity of the Tribal and the Modern." The allegory has a hero, whose virtuoso work, an exhibit caption tells us, contains more affinities with the tribal than that of any other pioneer modernist. These affinities "measure the depth of Picasso's grasp of the informing principles of tribal sculpture, and reflect his profound identity of spirit with the tribal peoples." Modernism is thus presented as a search for "informing principles" that transcend culture, politics, and history. Beneath this generous umbrella the tribal is modern and the modern more richly, more diversely human.

The power of the affinity idea is such (it becomes almost self-evident in the MOMA juxtapositions) that it is worth reviewing the major objections to it. Anthropologists, long familiar with the issue of cultural diffusion versus independent invention, are not likely to find anything special in the similarities between selected tribal and modern objects. An established principle of anthropological comparative method asserts that the greater the range of cultures, the more likely one is to find similar traits. MOMA's sample is very large, embracing African, Oceanian, North American, and Arctic "tribal" groups.[1] A second principle, that of the "limitation of possibilities," recognizes that invention, while highly diverse, is not infinite. The human body, for example, with its two eyes, four limbs, bilateral arrangement of features, front and back, and so on, will be represented and stylized in a limited number of ways.[2] There is thus a priori no reason to claim evidence for affinity (rather than mere resemblance or coincidence) because an exhibition of tribal works that seem

impressively "modern" in style can be gathered. An equally striking collection could be made demonstrating sharp dissimilarities between tribal and modern objects.

The qualities most often said to link these objects are their "conceptualism" and "abstraction" (but a very long and ultimately incoherent list of shared traits, including "magic," "ritualism," "environmentalism," use of "natural" materials, and so on, can be derived from the show and especially from its catalogue). Actually the tribal and modern artifacts are similar only in that they do not feature the pictorial illusionism or sculptural naturalism that came to dominate Western European art after the Renaissance. Abstraction and conceptualism are, of course, pervasive in the arts of the non-Western World. To say that they share with modernism a rejection of certain naturalist projects is not to show anything like an affinity.[3] Indeed the "tribalism" selected in the exhibition to resemble modernism is itself a construction designed to accomplish the task of resemblance. Ife and Benin sculptures, highly naturalistic in style, are excluded from the "tribal" and placed in a somewhat arbitrary category of "court" society (which does not, however, include large chieftainships). Moreover, pre-Columbian works, though they have a place in the catalogue, are largely omitted from the exhibition. One can question other selections and exclusions that result in a collection of only "modern"-looking tribal objects. Why, for example, are there relatively few "impure" objects constructed from the debris of colonial culture contacts? And is there not an overall bias toward clean, abstract forms as against rough or crude work?

The "Affinities" room of the exhibition is an intriguing but entirely problematic exercise in formal mix-and-match. The short introductory text begins well: "AFFINITIES presents a group of tribal objects notable for their appeal to modern taste." Indeed this is all that can rigorously be said of the objects in this room. The text continues, however, "Selected pairings of modern and tribal objects demonstrate common denominators of these arts that are independent of direct influence." The phrase *common denominators* implies something more systematic than intriguing resemblance. What can it possibly mean? This introductory text, cited in its entirety, is emblematic of the MOMA undertaking as a whole. Statements carefully limiting its purview (specifying a concern only with modernist primitivism and not with tribal life) coexist with frequent implications of something more. The affinity idea itself is wide-ranging and promiscuous, as are allusions to universal human capacities retrieved in the encounter between modern and tribal or invocations of the expansive human mind—the healthy capacity of modernist consciousness to question its limits and engage otherness.[4]

Nowhere, however, does the exhibition or catalogue underline a more disquieting quality of modernism: its taste for appropriating or redeeming otherness, for constituting non-Western arts in its own image, for discovering universal, ahistorical "human" capacities. The search for similarity itself requires justification, for even if one accepts the limited task of exploring "modernist primitivism," why could one not learn as much about Picasso's or Ernst's creative processes by analyzing the *differences* separating their art from tribal models or by tracing the ways their art moved away from, gave new twists to, non-Western forms?[5] This side of the process is unexplored in the exhibition. The prevailing viewpoint is made all too clear in one of the "affinities" featured on the catalogue's cover, a juxtaposition of Picasso's *Girl before a Mirror* (1932) with a Kwakiutl half-mask, a type quite rare among Northwest Coast creations (color plate 11). Its task here is simply to produce an effect of resemblance (an effect actually created by the camera angle). In this exhibition a universal

message, "Affinity of the Tribal and the Modern," is produced by careful selection and the maintenance of a specific angle of vision.

The notion of affinity, an allegory of kinship, has an expansive, celebratory task to perform. The affinities shown at MOMA are all on modernist terms. The great modernist "pioneers" (and their museum) are shown promoting formerly despised tribal "fetishes" or more ethnographic "specimens" to the status of high art and in the process discovering new dimensions of their ("our") creative potential. The capacity of art to transcend its cultural and historical context is asserted repeatedly (Rubin 1984:x, 73). In the catalogue Rubin tends to be more interested in a recovery of elemental expressive modes, whereas Varnedoe stresses the rational, forward-looking intellect (which he opposes to an unhealthy primitivism, irrational and escapist). Both celebrate the generous spirit of modernism, pitched now at a global scale but excluding—as we shall see—Third World modernisms.

At West Fifty-third Street modernist primitivism is a going Western concern. It is, Varnedoe tells us, summing up in the last sentence of the catalogue's second volume, "a process of revolution that begins and ends in modern culture, and because of that—not in spite of it—can continually expand and deepen our contact with that which is remote and different from us, and continually threaten, challenge, and reform our sense of self" (Rubin 1984: 682). A skeptic may doubt the ability of the modernist primitivism exhibited at MOMA to threaten or challenge what is by now a thoroughly institutionalized system of aesthetic (and market) value; but it is appropriate, and in a sense rigorous, that this massive collection spanning the globe should end with the word *self*.

Indeed an unintended effect of the exhibition's comprehensive catalogue is to show once and for all the incoherence of the modern Rorschach of "the primitive." From Robert Goldwater's formalism to the transforming "magic" of Picasso (according to Rubin); from Lévy-Bruhl's mystical *mentalité primitive* (influencing a generation of modern artists and writers) to Lévi-Strauss's *pensée sauvage* (resonating with "systems art" and the cybernetic binarism of the minimalists); from Dubuffet's fascination with insanity and the childish to the enlightened rational sense of a Gauguin, the playful experimentalism of a Picasso or the new "scientific" spirit of a James Turrell (the last three approved by Varnedoe but challenged by Rosalind Krauss, who is more attached to Bataille's decapitation, *bassesse*, and bodily deformations[6]); from fetish to icon and back again; from aboriginal bark paintings (Klee) to massive pre-Columbian monuments (Henry Moore); from weightless Eskimo masks to Stonehenge—the catalogue succeeds in demonstrating not any essential affinity between tribal and modern or even a coherent modernist attitude toward the primitive but rather the restless desire and power of the modern West to collect the world.

Setting aside the allegory of affinity, we are left with a "factual," narrowly focused history—that of the "discovery" of primitive art by Picasso and his generation. It is tempting to say that the "History" section of the exhibition is, after all, the rigorous part and the rest merely suggestive association. Undeniably a great deal of scholarly research in the best *Kunstgeschichte* tradition has been brought to bear on his specific history. Numerous myths are usefully questioned; important facts are specified (what mask was in whose studio when); and the pervasiveness of tribal influences on early modernist art—European, English, and American—is shown more amply than ever before. The catalogue has the merit of including a number of articles that dampen the celebratory mood of the exhibition: notably the

essay by Krauss and useful contributions by Christian Feest, Philippe Peltier, and Jean-Louis Paudrat detailing the arrival of non-Western artifacts in Europe. These historical articles illuminate the less edifying imperialist contexts that surrounded the "discovery" of tribal objects by modernist artists at the moment of high colonialism.

If we ignore the "Affinities" room at MOMA, however, and focus on the "serious" historical part of the exhibition, new critical questions emerge. What is excluded by the specific focus of the history? Isn't this factual narration still infused with the affinity allegory, since it is cast as a story of creative genius recognizing the greatness of tribal works, discovering common artistic "informing principles"? Could the story of this intercultural encounter be told differently? It is worth making the effort to extract another story from the materials in the exhibition—a history not of redemption or of discovery but of reclassification. This other history assumes that "art" is not universal but is a changing Western cultural category. The fact that rather abruptly, in the space of a few decades, a large class of non-Western artifacts came to be redefined as art is a taxonomic shift that requires critical historical discussion, not celebration. That this construction of a generous category of art pitched at a global scale occurred just as the planet's tribal peoples came massively under European political, economic, and evangelical dominion cannot be irrelevant. But there is no room for such complexities at the MOMA show. Obviously the modernist appropriation of tribal productions as art is not simply imperialist. The project involves too many strong critiques of colonialist, evolutionist assumptions. As we shall see, though, the scope and underlying logic of the "discovery" of tribal art reproduces hegemonic Western assumptions rooted in the colonial and neocolonial epoch.

Picasso, Léger, Apollinaire, and many others came to recognize the elemental, "magical" power of African sculptures in a period of growing *négrophilie*, a context that would see the irruption onto the European scene of other evocative black figures: the jazzman, the boxer (Al Brown), the *sauvage* Josephine Baker. To tell the history of modernism's recognition of African "art" in this broader context would raise ambiguous and disturbing questions about aesthetic appropriation of non-Western others, issues of race, gender, and power. This other story is largely invisible at MOMA, given the exhibition's narrow focus. It can be glimpsed only in the small section devoted to "*La création du monde*," the African cosmogony staged in 1923 by Léger, Cendrars, and Milhaud, and in the broadly pitched if still largely uncritical catalogue article by Laura Rosenstock devoted to it. Overall one would be hard pressed to deduce from the exhibition that all the enthusiasm for things *nègre*, for the "magic" of African art, had anything to do with race. Art in this focused history has no essential link with coded perceptions of black bodies—their vitalism, rhythm, magic, erotic power, etc.—as seen by whites. The modernism represented here is concerned only with artistic invention, a positive category separable from a negative primitivism of the irrational, the savage, the base, the flight from civilization.

A different historical focus might bring a photograph of Josephine Baker into the vicinity of the African statues that were exciting the Parisian avant-garde in the 1910s and 1920s; but such a juxtaposition would be unthinkable in the MOMA history, for it evokes different affinities from those contributing to the category of great art. The black body in Paris of the twenties was an ideological artifact. Archaic Africa (which came to Paris by way of the future—that is, America) was sexed, gendered, and invested with "magic" in specific ways. Standard poses adopted by "La Bakaire," like Léger's designs and costumes, evoked a

recognizable "Africanity"—the naked form emphasizing pelvis and buttocks, a segmented stylization suggesting a strangely mechanical vitality. The inclusion of so ideologically loaded a form as the body of Josephine Baker among the figures classified as art on West Fifty-third Street would suggest a different account of modernist primitivism, a different analysis of the category *nègre* in *l'art nègre*, and an exploration of the "taste" that was something more than just a backdrop for the discovery of tribal art in the opening decades of this century.[7]

Such a focus would treat art as a category defined and redefined in specific historical contexts and relations of power. Seen from this angle and read somewhat against the grain, the MOMA exhibition documents a taxonomic moment: the status of non-Western objects and "high" art are importantly redefined, but there is nothing permanent or transcendent about the categories at stake. The appreciation and interpretation of tribal objects takes place within a modern "system of objects" which confers value on certain things and withholds it from others (Baudrillard 1968). Modernist primitivism, with its claims to deeper humanist sympathies and a wider aesthetic sense, goes hand in hand with a developed market in tribal art and with definitions of artistic and cultural authenticity that are now widely contested.

Since 1900 non-Western objects have generally been classified as either primitive art or ethnographic specimens. Before the modernist revolution associated with Picasso and the simultaneous rise of cultural anthropology associated with Boas and Malinowski, these objects were differently sorted—as antiquities, exotic curiosities, orientalia, the remains of early man, and so on. With the emergence of twentieth-century modernism and anthropology, figures formerly called "fetishes" (to take just one class of object) became works either of "sculpture" or of "material culture." The distinction between the aesthetic and the anthropological was soon institutionally reinforced. In art galleries non-Western objects were displayed for their formal and aesthetic qualities; in ethnographic museums they were represented in a "cultural" context. In the latter an African statue was a ritual object belonging to a distinct group; it was displayed in ways that elucidated its use, symbolism, and function. The institutionalized distinction between aesthetic and anthropological discourses took form during the years documented at MOMA, years that saw the complementary discovery of primitive "art" and of an anthropological concept of "culture" (Williams 1966).[8] Though there was from the start (and continues to be) a regular traffic between the two domains, this distinction is unchallenged in the exhibition. At MOMA treating tribal objects as art means excluding the original cultural context. Consideration of context, we are firmly told at the exhibition's entrance, is the business of anthropologists. Cultural background is not essential to correct aesthetic appreciation and analysis: good art, the masterpiece, is universally recognizable.[9] The pioneer modernists themselves knew little or nothing of these objects' ethnographic meaning. What was good enough for Picasso is good enough for MOMA. Indeed an ignorance of cultural context seems almost a precondition for artistic appreciation. In this object system a tribal piece is detached from one milieu in order to circulate freely in another, a world of art—of museums, markets, and connoisseurship.

Since the early years of modernism and cultural anthropology non-Western objects have found a "home" either within the discourses and institutions of art or within those of anthropology. The two domains have excluded and confirmed each other, inventively disputing the right to contextualize, to represent these objects. As we shall see, the aesthetic-

anthropological opposition is systematic, presupposing an underlying set of attitudes toward the "tribal." Both discourses assume a primitive world in need of preservation, redemption, and representation. The concrete, inventive existence of tribal cultures and artists is suppressed in the process of either constituting authentic, "traditional" worlds or appreciating their products in the timeless category of "art."

Nothing on West Fifty-third Street suggests that good tribal art is being produced in the 1980s. The non-Western artifacts on display are located either in a vague past (reminiscent of the label "nineteenth-twentieth century" that accompanies African and Oceanian pieces in the Metropolitan Museum's Rockefeller Wing) or in a purely conceptual space defined by "primitive" qualities: magic, ritualism, closeness to nature, mythic or cosmological aims (see Rubin 1984:10, 661–689). In this relegation of the tribal or primitive to either a vanishing past or an ahistorical, conceptual present, modernist appreciation reproduces common ethnographic categories.

The same structure can be seen in the Hall of Pacific Peoples, dedicated to Margaret Mead, at the American Museum of Natural History. This new permanent hall is a superbly refurbished anthropological stopping place for non-Western objects. In *Rotunda* (December 1984), the museum's publication, an article announcing the installation contains the following paragraph:

> Margaret Mead once referred to the cultures of Pacific peoples as "a world that once was and now is no more." Prior to her death in 1978 she approved the basic plans for the new *Hall of Pacific Peoples*. (p. 1)

We are offered treasures saved from a destructive history, relics of a vanishing world. Visitors to the installation (and especially members of *present* Pacific cultures) may find a "world that is no more" more appropriately evoked in two charming display cases just outside the hall. It is the world of a dated anthropology. Here one finds a neatly typed page of notes from Mead's much-disputed Samoan research, a picture of the fieldworker interacting "closely" with Melanesians (she is carrying a child on her back), a box of brightly colored discs and triangles once used for psychological testing, a copy of Mead's column in *Redbook*. In the Hall of Pacific Peoples artifacts suggesting change and syncretism are set apart in a small display entitled "Culture Contact." It is noted that Western influence and indigenous response have been active in the Pacific since the eighteenth century. Yet few signs of this involvement appear anywhere else in the large hall, despite the fact that many of the objects were made in the past 150 years in situations of contact, and despite the fact that the museum's ethnographic explanations reflect quite recent research on the cultures of the Pacific. The historical contacts and impurities that are part of ethnographic work— and that may signal the life, not the death, of societies—are systematically excluded.

The tenses of the hall's explanatory captions are revealing. A recent color photograph of a Samoan *kava* ceremony is accompanied by the words: "STATUS and RANK were [*sic*] important features of Samoan society," a statement that will seem strange to anyone who knows how important they remain in Samoa today. Elsewhere in the hall a black-and-white photograph of an Australian Arunta woman and child, taken around 1900 by the pioneer ethnographers Spencer and Gillen, is captioned in the *present* tense. Aboriginals apparently

must always inhabit a mythic time. Many other examples of temporal incoherence could be cited—old Sepik objects described in the present, recent Trobriand photos labeled in the past, and so forth.

The point is not simply that the image of Samoan *kava* drinking and status society presented here is a distortion or that in most of the Hall of Pacific Peoples history has been airbrushed out. (No Samoan men at the *kava* ceremony are wearing wristwatches; Trobriand face painting is shown without noting that it is worn at cricket matches.) Beyond such questions of accuracy is an issue of systematic ideological coding. To locate "tribal" peoples in a nonhistorical time and ourselves in a different historical time is clearly tendentious and no longer credible (Fabian 1983). This recognition throws doubt on the perception of a vanishing tribal world, rescued, made valuable and meaningful, either as ethnographic "culture" or as primitive/modern "art." For in this temporal ordering the real or genuine life of tribal works always precedes their collection, an act of salvage that repeats an all-too-familiar story of death and redemption. In this pervasive allegory the non-Western world is always vanishing and modernizing—as in Walter Benjamin's allegory of modernity, the tribal world is conceived as a ruin (Benjamin 1977). At the Hall of Pacific Peoples or the Rockefeller Wing the actual ongoing life and "impure" inventions of tribal peoples are erased in the name of cultural or artistic "authenticity." Similarly at MOMA the production of tribal "art" is entirely in the past. Turning up in the flea markets and museums of late nineteenth-century Europe, these objects are destined to be aesthetically redeemed, given new value in the object system of a generous modernism.

The story retold at MOMA, the struggle to gain recognition for tribal art, for its capacity "like all great art . . . to show images of man that transcend the particular lives and times of their creators" (Rubin 1984:73), is taken for granted at another stopping place for tribal travelers in Manhattan, the Center for African Art on East Sixty-eighth Street. Susan Vogel, the executive director, proclaims in her introduction to the catalogue of its inaugural exhibition, "African Masterpieces from the Musée de l'Homme," that the "aesthetic-anthropological debate" has been resolved. It is now widely accepted that "ethnographic specimens" can be distinguished from "works of art" and that within the latter category a limited number of "masterpieces" are to be found. Vogel correctly notes that the aesthetic recognition of tribal objects depends on changes in Western taste. For example it took the work of Francis Bacon, Lucas Samaras, and others to make it possible to exhibit as art "rough and horrifying [African] works as well as refined and lyrical ones" (Vogel 1985:11). Once recognized, though, art is apparently art. Thus the selection at the Center is made on aesthetic criteria alone. A prominent placard affirms that the ability of these objects "to transcend the limitations of time and place, to speak to us across time and culture . . . places them among the highest points of human achievement. It is as works of art that we regard them here and as a testament to the greatness of their creators."

There could be no clearer statement of one side of the aesthetic anthropological "debate" (or better, *system*). On the other (anthropological) side, across town, the Hall of Pacific Peoples presents collective rather than individual productions—the work of "cultures." But within an institutionalized polarity interpenetration of discourses becomes possible. Science can be aestheticized, art made anthropological. At the American Museum of Natural History ethnographic exhibits have come increasingly to resemble art shows. Indeed

the Hall of Pacific Peoples represents the latest in aestheticized scientism. Objects are displayed in ways that highlight their formal properties. They are suspended in light, held in space by the ingenious use of Plexiglas. (One is suddenly astonished by the sheer weirdness of a small Oceanic figurine perched atop a three-foot-tall transparent rod.) While these artistically displayed artifacts are scientifically explained, an older, functionalist attempt to present an integrated picture of specific societies or culture areas is no longer seriously pursued. There is an almost dadaist quality to the labels on eight cases devoted to Australian aboriginal society (I cite the complete series in order): "CEREMONY, SPIRIT FIGURE, MAGICIANS AND SORCERERS, SACRED ART, SPEAR THROWERS, STONE AXES AND KNIVES, WOMEN, BOOMERANGS." Elsewhere the hall's pieces of culture have been recontextualized within a new cybernetic, anthropological discourse. For instance flutes and stringed instruments are captioned: "MUSIC is a system of organized sound in man's [*sic*] aural environment" or nearby: "COMMUNICATION is an important function of organized sound."

In the anthropological Hall of Pacific Peoples non-Western objects still have primarily scientific value. They are in addition beautiful.[10] Conversely, at the Center for African Art artifacts are essentially defined as "masterpieces," their makers as great artists. The discourse of connoisseurship reigns. Yet once the story of art told at MOMA becomes dogma, it is possible to reintroduce and co-opt the discourse of ethnography. At the Center tribal contexts and functions are described along with individual histories of the objects on display. Now firmly classified as masterpieces, African objects escape the vague, ahistorical location of the "tribal" or the "primitive." The catalogue, a sort of *catalogue raisonné*, discusses each work intensively. The category of the masterpiece individuates: the pieces on display are not typical; some are one of a kind. The famous Fon god of war or the Abomey shark-man lend themselves to precise histories of individual creation and appropriation in visible colonial situations. Captions specify *which* Griaule expedition to West Africa in the 1930s acquired each Dogon statue. We learn in the catalogue that a superb Bamileke mother and child was carved by an artist named Kwayep, that the statue was bought by the colonial administrator and anthropologist Henri Labouret from King N'Jike. While tribal names predominate at MOMA, the Rockefeller Wing, and the American Museum of Natural History, here personal names make their appearance.

In the "African Masterpieces" catalogue we learn of an ethnographer's excitement on finding a Dogon hermaphrodite figure that would later become famous. The letter recording this excitement, written by Denise Paulme in 1935, serves as evidence of the aesthetic concerns of many early ethnographic collectors (Vogel and N'diaye 1985:122). These individuals, we are told, could intuitively distinguish masterpieces from mere art or ethnographic specimens. (Actually many of the individual ethnographers behind the Musée de l'Homme collection, such as Paulme, Michel Leiris, Marcel Griaule, and André Schaeffner, were friends and collaborators of the same "pioneer modernist" artists who, in the story told at MOMA, constructed the category of primitive art. Thus the intuitive aesthetic sense in question is the product of a historically specific milieu.) The "African Masterpieces" catalogue insists that the founders of the Musée de l'Homme were art connoisseurs, that this great anthropological museum never treated all its contents as "ethnographic specimens." The Musée de l'Homme was and is secretly an art museum (Vogel 1985:11). The taxonomic split between art and artifact is thus healed, at least for

self-evident "masterpieces," entirely in terms of the aesthetic code. Art is art in any museum.

In this exhibition, as opposed to the others in New York, information can be provided about each individual masterpiece's history. We learn that a Kiwarani antelope mask studded with mirrors was acquired at a dance given for the colonial administration in Mali on Bastille Day 1931. A rabbit mask was purchased from Dogon dancers at a gala soirée in Paris during the Colonial Exhibition of the same year. These are no longer the dateless "authentic" tribal forms seen at MOMA. At the Center for African Art a different history documents both the art work's uniqueness and the achievement of the discerning collector. By featuring rarity, genius, and connoisseurship the Center confirms the existence of autonomous art works able to circulate, to be bought and sold, in the same way as works by Picasso or Giacometti. The Center traces its lineage, appropriately, to the former Rockefeller Museum of Primitive Art, with its close ties to collectors and the art market.

In its inaugural exhibition the Center confirms the predominant aesthetic-ethnographic view of tribal art as something located in the past, good for being collected and given aesthetic value. Its second show (March 12–June 16, 1985) is devoted to "Igbo Arts: Community and Cosmos." It tells another story, locating art forms, ritual life, and cosmology in a specific, changing African society—a past *and* present heritage. Photographs show "traditional" masks worn in danced masquerades around 1983. (These include satiric figures of white colonists.) A detailed history of cultural change, struggle, and revival is provided. In the catalogue Chike C. Aniakor, an Igbo scholar, writes along with co-editor Herbert M. Cole of "the continually evolving Igbo aesthetic": "It is illusory to think that which we comfortably label 'traditional' art was in an earlier time immune to changes in style and form; it is thus unproductive to lament changes that reflect current realities. Continuity with earlier forms will always be found; the present-day persistence of family and community values ensures that the arts will thrive. And as always, the Igbo will create new art forms out of their inventive spirit, reflecting their dynamic interactions with the environment and their neighbors and expressing cultural ideals" (Cole and Aniakor 1984:14).

Cole and Aniakor provide a quite different history of "the tribal" and "the modern" from that told at the Museum of Modern Art—a story of invention, not of redemption. In his foreword to the catalogue Chinua Achebe offers a vision of culture and of objects that sharply challenges the ideology of the art collection and the masterpiece. Igbo, he tells us, do not like collections.

> The purposeful neglect of the painstakingly and devoutly accomplished mbari houses with all the art objects in them as soon as the primary mandate of their creation has been served, provides a significant insight into the Igbo aesthetic value as *process* rather than *product*. Process is motion while product is rest. When the product is preserved or venerated, the impulse to repeat the process is compromised. Therefore the Igbo choose to eliminate the product and retain the process so that every occasion and every generation will receive its own impulse and experience of creation. Interestingly this aesthetic disposition receives powerful endorsement from the tropical climate which provides an abundance of materials for making art, such as wood, as well as formidable agencies of dissolution, such as humidity and the termite. Visitors to Igboland are shocked to see that artifacts are rarely accorded any particular value on the basis of age alone. (Achebe 1984:ix)

Achebe's image of a "ruin" suggests not the modernist allegory of redemption (a yearning to make things whole, to think archaeologically) but an acceptance of endless seriality, a desire to keep things apart, dynamic, and historical.

The aesthetic-anthropological object systems of the West are currently under challenge, and the politics of collecting and exhibiting occasionally become visible. Even at MOMA evidence of living tribal peoples has not been entirely excluded. One small text breaks the spell. A special label explains the absence of a Zuni war god figure currently housed in the Berlin Museum für Völkerunde. We learn that late in its preparations for the show MOMA "was informed by knowledgeable authorities that Zuni people consider any public exhibition of their war gods to be sacrilegious." Thus, the label continues, although such figures are routinely displayed elsewhere, the museum decided not to bring the war god (an influence on Paul Klee) from Berlin. The terse note raises more questions than it answers, but it does at least establish that the objects on display may in fact "belong" somewhere other than in an art or an ethnographic museum. Living traditions have claims on them, contesting (with a distant but increasingly palpable power) their present home in the institutional systems of the modern West.[11]

Elsewhere in New York this power has been made even more visible. "Te Maori," a show visiting the Metropolitan, clearly establishes that the "art" on display is still sacred, on loan not merely from certain New Zealand museums but also from the Maori people. Indeed tribal art is political through and through. The Maori have allowed their tradition to be exploited as "art" by major Western cultural institutions and their corporate sponsors in order to enhance their own international prestige and thus contribute to their current resurgence in New Zealand society (Mead 1984).[12] Tribal authorities gave permission for the exhibition to travel, and they participated in its opening ceremonies in a visible, distinctive manner. So did Asante leaders at the exhibition of their art and culture at the Museum of Natural History (October 16, 1984–March 17, 1985). Although the Asante display centers on eighteenth- and nineteenth-century artifacts, evidence of the twentieth-century colonial suppression and recent renewal of Asante culture is included, along with color photos of modern ceremonies and newly made "traditional" objects brought to New York as gifts for the museum. In this exhibition the *location* of the art on display—the sense of where, to whom, and in what time(s) it belongs—is quite different from the location of the African objects at MOMA or in the Rockefeller Wing. The tribal is fully historical.

Still another representation of tribal life and art can be encountered at the Northwest Coast collection at the IBM Gallery (October 10–December 29, 1984), whose objects have traveled downtown from the Museum of the American Indian. They are displayed in pools of intense light (the beautifying "boutique" decor that seems to be modernism's gift to museum displays, both ethnographic and artistic). But this exhibition of traditional masterpieces ends with works by living Northwest Coast artists. Outside the gallery in the IBM atrium two large totem poles have been installed. One is a weathered specimen from the Museum of the American Indian, and the other has been carved for the show by the Kwakiutl Calvin Hunt. The artist put the finishing touches on his creation where it stands in the atrium; fresh wood chips are left scattered around the base. Nothing like this is possible or even thinkable at West Fifty-third Street.

The organizers of the MOMA exhibition have been clear about its limitations, and they have repeatedly specified what they do not claim to show. It is thus in a sense unfair to ask why they did not construct a differently focused history of relations between "the tribal" and "the modern." Yet the exclusions built into any collection or narration are legitimate objects of critique, and the insistent, didactic tone of the MOMA show only makes its focus more debatable. If the non-Western objects on West Fifty-third Street never really question but continually confirm established aesthetic values, this raises questions about "modernist primitivism's" purportedly revolutionary potential. The absence of any examples of Third World modernism or of recent tribal work reflects a pervasive "self-evident" allegory of redemption.

The final room of the MOMA exhibition, "Contemporary Explorations," which might have been used to refocus the historical story of modernism and the tribal, instead strains to find contemporary Western artists whose work has a "primitive feel."[13] Diverse criteria are asserted: a use of rough or "natural" materials, a ritualistic attitude, ecological concern, archaeological inspiration, certain techniques of assemblage, a conception of the artist as shaman, or some familiarity with "the mind of primitive man in his [*sic*] science and mythology" (derived perhaps from reading Lévi-Strauss). Such criteria, added to all the other "primitivist" qualities invoked in the exhibition and its catalogue, unravel for good the category of the primitive, exposing it as an incoherent cluster of qualities that at different times have been used to construct a source, origin, or alter ego confirming some new "discovery" within the territory of the Western self. The exhibition is at best a historical account of a certain moment in this relentless process. By the end the feeling created is one of claustrophobia.

The non-Western objects that excited Picasso, Derain, and Léger broke into the realm of official Western art from outside. They were quickly integrated, recognized as master-pieces, given homes within an anthropological-aesthetic object system. By now this process has been sufficiently celebrated. We need exhibitions that question the boundaries of art and of the art world, an influx of truly indigestible "outside" artifacts. The relations of power whereby one portion of humanity can select, value, and collect the pure products of others need to be criticized and transformed. This is no small task. In the meantime one can at least imagine shows that feature the impure, "inauthentic" productions of past and present tribal life; exhibitions radically heterogeneous in their global mix of styles; exhibitions that locate themselves in specific multicultural junctures; exhibitions in which nature remains "unnatural"; exhibitions whose principles of incorporation are openly questionable. The following would be my contribution to a different show on "affinities of the tribal and the postmodern." I offer just the first paragraph from Barbara Tedlock's superb description of the Zuni Shalako ceremony, a festival that is only part of a complex, living tradition (1984:246):

Imagine a small western New Mexican village, its snow-lit streets lined with white Mercedes, quarter-ton pickups and Dodge vans. Villagers wrapped in black blankets and flowered shawls are standing next to visitors in blue velveteen blouses with rows of dime buttons and voluminous satin skirts. Their men are in black Stetson silver-banded hats, pressed jeans, Tony Lama boots and multicolored Pendleton blankets. Strangers dressed in dayglo orange, pink and green ski jackets, stocking caps, hiking boots and mittens. All

crowded together they are looking into newly constructed houses illuminated by bare light bulbs dangling from raw rafters edged with Woolworth's red fabric and flowered blue print calico. Cinderblock and plasterboard white walls are layered with striped serapes, Chimayó blankets, Navajo rugs, flowered fringed embroidered shawls, black silk from Mexico and purple, red and blue rayon from Czechoslovakia. Rows of Hopi cotton dance kilts and rain sashes; Isleta woven red and green belts; Navajo and Zuni silver concha belts and black mantas covered with silver brooches set with carved lapidary, rainbow mosaic, channel inlay, turquoise needlepoint, pink agate, alabaster, black cannel coal and bakelite from old 78s, coral, abalone shell, mother-of-pearl and horned oyster hang from poles suspended from the ceiling. Mule and white-tailed deer trophy-heads wearing squash-blossom, coral and chunk-turquoise necklaces are hammered up around the room over rearing buckskins above Arabian tapestries of Martin Luther King and the Kennedy brothers, The Last Supper, a herd of sheep with a haloed herder, horses, peacocks.

Notes

1. The term *tribal* is used here with considerable reluctance. It denotes a kind of society (and art) that cannot be coherently specified. A catchall, the concept of tribe has its source in Western projection and administrative necessity rather than in any essential quality or group of traits. The term is now commonly used instead of *primitive* in phrases such as *tribal art*. The category thus denoted, as this essay argues, is a product of historically limited Western taxonomies. While the term was originally an imposition, however, certain non-Western groups have embraced it. Tribal status is in many cases a crucial strategic ground for identity. In this essay my use of *tribe* and *tribal* reflects common usage while suggesting ways in which the concept is systematically distorting. See Fried 1975 and Sturtevant 1983.

2. These points were made by William Sturtevant at the symposium of anthropologists and art historians held at the Museum of Modern Art in New York on November 3, 1984.

3. A more rigorous formulation than that of affinity is suggested in Leiris 1953. How, Leiris asks, can we speak of African sculpture as a single category? He warns of "a danger that we may underestimate the variety of African sculpture; as we are less able to appreciate the respects in which cultures or things unfamiliar to us differ from one another than the respects in which they differ from those to which we are used, we tend to see a certain resemblance between them, which lies, in point of fact, merely in their common differentness" (p. 35). Thus, to speak of African sculpture one inevitably shuts one's eyes "to the rich diversity actually to be found in this sculpture in order to concentrate on the respects in which it is *not* what our own sculpture generally is." The affinity of the tribal and the modern is, in this logic, an important optical illusion—the measure of a *common differentness* from artistic modes that dominated in the West from the Renaissance to the late nineteenth century.

4. See, for example, Rubin's discussion of the mythic universals shared by a Picasso painting and a Northwest Coast half-mask (Rubin 1984:328–330). See also Kirk Varnedoe's association of modernist primitivism with rational, scientific exploration (Rubin 1984:201–203, 652–653).

5. This point was made by Clifford Geertz at the November 3, 1984, symposium at the Museum of Modern Art (see n. 2).

6. The clash between Krauss' and Varnedoe's dark and light versions of primitivism is the most striking incongruity within the catalogue. For Krauss the crucial task is to shatter predominant

European forms of power and subjectivity; for Varnedoe the task is to expand their purview, to question, and to innovate.

7. On *négrophilie* see Laude 1968; for parallel trends in literature see Blachère 1981 and Levin 1984. The discovery of things "nègre" by the European avant-garde was mediated by an imaginary America, a land of noble savages simultaneously standing for the past and future of humanity—a perfect affinity of primitive and modern. For example, jazz was associated with primal sources (wild, erotic passions) and with technology (the mechanical rhythm of brushed drums, the gleaming saxophone). Le Corbusier's reaction was characteristic: "In a stupid variety show, Josephine Baker sang 'Baby' with such an intense and dramatic sensibility that I was moved to tears. There is in this American Negro music a lyrical 'contemporary' mass so invincible that I could see the foundation of a new sentiment of music capable of being the expression of the new epoch and also capable of classifying its European origins as stone age—just as has happened with the new architecture" (quoted in Jencks 1973:102). As a source of modernist inspiration for Le Corbusier, the figure of Josephine Baker was matched only by monumental, almost Egyptian, concrete grain elevators, rising from the American plains and built by nameless "primitive" engineers (Banham 1986:16). The historical narrative implicit here has been a feature of twentieth-century literary and artistic innovation, as a redemptive modernism persistently "discovers" the primitive that can justify its own sense of emergence.

8. The twentieth-century developments traced here redeploy these ideas in an intercultural domain while preserving their older ethical and political charge.

9. On the recognition of masterpieces see Rubin's confident claims (1984:20–21). He is given to statements such as the following on tribal and modern art: "The solutions of genius in the plastic arts are all essentially instinctual" (p. 78, n. 80). A stubborn rejection of the supposed views of anthropologists (who believe in the collective production of works of tribal art) characterizes Rubin's attempts to clear out an autonomous space for aesthetic judgment. Suggestions that he may be projecting Western aesthetic categories onto traditions with different definitions of art are made to seem simplistic (for example, p. 28).

10. At the November 3, 1984, symposium (see n. 2) Christian Feest pointed out that the tendency to reclassify objects in ethnographic collections as "art" is in part a response to the much greater amount of funding available for art (rather than anthropological) exhibitions.

11. The shifting balance of power is evident in the case of the Zuni war gods, or Ahauuta. Zuni vehemently object to the display of these figures (terrifying and of great sacred force) as "art." They are the only traditional objects singled out for this objection. After passage of the Native American Freedom of Religion Act of 1978 Zuni initiated three formal legal actions claiming return of the Ahauuta (which as communal property are, in Zuni eyes, by definition stolen goods). A sale at Sotheby Parke-Bernet in 1978 was interrupted, and the figure was eventually returned to the Zuni. The Denver Art Museum was forced to repatriate its Ahauutas in 1981. A claim against the Smithsonian remains unresolved as of this writing. Other pressures have been applied elsewhere in an ongoing campaign. In these new conditions Zuni Ahauuta can no longer be routinely displayed. Indeed the figure Paul Klee saw in Berlin would have run the risk of being seized as contraband had it been shipped to New York for the MOMA show. For general background see Talbot 1985.

12. An article on corporate funding of the arts in the *New York Times*, February 5, 1985, p. 27, reported that Mobil Oil sponsored the Maori show in large part to please the New Zealand government, with which it was collaborating on the construction of a natural gas conversion plant.

13. In places the search becomes self-parodic, as in the caption for works by Jackie Winsor: "Winsor's work has a primitivist feel, not only in the raw physical presence of her materials, but also in the way she fabricates. Her labor—driving nails, binding twine—moves beyond simple systematic repetition to take on the expressive character of ritualized action."

References

Achebe, Chinua. 1984. "Foreword." *Igbo Arts: Community and Cosmos*, ed. H. M. Cole and C. C. Aniakor, pp. vii–xi. Los Angeles: Museum of Cultural History, UCLA.

Banham, Reyner. 1986. *A Concrete Atlantis: U.S. Industrial Building and European Modern Architecture*. Cambridge, Mass.: MIT Press.

Baudrillard, Jean. 1968. *Le système des objects*. Paris: Gallimard.

Benjamin, Walter. 1977. *The Origin of German Tragic Drama*. London: New Left Books.

Blachère, Jean-Claude. 1981. *Le modèle nègre: Aspects litéraires du mythe primitiviste au XXe siècle Apollinaire, Cendrars, Tsara*. Dakar: Nouvelles Editions Africaines.

Cole, Herbert, and Chike Aniakor, eds. 1984. *Igbo Arts: Community and Cosmos*. Los Angeles: Museum of Cultural History, UCLA.

Fabian, Johannes. 1983. *Time and the Other: How Anthropology Makes Its Object*. New York: Columbia University Press.

Fried, Morton. 1975. *The Notion of Tribe*. Menlo Park, Calif.: Cummings.

Jencks, Charles. 1973. *Le Corbusier and the Tragic View of Architecture*. London: Penguin.

Laude, Jean. 1968. *La peinture française (1905–1914) et "l'art nègre."* Paris: Editions Klincksieck.

Leiris, Michel. 1934. *L'Afrique fantôme*. Reprinted with new introduction. Paris: Gallimard, 1950.

———. 1953. "The African Negroes and the Arts of Carving and Sculpture." In *Interrelations of Cultures*, pp. 316–351. Westport, Conn.: UNESCO.

Levin, Gail. 1984. " 'Primitivism' in American Art: Some Literary Parallels of the 1910s and 1920s." *Arts*, Nov.: 101–105.

Mead, Sidney Moka, ed. 1984. *Te Maori: Maori Art from New Zealand Collections*. New York: Harry Abrams.

Rubin, William, ed. 1984. *"Primitivism" in Modern Art: Affinity of the Tribal and the Modern*. 2 vols. New York: Museum of Modern Art.

Sturtevant, William. 1983. "Tribe and State in the Sixteenth and Twentieth Centuries." In *The Development of Political Organization in Native North America*, ed. Elizabeth Tooker, pp. 3–15. Washington: The American Ethnological Society.

Talbot, Steven. 1985. "Desecration and American Indian Religious Freedom." *Journal of Ethnic Studies* 12(4): 1–18.

Tedlock, Barbara. 1984. "The Beautiful and the dangerous: Zuñi Ritual and Cosmology as an Aesthetic System." *Conjunctions* 6: 246–265.

Vogel, Susan. 1985. Introduction. In *African Masterpieces from the Musée de l'Homme*, pp. 10–11. New York: Harry Abrams.

———, and Francine N'Diaye, eds. 1985. *African Masterpieces from the Musée de l'Homme*. New York: Harry Abrams.

Williams, Raymond. 1966. *Culture and Society, 1780–1950*. New York: Harper and Row.

12

The White Peril and *L'Art nègre*

Picasso, Primitivism, and Anticolonialism

Patricia Leighten

Man is least himself when he talks in his own person. Give him a mask and he will tell you the truth.

—Oscar Wilde, *The Artist as Critic*

Africanism as a movement in early twentieth-century art in France is by now well known; its artists, their paintings, sculptures, and "influences" are documented and catalogued. But the generative impulse for this self-conscious undermining of French tradition is not yet well understood: primitivism as an avant-garde gesture, as a provocative rather than merely appreciative act, with social as well as stylistic consequences. An understanding of the political context of left-wing avant-gardism in pre-World War I Paris fundamentally alters the aesthetic view of much modern art nowhere so tellingly as in the Africanism of Picasso and his circle.[1] This essay will consider the concept of primitivism in pre-war France by examining the historical and political context of its role in modernist aesthetic radicalism, with special focus on Picasso's *Les Demoiselles d'Avignon* of 1907 (color plate 12). Criticism of the exhibition " 'Primitivism' in 20th Century Art" at the Museum of Modern Art in 1984 rightly suggested the need to look at the larger cultural context of the enthusiasm for *choses nègres*;[2] this essay will consider the approbation and appropriation of African art on the part of modernist artists as they extend to a larger social and political view of the people who made that art and, consequently, to a larger view of the social and political implications of primitivism.

It is well recognized that romantic attitudes toward so-called "primitive" peoples had a history in modern Europe going back at least to Rousseau, and that Gauguin's primitivist model appealed strongly to the next generation of modernists;[3] but it is not yet understood that a compelling nexus of political events and attitudes during the *avant-guerre* additionally—and inescapably—informed the response to African art and the motives of Africanizing artists. Picasso had long moved his work toward simplification and crudity under the influence of the Barcelona *modernistes*, who already admired Iberian and Catalan Romanesque art in the

1880s and '90s;[4] and he first introduced Iberian forms in his work during 1906. What is new in Picasso's work of 1907 is not only his more brutally primitivizing style, but resonances of the popular view of Africa and its relation to the French Empire. The "dark continent" captured the imaginations of artists and writers working in an anarchist vein as a result of scandals and fiery debates over French colonial policy in Africa that took place in 1905–6 and the resulting outcry of anticolonial opposition from anarchists and socialists. These revelations broke upon the world in 1905–6, in the same period that Picasso, Vlaminck, Derain, and others were inspired to "discover" an African art that had been visible in Paris since at least the 1890s.[5] The anarchist backgrounds of Picasso, Maurice Vlaminck, Kees van Dongen, Guillaume Apollinaire, Alfred Jarry, and many in their larger circle meant that everything to do with Africa, and especially France's colonies in West and Central Africa, became charged with political meaning during the *avant-guerre* and lent special force to their primitivism.

Yet the modernists did not extend this social criticism to a radical critique of the reductive view of Africans that was promoted for colonial justification. Instead, they embraced a deeply romanticized view of African culture (conflating many cultures into one), and considered Africa the embodiment of humankind in a precivilized state, preferring to mystify rather than to examine its presumed idol-worship and violent rituals. The modernists self-consciously subverted colonial stereotypes, both of the right and the left, but their subversive revisions necessarily remained implicated in the prejudices they sought to expose, so that modernist images now appear no less stereotypical and reductive than the racist caricatures they opposed. The modernists' method was to critique civilization by embracing an imagined "primitiveness" of Africans whose "authenticity" they opposed to a "decadent" West. This subject is therefore a difficult one for us, since it separates us profoundly from a generation that much criticism has domesticated to a comfortable neutrality and with whose modernity it has been inviting to identify. But if we are to understand early modern art, it is crucial to understand both this reductive impulse and its manifestation among the modernists: they wanted to subvert Western artistic traditions—and the social order in which they were implicated—by celebrating a Nietzschean return to those imagined "primitive" states whose suppression they viewed as having cut off a necessary vitality. Equally, we must recognize how profoundly these artists misunderstood African art and how utterly Western and *moderniste* were the terms of their admiration.

Elsewhere, I have demonstrated how Picasso's anarchist background and concerns informed his choice of the newsprint texts he incorporated into his collages of 1912–13, importing into his art demotic materials and themes directly relevant to political events and passions of the day.[6] I am making a parallel argument here, given the politically charged atmosphere of Paris beginning in 1905, with the public and government still reeling from disclosures of atrocities against the native populations in the French and Belgian Congos. In this period, to evoke scarified African masks was to evoke a larger Africa, and all its associations with colonial exploitation, legalized slavery, and resistance to French rule, associations that enrich and complicate other meanings in such works. Picasso's primitivism is part of a cultural discourse in which "Africa" conveyed widely accepted meanings that cannot be extricated from allusions to its art and people. Far from only wanting to borrow formal motifs from African forms, Picasso purposely challenged and mocked Western artistic traditions with his allusions to black Africa, with its unavoidable associations of white cruelty and exploitation.

The image of Africa that the artists inherited mingled both the noble and the savage. For the French people at this time, two colonies popularly exemplified these two notions and illuminate separate aspects of the popular image of the continent. From Dahomey in French West Africa came tales that obsessed the French popular press—of human sacrifice, animism, fetishism, and witchcraft—forming a frightening image of Africans as mysterious, primeval spirits. From the French and Belgian Congos in Central Africa, on the other hand, came revelations of the white colonialists' systematic destruction of tribal life in the interests of exploitation and of white atrocities, which caused an international outcry and public scandals in Brussels and Paris. Both sides of this "Africa" informed the ways Picasso and his circle thought of the African art in the Musée d'Ethnographie (now the Musée de l'Homme) in the Trocadéro. Likewise, this mythology inevitably informed the ways their audience understood the appearance of "tribal" forms in their art. Thus we need to look at the history of French popular perceptions of Dahomey and the French and Belgian Congos to understand modernist appropriation of things African.[7]

It was their anarchism that prepared Picasso and many in his circle to adopt anticolonial postures, which are abundantly evident in the political cartoons made by central modernist figures. After examining French views of Africa and the anticolonialist rhetoric, I will consider the satires on colonialism by Picasso's friend and mentor Jarry, the influential absurdist playwright, and, finally, *Les Demoiselles d'Avignon*.[8] This discussion will, I hope, help illuminate the concept of primitivism, which extends far beyond the confines of those works of 1907–8 that actually quote African art and provides a clearer idea of the larger modernist project of this avant-garde circle.

In a recent book, I delineated the importance of anarchist thought and the anarchist movement for Picasso and his artistic and political milieu in early twentieth-century Paris.[9] The overlapping avant-garde and political bohemias of Barcelona and Paris were especially attracted to the most extreme, individualist rhetoric of destruction, since art could metaphorically express those acts of violence known as *la propagande par le fait*, or "propaganda of the deed." For the modern artist to pursue strategies of primitivism and spontaneity in both art and life was to rebel against bourgeois morality and bourgeois art. An unshakable tenet of anarchism was antinationalism; thus the anarchists found anathema the Colonial Party's assertion of France's national destiny and her *mission civilisatrice* to the "undeveloped" peoples of Africa and Asia. One of the major sources of ideas and images of Africa shared by *la bande à Picasso* came from anarchist and socialist anticolonial rhetoric.

In addition, the modernists, along with the rest of France, were influenced by popular sources of information about Africa. Beginning in the late nineteenth century, the Jardin d'Acclimatation, a zoo in the Bois de Boulogne, and international expositions in Paris concocted displays of colonial peoples in live exhibits, purporting to show the French how "exotics" really lived. Prior to 1906, individual Africans, supplied by wild animal importers, were regularly exhibited. For Picasso's generation, the best-known such spectacle in Paris was held at the Exposition Universelle of 1900, which mounted enormous ethnographic exhibits, including "re-creations" of Dahomean and Congolese villages complete with "pikes on which were stuck the actual skulls of slaves executed before the eyes of Bahanzin," last king of Dahomey, and reenactments of "the rites of fetishism, performed by haggish witch-doctors and priests in their native costumes," as one guidebook advertised.[10] Part of the aim of these government-sponsored exhibits was to propagandize for French colonial possessions around the world and to rationalize their cultural transformation, each colony

having its own section of the Exposition.[11] Picasso may well have visited this part of the Exposition on his first trip to Paris since he was exhibiting a painting in another building.

The major source of images and information about Africa was the popular press, itself influenced by prejudice, fantasy, and political interests that predated actual French contact with urban and tribal populations in Africa and were reinforced by novels and accounts by soldiers, missionaries, and explorers, often accompanied by lurid and fantastic illustrations.[12] To this were added the exposés of forced labor and terror in the two Congos, which dominated discussion in late 1905.[13] These elements necessarily mingled in the modernists' minds, inspiring both political outrage and hard-boiled, yet still essentially romanticized, notions about instinct and "fetish" worship.

The French presence in Africa was of long standing. In 1670 France signed a "Treaty of Commerce and Friendship" with the king of Dahomey, the first step toward what would become an enormous French empire in West and Central Africa by the end of the nineteenth century, constituting some 1.8 million square miles.[14] In the Dahomean Wars of 1890 and 1892, during the European scramble for colonies, the French conquered Dahomey. Travelers who ventured into the interior earlier in the nineteenth century had frequently returned with sensational and fanciful tales of human sacrifice, cannibalism, despotism, and anarchy that were made much of in the French press. Such mass illustrated magazines as *Le Journal illustré*, *L'illustration*, and *Le Tour du monde* and the illustrated supplements of the newspapers *Le Petit Journal* and *Le Petit Parisien*, emphasized the purported savagery of customs they misconstrued in accordance with their preconceptions.[15] For example, in a "Scene of Human Sacrifice" published in *Le Tour du monde* in 1863, the Dahomean king watches from beneath a canopy while the priests sacrifice his chosen victims, holding their heads aloft. The female warrior illustrating Frederick Forbes' account of 1851 seems to represent similarly bloodthirsty impulses, if more dispassionately.[16]

During the Dahomean Wars, the French popular press played up such hair-raising tales, as part of a quite successful attempt to justify French conquest. The press followed the wars only superficially, concentrating instead on the legendarily grotesque practices of the natives and illustrating their accounts with uncredited and rather free copies of earlier engravings.[17] "Scene of Human Sacrifice," for instance, accompanies a text whose author confesses that he himself had only witnessed the sacrifice of a hyena.[18] The implication of cannibalism in these rites was likewise asserted and popularly believed. Though all the tales of cannibalism did not actually come from the Dahomean Kingdom, so little distinction was popularly made between various tribes and regions of Africa that such images resonated around the word "Dahomey." It goes without saying that such accounts were given lurid coverage in the popular press, and in a remarkably short time Dahomey came to represent in France all that was most thrillingly barbaric and elemental on the "dark continent." It was precisely the grotesquery popularly associated with the "tribal" that attracted Symbolists and modernists in these years, an extremely important feature of modernism to understand.[19]

The French and Belgian Congos summon the other side of the image of Africa, which mixed in telling ways with the Dahomean. The scandals following government inquiries into events in both the French and Belgian Congos aroused fiery socialist and anarchist opposition, inspiring a heated debate of which modernist writers and artists could not possibly have been unaware, even had they been uninterested. Indeed, members of Picasso's

circle reveal their attitudes toward events in the Congo in political cartoons made in these very years. The Belgian Congo represents the most staggering instance of brutality, but the French Congo closely followed the Belgian model and inspired the equal censure of the left wing.

The Congo Free State—all of which land became the "personal property" of King Leopold of Belgium—was legitimized by the General Act of the Berlin Conference of 1885, which attempted to direct the European powers (or represent them as directed) toward development, rather than exploitation, of the colonies.[20] Article VI read: "All the Powers exercising sovereign rights or influence in these territories pledge themselves to watch over the preservation of the native populations and the improvement of their moral and material conditions of existence, and to work together for the suppression of slavery and of the slave trade."[21] King Leopold freely interpreted the charge enacted here, to which Belgium and France were signatories, and in 1898 defended his rather ominous view of Belgium's "civilizing mission":

> The mission which the agents of the State have to accomplish on the Congo is a noble one. They have to continue the development of civilisation in the centre of Equatorial Africa, receiving their inspiration directly from Berlin and Brussels. Placed face to face with primitive barbarism, grappling with sanguinary customs that date back thousands of years, they are obliged to reduce these gradually. They must accustom the population to general laws, of which the most needful and the most salutary is assuredly that of work.[22]

The Force Publique, or military arm, of the Congo Free State at first enjoyed popularity in Europe for its destruction of the Muslim slave trade, still flourishing in the early 1890s.[23] But soon there were reports of rapacious economic exploitation of the natives and of the land. As King Leopold's agents struggled to establish control of the vast region, eighty times the size of Belgium,[24] Africans were forced into labor for their new rulers and into the Force Publique. Requisitioned from village chiefs, the new slaves had iron rings locked around their necks, in the so-called "national collar," and were chained together to prevent escape.[25] Between 1892 and 1914, 66,000 blacks passed through the ranks of the Force Publique, which constituted for many Congolese their major contact with the West.[26] In the French Congo, too, colonial laws imposed forced labor so many days a year—legally fluctuating between ten and eighty—upon all males between the ages of eighteen and sixty, a practice not discontinued until 1946.[27] In Leopold's Congo, across the river, forty hours per month were required, beginning in 1903.[28] Very often the conditions of labor were appalling, and workers approaching the end of their servitude all too frequently found their "contracts" renewed.

Rumors of these abuses came periodically to Europe and America from the beginning, but more (and more appalling) details were published after the turn of the century, growing by 1905 into a scandal that rocked Western Europe. Parisian artists responded strongly, as can be seen in a series of cartoons from *L'Assiette au beurre*. In a special issue of 1902 on the distribution of French government medals, Caran d'Ache depicts, in front of a huddled mass of underfed Africans, a vicious dog and a whip-wielding, well-fed brutish overseer reading the following letter from the minister: "Dear Friend, here people have reported that you have sold blacks, what slander! In any case, between now and July 14, just barter them and I guarantee you [your decoration]."[29] An unsigned cartoon of 1905 illustrates

Figure 12.1 Auguste Roubille, " . . . il est souvent sublime," *L'Assiette au beurre*, 21 January 1905, Morris Library, University of Delaware.

with brutal irony the racial contempt of the French colonial officer who exclaims about "education," pointing his gun into the mouth of a helpless African: "Pack of brutes! One can get nothing into their heads!"[30] In a special issue of *L'Assiette au beurre* of 1905 (fig. 12.1), Auguste Roubille uses a powerful image of murder, fire, and starvation to illustrate a bourgeois thought that, "If the worker is sometimes vile [when he strikes and rebels in France] . . . he is often sublime [when he commits 'legal' atrocities in the army]."[31]

By far the worst abuses in the Congo involved the collection of rubber from the wild vines that grew in the forest regions. Rubber was the most valuable export from Central Africa, and, though conditions varied greatly throughout the Congo,[32] the delegation of this labor to the Force Publique and its mercenaries was common. Armed by the State, they were allowed to pillage and massacre so as to "encourage" the natives to furnish rubber. Administrators and company agents received, in addition to their salaries, bonuses for rubber collected under them, which invited coercion and violence.[33] Profitable procedures included taking women and children as hostages, as well as simpler forms of brutality such as mutilations and executions, sometimes on a large scale. Nominally, most, though not all, of these methods were illegal, but in practice considerations of profit remained a sufficient rationale for what amounted to a system of atrocity. This system was criticized by the

Figure 12.2 Juan Gris, "Guidés par un besoin d'expansion propre a toute nation civilisée, les Turcs iront dans les pays sauvages, porter procédés de civilisation," *L'Assiette au beurre*, 29 August 1908, Bibliothèque nationale, Paris.

Report of the Congo State Commission of Inquiry that Leopold had been forced to initiate, a document published in the *Bulletin officiel* in Brussels in September–October 1905.[34] For example, the famed "Casement Report," sent to the British Foreign Office in 1903 and published in 1904, recorded the bizarre accounting system the Belgians used to keep track of ammunition: they required a human hand, the right one, as "proof" of an unwasted bullet. (This was to prevent the soldiers from using their ammunition to hunt game, though many reports noted that soldiers often did hunt animals, then simply used another method to obtain the requisite hand.) Roger Casement, sent to investigate by the British government, reported that the State, in one six-month period, had used six thousand bullets and concluded, "This means that 6,000 people are killed or mutilated. It means more than 6,000, for the people have told me repeatedly that soldiers kill children with the butt of their guns."[35]

In addition to the scandalized political realms, the artists of Montmartre took such events and accounts to heart, as is again illustrated by cartoons in *L'Assiette au beurre* and *Les Temps nouveaux*. Juan Gris, a neighbor and close friend of Picasso's at this time, suggests in a special issue on Turkish despotism of 1908 (fig. 12.2) that the infamously cruel Turks can learn cruelty from the French, whose deeds—as outlined in the Casement Report—he illustrates. In words that echo the rationale of the Colonial Party, the caption reads: "Guided by a need for expansion proper to every civilized nation, the Turks will go

into the savage lands to bring civilized ways."[36] Another figure especially close to Picasso, the poet and journalist André Salmon, worked on a special issue of *L'Assiette au beurre* in 1904 devoted to Leopold's Congo, for which he wrote the captions and the following song parodying the Belgian national anthem:

> Ignorant of your happiness, in order that Cobourg and Co. prosper,
> Work with a boot in the rear, Belgians of color!
> Grumble no more, poor devils, the price of rubber will rise again.
> Inscribe on your banners: King, Law and Liberty.[37]

Kees van Dongen (like Gris, a neighbor and close friend of Picasso's before 1909) and František Kupka, both openly anarchist, condemned colonialism through their attacks on Christianity and its missionaries. Kupka's special issue on religions in *L'Assiette au beurre* of 1904 includes the work "Christian Heaven According to the Blacks," in which white devils (one grasping a chain in his clawed fist) and a black God the Father, an avenging angel, and seraphim neatly constitute a color-inverted Heaven avenging the devilish cruelties of whites in Africa.[38] Van Dongen, in Jean Grave's anarchist newspaper *Les Temps nouveaux* in 1905, simply and eloquently calls Christ "The White Peril," as he stands possessively and smiles with idiot complacency over cities, factories, armies, cannons, and ships sailing off to exploit exotic lands.[39]

Neither was this political indignation inconsistent for the modernist's vision of the imagined ferocity of dark-spirited "fetish" worship among the Africans on whose behalf they drew attention to injustice, as is demonstrated by another cartoon from Kupka's special issue on religions. Here a tropical African frenziedly drives spikes into a rigid hieratic statue in order—as the caption satirically states—to get his god's attention.[40] A sinister allusion to human sacrifice appears in the skulls rolling around the statue's feet. What Kupka attacks in his whole issue is superstition itself, in all religions, and the ways it serves various oppressive power structures; he thus adopts the familiar anarchist strategy of inversion, leveling "savage" and "civilized" in much the way that Picasso does three years later in an Africanizing work such as his *Mother and Child*—a picture based on traditional Madonna with Child compositions and complete with the halo and blue robe of Heaven—though Picasso goes much further than Kupka in trying to bring such maneuvers into his painting.[41]

The Belgian government's so-called "red-rubber" policy destroyed whole areas of the Congo and did more to depopulate the region than the twin ravages of sleeping sickness and smallpox that followed the break-up of tribal life. Casement and others noted "the great reduction observable everywhere in native life;" for example, in a typical region of the Congo Free State, the population dropped from about two thousand to two hundred between 1898 and 1903.[42] The system of rubber collection was quite similar if slightly less grotesque in the French Congo, where tax collection also proceeded on an incentive basis, resulting in abusive methods, including the taking of women and children as hostages and outright extermination of "lazy" and uncooperative natives. As a result, village life was almost completely destroyed in the rubber-producing areas of both Congos, resulting in widespread famine and depopulation. Altogether somewhere between eight and twenty million Congolese died in the red-rubber period.[43] Such were the stories that first trickled and then flooded out of Africa.

Simultaneous with the revelations of the Belgian inquiry into Leopoldian excesses (and inefficiencies) mentioned above, a scandal broke in France that resulted in a government inquiry—called the Brazza Mission—into conditions in the French Congo. Numerous arbitrary executions and grotesque murders by the French government Administrators Gaud and Toqué were described in the press and commented upon in the inflammatory *L'Assiette au beurre*'s special issue of 11 March 1905, on "The Torturers of Blacks." The most famous case of brutality, illustrated by Bernard Naudin, was the dynamiting of an African guide (as a sort of human firecracker) on Bastille Day, 1903, an atrocity whose stated, and doubtless successful, purpose was to "intimidate the local population."[44] And in an image that could have come straight out of *Heart of Darkness* (written following Conrad's trip up the Congo River in 1890),[45] Gaud and Toqué were also accused of forcing one of their servants to drink soup they had made from a human head. Maurice Radiguez imagines this hideous scene, with the dissipated Toqué's contemptuous justification to the horrified African: "You'd perhaps like veal better? Well, it's plenty good enough for pigs like you!"[46] In the same issue, Naudin and Aristide Delannoy suggest, depicting "hunts" and enormous piles of bones, that such methods were rather more systematic than spontaneously patriotic.[47] Indeed Toqué's confession, reported in *Le Temps* in 1905, lays the blame on French colonial policy:

> It was a general massacre, perpetrated in order to make the service work. . . . Toqué, under examination, described the procedure employed to obtain porters before setting off for the outpost. Raids were made on the villages. The women and children were carried off; they were hidden in small huts so that passers-by should not see them. These women and children often died of hunger or smallpox; the women were raped by the local police. These hostages were not set free until the porters arrived. The same method was employed for tax collections.[48]

Though the scandal was eventually hushed up, the report of the Brazza Mission suppressed, and the perpetrators released after a short time in prison, there was widespread outrage expressed in the newspapers and numerous fierce debates in the Chamber of Deputies. The Socialist leader Jean Jaurès, with Joseph Caillaux and Gustave Rouanet, led a joint attack on the forced labor system, though eventually all that resulted was minor juridical reform, and essentially the same methods continued. André Gide saw scenes of coercion identical to those described above during his trip up the Congo in 1926.[49] King Leopold, however, lost his private kingdom. After the international outcry and the inquiry that he was forced to establish, his domain was reluctantly taken over by the Belgian government in 1908, though again the methods of economic exploitation changed little, and often the agents and administrators themselves stayed on.[50]

Since much of the substance of the debates both in and out of the Chamber during the Gaud-Toqué Affair in 1905–6 would have been of special interest to the modernists and their political circle, it is important to consider the rhetoric marshaled against the justifications of the influential Colonial Party.[51] The arguments of the so-called anticolonialists ranged from critics who wanted a colonial empire, but one that was both more humanitarian and more efficient, to those who refused to recognize the right of France to impose its will, even in the name of civilization, upon other people.[52] Jaurès, for example, during the

1890s and the early part of the twentieth century, accepted the concept of France's "civilizing mission," which he saw as benevolently spreading Enlightenment principles and, eventually, socialist egalitarianism. In 1903, he said to the Chamber of Deputies, "If we have always combatted the politics of colonial expansion by war, the politics of armed expeditions and of violent protectorates, we have always seconded and we are always ready to second the peaceful expansion of French interests and of French civilization."[53] By 1905, Jaurès had fundamentally altered his position on colonialism and especially its relation to the larger social system and the threat of pan-European war over competition for new markets and new colonial possessions.[54] His outrage at the information emerging from the French Congo was scathing, and his newspaper *L'Humanité*—in an unrelenting series of articles by Gustave Rouanet—played the major role in exposing the scandals in 1905 and 1906.

In a more explicitly humanitarian response, Charles Péguy—beginning to shift from his early socialism to his later nationalism—used his *Cahiers de la quinzaine* to publish exposés of conditions in the two Congos by Pierre Mille and Félicien Challaye, who had been a member of the Brazza Mission and whose reports the leading newspaper *Le Temps* had refused to publish.[55] Though Péguy declared his devotion to "the liberty of peoples," like Mille and Challaye, he called for reform rather than withdrawal. When the pacifist Challaye published an expanded form of this pamphlet in 1909, he wrote: "Colonization is a necessary social fact. . . . But justice demands that the domination of the whites should not involve the worst consequences—slavery, robbery, torture, assassination—for the blacks. Justice demands that the natives should derive some advantages from our presence among them."[56] Challaye and Mille also supported the Ligue pour la Défense des Indigènes du Bassin Conventionnel du Congo, whose mouthpiece was *Le Courier européen*, founded in 1904 under the patronage of Edmund Morel, an English opponent of the economic system operative in the two Congos.

On the more revolutionary side, the socialist Paul Louis wrote an analysis of the evils of the colonial enterprise in *Le Colonialisme* of 1905, which came to be well known, asserting (with some naïveté) that,

> The working class will not let itself be taken in by the mirage of words, the seductions of humanitarian phraseology. It must recognize that there is no peaceful colonization, that all colonization is based on violence, war, the sacking of towns, sharing out of the loot, and slavery, however well or thinly disguised. Its authority is already sufficient to make its solidarity with the oppressed native population effectively felt, in reclaiming for the latter their essential rights, safeguarding existence and subsistence; it will profit from all debates held anywhere with the aim of frustrating overseas conquests, and pointing out the logical consequences of imperialist expansion.[57]

And the socialist Léon Bloy uncompromisingly warned that any Christian who participated in the colonial system was working for the Devil.

Among the anarchists, the deputy and former colonial doctor Paul Vigné d'Octon attacked colonialism both in the Chamber of Deputies and his book, *Les Crimes coloniaux de la II^e Republique* of 1907, which was published by the revolutionary socialist Gustave Hervé, in whose journal, *La Guerre sociale*, Vigné d'Octon also kept up a stream of articles. In the preface to *Les Crimes coloniaux*, Vigné wrote:

I had this dream: at last there existed on this earth justice for all subject races and con-
quered peoples. Tired of being despoiled, pillaged, suppressed and massacred, the Arabs
and the Berbers drove their oppressors from North Africa, the blacks did the same for the
rest of the continent, and the yellow people for the soil of Asia.

Having thus reconquered by violence and force their unconquerable and sacred rights,
ravished from them by force and violence, each of these human families pursued the road
of its destiny which for a time had been interrupted.[58]

The Comité de Protection et de Défense des Indigènes was formed, which from 1905 to
at least 1910 held protest meetings and published numerous pamphlets with such inflam-
matory titles as "Les Illégalités et les crimes du Congo, meeting de protestation (31 octobre
1905)" and "Voeux adoptés par le comité dans sa réunion du 13 juin 1907, en faveur de l'ap-
plication des lois de la guerre aux indigènes des colonies et des pays de protectorat."[59]

At the protest meeting of 31 October 1905, called jointly by the Comité and the influen-
tial Ligue des Droits de l'Homme, speakers included the economist and ardent pacifist
Frédérick Passy; the socialists Francis de Pressensé and Gustave Rouanet, who was exposing
the scandals in the party organ *L'Humanité*; and Pierre Quillard, a well-known anarchist
and close friend of Alfred Jarry's. At this meeting, an ex-colonial doctor, M. Barot-Forlière,
discussed the criminality of those who came to work in the colonies, saying that he had
seen all the effects of debt, alcoholism, syphilis, and malaria, as well as violence, cruelty,
and the abuse of power. "There is no point in accusing the men," he concluded to cries of
approbation, "but it is above all necessary to accuse our colonial system."[60] Paul Viollet
argued against all colonialism: "The martial power of Western nations came, thanks to
destructive inventions, to make enormous progress, at the moment when half of the world,
until then ignorant, was opened to our little Europe. All those who did not have our
weapons, savage or civilized, were enslaved, were crushed. A completely new kind of con-
quest was created: the colony."[61] In milder conclusion, the meeting voted to publish the
following statement: "The Assembly, profoundly moved by the exposé of illegalities and by
the recital of iniquities and crimes which have occurred in several colonies, beseech the
government to respect in all the extent of the colonial domain the fundamental principles
of Justice and of Law, to refer to tribunals all crimes committed against the natives in colo-
nized lands, in protected lands and in explored lands."[62]

Quillard is especially interesting since he knew members of Picasso's circle well. Refer-
ring to an earlier speech of the evening, he inflamed the crowd with his radicalism: "Just
now we were told that there is in the French press an indifference to colonial issues, an
indifference to the crimes that were committed in the Congo and elsewhere. There is no
indifference, there is something worse, there is vindication, there is glorification of these
crimes." Quillard addressed his speech, as he pointed out, not to the white men and women
in the audience but to the blacks; and he concluded not with pity for their "savagery" but
with a most unusual recognition of their humanity: "It is as a man of a race calling itself
superior and advanced that I want here to make . . . a sort of public confession, and to ask
my brothers of another skin and another color to please forgive us for the crimes that we
have committed against them."[63]

Whether this speech was heard by Picasso or his friends that night, such rhetoric reap-
peared in the daily papers and would have been repeated in the highly politicized circles in

which they moved in these years. The debates and scandals brought a new and heightened awareness of France's African colonies and, for a politicized avant-garde, concentrated a range of politically charged meanings on everything to do with "Africa."

For Alfred Jarry, as for Quillard, "Africa" had long been a special preoccupation. Although the larger milieu of Paris's artistic and political bohemia confirmed in Picasso the anarchist aesthetics that he had already absorbed in Barcelona, Apollinaire, Jarry, and Salmon were especially important since they became his closest friends and strongest influences, and had their own anarchist histories.[64] Jarry—absurdist playwright, master of black humor, and anarchist artist per excellence—is of particular interest since he made colonialism one of his major targets, at the same time that he summoned up in his works an irrational world of "Dahomean" intertribal slavery and cannibalism. The whole range of colonial debate stayed within the confines of Enlightenment principles, swinging between an image of the black as noble savage (a state out of which whites had long ago evolved) and an image of the black as degenerate savage (from which condition the native must be saved). In contrast to this, Picasso and Jarry implicitly reject both positions by pointedly reveling in ethnic difference, by evoking "tribal" life and art, which they saw as irrational, magic, and violent, and by embracing precisely the symptoms of its so-called degeneracy. Unlike the rationalist Kupka, their works play with the idea that it is these very qualities that make African superior to European culture, especially as it is represented by Jarry.

Jarry was the quintessential anarchist artist, whose political satire was unmistakable to his contemporaries. I have elsewhere discussed his work in relation to anarchism and Picasso; here I would like to focus on Jarry's frequent anticolonialism.[65] In *Ubu colonial* of 1901, Dr. Gasbag meets Père Ubu on his return from a self-described "disastrous voyage of colonial exploration undertaken by us at the expense of the French government;" like the bloated, self-satisfied bourgeois that Ubu represents, seeking profits for himself at the public's expense, he brags of his adventures in terms that illuminate the colonial mentality:

> Our first difficulty in those distant parts consisted in the impossibility of procuring slaves for ourself, slavery having unfortunately been abolished; we were reduced to entering into diplomatic relations with armed Negroes who were on bad terms with other Negroes lacking means of defense; and when the former had captured the latter, we marched the whole lot off as free workers. We did it, of course, out of pure philanthropy, to prevent the victors eating the defeated, and in imitation of the methods practiced in the factories of Paris.[66]

This anticolonial theme—with its parallel between the exploitation of poor workers at home and the search for even cheaper labor abroad—recurs frequently in Jarry's work. Inverting what he saw as the fiction of Western cultural and racial superiority to "primitive" peoples, Jarry tells of a black who fled from a bar in Paris without paying for his drinks; not at all a criminal, he asserts, the man must have been an explorer from Africa investigating European life and caught without "native" currency.[67]

For Jarry, satire served the high purpose of debunking the past and ruthlessly exposing the venality of the political present. In a piece of vicious "nonsense" in the conclusion of *Ubu colonial*, Ubu in his disingenuous way attacks Dr. Gasbag for failing to appreciate the black as a completely different animal from the Frenchman:

PA UBU: We had been rash enough to put up a notice outside our house saying: No dumping; and since the Negro takes pleasure only in disobedience, they came running from every corner of the town. I remember a little pickaninny who arrived each day from a distant part of town just to empty a lady's chamber pot under the windows of our dining room, presenting the contents for our inspection with the remark:

Hey you folks look heah: me black me make yellow crap, ma mistress she white she make black crap.

Dr. Gasbag is thunderstruck:

GASBAG: This would merely prove that the white man is simply a Negro turned inside out like a glove.

PA UBU: Sir, I am astonished that you should have discovered that all on your own. You have clearly profited from our discourse and deserve advancement. Possibly, when turned inside out in the manner you have described, you may suitably replace the specimen of black slave.[68]

Jarry here confronts and manipulates colonial stereotypes and rhetoric as reflected in the French press, reveling in a deliberate vulgarity satirizing the prejudices of French colonials. His stunningly offensive play with the theme of anticolonialism is the other side of his primitivism: the worship of puppets, instinct, violence. By giving a political context to the African figures in such works as these, Jarry refuses to trade in the essentialized, timeless image of the noble savage. Instead, he contextualizes it, acknowledging in his treatment of the theme the political realities that have brought the Oceanic and African "fetishes" into the view of the avant-garde. And, like a good modernist subversive, he plays off the political oppressions foisted on the natives by men like Ubu against an image of the African as a cannibal rather than as a mere innocent, combining the "Dahomean" with the "Congolese" image of the black. He likewise satirically celebrates a whole range of other racist (and furtively titillating) stereotypes that colonial rhetoric traded in: nudity, rampant sexuality, and lack of inhibition of all sorts, as Bonnard confirms in his illustration for *Ubu colonial* (fig. 12.3). (Another early modernist hipster, André Salmon, likewise trades on this image in the black slave dancer who figures prominently in his novel, *La Négresse du Sacré-Coeur*, which was written in 1907–8 and set in a "plantation" in Montmartre.[69])

"In shattering a fragment of the artistic façade," the Symbolist poet Gustave Kahn wrote in 1897, the artist "touches the social façade."[70] Parallel to Jarry's destruction of the atrical forms and traditions, Picasso's attack on inherited artistic conventions implied an attack on "the social façade." For the modernists, primitivism became a method for revolutionizing style; more, this formal radicalism often served, depending on the attitude of the artist, to present an alternative—mingling concepts of authenticity, spontaneity, freedom from the repression of bourgeois constraints, and *amour libre*—to currently entrenched social and aesthetic forms. The primitivism of Picasso and Derain most notably, like that of Gauguin before them, gestured toward cultures whose transformative powers they admiringly offered as escape routes from the stultification of French culture and academic art.[71] Picasso's Iberian period, for example, simultaneously cast the human form in a Spanish version of archaic Greek sculpture and summoned images of Arcadia into play.[72] In addition to these familiar forms and associations of primitivism, Picasso was able in his works of 1907 to summon up

Figure 12.3 Pierre Bonnard,
Illustration for Alfred Jarry,
Ubu colonial from *Almanach
illustré du Père Ubu*, Paris,
1901. © Copyright 2001
Artists Rights Society (ARS),
New York/ADAGP, Paris.

disturbing images of Africa, with its now unavoidable associations of exploitation and white—as well as black—savagery.

The "discovery" of African sculpture by the Fauves and the date of Picasso's first encounter have been much debated by scholars; most recently Paudrat, using a careful reading of all the artists' and witnesses' statements, as well as a visual study of the artists' painting, has proposed autumn 1906 as the date of the first real impact of African art on Vlaminck, Derain, and Matisse.[73] Scholars currently agree that Picasso would have seen the African works at this time, and Rubin rightly points out that it was not until June 1907 that African influence appeared in his work. But all these artists' familiarity with African sculpture may predate their interest in it—and its influence on their work—by an even longer time, given the presence of the "fetishes" from the colonies in Parisian junk shops and the Musée d'Ethnographie since the nineteenth century. Thus Picasso and others may well have been familiar with, but not more than mildly interested in, African objects until events brought the whole subject of Africa to their notice, in a pointedly political way. Picasso himself said nothing about it for almost thirty years, except for his facetious remark in 1920, "L'art nègre? Connais pas!"[74]

Picasso's allegiance to concepts of primitivism that date back to his Nietzschean period at the turn of the century and his parallel anarchism would have made the Congo revela-

tions and debates of interest to him and may well have led him and others, especially the self-proclaimed anarchist Vlaminck, to look freshly at what already existed around them. Vlaminck, by his own account, had looked at African art with Derain at the Musée d'Ethnographie several times before his "revelation"—at the time of the scandals—in the bistro in Argenteuil, the revelation that resulted in his first acquisition of masks.[75] Further, this delayed "discovery" parallels Picasso's incorporation of Iberian sculpture into his art in 1906, sculpture that he, and all the Barcelona *modernistes*, had known since the 1890s,[76] and it perhaps explains why he incorporated largely African—and not Oceanic—forms into his art in 1907–8, despite Salmon's claim of Picasso's equal formal interest in African *and* Oceanic sculpture, and despite the fact that he collected both kinds of art.

At least as early as 1905 Picasso was conscious of Africa's tribal and colonial setting. A drawing in a sketchbook of that year (also containing studies for the *Family of Saltimban-ques*) shows an African native in front of a grass hut, two palm trees, and a river with a tiny figure in a canoe. The African is emaciated, mere skin and bone, with an overlarge and crudely simplified head, his arms on his hips forming a diamond shape. This drawing testi-fies, à la Jarry, to Picasso's interest in Africa as a place both culturally fascinating and polit-ically oppressed. The insistence on the symmetry of the diamond-shaped posture of the upper body and its repetition in the strange skirt(?) below possibly suggest forms reminis-cent of the Kota reliquaries from the French Congo visible in the Musée d'Ethnographie from the 1880s. Indeed, this may represent Picasso's first effort to combine an image, more nearly Expressionist than either elegantly mannered or geometrixing, with an echo of African sculpture; if so, the idea retreated until he conceived its more potent manifestation two years later.

In 1907, reference to African art not only allowed Picasso to "primitivize" the figures in his works, as in, for example, *Head*, but it allowed him to introduce Africa into his work as an allusion, or "iconography," whose associations for his French viewers (whether an actual or imagined public) were extraordinarily complex. Conflating his figures with recognizably African forms—such as the Kota reliquary or André Derain's Fang mask from the French Congo—violently subverted the formal treatment of the human figure. As several have pointed out, the search for the "right" mask is misguided, since Picasso synthesized aspects of various African works rather than copying any single one, though they were certainly all from various parts of the French Empire.[77] It was the idea of Africa that Picasso sought, and his synthesis valorized the products of native culture while it accused the French of "hypocrisy" and "bankrupt" artistic traditions during the intense political debate on colo-nial brutality.

African sculpture offered a model of conceptualizing simplification based on folk tradi-tions that go back into prerecorded history, representing to modernists authentic "primitive" expressions of thought and feeling. Additionally, as Frances Connelly has demonstrated, French culture as far back as the sixteenth century connected concepts of the "grotesque" in two dimensions with caricature, ornament, and the fantastical, while the "grotesque" in three dimensions was connected with the monstrous and the horrific, and specifically asso-ciated with Africa.[78] African sculptures, especially, were viewed as "idols" and "fetishes," and to Europeans represented manifestations of the "irrational, mute, and fearful world" in which they imagined the "primitive" to live. Conversion to Christianity routinely involved destruction (or exportation) of such too-powerful three-dimensional art, and the shock felt

by eighteenth-century Europeans gradually took on shades of sarcasm and contempt as colonialization proceeded.[79] Thus, any pre-war French artist or audience thoroughly identified an imagined primal savagery with images of African sculpture and references to it. Their appearance in Picasso's already "grotesque" painting echoed inherited images and evoked associations of superstition, irrationality, darkness, and horror, adding to the artist's considerable arsenal of anticlassical devices.

In *La Jeune Peinture française* (1912), Salmon records Picasso's stated interest in Oceanic and African objects as "*raisonnables*," usually interpreted as "conceptual;"[80] this was generally cited as Picasso's whole relationship to African art in the first half of the century. Given the absurdist spirit in which Picasso "authorized" facetious disinformation about his art,[81] it is useful to ask what "reasonable" might mean in regard to the African art that he would have seen. The Kota reliquary reproduced here was acquired by the Musée d'Ethnographie in 1883; and the Grebo mask from the Ivory Coast, whose formal influence was felt on his *Guitar* of 1912, was acquired by the Musée d'Ethnographie in 1900. If such works—altered by ritual use, incorporating the most "unartistic" materials from the traditional Western viewpoint, and as far from illusionistic in style as Picasso could ever have seen—can appear "reasonable" to a Western artist, that artist has performed an almost magical act of projection and inversion of the ordinary meaning of the word as "rational."

Certainly Salmon acknowledges no contradiction in the use of such a word, going on to say in a later section of the same chapter that, "in choosing savage artists as guides," Picasso "was not unaware of their barbarity." He was "the apprentice sorcerer always consulting the Oceanic and African enchanters." Abandoned by friends who did not understand his new art, "a bit deserted, Picasso found his true self in the society of the African augurs."[82] Elsewhere, Salmon called Picasso's collection of African and Oceanian sculptures "grimacing idols" and "primitive marvels."[83] What Picasso produced in response to this influence, according to Salmon, were "forbidding nudes, grimacing and perfectly worthy of execration," a human effigy that "appears to us so inhuman and inspires in us a sort of horror."[84] Apollinaire used similar nonformalist language to discuss the Congolese objects owned by Vlaminck and Derain, naming them (admiringly) "masks and fetishes," "grotesque and crudely mystical works," and "barbaric sculptures."[85] In 1937, Picasso gave a lengthy, compelling, and secret account of his first trip to that warehouse of colonial plunder, the Musée d'Ethnographie, to André Malraux, who did not publish it until after Picasso's death:

When I went to the old [Musée d'Ethnographie], it was disgusting. . . . I was all alone. I wanted to get away. But I didn't leave. I stayed. I understood that it was very important. . . .

The masks weren't just like any other pieces of sculpture. Not at all. They were magic things. . . . They were against everything—against unknown, threatening spirits. I always looked at fetishes. I understood; I too am against everything. . . . Spirits, the unconscious (people still weren't talking about that very much), emotion—they're all the same thing. I understood why I was a painter. All alone in that awful museum, with masks, dolls made by the redskins, dusty manikins. *Les Demoiselles d'Avignon* must have come to me that very day, but not at all because of the forms; because it was my first exorcism-painting—yes absolutely![86]

The interpretation Picasso gives here has been filtered through the experience of Dada and Surrealism—especially in using the concept of the unconscious[87]—(and filtered

through Malraux), but at the very least we can say that Picasso's interest in African art lay as much in what he imagined to be their function as ritual objects as in their forms, whose very abstraction encoded the mystical power he wanted to appropriate.

In *Les Demoiselles d'Avignon* (color plate 12), the Iberian faces of the two central figures and their crudely simplified forms ally them with Spain's prehistoric past and announce Picasso's origins and preoccupations as outside (and against) the French classical tradition.[88] The context of the brothel painfully points up the prostitutes' loss of freedom (they are bought and sold like slaves). At the same time, the exaggeration of their sexual display threatens the spectator-customer, as they turn their attention from the room to the world beyond the frame. Their "primitive" power and hypnotic gaze are anything but alluring, yet they pale in comparison with the violence of the two right-hand figures, whose faces (but not bodies) are transformed by African rather than Iberian models and whose presences considerably increase the horrific voltage of this work; they mock such sexual display and, as "Africanized" figures, aggressively challenge the "bankrupt" Western artistic tradition.

Africa, as imported into the work, represents not an idyllic, pre-European society, but the very opposite of "civilized" Europe and, as such, a threat to it. And what Picasso's primitivism does to European art, it also does to European art's idealizations of sexuality. The radical treatment of the traditional idealized nude female announces the end of the old world of art with a new, staggering violence. The violence comes not only from the savage treatment of the distorted faces and forms of the two "African" figures, and from the transformation of usually passive nudes in tamed attitudes into aggressively challenging mock-temptresses, but also from the very allusion to the dark continent unavoidably carried with them. The tremendous powers of "primitive" spirituality—"African soothsayers," as Salmon called them—overwhelm the European tradition in a flamboyant act of rebellion. In addition, all those thrillingly nightmarish and well-publicized tales from Dahomey inevitably echo in the African forms imported into this work, summoning up an imagined ruthless barbarity that the modernist makes it his mission bravely to face. Salmon's novel, *La Négresse du Sacré-Coeur*, stars a painter—whom Salmon later identified as Picasso—who is obsessed with what he calls "Dahomeyan" sculpture, about which he is presented as knowing a great deal. Yet, though the plunder from the Dahomean Wars was available from the 1890s at the Musée d'Ethnographie, Picasso never exhibited any interest in appropriating its quite realistic forms, looking instead to the more abstract Congolese objects for the most part, such as Fang masks and Kota reliquaries from the French Congo. Thus, what Salmon appropriates here on behalf of his Picasso-surrogate was not the *art* of Dahomey, but the popular resonance of its human sacrifice, animism, fetishism, and savagery. His character murmurs in conclusion, "I am haunted, haunted."[89]

All this "horror" mingles—in a way that evidently did not seem contradictory—with the modernists' outrage at the brutality of the white colonialists. Jarry and Conrad exhibit a fascination with both sides of this strange African coin. In the beginning of *Heart of Darkness*, Marlow is appalled to see Europeans using chain gangs of blacks, overworked and dying; but, finally, for Conrad it is the indigenous evil of human sacrifice, which the primeval forest somehow compels and to which Mr. Kurtz succumbs through his participation, that is the worst. The attraction to the grotesque, the artist's obligation to acknowledge, even to experience on some level, the most horrific human truths, was already thoroughly established in the Symbolist period by the Decadents, with precedents as distant as the Roman-

tics of the early nineteenth century. Mario Praz's classic study of this subject details a whole literature's fascination with a catalogue of horrors that includes incest, murder, vampirism, Satan-worship, and necrophilia.[90] That the modernists were profoundly influenced by the generation of Symbolists is as true in the visual arts as in poetry and the novel, in this as in other things. And that this embracing of "horror" could be conflated with a larger agenda of social criticism and "liberation" was likewise explored by the previous generation. The new venue was Africa itself.

Thus both stylistically and thematically, the "African" figures in *Les Demoiselles* are not only unsympathetic to the art and life of established European culture, but are its enemy. The painting's "rhetoric" owes much to those anticolonial satires on black Africa that are central to Jarry's oeuvre. The raw sexuality of his black characters, their perverseness, stands against the rational, orderly, decorous world of their rulers; and behind it all lies the exploitation and the brittle and vainglorious cultural superiority that Jarry ridiculed.

I view these echoes of French politics and attitudes toward Africa as an important part, but only one part, of the complexity of meanings of this rich work. Such scholars as Robert Rosenblum, Leo Steinberg, and Ron Johnson have compellingly explored the painting's variety of art-historical allusions, its psychosexual ambiguity, and Nietzschean primitivism.[91] The allusion to Africa is part of this mix, part of the assault on European traditions of representation and taste that Picasso brilliantly launches through his daring transformations of figure, space, color, and form.[92] Formally and thematically, *Les Demoiselles d'Avignon* was the most outrageous artistic act conceivable at that time, for this and many other reasons, and is certainly the best instance of the association of a primitivizing style, with its crudely simplified geometry and flattened repetitious forms, with all that Africa represented for the culture in which Picasso lived.

Picasso's primitivism subverts aesthetic canons of beauty and order in the name of "authenticity," as a way of contravening the rational, liberal, "enlightened" political order in which they are implicated.[93] The deliberate ugliness of a painting like the *Demoiselles* is meant to assert the persistence, within a self-congratulatory "modern" culture, of the ugly realities that a complacent modernity would prefer to elide. His primitivism expresses something like a Nietzschean transvaluation of the values encoded in contemporary debate about Africa. That he means to outrage conservatives who view Africans as subhuman (and outrage their ideals of "art" and "beauty") goes without saying; but his Jarryesque affront is directed far more powerfully at socialists and liberals who would deplore the abuses in the French Congo on "humanitarian" grounds, arguing that these "savages" should not be brutalized, but rather, in effect, be remade in the image of the tolerant, enlightened Frenchman.

In opposition to this, Picasso's imagery attacks the liberal, enlightened ideal of "man," even as it offers a critique, and an alternative, to the commodified status of the artwork in a modern consumerist society.[94] He conjures with the anxiety that civilization has done its work too well, made us too tame, and thus cut us off from sources of magic, fear, and dread, sources on which a more "primitive" art might still draw and to which it might still be able to return us. His imagery asserts that the culture of such "savages" has a power and a beauty all its own. Picasso's primitivizing proposes a more subversive alternative ruled out of the accepted terms of debate, namely that the African is neither an inferior brute nor a misunderstood equal, but something more like an absolute other who remains possessed of primordial powers with which "modern" culture has lost touch—much to its disadvantage.

Picasso's primitivizing style aspires, like the African sculptures he so admired, to an act not of mere decoration, but of power. Picasso paints here not as the Nietzschean artist, a conduit for the charged outpouring of "genius," but as a shaman, exorcising the thralldom of civilized decorums and summoning against them the primordial forces of awe and dread so compellingly embodied in the "savage fetishes" whose meanings and motives ("they were against everything") he wanted to appropriate for his own project. Thus primitivism was much more to the modernists than allusion, even to such a powerful complex of associations as those I have described. Primitivism was also a bid to recapture kinds of representational "power" that the arts of civilized, Enlightened Europe had lost.

Critics, too, then conceived of Picasso and much of the literary and artistic avant-garde as "anarchists in art," as the journalism of the day abundantly demonstrates.[95] By 1910 art reviewers were also using the language of "the primitive" to characterize modern art, which allows us insight into the ways the concept—allied with simplification, deformation, ugliness, and the grotesque—was understood. For example, Henri Guilbeaux, reviewing Picasso's exhibition at Vollard's in *Hommes du jour* in 1911, noted that, "M. Picasso, after having given more than promises, set about one day totally abdicating his personality. He imitated these Spanish masters and others, and he willed himself the humble continuer of Primitives. That which he offers us today accentuates willful deformations that sometimes achieve the grotesque and the ugly."[96]

Writing on the "crisis in French painting" in response to the Salon of 1910, Georges Lecomte warned artists that the public will be "before long worn out with vulgarity, with violence and with savagery, with deformation and with ugliness, with coarse roughness."[97]

A debate published in September and October 1912 in *La Vie* and *L'Action française* wonderfully reveals the public knowledge of the uses of modern primitivist painting and of its political ambience. An anonymous item in *La Vie* noted: "Some artists have grouped themselves to study the savage soul in its pacifistic manifestations; their aim consists in acquiring a more profound knowledge of 'l'art nègre.' "[98] This group, the article continued, proposed to collect art as well as all sorts of historical objects and curiosities, to organize voyages to the colonies, and to found a small museum, "which will interest in the highest degree artists and scholars."[99] To give some background to this proposed museum and the interest in African art it manifests, the author noted that an antiquary shop in the Rue de Rennes displayed Dahomean masks, "fetishes" from the Congo, and symbolic statues from Guinea in its window. He continued:

> It is there that M. Henri Matisse saw them. This painter, of equatorial coloring and mad with cruel stylization, acquired some to decorate his studio. After him, the Spaniard Picasso, the rigorous draughtsman, bought some. . . . At Vollard's where the exotics are found in front of the frescoes of Gauguin and the gods of Easter Island, the beautiful painter Vlaminck exchanged many of his powerful landscapes for barbaric statues. It is there also that M. Derain obtained some: he draws inspiration not only in his paintings of a hieroglyphic synthesis, but also in his sculpted works.

The article concludes with heartfelt enthusiasm: "In the Musée Guimet, in the Musée Cernuschi are collected the masterpieces of the Yellow race. Let each of us work so that Paris will soon possess its Museum of Black Art!"[100] Apollinaire had supported a similar

idea in an article in *Paris-Journal* a week earlier, when he proposed a State-sponsored "museum for exotic art," which would receive all of the "artistic" objects from the Trocadéro (as opposed to those of merely "ethnographic" interest) as well as ongoing supplements from colonial administrators.[101]

In the month following this discussion—which reveals an animated sympathy with the modernists, though perhaps not an insider's view—*La Vie* reprinted a stunningly racist response to their item, which had since appeared in the royalist *L'Action française*:

> Such is the latest of contemporary aesthetic fantasies. In the ladder of the perversions of taste, it appears it must be the bottom. Below black fetishes, there is nothing. Let us take this occasion to recall that the indulgence professed for the Byzantine mosaics and the ape-statues of the basilicas, for the figures of reindeer traced in caves and for the scribbling of infants in primary school, must lead there. The love of the primitive, in art as in politics, suits the black.[102]

Most of the "grotesqueries" admired by the modernists since the 1880s are here named with the most withering contempt; and, moreover, the admirers of such art are themselves compared to blacks, in their uncivilized tastes as in their uncivilized politics. Indeed, *La Vie*'s answer affirmed its general support of modernism and its broadly humanistic left-wing politics: "We have never dreamed of recommending black art as a canonical *model*, but its masterpieces can be precious *indications* for all intelligent artists, for those who do not search simply but impurely to imitate like these traditionalists who wish to restore all the classicisms. One grasps, by studying them, the spontaneity of the aspiration common to all humans."[103]

Thus for the modernists, to "primitivize" was not merely to do something to a painting; it was to do something to oneself, and it implied an ambition to do something to the culture at large. It was an act of sympathy with the most profoundly human states and impulses, an act of recognition, even when it entailed "horrors" that the refined bourgeois refused to face. The fascination with savagery and barbarism attributed to Africans, and the emphasis on fetishism in discussions of African art by Picasso's friends, ironically reflects the image of Dahomey that justified its conquest for the French. The irony stems from the accusatory presence of African forms in his works of 1907 and 1908 that evoke the political echoes of the Gaud-Toqué Affair. Like Jarry's and Conrad's, Picasso's political indignation is counterbalanced by an interest in knowing the worst and by the desire to appropriate the power of these associations to his art. The complex interweaving of these ideas and events forms an important part of the dense and sophisticated fabric of associations that *Les Demoiselles d'Avignon* summoned up at the time for the circle to whom Picasso showed it.

Although the painting was not publicly exhibited at the time, numerous people saw the work in Picasso's studio, which was quite accessible to a large avant-garde circle of friends, acquaintances, collectors, and hangers-on.[104] And in any case, the scale and careful preparation of this large and ambitious work indicate that Picasso saw it as a major statement and necessarily imagined a public for it. Certainly this public was both an abstraction and a wide circle of acquaintances of the artist. The enormously inventive subversive maneuvers of the work speak to many levels of public and private experience, as well as to conventions of

inherited tradition, which this public would have recognized and which Picasso would have expected it to recognize. And part of this recognition, by virtue of "masking" his figures (traditionally masks reveal rather than hide truth[105]), would have inescapably involved the complicated mixture of ideas, fantasies, political postures, and racial attitudes relating to Africa as the French public "knew" it in 1907, a public recently agitated by reports of nearly unbelievable yet documented cruelty and illegal exploitation in a colony largely viewed as undergoing a process of "civilization" by their own superior culture.

Avant-garde painters for a century and more—David, Géricault, Delacroix, and Courbet—had offered finely calculated provocations of subject and theme at moments of political anxiety, crisis, and scandal. Picasso's provocation is similarly motivated, but additionally grapples with a central problem of modernism in general: how to radicalize structure and form, and abandon realism and narrative, without also abandoning centrally important issues of content and allusion to real-life concerns. The parallel of his Africanism with his later incorporation of newsprint into the collages at a time when Cubism hovered close to pure abstraction is significant; and, interestingly, these two episodes frame the only period of Picasso's oeuvre—Analytical Cubism—about which claims for the "autonomy" of his art could (later) have been made, by him or by subsequent generations of critics.[106]

The alliance of Africa, then, with its brutal colonial history and mysteriously "primal" spiritism, and these prostitutes, in Picasso's oeuvre among the most cruelly exploited and spiritually damaged groups in European society,[107] indicts not only the old artistic order but also the old moral and political order as well. The overlay of African masks—evocative of economic exploitation and forced labor—on white female "slaves" is strongly reminiscent of the strategy of anarchist critique-by-inversion so familiar in the work of Jarry, Picasso, Kupka, and Van Dongen.[108] By "masking" his figures, Picasso identifies an exploited group external to Western society with one of the most exploited groups within it, analogizing the ironically more visible periphery with the corrupt center of French culture. Yet, if the masks of the individual demoiselles are horrifying, the painting as a whole is more so. Although a prostitute's job is to please (indeed, to bring out the beast within), Picasso's "fetishes" terrify and repel the spectator, and the painting itself mocks and challenges the time-honored status of the easel painting-as-commodity in its refusal to charm, in its principled ambition to offend.

Even Picasso's closest circle had difficulty following him this far. Salmon wrote of this work in 1912, "Nudes came into being, whose deformation caused little surprise—we had been prepared for it by Picasso himself, by Matisse, Derain, Braque, Van Dongen, and even earlier by Cézanne and Gauguin. It was the ugliness of the faces that froze with horror the half-converted."[109] Gertrude Stein was silent, Leo Stein laughed, Matisse was annoyed by what he saw as a mockery of his own more hedonistic modernism: that comfortable armchair for the tired businessman that he offered as an image for his ambitions as an artist.[110] *Les Demoiselles d'Avignon* announces other ambitions: Braque's famous response, summoning up tow and gasoline, likened the work to an anarchist bomb.[111] Even Apollinaire was taken aback and worried that Picasso might destroy the reputations they had both worked hard to establish; he said only one word: *révolution*.[112]

Frequently Cited Sources

Anstey, R., *King Leopold's Legacy: The Congo under Belgian Rule, 1908–1960*. London, New York, and Ibadan, 1966.

Cohen, W., *The French Encounter with Africans: White Response to Blacks, 1530–1880*, Bloomington and London, 1980.

Fry, E., *Cubism*, London and New York, 1966.

Gann, L., and P. Duignan, *The Rulers of Belgian Africa, 1884–1914*. Princeton, 1979.

Leighten, P., *Re-Ordering the Universe: Picasso and Anarchism, 1897–1914*, Princeton, 1989.

Rubin, W., ed., *"Primitivism" in 20th Century Art*, New York, 1984.

Salmon, A., *La Jeune Peinture française*, Paris, 1912.

Schneider, W., *An Empire for the Masses: The French Popular Image of Africa, 1870-1900*, Westport, CT and London, 1982.

Suret-Canale, J., *Afrique noire* (Paris, 1964), II: *L'Ere coloniale 1900-1945* (trans. T. Gottheiner, New York, 1971).

Notes

1. A shorter version of this essay was presented at the College Art Association Annual Meeting of 1989, San Francisco, and is part of a larger study, *Art and Social Radicalism in France, 1900–1914*, on which I am currently engaged. Initial stages of research on this project were aided by J. Paul Getty Fellowship in the History of Art and the Humanities in 1985–86, and grants from the American Philosophical Society in 1985, the University of Delaware in 1987, and the National Endowment for the Humanities in 1989, for which I would like to express my gratitude. I am additionally grateful for a Samuel H. Kress Senior Fellowship at the Center for Advanced Study in the Visual Arts, where I completed the final research and writing of this essay. I would especially like to thank Mark Antliff, Jody Blake, Suzanne Preston Blier, and Jeffrey Weiss for discussions on various aspects of this subject.

2. For considerations of Picasso and Africanism, see R. Goldwater, *Primitivism in Modern Painting*, New York (1938), rev. ed., 1967; J. Laude, *La Peinture française (1905–1914) et "l'art nègre,"* Paris, 1968; W. Rubin, "Picasso," in Rubin, 241–343; and Y.-A. Bois, "Kahnweiler's Lesson" *Representations*, Spring 1987, 33–68. Bois' article, pp. 38ff, valuably distinguishes between Picasso's initial "morphological-expressionist" interest in *l'art nègre* and his "structural" interest beginning in 1912; my study is concerned with Picasso's first period of involvement, looking here at African art as a cultural allusion whose meanings reverberated in the surrounding milieu.

For the lengthy debate over the "'Primitivism' in 20th Century Art" exhibition at the Museum of Modern Art, see J. Clifford, "Histories of the Tribal and the Modern," in this collection; Y.-A. Bois, "La Pensée sauvage," *Art in America*, April 1985, 178–188; T. McEvilley, "Doctor Lawyer Indian Chief," *Artforum*, Nov. 1984, 54–60, and the ensuing debate in "Letters" *Artforum*, Feb. 1985, 42–51; and M. Peppiatt, *Connaissance des arts*, Sept. 1984, 84–95.

3. For the French views of "Africa" and traditions of primitivism, see C. Miller, *Blank Darkness: Africanist Discourse in France*, Chicago and London, 1985, and F. Connelly, "The Origins and Development of Primitivism in Eighteenth- and Nineteenth-Century European Art and Aesthetics," Ph.D. diss., University of Pittsburgh, 1987. For Gauguin and primitivism, see K. Varnedoe, "Gauguin," in Rubin, 179–209.

4. See Leighten, 78–84.

5. See J. Paudrat, "From Africa," in Rubin, 125–175, for a discussion of what was available in Paris at this time.

6. P. Leighten, "Picasso's Collages and the Threat of War, 1912–13," *Art Bulletin*, LXVII, 1985, 653–672.

7. Miller (as in n. 3), 5, has analyzed this paradigm in more general terms: Africa has been made to bear a double burden, of monstrousness *and* nobility, all imposed by a deeper condition of difference and instability (Pliny's "newness"). The result is a European discourse at odds with itself. . . . The gesture of reaching out to the most unknown part of the world and bringing it back as language . . . ultimately brings Europe face to face with nothing but itself, with the problems its own discourse imposes."

8. John Richardson, currently engaged in writing what will likely be the definitive biography of Picasso, noted (at the Picasso/Braque seminar held at the Museum of Modern Art, 10–13 November 1989) that he no longer believes Picasso met Jarry, though he affirmed to me in conversation that he nonetheless considers Jarry enormously influential on Picasso. I look forward to reading the reasons for his new judgment, but meantime must depend on those memoirs recording various events at which Picasso and Jarry were both said to be present, such as Max Jacob's *Chronique des temps héroïques* (Paris, 1956, 48–49).

9. Leighten. See also D. Egbert, *Social Radicalism and the Arts: Western Europe. A Cultural History from the French Revolution to 1968*, New York, 1970, 45ff.

10. J. Boyd, *The Paris Exposition of 1900*, Chicago, 1900, 449–450; my thanks to Jody Blake, who kindly brought this reference to my attention.

11. For example, an enormous book, L. Brunet and L. Giethlen, *Dahomey et dépendances (Exposition Universelle de 1900—Les Colonies françaises)*, Paris, 1900, accompanied the Dahomean exhibition, detailing Dahomey's history and its current—i.e., French—organization, administration, ethnography, production, agriculture, and commerce, all in the most glowing, propagandistic terms.

12. For example, N. Baudin, *Fetichism and Fetich Worshippers*, New York, Cincinnati, and St. Louis, 1885 (trans. of French original). See Cohen, 258ff; Miller; Connelly; and Schneider. For a highly readable history of the imperial procedures of this period, see E. Hobsbawm, *The Age of Empire 1875–1914*, New York, 1987.

13. See Suret-Canale, 34–36; and M. Loutfi, *Littérature et colonialisme: L'Expansion coloniale vue dans la littérature romanesque française. 1871–1914*, Paris, 1971, 119.

14. Général Duboc, *L'Epopée coloniale en Afrique Occidentale Française*, Paris, 1938, 395; and J. Fage, *A History of West Africa*, Cambridge, 1969, 175. For Dahomey and French West Africa, see J. Webster and A. Boahen, *History of West Africa: The Revolutionary Years—1815 to Independence*. New York and Washington, DC, 1970; and R. Cornevin, *Histoire du Dahomey*, Paris, 1962.

15. See V. Champion-Vincent. "L'Image du Dahomey dans la presse française (1890–1895): Les Sacrifices humains," *Cahiers d'etudes africaines*, VII, 1967, 27–58; Fage (as in n. 14), 199–200; Cohen, 257–260; and Schneider, 97–109.

16. Plate from F. Forbes, *Dahomey and the Dahomans*, London, 1851.

17. Figure 4 originally appeared in Dr. Répin, "Voyage du Dahomey," *Tour du monde*, VII, 1863, 65–110, and was reproduced, at the beginning of the French conquest, in *Le Journal illustré* on 9 March 1890, and in *Le Petit Parisien* a week later, neither with any indication that the engraving was nearly thirty years old; see Schneider, 97–109.

18. Cohen, 258.

19. Dahomey, ruled from the central city, Abomey, had a truly urban social structure by the eighteenth century, another aspect of the African culture that modernists distorted and misunderstood in their admiration; see R. Thompson, *Flash of the Spirit: African and Afro-American Art and Philosophy*, New York, 1983, and M. Fried, *The Notion of the Tribe*, Menlo Park, 1975. C. Diop, *Precolonial Black Africa, A Comparative Study of the Political and Social Systems of Europe and Black Africa, from Antiquity to the Formation of Modern States*, trans. H. Salemson, Westport, CT, 1987, 72–75, discusses the extent to which this was true for all of Africa.

20. On the Belgian Congo, see Gann and Duignan; and Anstey.

21. A. Doyle, *The Crime of the Congo*, New York, 1909, 8.

22. Trans. in J. Conrad, *Heart of Darkness* (*Norton Critical Edition*, ed. R. Kimbrough), New York, 1971, 86.

23. Gann and Duignan, 55–58.

24. Anstey, 4.

25. As one witness, G. Burrows, wrote and published in 1903 (*The Curse of Central Africa*, London, 1903, 22 and 174–175): "As the State established its authority . . . a regular system of recruiting was instituted, each district being called upon to furnish a certain number of conscripts. . . . The *commissaires de district* have orders to see that their quotas are promptly forthcoming, and each naturally enough delegates the duty of recruiting to his *chefs de zone* who, in their turn, call upon the more subordinate *chefs de poste* to levy upon the local chiefs for the men required. The native chieftain usually makes his selection from the worthless and recalcitrant slaves of the village, who, when they reach the station, are promptly placed in the chain, or 'collier national' as the Belgians call it, so that they cannot escape." Guy Burrows was a former district commissioner of the Congo Free State, whose book exposed many abuses of Leopold's rule; though he presents such evils in a heated and occasionally exaggerated form, his book is considered reliable; see Gann and Duignan, 77.

26. Gann and Duignan, 79; Burrows (as in n. 25), 92–93.

27. Webster and Boahen (as in n. 14), 271.

28. Anstey, 5.

29. *L'Assiette au beurre*, 4 Jan. 1902: "Cher ami, ici l'on a raconté que vous vendiez des négres, quelle infamie! Dans tous les cas, d'ici au 14 Juillet, ne faites que de simple échanges et je vous garantis que vous le serez. Agréez, etc.;" trans. in S. Appelbaum, *French Satirical Drawings from "L'Assiette au Beurre,"* New York, 1978, 10. This cartoon is the more interesting since Caran d'Ache was generally conservative, but was here moved to attack the government.

30. Leighten trans. *L'Assiette au beurre*. 11 Mar. 1905 (special issue on "Les Bourreaux des noirs"): "Education:—Tas de brutes! On ne peut rien leur faire entrer dans la tête!"

31. Ibid., 21 Jan. 1905: "Quant à l'ouvrier, s'il est quelquefois ignoble . . . il est souvent sublime."

32. Gann and Duignan, 104.

33. Anstey, 4–5; Gann and Duignan, 136.

34. Cited in Anstey.

35. F.O. 10/806, Casement to Lansdowne, 11 Dec. 1903, 20–21; cited by Anstey, 7.

36. Leighten trans. *L'Assiette au beurre*, special issue on "La Turquie regénérée" (with text by anarchist leader Charles Malato), 29 Aug. 1908: "Guidés par un besoin d'expansion propre à toute nation civilisée, les Turcs iront dans les pays sauvages, porter les procédés de civilisation."

37. Ibid., 17 Sept. 1904 (text by André Salmon): "Ignorants de votre bonheur,/Pour que Cobourg et Cie prospèrent,/A coups de pied dans le derrière/Travaillez, Belges de couleur!/Ne vous plaignez plus, pauvres hères,/Le caoutchouc va remonter./Inscrivez donc sur vos bannières:/Le Roi, la Loi, la Liberté."

38. Ibid., 7 May 1904.

39. *Les Temps nouveaux*, 30 Sept. 1905.

40. *L'Assiette au beurre* (as in n. 38): "Dieux Nègres: ils sont obéissants comme des Saint-Guirec dont notre catholique Bretagne est pourvue. Pour que son Dieu s'occupe de lui, il le lui fait sentir à sa façon." In fact, nails were driven into power images precisely to get the god's attention, after which an oath was attached to the new nail (my thanks to Emily Hanna for discussion on this subject).

41. In the Musée Picasso, Paris; I have discussed this work at greater length in Leighten, 92. This question of the different forms and strategies of anarchist artists in pre-war Paris, including those of Picasso and Kupka, will be taken up in the book of which this essay is a part.

42. *La Domaine de la couronne*, cited in Anstey, 8.

43. See R. Daigre, *Oubanghi-Chari, témoignage sur son évolution (1900–1940)*. Issoudun, 1947, 113–117; and Suret-Canale, 24–34.

44. *L'Assiette au beurre* (as in n. 30), accompanied by an excerpt from the press.

45. Joseph Conrad wrote *Heart of Darkness* in 1898–99, and first published it serially in *Blackwood's Magazine* in 1899; it first appeared in a separate volume in 1902.

46. Leighton trans. *L'Assiette au beurre* (as in n. 30): "Le Bouillon de Tête:—Vous aimeriez peut-être mieux du veau? . . . Mais c'est bien assez bon pour des cochons comme vous!"

47. Both are from ibid.

48. *Le Temps*, 23 Sept. 1905, trans. in Suret-Canale, 35.

49. A. Gide, *Voyage au Congo*, Paris, 1927. Gide dedicated his book "To the Memory of Joseph Conrad."

50. Opinions on this vary; see Gann and Duignan, 214ff, and Anstey, whose whole book addresses this question.

51. The best discussion of French colonial theory is R. Betts, *Assimilation and Association in French Colonial Theory, 1890–1914*, New York and London, 1961; see also C. Andrew and A. Kanya-Forstner, "The French Colonial Party: Its Composition, Aims and Influence, 1885–1914," *Historical Journal*. XIV, 1971, 99–128; and R. Girardet, *L'Idée coloniale en France de 1871 à 1962*, Paris, 1972.

52. On anticolonialism, see H. Brunschwig, *Mythes et réalités de l'imperialisme colonial français, 1871–1914*, Paris, 1960, 173–184; C. Ageron, *L'Anticolonialisme en France de 1871 à 1914*, Paris, 1973; and R. Jeaugeon, "Les Sociétés d'exploitation au Congo et l'opinion française de 1890 à 1906," *Revue française d'histoire d'outre-mer*, XLVIII, 1961, 353–437.

53. See Jaurès' speeches in the Chamber of Deputies, *Journal officiel*, Mar. and Dec. 1895; and H. Goldberg, *The Life of Jean Jaurès*, Madison, WI, and London, 1968, 202–203.

54. See Goldberg (as in n. 53), 348.

55. See F. Challaye and P. Mille, *Les Deux Congos: Devant la Belgique et devant la France*, Paris, 1906; and F. Challaye, *Le Congo français*, Paris, 1906.

56. F. Challaye, *Le Congo français*, Paris, 1909, 313; trans. in Suret-Canale, 127.

57. P. Louis, *Le Colonialisme*, Paris, 1905, 109; trans, in Suret-Canale, 125.

58. P. Vigné d'Octon, *Les Crimes coloniaux de la IIe Republique*, Paris, 1907, 8; trans. in Suret-Canale, 139.

59. Published by the Comité de Protection et de Défense des Indigènes in Paris; see also "Abus financiers dans les colonies," "Au Congo: Les Considérations d'un arrêt du Conseil d'état," and "Projet de statuts d'une union internationale pour la protection et la défense des indigènes (adoptés par le comité dans sa séance du 4 février 1908)." The Comité may have published more pamphlets, though I have not been able to find any further record.

60. Leighten trans. "Discours de M. Barot-Forlière," *Les Illégalités et les crimes du Congo (Comité de Protection et de défense des Indigènes—Meeting de protestation 31 Oct 1905)*, Paris, 1905, 46: "Il ne faut pas trop accuser les hommes, mais qu'il faut surtout accuser notre système colonial (Approbation)."

61. Leighten trans. "Discours de Paul Viollet," in ibid., 9: "La puissance guerrière des nations occidentales venait, grâce à des inventions destructives, de faire de gigantesques progrès, lorsqu' une moitié du monde, jusque la ignorée, fut ouverte à notre petite Europe. Tous ceux qui n'avaient point nos armes, sauvages ou civilisés, furent asservis, furent broyés. Un genre de conquête tout nouveau se créa: la colonie."

62. Leighten trans. "Ordre du jour," in ibid., 70: "L'Assemblée, profondément émue par l'exposé des illégalités et par le récit des iniquités et des crimes dont plusieurs colonies sont le théâtre, Adjure le gouvernement de faire respecter dans toute l'etendue du domaine colonial les principes fondamentaux de la Justice et du Droit, de déférer aux tribunaux tous crimes commis contre les indigènes en pays colonisés, en pays protégés et en pays explorés."

63. Leighten trans. "Discours de Pierre Quillard," in ibid., 54–57: "Tout à l'heure on nous disait qu'il y a dans la presse française une indifférence pour les choses coloniales, une indifférence pour les crimes qui se commettent au Congo ou ailleurs. Il n'y a pas d'indifférence, il y a quelque chose de pire, il y a l'apologie, il y a la glorification de ces crimes. . . . c'est en tant qu'homme d'une race soi-disant superieure et évoluée, que je voulais ici faire . . . une sorte de confession publique et demander à mes frères d'autre peau et d'autre couleur, de bien vouloir nous pardonner les crimes que nous avons commis envers eux (Applaudissements)."

64. See n. 8.

65. See Leighten, 63–69 and 135–139.

66. A. Jarry, "Ubu colonial," *Almanach illustré du Père Ubu*, Paris, 1901; trans. in Jarry, *Selected Works of Alfred Jarry*, ed. R. Shattuck and S. Taylor, New York, 1965, 53–54.

67. Cited by R. Shattuck, *The Banquet Years: The Origins of the Avant-Garde in France. 1885 to World War I*, New York, rev. ed., 1968, 237.

68. Trans. in Jarry, 1965 (as in n. 66), 59.

69. A. Salmon, *La Négresse du Sacré-Coeur*, Paris, 1920. For a discussion of this rhetoric, see G. Brooks, "Artists' Depiction of Senegalese Signares: Insights Concerning French Racist and Sexist Attitudes in the Nineteenth Century," *Journal of the Swiss Society of African Studies*, 1979, 77–89.

70. G. Kahn, *Prèmiers poemes*, Paris, 1897, 24; trans. in E. Herbert, *The Artist and Social Reform: France and Belgium, 1885–1898*, New Haven, 1961, 54.

71. J. Flam, "Matisse and the Fauves," in Rubin, New York, 212, rightly points to the way African art allowed Picasso and the Fauves to escape "history and inherited cultural traditions," though the resonances of such "acts" among these artists vary. See also J. Lee, "L'Enchanteur pourrissant," *Revue de l'art*, LXXXII, 1988, 51–60, for Derain's more generalized primitivism in the service of his Symbolist religious themes.

72. See Leighten, 78–84.

73. See Paudrat (as in n. 5), 137–141; Rubin, 248, and Flam (as in n. 71), 216–217, concur in this date, though Flam has suggested more recently, if I read him correctly, in *Matisse: The Man and His Art, 1869–1918,* Ithaca and London, 1986, 173–174, that Matisse's first purchase was in spring of that year.

74. "Opinions sur l'art nègre," *Action*, III, Apr. 1920, 26.

75. M. Vlaminck, *Portraits avant décès*, Paris, 1943, 106.

76. The impetus in this case, however, came not from a political event but probably from the exhibition of the Osuna reliefs in the Louvre in the spring of 1906; see Leighten, 79–81.

77. See Rubin, 274–278. See also J. Donne, "African Art and Paris Studios, 1905–20," in *Art in Society: Studies in Style, Culture, and Aesthetics*, ed. M. Greenhalgh and V. Megaw, London, 1978, 105–120, for a discussion of the exclusively colonial origins of the African art that Picasso was able to see.

78. See Connelly (as in n. 3), 164 and 237; for a discussion of the relation of caricature to primitivism and Cubism, see A. Gopnik, "High and Low: Caricature, Primitivism, and the Cubist Portrait," *Art Journal,* Winter 1983, 371–376.

79. Connelly (as in n. 3), 260–261 and 266–269.

80. Salmon, 43.

81. See Leighten, "Dreams and Lies of Picasso," *Arts Magazine*, Oct. 1987, 50–55.

82. Salmon, 44–51 (author's trans.).

83. Ibid. trans. in Fry, 89; and Salmon, "Pablo Picasso," *Paris-Journal*, 21 Sept. 1911, trans. in Fry, 68.

84. Leighten trans. Salmon, 48 and 51.

85. G. Apollinaire, "The Beginnings of Cubism," *Le Temps*, 14 Oct. 1912; trans. in L. Breunig, *Apollinaire on Art: Essays and Reviews, 1902–1918*, New York, 1972, 259–261.

86. A. Malraux, *Picasso's Mask*, trans. J. Guicharnaud (Paris, 1974), New York, 1976, 10–11.

87. The term "unconscious" was current among the Zurich Dadaists ca. 1916; see H. Richter, *Dada: Art and Anti-art*, London, 1965.

88. For a lengthy consideration of Picasso's relation to the "classical tradition," see E. Fry, "Picasso, Cubism, and Reflexivity," *Art Journal*, Winter 1988, 296–310.

89. Salmon (as in n. 69), 92.

90. M. Praz, *The Romantic Agony*, Oxford, 1933 and 1970.

91. This consideration of the larger resonance of Africa for the audiences of Picasso's pre-war work adds to, rather than displaces, other studies and interpretations of Picasso's primitivism and, especially, of *Les Demoiselles d'Avignon*. See L. Steinberg, "The Philosophical Brothel," *Art News*, Pt. 1, Sept. 1972, 20–29; and Pt. 2, Oct. 1972, 38–47; R. Rosenblum, "*Demoiselles d'Avignon* Revisited," *Art News*, Apr. 1973, 45–48; R. Johnson, "The Demoiselles d'Avignon and Dionysian Destruction," *Arts*, Oct. 1980, 94–101; and *idem*, "Picasso's *Demoiselles d'Avignon* and the Theater of the Absurd," *Arts*, Oct. 1980, 102–113; M. Gedo, "Art as Exorcism: Picasso's *Demoiselles d'Avignon*," *Arts*, Oct. 1980, 70–82; and W. Rubin, "From Narrative to 'Iconic' in Picasso: The Buried Allegory in *Bread and Fruitdish on a Table* and the Role of *Les Demoiselles d'Avignon*," *Art Bulletin*, LXV, 1983, 615–649; and see Rubin, Steinberg, and P. Daix in *Les Demoiselles d'Avignon*, Paris, 1988.

92. See Fry (as in n. 88) and Leighten, 96–120.

93. L. Trilling argued in *Sincerity and Authenticity*, Cambridge, MA, 1971, that the idea of "authenticity" has governed much of modernist art, which rejects received canons of beauty and order because these are implicated in other, received structures of social order and dominance that the adversarial artist aspires to subvert. Trilling points out that: "Authenticity is implicitly a polemical concept, fulfilling its nature by dealing aggressively with received and habitual opinion, aesthetic opinions in the first instance, social and political opinion in the next. One topic of its polemic, which has reference to both aesthetic and social opinion, is the error of the view that beauty is the highest quality to which art may aspire" (p. 94).

94. See Leighten, 130–131, for a discussion of Picasso's nonparticipation in the "legitimate" art market—the Salons—in his pre-war period.

95. Critics of the 1890s and early 1900s typically saw departures from artistic tradition in political terms; for example, A. Lehmann, *The Symbolist Aesthetic in France: 1885–1895*, Oxford, 1950, 181, quotes the critic Recolin, *Anarchie littéraire*, Paris, 1898, xii, who was hostile to *vers libres* and a defender of "le vieux bon sens français": "L'anarchie est évidente. Elle est logique aussi. Elle a ses causes, dont les deux principales sont: la rupture avec la tradition et l'individualisme." And though no critics discussed *Les Demoiselles d'Avignon* in the contemporary press, Cubism was immediately equated with anarchism; for a discussion of this subject, see Leighten, 98–101.

96. Leighten trans. H. Guilbeaux, "Exposition Pablo Picasso," *Hommes du jour*, Jan. 1911 [p. 8]: "M. Picasso, après avoir donné plus que des promesses, se mit un jour à abdiquer totalement sa personnalité. Il imita ces maîtres espagnols et d'autres, et il se voulut l'humble continuateur des Primitifs. Ce qu'il nous offre aujourd'hui accuse des déformations volontaires qui parviennent parfois au grotesque et à la laideur."

97. Leighten trans. G. Lecomte, "La Crise de la peinture française," *L'Art et les artistes*, Oct. 1911, 23–32: "Le public, bientôt excédé de la vulgarité, de la violence et de la sauvagerie, de la déformation et de la laideur, de l'ébauche grossière. . . . "

98. Leighten trans. "L'art noir," *La Vie*, 21 Sept. 1912, 393: "Quelques artistes se sont groupés pour étudier l'âme sauvage dans ses pacifistes manifestations; leur but consiste à acquérir une connaissance approfondie de 'l'art nègre.'" My thanks to Jeffrey Weiss for bringing this exchange to my attention.

99. Ibid.: "Qui intéressera au plus haut point les artistes et les érudits."

100. Ibid.: "C'est là que les vit M. Henri Matisse. Ce peintre, de coloris équatorial et féru de stylisation cruelle, en acquit pour décorer son atelier. Après lui, l'Espagnol Picasso au dessin rigoriste en acheta. . . . Chez Vollard où les exotiques se retrouvent devant les fresques de Gauguin et les dieux de l'île des Pâques, le beau peintre Vlaminck échangea maints de ses puissants paysages contre des statues barbares. C'est là aussi que s'en procura M. Derain: il s'en inspire non seulement dans ses tableaux d'une synthèse hiéroglyphique, mais encore dans ses meubles sculptés. Au Musée Guimet, au Musée Cernuschi sont recueillis les chefs-d'oeuvre des Jaunes. Que chacun travaille à ce que Paris possède blentôt son Musée d'art noir!"

101. Apollinaire, "Exoticism and Ethnography," *Paris-Journal*, 12 Sept. 1912; trans. in Breunig (as in n. 85), 243–246.

102. Leighten trans. "L'art négre à Paris," *La Vie*, Oct. 30, 1912, 141 (repr. from *L'Action française*): "Telle est la dernière en date des fantaisies esthétiques contemporaines. Dans l'échelle des perversions du goût, elle paraît devoir être la dernière. Au-dessous des fétiches négres, il n'y a rien. Prenons cette occasion de rappeler que l'indulgence professée pour les mosaïques byzantines et les magots des basiliques, pour les figures de rennes tracées dans les cavernes et pour les barbouillages d'enfants de l'école primaire, devait mener là. L'amour du primitif, en art comme en politique, va au négre."

103. Ibid.: "Nous n'avons jamais songé à racommender l'art noir comme *un modéle* canonique, mais ses chefs-d'oeuvre peuvent être de précieuses *indications* pour tous artistes intelligents, pour ceux qui ne cherchent pas simplement mais impurement à imiter comme ces traditionalismes qui veulent restaurer tous les classicismes. On saisit, à les étudier, la spontanéité de l'aspiration chez des humains."

104. At the Picasso/Braque seminar at the Museum of Modern Art, 10–13 November 1989, John Richardson's estimate of the number of people who had access to Picasso's studio in this period was approximately fifty. See Leighten, 130–131; see also R. Jensen, "The Avant-Garde and the Trade in Art," *Art Journal*, Winter 1988, 360–367, for a consideration of the larger implications of Picasso's and other avant-garde artists' relations to the art market.

105. M. Barasch, "The Mask in European Art: Meanings and Functions," in *Art, The Ape of Nature: Studies in Honor of H. W. Janson*, ed. M. Barasch and L. Sandler, New York, 1981, 253–264.

106. For further discussion of this question, see Leighten, "Editor's Statement: Revising Cubism," *Art Journal*, Winter 1988, 269-276.

107. See Leighten, 34–36.

108. For example, Jarry's *Ubu colonial* of 1901 with its Paris factory slaves; Picasso's *Mother and Child*, 1907, with its Africanizing of the Madonna with Child; Kupka's *Christian Heaven According to the Blacks*, 1904; and Van Dongen's brilliant *White Peril*, 1905; see the discussion above, 000–000 and 000.

109. Salmon, 1912; trans. in Fry, 84.

110. R. Penrose, *Picasso: His Life and Work*, rev. ed., New York, 1973, 133–134; H. Matisse, "Notes d'un peintre," *La Grande Revue*, 25 Dec. 1908, 731–745; trans. in H. Chipp, *Theories of Modern Art, Berkeley*, 1968, 135.

111. Salmon, in *L'art vivant*, Paris, 1920, 123, quotes Braque as having said, "C'est comme si tu buvais du pétrole et mangeais de l'étoupe enflammée!" F. Olivier, *Picasso et ses amis*, Paris, 1933 (trans. J. Miller, London, 1964), 120, remembered a slight variation on this: "Mais, finit-il par répondre, 'malgré tes explications, ta peinture c'est comme si tu voulais nous faire manger de l'étoupe ou boire du pétrole.'" In both statements, Braque brings together the components of a Molotov cocktail.

112. Cited in P. Cabanne, *Pablo Picasso: His Life and Times,* New York, 1977, 119.

13

New Encounters with
Les Demoiselles d'Avignon

Gender, Race, and the Origins of Cubism

Anna C. Chave

What was "the amazing act upon which all the art of our century is built"? What is "the most innovative painting since Giotto," the " 'harbinger comet of the new century,' " the very "paradigm of all modern art," no less?[1] What is the modern art-historical equivalent of the Greatest Story Ever Told? What else but the monumental *Les Demoiselles d'Avignon* (color plate 12) painted by Picasso in 1907? Six years ago, this single painting, "probably the first truly twentieth-century painting," occasioned a major exhibition at the Musée Picasso in Paris commemorated by a ponderous two-volume catalogue.[2] The director of the department of painting and sculpture at the Museum of Modern Art in New York swore he would kill himself if the plane transporting the work to that event were to crash.[3] What can account for such hyperbole, for such an unparalleled fixation on a particular picture?

"In mystical terms, with this painting we bid farewell to all the paintings of the past," pronounced André Breton of *Les Demoiselles*.[4] More than any other work of art, Picasso's picture has been held to mark or even to have precipitated the demise of the old visual order and the advent of the new. That art historians should have conscripted *Les Demoiselles* to serve in such a strategic capacity might seem odd, however, if we take into account that the cognoscenti resoundingly rejected the picture at the time it was painted, and that it remained all but invisible to the public for three decades thereafter, when it finally found an audience—though at first only in the United States.[5] The painting "seemed to everyone something mad or monstrous," the dealer Daniel-Henry Kahnweiler recalled; "Derain told me that one day Picasso would be found hanging behind his big picture."[6]

Why have historians parlayed this once reviled and ignored image of five rather alien-looking prostitutes vying for a client into the decisive site of the downfall of the prevailing visual regime?[7] Undeniably, Picasso violated pictorial convention in *Les Demoiselles d'Avignon*: by his deidealization of the human form, his disuse of illusionistic space, and his deployment of a mixture of visual idioms. In the standard art-historical narratives, however, these violations on the artist's part tend to get conflated with the putatively violent aspect of the women he depicted, who often come to assume a kind of autonomous agency. And whereas Picasso's contemporaries fingered *him* as the perpetrator who "attacked" his female figures, later accounts often cast the artist together with the viewing

public as the prostitutes' victims.[8] Leo Steinberg experienced the picture as a "tidal wave of female aggression . . . an onslaught;" Robert Rosenblum perceived it as an "explosion" triggered by "five nudes [who] force their eroticized flesh upon us with a primal attack;" and Max Kozloff deemed it simply "a massacre."[9]

Les Demoiselles d'Avignon is generally credited not only with a momentous act of destruction, but also with one of creation. Long designated the first Cubist painting—"the signal for the Cubist revolution" in its full-fledged dismantling of representational conventions[10]—the painting is now more loosely considered a curtain raiser or trigger to Cubism.[11] Others had pulled crucial triggers before Picasso, however. When Baudelaire told Manet, "You are only the first in the decrepitude of your art," he referred to the scandalously frank picture of a courtesan, *Olympia*, rendered with startling flatness in 1865 (color plate 4). For that matter, a compressed or otherwise compromised female form, often that of a prostitute or femme fatale, would come to serve almost as an avatar of modernism.[12] Feminist critics have lately diagnosed this fact, that the avant-garde's testing of cultural limits so often played itself out on the female body, as symptomatic of a visual regime where "Woman" serves as "the very ground of representation, both object and support of a desire which, intimately bound up with power and creativity, is the moving force of culture and history."[13]

The Greatest Story Ever Told was perforce a narrative of exclusion, then: a story told by a heterosexual white male of European descent for an audience answering to the same description; and the stories told ever since about that Greatest Story have mostly been no less narratives told by straight white males for a like public. Virtually every critic who has addressed *Les Demoiselles* has not only assumed what is indisputable—that the picture's intended viewer is male and heterosexual—but has also elected to consider only the experience of that viewer, as if no one else ever looked at the painting. (Through *Les Demoiselles*, Picasso "tells *us* what *our* desires are," one critic declared, peremptorily.[14]) No doubt Picasso's chosen subject dictates this scenario, since today, just as in 1907, prostitution marks an indelible social boundary between the sexes: between men, who can routinely contract for the sexual services of women, and women, who have never had a comparable opportunity.[15]

Among my objectives in the present text, then, is to examine where *Les Demoiselles d'Avignon* positions some of its unanticipated viewers; to explore the painting from, as it were, unauthorized perspectives. What follows is a study in reception, present and past, in short, but one that takes its focus through the critical lenses of gender and race. (Examining the painting's reception history from a given, raking angle, not in a full, even light, will bring some neglected aspects of that history into relief while, admittedly, flattening or obscuring other elements that would figure prominently in a more general or comprehensive kind of reception study.[16]) Poststructuralist and reception theories have shown that all publicly circulated images accrue meanings beyond their makers' intent and control, or that the meanings of works of art are more contingent than immanent, for in the act of interpreting art works critics shape their significance by shaping how and what the public sees. As for the terms in which *Les Demoiselles* has been read, they have often been incipiently sexist, heterosexist, racist, and neocolonialist: so I will argue. (I should perhaps add plainly that neither Picasso's own intentions for the picture nor his susceptibility to the biases enumerated above are the principal subjects of investigation here.)

To begin with, the place that *Les Demoiselles d'Avignon* conspicuously marks out for a client-viewer is hopelessly unsuited to me—a heterosexual, feminist, female viewer.[17] But I

can find some basis to identify with its protagonists. Although my privileged background has insulated me from the desperate straits that have long driven women to toil in the sex industry, like other independent women I nonetheless have an inkling of what it means to be treated as a prostitute. When I traverse the city streets alone I am subject to pestering by strange men who lewdly congratulate me on aspects of my anatomy while ordering me to smile. If I am not mistaken for a prostitute, given my reserved dress and behavior, I remain prey to that pervasive suspicion that a trace of whore lurks in every woman—just as an "honest" woman supposedly lurks in every whore.

As it happens, the streets in my own longtime neighborhood on Manhattan's Lower East Side encompass a major prostitute "stroll." The streetwalkers I encounter there are a lower class of prostitute, more drug-addicted and ill than the type of woman Picasso portrayed, but I occasionally see them assume the poses of the two demoiselles at the center of the painting, their arms crooked over their heads in an age-old formula for seductive femininity. On the Lower East Side, as in Picasso's picture, however, the woodenness of the women's stances and their faces' masklike stolidity suggest that they know they are party to a tiresome artifice. Like virtually all women, I have engaged in such half-hearted acts of simulation, engaged in such a "masquerade,"[18] and this helps me to view the demoiselles empathetically: they seem to me at once to demonstrate and to withdraw from patriarchal stereotypes of femininity, as if in an act of noncooperative cooperation. These women—who are Picasso's fictions no doubt, but fictions founded on his observations of actual, disgruntled women and prostitutes—these women can be had, of course, but on another level they are not for the having, and that puts the client-viewer in a position of nerve-wracking uncertainty; of not knowing what lies behind the mask. For women, meanwhile, the price of this strategy is a profound sense of alienation, insofar as "the masquerade . . . is what women do . . . in order to participate in man's desire, but at the cost of giving up [their own]."[19]

A different kind of masquerade, an act not only of mimicry but also of minstrelsy, is figured by the two boisterous women on the right-hand side of the picture, where Picasso caricatured sacred African masks and employed them in a brazenly disrespectful way.[20] Mimicry is an act of appropriation and "one of the most elusive and effective strategies of colonial power and knowledge," observes Homi Bhabha, adding, "mimicry is at once resemblance and menace."[21] These demoiselles offend me, then—and yet, I confess, they attract me too: not because their outrageous headgear pokes fun at Africans but because it makes fun of the prostitutes' clients, despoiling their sexual appetites. In the boldly squatting figure at the lower right—with her backside turned as if she were "mooning" the johns, while her mask is swiveled forward to terrify them—and in the energy of the woman barging through the curtains above her, I see bodies that educe comparatively natural and confident postures. And I identify with these disruptive figures who impetuously signal their clientele to get lost, while damning the consequences.

In other critics' accounts, the demoiselles in Africanesque masks have never figured in any way as sympathetic, but only as repellent—indeed, as by far the most repellent of all five women, who are generally viewed as disease-ridden harpies. The demoiselles appear not hideous or sickly to me, however, but plain and strong. Their exaggerated, stylized features render them somewhat comical—a bit like the simple figures in the "Little Jimmy" cartoons that Picasso loved at the time he painted this picture—but no more ugly than the

artist himself appeared in self-portraits of this period, similarly stylized images that critics do not call grotesque.[22] True, the demoiselles are thick-limbed, angular, and broad-featured, a physiologic type associated with laborers' stock, but Picasso also had a stocky body and critics hardly find it gross.

To my eye, the unmasked faces of the three figures on the left side of the picture suggest not syphilitic monsters but the glazed-over visages of hard-worn pros. The two women at the picture's center appear to direct a jaundiced gaze toward the unending parade of men before them. The woman farther to the left, the most covered and stiffly restrained of the figures, seems especially businesslike; she evokes a madam holding open the drapery for the patrons' sake while keeping a steady eye on her charges. (I note that her two hands and one of her feet are visible, moreover, whereas, among the other four women, only a single hand and no feet were depicted: thus Picasso symbolically disabled those figures.) Together, the demoiselles might recall the prostitutes and madams in Brassai's later photographs—unashamed, competent, solid, and tough-looking women trapped in miserable circumstances.[23]

If being the same sex as the demoiselles, the second sex, puts me at a disadvantage in front of this picture, it entails some advantage too—a moral advantage over the men who are supposed to be standing where I stand, men who would readily exploit fellow human beings in this vile way.[24] Instead of letting me bathe in a sense of innocence, however, the picture brings me also a guilty thrill at gaining this close-up view of a tawdry ritual that men ordinarily perform well removed from the curious and censorious gaze of women such as myself. That sense of my anomalousness at the scene of this impending transaction underlines the separation between the demoiselles and myself, driving home the fact that prostitutes were and are far more vulnerable than I. Yet the demoiselles are not, after all, the streetwalkers who are most often the targets of psychopathic Jack the Rippers and Joel Rifkinds; they reside in a brothel under state-regulated conditions,[25] and they appear to me quite unafraid. The terror in this situation has appertained instead, for reasons I shall explore, to the male viewing public.

By no means would I wish to argue that there has been a uniform and univocal response to *Les Demoiselles d'Avignon* among its male audience. Yet I can state that something like a prototypical male response to the picture has emerged, particularly in treatments of it over the last two decades—a response centering on the awfulness and fearsomeness of the depicted prostitutes. Given that prostitution orginated and exists precisely to fulfill male desires, how are we to account for the unmitigated dearth of pleasure expressed by male viewers of the painting?[26] So gripped by anxiety has the (prototypical) male viewer been that he has failed to anticipate any gratification the demoiselles' nude bodies might augur. As Charles Bernheimer portrays him, this viewer quails before the spectacle of women who embody "his worst fears of their atavistic primitivism, animalistic destructiveness, and cold, impersonal eroticism."[27] Such feelings of "deep-seated fear and loathing of the female body" are often attributed equally to the picture's author. And William Rubin comments that such attitudes are "commonplace in male psychology" in any case, so that Picasso's great achievement in *Les Demoiselles* was to make this syndrome emerge as "a new insight—all the more universal for being so common-place."[28]

That contempt for women is integral to normal male psychology was suggested, predictably, by Freud; noting the prevalence of men's "desire to depreciate" women, he observed that "the curb put upon love by civilization involves a universal [read: male] ten-

dency to debase sexual objects."[29] In this light, we might note the critics' penchant for describing the women Picasso depicted not simply as prostitutes, but as whores, sluts, harlots, strumpets, trollops, and doxies (to take Steinberg's lexicon) or as "a species of bitch goddess" whose bodies "may not even deserve the name human" (as Kozloff calls them).[30] That the psychological mainspring of the response to *Les Demoiselles* has been more contempt and fear than desire surely stems in no small part from the fact that viewers find themselves exposed not to just any brothel, moreover, but to a "brothel reverting to jungle," one inhabited by more or less exotic-looking women.[31]

Inasmuch as they figure the exotic, the demoiselles' bodies are doubly branded as sexual, for historically, the exotic—or, more specifically, the African and the so-called Oriental woman—has often been conflated with the erotic in the European imagination.[32] The prostitute functions too, of course, as evidence of an excess of sexuality. And by the turn of the century, as Western women generally chafed at the bit for more freedom of movement, the "conjunction" of women and the city epitomized by the prostitute "suggest[ed] the potential of an intolerable and dangerous sexuality, a sexuality which is out of bounds precisely as a result of the woman's revised relation to space, her new ability to 'wander' (and hence to 'err')."[33] Fear of the prostitute spilled over into anxiety about the sexual continence of all women, anxiety about distinguishing decent women from indecent ones, and concern that the former may yet vanish.[34]

In the view of some astute observers of modern life, including most notably Walter Benjamin, the prostitute would emerge as a key figure of urban modernity. With the flourishing of capitalism came the ascent of the commodity, and in the prostitute's collapsing of the distinction between the merchandise and the merchant we find (as Benjamin said) the very apotheosis of the commodity.[35] The prostitute could be identified with and blamed for not only the encroaching commodification, the growing coldness or superficiality of social relations, but also the very "decline of love" itself.[36] Where images of nude women once stood as tokens of plenitude and joy, pictures of nude prostitutes would stand instead as the specters of a society that no longer makes room for joy or love unless they can be bought and sold. From one feminist perspective, then, these figures raise the question: "Does pleasure, for masculine sexuality, consist in anything other than the appropriation of nature, in the desire to make it (re)produce, and in exchanges of its/these products with other members of society? An essentially *economic* pleasure."[37]

In her connection to a peculiarly modern and virulent form of social plague, then, the prostitute made a specially fitting emblem of modernity—which should help explain why *Les Demoiselles d'Avignon* has been singled out as the very "paradigm of all modern art." But such accounts of the prostitute's moment do not explain why this *specific* painting attained a unique prominence surpassing that of, say, *Olympia*. After all, since it debuted in the Salon and passed after Manet's death into the collection of the state, *Olympia* could and did serve as a continuing reference point for critics and other artists, whereas for several decades after Picasso completed *Les Demoiselles*, it remained largely unseen and unmentioned.

What made Picasso's painting initially seem less suited for public display than for the studio was that, in deploying disparate visual idioms to render different physiognomic types, he left the work in a disjunctive state, such that historians debated for some time whether it was actually finished. If the disintegration of the great traditions of painting could already be detected in *Olympia*, the evidence of that decrepitude was plainly that

much further advanced in *Les Demoiselles*. And insofar as it calls the very notion of a unified style, and so the possibility of finish, into question, the painting's ruptured aspect made it serve the purpose of signifying a moment of rupture particularly well. The evolution of Cubism was impelled by a realization of "the conventional rather than the imitative nature of representation," as Christine Poggi succinctly phrases it; and a corollary of that realization was "that style can be a kind of mask, to be worn at will," so that "there was no reason to observe the law of unity": an insight clearly at work in *Les Demoiselles d'Avignon*.[38]

On another plane, what separate *Les Demoiselles* from *Olympia* are matters of class and race. Critics saw both Picasso's and Manet's prostitutes as working-class women owing to their compact muscularity and the perceived coarseness of their features.[39] The superior station of Manet's prostitute is evident, however, from her sumptuous accessories and surroundings; it emerges, too, from the fact that she is quite alone but for the black maid whose servitude establishes the existence of an underclass compared with which the courtesan enjoys an elevated social standing. By contrast, Picasso's subjects are humble brothel denizens, women who would have been on call, if not always on their feet, from noon until three o'clock in the morning, available to any passerby with a modicum of disposable income (on a busy day they might have serviced from sixteen to twenty-five men each, while the courtesan limited her sessions to prearranged and costly assignations).[40] Far from having dark-skinned servants to wait upon them, the demoiselles are themselves arguably in a position of some servitude to the woman at the left; and the Africanesque masks worn by two of them symbolically elide the distinction, and so the expected discrepancy in social status, between a white woman and a woman of color. Whereas Manet's picture presumed the viewer an *haut bourgeois*, Picasso's demoted him socially, implying that he procured his sexual goods at the equivalent of, say, K-Mart and not Saks Fifth Avenue; and there were larger signs of social slippage in the implication that the prospective public for a major art work would be not the elite but hoi polloi.

Among other, more evident changes, a certain downward mobility might be detected in Picasso's images of women in the period immediately preceding *Les Demoiselles*. In 1906, the artist passed from the wan, Italianate nudes of his Rose period to some bloated, marmoreal, but still classicized figures. In *Two Nudes* of that year (fig. 13.1), the figures face one another, replicate one another, so that almost the entirety of a nude female form is made available to the gaze. The figures' groins are discreetly angled out of view, however, and as with most of Picasso's painted female nudes up to this point, their legs are close together, sealing off their crotches. At the same time, the women peel apart a curtain behind them, opening a space in the pinkish brown field that might be said to function abstractly as a displaced vagina or transposed female sexual space.[41] In a way, the picture thus subtly demonstrates what Picasso illustrated more literally in a drawing of around 1901: the conventional identity of the body of a woman with the body of the paper or canvas—that space plainly available to the probing of the painter's phallic pen or brush.

Conventionally, both the act of painting and that of viewing have been described as phallic acts, acts of penetration performed on that passive receptacle, the blank field of the canvas.[42] "I paint with my prick," Renoir supposedly boasted. "A painter has also to paint 'with [his] balls,'" bragged Picasso to his mistress, the painter Françoise Gilot. "I guess that even if a painter fucks a picture to a real climax once a year, it is quite a record," Mark Rothko later estimated. And the critic Jean Clair once pithily proclaimed, "The gaze is the

Figure 13.1 Pablo Picasso, *Two Nudes*, 1906, oil on canvas. © Copyright 2001 Estate of Pablo Picasso/Artists Rights Society (ARS), New York. Museum of Modern Art, New York (Gift of G. David Thompson in honor of Alfred H. Barr, Jr.). Photo © copyright 2001 Museum of Modern Art, New York.

erection of the eye."[43] Such metaphors and the general conceit of penetration as a trope for knowing implicitly exclude the female artist and viewer, of course. But in a less obvious way, these metaphors also exclude the artist and the viewer of color, for dark-skinned peoples of both genders have long been grouped with the feminine as objects for penetration, objects not knowing but subject to being discovered and known. James Olney refers to the colonialist "perception of the [African] countryside as an immense vagina," while Christopher Miller calls the African continent a "blank slate" endlessly inscribed with colonialist desires and fears.[44] These various images converge, for example, in Kandinsky's suggestive recollection of how he mastered his craft:

I learned to battle with the canvas, to come to know it as a being resisting my wish (= dream), and to bend it forcibly to this wish. At first it stands there like a pure chaste virgin with clear eye and heavenly joy. . . . And then comes the willful brush which first here, then there, gradually conquers it with all the energy peculiar to it, like a European colonist, who pushes into the wild virgin nature, hitherto untouched, using axe, spade, hammer, and saw to shape it to his wishes.[45]

Deferring the matter of race for the moment, I wish to pursue another question at this juncture—one that may facilitate a much-needed feminist analysis of Cubism more generally—and that is what the phenomenon of the vaunted new "Cubist space" signified in gendered terms. To this end, I must underline the phallicism endemic to the dialectics of penetration routinely deployed in descriptions of pictorial space and the operations of spectatorship. The type of space that *Les Demoiselles d'Avignon* inaugurated or, rather, prognosticated is a shallow space where voids seal over, becoming solid, while solids flatten and fragment. In Cubist space, movement transpires mostly laterally, through the mechanisms of *passage*, over borders broken down (perhaps under the pressure—to judge by the evidence of the stranger-looking demoiselles—of foreign influence). How are we to understand this sealing-off of that deep pictorial space which had for so long been identified with the feminine sexual body? And how are we to understand the disintegration of those penetrant masses which are readily identified with a masculine sexual presence?[46] ("The radical quality of *Les Demoiselles* lies, above all, in its *threat* to the integrity of mass as distinct from space," Rosenblum declared; and other critics have used comparable phrases.[47])

One could argue that the space in full-fledged, analytic Cubist paintings is penetrable to a slight degree, but only at the viewer's peril owing to the pictures' shattered aspect; or one could say that a painting such as *Ma Jolie (Woman with a Zither or Guitar)* of 1911–12 is effectively impenetrable and that, in either case, this sealing-over of the pictorial space has a subtly emasculating or dephallicizing effect on the male viewer. If his penetrant member no longer functions as a passkey to the world of knowledge, with its keyholes newly obstructed, he must prepare to apprehend pictures—and perhaps not pictures alone—in another way.

Some Cubist paintings do allude, obliquely and teasingly, to the canvas as a female sexual space. But they do so with a new focus on female self-penetration, which renders the male organ extraneous. In *Girl with a Mandolin (Fanny Tellier)* of 1910 (fig. 13.2), the nude woman's torso visually echoes the body of an instrument that is (also) at once volume and void, while her hand's placement at the rim of the sound hole carries a mild autoerotic suggestion. In *Ma Jolie*, by contrast, the woman's body melds with the body of the instrument, while both are shattered to the point that the viewer cannot distinguish mass from void. If the canvas remains in any sense a female space, it is no longer a fully available or penetrable one.[48] Rosalind Krauss thus pinpoints *Girl with a Mandolin* as the moment when Picasso "watched depth and touch—what we would call the carnal dimensions—disappear, quite literally from sight."[49]

Picasso's move to seal off the canvas from the penetrating movement of the viewer could be construed as an attempt to protect that viewer from what he had come to perceive as the horrors of the space the canvas once opened up. In 1912, as he began the process of building up forms materially on top of the canvas—in a further move away from opening up spaces behind the picture's surface—he crowed to Braque, "I am in the process of conceiving a guitar and I use a little dust against our horrible canvas."[50] Why the canvas had become horrible in Picasso's sight is the question—though a further question is whether it was more a matter of an artist contriving to be rid of pictorial holes that had become repugnant to him, or whether those holes had, in a sense, already sealed themselves off insofar as artists had been progressively disusing the potentially deep space of the canvas since the latter part of the nineteenth century.[51]

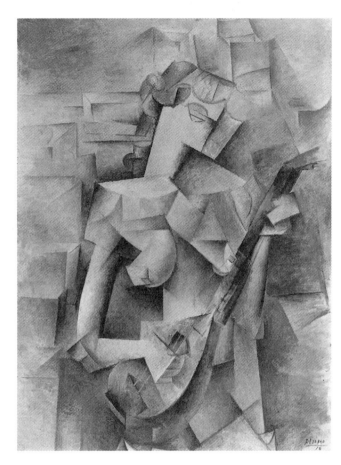

Figure 13.2 Pablo Picasso, *Girl with a Mandolin*, 1910, oil on canvas. © Copyright 2001 Estate of Pablo Picasso/Artists Rights Society (ARS), New York. Museum of Modern Art, New York (Nelson A. Rockefeller Bequest). Photo © copyright 2001 Museum of Modern Art, New York.

The phenomenon of the gradual and inexorable flattening of pictorial space in the evolution of modernist art has been variously explained. Long established was Clement Greenberg's formalist delineation of an ongoing consolidation of the means unique to each art medium, such that painting (for one) would increasingly reveal its fundamental two-dimensionality. More recently, T. J. Clark has compellingly argued that the shallowing of the picture space may be associated with a shallowing or depleting of the full texture of human experience under capitalism. But neither rationale quite accounts for the utter loathing of holes expressed by numerous modernists.[52] I would argue that that element of horror might best be understood in relation to deep-seated and pervasive fears of the feminine body,[53] or (in Freud's formulation) of the "dark continent" more broadly. That horror corresponds, in other words, to what some feminists have diagnosed as a crisis of masculinity brewing in the West by and after the turn of the century, as women and peoples of color increasingly made felt not merely their presence, but also their discontent with their inferiorized and subjugated status. The white male's privileged position was thus threatened by increasing claims for political and social autonomy on the part of European women, and by an influx of intriguing artifacts (such as African masks) that testified to the existence of impressive though alien visions and values in colonized societies at once derided and admired as "primitive."

To return to *Les Demoiselles d'Avignon*, then: the picture evidences not a full-fledged, almost fully flattened Cubist space, but "depth under stress," as Steinberg aptly put it. "This is an interior space in compression like the inside of pleated bellows, like the feel of an inhabited pocket, a contracting sheath heated by the massed human presence," Steinberg continued, framing the experience of viewing the work almost luridly as an act of coitus. The "very subject [of *Les Demoiselles*] is a connection—a passage from out here inward into the body of the representation," he averred. "Our vision heaves in and out" in "a similitude of sexual energy," as the painting offers us "an interior apprehended on the model of touch and stretch, a nest known by palpation, or by reaching and rolling, by extending one's self with it." Steinberg likewise constructed Picasso's experience in painting the picture as a simulacrum of coitus: the artist, here a Nietzschean figure, "wanted the orgiastic immersion and the Dionysian release," so that "one insistent theme" of *Les Demoiselles* is "the spasmodic action, the explosive release in a constricted space, and the reciprocity of engulfment and penetration."[54]

If *Les Demoiselles* provides a metaphorical sex act for the presumedly heterosexual male viewer, then it may well be the sex act to end all sex acts, an experience too awful to risk repeating. "Doesn't [the prostitutes'] shattering gaze rid us of any desire to enter into the picture's space?" queries Yve-Alain Bois.[55] That the prospective act of coitus in question might be a treacherous one emerged also from Steinberg's account: *Les Demoiselles* "declares that if you wholly accept and undergo the esthetic experience, if you let it engulf and 'frighten' you . . . then you become an insider. It is in the contagion of art that . . . the distinction between outsider and insider falls away. Not every picture is capable of such overriding contagion."[56] Though he used the term "contagion" metaphorically here, elsewhere Steinberg and others have tied the daunting aspect of *Les Demoiselles* and the anger toward women it evinces to Picasso's alleged experience with a sexually transmitted disease. What has helped to frighten some critics, then, is the same (fantasized) prospect of being infected by the demoiselles with an illness that spells at best a chronic nuisance, at worst a slow and grisly death.[57] (To my own eye, the demoiselles do not appear unwell, let alone syphilitic, but my disinclination as a straight female to patronize them immunizes me in any case from the possibility of contracting a disease.)

"Right from the first sketches," *Les Demoiselles* was really a projection of Picasso's "complex and contradictory feelings about women," Rubin asserts, while Bois explains the artist's production of the painting in terms of his rampant castration anxiety: "The Medusa (castration) metaphor . . . best accounts for . . . the apotropaic brutality of the finished picture."[58] Like the Oedipal narrative, the Medusa narrative, can indeed be mapped onto many acts of cultural production; but such exercises too often lead in circles, explaining a certain masculinist vision of sexuality by a like vision of sexuality in a way that inevitably debases women. In sustaining a focus on the artist's vulnerable psyche, moreover, we may lose sight of the social ramifications of his acts. If we wish to pursue the hoary tale of castration with the idea of moving in a new direction—one with a view to social and historical realities as well as psychological ones[59]—we might turn our attention to the two figures at the center of the picture with their arms raised in the pose of the Venus Anadyomene.

An image of Venus born of the sea foam, standing and wringing water from her hair, was a topos of history painting in the late nineteenth century, realized by Ingres among others.[60] Unsurprisingly, what was not depicted was how the foam that sired the glorious

goddess of love flowed from the severed genitals of Uranus, who had been castrated by his son Cronus in revenge for having been jettisoned into the underworld (along with Uranus' other sons, the Titans—the first human race). A buried subtext of *Les Demoiselles d'Avignon*, then, is the story of a woman coming to power at the expense of a patriarch whose authority was unexpectedly and irretrievably revoked. From a masculinist vantage point, this is certainly a horror story, but from a feminist one it could be, to the contrary, a fable or even a good omen of vengeance won against male tyranny.

Although the female body figures in male fantasy as mapped by Freud as a castrated body, it is not thereby simply a figure of impotence; rather, the woman's putative "wound" becomes invested "with such intense negative cathexes that the castrated woman becomes phallic through her association with this powerful fantasmatic energy."[61] As Steinberg and others see them, Picasso's demoiselles are eminently phallic: the prostitute second from left "arrives like a projectile;" the one in the center is "a pillar nude;" the crouching figure at the right evokes "a jumping jack;" and all the women "start up like jerked puppets."[62] To construct the female figure as a phallus is, in Freudian terms, a fetishistic strategy, a gesture at once of recognition and disavowal of the alarming fact that women have no penises. Numerous critics have framed Picasso's act in creating *Les Demoiselles* in related terms, as a self-ministering ploy to exorcise his private "demons," his fear of women and others. "My first exorcism-painting," the artist once called the picture, in an oft-quoted statement.[63]

Picasso's irrational fears would not, of course, die with Picasso. For the past two decades, critics have repeatedly explored and, it seems, empathetically reexperienced the artist's fears while discounting the more justified pain of those his art would exorcise, namely his declared "enemy," women, and his undeclared enemy, peoples of color—whom he erased or diminished in other ways, by denying the influence of their visual culture on his work. " 'L'art nègre?' Never heard of it," Picasso reportedly snapped at an interviewer interested in the impact of tribal art on his work. By World War II—that is, at the moment *Les Demoiselles* first emerged into the limelight by entering the collection of the Museum of Modern Art in New York—Picasso was routinely denying that he had been affected by tribal art in composing *Les Demoiselles*, claims that were until not long ago parroted by historians. In fact, he had seen "examples of art négre here and there for at least six months before he absorbed it into the fabric of the *Demoiselles*," argued Rubin in 1983.[64] It is now a commonplace of the art-historical literature, however, that " 'primitive' artefacts were invested with value at the same time as—or even *after*—similar technical innovations appeared within Western art practices" in a phenomenon of sheerly coincidental cultural convergence.[65] Comments Michele Wallace sharply, "Black artists and intellectuals widely assume that a white world is simply unable to admit that art from Africa and elsewhere in the third world had a direct and profound influence on Western art because of an absolutely uncontrollable racism, xenophobia and ethnocentrism."[66]

What is symptomatized by *Les Demoiselles d'Avignon* and by its reception, and symptomatized (more abstractly and indirectly) by the shallowed space of the Cubist canvas, is a fear that spirals through Western society from the late nineteenth century to the present: the fear of women and outsiders, including peoples of color, usurping masculine roles and Western prerogatives, assuming agency. In other words, a fear of the loss of male hegemony together with a fear of the loss of hegemony of the West is at issue in *Les Demoiselles*, so that the painting may be read as a gesture of "recognition and disavowal . . . of the fact

that the west—its patriarchal subject and socius—is threatened by loss, by lack, by others," as Hal Foster astutely observes.[67]

If *Les Demoiselles d'Avignon* has functioned historiographically as the preeminent modern site where shifts in the dominant visual order took place, it has held that position not simply because it announced the advent of Cubism, or because it featured prostitutes, those allegorical figures of the modern, but because those prostitutes' physiognomies are more or less foreign-looking, ranging (from left to right) from stylized Egyptian and Iberian to caricatured African types. The hidden shoal on which the ship of mimetic, Mediterranean visual ideals is widely said to have foundered is not just the body of a debauched woman, but of an exotic debauched woman. And the rhetoric critics used to describe that body (while trying to capture the spirit of Picasso's visual rhetoric) at times seems to betray a fear of the decline of the West spelled by the breaching of Western borders by others—an irrational fear, of course, since Westerners had invaded other continents and not the reverse. A term such as "decivilizing," for instance, applied to the demoiselles, resonates with an echo of the vocabulary of that colonialist discourse which underpinned sweeping and draconian policies wherein "the other is there only to be reappropriated, recaptured, and destroyed as other," as Hélène Cixous phrases it.[68]

Although the women in *Les Demoiselles d'Avignon* are all light-skinned, critics often differentiate the two with African-looking masks as distinctly ugly, bestial, and dirty or contagion-ridden—that is, with all the scathing stereotypes that have so long dogged dark-skinned peoples. To Western eyes, the African art that engaged Picasso appears "unbearably ugly," pronounced Rosenblum.[69] Rubin refers to "the monstrously distorted heads of the two *whores* on the right," contrasting them with "the comparatively gracious 'Iberian' *courtesans* in the center."[70] And in the view of Rubin and Bernheimer both, *Les Demoiselles* effectively illustrates "the very process of atavistic regression, from the 'normal' heads of the two central figures through the dark metamorphosis of the woman on the left, to the Africanized masks and twisted, disordered anatomies of the two right-hand figures." The painting thus betrays "a fantasy about the active presence in woman's sexual nature of her dark, primitive, degenerate, perhaps diseased biological origins."[71] Frances Frascina actually compares African masks that bear some relation to those concocted by Picasso with medical photographs of figures horribly deformed by the effects of syphilis, claiming (quite unconvincingly, to my eye) that there are similarities between them.[72] Observes Bhabha sagely: "Black skin splits under the racist gaze, displaced into signs of bestiality, genitalia, grotesquerie, which reveal the phobic myth of the undifferentiated whole white body."[73]

The subtext to all these texts on the relation of the more European-looking figures to the two figures in Africanesque masks is a narrative of regression: of normality regressing into deviancy, of well-being degenerating into disease, and of contained eroticism lapsing into raw animality. In this light, I must note that in numerous critics' eyes, the two women whom I describe as wearing African-looking masks do not wear masks at all, but are hybrid creatures instead. (What might justify this reading is the striated, greenish shading on the breast of the figure at the upper right, which echoes the green stripes on her face or mask, though I would maintain that the disjunction between these figures' heads and their bodies is otherwise so marked as to invite us to see them as wearing masks.) That these white women might be metamorphosing into "jungle-nosed nudes" is a cause for terror (as parallel scenarios

of humans turning into insects or monsters in later horror movies would be) because mongrels are viewed as impure, degenerate, and corrupting—the notion that indigenous populations are degenerate and savage having been indispensable, of course, to the rationale for colonizing them. What looms in *Les Demoiselles* also is what Mary Doane identifies as "a strong fear that white women are always on the verge of 'slipping back' into a blackness comparable to prostitution. The white woman would be the weak point in the system, the signifier of the always too tenuous hold of civilization."[74]

The identification of the European woman with the figure of the primitive, played out in *Les Demoiselles d'Avignon*, is a familiar one, encapsulated by Freud's allusion to white women as the "dark continent." Freud associated white female sexuality with the sexuality of "races at a low level of civilization," where (as with children) sexuality is allowed "free rein" in a course held to account for the putative evidence of diminished cultural achievement among these populations.[75] In colonialist fantasies, then, the notion of the dark continent "contains the submerged fear of falling out of the light, down the long coal chute of social and moral regression," as Patrick Brantlinger phrased it; and that

> fear of backsliding has a powerful sexual dimension. . . . In European writings about Africa, [Dominique] Mannoni says, "the savage . . . is identified in the unconscious with a certain image of the instincts. . . . And civilized man is painfully divided between the desire to 'correct' the 'errors' of the savages and the desire to identify himself with them in his search for some lost paradise (a desire which at once casts doubt upon the merit of the very civilization he is trying to transmit to them)."[76]

Like Gauguin, Matisse, and many other modernists, for a time Picasso hoped to pioneer a new vision by looking to a new place, far from Europe. While Matisse would contrive a safe, masculinist utopia or pornotopia set in a France magically refashioned as an Orientalist, white North Africa, however, Picasso composed a dangerous, masculinist dystopia set in a Paris abruptly invaded by elements of black Africa. "As the Orientalist dream dies, the surprise is to find Africa within the self," notes Miller, and that surprise was an unpleasant one, for "Africanist discourse is at the least an *unhappy* Orientalism, a discourse of desire unfulfilled and unfulfillable."[77]

From a certain perspective both Matisse's paradise and Picasso's hell might qualify as regressive visions. But to some, the specter of affluent white men not getting what they wanted or, as it were, getting more than they bargained for from the women and dark-skinned peoples they exploited is at least more heartening than seeing those same men's desires indulged. Traditionally, art-historical narratives construe Picasso's and Matisse's projects both as progressive, of course, on the understanding that the artists' recourse to cultures their own society had deemed primitive implied a critique of that (parent) society's values.[78] Had *Les Demoiselles* been prominently exhibited and discussed in the years after it was painted, it might conceivably have had that impact, so shocked was the reaction to the picture among the small audience it reached. But the painting was effectively suppressed until such time as the potential for critique represented by the "primitive" had been "contravened, absorbed within the body of modern art," so that, from the moment it became the object of sustained attention, *Les Demoiselles* could be vaunted as the greatest achievement of the world's greatest modern artist.[79]

Surely *Les Demoiselles d'Avignon* could never have enjoyed the phenomenal celebrity it has if it did not function in some ways to confirm prevailing social biases. By the time the great icon's retrogressive implications had at last begun to emerge to view, however,[80] its pivotal standing was already subject to question. If the picture's great stature has ostensibly remained undiminished—witness the major homage organized by the Musée Picasso—its position has become, increasingly, oddly isolated. As analyses of Cubist practice have recently (and for good reason) shifted to semiologic models that better suit more abstract idioms than Picasso was yet prepared to deploy in 1907, the status of *Les Demoiselles* has become a somewhat separate matter.[81] The move toward isolating the picture well anticipated this methodological shift, however. And I suspect a contributing, though doubtless subliminal factor in the severing of *Les Demoiselles* from that Cubist corpus it was once said to engender—namely, an impulse to, in a sense, quarantine the painting's notoriously "contagion"-ridden body.

Les Demoiselles d'Avignon was hailed as the first Cubist painting during a period when its subject matter was scarcely mentioned.[82] Until the picture's theme became an explicit focus of interest—owing to Steinberg's groundbreaking essay of 1972—the "young ladies" of Avignon enjoyed an exalted status as the virtual mothers of modernist painting. But once they were openly fingered as whores who merely hid behind the flimsy curtain of a euphemistic title,[83] the demoiselles would be sternly and painstakingly stripped of their maternal status.[84] Not only are prostitutes conventionally thought to be barren, but what children they do bear must be of uncertain parentage; and Cubism could not be tainted as an illegitimate production. Worse yet that Cubism should be exposed as a black bastard; yet of the five demoiselles, critics had pinpointed above all the Africanized nudes as the site of Cubism's birth. Steinberg referred to "the intruding savage, deeply recessed, trapped in the cleft of a curtain whose collapsing pleats simulate an impenetrable solidification of space—the famous birthplace of Cubism," while Kahnweiler isolated the figure at the lower right, with her legs spread wide as they would be in giving birth, as "the beginning of Cubism, the first upsurge."[85] No doubt the right-hand side of the painting, which Picasso finished last, is the more innovative part; but that these specific figures should have been isolated as *the* crucial site on *the* crucial site of origin for modernist painting also betrays a Western habit of symbolically pressing Africa into service as the originary realm, together with the habit of leveling the image of Africa into that of an ever penetrable, yet ever unknowable, feminine body.[86]

When we first spy the crouching woman at the lower right of *Les Demoiselles*, our attention is arrested by the frontally poised, vividly drawn, Africanesque mask that serves as her face and, as our gaze travels downward, we expect to find that her whole body faces us with the genitals lewdly exposed between her boldly spread legs (a vision the artist initially considered, as sketches show).[87] But Picasso elected instead to tease us, turning the woman's back to us so that her sexual organs are suppressed, while her mask might be seen (on second thought) as covering the back of her head. Picasso's gesture, of withdrawing what he had seemed to promise—a graphic view of the tabooed area of the labia and vagina— must be viewed in light of the subsequent sealing-off of pictorial space that Cubism effected. On the one hand, we could construe that shallow Cubist space as implementing metaphorically a wishful recovery of the hymen so as to render the feminine body of the canvas intact, in a sense presexual, and so unthreatening. But sealed female genitalia may

also connote what has been regarded as deviant feminine sexuality, that is, lesbianism or barrenness, both of which were associated with the prostitutes' subculture (as virginity, needless to say, was not). Numerous critics discern a masculine quality to some or all of the women in *Les Demoiselles d'Avignon*, pointing to their sometimes flattened breasts—which might evoke the virilized form of the New Woman, as well as certain stereotypes about the lesbian body. To other critics, however, the demoiselles' bodies suggest the hypersexualized figure of the femme fatale. Significantly at issue in both these disparate interpretations is a nonprocreative feminine type.[88]

The figures with African-looking masks, once universally accepted as Cubism's mothers, began to be accorded more complicated and more sinister roles in the early 1970s, then, at a moment when African Americans and women generally in the United States were assuming more aggressive roles including, for women of every color, that of winning and exercising the right to refuse maternity. No longer cast as the harbingers of a great birth, the figures in Africanesque masks became instead the avatars of a ghastly death. To Rubin, the " 'African' faces express more . . . than just the 'barbaric' character of pure sexuality . . . their violence alludes to Woman as Destroyer—vestiges of the Symbolist *femme fatale*."[89]

The figure of the femme fatale articulates "fears surrounding the loss of stability and centrality of the self, the 'I,' the ego. These anxieties appear quite explicitly in the process of her representation as castration anxiety," argues Doane.[90] Owing to what were imagined as the devouring mouths and fathomless depths of their vaginas and uteruses, women have been poetically associated with the vertiginous terrors of the abyss;[91] and in many critics' eyes the demoiselles have spelled precisely the threat of that abyss. Though he did not leave gaping holes in the painting's structure, and though he kept the women's mouths drawn closed and their vaginas occluded from view, there remained a nagging doubt: "What secret reserves of space does that jungle-nosed nude, looking in from backstage, leave behind?" as Steinberg anxiously expressed it.[92]

Just as the female body enfolds certain distinct and vital holes or spaces (which are not, of course, generally scary or fully unknowable to women themselves), women have been associated symbolically with the holes or gaps in the epistemological fabric of the culture— and not women alone. Black Africa has had a parallel status in the Western imagination: the very word, Africa, "is practically synonomous with absence in Western discourse."[93] Because the experience of women and peoples of color has historically been discounted under patriarchy, once the paternal order's epistemological fabric began to shred, those missing threads became the subject of increasing anxiety and interrogation.

The crisis of legitimation associated with the advent of modernity entailed a kind of dethroning of the sovereign white male subject. And "discussion of loss of authority inevitably comes around to women," Alice Jardine aptly notes; " 'Woman,' 'the feminine,' and so on have come to signify those *processes* that disrupt symbolic structures in the West."[94] Not only women but also dark-skinned peoples "have traditionally been perceived as figures of disorder, 'potential disrupters of [European] masculine boundary systems of all sorts.' " From the dominant perspective, as Elaine Showalter writes (though with a view only to women), these populations' "social or cultural marginality seems to place them on the borderlines of the symbolic order, both the 'frontier between [white] men and chaos' and dangerously part of chaos itself, inhabitants of a mysterious and frightening wild zone outside of patriarchal culture."[95]

To the majority of critics, in *Les Demoiselles d'Avignon* Picasso conjured an exceedingly compelling vision of just such a wild zone. But on finishing that picture, the artist would soon proceed to calmer territory—by moving for time toward resisting or suppressing the feminine, the bodily, and the foreign. Thus the analytic Cubist paintings to follow feature tamely banal motifs: still lifes, landscapes, portraits, and (fewest of all) rather chastely abstract nudes.[96] Museum visitors traversing the galleries of the comprehensive "Pioneering Cubism" exhibition at the Museum of Modern Art in 1989—after having been greeted at the show's entrance by the always galvanizing presence of the demoiselles—might well have wondered: What happened to that flagrant, raw nudity as Cubism developed? What happened to those baldly African elements?

Numerous historians would answer that Picasso "purged himself of these barbaric impulses." Subdued by "the disciplining influence of the French tradition," represented by Cézanne and Braque, he turned away from these profound sources of inspiration—African art and Spanish art—and succumbed to "the classicizing influence of Braque."[97] The result was that the African sources of "high" Cubist art would remain comparatively inevident, and scholars would tend to diminish them in any case, the better to qualify Cubism as a classic art.[98] What has been neglected also is that, in retreating from the jarring content of *Les Demoiselles*, Picasso equally retreated from his own heritage, since he had specifically conceived two of the women as Iberian, and southern Spain—his birthplace—lies closer to Africa than any place else in Europe.[99] Later in his life, Picasso liked to say that "cubism is Spanish in origin" and that "it was I who invented cubism."[100] But Braque invented it with him in the wake of the storm caused by *Les Demoiselles*, and Braque had no penchant for the dark, bold, sensual, and tragic dramas of Spanish art or for the aspects of tribal art that so gripped Picasso. Braque "was never at all afraid of [the 'Negro pieces']," marveled Picasso, "because he wasn't affected by what I called 'the whole of it,' . . . everything that surrounds us, everything that is not us—he didn't find all of that hostile."[101]

Another answer to the question: what happened to those big-as-life, bawdy women in the aftermath of *Les Demoiselles* is that they got dissected—first by Picasso and, much later, by a legion of art historians who would probe the painting's innards, examining its gestational process in microscopic, and admittedly intriguing, detail. Such was the impetus behind the sedulous and scrupulous scholarship assembled to accompany the Paris exhibition commemorating the painting, a show praised for having "brilliantly . . . dissected such a point of origin"[102]—or, in a manner of speaking, for performing a successful autopsy on the former prostitute-mothers of modernist painting. (Historically, prostitutes had been the object of dissection in literal ways as well, "for the corpses of destitute prostitutes often served for anatomical dissection, thereby fulfilling the explicit fantasy of numerous nineteenth-century writers to examine female physiology by literally cutting women up."[103])

As Doane and others have diagnosed it, the urge to plumb the depths of feminine sexuality stemmed from the sense that women harbor a threatening "secret, something which must be aggressively revealed, unmasked, discovered."[104] In this light, the shallow, sealed-off space of analytic Cubism might be understood to function defensively as a space where almost everything lies on the surface, revealed to view. In its hiddenness, women's interiority was, like "the invisibility of nature's interiority . . . threatening precisely because it threatens the balance of power between man and nature, and between men and women," observes the historian of science, Evelyn Fox Keller. "To this problem, the culture of modern

science has found a truly effective solution. . . . Instead of banishing the Furies underground, out of sight, as did the Greeks, modern science has sought to expose female interiority, to bring it into the light, and thus to dissolve its threat entirely."[105]

Protracted efforts at exposing the hidden, inner workings of *Les Demoiselles d'Avignon* have not noticeably assuaged the critics' uneasiness, however. The discourse on the picture over the past two decades—since Steinberg substantially redirected the course of discussion—might be said to prove instead its sustained ability to move men to reexperience their deepest anxieties about questions of origins (about the unequaled powers of the mother and the invisibility of the father), to the point where they have hoped to exorcise the "exorcism-painting," to expel it from Cubism's cherished body. Thus, *Les Demoiselles* has gradually assumed the form of a detached preface to a new, improved version of the Greatest Story Ever Told, which now centers on the relatively de-ethnicized and disembodied corpus of "high" Cubism; for now we are offered a Cubism that commences at ever later dates: in 1908, according to Rubin, and as late as 1912 by Bois' account.[106] Though Rubin and Bois continue to insist on the momentousness of *Les Demoiselles*, such claims plainly lose some freight once the case is made that the painting did not, in fact, inaugurate Cubism.

Viewers of *Les Demoiselles* have mostly reacted in extreme ways from the very first. An exception was the critic Félix Fénéon, who mildly advised the artist that he really ought to take up caricature.[107] And maybe Fénéon got it right; for *Les Demoiselles* might almost be read as a giant cartoon. What is comical to me are those two mischief-makers in outlandish masks galling their prospective johns as their co-workers coolly take the measure of the (now unnerved) men who dawdle and gawk before them—men as interchangeable as the currency in their wallets which surely forms their only true appeal. What amuses me no less, however, is the nervous response to this spectacle of feminine effrontery by my fellow historians; for no other modern picture has elicited such widespread and visceral discomfort, mounting at times to a hysterical pitch. For decades, the line of women in *Les Demoiselles* has functioned for many critics like a dreaded dream that will not fade. And the nightmare in question—which these critics think (with reason) is the same bad dream that impelled Picasso to paint the picture—features a file of sturdy, experienced, working women of ambiguous heritage and humble descent; women apparently unimpressed and unbowed by the men who approach them; "women whose independence was clearly menacing," as Pierre Daix describes them.[108] What is humorous, then, is the notion that this dream should rightly petrify us all, while to some of us, of course, such figures—however summarily, distortedly, or abstractly drawn—do not evince aliens, much less monsters: to the contrary, they bear a passing resemblance to ourselves.

Prostitutes and femme fatales admittedly make less than perfect feminist heroines. And white prostitutes sporting goofy, pseudo-African masks no doubt make poor heroines for people of African descent: plainly it would be far-fetched to construct the demoiselles in heroic terms pure and simple. Doane points out that far from being "the subject of feminism," the femme fatale is rather "a symptom of male fears about feminism;" yet "because she seems to confound power, subjectivity, and agency with the very lack of these attributes, her relevance to feminist discourse is critical."[109] If the demoiselles can never function successfully as models of empowerment, they have, nonetheless, already functioned effectively as lightning rods for *fear* of the empowerment of women and peoples of color. One

story *Les Demoiselles* and its reception teaches is how "a crisis in phallocentric culture was turned into one of its great monuments," as Foster aptly puts it.[110] The sense of crisis or panic that has animated the literature on *Les Demoiselles* and the ongoing efforts to encapsulate the picture in an isolated discursive space prove that it has had some destabilizing or decentering effects on the viewers for whom it was intended. It may, by the same token, be capable of having some more centering effects on the rest of us.

Writing from the position of the so-called exotic woman, perenially subject to the perorations of that "vague entity" Man, who has presumed to speak for all humanity, Trinh T. Minh-ha protests:

> I am profoundly indifferent to his old way of theorizing—of piercing, as he often claims, through the sediments of psychological and epistemological "depths." . . . Seeking to perforate meaning by forcing my entry or breaking it open to dissipate what is thought to be its secrets seems to me as crippled an act as verifying the sex of an unborn child by ripping open the mother's womb.[111]

In light of the violence and phallicism of these Western epistemological ideals—of penetrating and dissecting as supreme forms of learning, knowing, and so possessing—the received reading of *Les Demoiselles d'Avignon* as the most apotropaic of all modern images takes on another valence; for here is a paradoxical case of those most penetrable of all women, prostitutes, arrayed across that reputedly penetrable fine-arts vehicle, the canvas, yet being apprehended widely as the fiercest of warnings not to penetrate, but to stay at a safe, respectful remove.

Those feminists who are leery of further inflating Picasso's already outsized stature may yet find some purpose, then, in protecting the iconic status of his most brazen and motley picture. After all, the viewers this painting specifically addresses—men mostly used to deriving at the least some basic form of acknowledgment and so reassurance from works of art—have often found themselves deeply troubled by *Les Demoiselles d'Avignon*. What jars them is a glimpse it seems to afford of a time and circumstance when the continued primacy, or even viability, of their habitual modes of perceiving and knowing appears not merely doubtful, but also distinctly unwelcome.

Frequently Cited Sources

Bernheimer, C., *Figures of Ill Repute: Representing Prostitution in Nineteenth-Century France*, Cambridge, MA, 1989.

Bois, Y.-A., 1988, "Painting as Trauma," *Art in America*, LXXVI, no. 6, June, 130–41, 172–73.

——, 1992, "The Semiology of Cubism," in *Picasso and Braque: A Symposium*, ed. L. Zelevansky, New York, 169–208.

Buci-Glucksmann, C., "Catastrophic Utopia: The Feminine as Allegory of the Modern," in *The Making of the Modern Body: Sexuality and Society in the Nineteenth Century*, ed. C. Gallagher and T. Laqueur, Berkeley, 1987, 220–29.

Corbin, A., *Women for Hire: Prostitution and Sexuality in France after 1850*, trans. A. Sheridan, Cambridge, MA, 1990.

Daix, P., 1988, "Dread, Desire, and the Demoiselles," *Artnews*, LXXXVII, no. 6, Summer, 133–37.

——, 1993, *Picasso: Life and Art*, trans. Haus. O. Emmet, New York.

Doane, M. A., *Femmes Fatales: Feminism, Film Theory, Psychoanalysis*, New York, 1991.

Foster, H., "The 'Primitive' Unconscious of Modern Art, or White Skin Black Masks," in *Recodings: Art, Spectacle, Cultural Politics*, Port Townsend, WA, 1985, 181–208.

Kozloff, M., "Cubism and the Human Comedy," *Artnews*, LXXI, no. 5, Sept. 1972, 35–41.

Leighten, P., *Re-Ordering the Universe: Picasso and Anarchism, 1897–1914*, Princeton, NJ, 1989.

Malraux, A., *Picasso's Mask*, trans. J. Guicharnaud with J. Guicharnaud, New York, 1976.

McCully, M., ed., *A Picasso Anthology: Documents, Criticism, Reminiscences*, London, 1981.

Miller, C. L., *Black Darkness: Africanist Discourse in French*, Chicago, 1935.

Poggi, C., *In Defiance of Painting. Cubism, Futurism, and the Invention of Collage*, New Haven, 1992.

Richardson, J., *A Life of Picasso, 1 (1881–1906)*, New York, 1991.

Rosenblum, R., *Cubism and Twentieth-Century Art*, New York, 1960.

Rubin, W., 1983, "From Narrative to 'Iconic' in Picasso: The Buried Allegory in *Bread and Fruitdish on a Table* and the Role of *Les Demoiselles d'Avignon*," *Art Bulletin*, LXV, no. 4, 1983, 615–49.

——, 1989, *Picasso and Braque: Pioneering Cubism*, exh. cat., Museum of Modern Art, New York.

Seckel, H., et al., *Les Demoiselles d'Avignon*, 2 vols., exh. cat., Musée Picasso, Paris, 1988.

Steinberg, L., "The Philosophical Brothel, Part I," *Artnews*, LXXI, no. 5, Sept. 1972, 20–29; "The Philosophical Brothel, Part 2," ibid., LXXI, no. 6, Oct. 1972, 38–47.

Zelevansky, L., ed. *Picasso and Braque: A Symposium*, New York, 1992.

Notes

I thank Christine Poggi, Lisa Saltzman, and Lorraine O'Grady for their comments on earlier versions of this manuscript.

1. Bois, 1988, 172; Richardson, 475; a phrase of Max Jacob's employed by Arianna S. Huffington to describe *Les Demoiselles* (A. S. Huffington, *Picasso: Creator and Destroyer*, New York, 1988, 93); and Steinberg, 20 (Steinberg says that the painting has come to be regarded in such terms, not that he himself sees it in that way).

2. E. F. Fry, *Cubism*, New York, 1966, 12; and Seckel.

3. This story is told by Bois, who helpfully suggested to William Rubin that he ride along with the painting, thereby sparing the necessity for the suicide (Bois, 1988, 172, n. 14).

4. Cited by Daix, 1993, 187. Breton became a champion of the painting in the 1920s; in 1923 he engineered its (initial) sale, to Jacques Doucet; and in 1925 he reproduced it in *La Révolution surréaliste* (ibid., 69, 252).

5. *Les Demoiselles* was first reproduced in the *Architectural Record* of May 1910. Though it was visible in a studio photograph published by André Salmon in 1912, it was not properly reproduced in France until 1925 (see n. 4, above). The painting was first exhibited by Salmon at the Salon d'Antin in 1916, but it met "with indifference." In 1939 Alfred Barr acquired it for the Museum of Modern Art, where it has remained ever since, the virtual centerpiece of the collection. It was not shown again in France until 1953, when it again "receive[d] very little attention" (Daix, 1993, 68–69).

6. Cited in Rubin, 1989, 348. Those openly critical of the picture included Georges Braque, Leo Stein, Guillaume Apollinaire, and Félix Fénéon (ibid., 348, 346), Ambroise Vollard (Daix, 1993, 79), and the collector Sergei Shchukin, who appeared at Gertrude Stein's home, "almost in

tears," bemoaning the "loss for French art" (G. Stein, *Picasso* [1938], New York, 1984, 18). Stein supported the picture (Daix, 1993, 79), as did Salmon and Ardengo Soffici (Rubin, 1989, 348).

7. That this way of narrating the story of modern art has entailed an overestimation of Picasso at the expense of other modernist pioneers, including some active in centers other than Paris, could easily be, though it will not be, a subtheme of the present essay.

8. The word is Salmon's, cited in McCully, 57.

9. Steinberg, 22; R. Rosenblum, "The 'Demoiselles d'Avignon' Revisited," *Artnews*, LXXII, no. 4, Apr. 1973, 45; and Kozloff, 35. Kozloff does not clarify whom he regards as the sociopath(s), whether Picasso (whose "antipathy to his disfigured subjects" is mentioned) or the prostitutes (those "avenging furies of a new order"), or who would be the victims (Kozloff, 38, 37).

10. Salmon's phrase, cited in McCully, 140.

11. The earliest dissenter from the position (promulgated by such authorities as Kahnweiler and Barr) that *Les Demoiselles* was the first Cubist picture was John Golding, who still regarded the picture as "a natural starting-point for the history of Cubism" (J. Golding, "The 'Demoiselles d'Avignon,'" *Burlington Magazine*, c. 1958, 162–63). Rubin much later took up this point, arguing that the picture "pointed mostly in directions opposite to Cubism's character and structure—although it cleared the path for its development." Further, "none of the earliest references to the Demoiselles characterizes it as Cubist; nor did Kahnweiler so qualify it in 'Der Kubismus' [of 1916]. . . . By 1920, he had apparently changed his mind" (Rubin, 1983, 628, 644). Richardson persists in the view that the picture "established a new pictorial syntax" (Richardson, 475).

12. "From the mid-nineteenth century to the beginning of the twentieth, modernism obsessionally and anxiously displays its innovative desire by fragmenting and disfiguring the female sexual body, epitomized in male fantasy by the prostitute," observes Bernheimer, 266. Baudelaire's remark is cited in ibid., 292, n. 51.

13. T. de Lauretis, *Alice Doesn't: Feminism, Semiotics, Cinema*, Bloomington, IN, 1984, 13. Also, "masculine sexuality and in particular its commercial exchange dominate the works seen as the 'founding monuments of modern art,'" notes Janet Wolff (who credits Griselda Pollock for this insight); it follows that "the definition of the modern, and the nature of modernism, derived from the experience of men and hence excluded women" (J. Wolff, *Feminine Sentences: Essays on Women and Culture*, Berkeley, 1990, 57, 58).

14. R. Johnson, "The 'Demoiselles d'Avignon' and Dionysian Destruction," *Arts*, Oct. 1980, 94: my emphasis.

15. First to remark on the dynamic of exclusion at work in *Les Demoiselles* was C. Duncan, "The MoMA's Hot Marnas," *Art Journal*, XLVIII, no. 2, Summer 1989, 175–76.

16. A more traditional study of the reception of *Les Demoiselles* is promised by a new publication—William Rubin, *Les Demoiselles d'Avignon*, Studies in Modern Art, no. 3, New York, 1994—which was as yet unavailable when the present essay went to press.

17. Though I do not address the position of the lesbian viewer in this essay, it is an issue worth pursuing, particularly considering that aristocratic, lesbian patrons frequented brothels to an extent in turn-of-the-century Paris, and that prostitutes at the better establishments were trained and expected to serve this clientele. See Corbin, 125.

18. That womanliness and masquerade are in a sense one and the same was initially suggested by the psychoanalyst Joan Riviere (J. Riviere, "Womanliness as a Masquerade" (1929), in *Formations of Fantasy*, ed. V. Burgin, J. Donald, and C. Kaplan, London, 1986, 35–44; see also S. Health, "Joan Riviere and the Masquerade," in ibid., 45–61).

19. Luce Irigaray, cited in Heath (as in n. 18), 54.

20. Whether Picasso's intention in giving caricatured African masks to these prostitutes was consciously denigratory or not is a moot point. Leighten, who was the first to focus on the issue of colonialism in relation to *Les Demoiselles*, has argued strenuously, but I believe unconvincingly,

that his gesture was one of fervent solidarity with anticolonial thinking (P. Leighten, "The White Peril and *L'Art nègre*: Picasso, Primitivism, and Anticolonialism," *Art Bulletin*, LXXII, no. 4, 1990, 609–30).

21. H. Bhabha, "Of Mimicry and Man: The Ambivalence of Colonial Discourse," October, no. 28, Spring 1984, 126–27. Mimicry can go two ways, of course, but for a white person to imitate a person of color, to perform in effect as a minstrel, is at once to acknowledge and to disavow "difference at the level of the body." From that perspective, ministrelsy emerges as a form of fetishism, an attempt to restore the wholeness and unity threatened by the sight of difference, yet because it enters into the game of mimicry it is condemned to keep alive the possibility that there may be 'no presence or identity behind the mask'" (T. Modleski, "Cinema and the Dark Continent: Race and Gender in Popular Film," in L. S. Kauffman, ed., *American Feminist Thought at Century's End: A Reader*, Cambridge, MA, 1993, 76).

22. See, e.g., Picasso's *Self-Portrait* of 1907, in the National Gallery, Prague, reproduced in *Pablo Picasso*, ed. W. Rubin, exh. cat., Museum of Modern Art, New York, 1980, 92. On Picasso's liberal use of cartoons and caricature, see A. Gopnik, "High and Low: Caricature, Primitivism, and the Cubist Portrait," *Art Journal*, XLIII, no. 4, Winter 1983, 371–76.

23. Art historians have tended to concern themselves, at most, with the abstract figure of the prostitute as metaphor, rather than with the realities of such women's experience. In the absence of studies describing the texture of French prostitutes' lives at the turn of the century, we might refer to feminist historian Ruth Rosen's work on prostitutes in the U.S. Rosen observes that poor and unskilled women at this time often faced unenviable decisions: between entering loveless marriages merely to gain economic protection, working for starvation wages, or selling their bodies as "sporting women," so that entering brothels was not invariably their worst option. Further, she identifies a prostitutes' "subculture with its own values, class structure, political economy, folk culture, and social relations," including a sometimes beneficent form of "sisterhood" (a picture one might have inferred from E. J. Bellocq's affecting portraits of the brothel inmates in Storyville, LA). Typically, prostitutes did not disparage themselves or their trade, but "maintained an attitude of defensive superiority toward 'respectable' members of the rest of the society," including their clients, whom they generally regarded as suckers. "Even the language of the trade, 'turning a trick,' reflected the hoax that the prostitute was perpetrating on the customer" (R. Rosen, *The Lost Sisterhood: Prostitution in America, 1900–1918*, Baltimore, 1982, xiv, xvii, 102, 91). French slang for a john was "*michet*," which translates roughly as "sucker" or "dude" (Corbin, 83).

24. Though of course not all men patronize prostitutes, *Les Demoiselles* effectively implicates all straight men as possible customers, thus placing those men who deplore prostitution in a specially disconcerting position. It bears adding that the patronizing of prostitutes is probably more stigmatized in the U.S. than in Europe, a discrepancy explained in part by a loose (and now eroded) tradition that European men are sexually initiated by prostitutes, while North American men are expected to lose their virginity to female intimates, if not to their wives. American men who do not avail themselves of prostitutes' services may find themselves in a more awkward position before Picasso's painting than their European counterparts, then—though I note that embarrassment has not been among the feelings reported by male critics.

25. See Corbin, passim.

26. Bernheimer's careful analysis of the ambivalent position of the male viewer of Degas' monotypes of brothel scenes (works Picasso deeply admired) provides one answer. Bernheimer concedes that these pictures "appear to address the male viewer's social privilege, to construe him as a voyeur, and to cater to his misogyny," but he argues that "they undertake this construction duplicitously," granting the spectator a privileged view of the sexually available female body while depriviledging that view by presenting not nubile temptresses but conspicuously "alienated products of a consumer culture" that thwart the spectator's desire. Deflecting attention from a

persistent biographical question, whether Degas himself was a misogynist, Bernheimer observes that "misogyny, cruelty, disdain—attitudes often attributed to Degas, as if his art were a space of self-representation—can more accurately be interpreted as functions of the capitalist ideology that defines and confines woman's value in representational practice" (Bernheimer, 185, 189). *Pace* Bernheimer, Degas' (and Picasso's) art is *also* a space of self-representation. To my mind, the sense of malaise permeating their prostitute images evinces less concern for the women's plight than anxiety about the artists' own, as well as, by extension, for the fate of other male subjects like themselves.

27. Ibid., 269–70.

28. Rubin, 1983, 629. Picasso's "Andalusian misogyny" is mentioned by Richardson, 68; his "obsessive fear of the destructive power of women" is described by Daix, 1988, 136.

29. Cited in S. Kofman, *The Enigma of Women: Woman in Freud's Writings*, trans. C. Porter, Ithaca, NY, 1985, 81.

30. Steinberg, passing; and Kozloff, 35–36.

31. Steinberg, 24.

32. "The seduction and conquest of the African woman became a metaphor for the conquest of Africa itself . . . to both were attributed the same, irresistible, deadly charm" (Nicolas Monti, cited in Doane, 213). Regarding the hypersexualization of the black female body; see also S. L. Gilman, "Black Bodies, White Bodies: Toward an Iconography of Female Sexuality in Late Nineteenth-Century Art, Medicine, and Literature," in H. L. Gates, Jr., ed., *"Race," Writing, and Difference*, Chicago, 1986. Gilman stresses the fascination of Europeans with the pronounced buttocks of some women of African descent, a point that bears on the lavish display of buttocks by the woman in the African mask at the lower right of *Les Demoiselles*. See also his essay in this volume.

33. Doane, 263.

34. See H. Clayson, *Painted Love: Prostitution in French Art of the Impressionist Era*, New Haven, 1991.

35. See Clayson's discussion of Benjamin, Baudelaire, and Simmel on the subject of prostitution in ibid, 7–9.

36. An insight credited to Benjamin by C. Buci-Glucksmann, 224.

37. L. Irigaray, "Women on the Market," in *This Sex Which Is Not One*, trans. C. Porter, Ithaca, NY, 1985, 184; author's emphasis. Besides confusing that once basic distinction between the seller and the sold, the prostitute also disturbed the opposition between work and sex which forms the basis for the concept of sublimation. The very possibility of the development of civilization is predicated—so Freud taught—on the systematic instilling of habits of sublimation. From this vantage point, the prostitute marks nothing less than the decline of civilization. See Doane, 260–1, 264, on which I rely for this observation.

38. Poggi, 45, 32.

39. On the complexities of Olympia's social standing, see T. J. Clark, "Olympia's Choice," in *The Painting of Modern Life: Paris in the Art of Monet and His Followers*, New York, 1985, 79–146.

40. Corbin, 127, 81. Picasso's picture reveals little of the appointments of the brothel that the demoiselles occupy, but the assembling in a salon of "two lines [of prostitutes] in a previously arranged order" was typical of a higher rank of *maison de tolérance* (a term for government-regulated brothels), as opposed to the lowest class of establishment, where the client's "choice was made in the adjoining bar where each woman would solicit the clients in turn." Protocol dictated that the lined-up women could not solicit the client by "a verbal invitation, but they all tried to tempt the visitor with winks, smiles, movements of the tongue, or exciting postures" (ibid., 83).

41. I owe this observation to a former graduate student at Harvard, the critic David Pagel.

42. See S. Gubar, " 'The Blank Page' and the Issues of Female Creativity," in *The New Feminist Criticism: Essays on Women, Literature, and Theory*, ed. E. Showalter, New York, 1985, 292–313,

which cites Sandra McPherson: "The female genital, like the blank page anticipating the poem, is an absence, a not me, which I occupy" (ibid., 292). See also B. Johnson, "Is Female to Male as Ground Is to Figure?" in *Feminism and Psychoanalysis*, ed. R. Feldstein and J. Roof, Ithaca, NY, 1989, 253–68.

43. S. M. Gilbert and S. Gubar, *The Madwoman in the Attic*, New Haven, 1979, 6 (this statement is evidently apocryphal); Rubin, 1989, 54, n. 1: J. E. B. Breslin, *Mark Rothko: A Biography*, Chicago, 1993, 360; and A. Solomon-Godeau, *Photography at the Dock: Essays on Photographic History, Institutions, and Practices*, Minneapolis, 1991, 229.

44. Cited in Miller, 245; ibid., 248. Declared a nineteenth-century French author, "the Black seems to me the female race" (ibid., 244).

45. Wassily Kandinsky, "Reminiscences" (1915), in Robert L. Herbert, ed., *Modern Artists on Art*, Englewood Cliffs, NJ, 1964, 35.

46. Rubin addressed this problem tellingly (though, to my mind, unhelpfully) by distinguishing Picasso's contribution to Cubist practice from Braque's as follows: Braque provided the "passive, feminine side of the formal equation (. . . a vision of Tellus Mater notably open-laned, inviting entry)," while "the vigorous Picasso thrusts his hard, sculptural morphology" into that "syntactical-spatial structure" (W. Rubin, "Pablo and Georges and Leo and Bill," *Art in America*, LXVII, Mar.–Apr. 1978, 136).

47. Rosenblum, 1960, 25; my emphasis.

48. Painting in Cubism's wake, Rothko observed in 1956. "There is something about our times that does not allow us as artists to represent woman. Matisse still felt about the woman as one does about a chattel. He used her, he fucked her. He painted her as he lived with her. Today woman has her independence: man looks at her as his equal and something indefinable stands between them. Not as yet to my mind has anyone discovered what this something is. Whatever it is, it blocks the painter from seeing her the way former generations did. Because as an artist today I cannot see her, I paint the abstract image of woman until something happens to show me the way toward a direct representation—a new attitude perhaps toward her" (Breslin [as in n. 43], 360–61).

49. R. Krauss, "The Motivation of the Sign," in Zelevansky, 271 (my thanks to Christine Poggi for reminding me of this passage). It bears noting that Picasso experienced a kind of crisis in realizing this picture: so many sessions did he demand from the model, whose presence he found "somewhat embarrassing," that she lost patience and declined to return, leaving the artist with what he regarded at the time as an unfinished work (R. Penrose, *Picasso: His Life and Work*, rev. ed., New York, 1973, 169).

50. Cited in Poggi, 5. The holes in the canvas opened by illusionistic or perspectival space had become "of ill repute during the late nineteenth and early twentieth centuries, implying deception about the nature of the medium," Poggi notes, while pursuing the case of a much discussed collage of 1913, *Still Life: At Bon Marché*, in which Picasso employed the phrase "un trou ici" in such a way that it apparently alludes to the genitals of a partially visible female figure. "In Picasso's collage, the newspaper text asserts the presence of a *Trou* without, however, creating the illusion of one. The hole remains an effect of writing pasted, with Picasso's characteristic wit, to a slight projection in the wall-like ground, for in a sense, it is a wall that is depicted here" (ibid., 152).

51. Steinberg implies the latter when he argues that "much of the disquiet in the left half of [*Les Demoiselles*] represents Picasso's rage against the solid drop of the canvas" (Steinberg, 25).

52. What promises to provide a gendered account of the "modern psychopathology of space" associated with the "psychology of abstraction" is the socially and architecturally oriented study "Modernism and Spatial Phobia" on which Anthony Vidler is currently engaged, as evidenced by his richly suggestive paper under that title given at the CAA conference, New York, Feb. 17, 1994 (citations here are from my notes on that occasion).

53. That such fears emerge with a vengeance in the late nineteeth and early twentieth centuries has been persuasively shown by E. Showalter, *Sexual Anarchy: Gender and Culture at the Fin de Siècle,* New York, 1990; S. Gilbert and S. Gubar, "Tradition and the Female Talent," in *The Poetics of Gender*, ed. N. K. Miller, New York, 1986; and *idem, No Man's Land: The Place of the Woman Writer in the Twentieth Century*, New Haven, 1989.

54. Steinberg, 46, 23, 25, 40, 46. Richardson pursues this line of thinking about Picasso, noting "the misogynistic pasha's" rendering of his mistress Marie-Thérèse Walter as "a thing of flesh and orifices": toward the end of his life, "the sexual act and creative act become metaphors for each other, the work gapes with vaginas, which the loaded brush . . . would remorselessly probe" (Richardson, 68).

55. Bois, 1988, 137.

56. Steinberg, 40.

57. Daix, in the minority, argues against this connection, noting that the authorities directed their anti-venereal disease campaign against streetwalkers, while "bordellos were considered clean, regulated places" (Daix, 1993, 67). Steinberg notes that Mary Gedo, in an interview with Gilot (who did not meet Picasso until many years later) "substantiated" John Berger's suspicion that the artist had had a venereal disease; thus, in her *Picasso: Art as Autobiography*, she "interpreted much of the evolution and final character of the *Demoiselles* in the light of the artist's medical history." Steinberg finally argues that while the revelation of Picasso's illness is meaningful, it cannot be said to provide us with the "rock-bottom truth" about *Les Demoiselles* (L. Steinberg, "Retrospect: Sixteen Years After," postscript to reprint of "The Philosophical Brothel," *October,* no. 44, Spring 1988, 71). Bernheimer cautions against dismissing the import of Picasso's medical history, pointing to the strong "fantasmatic association" which has linked modernist art with prostitution and disease (Bernheimer, 268). In preliminary studies for *Les Demoiselles,* Picasso considered including a skull, which some scholars have seen as marking a continuation of concerns expressed earlier, when the artist painted the sorrowful denizens of a hospital for ill prostitutes. Michael Leja suggests that those Blue Period pictures manifest a compassionate, "anarchist attitude—a view of prostitutes, particularly those of lower station, as victims of the economic and political status quo" (M. Leja, " 'Le Vieux Marcheur' and 'Les Deux Risques': Picasso, Prostitution, Venereal Disease, and Maternity, 1899–1907," *Art History*, VIII, no. 1, Mar. 1985, 67). And Leighten would have us view *Les Demoiselles* in related terms, almost as an anarchist manifesto, an "explosive act . . . of la propagande par le fait" (Leighten, 1989, 74). Such claims reaffirm Picasso's standing (that enjoyed almost automatically by the avant-garde's membership) as ally of the downtrodden, but in most critics' eyes, *Les Demoiselles* appears not as a testament to his deep sympathy for the prostitute, but as a report on his pathological hatred of women.

58. W. Rubin, "Picasso," in *"Primitivism" in 20th Century Art: Affinity of the Tribal and the Modern,* 2 vols., exh. cat., Museum of Modern Art, New York, 1984, 1, 253 (Rubin credits Steinberg for this revelation); and Bois, 1988, 138.

59. "Psychoanalysis gives us sexual identity as construction," but "the terms of that construction" seem "to fix things forever in the given, and oppressive, identities, with no connections through to the *social-historical* realities that it also seems accurately to be describing. . . . No doubt it is an articulation of the psychical and the social in the construction of sexuality and sexual identity that we need to break the deadlock" (Health [as in n. 18], 56–57).

60. Frances Frascina identified the type of pose in question and traced its history (F. Frascina, "Realism and Ideology: An Introduction to Semiotics and Cubism," in C. Harrison, F. Frascina, and G. Perry, *Primitivism, Cubism, Abstraction: The Early Twentieth Century*, New Haven, 1993, 112–20).

61. Bernheimer, 272.

62. Steinberg, 25, 43.

63. Malraux, 11. With *Les Demoiselles*, Picasso "succeeded in overpowering the demons that were causing him so much anguish, achieving what William Rubin has called, 'a relentless self-confrontation . . . comparable in this sense only to Freud's solitary self-analysis'" (Daix, 1988, 137).

64. See "Appendix VII: Picasso's Equivocations with Respect to Art Nègre," in Rubin, 1983, 632.

65. G. Perry, "Primitivism and the 'Modern,'" in Harrison et al. (as in n. 60), 3; author's emphasis. Adds Perry, "The characteristics of 'primitive' sources were thus seen to *conform* to, rather than to simply *inspire* the changing interests of modern artists" (ibid.). In 1942, Zervos stated, "The artist has formally certified to me that at the time he painted the *Demoiselles d'Avignon*, he knew nothing of the art of black Africa" (cited in Leighten, 1989, 86). Kahnweiler protested on the artist's behalf in 1948, "I must, once more, dispute the validity of the thesis of a direct influence of African art on Picasso and Braque. . . . The real question was one of convergence," that is, "in Negro art, the Cubists rediscovered their own conception of the work of art as *object*" (D.-H. Kahnweiler, "Negro Art and Cubism," *Horizon*, XVIII, no. 108, Dec, 1948, 413, 414). Observed Gertrude Stein, African art "consoled Picasso's vision [rather] than aided it. . . . Picasso first took as a crutch African art and later other things" (Stein [as in n. 6], 19). In 1940, in an exceptional admission of the impact of tribal art on his work (one notable, however, for its intimation of paranoia), Picasso expressed his initial sense of relation to the "fetishes" in the Trocadéro: "The Negro pieces were *intercesseurs*, mediators. . . . They were against everything. . . . I too am against everything. I too believe that everything is unknown, that everything is an enemy! Everything! Not the details—women, children, babies, tobacco, playing—but the whole of it! I understood what the Negroes used their sculpture for . . . all the fetishes . . . were weapons. To help people avoid coming under the influence of spirits again, to help them become independent. They're tools" (Malraux, 10–11).

66. M. Wallace, "Modernism, Postmodernism and the Problem of the Visual in Afro-American Culture," in *Out There: Marginalization and Contemporary Cultures*, ed. R. Ferguson et al., Cambridge, MA, 1990, 48.

67. Foster, 182.

68. H. Cixous, "Sorties," in H. Cixous and C. Clément, *The Newly Born Woman*, trans. B. Wing, Minneapolis, 1986, 71.

69. Rosenblum, 25.

70. Rubin, 1983, 630; my emphasis. The "'African' faces . . . finally conjure something that transcends our sense of civilized experience, something ominous and monstrous such as Kurtz discovered in the heart of darkness" (ibid., 632). (For an insightful reading of Joseph Conrad's *Heart of Darkness* as the paradigmatic Africanist text, see Miller, 170–71.)

71. Bernheimer, 270; see also Rubin, 1983, 635, which expresses parallel concepts.

72. Frascina (as in n. 60), 128–29.

73. Bhabha (as in n. 21), 132–33.

74. Doane, 214.

75. Cited in ibid., 210.

76. P. Brantlinger, "Victorians and Africans: The Genealogy of the Myth of the Dark Continent," in Gates, ed. (as in n. 32), 215.

77. Miller, 150, 23; author's emphasis.

78. Thus, Picasso's primitivism "gestured toward cultures whose transformative powers [he] admiringly offered as escape routes from the stultification of French culture and academic art" (Leighten, [as in n. 20], 622).

79. Foster, 194.

80. Foster was the first to wonder publicly, in 1985, "Is this aesthetic breakthrough [represented by *Les Demoiselles*] not also a breakdown, psychologically regressive, politically reactionary?" (ibid., 181). In 1990 Michelle Wallace ventured that the painting "seems to represent the desire to both

reveal and repress the scene of appropriation as a conjunction of black/female bodies and white culture—a scene of negative instruction between black and white art or black and white culture" (Wallace [as in n. 66], 45).

81. Here the pioneers have been Bois (1992) and Poggi.

82. What made *Les Demoiselles* "truly revolutionary" was that "in it Picasso broke away from the two central characteristics of European painting since the Renaissance: the classical norm for the human figure, and the spatial illusionism of one-point perspective," pronounced Fry (as in n. 2), 13, though both those paradigms had long since been disused, as others have by now pointed out.

83. In 1916 Salmon gave the painting the title by which it has always been publicly known (Daix 1993, 65). Picasso protested in 1933: "*Les Demoiselles d'Avignon*, how this title irritates me. . . . You know very well that the original title from the beginning had been *The Brothel of Avignon*" (D. Ashton, ed., *Picasso on Art: A Selection of Views*, New York, 1972, 153).

84. "The dazzling discoveries of Cubism . . . are nowhere to be found, even in their germinal state in *Les Demoiselles*," Daix could state categorically by 1988 (Daix, 1988, 137).

85. Steinberg, 45; McCully, 60.

86. "In the face of the male desire to collapse sexual and racial difference into oceanic plenitude, feminism needs to insist on the complex, 'multiple and cross-cutting' nature of identity," Tania Modleski reminds us, while asking further: "How do we rid ourselves of the desire for a 'line of origin,' how avoid positing either sexuality or race as theoretically primary, while we at the same time undertake to understand the vicious circularity of patriarchal thought whereby darkness signifies femininity and femininity darkness" (Modleski [as in n. 21], 78). Some African-born writers now "depict the African past as a purloined, kidnapped, and usurped origin, as an originary violence that precludes the autonomy of any given object, leaving only a void" (Miller, 233).

87. See drawings 46r and 47r in sketchbook 3, as reproduced in Seckel, 1, 163.

88. Women become "widely available commodities with the 'massification' of industrial labor and society, simultaneously losing their 'natural' qualities (a feminine essence, a nature determined by child-bearing) and their poetic aura" (Buci-Glucksmann, 222). "The femme fatale is represented as the antithesis of the maternal—sterile or barren, she produces nothing in a society which fetishizes production" (Doane, 2). His sketches show that Picasso considered including a bitch suckling her puppies in *Les Demoiselles*—an emblem of natural, maternal femininity to contrast with the prostitutes' unnatural femininity—and some critics suggest that he intended thus to convey a message to his erstwhile lover, Fernande Olivier (whom he associated with the demoiselles), because of his dismay at her infertility. Olivier left Picasso for a matter of months soon after he completed the painting. To please him, she had adopted a daughter, but she returned the adolescent girl to the orphanage when he took too active an interest in her. "It is impossible not to infer that it is Fernande whose image he was now [that is, in *Les Demoiselles*] destroying," argues Daix, 1993, 71–72.

89. Rubin, 1983, 632. The modern "woman's body, deprived of its maternal-body, becomes desirable only in its passage to the limit; as death-body, fragmented-body, petrified-body," asserts Buci-Glucksmann, 226.

90. Doane, 2.

91. "This Baudelairean abyss—an inclination for chasm-like ruin and nothingness— . . . lives through a *continuous metaphor*, that of the feminine sex" (Buci-Glucksmann, 228); author's emphasis. "We have been frozen in our place between two terrifying myths: between the Medusa and the abyss. It would be enough to make half the world break out laughing, if it were not still going on. For the phallo-logocentric *aufhebung* [sublation] is there, and it is militant, the reproducer of old schemes, anchored in the dogma of castration. They haven't changed a thing: they have theorized their desire as reality," comments Cixous (as in n. 68), 68–69. That the image of

the abyss does not terrify everyone is suggested by the example of Georgia O'Keeffe, whose abstract chasms hold positive connotations of sexual identity. (For that matter, Indian Buddhists write of the "Peace of the Uttermost Abyss.")

92. Steinberg, 41.

93. Miller, 175.

94. A. A. Jardine, *Gynesis: Configurations of Woman and Modernity*, Ithaca, NY, 1985, 67, 42.

95. Showalter (as in n. 53), 7–8. "From the earliest times, Black Africa was experienced as the literal end of European knowledge," notes Miller; "Africanist discourse in the West is one in which the head, the voice—the logos, if you will—is missing" (Miller, 22, 27).

96. Further, Picasso scarcely individualized and rarely named his female subjects, whereas he often managed to make his male sitters recognizable, in spite of the difficulties involved (Kozloff, 38–39).

97. Rosenblum, 26; Rubin, 1983, 636.

98. "At the very crux of MOMAism, analytical cubism in particular must be protected from outside influence; thus tribal art is assigned 'but a residual role' in it" (Foster, 193). Bois separates the ritual from the "purely formal" aspects of African art, and associates the former with *Les Demoiselles*, the latter with Cubist collage (Bois, 1992).

99. An argument can be made that Picasso was, however unconsciously, protecting himself as a foreigner in France, where "from the first Moroccan Crisis of 1905, . . . 'nationalism became an atmosphere'" (D. Cottingham, "Cubism, Aestheticism, Modernism," in Zelevansky, 62). He did not succeed, however, for during World War I French critics condemned the Cubists as "mostly foreigners" (Leighten, 99).

100. Cited in Ashton, ed. (as in n. 83), 154.

101. Malraux, 11. Braque's famous comment to Picasso with regard to *Les Demoiselles* has been variously reported and variously translated: "It's as though you wanted to make us eat tow or drink kerosene," or "It is as if someone had drunk kerosene to spit fire" (cited in Rubin, 1989, 348).

102. Bois, 1988, 172.

103. Bernheimer, 270–71. The first serious study of prostitution, done in 1836 by Alexandre Parent-Duchatelet, was impelled "by a fantasy that pervades literary and artistic production in its wake;" that "of knowing female sexuality and defining its essential difference" (ibid., 270). Regarding the urge to dissect female bodies of African descent, see Gilman (as in n. 32).

104. Doane, 1.

105. E. F. Keller, "Making Gender Visible in Pursuit of Nature's Secrets," in Kauffman (as in n. 21), 195.

106. Rubin asserts that Braque painted the first Cubist pictures, his L'Estaque landscapes (Rubin, 1983, 643); Bois, 1992, 169. If we accept that the issue of when Cubism began is a patently unresolvable one, the fact of the historians' unending quest to determine and claim a point of origin for it—and so effectively to imprint its birth with their own names—assumes a significance all its own.

107. See Seckel, II, 656.

108. Daix, 1988, 136.

109. Doane, 2–3.

110. Foster, 182.

111. T. T. Minh-ha, *Woman, Native, Other: Writing, Postcoloniality and Feminism*, Bloomington, IN, 1989, 48–49.

14

Wilfredo Lam

Painter of Negritude

Robert Linsley

The work of Wifredo Lam is an alchemical mixture of Third World liberation, Surrealism and Negritude. The active ingredients are the ideas of Breton and the Surrealists and of Aimé Césaire, the first poet of Negritude. The crucible was *Tropiques*, a journal published during the war by Césaire and his wife Suzanne in Martinique, where all of these individuals briefly came together. The friendship between Lam and Césaire is well known. What has not been remarked is that Lam, though a Spanish rather than a French colonial, followed virtually the same trajectory and bore inside himself the same contradictions as the Negritude writers in his search for an authentic and contemporary Black art. Lam is really the painter of Negritude, and the development of his work, its difficulties and successes, can best be understood in the light of the later history of Negritude.

Negritude began as a literary movement among assimilated Blacks living in Europe. Africans educated in France to the highest level, as were Léopold Senghor and Césaire, the two leading proponents of Negritude, had embraced the humanism of the West, which declares the dignity and essential equality of all individuals, yet found in practice that its values were not upheld. Western culture claims an absolute and universal value, which historically is expressed as an assumption of superiority; but after having destroyed the basis of his culture, the racism of the West then rejects the Black from full participation in Western culture. Like a drowning man the Negro clutches at whatever will float. His subjectivity, his Blackness is all that Western culture has left him. He finds within himself the unique qualities of Black culture, qualities that had been delineated in the writings of White ethnologists. Poetry becomes a kind of return to an Africa of the imagination.[1]

It was in the most advanced Western thought that these Blacks found the elements out of which they created Negritude. Senghor, for instance, was frank about the debt that they owed to European scholarship for the recovery of their culture—the same scholarship that we now see clearly as an indispensable adjunct of colonialism, accompanying all its voyages of discovery and conquest. But their thinking also ran parallel to that of the Surrealists, who were looking to primitive cultures for something to counteract an oppressive and flawed rationality:

But I have to stress over and over again that it was also Europe, that it was France which saved us . . . especially by teaching us the values of Black Africa. It will be remembered that the First World War had, in the view of the most lucid minds in Europe, marked some degree of bankruptcy of civilization, i.e. their civilization, through its absurdity as well as the spiritual and material ruins in its wake. . . . Their criticism became radical and extolled the rehabilitation of intuitive reason and of the collective soul, of archetypal images arising from the abysmal depths of the heart, from the dark regions of the groin and the womb. . . . The vocabulary of the ethnologists who were just beginning to unveil black Africa's secrets was adopted: like them one spoke of life forces. . . . This was all the young Negro elite was asking for. . . . We had regained our pride. Relying on the works of the anthropologists, prehistorians, and ethnologists, who paradoxically were white, we proclaimed ourselves in the phrase of the poet Aimé Césaire, "the eldest sons of the earth."[2]

This fruitful exchange between European culture and the Black imagination did not stop when these writers had gained the self-confidence of their newly discovered Negritude. One of the most important documents of Negritude is in fact an essay by Jean-Paul Sartre, *Black Orpheus*,[3] written in 1948 as the introduction to an anthology of African poetry edited by Senghor. Though in no way prescriptive and highly sympathetic, Sartre's essay remains the most penetrating and critical discussion of the subject, and one that influenced later generations of Black intellectuals. In it he pointed out the paradox of the Black poet who, in order to communicate with his fellow Blacks spread across the earth from the Caribbean to the Congo, must write in French: "When the Negro declares in French that he rejects French culture, he takes in one hand that which he has pushed aside with the other."[4] Here the Surrealist technique of juxtaposing unrelated images that disrupt the normal patterns of thought provided the weapon that the Black poets needed, the technique that allowed them to use the language of the colonizers themselves against the oppressive persuasiveness of their culture. As Sartre put it, "Since the oppressor is present even in the language they speak, they will speak this language to destroy it."[5] Sartre drives home the point that the Black poet's desire to escape from the "prison house of language," from language's power to determine his thinking, is rooted in his concrete political situation. The Negritude poet is a Surrealist out of necessity; he does not belong in the European world, and so he seeks the wholly other reality evoked by the shock of the Surrealist image. And for him that imaginary reality is the Africa that once was and perhaps could be again.

If for African Blacks such as Senghor there appeared an easy connection between Negritude and nationalism, for the Blacks of the diaspora the situation was more complex. For them Africa could never be anything more than a vague and distant memory, but one that had the potential to inspire resistance. The first major expression of Negritude was a long poem written in 1938–39 by the Martinican Césaire entitled *Cahier d'un retour au pays natal*. The violence and vividness of its language quickly placed it in the front rank of Surrealist writing; Breton later described it as "nothing less than the greatest lyric monument of our time."[6] On one level the work is a spiritual and metaphorical homecoming to Africa; on another it is Césaire's reconciliation with his own Blackness, which his colonial upbringing had taught him to despise. But it is also about a literal return to Césaire's country of birth, a journey in which he had to confront the history of slavery and the miserable and defeated condition of his fellow Antillean Blacks:

To go away. My heart was pounding with emphatic generosities. To go away . . . I would arrive sleek and young in this land of mine and I would say to this land whose loam is part of my flesh: "I have wandered for a long time and I am coming back to the deserted hideousness of your shores."

I would go to this land of mine and I would say to it: "Embrace me without fear . . . And if all I can do is speak, it is for you I shall speak."

And again I would say:

"My mouth shall be the mouth of those calamities that have no mouth, my voice the freedom of those who break down in the solitary confinement of despair."

And on the way I would say to myself:

"And above all, my body as well as my soul, beware of assuming the sterile attitude of a spectator, for life is not a spectacle, a sea of miseries is not a proscenium, a man scream- ing is not a dancing bear. . . ."[7]

In Césaire's case, the assertion of Blackness put him sharply at odds with a still existing colonialism and its very painful and humiliating history that could not be forgotten. Even to suggest that Blacks had a right to be proud of their color was revolutionary in Mar- tinique at this time.

Césaire returned to Martinique permanently just before the war, and it was there in 1941 that he met Breton and Lam, who were refugees from Europe. It was this meeting that cemented the alliance of Surrealism and Negritude; and it was in the pages of *Tropiques* that there occurred the mix of Surrealist literature, radical politics, and ethnicity that gave Lam the elements of his style. *Tropiques* contained poetry, criticism, and articles that attempted to lay the foundations for an indigenous Antillean culture, interspersed with accounts of the natural history of Martinique. For the first half of its life, from 1941 to 1943, the magazine was subject to censorship by the island's Vichy government, and this period of political conservatism played an important role in radicalizing the Blacks of Mar- tinique. Part of the French fleet loyal to Vichy was blockaded in Fort-de-France by the Americans and 10,000 openly racist sailors had the run of the island, upsetting the normal ecology of race relations. In the summer of 1943 a rebellion broke out that overthrew the government and put the island in the hands of de Gaulle's Free French. The issue of *Tropiques* that came out immediately after this uprising contained an article on Surrealism by Suzanne Césaire, in which she quoted Breton's claim that "the surrealist cause, in art as in life, is liberty" and that it was due to Surrealism that "during the hard years of Vichy domination, the image of liberty did not totally fade."[8] In an interview published in 1978 Césaire was emphatic about the infulence of Surrealism and of Breton in particular. At the time of their meeting in 1941 he had "realized that most of the problems he faced had been resolved by Breton and the Surrealists."[9]

It is not hard to understand the affinity that Third World intellectuals felt with Surreal- ism. Not only did it provide them with a technique through which they could find their own voice, but the Surrealists had an ingrained hostility to colonialism. Alone among the numerous avant-garde artists who looked to primitive art for inspiration, the Surrealists seemed to be able to conceive of the non-Western, primitive "other" as a real political force that could play its part in the destruction of a moribund European civilization. As early as 1925, during the Moroccan war, the Surrealists had openly sided with the rebels of the

Riff.[10] By the fifties this sensitivity had led both to a reassessment of the whole enterprise of borrowing from other cultures and a special hope invested in those artists, like Césaire and Lam, who by virtue of their ethnic origins could move closer to primitive sources. As Breton wrote in 1955:

> Unfortunately, ethnography was not able to take sufficiently great strides to reduce, despite our impatience, the distance which separates us from [primitive cultures] because we remain ignorant of their aspirations and have only very partial knowledge of their customs. The inspiration we were able to draw from their art remained ultimately ineffective because of a lack of basic organic contact, leaving an impression of rootlessness.[11]

The recognition that primitive art could no longer be appropriated to the needs of Western artists must be related to increasing decolonization, particularly the looming loss of France's African colonies, and to the fact that Third World artists, such as Lam and Césaire, were reclaiming their heritage.[12]

Of mixed Chinese and African blood, Lam had a middle-class upbringing in Cuba and a conventional academic training in Madrid. After fighting in the Spanish Civil War he made his way to Paris, where he immediately became Picasso's protégé. It was here, partly through Picasso's influence, that he discovered primitive art, his Paris work closely resembling Picasso's own African period of 1906. Though heavily influenced by Picasso, his work really began to come into its own when he fell in with the Surrealists. His illustrations for Breton's *Fata Morgana,* designed in Marseilles, where he was waiting, with most of the other Surrealists, for passage from Europe, show Lam's break with his earlier Picasso-influenced Africanism. Perhaps through a kind of automatic drawing, or simply thanks to the Surrealists' encouragement of spontaneity, Lam evolved the forms that would become characteristic of his later work. As the *Fata Morgana* drawings reveal, Lam also absorbed Masson's method of blending human figures with plant forms, something that he would find later in Césaire's poetry.[13]

The Surrealists finally found a ship that delivered them to Martinique, where they were forced to stay for some time. Lam eventually made his way back to Cuba and began to paint again, rebuilding his style and incorporating everything he had learned in Paris and more recently in Martinique. Of all the influences on him, certainly the most important at first was Picasso. According to a 1945 article by Pierre Mabille, a Surrealist writer and at that time cultural attaché to the French embassy in Haiti, the only possessions Lam had brought back to the Antilles with him were some reproductions of Picasso's work and a few copies of *Cahiers d'art* and *Minotaure.*[14]

Lam was also thinking seriously about African tribal sculpture, but in general he treated this art as a source of forms to be reused in a very different context and for very different purposes, in much the same way as Picasso and other European painters had. The round-horned heads of Baule Goli masks appear frequently in Lam's work, as does the motif of a bird perched on top of a head found in Gouro masks of the Ivory Coast. Examples of these masks were in Lam's own collection of primitive art, though after his death they were almost all found to be fakes.[15]

Apart from specific formal features, one quality of African art that Lam especially responded to was its literalness and realism, a quality that Breton in particular despised.

The Surrealists found African art too pedestrian and felt that Oceanic art was far better at evoking the terrors of the primitive universe. But Lam, with his partly African descent, searched African art for the elements out of which he could create an authentic contemporary Black art. Here his understanding of how this plastically inventive, non-academic art could at the same time be realist brought him closer to a concept of how his art could serve a concrete political purpose. When Lam arrived back in Cuba, the degradation and misery of the population under the dictatorship of Battista filled him with disgust. Cuba was a playground, and brothel, for the wealthy of America and Europe. As Lam himself said:

When I returned to Havana [my first impression] was one of profound sadness. The whole colonial drama of my youth seemed to be reborn in me. . . . What I saw on my return was like some sort of hell. For me, trafficking in the dignity of a people is just that, hell. Poetry in Cuba was either political and committed . . . or else written for the tourists. The latter I rejected, for it had nothing to do with an exploited people, with a society that crushed and humiliated its slaves. No, I decided that my painting would never be the equivalent of that pseudo-Cuban music for nightclubs. I refused to paint cha-cha-cha. I wanted with all my heart to paint the drama of my country, but by thoroughly expressing the Negro spirit, the beauty of the plastic art of the Blacks. In this way I could act as a Trojan horse that would spew forth hallucinating figures with the power to surprise, to disturb the dreams of the exploiters. I knew that I was running the risk of not being understood by the man in the street or by the others. But a true picture has the power to set the imagination to work, even if it takes time.[16]

Pictures such as *The Jungle* (color plate 13) of 1942–43, Lam's first major piece and a synthesis of all the influences on his developing style, were intended to be seen as literal evocations of Cuban life at that period, and as such political weapons against the oppression of a colonialism that was only legally ended. Lam describes this piece in the following way:

Rousseau, you know, painted the jungle. He does not condemn what happens in the jungle. I do. Look at my monsters and the gestures they make. The one on the right proffering its rump, obscene as a whore. Look, too, at the scissors in the upper right hand corner. My idea was to represent the spirit of the Negroes in the situation in which they were then. I have used poetry to show the reality of acceptance and protest.[17]

The picture is an attack on colonialism comparable to Césaire's *Cahier:* firstly because any assertion of Africanicity by a colored within the colonial context is an act of defiance; and secondly, or so Lam hoped, through the shock value of its hybridization of plants, animals, and people, corresponding to Surrealist use of language.

More directly borrowed from Césaire and his circle are the vegetal motifs and the confusion of plant forms with body parts. In the fifth issue of *Tropiques,* Suzanne Césaire asked "What is the Martinican?", and answered "A plant-man":

Above all and everywhere, in the least manifestations . . . trampled but evergreen, dead but being reborn, the plant free, silent and proud. . . . In the depths of his consciousness, he is the plant-man, and in identifying himself with the plant, his wish is to abandon himself to the rhythms of life.[18]

Trodden down but still living, the plant is a symbol of the patient defiance of the slave; but in the Césairean universe it also symbolizes the nature of African spirituality, in tune with the "rhythms of life." Aimé Césaire elaborated further in a 1961 interview:

> But I am an African poet! I feel very deeply the uprooting of my people. Critics have remarked upon the recurrence of certain themes in my works, in particular plant symbols. I am in fact obsessed by vegetation, by the flower, by the root. There is nothing gratuitous in that, it is linked with my situation, that of a Black man exiled from his native soil. . . . The tree, profoundly rooted in the soil, is for me the symbol of a man who is self rooted—the nostalgia of a lost paradise.[19]

Vegetative imagery economically combines the fact of dispossession and the poetic evocation of Africa. Like Negritude itself it is both historical and redemptive.

Unusually for a literary magazine, *Tropiques* included several articles on natural history. These were intended to stimulate Antilleans to a new respect for their own environment—for, thanks to the colonial education system, they often knew more about France than about their own home. But the presence of these articles in the magazine also reflected Césaire's mystical interest in plants. Lam was certainly affected by these ideas during his stopover in Martinique, introducing many motifs of the local flora into the early Cuban works, including *The Jungle*. Lam's *Jungle* is still a metaphorical one, however, for there is no jungle as such in Cuba; what we mostly see in this picture are stems of sugar cane. In Lam's work, sugar cane and prostitutes, twin symbols of exploitation in the neo-colonial economy, inhabit the imaginary jungle of Negritude, just as Césaire's *Cahier* had evoked both the Antillean reality and a dimly remembered African home.

In the placement of the figures and their gestures, *The Jungle* is a close paraphrase of the *Demoiselles d'Avignon* (color plate 12).[20] Lam's remarks quoted above suggest that, like the older painting, *The Jungle* depicts a group of prostitutes. But though the *Demoiselles* may be an important source for the imagery of Lam's work, he is not as interested in Picasso's radical flattening and conceptualization of volume as he is in the actual volumes of African sculpture. The work is partly a homage, coming out of Lam's enormous respect for Picasso, and partly a kind of "blackening" of the tradition represented by the older master.[21] When the Negritude writers, imprisoned within the dominant culture, seized on Surrealist technique to make a crack through which they could express their own voice, they were actually widening an opening that already allowed a sporadic two-way flow. European culture had already accepted primitive art into itself, had been colonized in reverse as it were. Now Third World artists were themselves entering this culture and twisting it to their own purposes, effecting a more complete Africanization of Western art. Of course, what was really coming into existence was another, global culture. The revolutionary implications of this were an important topic of discussion in Marxist circles during the forties and fifties. In 1948, Sartre had this to say:

> In Césaire, the great Surrealist tradition is achieved, takes its definite sense, and destroys itself. Surrealism, a European poetic movement, is stolen from the Europeans by a Black who turns it against them. . . . In Europe, Surrealism, rejected by [the proletariat], languishes and expires. But at the moment it loses contact with the Revolution, here in the

West Indies it is grafted on to another branch of the Universal Revolution. . . . The orig-inality of Césaire is to have cast his direct and powerful concern for the Negro, for the oppressed, and for the militant into the world of the most destructive, the freest, and the most metaphysical poetry at a time when Eluard and Aragon were failing to give political content to their verses.[22]

To paraphrase Sartre's remarks, we can say that Lam is casting his knowledge of Mod-ernism, represented by the seminal masterpiece of his friend and mentor Picasso, into the real political turmoil of the Third World. The *Demoiselles d'Avignon* have become the *Demoiselles d'Havane*. The Modernist tradition—revolutionary in the sphere of culture and inspired by the example of primitive art, the spoils of colonialism—fulfills itself as the voice of the native raised in protest against that same colonialism. But what was really sub-versive about Lam's treatment of Picasso's image, and remains so today, was not his overt political intentions or his stylistic modifications, though both were important. It was the fact that a colonial was aggressively claiming a place within a now global Western culture and restructuring the aesthetic debate at the core of that culture in his own terms.[23]

Césaire suggested as much in a 1946 article:

In a society where money and the machine have immeasurably increased the distance between Man and things, Wifredo Lam fixes on canvas the ceremony through which everything exists; the ceremony of the physical union of Man and the world. . . . Paint-ing is one of the few weapons left to us against the sordidness of history. Wifredo Lam is there to prove it. And this is one of the meanings of this richest of all paintings: that it stops the Conquistador in his tracks; that it demonstrates to this bloody epoch of bas-tardization its own failure by *the insolent affirmation that something is happening in the Antilles* [italics mine]. Something that has nothing to do with quotas in sugar and rum, with military bases, with constitutional amendments, something unusual, something eminently disturbing to economic agreements and political plans, and that threatens to upset any regime that ignores it. . . . One must break with the powerful lovers of post-cards; break with those many who tremble at the thought of a raid from the imagination come to dispossess them of their puny good sense that clings to a cowardly happiness and a stultifying peace. Wifredo Lam doesn't hesitate to take the part of a great disturber. . . . Wifredo Lam gives the boot to academies and conformities.[24]

Modernism in art and anticolonialism in politics, Marxism and poetry, these all coexist in the moment of Negritude. But this Negritude, a hybrid of African and Western cultures, is not content that all cultural influences should be communicated in one direction only. It wants to be heard. And it was how Lam would react to the continued marginalization of the indigenous and the colonized within the internationalism of the later post-war world that would determine the eventual fate of his work.

Lam's absorption in Black culture eventually led him to investigate Voodoo. Within the context of Negritude, Voodoo could be seen as a form of indigenous Black spirituality, but Lam's interest in it also kept him in dialogue with the Surrealists, who were becoming increasingly fascinated with occultism and magic. Voodoo, or in its Cuban form Santeria,

is the survival in the New World of a pre-Christian, pre-colonial African vision of the universe. Its complete lack of morality, of the Christian dualism of good and evil, made it especially appealing to the Surrealists. It also represents a tradition of political resistance. Voodoo is most deeply rooted in Haiti, the Black republic that threw off the French at the beginning of the nineteenth century in a slave rebellion which, according to tradition, was planned at a Voodoo ceremony.[25] The Voodoo rite is a state of possession in which the servitor is taken over by a Loa or god. The Loas have specific attributes, areas of influence, modes of dress, favorite foods and so on. They are distinct personalities and completely real to the Voodoo believer.

Lam's interest in Voodoo dates from a visit to Haiti in 1944 with Breton and Mabille.[26] It was first expressed in a series of still lifes that were actually altars to the Orishas, gods of the Santeria cult, but before long he began to depict the state of possession. A common Voodoo ceremony is a ritual marriage between a Loa and his or her human devotee,[27] an event perhaps portrayed in *The Wedding*, painted in 1947. The mood of diabolism and black magic that permeates this picture was the sort of thing that fascinated the Surrealists at this time; myth and the occult were the themes of the major International Surrealist Exhibition of the same year at the Galerie Maeght.[28] The rather severe geometry of limbs, swords, and circle is derived from the *vever*, a diagram drawn on the ground with flour or ashes that summons the Loa in Haitian Voodoo,[29] while the swords and candlestick are borrowed from the altar arrangements typical of Santeria[30]—in fact, one of Lam's own contributions to the 1947 show was an altar featuring a pair of swords such as can be seen in this picture.[31] But though Lam's borrowings from Voodoo were extensive, they were never exclusive and were frequently mixed with the iconography of European painting. For example, Lam often makes hybrid human-horse figures, indicated either by equine heads, tails, or hooves. These allude to Voodoo terminology, in which the devotee is called a "horse," to be figuratively mounted by the Loa in the act of possession.[32] This motif appears in *The Wedding*, though here the figures have the split hooves of a goat as Lam combines motifs of Afro-Cuban religion with what must be memories of Goya's scenes of witchcraft, which he had known in Madrid.

The eclecticism of Lam's Voodoo imagery, as well as its association in his work with more conventional Western images of demonism, suggests that his interest in Voodoo links him more closely with his European colleagues in the Surrealist movement than with his African roots. Though very good at evoking a kind of general ambience of the occult, his pictures are less effective if we try to determine exactly what they are about. Lam himself was emphatic that he had no interest in the literal meanings of cultic symbols.[33] In Haiti in 1944 Lam and Breton met Hector Hippolyte, a Voodoo *houngan* or priest and painter of devotional images.[34] A comparison of a painting by Lam and one by Hippolyte of the same theme brings out the exoticism and the essentially literary nature of Lam's use of Voodoo imagery. Both of these pictures depict Ogoun Feraille, an avatar of Ogoun, a Yoruba deity translated into the Voodoo pantheon. Hippolyte's image is literal and contains many of the god's attributes, such as swords and quasi-military dress. When compared with a photograph taken in 1975 of a possessed Voodoo believer sitting at a small table distributed with skulls, bottles, and playing cards used in divination,[35] Hippolyte's painting can be seen to be a truthful transcription of the ambience of Voodoo. It also exhibits direct iconographic survivals from African images of the same god.[36] Lam's picture

was reportedly painted during the visit he made to Haiti with Breton in 1945, when they had met Hippolyte and attended Voodoo ceremonies,[37] yet it is a melange of African masks and Modernist devices, none of which are related to the subject. The only trace of Ogoun is a horseshoe that alludes to his status as the god of iron. But most importantly, and somewhat suprisingly, Lam's work eliminates the overt political associations of Ogoun who, characterized as a martial hero, is linked with the historic liberators of Haiti.[38] These two works reiterate in the Third World context the difference between the Modernist and the popular artist. Hippolyte's image is readable, literal, and has a certain obvious craft of representation. Above all, for him Ogoun is a real person with very specific attributes. By contrast, Lam's work is synthetic and imaginative; he is a modern intellectual who plunders pictorial motifs from folk culture in order to use them in an entirely different context. He certainly has no personal experience of Voodoo possession, which would have given him a first-hand knowledge of the characteristics of Ogoun.

But looking at Hippolyte further we find other ambiguities in his situation. Although more directly in touch with his African heritage than Lam—he is after all Black and a citizen of a state that had been independent from Europe for 150 years—he yet evinces considerable anxiety in his own search for authentic Black roots. He told a story of traveling to Africa, where he spent seven years communing with the Loas on their home ground. He also claimed to have walked across the continent from Senegal to Ethiopia.[39] With its echoes of Garveyism, the back to Africa movement that swept the Caribbean in the twenties and thirties, this story is probably a fantasy. It is safe to say that if he had ever actually visited Ethiopia, where the poverty is even deeper than in Haiti, that particular nostalgia would have evaporated.

Though Lam's intentions and his thematic and formal sources are clear, his desire to connect with his African roots is problematic because his experience of Africanicity is so mediated by Western culture. But the experience of Hippolyte suggests that even for a West Indian Black without Lam's or Césaire's degree of acculturation, the problem of authenticity is acute. No degree of atavism can wish away the real historical damage caused by slavery; for a Black of imagination, whatever his education, Negritude as a dream of homecoming to an Africa of the spirit is an inevitable and natural response to that damage.

There is a psychosexual dimension to the question of Blackness in the colonial world, one that seems to inflect Lam's work in ways of which he was perhaps unconscious. Frantz Fanon, a psychiatrist and, like Césaire, a native of Martinique, has analyzed the sexual complexes created by colonialism, complexes that affect both Mulatto and Black.[40] In the rigid colonial or postcolonial society, color is tied to an economic and political hierarchy. The land-owning class is White and on the top; Mulattos form a middle class of functionaries and merchants; the Blacks are at the bottom and, of course, laborers. Whiteness has an absolute value, both socially and psychically: Black women want only to marry a man lighter than themselves; Black men likewise are attracted to lighter women. Through marriage to a lighter partner one's family and children are moved higher up the social scale. This whole neurotic complex causes great pain for the Blacks. Their culture has been crushed and their very being has been labeled by White civilization as inferior; in the West the simple color black bears negative associations. The colonized Black suffers under an immense inferiority complex, which naturally involves sexuality as a component of an identity that has been negated.

As much as Césaire and Fanon, Lam felt all of this acutely, but he also suffered the ambiguity of his status as a Mulatto, a shifting position within the sexual hierarchies of colonialism. On one level, Negritude is a simple reversal of the Black's self-image. In every respect where White culture has labeled him bad, he asserts that there is his identity, and that it is good. As White society has repressed Blacks both socially and sexually, it has also identified Black sexuality as a force negative and threatening enough to require repression in the first place. For the Black, then, dreams of liberation inevitably have a highly sexualized character. In its affirmative aspect, the poetry of Negritude is replete with images of potency:

> Suddenly now strength and life assail me like a bull and the water of life overwhelms the papilla of the morn, now all the veins and veinlets are bustling with new blood and the enormous breathing lung of cyclones and the fire hoarded in volcanoes and the gigantic seismic pulse which now beats the measure of a living body in my firm conflagration.[41]

On the other hand, colonialism is identified with castration,

> Oh Yes the Whites are great warriors hosannah to the master and to the nigger-gelder![42]

and life under colonialism is suffused with impotence:

> At the end of the wee hours, life prostrate, you don't know how to dispose of your aborted dreams, the river of life desperately torpid in its bed. . . . [43]

For Lam, with his mixed descent, the situation was not quite as clear as it is for a Black. His description of a painting of 1945, *The Eternal Presence* (fig. 14.1), gives us some clues to the imagery of his work and the psychology behind it:

> The figure on the left is a stupid whore. With her two mouths she feels ridiculous. From her heart comes nothing but an animal's paw. In her heterogeneity she evokes cross breeding, the degeneration of the race. The figure on the right has a knife. He suggests the indecision of the mulatto, who does not know where to go or what to do. The vessel on the right, full of rice and with a head emerging from it, represents religion, the mysteries. And in the central figure with folded limbs we can see the dream . . . in the upper right corner I placed the symbol of Shango, the god of thunder.[44]

A Freudian reading of this description would notice his revealing association of the two outside figures. If the Mulatto were to fight, he would attack the "stupid whore." Lam is expressing his ambivalent feelings towards the woman who marries out of her race, as his mother did, and his resentment at being stranded in the ambiguous role of Mulatto as a consequence. Lam also betrays an insecurity about his own sexual role; the Mulatto, whom Lam refers to as "he," is clearly female. The sexual neuroses of colonialism, combined with White sexual fantasies, made Mulatto women the favorites as prostitutes. When Lam returned to Cuba there were 60,000 prostitutes in Havana alone.[45] The picture, full of vulva and knife forms, is a nightmare of castration; the whore herself has a huge cleaver. The battle of sexual dominance, castration, rage, and seduction permeates Lam's imaginative world and he seems

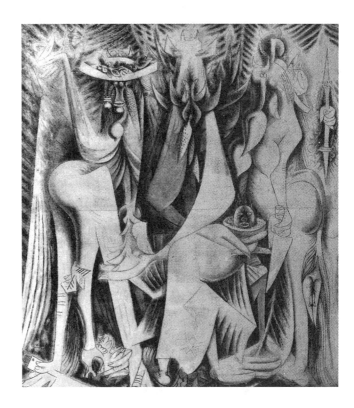

Figure 14.1 Wilfredo Lam, *The Eternal Presence*, 1944, oil on canvas. © Copyright 2001 Artists Rights Society (ARS), New York/ADAGP, Paris. Museum of Art, Rhode Island School of Design, Nancy Sayles Day Fund, Providence, RI.

to be trapped within it. He cannot externalize his conflicts and draw a simple equivalence between sexual and social oppression any more than he can securely identify himself as Black, White, or Chinese, for part of himself belongs to each of these cultures. The reference to Shango, and Lam's adaptation of the cult image of the god Ellegua, the small head in a vessel, to which he has added the horns of a Baule mask, again point up the literary nature of Lam's Voodoo borrowings, layered as they are on top of an image of angry and ambivalent sexuality. Nevertheless, in its anxiety and its exposure of the sexual neurosis of colonialism, *The Eternal Presence* does make contact with the real experience of oppression.

In the late forties and early fifties Lam made many pictures of seated or standing female figures, often structured according to a light/dark contrast. In *Zambezi-Zambezi*, for example, we can see a Black shadow figure behind the White foreground figure. In Lam's primarily tonal rather than colorist art, black and white have a symbolic value. We could read the Black figure in the background as the ancestral presence, the God who takes possession of the devotee; but it is hard not to see the picture also as emblematic of Lam's conflicts. He is attracted to the White woman of Europe, for colonialism has made her desirable above all others; yet his deeper feelings are pledged in loyalty to the Black woman of Africa, to whom he is tied by blood. The bestiality of Lam's women certainly refers to the "horse" of Voodoo possession, but it also expresses the fear and repulsion that must be mingled with attraction to both White and Black women in this socially and sexually conflicted situation. In *Murmur of the Earth* we can see a similar two-level structure, but a much more violent imagery. The picture can be read as an image of possession: the goat-like hooves

allude to sacrificial animals used in the Voodoo ceremony, the light foreground figures to visible human beings in postures of convulsion, the darker forms behind representing the invisible Loas. But the extreme light/dark contrast of this highly abstracted yet violently sexual image certainly reflects the sexualization of race that possesses Lam's psyche.

Breton seemed to regard Césaire and Lam as possessed of an inspiration inaccessible to Whites, which itself indicates the spell cast by Negritude and the myth of Blackness. Though far more analytical than Breton, Sartre, in *Black Orpheus*, also extended a kind of special dispensation to the poets of Negritude.[46] According to Sartre, the Black's awakening to his own subjectivity is a necessary part of the historical process, and therefore in essence political. The Black is even entitled to that subjectivity, and entitled to celebrate it in poetry, in a way that the White proletarian is not. It is as if what Russell Jacoby has called the missing subjective dimensions of Marxism can only be found in Negritude.[47] This subjectivity is not to be confused with bourgeois individualism for it does not express the feelings of the individual, but the self-consciousness of the race; and the force of that awakening self-consciousness must inevitably lead to confrontation with colonialism and finally the identification of the interests of the colonized with those of the working class everywhere. For Sartre, Negritude, though necessary and valuable in itself, is thus only a stage in the historical struggle, a stage that must be succeeded by another in which the mystifications of the Black myth give way to objectivity and concrete political action. Césaire himself was explicit on this point: for him there was no break between his activities with *Tropiques* during the war and his later political life—one led inevitably into the other.[48] But the story of Negritude, of Césaire and Lam, is the story of how the subjectivity of the poet finds a particular balance against the objective forces of history. It was this balance that had always preoccupied Breton; the source of his enormous regard for Césaire was his recognition that for this poet the relation between the artistic and the political revolution was less problematic than it was for Breton himself. But for Lam the balance seems to have shifted for the worse as time went on. As his work became increasingly populated with motifs drawn from Santeria, it also lost its connection with its social context. This process became especially pronounced after the Cuban revolution, when Lam's Negritude became more a matter of the mystifications of the Black myth and African religions and less one of revolutionary self-definition.

In Battista's Cuba, Lam's ghoulish nocturnes with their animalistic women could serve as metaphors for the condition of life in an oppressive and exploitative society, and Voodoo possession, the eruption of African gods from the collective memory of the oppressed masses of Blacks, could be a symbol of the social upheaval taking place, the popular revolution of those former slaves against their neo-colonial masters. Some of the pictures from 1958 and 1959 are among Lam's best; their titles, such as *We Are Waiting* and *Early Hours of the Dawn* even seem to allude to the history taking shape at that time. It is later, during the sixties and seventies, that Lam's occultism, like that of his Surrealist friends, begins to wear thin. Though Lam's borrowings from Santeria costumes and ritual objects are exhaustive, the degree of detachment implied by his very conscious synthesis of motifs becomes more and more obvious, as is exemplified in a work such as *Osun and Ellegua* of 1962. The bird is an *osun*, a sculpture of a bird normally placed on the end of a staff used in the cult of Osanyin, the god of herbalistic medicine.[49] The little head in the figure's other hand represents an icon of the god Ellegua—usually a small cement or clay head sitting on a plate.[50]

Figure 14.2 Abakua ideographs. Photo courtesy Robert Farris Thompson.

This display of artifacts is more akin to ethnographic painting than a convincing expression of Afro-Cuban spirituality.

Another important ethnic source for Lam was the Abakua, an Afro-Cuban secret society. Echoes of Abakua ideographs can be found in the arrows and branching symmetrical shapes of a picture such as *Murmur of the Earth* of 1950. But though Lam's works often appear ideographic, they do not express the cultic meanings of the Abakua symbols, in which he had no interest. One series of drawings from the late seventies is directly derived from Abakua drawings in white chalk on black paper (fig. 14.2), yet it is typical of Lam's synthetic approach that these drawings also seem to respond to some of the work of Picasso's last period. This comparison is emblematic of Lam's later work, always circling between his European and his ethnic roots but failing to find that particular relationship between the two traditions that gave the work of the forties, such as *The Jungle*, its political meaning.

Fanon was strongly affected by Sartre's *Black Orpheus*, and his reading of it marked his disillusionment with Negritude. It is Fanon's experience as an educated Black in racist European society, and his analysis of the psychosexual damage inficted by colonialism, that opens up to us the unconscious content of Lam's work and the significance of its bestiality and sexual obsessiveness. But as a Black of a younger generation who came to reject the mystifications of Negritude, Fanon also provides the medium for reflection back on the meaning of Negritude in its context and what later became of it. At the First Conference of Negro Writers and Artists in 1956 Fanon gave a psychosocial analysis of Negritude:

> The culture put into capsules, which has vegetated since the foreign domination, is revalorized. It is not reconceived, grasped anew, dynamized from within. It is shouted. And this headlong, unstructured, verbal revalorization conceals paradoxical attitudes.[51]

These paradoxical attitudes are the ambivalent self-image of the Negro under colonial-ism and the Black intellectual's intimate relationship with the culture of the colonizer. Yet for Fanon this is a very important stage since for the Negro "the plunge into the chasm of the past is the condition and source of freedom" and "the logical end of this will to strug-gle is the total liberation of the national territory."[52] For Fanon, Negritude does not give way to the universal class struggle, as Sartre had suggested, but to a more active anti-colo-nialism. Five years later, in *The Wretched of the Earth*, Fanon laid out the cultural pro-gramme for revolutionary Africa, stating that "The native intellectual who wishes to create an authentic work of art must realize that the truths of a nation are in the first place its realities."[53] This is where Césaire and Lam had begun, with the reality of colonalism, but increasingly throughout the fifties and later, Lam's work, however accomplished it becomes, fails to live up to this ideal.

Lam supported the Cuban revolution but kept his distance from it. In 1967 he organized an exhibition in Havana at which the entire Salon de Mai of that year was shown, and in 1968 he participated in a cultural congress in Havana at which European intellectuals demon-strated their solidarity with the revolution; but he lived mostly in Europe, finally settling in Italy. In later years, Lam shows himself primarily an excellent designer, producing variations of his stock motifs that sold very well. His late pictures are usually hybrids of animals, human figures, and African sculpture without any background or context; where they appear, the plant motifs which filled the backgrounds of the works of the forties with their powerful symbolism, inherited from Césaire, have become ornamental. These works, spectral presences looming in the night, are formally very beautiful with their reduction to two or three tones keyed to a dark ground, but Lam had become a solitary star drifting far from that constella-tion of political and creative forces that made his art revolutionary in the forties.

History eventually caught up with Negritude. In 1945 Césaire took his seat in the Cham-ber of Deputies. In 1959 Battista was overthrown in Cuba and in the same year Senghor became president of Senegal. Later definitions of Negritude reflect these political changes. In 1962, for instance, Senghor described Negritude as "the sum total of the cultural values of the Negro world."[54] This very general, rather vague definition befits the leader of an emergent African state that is in the process of rethinking its political and economic struc-tures, for this was the period when there was much talk about an indigenous African Social-ism, and Senghor's polite formula is in line with his liberal and Pan-African policies. How different Césaire sounds; in a 1971 interview he said simply that "Negritude is the affirma-tion that one is black and proud of it."[55] This assertion of Blackness is still a challenge to the status quo, doubly so within the neo-colonial situation of Martinique. Césaire has remained centered in an attitude that opens out into both an aesthetic and a political posi-tion; he has sustained the possibility of a historical subjectivity.

Throughout the fifties and sixties, as one after another of the former colonies achieved their independence, there was heard the same refrain of universalism, whether in the Marx-ist sense of a universal revolution (*vide* Sartre), or in the dream of a United Nations in which all indigenous cultures could play an equal part. As Senghor said in 1961: "[Negri-tude] must be the contribution from us, the peoples of sub-Saharan Africa . . . to the build-ing of the Civilization of the Universal."[56] It was inevitable that Negritude should issue out into a kind of universalism, for the idea that African culture can be considered apart from European culture is a fiction. Black culture has been continually affected by its contact with Europe over the last five hundred years. Though the Black intellectual can scarcely

escape this fact, the ingrained racism of the West will hardly admit that the opposite is also true. African culture and European culture are essentially different yet intertwined and inseparable; the very history of Negritude itself is a dialogue between both cultures. But it is the essence of Césairean Negritude never to lose sight of the particularly Black experience within this larger context.[57] During a period in the fifties Césaire also showed a preoccupation with Voodoo and Black mysticism, but after the upheavals in Africa at the end of the decade he temporarily gave up poetry and began work on a series of dramas based on episodes from Black history.

Yet the history of the post-war world is also marked by the overarching global market economy's attempts to eliminate the specificity of local cultures and draw them into a universalism that is the inverse of Senghor's utopian hopes. The slave trade, the historical trauma that haunts Negritudes, and especially the poetry of Césaire, was itself only an early stage of this process. Sartre was right to argue that Negritude represented a stage in the historical evolution of Black consciousness, but the new international order conceals yet another form of colonialism, in which all local cultures are still suppressed even as the art market opens up to their products. In the world of the multinational corporations signs of ethnicity are national trademarks as all cultures become equally commodified. The global culture is really Western culture, still triumphant over a Third World now colonized through the mass media and a global marketplace. For even as the old Negritude dies away in the concrete achievements of Black nationalism, the Black artist finds himself confronting a worldwide culture industry that will not admit the fullness of Black culture into itself without adaptation, and certainly will not surrender to the margins any power to inflect the debate at the center. Césaire holds open the possibility of resistance to this situation precisely by clinging to a notion of Negritude as subjectivity grounded in real historical experience.

In his later years Lam does not offer the same hope. Although he was in no way alienated from revolutionary Cuba[58] his work seemed to have little to say to it, and was really more at home in the European art market. Perhaps Lam had always been too closely tied to Europe, but the way in which his work increasingly became a manipulation of motifs and less specifically about the Antillean experience certainly smoothed its success outside Cuba.

Like Breton, like Césaire, Lam stubbornly claims that meaning lies in his subjectivity in a period when on one side the logic of the Marxist argument declares it obsolete, and on the other the relentless commodification of capitalism renders it increasingly hollow. His inability to express that subjectivity in historical terms after 1959 was his inability to cope with a changed political situation, albeit a very difficult one. But for a moment, in the forties, a Black subjectivity born of the meeting of Black historical experience with European culture became an effective instrument of both the creative revolution and anti-colonialism. This should remind us that there are a multitude of local conditions and local aspirations that have not yet been brought into line with multinational capitalism and that there is a history of Modernism that is the history of its encounter with this wider world.

Notes

This essay grew out of a seminar conducted by Professor Serge Guilbaut at the University of British Columbia in 1986–87.

1. For a discussion of this mechanism, see Frantz Fanon, *Black Skin, White Masks*, trans. Charles Lam Markham, New York, 1967, ch. 5.

2. L. S. Senghor, "Pierre 'Teilhard de Chardin et la politique africaine" in O. R. Dathorne and Willfried Feuser (eds.), *Africa in Pross*, London, 1969, p. 341.

3. J. P. Sartre, *Black Orpheus*, trans. S. W. Allen, Paris, 1951.

4. Ibid., p. 23.

5. Ibid., p. 26.

6. André Breton, "Martinique charmeuse des serpents, un grand poéte noir," *Tropiques*, no. 11, May 1944, p. 122. All quotes from *Tropiques* are my translation from the Facsimile Edition, Paris, 1978.

7. "Notebook of a Return to the Native Land," Clayton Eshleman and Annetic Smith (trans. and ed.) *The Collected Poetry of Aime Césaire*, University of California, 1983, p. 45.

8. Suzanne Césaire, "1943: le Surrealisme et nous," *Tropiques*, nos. 8–9. October 1943, p. 15.

9. Interview with Jacqueline Leiner, *Tropiques*, facsm, edn., Paris, 1978, p. VI.

10. During the famous uproar of the St Pol Roux banquet, Michel Leiris' cries of "Down with France" mingled with shouts of "Up the Riffs" and "Bravo China," referring to another current colonial rebellion. Maurice Nadeau, *History of Surrealism*, trans. Richard Howard, London, 1973, p. 128.

11. André Breton, *Surrealism and Painting*, trans. S. W. Taylor, New York, 1972, p. 333.

12. This last quotation is taken from an article on Gaulish coins to which Breton was looking for evidence of an indigenous European abstraction. After relinquishing African art to the Africans, Breton was trying to find inspiration in the primitive art of Europe. It would be reasonable to ask whether or not the same political factors played a part in the European Primitivism of Cobra. Parallels between Lam's ethnicity and that of the Cobra artists, with whom he was in touch, have been drawn; see Per Hvydenakk, *Wifredo Lam Retrospective*, Musée d'art moderne de la ville de Paris, 1983.

13. Illustrated in *Arts Magazine*, December 1985, p. 24. There are only five copies of this book in existence, one in the Museum of Modern Art, New York.

14. Pierre Mabille, "La Jungle," *Tropiques*, no. 12, January 1945, p. 183. A motif that recurs again and again in Lam's work, including *The Jungle*, is a phallic shape hanging down from a pair of lips—a motif probably borrowed from Brancusi's *Adam and Eve*, the top half of which was originally developed as a portrait of a Negro singer. However, *Cahiers d'art* of 1938 had a long section on Picasso which included some of the *Drawings for a Crucifixion* of 1929, in which the features of a woman's face are arranged in a phallic configuration. This is an issue that Lam probably owned.

15. William Rubin, *Primitivism in Twentieth Century Art: Affinity of the Tribal and the Modern*, New York, 1984, p. 14.

16. Max-Pol Fouchet, *Wifredo Lam*, New York, 1976, p. 188.

17. Ibid., p. 199.

18. Suzanne Césaire, "Malaise d'une civilisation," *Tropiques*, no. 5, April 1942, p. 45.

19. Aimé Césaire, *Cadastre*, trans. Emile Snyder and Sanford Upson, New York, 1973. In 1955 the flower of the *basilier*, an indigenous Martinican tree, was chosen as the emblem of the Parti Progressiste Martiniquais, Césaire's party.

20. The figure on the left has her arms extended upwards in a gesture similar to that of the woman holding open the curtains in Picasso's piece. The second figure from the left and the figure on the extreme right have their arms folded behind their heads like two of Picasso's figures, and the second figure from the right has her body and head back to front, just like the crouching presence in the lower right-hand corner of the *Demoiselles*.

21. Thanks to Serge Guilbaut for suggesting this reading.

22. Sartre, op. cit., p. 39.

23. It is ironic that this painting was bought by the MOMA from its first exhibition in New York and that it has hung there along with the *Demoiselles* for over forty years without provoking comment on the nature of the relationship between the two pieces. A certain family resemblance

has been noted, however. See Evan Maurer on the influence of primitive art on Dada and Surrealism, William Rubin (ed.), *Primitivism in Twentieth Century Art: The Affinity of the Tribal and the Modern*, New York, 1984, p. 583.

24. Aimé Césaire, "Wifredo Lam," *Cahiers d'art*, nos. 20–1, 1947, p. 357.

25. C. I. R. James, *Black Jacobins*, 2nd ed., New York, 1963, p. 86.

26. Fouchet, op. cit., p. 205.

27. Maya Deren, *Divine Horsemen: The Living Gods of Haili*, New York, 1953, appendices.

28. Marcel Jean, *History of Surrealism*, trans. Simon Watson Taylor, London, 1960, p. 341.

29. Robert Farris Thompson, *Flash of the Spirit: African and Afro-American Art and Philosophy*, New York, 1983, p. 188.

30. *Art in America*, March 1987, p. 25 illustrates Cuban ritual paraphernalia exhibited at the Second Havana Biennial.

31. Jean, op. cit., p. 342.

32. Deren, op. cit. Aline Vidal suggests that the figures in *The Jungle* have horse heads, and that they are "without doubt possessed by a Loa" (*Wifredo Lam Retrospective*, Musée d'art moderne de la ville de Paris, Paris, 1983, introduction). Mabille, in his 1945 article in *Tropiques*, also talks about *The Jungle* in terms of Voodoo. However, though other works of this period do clearly show figures with horses' hooves, I do not think that references to Voodoo are an important feature of Lam's work before 1944. One of Césaire's poems published in *Les Armes miraculeuses* of 1946, called "The Virgin Forest," seems to include a description of *The Jungle*. In this text the figures are described as ape-like. Eshleman and Smith (trans. and eds.), *The Collected Poetry of Aimé Césaire*, University of California, 1983, p. 131.

33. Fouchet, op. cit., p. 204.

34. Breton bought five of his works and included him in the 1947 exhibition. Jean, op. cit, p. 341.

35. Thompson, op. cit., p. 184.

36. Thompson, op. cit., pp. 166–7.

37. Fouchet, op. cit., p. 252.

38. Deren, op. cit., p. 125.

39. Selden Rodman, *Miracle of Haitian Art*, New York, 1974, p. 28.

40. For this description, and for the following discussion, I am indebted to Frantz Fanon, *Black Skin. White Masks*, trans. Charles Lam Markham, New York, 1967.

41. Aimé Césaire, "Notebook of a Return to the Native Land," *Collected Poetry*, p. 77.

42. Ibid., p. 61.

43. Ibid., p. 41.

44. Ibid., p. 204.

45. Fouchet, op. cit., p. 183.

46. Sartre, op. cit.

47. Russell Jacoby, *Social Anonesia: A Critique of Conformist Psychology*, Boston, 1975, ch. 4.

48. Interview with Jacqueline Leiner, p. VIII.

49. Thompson, op. cit., p. 46.

50. Ibid., p. 23.

51. Frantz Fanon, *Toward the African Revolution*, trans. Haakon Chevalier, New York, 1969, p. 42.

52. Ibid., both quotes p. 43.

53. Frantz Fanon. *The Wretched of the Earth*, trans. Constance Farrington, New York, 1968, p. 225.

54. L. S. Senghor, "Pierre Teilhard de Chardin et la politique africaine," O. R. Dathorne and Willfried Feuser (eds.), *Africa in Prose*, London, 1969, p. 341.

55. Susan Frutkin, *Aimé Césaire: Black Between Worlds*, University of Miami, 1973, p. 1.

56. L. S. Senghor, "Discours devant le Parlement du Ghana, fevrier 1961," John Reed and Clive Wake (trans. and eds.), *Léopold Sedar Senghor: Prase and Poetry*, London, 1965, p. 97.

57. It was the lessons of Black history that for Césaire set the terms of the debate within the French Communist Party between Social Realism and Modernism. In 1955 René Depestre, a Haitian poet and friend of Césaire, had come out publicly for the official line in literature. In a poetic reply, Césaire defends his aesthetic by linking it with the slave revolt in Haiti:

> It is a Seine night
> and as if in drunkenness I recall
> the insane song of Boukman delivering your country
> with the forceps of the storm . . .

Boukman was the Voodoo priest who touched off the revolt on the right of a wild tropical storm:

> shall we escape like slaves Depestre like slaves?
> (marronnerons-nous Depestre marronnerons-nous?)

Here Césaire coins a new verb from "marrons," who were bands of runaway slaves.

> Depestre I indict the bad manners of our blood
> is it our fault
> if the squall hits
> suddenly unteaching us to count on our fingers
> to circle three times and bow . . .

The storm is the poet's Blackness, his subjectivity which he cannot deny. But this subjectivity cannot adapt itself to a programmatic form without being suppressed. Here Césaire gets in a dig at Socialist Realism in general:

> Comrade Depestre
> It is undoubtedly a very serious problem the relation between poetry and Revolution the
> content determines the form.
> and what about keeping in mind as well the dialectical
> backlash by which the form taking its revenge
> chokes the poem like an accursed fig tree.

In 1956 Césaire quit the party. He had found that he was expected to subordinate the needs of his Black constituency to the program of the European party. History makes the point that the interests of Third World peoples will never be a consideration in European politics. The French Communist party refused unequivocally to support Algerian independence; and Césaire could remember that Napoleon invaded Haiti in 1803 under the tricolor, in the name of the revolution, expressly to reinstate slavery. This is the political background against which Césaire invokes Negritude, subjectivist Black poetry, as "marronner," Eshleman and Smith (trans. and eds.), *Collected Poetry*, University of California. 1983. For a more detailed treatment of this incident, see A. James Arnold, *Modernism and Negritude: The Poetry and Poetics of Aimé Césaire*, Harvard, 1981.

58. In a 1965 address Che Guevara spoke approvingly of Lam's Africanism, *Granma*, Havana, 16 October 1967, p. 17. In the opening address to the Salon de Mai of 1967 at its exhibition in Havana, Raoul Roa, then Minister of External Relations, spoke about the compatibility of revolutionary Modernism with the political revolution in Cuba, and affirmed "the right of artists and writers to freely express reality." *Granma*, Havana, 31 July 1967, p. 2.

15

Sargent Johnson

Afro-California Modernist

Judith Wilson

Until recently, most accounts of modernism in American art have ignored race and mini-
mized region as productive factors. But, as scholars shift from viewing "modernism" as a
discrete entity to seeing it as a necessarily relational term, geography—as both literal place
and symbolic position—becomes central to our understanding of modernism's protean
character.[1] Race tends to deterritorialize difference in one sense, positing biological essences
that remain unchanged despite transport across continents and over seas. But because it
also imposes social boundaries, race can produce symbolic geographies and actual
socialscapes. Thus, it seems useful to consider ways in which being an African-American
artist in early- to mid-twentieth-century California placed Sargent Johnson in a unique
position in relation to modern art and modern life.

Sargent Johnson operated at the intersection of an emergent Afro-United States modernism
and an emergent California, or better, Bay Area modernism. Although Grafton T. Brown,
an African American who was a commercial lithographer and landscape painter, had
lived in San Francisco as early as the 1860s, and work by the sculptor Edmonia Lewis had
appeared at the San Francisco Art Association in 1873, black practitioners of the visual
arts rarely surface in California history prior to Johnson's emergence in the late 1920s.[2]
Indeed, when the Oakland Municipal Art Gallery (precursor to the Oakland Museum of
California) hosted the Harmon Foundation's traveling exhibitions of Negro art in 1930
and 1931, Johnson is said to have been "the only Californian" included.[3] Although other
African-American artists were active in California at the time, Johnson alone achieved a
national reputation.[4]

If Johnson's status as an artist who was professionally prominent and black is singular
in the history of early modern California art, so too is his place in the early modern his-
tory of African-American art. Alone among United States black sculptors of his time, he
was hailed as the producer of work that successfully combined "the modernist mode" with
an "essentially racial" treatment of subject matter.[5] It seems likely that the origins of John-
son's averred preoccupation with "producing a . . . Negro art" predate his arrival in Cali-
fornia.[6] But I would argue that conditions unique to the San Francisco Bay Area in the
years between the two World Wars enabled the artist's realization of his goal.

Sargent Johnson and European modernism reached California about the same time. Before 1915, although a few Bay Area artists went abroad "to study modern art," the majority were forced to rely on sketchy reports and black-and-white images in art journals for news about recent developments in Europe and on the East Coast.[7] As a result, San Francisco's Panama-Pacific International Exposition of 1915 is generally credited with giving local artists their "first full-fledged introduction to modern art."[8] By pairing (and implicitly *comparing*) the European discovery of the Pacific Ocean with a modern technological feat—completion of the Panama Canal—the exposition proudly announced San Francisco's sense of being at a historic juncture. For, with the canal's completion, the city seemed poised to dominate trade between Asia and the Americas.[9] That this economic exchange was seen in colonial terms, rather than as trade between equals, seems hinted at by the exposition's thematization of an Age of Exploration that set the stage for Europe's exploitation of the rest of the world. Thus, it is no surprise that a city whose economic future hinged on its Pacific Rim location chose to advertise its cultural sophistication by importing examples of European (and European-derived) modern art.

In scope, scale, and local impact, the resulting exhibition rivaled New York's 1913 Armory Show.[10] Although most of the more than eleven thousand works shown adhered to familiar academic formulas, "numerous examples of avant-garde . . . art, ranging from Post-Impressionism to Italian Futurism," were also displayed.[11] The aesthetic debates and social turmoil that spawned these stylistic revolts may have seemed remote or inscrutable to Pacific Slope artists at the time. But they were nonetheless galvanized by the new art's formal innovations, which they freely borrowed and promiscuously blended.[12] A cataclysmic event, the region's collective first encounter with European modern art altered the local artistic landscape, producing new alignments and unprecedented conjunctions. Thus, when a twenty-seven-year-old African-American migrant named Sargent Claude Johnson arrived in San Francisco, the Bay Area's art communities were experiencing the Big Bang that would launch their evolution of a modernism of their own.

An eclectic affair from the outset, Bay Area modernism developed within a larger, geographically determined social matrix that left more room for a figure like Johnson than East Coast cultural configurations did. Yet, he would not surface as an active participant in the local art scene until 1925. Several factors probably account for the ten-year delay. Although he is said to have initially tried his hand at sculpture during an adolescent stay with his aunt, the sculptor May Howard Jackson (1877–1931), and to have subsequently practiced modeling by copying tombstone figures while living with grandparents in Virginia, Johnson seems to have had no formal training in sculpture prior to his arrival in California. He had attended "a night-school course in drawing and painting" in Boston and quickly resumed classes in drawing and painting in the Bay Area. But Johnson would not begin training in sculpture at the California School of Fine Arts (CSFA) until four years later.[13]

His marriage in 1915 and his daughter's birth in 1923 produced new financial responsibilities that probably curtailed his artistic activity. These vicissitudes at least partly explain Cedric Dover's description of Johnson in the 1920s as a creator of "exquisite *spare-time* works" (emphasis mine). But it must also be remembered that few Americans—married or single, parents or childless—could devote themselves exclusively to art making in the days before government patronage of the arts, least of all artists in the West. But there are indi-

cations that Johnson's dream of becoming an artist initially may have also been hampered by racial conditions in the Bay Area.

In a history of San Francisco's African-American population, Douglas Henry Daniels states that it "very possibly" may have been "more difficult for a Negro to obtain good employment in the Bay Area, especially in San Francisco, than in just about any major American city until World War II." Once the region's gold rush-era boom subsided, black San Franciscans had little chance of working as "skilled craftsmen or ordinary laborers, as these jobs were monopolized by whites." From 1860 to 1940, for Bay Area blacks, "[e]mployment in the service realm predominated."[14] Writing in 1912, W. E. B. DuBois observed that "on the whole a Negro mechanic is a rare thing" in the state of California.[15] Thus it is not entirely surprising that Johnson was employed as a framer (the period term *fitter* has caused some confusion as to what kind of work he did) beginning in 1917. But if Johnson's efforts to become an artist were initially hampered by race-based economic difficulties, the artist he eventually became probably benefited in several ways from the unique position of African Americans in the Bay Area.

"In 1918, on the day an all-black army unit recruited from the East Bay left Oakland for World War I training, the city council passed an ordinance prohibiting blacks from buying property in the newly opened Santa Fe tract north of Forty-Seventh Street." The authors of a recent history of African-American life in the East Bay go on to explain that "the emergence of all-white residential areas" did not immediately produce "black ghettoes." Instead, in a pattern that had been typical of many United States cities prior to World War I but that persisted in the Bay Area until World War II, "the districts to which blacks were restricted were inhabited by multi-ethnic mixtures of middle- and working-class families and single people."[16] Across the bay in San Francisco, a wartime study by the eminent African-American sociologist Charles S. Johnson found "no rigidly segregated Negro community existed" until the 1940s. "Even along Fillmore Street," black San Franciscans "lived among Japanese, Chinese, Filipinos, and 'sizeable groups of whites'" throughout the 1930s.[17]

Thus, although they were not entirely exempt from housing discrimination, Bay Area blacks probably enjoyed a greater degree of residential integration than any other Afro-United States population in the interwar years. And because local demographics frequently supplied them with neighbors of Asian-Pacific origin, African Americans in the Bay Area were less apt than other blacks in the United States to view the world in binaristic, black-white terms. The unusual latitude in housing choices Bay Area blacks experienced suggests the existence of comparatively fluid patterns of interaction between individuals of different races. Such conditions probably account for Johnson's acceptance into the local art establishment—as signaled by his election to the San Francisco Art Association in 1932 and to a seat on its Council Board in 1934, as well as his numerous stints on the sculpture jury for the association's annual exhibition—and his achievement of a status there that "no black artist in the East" had managed to attain since the nineteenth-century New England landscapist Edward Mitchell Bannister.[18] Above all, the combination of unparalleled access to local, dominant art circles and immersion in the region's relatively fluid, multicultural milieu allowed Johnson to synthesize material borrowed from a wide range of cultures, molding them into his own brand of Afro-United States modernism.

Johnson's 1927 portrait bust, *Elizabeth Gee* demonstrates this convergence of stylistic eclecticism with multicultural experience. A relatively naturalistic work, at first glance the

glazed stoneware child's bust seems either to reject or to retreat from modernist precedents in sculpture. *Elizabeth Gee* lacks the expressive surface of a Rodin or a Matisse, the planarity of a Gabo or an Archipenko, the radical simplification of a Modigliani or a Brancusi. Instead, Johnson's portrait declares its modern-ness through its use of color and choice of materials—both of which violate "high art" norms and embrace "decorative" properties.

This promiscuous mixing of modes is consistent with canonical modernism—with the paradoxical union of a utilitarian object (a cup) and its nonutilitarian treatment (its rendition in solid wood) seen in Brancusi's 1917 *Cup*, or the emulation of so-called naïve art by Elie Nadelman. But it is also symptomatic of a distinctly "Bay Area" brand of stylistic eclecticism that took its cues from Asian and Meso-American artistic traditions, as well as from the democratic impulses of European modernism. Although the bust to which Johnson applies color is modeled in a relatively naturalistic style, he rejects the mimetic goals that led nineteenth-century sculptors from Charles-Henri Joseph Cordier to Max Klinger to polychrome sculpture. By conflating an elite genre—portraiture—with a commercial or "decorative" medium—glazed stoneware—Johnson closed the conventional gap between art and object in post-Renaissance Western aesthetics several decades before West Coast ceramic sculptors like Peter Voulkos and Robert Arneson.

From an early date then, Sargent Johnson was producing sculpture that reconfigured various hegemonic modernist tropes in a characteristically "San Francisco modernist" manner. But the regional specificity of this work is not a matter of style alone. Johnson's subject—a Chinese child whose family lived next door to the artist—also points to a key fact of Bay Area life. A long history of Asian presence and anti-Asian prejudice had ironically facilitated the preservation of Asian culture and identity, thus enabling a politically, socially, and economically marginalized group to exert a pervasive, if widely unrecognized, cultural influence. At the same time, African Americans represented a minuscule proportion of the Bay Area population and, as a result, enjoyed greater residential latitude there than anywhere else in the country. And, whereas whites clearly dominated the region, its geography, local demographics, and history produced a society in which difference did not gravitate exclusively around opposing poles of whiteness and blackness. This seems to have opened a significant window of opportunity for Sargent Claude Johnson. Comparison with his eastern counterparts makes this clear. For, as Cedric Dover has observed: "Among the sculptors of the 'twenties, though Meta Fuller and May Jackson reached new heights and Richmond Barthé looked promising, the only evidence of a definitely new talent was seen in the exquisite spare-time works, contemporary in feeling and entirely unclutttered by virtuosity, of Sargent Johnson."[19]

Artists who had reached maturity a decade before the 1920s Negro Renaissance, Meta Warrick Fuller (1877–1968) and May Howard Jackson were products of an earlier phase of African-American social and cultural history. Both natives of Philadelphia and members of that city's frequently light-skinned, black bourgeoisie, the two women's social origins reflect patterns that are familiar to students of African-American artistic activity during the preceding century and should be placed in a larger context of pre- and postbellum restriction of African-American artisanal activity.[20] Only gender distinguishes them from such figures as the photographers Jules Lion (ca. 1809/10–1866) and James P. Ball (1825–ca. 1904/5), the sculptor Eugene Warburg (ca. 1825–1859), or the painters Robert S. Duncanson (1821–1872), Edward Mitchell Bannister (1828–1901), and Henry Ossawa Tanner (1859–1937), each of

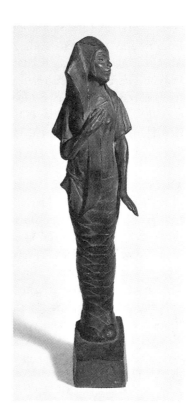

Figure 15.1 Meta Warrick Fuller, *Ethiopia Awakening*, 1915–21. Yale Collection of American Literature, Beinecke Rare Book and Manuscript Library.

whom enjoyed significant advantage over the majority of their black contemporaries, thanks to a combination of mixed ancestry, free and generally Northern birth, and concomitant access to education and skills denied most African Americans.[21] Like their Philadelphia predecessors, Robert Douglass and Tanner, as well as Pittsburgh native Alfred B. Stidum, Fuller and Jackson also profited from affiliations with the Pennsylvania Academy of the Fine Arts, one of the nation's top art schools.[22]

Ideologically, their sculpture projected the goals and assumptions of an early-twentieth-century Negro elite determined to "uplift" the less fortunate majority of their race. In works like her 1913 *Emancipation* group and 1915–21 *Ethiopia Awakening* (fig. 15.1), Fuller celebrated African-American history and promoted pride in African heritage, while Jackson advertised contempory black achievement by sculpting portrait busts of figures such as the poet Paul Laurence Dunbar, novelist Jean Toomer, the educator Kelly Miller, and the scholar-activist W. E. B. DuBois. It may be easy now to criticize their highbrow cultural mission, but in the face of a "crimson tide" of antiblack violence, a towering wall of legal repression, and widespread acceptance of demeaning racial stereotypes, asserting black dignity would have seemed radical. Notably lacking any appeal to white altruism or amusement, work like Fuller's and Jackson's announced the birth of a New Negro in the visual arts.[23] Thus, their sculpture can be linked thematically to an emergent modern black consciousness. But stylistically, both women remained wedded to the academic tradition in which they had been so thoroughly trained.

Among the artists who, like Sargent Johnson, emerged during the so-called Harlem Renaissance were three prominent sculptors: Elizabeth Prophet (1890–1960), Augusta Savage

(1892–1962), and Richmond Barthé (1901–1989). Prophet, who lived and worked in Paris from 1922 to 1934, seems to have been the most original of Johnson's black contemporaries. Although she sometimes balked at being labeled "negro"—claiming her father's one-quarter Pequod-Narragansett ancestry as her full patrimony instead—during her years abroad she received the NAACP magazine *The Crisis* "on a regular basis" and corresponded with its editor, W. E. B. DuBois, about "black American achievements." In Paris, she occasionally visited Henry Ossawa Tanner, met the much-lionized Harlem Renaissance poet Countee Cullen, and welcomed Augusta Savage, on her arrival in 1929.[25] Thus, she undoubtedly was aware of the cultural ferment in progress among African-American artists and intellectuals. That she shared their interest in redeeming the black visage from at least a century's worth of malign caricature and emulating the accomplishments of traditional African carvers is indicated by a letter to DuBois in which she reports on some of the African sculpture displayed at the 1931 Colonial Exposition and rhapsodically praises "heads that are [of?] such a mental development [as is?] rarely seen among Europeans. Heads of thought and reflection, types of great beauty and dignity of carriage. I believe it is the first time that this type of African has been brought to the attention of the world of modern times."[26]

Although her remarkable talent was recognized by such figures as Tanner and DuBois, Prophet's career was plagued by poverty, insufficient patronage, and emotional instability.[27] As a result, little of her work survives. Photographs of thirteen lost works, as well as four extant examples in public collections, show a preponderance of heads and busts, with only three full-figure statues.[28] Four carved wooden heads and two plaster busts appear to depict African or African-American subjects, with three—the wooden *Head of a Negro* (ca. 1926–27), the plaster bust of the same name (ca. 1925–29), and *Congolais* (ca. 1931)—identified as such.

After an initial period of technical groping, Prophet worked with equal fluency in wood, plaster, and stone. Her style blends an exquisite mastery of physiognomy and psychological nuance with an antinaturalistic emphasis on the artist's touch (especially visible in her wood carvings and plasters) and the tactile qualities of her medium (most pronounced in her marble works). Balancing a high degree of naturalism and an idealizing semimuted treatment of detail, Prophet adheres to the moderate abstraction generally associated with turn-of-the-century Symbolism. "Progressive" in comparison with the work of Fuller and Jackson, Prophet's sculpture was considerably less innovative than Johnson's in both formal and thematic terms. Comparison of her best-known work, *Congolais*, of about 1931, with Johnson's contemporaneous *Chester* (color plate 14) makes this apparent.

Prophet's *Congolais* is an iconographic pastiche. Its title refers to Central Africa—today's People's Republic of the Congo and the Democratic Republic of Congo—while its one culturally specific visual element—a Masai warrior's plaited forelock—points to East Africa, the Masai's Kenyan and Tanzanian home. Prophet was frequently unable to afford a model, and the schematic look of certain works suggests they were not sculpted from life. Although there is something abstract and lifeless about the artist's treatment of the eyes in *Congolais*, there is a close resemblance between the carving's facial features and Prophet's own. Thus, it seems likely that the head was carved from imagination, memory, or in front of a mirror—adding another layer of pastiche. While this sort of conflation of disparate sources, including the "real" and the "imaginary," is consistent with Symbolist aesthetics— think, for example, of Gauguin's 1889 *Christ in the Garden of Olives* (Norton Gallery of

Art, West Palm Beach, Florida), in which Jesus is given the artist's face—Symbolism itself was hardly *au courant* by the 1930s.

Johnson's *Chester*, however, is a work completely "of its time." Where Prophet carved a single block of cherry wood, leaving the area at the base of the neck rough so as to imply— in a Rodinesque manner—the form's emergence from the wood block and to reveal the artist's "touch," Johnson modeled a terracotta head and accompanying hand, each of which sprouts from spherical openings in the top of a cube-shaped wooden base that has been painted black. In its juxtaposition of truncated forms, *Chester* echoes the Dadaist/ Cubist/Surrealist penchant for fragmentation and uncanny juxtapositions. While there is nothing inherently "uncanny" about a hand placed against the side of a face, the apparent "naturalness" of this conjunction is subtly undermined by the strangeness of body parts emerging from holes in a block of wood. Thus, Johnson eschews the conspicuous strangeness of Surrealism and its European modernist forerunners, opting instead for an aesthetic balancing act in which the child's hand functions transitionally, its blunt contours echoing the work's rectilinear base, while its anatomical detail—though limited—seems to anticipate the fuller volumes of the face. For *Chester* participates in several other strains of modernism that were in circulation in 1931.

On the one hand, with its blunt digits and smooth, undifferentiated cap of hair, *Chester* resembles the work of a so-called naïve artist at a time when folk art was very much in vogue.[29] On the other, by uniting formal reductiveness with sensitive ethnic description, Johnson managed to fulfill Alain Locke's injunction to produce a truly "Negro" modern art—that is, one that synthesized "the lesson . . . of technical control" and "complete plastic freedom" embodied in African sculpture and conceived "Negro physiognomy . . . freshly and objectively . . . on its own patterns."[30]

The valorization of folk art was part of a widespread, interdisciplinary interest in United States folklife that inspired important studies of American folklore, as well as scholarly efforts to document and record "authentic" examples of folk music and museum acquisitions of traditional American crafts, which also became items of fashionable decor. At the same time, contemporary drama, literature, and film also demonstrated elite fascination with "the folk"—that is to say, with the ordinary, often poor, inhabitants of small towns and rural areas, people whose ways of life were thought to reflect the nation's regional diversity, on the one hand, and to embody "American" cultural essences, on the other. In the visual arts, this impulse underwrote a broad spectrum of nativist tendencies—ranging from the stylistic conservativism of Regionalists like Thomas Hart Benton and Grant Wood to the figurative expressionism of Marsden Hartley and the precisionism of Charles Sheeler.

Insofar as it reflected a parallel interest in locating cultural essences unique to American black life, the dream of an African-American modernism articulated by Locke and others was a by-product of this upsurge of cultural nationalism. But any ostensible parity between the African-American and Euro-American modernist projects is belied by an underlying conceptual problem: the international character of black "nationalism"—that is to say, the cruciality of African heritage to most theories of black cultural difference.[31] Locke's emphasis on the formal potential of African art for African-American modernism obliquely references this problem, which had previously been articulated in thematic terms by cultural theorists such as DuBois and by Locke himself. And, as we have seen, at least one artist of the prior generation—Meta Fuller—had taken on this challenge in iconographic terms.

Among the painters and sculptors of the Negro Renaissance, both African heritage in general and African art in particular were often addressed thematically.[32] Indeed, this can be identified as a key trope that distinguishes this generation's art from the bulk of its predecessors'. Work that took its *stylistic* cues from African sources was much less common, however.[33] Among the major sculptors, only Sargent Johnson produced objects that exhibit African style traits—ranging from the masklike stylization of his faces and his use of polychrome to the head-to-body ratio of the female figure and the hieratic proportion of the children's bodies in relation to the mother's in *Forever Free* (color plate 15).[34] And in doing so, Johnson successfully resolved the national/international (or local/transatlantic) dichotomy embedded in Locke's prescription.

Johnson's forerunners, from James P. Ball and Robert Douglass on, had recognized the importance of redeeming the black image—that is, rescuing it from cruel caricature via accurate description.[35] It seems likely that Johnson's desire "to show the natural beauty and dignity in that characteristic lip, that characteristic hair, bearing and manner" of "the pure American Negro" stemmed from a variety of sources, including Negro Renaissance cultural agendas.[36] But at least two biographical sources also suggest themselves. On the one hand, the hardships resulting from his parents' interracial marriage and the estrangements of several of his siblings, who chose to "pass," provided strong psychological motives for celebrating the visible signs of blackness he himself lacked.[37] On the other, during his adolescent stay with his aunt, May Howard Jackson, he is likely to have been exposed to her views on the subject.

Like Johnson, Jackson was extremely fair-skinned and probably was frequently mistaken for white, producing an inconsistent experience of race-based exclusion that can be more jarring than a life in which such exclusion is predictably routine and, hence, to a degree, taken for granted. On her death in 1931, she was described by W. E. B. DuBois as "bitter and fierce," a woman whose soul was "tor[n] asunder" by "the contradictions and idiotic ramifications of the Color Line."[38] In his pioneer history of African-American art, Alain Locke hailed her as "the first [Negro artist] to break away from academic cosmopolitanism [and move] to frank and deliberate racialism. May Howard Jackson," he continued, "was always intrigued by Negro types, their puzzling variety and distinctive traits."[39] Unlike her nephew though, Jackson did not focus on the predominantly African-seeming or "pure" American Negro. Instead, her interest centered on precisely the "culturally mixed" urban type that Johnson eschewed.[40] Although such an orientation was novel at the time and apparently earned her considerable opprobrium, it strikes us now as perfectly consistent with the genteel preoccupations of the early-twentieth-century "Talented Tenth" to which Jackson belonged, whereas Johnson's statement that "[t]he slogan for the Negro artist should be 'go South, young man'" is equally redolent of the interests in regionalism, unspoiled "folk" enclaves, and ethnocultural essentialism that characterize the period in which he came to the fore.[41]

Given the centrality of these issues to Negro Renaissance thought and their wide currency in the dominant culture, it seems strange that none of the African-American artists clustered in East Coast centers like New York, Washington, or Philadelphia arrived at an equally compelling solution to the problems posed by Locke's prescription for an African-American modernism. In outlining the various conjunctions of Bay Area art history and Johnson's personal preoccupations, Bay Area ethnocultural configurations and their osten-

sible effects on his work, as well as the main features of the development of early-twentieth-century African-American sculpture and the character of Johnson's achievement in that regard, I hope to have suggested some of the ways that his unique position within a series of overlapping artistic and social landscapes probably conditioned Sargent Johnson's unique approach to the problem of Afro-American modernism.

Notes

1. As Richard Cándida Smith has observed, modernism is relational in two senses. On the one hand, it has functioned comparatively through its nostalgic evocation of a "classic age one has missed." On the other, because artists' "responses to the simultaneous expansion of knowledge and imagination [triggered by the scientific/technical revolution] varied across time, place, and position," the development of modernism was uneven and must be viewed relatively. Richard Cándida Smith, "The Elusive Quest of the Moderns," in *On the Edge of America: California Modernist Art, 1900–1950*, ed. Paul J. Karlstrom (Berkeley and Los Angeles: University of California Press, 1996), p. 34.

2. Elizabeth Parker, "A Walking Tour of Black San Francisco," in *Our Roots Run Deep, Volume One: The Black Experience in California, 1500–1900*, ed. John William Templeton (San Jose, CA: Electron Access, 1991), pp. 330–31, 336, 338–39, 341.

That Johnson was not the only resident black artist but the only one to gain recognition in California at the time is asserted by the (only) black *Oakland Tribune* columnist Delilah Beasley in a 1933 Harmon Foundation exhibition catalogue: *Exhibition of Productions by Negro Artists*, exh. pamphlet (New York: The Harmon Foundation, 1933), p. 17.

3. Romare Bearden and Harry Henderson, *A History of African-American Artists, from 1792 to the Present* (New York: Pantheon, 1993), p. 219.

4. According to Beasley, a canvas by a contemporary African-American painter named Eugene Alexander Burkes had been offered to the Oakland Municipal Art Gallery for its permanent collection. Beasley also cites the Los Angeles resident Julian C. Robinson and the Oakland ceramicist and illustrator Eleanor E. Paul among "Negro artists and art students . . . scattered all over the Western states" whose "shyness" hampered professional recognition. Beasley paraphrased in 1933 Harmon pamphlet, p. 17.

5. Noting that Johnson's *Sammy* "showed him already committed in 1928 to a strongly simplified style," Alain Locke declared, "he has come to reflect more than any other contemporary Negro sculptor the modernist mode and the African influence." Writing about a 1934 traveling exhibition of work by African-American artists that was cosponsored by the Harmon Foundation and the College Art Association, Rose Henderson observed that "while Negro subjects predominated, the treatment, with the exception of Sargent Johnson's work, was not essentially racial." Alain LeRoy Locke, *Negro Art: Past and Present* (1936; Salem, NH: Ayer Company Publishers, 1991), p. 78. Henderson, "Negro Art Exhibit," *Southern Workman* 63, no. 7 (July 1934): 217.

6. In a 1935 interview in the *San Francisco Chronicle*, Johnson claimed to be "producing a strictly Negro art." "San Francisco Artists," *San Francisco Chronicle*, October 6, 1935, p. D3.

7. Terry St. John, "California Painting and Sculpture from 1915 to 1960," in *The Art of California: Selected Works from the Collection of the Oakland Museum*, ed. Christina Orr-Cahall (Oakland: The Oakland Museum; San Francisco: Chronicle Books, 1984), p. 20.

8. Thomas Albright, *Art in the San Francisco Bay Area, 1945–1980: An Illustrated History* (Berkeley and Los Angeles: University of California Press, 1985), p. 1.

9. Henry T. Hopkins, *Painting and Sculpture in California: The Modern Era,* exh. cat. (San Francisco: San Francisco Museum of Modern Art, 1976), p. 21.

10. Hopkins, *Painting and Sculpture in California,* pp. 22–24.

11. St. John, "California Painting and Sculpture," p. 20.

12. Albright, *Art in the San Francisco Bay Area,* pp. 2–4. Hopkins, *Painting and Sculpture in California,* pp. 22–24.

13. Bearden and Henderson, *A History of African-American Artists,* pp. 216, 217.

14. Daniels writes that the Bay Area "offered Afro-Americans the same kinds of jobs in 1910 and 1930 as in 1860," with 48 percent of black men and 70 percent of black women engaged in service work in 1910, while employment statistics for 1930 show 51 percent of black men and 89 percent of black women at work "in the service sector of San Francisco's economy." The situation was the same in Oakland from 1900 to the beginning of World War II. Douglas Henry Daniels, *Pioneer Urbanites: A Social and Cultural History of Black San Francisco* (Philadelphia: Temple University Press, 1980), pp. 17, 31–32.

15. DuBois, *The American Negro Artisan* (1912), cited in Daniels, ibid., p. 34 n. 39. As Daniels points out, this situation reflects an ironic feature of San Francisco's historic liberalism, which empowered labor unions that practiced racial discrimination, systematically barring blacks and the Chinese from membership. As a result, from 1880 to 1920, African Americans were largely excluded from industry and the skilled trades. A wave of government-inspired anti-communist hysteria and a rash of pro-labor bombings temporarily broke labor's grip, however, and "an open shop policy prevailed in San Francisco" during the 1920s. Although this produced a marked increase in industrial jobs for local blacks, there does not seem to have been a corresponding rise in opportunities for black artisans. Daniels, ibid., pp. 17, 27, 34, 42.

16. Lawrence P. Crouchett, Lonnie G. Bunch III, and Martha Kendall Winnacker, *Visions Toward Tomorrow: The History of the East Bay Afro-American Community, 1852–1977* (Oakland: The Northern California Center for Afro-American History and Life, 1989), pp. 21–22.

17. Charles S. Johnson, *The Negro War Worker in San Francisco: A Local Self-Survey* (1944), p. 3, quoted in and paraphrased by Daniels, *Pioneer Urbanites,* p. 99.

18. Bearden and Henderson also cite Johnson's eventual promotion to unit supervisor on California's WPA art project "without the struggle required in the East and elsewhere to win such posts for African-American artists." Bearden and Henderson, *A History of African-American Artists,* pp. 219–21.

19. Cedric Dover, *American Negro Art* (1960; Greenwich, CT: New York Graphic Society, 1970), p. 35.

20. John Hope Franklin, *From Slavery to Freedom: A History of Negro Americans,* 3d ed. (New York: Vintage, 1969), pp. 222–23, 312–13.

21. Of these artists, only Lion, Ball, and Warburg were not Northern-born. Lion was born and raised in France, Ball in Virginia, and Warburg in New Orleans. As *gens de couleur libre,* Lion (a New Orleans resident from 1836 or 1837) and Warburg belonged to the most economically and socially privileged group of people of African descent in the antebellum United States. Ball is the only one of these artists who might have been born a slave. Patricia Brady, "A Mixed Palette: Free Artists of Color of Antebellum New Orleans," *International Review of African American Art* 12, no. 3 (1995): 5–14, 53–57. Deborah Willis, *J. P. Ball: Daguerrean and Studio Photographer* (New York: Garland, 1993), pp. xiv–xix. Joseph D. Ketner, *The Emergence of the African-American Artist, 1821–1872* (Columbia: University of Missouri Press, 1993), pp. 2, 11–13. Juanita Marie Holland, "Reaching Through the Veil: African-American Artist Edward Mitchell Bannister," in *Edward Mitchell Bannister, 1828–1901,* exh. cat. (New York: Kenkeleba House and Harry N. Abrams, 1992), p. 17.

22. Robert Douglass participated in the academy's 1876 and 1878 annuals and is thought to have received some private instruction from Philadelphia's leading portrait painter, Thomas Sully,

a member of the academy's faculty. Tanner studied with Thomas Eakins at the academy intermittently from 1879 through 1885. Sridum studied at the academy 1880–83. May Howard attended the academy from 1895 through 1898 and 1900 to 1902. Having already spent 1896–99 at the Pennsylvania Museum and School of Industrial Art and trained at the Ecole des Beaux-Arts and Académie Colarossi in Paris during 1899–1902, Meta Warrick took classes with the sculptor Charles Grafly at the Pennsylvania Academy in 1906–7. Steven Loring Jones, "A Keen Sense of the Artistic: African American Material Culture in Nineteenth-Century Philadelphia," *International Review of African American Art* 12, no. 2 (1995): 11, 22, 23, 27 n. 57. Dewey F. Mosby, "Student Years and Early Career, 1873–1890," in *Henry Ossawa Tanner*, exh. cat. (Philadelphia: Philadelphia Museum of Art, 1991), pp. 59–60. Kathleen James and Sylvia Yount, "Chronology," in *Henry Ossawa Tanner*, p. 36. Tritobia Hayes Benjamin, "May Howard Jackson and Meta Warrick Fuller: Philadelphia Trail Blazers," in *Three Generations of African-American Women Sculptors: A Study in Paradox,* exh. cat. (Philadelphia: The Afro-American Historical and Cultural Museum, 1996), pp. 20, 21, and n. 10. Judith Nina Kerr, "God-Given Work: The Life and Times of Sculptor Meta Vaux Warrick Fuller" (Ph.D. diss., University of Massachusetts, Amherst, 1986), pp. 46, 66, 68, 141.

23. Periodizing the phenomenon of the "New Negro" is problematic, given the enormous disparities between and gaps in existing accounts. For example, Henry Louis Gates, Jr.'s, well-known essay "The Face and Voice of Blackness" dates "the creation of the New Negro" to the years 1895–1925, ostensibly because this was a period of unprecedented literary production. Yet, he phrases this in a way that also alludes to important sociopolitical factors ("Between 1895 and 1925, at the height of racially inspired violence towards African-Americans, . . . black writers published at least 64 novels") without detailing their nature or pursuing questions of historical agency. In contrast, Ernest Allen, Jr., targets a narrower slice of the same period in his essay "The New Negro: Explorations in Identity and Social Consciousness, 1910–1922," but outlines specific political, social, and historical conditions he feels account for the rise of a "New Negro movement." The incongruence of accounts such as Allen's and Gates's suggests the need for a thorough reexamination of the whole subject. Gates, "The Face and Voice of Blackness," in *Facing History: The Black Image in American Art, 1710–1940*, ed. Guy C. McElroy, exh. cat. (San Francisco: Bedford Arts; Washington, DC: The Corcoran Gallery of Art, 1990), p. xxxiii. Ernest Allen, Jr., "The New Negro: Explorations in Identity and Social Consciousness, 1910–1922," in *1915, the Cultural Moment: The New Politics, the New Woman, the New Psychology, the New Art, and the New Theatre in America*, ed. Adele Heller and Lois Rudnick (New Brunswick, NJ: Rutgers University Press, 1991), pp. 48, 49, 50–62.

24. Lynn Moody Igoe, *250 Years of Afro-American Art: An Annotated Bibliography* (New York: R. R. Bowker, 1981), p. 1039. Juanita Marie Holland, "Augusta Christine Savage: A Chronology of Her Art and Life, 1892–1962," in *Augusta Savage and the Art Schools of Harlem*, exh. cat. (New York: The Schomburg Center for Research in Black Culture, the New York Public Library, 1988), pp. 12, 19. Judith Wilson, "Art," in *Black Arts Annual, 1988–89*, ed. Donald Bogle (New York: Garland, 1990), p. 55.

25. Dover, *American Negro Art*, p. 56. Theresa Leininger, "Elizabeth Prophet (1890–1960): Sculptor, Educator," in *Notable Black American Women*, ed. Jessie Carney Smith (Detroit: Gale Research, 1991), pp. 890, 893. Blossom S. Kirschenbaum, "Nancy Elizabeth Prophet, Sculptor," *Sage: A Scholarly Journal on Black Women* 4, no. 1 (Spring 1987): 46.

26. Elizabeth Prophet to W. E. B. DuBois, August 20, 1931, quoted in Leininger, "Prophet," p. 896.

27. In a 1928 letter of recommendation, Tanner wrote: "Of the many, many students over here either white or black I know of none with such promise as Mrs. Prophet." Leininger, "Prophet," pp. 892–93.

DuBois, in a March 14, 1940, letter to the photographer Alexander Alland, tersely compared Prophet and Savage: "Augusta Savage is a hard working artisan but scarcely a first class sculptor.

Our greatest Negro sculptor is Elizabeth Prophet." DuBois, "Letter to Mr. Alexander Alland, Atlanta, Ga., March 14, 1940," in *The Correspondence of W. E. B. DuBois, Vol. II: Selections, 1934–1944,* ed. Herbert Aptheker (Amherst: University of Massachusetts Press, 1976), p. 221.

28. For the thirteen lost works, see photographs from the Carl Russell Gross Papers (1888–1971), Special Collections, Adams Library, Rhode Island College, Providence, reproduced in Theresa Leininger-Miller, "African-American Artists in Paris, 1922–1934," vol. 3, Illustrations (Ph.D. diss., Yale University, 1995), pp. 417–21, 424–28, 430–33. Three of the four works in public collections are located in the Museum of Art, Rhode Island School of Design. The third is in the Whitney Museum of American Art. They are reproduced in Leininger-Miller, pp. 416, 422–23, 429, 434.

29. Judith Stein, "An American Original," in *I Tell My Heart: The Art of Horace Pippin*, exh. cat. (Philadelphia: Pennsylvania Academy of the Fine Arts; New York: Rizzoli, 1993), pp. 2, 12.

30. Alain LeRoy Locke, "The Legacy of the Ancestral Arts," in *The New Negro* (1925; reprint, New York: Atheneum, 1968), pp. 256, 260, 264.

31. The principal exception would be theories that make slavery and its legacy of social disadvantage the sole source of black difference, arguing or implying that the depradations of bondage erased all cultural traces of an African past among African Americans.

32. Well-known examples include Archibald Motley's *Kikuyu God of Fire* (1927), reproduced in Jontyle Theresa Robinson and Wendy Greenhouse, *The Art of Archibald J. Motley, Jr.*, exh. cat. (Chicago: Chicago Historical Society, 1991), p. 81; Elizabeth Prophet's previously discussed carving, *Congolais*; Malvin Gray Johnson's *Self-Portrait* (1932), reproduced in Gary A. Reynolds and Beryl J. Wright, *Against the Odds: African-American Artists and the Harmon Foundation*, exh. cat. (Newark: The Newark Museum, 1990), p. 208; Lois Mailou Jones's canvas *The Ascent of Ethiopia* (1932), reproduced in Alvia J. Wordlaw, *Black Art Ancestral Legacy: The African Impulses in African-American Art*, exh. cat. (Dallas: Dallas Museum of Art, 1989), p. 159; Palmer Hayden's still life *Fétiche et fleurs* (ca. 1932–33), reproduced in Allan M. Gordon, *Echoes of Our Past: The Narrative Artistry of Palmer C. Hayden,* exh. cat. (Los Angeles: The Museum of African American Art, 1988), p. 34; the first panel of Aaron Douglas's *Aspects of Negro Life* (1934) mural cycle, reproduced in Amy Helene Kirschke, *Aaron Douglas: Art, Race, and the Harlem Renaissance* (Jackson: University Press of Mississippi, 1995), pl. 79, after p. 76; and Richmond Barthé's bronze statue *Feral Benga* (1935), reproduced in Reynolds and Wright, *Against the Odds*, p. 122, pl. II.

33. The painter Hale Woodruff managed to do so by cannily conflating references to Cézanne, Cubism, and Fang white-faced masks in his *Card Players* (1929–30), reproduced in Alain LeRoy Locke, *The Negro in Art: A Pictorial Record of the Negro Artist and of the Negro Theme in Art* (1940; New York: Hacker Art Books, 1979), p. 54, and similar intent can be ascribed to Malvin Gray Johnson's placement of a pair of (presumably) African masks in the background of a self-portrait rendered in Cubist perspective.

34. The ratio of the head to the overall body of the female figure is approximately 1:5. In sub-Saharan African sculpture, head-to-body proportions of 1:3 and 1:4 are most common, in comparison with European proportions of 1:7 or 1:8. The 1:5 ratio is also found in sub-Saharan African sculpture, though less frequently than 1:3 or 1:4. Jan Vansina, *Art History in Africa: An Introduction to Method* (New York: Longman, 1984), pp. 84–85. I interpret the proportions of the mother and children in *Forever Free* as "hieratic" because the children seem both too large for their apparent ages (thus, their size does not correspond to Western naturalistic proportions) and sufficiently small in comparison with the mother to signal their status in relation to her. Among the most famous African examples of this gauging of size according to status (i.e., "hieratic proportions") are the multifigured metal plaques from the court of Benin, which Johnson is likely to have known.

35. Jones, "A Keen Sense of the Artistic," pp. 10–15.

36. Johnson quoted in *San Francisco Chronicle*, October 6, 1935.

37. Bearden and Henderson, *A History of African-American Artists*, pp. 216, 217.

This need to validate what was most problematic in his own individual and his family's history—his African-derived or "pure American Negro" identity—would also explain Johnson's otherwise anomalous preference for "studying not the culturally mixed Negro of the cities, but the more primitive slave type." Johnson quoted in *San Francisco Chronicle*, October 6, 1935.

38. DuBois, *The Crisis* (October 1931), p. 351, quoted in Benjamin, "Jackson and Fuller," p. 21.

39. Locke, *Negro Art*, pp. 30–31.

40. Locke, ibid., p. 31, quotes an unnamed "critic" about this aspect of Jackson's portraiture: "The composite group of American Negroes has not yet been recognized as a people in whom intellect as well as sensuality exists in a variety of interesting forms. This is the new field to which she had dedicated an original and experimenting talent."

41. *Talented Tenth* was DuBois's term for an educated, African-American leadership class. W. E. B. DuBois, *The Souls of Black Folk* (1903; Greenwich, CT: Fawcett, 1961), pp. 84–85. Johnson quoted in *San Francisco Chronicle*, October 6, 1935.

16

Horace Pippin's Challenge
to Art Criticism

Cornel West

The art of Horace Pippin poses grave challenges to how we appreciate and assess art-works in late twentieth-century America. A serious examination of Pippin's place in art history leads us into the thicket of difficult issues that now beset art critics. What does it mean to talk about high art and popular culture? Do these rubrics help us to evaluate and understand visual artifacts? Is folk art an illuminating or oxymoronic category? Can art be more than personal, racial, or national therapy in American culture? Has the com-mercialization of art rendered it a mere commodity in our market-driven culture? Can the reception of the work of a black artist transcend mere documentary, social pleading or exotic appeal?

These complex questions often yield Manichaean responses—self-appointed defenders of high culture who beat their breasts in the name of craftsmanship and quality, and self-styled avant-gardists who call for critique and relevance. The former tend to use the mon-umental touchstones of the recent past—especially those of high modernism—to judge the present. The latter reject monumentalist views of art history even as they sometimes become highly paid celebrities in the art world. Pippin's work shows this debate to be a sterile exchange that overlooks much of the best art in the American grain: high-quality craftsmanship of art objects that disclose the humanity of people whose plight points to flaws in American society. Pippin's paintings are neither monumentalist in the modernist sense nor political in a postmodernist way. Rather they are expressions of a rich Emerson-ian tradition in American art that puts a premium on the grandeur in the commonplace, ordinary, and quotidian lives of people. This tradition promotes neither a glib celebration of everyday experiences nor a naive ignorance of the tragic aspects of our condition. Rather, Pippin's Emersonian sensibility affirms what John Dewey dubbed "experience in its integrity."[1] Pippin's so-called folk art boldly exclaims with Emerson,

> I ask not for the great, the remote, the romantic; what is doing in Italy or Arabia; what is Greek art, or Provençal minstrelsy; I embrace the common, I explore and sit at the feet of the familiar, the low. Give me insight into day and you may have the antique and future worlds.[2]

This artistic affirmation of everyday experiences of ordinary people is anti-elitist but not anti-intellectual—that is, it shuns a narrow mentality that downplays the joys and sufferings of the degraded and despised, yet it heralds high standards for how these joys and sufferings are represented in art. Pippin's paintings—as a grand instance of the Emersonian tradition in American art—attempt to democratize (not denigrate) the aesthetic by discerning and displaying tragedy and comedy in the ordinary experiences of common folk (see color plate 16). In this way, his work echoes the Emersonian sensibility of John Dewey:

> In order to *understand* the aesthetic in its ultimate and approved forms, one must begin with it in the raw; in the events and scenes that hold the attentive eye and ear of man, arousing his interest and affording him enjoyment as he looks and listens. . . . The sources of art in human experience will be learned by him who sees how the tense grace of the ball-player infects the onlooking crowd; who notes the delight of the housewife in tending her plants, and the intent interest of her goodman in tending the patch of green in front of the house; the zest of the spectator in poking the wood burning on the hearth and in watching the darting flames and crumbling coals.[3]

We see such precious moments in Pippin's *Harmonizing* (1944) with black men *joyfully* singing on the block (fig. 16.1)—or *Domino Players* (1943) with black women *enjoying* a domino game. We also realize that Pippin's link to Abraham Lincoln is not so much a link to the President as emancipator of black people, nor the President as hypocrite, but rather to Abe as the folk hero who is believed to have said that God must have loved common folk since he made so many of them. *Abe Lincoln, The Good Samaritan* (1943) fuses this Emersonian sensibility of Lincoln with a Christian theme of concern for the disadvantaged ("let Christianity speak ever for the poor and the low"[4]).

Yet Pippin's Emersonian practice—which sidesteps the sterile "quality versus diversity" debate—lends itself to establishmentarian abuse. A genuine artistic concern with the common easily appears as an aspiration for authenticity—especially for an art establishment that puts a premium on the "primitive" and hungers for the exotic. The relative attention and support of the self-taught Pippin at the expense of academically trained black artists reflects this establishmentarianism abuse. This situation is captured by Richard J. Powell in his pioneering book *Homecoming: The Art and Life of William H. Johnson*, when he discusses the response of Alain Locke and a local critic to Johnson's new "primitive" works in the summer of 1940 at the Exhibition of the Art of the American Negro (1851–1940) for the American Negro Exposition in Chicago:

> For both the reviewer in Chicago and Alain Locke, Johnson's flirtation with images and forms that suggested naiveté was symptomatic of the art world's then-current fascination with self-trained "daubers," "scribblers," and "whittlers," whose creative lives had been spent (for the most part) outside of the art world proper. One of the most celebrated of these folk artists, black American painter Horace Pippin, worked in a somewhat similar manner to Johnson, with oil paints applied in a thick, impasto consistency, and visual narratives punctuated by strong, solid areas of pure color. Schooled and dedicated artists like Johnson must have felt a little envious of these self-taught painters such as Pippin who, in only a few years, had several museum and gallery exhibitions to their credit.

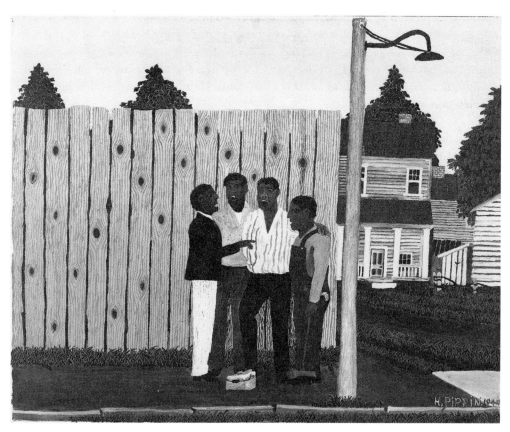

Figure 16.1 Horace Pippin, *Harmonizing*, 1944, oil on canvasboard, 61 × 76.2 cm. Allen Memorial Art Museum, Oberlin College, OH. Gift of Joseph and Enid Bissett, 1964.

As Johnson's past comments about primitivism and folk culture demonstrate, he acknowledged the innate power and spirituality that emanated from the art of common people and had decided to allow that part of his own folk heritage to assert itself in his work. Although no less eager to have his own work seen and appreciated, Johnson no doubt accepted the broad appeal of those folk artists then deservedly enjoying the art world's spotlight.[5]

This institutional dilemma regarding the dominant white reception of Pippin's work raises crucial issues about the trials and tribulations of being a black artist in America. In Pippin's case, being a self-taught black artist in America in the Emersonian tradition complicates the matter. On the one hand, a professional envy among highly trained black (and white) artists is understandable, given the limited slots of visibility—and given the history of racist exclusion of black artists in the art world. On the other hand, the absence of professional training does not mean that there is no quality in Pippin's art. Even Alain Locke, the elitist dean of African American art in mid-century America, described Pippin as "a real and rare genius, combining folk quality with artistic maturity so uniquely as almost to

defy classification."[6] Yet the relation of the politics of artistic visibility to the quality of visible artworks requires critical scrutiny. As James Clifford rightly notes,

> the fact that rather abruptly, in the space of a few decades, a large class of non-Western artifacts came to be redefined as art is a taxonomic shift that requires critical historical discussion, not celebration.[7]

Clifford does not have Pippin's work in mind here—especially since Pippin's art was recognized as such, as seen in the inclusion of four of his works in a Museum of Modern Art exhibit called Masters of Popular Painting in 1938. But Pippin's works can easily be tarred with the brush of "primitivism," even "exoticism," highlighting his lack of schooling and his subject matter rather than the quality of his art. In her discussion of the Primitivism show at the Museum of Modern Art in 1984, Michele Wallace shows how these issues surrounding the reception of Pippin's work remain alive in our time:

> Black criticism was blocked from the discussions of Modernism, which are defined as exclusively white by an intricate and insidious cooperation of art galleries, museums and academic art history, and also blocked from any discussion of "primitivism," which has been colonized beyond recognition in the space of the international and now global museum. At this juncture one is compelled to ask, "Is multiculturalism, as it is being institutionally defined, occupying the same space as 'primitivism' in relationship to Postmodernism?" For me, a response to such a question would need to include a careful scrutiny of the history of black popular culture and race relations, and account for the sexualization of both, thus defining the perimeters of a new knowledge which I can only name, at this point, as the problem of the visual in Afro-American culture.[9]

Is a black artist like Pippin caught in a catch-22 dilemma—unjustly excluded owing to his blackness *qua* "inferior" (artist) or suspiciously included due to his blackness *qua* "primitive" (artist)? Is this especially so for those black artists in the Emersonian tradition, such as Sterling Brown in poetry or Bessie Smith in music? These questions get at the heart of what it is to be a black artist in America.

To be a black artist in America is to be caught in what I have called elsewhere "the modern black diasporan problematic of invisibility and namelessness."[10] This problematic requires that black people search for validation and recognition in a culture in which white-supremacist assaults on black intelligence, ability, beauty, and character circumscribe such a search. Pippin's example is instructive in that, unlike the other two celebrated mid-century black artists in this country—Richmond Barthé and Jacob Lawrence—Pippin lived and functioned outside the cosmopolitan art world. Like the early blues and jazz artists in American music, Pippin's art remained rooted in black folk culture, yet also appealed to the culture industry of his day. He indeed gained significant validation and recognition from the white art establishment—but at what personal and artistic cost? Do all American artists in our market culture bear similar costs?

Unlike William H. Johnson and Beauford Delaney, Pippin did not go mad. But his wife did spend her last months in a mental institution after a breakdown. Pippin did drink heavily—yet we do not know whether this was related directly to his art career. So in

regard to the personal costs; our answer remains open-ended. The artistic cost paid by Pippin is best summed up in this brief characterization of his career by a leading art historian in 1956:

> Horace Pippin (1888–1946), an unschooled Negro of West Chester, Pennsylvania, unfitted for labor by a war wound, turned to painting. "Pictures just come to my mind," he explained, "and I tell my head to go ahead," an explanation of his innocent art which needs no further comment. His discovery and exploitation as a painter in 1937 did not change his art, although it was too much for him as a human being.[11]

This view of Pippin as an "innocent autodidact" chimes well with the image of the black artist lacking sophistication and subtlety. We cannot deny the poignant simplicity of Pippin's art—yet simplicity is neither simplistic nor sophomoric. Rather Pippin's burden of being a black artist in America required that he do battle with either primitivist designations or inferiority claims about his art. This struggle is best seen in the words of one of Pippin's black artistic contemporaries, William H. Johnson, quoted by the distinguished abstract sculptor of African descent, Martin Puryear:

> I myself feel like a primitive man—like one who is at the same time both a primitive and a cultured painter.[12]

This sense of feeling like a primitive and modern person-artist is one form of the black mode of being in a white-supremacist world—a world in which W. E. B. DuBois claimed that the black person and artist is

> born with a veil, and gifted with second-sight in this American world,—a world which yields him no true self-consciousness, but only lets him see himself through the revelation of the other world. It is a peculiar sensation, this double-consciousness, this sense of always looking at one's self through the eyes of others, of measuring one's soul by the tape of a world that looks on in amused contempt and pity. One ever feels his twoness,—an American, a Negro; two souls, two thoughts, two unreconciled strivings; two warring ideals in one dark body, whose dogged strength alone keeps it from being torn asunder.
>
> The history of the American Negro is the history of this strife—this longing to attain self-conscious manhood, to merge his double self into a better and truer self. In this merging he wishes neither of the older selves to be lost. He would not Africanize America, for America has too much to teach the world and Africa. He would not bleach his Negro soul in a flood of white Americanism, for he knows that Negro Blood has a message for the world. He simply wishes to make it possible for a man to be both a Negro and an American, without being cursed and spit upon by his fellows, without having the doors of Opportunity closed roughly in his face.[13]

This classic characterization of being black in xenophobic America means that black artists are always suspect for not measuring up to rigorous standards or made to feel exotic in a white world that often associates blackness with bodily energy, visceral vitality, and sexual vibrancy. Pippin's art is a powerful expression of black spiritual strivings to attain self-conscious

humanhood—to believe truly one is fully human and to believe truly that whites can accept one's black humanity. This utopian endeavor indeed is crippled by black self-hatred and white contempt, yet the underlying fire that sustains it is not extinguished by them. Rather this fire is fueled by the dogged fortitude of ordinary black folk who decide that if they cannot be truly free, they can, at least, be fully themselves. Pippin's art portrays black people as "fully themselves"—that is, as they are outside of the white normative gaze that requires elaborate masks and intricate posturing for black survival and sanity. This does not mean that behind the masks one finds the "real faces" of black folk or that beneath the posturing one sees the "true gestures" of black bodies. Instead, Pippin's art suggests that black people within the white normative gaze wear certain kind of masks and enact particular kinds of postures, and outside the white normative gaze wear other kind of masks and enact different sort of postures. In short, black people tend to behave differently when they are "outside the white world"—though how they behave within black spaces is shaped by their battles with self-hatred and white contempt.

As I noted earlier, Pippin's art reminds one of Sterling Brown's poetry or Bessie Smith's music, in that all three artists reject the two dominant models of black art in the *white* world at the time: black art as expressive of the "new Negro" and black art as protest. Instead they build on the major paradigm of black art in the *black* world: black art as healing, soothing yet humorously unsettling illuminations of what it means to be human in black skin in America.

Pippin's work appears a decade or so after the celebrated Harlem Renaissance. This fascinating moment in black culture remains a highly contested one in regard to what it was and what it means. A renaissance is a rebirth by means of recovering a classical heritage heretofore overlooked or ignored. Do the works of the major artists of the Harlem Renaissance—Countee Cullen, Claude McKay, Nella Larsen, Jessie Fauset, Rudolf Fisher, Wallace Thurman, early Aaron Douglas and others—engage in such a recovery? I think not. Instead of serious and substantive attempts to recover the culturally hybrid heritage of black folk, we witnessed the cantankerous reportage of a black, middle-class identity crisis. The Harlem Renaissance was not so much a genuine renaissance, but rather yearning for a renaissance aborted by its major artists owing to a conscious distance from the very cultural creativity they desired. In this sense, the Harlem Renaissance was a self-complimentary construct concocted by rising, black, middle-class, artistic figures to gain attention for their own anxieties at the expense of their individual and social identities, and to acquire authority to impose their conceptions of legitimate forms of black cultural productions on black America.

The dominant theme of romanticizing the "primitivism" of poor black folk and showing how such "primitivism" fundamentally affects the plights and predicaments of refined and educated, black, middle-class individuals (Claude McKay's best-seller *Home to Harlem* is paradigmatic here) looms large in the Harlem Renaissance. This theme fits in well with the crisis in European and American civilization after World War I. The war was the end of an epoch—an epoch regulated by nineteenth-century illusions of inevitable progress and perennial stability for emerging industrial societies. With the shattering of European self-confidence—as history is viewed no longer as a train for smooth amelioration but rather as Joyce's "nightmare" or Eliot's "immense panorama of futility and anarchy"—appetites for "primitivism" were whetted. With the rise of non-Western nations—Japan's victory

over Russia (1905), revolutions in Persia (1905), Turkey (1907), Mexico (1911), China (1912)—ferocious nationalisms appealed to machismo-driven myths of virility and vitality as Woodrow Wilson's Fourteen Points squared off against Lenin's doctrine of national self-determination. The economic boom in the United States, facilitated by economic expansionism abroad (especially the takeover of Latin American markets from Britain after the war) and protectionism at home, ushered in mass communications (radio, phonograph, and talking film) and mass culture for the middle classes—a mass culture already saturated with black cultural products. The great talents of George Gershwin, Jerome Kern, Benny Goodman, and Paul Whiteman rest in large part on the undeniable genius of Louis Armstrong, Duke Ellington, Bessie Smith, and Ma Rainey. Lastly, the great migration of black people from the Jim and Jane Crow South to the industrial urban centers of the North produced not only social dislocation, cultural disorientation, and personal disillusionment, it also contributed to the makings of a massive political movement (Marcus Garvey's Universal Negro Improvement Association) and the refinement of the great black cultural renaissance actually taking place far removed from most of the Harlem Renaissance artists and critics—the evolution of jazz in New Orleans, St. Louis, Memphis, and Chicago.

Like its European counterpart in France (the Negritude movement led by Léopold Senghor), the Harlem Renaissance conceived of black art as the refined expressions of the new Negro. In the exemplary text of the Harlem Renaissance, *The New Negro* (1925)—"its bible," as rightly noted by Arnold Rampersad[14]—black art is conceived to be the imposition of form on the rich substance of black folk culture. Influenced by the high modernisms of Europe, and suspicious of art forms already operative in black folk culture (e.g. blues, dance, sermon, sports—none of which are examined in *The New Negro*) Alain Locke states

> there is ample evidence of a New Negro in the latest phases of social change and progress, but still more in the internal world of the Negro mind and spirit. Here in the very heart of the folk-spirit are the essential forces, and folk interpretation is truly vital and representative only in terms of these. (Foreword)

These "essential forces" of the folk, primitive, raw, coarse, and unrefined, require the skills of cultivated and educated artists to disclose black life to the world. In the only essay on jazz in *The New Negro,* by J. A. Rogers, this Lockean aesthetic attitude is amplified:

> Yet in spite of its present vices and vulgarizations, its sex informalities, its morally anarchic spirit, jazz has a popular mission to perform. Joy after all, has a physical basis. . . . Moreover, jazz with its mocking disregard for formality is a leveller and makes for democracy. The jazz spirit, being primitive, demands more frankness and sincerity. . . . And so this new spirit of joy and spontaneity may itself play the role of reformer. Where at present it vulgarizes, with more wholesome growth in the future, it may on the contrary truly democratize. At all events, jazz is rejuvenation, a recharging of the batteries of civilization with primitive new vigor. It has come to stay, and they are wise, who instead of protesting against it, try to lift and divert it into noble channels. ("Jazz at Home," pp. 223–24)

For Rogers, jazz is not a distinct art form with its own integrity and cultivated artists. Instead it is a primitive energy in search of political funnels that will expand American

democracy. In fact, he claims that jazz is popular because, after the horrors of the war, "in its fresh joyousness men found a temporary forgetfulness, infinitely less harmful than drugs or alcohol" (pp. 222–23). Locke would not go this far in his therapeutic view of folk culture and his modernist conception of art—yet Locke and Rogers agree that popular culture is not a place where art resides but rather provides raw material for sophisticated artists (with university pedigrees and usually white patrons) to create expressions of the "New Negro."

Pippin's Emersonian sensibility rejects this highly influential view of black art—a view that shaped the crucial activities of the Harmon Foundation.[15] And although Locke recognized Pippin's genius in 1947, it is doubtful whether he would have in 1925.[16] Like Sterling Brown or Bessie Smith, Pippin is less concerned about expressing the sense of being a "New Negro" and more focused on artistic rendering of the extraordinariness of ordinary black folk then and now. The "New Negro" still seems too preoccupied with how black folk appear to the white normative gaze, too obsessed with showing white people how sophisticated they are, how worthy of white validation and recognition. For Pippin, such validation and recognition is fine, yet only if it does not lead him to violate the integrity of his art or blind him to the rich experiences of ordinary black folk while trying to peddle "the black experience" to white America.

The next dominant conception of black art as protest emerged after the collapse of the Harlem Renaissance, principally owing to the depression. The great black literary artwork of protest was Richard Wright's *Native Son* (1940). This conception of black art displaced the sophisticated and cultivated New Negro with the outraged and angry Mad Negro. Gone were the attempts to distance oneself from the uncouth, "primitive" black masses. In place of the sentimental journeys behind the veil to see how black folk live and are, we got the pervasive physical and psychic violence of black life turned outward to white America.

The irony of the view of black art as protest—as description of the inhuman circumstances of much of black life and as heartfelt resistance to these circumstances—is that it is still preoccupied with the white normative gaze, and it reduces black people to mere reactors to white power. Pippin's *Mr. Prejudice* (1942) contains protest elements, yet it refuses to view the multilayered character of black life as a reaction to the sick dictates of xenophobic America. Pippin's Emersonian orientation refuses to cast art as a primary agent for social change or a central medium for protest—even when he shares the values of those seeking such change or promoting such protest. This kind of redemptive culturalism—the notion that culture can yield political redemption—flies in the face of Pippin's view of black art as those ritualistic activities that heal and soothe, generate laughter and unsettle dogmas, with such style and form that they constitute black ways of being human. To pursue such a conception of black art in a white world obsessed with black incapacities and atavistic proclivities means to run the risk of falling into the traps of "primitivism."

Nearly fifty years after his death, Pippin's art still reminds us of how far we have *not* come in creating new languages and frameworks that do justice to his work, account for his narrow receptions, and stay attuned to the risks he took and the costs he paid. The Horace Pippin exhibition (January 1994) courageously and meticulously mounted by the Pennsylvania Academy of Fine Arts once again puts American art criticism on trial—not for its verdict on Horace Pippin but for how our understandings of Pippin's art force us to reconceive and reform the art world as it now exists.

Notes

1. John Dewey, *Art as Experience* (1934), *Later Works*, 10:278, ed. Jo Ann Boydston (Carbondale: Southern Illinois University Press).

2. Ralph Waldo Emerson, "The American Scholar," *Selected Writings of Ralph Waldo Emerson*, ed. William H. Gilman (New York: New American Library, 1965), p. 239.

3. John Dewey, *Art as Experience*, 10:10–11.

4. Ralph Waldo Emerson, *Emerson in His Journals*, selected and edited by Joel Porte (Cambridge: Harvard University Press, 1982), p. 136.

5. Richard J. Powell, *Homecoming: The Art and Life of William H. Johnson* (Washington, DC: Smithsonian Institution, 1991), p. 138.

6. Alain Locke, "Horace Pippin, 1888–1946," Horace Pippin Memorial Exhibition, exhibition catalogue (Philadelphia: The Art Alliance, 1947).

7. James Clifford, *The Predicament of Culture: Twentieth Century Ethnography, Literature and Art* (Cambridge: Harvard University Press, 1988), p. 196.

8. Samella Lewis, *Art: African American* (New York: Harcourt Brace Jovanovich, 1978), pp. 105–6.

9. Michele Wallace, "Modernism, Postmodernism and the Problem of the Visual in Afro-American Culture," *Out There: Marginalization and Contemporary Cultures*, eds. Russell Ferguson, Martha Gever, Trinh T. Minh-ha, and Cornel West (Cambridge: MIT Press, 1990), pp. 47-48.

10. See "The Cultural Politics of Difference," in *Keeping Faith* by Cornel West (New York: Routledge, 1993).

11. E. P. Richardson, *Painting in America: The Story of 450 Years* (New York: Thomas Y. Crowell, 1956), p. 389.

12. Martin Puryear, introduction to Richard J. Powell, *Homecoming*, p. xix.

13. W. E. B. DuBois, *The Souls of Black Folk* (1903; rpt. New York: Penguin, 1989), introduction by Donald B. Gibson, p. 5.

14. Arnold Rampersad, introduction to *The New Negro*, ed. Alain Locke (New York: Atheneum, 1991), p. ix.

15. For Alain Locke's influence on the intellectual framework that shaped the practices of the William E. Harmon awards for distinguished achievement among Negroes, and the 1928 to 1933 annual Harmon Foundation Exhibitions, see the fine essay by Beryl J. Wright, "The Harmon Foundation in Context: Early Exhibitions and Alain Locke's Concept of a Racial Idiom of Expression," *Against the Odds: African-American Artists and the Harmon Foundation*, ed. Gary A. Reynolds and Beryl J. Wright (Newark, NJ: The Newark Museum, 1989), pp. 13–25. Leslie Bolling was the only "folk artist"—with no formal art training (though he did attend the Harmon Institute and Virginia Union University)—who exhibited with the Harmon Foundation.

16. For Locke's complex development as an art critic—especially his modernist views of African and African American art, see *His Negro Art: Past and Present* (Associates in Negro Folk Education, Albany, NY: The J.B. Lyon Press, 1936). See especially his discussion of the notion of the "primitive" in African and European art, pp. 93–116.

17

In Search of the "Inauthentic"

Disturbing Signs in Contemporary Native American Art

Jean Fisher

For those of us who bridge the gaps within our culture in possession of Indian knowledge, as well as trained artists, I coin the label of "Contemporary Traditionalists."

—James Luna[1]

It was perhaps with more enthusiasm than sobriety that, in 1987, Jimmie Durham and I coordinated an exhibition of contemporary Native American art, "We the People," at Artists Space, New York.[2] Artists from across the country had been invited to submit projects reflecting their local concerns, with the aim of celebrating both the diversity and commonality of Native American experiences. In this way, we hoped to create a context for Native artists in current debates on cultural difference, and to intervene in long-held assumptions about Native American perceptions of contemporary life. The two main spaces of the exhibition were designed, with attempted irony, to draw attention to the conventions of display.[3] The fact that, despite its public popularity, the exhibition was met with near total silence from the art press raised questions about the relations between Native artists and mainstream institutions.[4]

The work itself covered a broad range of media practices, from stone carving to video; what distinguished it, however, was a critical position that not only posed a challenge to Western expectations of what "authentic" Indian art is, but presented an ethical and political critique of the configurations of (neo)colonialism experienced by Native peoples.

I shall argue here that contemporary Native American art presents aesthetic and political strategies that do not conform to the categories usually assigned to it. When the Native artist speaks as the author rather than the bearer of (an other's) meaning, she or he precipitates an epistemological crisis, which exposes the fundamental instability of those knowledges that circumscribe the social and political place of colonized peoples. The present essay traces the contours of this crisis, first, through a brief summary of the persistently colonial nature of the exhibition contexts offered to Native American artists, despite cura-

torial good intentions; and second, through challenges to the coherence of the colonial text posed by the work of two artists in particular, James Luna and Jimmie Durham.

"We the People" was immediately preceded in New York by two institutional shows of particular significance to this debate; " 'Primitivism' in Twentieth-Century Art," at the Museum of Modern Art, 1984, and "Lost and Found Traditions: Native American Art, 1965–1985," at the American Museum of Natural History, 1986. I do not wish to reiterate the critical debates that surrounded the former show, except to note that they illustrated that a modernist and imperialist view of the relationship between Western and non-Western cultures could no longer be sustained, providing added impetus for questions of cultural difference to enter into postmodernist aesthetic discourse.

"Lost and Found," described in the catalogue as a collection of "contemporary traditional" Native American arts, was compiled by the curator of an earlier exhibition of strictly historical arts, "Sacred Circles: Two Thousand Years of North American Art."[5] "Sacred Circles" actually opened in Britain as part of the 1976 Independence Bicentennial celebrations. However, it was contested there by a group of contemporary Native American artists, organized jointly by the American Indian Movement (AIM) and Artists for Democracy, on the grounds that the show failed to acknowledge not only the circumstances under which such collections are formed but also the modern existence of Native peoples.

Historical arts were again hijacked to celebrate settler culture in the more recent "The Spirit Sings/Le Souffle de l'Esprit" at Calgary's Glenbow Museum. Advertised as "the flagship event of the 1988 Olympic Arts Festival" by its corporate sponsor, Shell Canada, it was the target of another "alternative" show, "Re-visions," at the Walter Phillips Gallery in Banff, and a boycott called by the Lubicon Cree in support of a resolution to their land claim and a cessation of the infringement by oil companies on the disputed territory.

"Lost and Found" was an attempt by its curator to demonstrate the survival of Native American "traditions through contemporary examples of tribal processes and artifacts, some of which, however, were "rediscovered" by the curator himself and reintroduced into communities from which they had ostensibly disappeared. Although subtitled "Native American Art 1965–1985," art that engaged with modernist strategies was absent, reproducing a Western tendency to position "ethnic" artists outside the discourses of modern experience.

This promotion of the "tribal" artifact as the signifier of "authentic" Indian art reappeared in the selection of Native American artists for the global art show "Magiciens de la terre" in Paris, 1989 (whose development was heavily dependent on the advice of anthropologists), in a curatorial quest for art "uncontaminated" by Western influence that could be juxtaposed with an elite selection of Euro-American artists, implying that modernist practices somehow possessed less "authenticity" as a means of expressing experience for non-Western artists.[6] Both exhibitions, undoubtedly mindful of the ethnocentric follies of MOMA's "Primitivism," scrupulously authorized and geographically located each work. The catalogue for "Magiciens" also illustrated a world map for each artist that centered his or her place of origin. These strategies were contradictory: while they advanced the notion that the (post)colonial artist possesses the status of a full speaking subject equivalent to that of the Euro-American male artist, ignoring the political and economic relations between the "First" and "Third" Worlds, they reintroduced the centered subject of modernism, which, as postmodern debates (to which the curators laid claim) have argued, now has to be regarded as an untenable Western ideological illusion.

The persistent institutional *reduction* of Native American arts to "ethnographic" spectacle has several implications. The widely held view that aesthetics and scholarship are distinct categories with no responsibility to sociopolitical life means that institutions controlling such discourses are not obliged to interrogate the ideological assumptions of their own practices. This inevitably and conveniently *excludes* the voice of contemporary peoples for whom there may be no such category distinctions, and denies their status as *historical and political* subjects. The emphasis on the "premodern" artifact, decontextualized from its cultural meaning, as in "Magiciens," or displaced into "natural history," as in "Lost and Found," reinforces the notion that Native America has truly vanished,[7] or, in a maneuver that erases five hundred years of ethnocide, that Native America exists in some preindustrial arcadia perpetually available for rediscovery by the next Lieutenant Dunbar, cultural explorer. Indeed, this is the inescapable conclusion to be drawn from the consistency with which "collecting" and "exploring" recur throughout the texts of these exhibitions. But it becomes clear that to explore is not to discover the other's reality.

The persistent refusal of a Native American voice outside the acceptable signs of "Indianicity"—a voice that would indeed contaminate the aesthetic with the political—ensures that the "explorer" secures the coherence of his own boundaries and maintains mastery of the narrative. Moreover, since this coherence demands absolution from a guilty past—a question, as Michael Rogin suggests, of "how to reconcile the elimination of the Indians with the American liberal self-image"—then the repeated return to "exploring" has to be seen as a reinscription and sanitization of history.[8]

Undoubtedly, the obsession with exploring also arises from a recognition that there is something in Native American cultures that exceeds the limits of the prescribed Indian other; and, to be sure, when the explorer seeks this other, as does one of the curators of "Magiciens," it constantly "eludes his grasp;"[9] the other is never where the seeker expects to find him.

I want to pursue this seeker, since Jimmie Durham's theme for "We the People"—"us looking at them looking at us"—and a substantial body of his own work refer directly to the exploratory ethnographic gaze by which the other is structured in the colonial text. But does Durham's theme imply a simple reversal of the Euro-American gaze as it constructed its colonial other—"redness" substituted for "whiteness"? Or does it suggest a far more complex articulation of Native American positions? What, first of all, does the seeker desire to see?

Since the first contact, Native America has been the object of the feverish state of the Euro-American and his obsession with collecting and documenting. Through an elision of the ways by which indigenous peoples, as active and historical subjects in their own right, perceived, or looked back, at the European, the writing of Anglo-Indian history has privileged the perspective of the colonizer, whose story this becomes. Despite the claims of postmodern debate to open a space for the marginal, recent exhibition strategies indicate that this structure remains largely in place. The inclusion of "ethnic" artists in such shows as "The Decade Show," 1990, at New York's New Museum and Studio Museum, suggest that "multiculturalism" is a new variant of "assimilation"—a means by which the mainstream incorporates diverse cultural perspectives, without essentially relinquishing control.

The image-effects of the gaze that both empower colonial discourses (insofar as they form a "knowledge" of the other that facilitates surveillance and control), and disempower it (insofar as an excess always escapes the colonizer's framing devices), are primarily a function

of European desire. By far the most provocative and insightful analyst of this process remains Frantz Fanon. Some years ago Fanon wrote in frustration of Jean-Paul Sartre's relativizing of "negritude" in his reading of historical process. Fanon cites Sartre's dismissal of black experience as symptomatic of the difficulties he faced in entering Western discourse as a black man speaking in his own right, given the existing relations of power between the colonizer and his narrated other.[10] European culture was the privileged term that defined all others, denying the latter a legitimate historical and political space. Fanon recognized that a path to the realization of black selfhoods lay in unraveling the politics of a psychic economy that coerced the colonized person into a masquerade of identification with the white European and his (mis)recognition of black subjectivity "perceived on the level of the body image."[11] "Blackness" was that difference which challenged Eurocentric narratives of an ideal, unitary self-identity.

If not framed in exactly the same way, European perceptions of America's indigenous peoples and seeming unbounded "wilderness" as a state of nature they felt themselves to have transcended clearly provoked a fear of loss of ego boundaries that had, somehow, to be brought under control. Even now, in an era described as postcolonial, which purports to encompass a plurality of voices, indigenous peoples remain bound to a state paternalism that is more disciplinary than benevolent. The suppression of AIM during the 1970s and of the Mohawks at Oka in Quebec in 1990 shows that attempts by Native peoples to organize themselves and air legitimate grievances are still met by institutional violence. The extent to which the latter exceed the demands of the situation, and the unwillingness of authorities to negotiate, suggest that there is no legitimate ground or text from which the colonized person can speak back. If this is so, colonial discourse reduces its subject to an abject state of psychic dependence and inaction, where, as Fanon says of the colonized African, "the goal of his behavior will be The Other (in the guise of the white man), for The Other alone can give him worth."[12]

Following Fanon, Homi Bhabha suggests that the colonial other arises in the space of an ambivalence: between the colonizer's narcissistic identification with what she or he sees as a reflection of an ideal unified image of the self (the sameness of the native), and with what he perceives as a discontinuity or lack of the self (the radical otherness of the native). According to Bhabha, "It is precisely these two forms of 'identification' that constitute the dominant strategy of colonial power exercised in relation to the stereotype which, as a form of multiple and contradictory belief, gives knowledge of difference and simultaneously disavows or masks it."[13] However, the Freudian narcissistic self, fearing loss of ego integrity, "goes out from itself, but not into 'otherness'; it remains one with itself, having simply 'introjected' into its sphere the spatially distinct object."[14]

What gives the configuration of Indian stereotypes its particular nuance is indeed "introjection." As Michael Rogin has meticulously noted, Anglo-Indian relations are inscribed with a familial pathology that casts the state in the role of the (benevolent) father and Indians as children:

> In the white fantasy, Indians remain in the oral stage, sustained by and unseparated from mother nature. They are at once symbols of a lost childhood bliss and, as bad children, repositories of murderous negative projections. Adult independence wreaks vengeance upon its own nostalgia for infant dependence. The Indian's tie with nature must be bro-

ken, literally by uprooting him, figuratively by civilizing him, finally by killing him. . . .
In relation to Indians, whites regressed to the most primitive form of object relation,
namely the annihilation of the object through oral introjection.[15]

Thus the colonial discourse framing Native America has a curiously vampiric configura-
tion. Repression of Native American difference differs from that of India under British
rule, which infiltrated an existent hierarchical Indian society with a civil and legal organiza-
tion administered by a subaltern class schooled in the "British way of life." But the intro-
jective gaze of United States colonialism stages the Native American not as the "partial
presence" of Bhabha's mimic man of the British Raj, but as a disappearance; he is not
"almost the same but not quite": rather, he is not there at all. He has vanished, later to be
mourned and resurrected through a constant return to the signs of his once-having-been-
there—which is what gives the institutional obsession with "tribal" artifacts its particular
psychic charge, and through white hybrids (the character of Lieutenant Dunbar also known
as Dances with Wolves, in the eponymous film is the most recent revenant), by which the
Euro-American white male subject may endlessly incorporate himself as his desired other
in a constant disavowal of its absence. As Jimmie Durham dryly remarked, "At some point
late at night by the campfire, presumably, the Lone Ranger ate Tonto."[16]
 While the United States failed to assimilate fully the Native American body into a
labor economy, it nonetheless, as Edgar Heap of Birds points out, turned its image into
fetishized commodities,[17] or into psychic capital held in reserve as "an insurance policy on
humanness." As Fanon says, quoting a friend, "When the whites feel that they have
become too mechanized, they turn to the men of color and ask them for a little human
sustenance."[18]
 If "Indianicity," as a body of signs, acquires meaning from the symbolic order that pro-
duces it—dominant Euro-American society—Fanon helps us to grasp how Native Amer-
ica might internalize an identity constructed by the colonial text, and its efficacy as a
mechanism of control and dependency. Durham articulates the alienation of the self in the
Imaginary of the Other (the "noble savage," in this case as the feeling of inauthenicity:
"We do not feel that we are real Indians. But each of us carries this 'dark secret' in his
heart, and we never speak about it. . . . For the most part, we just feel guilty, and try to
measure up to the whiteman definition of ourselves."[19] Thus, with the attempted dismem-
berment of traditional Native organizations and the life world that gives them meaning
and authority, the individual, as Fanon says, risks losing his own framework of identity to
the Euro-American systems of signification that take its place and that tell him who he is.
Incapable of accepting difference or ambiguity, this totalizing system appropriates selective
signifiers of the subject people and reassigns them to narrative capable of containing the
threat that difference poses to the coherence of colonial order. Deformed and dislocated
from their "proper" context, these signifiers nevertheless remain recognizably "Indian" and
potential sites of (mis)identification for the people themselves.
 If this is one means of reproducing those knowledges by which colonial discourse strives
to maintain its culture hierarchies, is it impervious to resistance? What interested Fanon
and concerns me here is a question of agency: is the colonized individual irrevocably
trapped in his or her assigned roles, or does a space exist for him or her to develop some
form of emancipatory action?

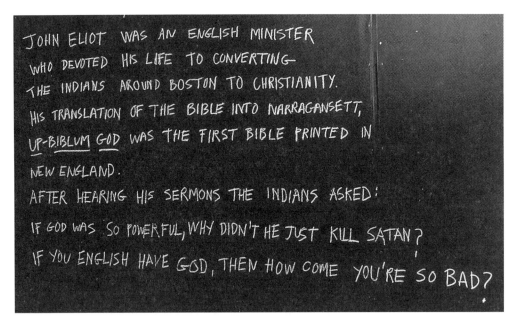

JOHN ELIOT WAS AN ENGLISH MINISTER
WHO DEVOTED HIS LIFE TO CONVERTING
THE INDIANS AROUND BOSTON TO CHRISTIANITY.
HIS TRANSLATION OF THE BIBLE INTO NARRAGANSETT,
UP-BIBLUM GOD WAS THE FIRST BIBLE PRINTED IN
NEW ENGLAND.
AFTER HEARING HIS SERMONS THE INDIANS ASKED:
IF GOD WAS SO POWERFUL, WHY DIDN'T HE JUST KILL SATAN?
IF YOU ENGLISH HAVE GOD, THEN HOW COME YOU'RE SO BAD?

Figure 17.1 Alan Michelson, *Up-Biblum God* from "We the People," mixed media installation, detail, 1987, photo Alan Michelson, Artists Space, New York.

The Mohawk artist Alan Michelson's installation *Up-Biblum God* (fig. 17.1) introduces a historical instance in which the colonizer's gaze was, however momentarily, turned on itself. Michelson recounts an attempt by the English evangelist John Eliot to convert the Narragansett to Christianity. After listening to his sermons, the Indians asked, "If God was so powerful, why didn't he just kill Satan? If you English have God, then how come you're so bad?" Such fractures in the logic of the colonial text suggest the impossibility of a narrative uncontaminated by the voice of its other; indeed, one might begin to ask whether such narratives are formed equally by it, with all the inconsistencies that this implies. Moreover, one might argue that despite the totalizing efforts of colonial discourse and the worst excesses of its practice, local memory and the reservation system have provided the ground for a continuity of Native American social and cultural narratives, tending to confirm Jacques Derrida's contention that "totalizations never succeed in producing a perfect structure of inclusions and exclusions . . . the unassimilable elements determine (and disallow) any totality."[20] It is to these "unassimilable elements," expressed in contemporary art, that I now turn.

During the mid-eighties, both Jimmie Durham and the Luiseño artist James Luna independently made installations referring directly to the ethnographic gaze. Durham's *On Loan from the Museum of the American Indian*, 1985, was a collection of part-found, part-fabricated "artifacts," "sociofacts," and "scientifacts," displayed with printed labels and notes both in a museum vitrine and on the wall (color plate 18). It purported to illustrate the "natural history" of the Indian. However, family photographs, "An Indian Leg Bone," "Real Indian Blood," a series of map diagrams showing "Current Trends in Indian Land Ownership," a story about death by dehydration (a reference to Indian water rights),

among other things, presented a portrait of a body *dismembered* and reassigned to the dead space of the museum. Despite the absurdity of the items, their signs of "Indianicity" led many viewers to mistake them for genuine museum articles, missing the parodic humor in this *mime* of the act of ethnographic surveillance.

Durham's exposure of the ambivalence of accepted signs of "Indianicity" provides a commentary on the primacy of vision as the medium of "knowledge" or "authenticity" in the Western symbolic order, and its assumption that the signifier and signified are analogous. What Roland Barthes describes as a "symbolic consciousness of the sign" is distinguished by a "massive privilege of resemblance," where "the form resembles the content, as if it were actually produced by it." He goes on to say, "Indeed, for the symbolic consciousness, the symbol is much less a (codified) form of communication than an (affective) instrument of participation. . . . What interests it in the sign is the signified; the signifier is always a determined element."[21]

This consciousness characterizes the ethnographic gaze, in which the object, displaced from the cultural knowledge that gave it meaning, as in "Magiciens," becomes a pastiche of itself: the bearer, as *On Loan* points out, of misrecognized signifiers redirected toward meanings authorized by alien systems of signification, coming to rest finally in an affective liberal sentimentalism.

Luna's *The Artifact Piece*, 1987, first installed among the Kumeyaay exhibits at the Museum of Man in San Diego, presented the artist lying on a bed of sand in a museum case, complete with name tag (color plate 17). Accompanying labels drew attention to scars on his body, documenting injuries received during an episode of "excessive drinking."[22] Two additional cases contained the artist's personal documents and ceremonial items from the Luiseño reservation.[23] These, together with the impression of his body in the sand, constituted the signs of his presence at moments when he was absent from the case.

Following the installation of *The Artifact Piece* in "The Decade Show" in New York in 1990, one reviewer had this to say: "The realization that Luna was not an inanimate object was stunning. Who was watching whom? I already had a relationship with this person. What would he do if I talked to him? Touched him? I felt self-conscious staring at Luna, yet I was riveted."[24]

There is a diabolic humor in this parody of the "Indian" in the realm of the "undead." But Luna's work does not look back in any literal sense; it does not simply *reverse* the gaze. (To do so would be to accept the terms of established structures of power, which was a limitation of political activism in art of the 1970s.) If the purpose of the undead Indian of colonialism is to secure the self-identity of the onlooker, the shock of his real presence and the possibility that he may indeed be watching and listening disarms the voyeuristic gaze and denies it its structuring power.

Michel de Certeau claims that this frustration of desire behind the gaze is produced by a *speaking* more than a *visible* body, and that, if I understand him correctly, this evolves from an oral tradition.[25] Marked by scars in Luna's case, and by scars and text in Durham's *Self-Portrait* of 1986, this body "speaks" itself as the site both of colonialism's disciplinary demands and of a possible liberation.

Durham's *Self-Portrait* presents a life-size canvas cutout body, like a two-dimensional target-practice figure or flayed skin, topped by a masklike carved wood-and-bone head. The surface of this "body without organs" is crisscrossed by a doubled language (English

text and "Indian" signs), and a doubled form of address: direct and indirect speech ("Hello! I'm Jimmie Durham . . ."; "Mr. Durham has stated that . . .").

While the work resembles its maker, it is not coincidental with him. Like the assumed Anglo name, this "disabled" body is a feint or masquerade that mimes and parodies stereotypes of "authentic" "Indianicity" (unemployment, alcoholism, sexuality, and so forth); but there is, literally, nothing behind it. Indeed, the masquerade masks a nonidentity (the other is never where he is sought, since he is, in truth, of the Euro-American Imaginary); through its laughter the boundaries of the stereotype are exceeded and the colonial text loses its coherence.

Strictly speaking, the form of aesthetic utterance these artists employ is less a statement or a representation in the Western sense than a performative act—a "speaking" body continuously retracing the boundaries of the self in the world. In such an utterance the art *object* is not necessarily privileged over the *gesture* that informs it or the communal space it addresses.

Does this distinguish a Native American "tradition" from that of Western modernism? In any case, Luna's definition of the "contemporary traditionalist" challenges the interpretation of this term presented by "Lost and Found." Although the persistence of non-Western forms can be argued as evidence of resistance to the hegemony of Western culture, for them to function as such beyond their cultural boundaries depends on a radical reconceptualization of existing conventions of transmission and reception—a fact well understood by Native artists such as Luna and Durham, but that institutions have so far failed to realize. At the same time, a past dependence by Native peoples on institutional definitions of cultural "authenticity" has often seemed a retreat into nostalgia, an avoidance of resolving the conflicts of the present, or a capitulation to the demands of the marketplace. The latter has also been true for much work confined by an imposed European aesthetic, a phenomenon that "gives art a burden of tradition without real value for us."[26]

Luna and Durham express "traditional" aesthetics through what the latter calls "turning around on purpose: acts and perceptions of combining, of making constant connections on many levels."[27] "Tradition," then, lies not in the object itself, but in organizing principles of thought: the dynamics of circulation and return, continuity and change by which Native systems of knowledge synthesize the paradoxes and heterogeneity of life experience. Alien to the European concept of progress, such systems produce art that is transgressive rather than progressive, and resistant to easy commodification.

Its elusiveness lies in the "tricksterlike" mobility with which it dances between a nonmarketable or vernacular speech, which has meaning or value only to the culture that generates it, and the commodifying language of dominant culture referred to by Heap of Birds, which, in Western society, ceaselessly works to erode the former in its demand for a homogeneous consumer.[28] But Native American values, histories, and experiences exceed the representational frame of the European, providing the potential for a constant renewal, transformation, and diversification of cultural meanings. If contemporary Native American art eludes our totalizing efforts to place it, it is perhaps because it is not reducible to our commodifying systems of signification. This is not necessarily because there is a transcendental or impenetrable "authenticity" to Native American cultures, but because "authenticity" is a category of our Euro-American invention—a function of the gaze, which displaces to the margin the otherness it fails to see at the center of our own being.

Postscript: At the time of writing, the full implications of the Indian Arts and Crafts Board Act, Public Law 101-644, passed by the United States Congress in 1990, are now being realized. It is an act designed ostensibly to secure the "authenticity" of Native arts, but I know of no other ethnic group whose artistic identity is legislated by the state, rather than by self-determination.

Notes

1. James Luna. *James Luna,* exh. cat. San Diego: Centro Cultural de la Raza Gallery, 1985.

2. See *We the People,* exh. cat. New York: Artists Space, 1987. The catalogue lists the participants in the exhibition and film/video program.

3. We faced obvious limitations, but the design of the first room was intended to evoke an "ethnographic" display, while the second space attempts to override rectangularity through the curved placement of sculpture pedestals and by flooding the space as far as possible with color and sound (John Ramet, Jr.'s flute music).

4. The show had two reviews, one in a radical but marginal art paper. Lucy R. Lippard, "Holding Up a Mirror to America," *Guardian,* December 16, 1987, and one in an English journal by a reviewer who had clearly never visited the exhibition.

5. See Ralph T. Coe, *Sacred Circles: Two Thousand Years of North American Art,* exh. cat. (London: Hayward Gallery. Arts Council of Great Britain, and the British, American Associates, 1976: and idem, *Lost and Found Traditions: Native American Art, 1965–1985,* exh. cat. New York: American Federation of Arts, 1980.

6. For critiques of "Magiciens de la terre," see Rasheed Araeen, "Our Bauhaus Others' Mudhouse," *Third Text* 6 (Spring 1989): 3–14; and Jean Fisher, "Fictional Histories," *Artforum* 28 (September 1989): 158–62.

7. In a Sunday morning TV arts program, a schoolteacher in the "Lost and Found" exhibition was heard telling her pupils, "These were the kinds of things the Indians used to make when they lived on our land."

8. Michael Rogin, *Ronald Reagan, the Movie and Other Episodes in Political Demonology* (Berkeley: University of California Press. 1978), 134.

9. Mark Francis, "True Stories ou Carte du monde poetique." In *Magiciens de la terre,* exh. cat. (Paris: Centre Georges Pompidou, 1989), 14–15.

10. Frantz Fanon, *Black Skin, White Masks* (London: Pluto Press, 1986), 133.

11. Ibid., 161.

12. Ibid., 134.

13. Homi Bhabha, "The Other Question: Difference, Discrimination and the Discourse of Colonialism," in Francis Barker, Peter Hulme, Margaret Iversen, and Diana Loxley, eds., *Literature, Politics, and Theory* (London: Methuen, 1986), 164.

14. Henry Staten, *Wittgenstein and Derrida* (Oxford: Basil Blackwell, 1985), 152.

15. Rogin, *Ronald Reagan.* 138–39.

16. Jimmie Durham, "Cowboys and . . . ," *Third Text* 12 (Autumn 1990): 11.

17. Edgar Heap of Birds, *Sharp Rocks* (Buffalo: CEPA, 1986).

18. Fanon, *Black Skin,* 129.

19. Jimmie Durham, *Columbus Day* (Minneapolis: West End Press, 1983), 84.

20. Jacques Derrida paraphrased by Robert Young in *White Mythologies: Writing History and the West* (London: Routledge, 1990), 137.

21. Roland Barthes, "The Imagination of the Sign," in *Selected Writings* (Glasgow: Fontana Press, 1989), 213.

22. James Luna, "The Artfact Piece," *Fiction International* 18, no. 1 (1987): 38–42.

23. Judith McWillie, *James Luna: Two Worlds/Two Rooms*, exh. cat. (New York: Intar Gallery, 1989).

24. Elizabeth Hess,"The Decade Show: Breaking and Entering," *Village Voice*, May 1990.

25. Michel de Certeau, "Montaigne's 'Of Cannibals': The Savage 'I'," in *Heterologous Discourse on the Other*, trans. Brian Massumi (Minneapolis: University of Minnesota Press, 1986), 67–79.

26. Jimmie Durham, "Ni' Go Tlunh A Doh Ka [We Are Always Turning Around on Purpose]," in *Ni' Go Tlunh A Doh Ka,* exh. cat. (Old Westbury: Amelie A. Wallace Gallery, State University of New York, 1986), 1. The exhibition was curated by Jess Fisher and Jimmie Durham.

27. Ibid., 2.

28. This thought was prompted by Ivan Illich, "Vernacular Values," in *The Schmacher Lectures* (1980), ed. Satish Kumar (London: Abacus, 1982), 70–79.

18

Altars of Sacrifice

Re-membering Basquiat

bell hooks

Is your all on the altar of sacrifice laid?
—Black church song

At the opening of the exhibition of Jean-Michel Basquiat's work at the Whitney Museum in the fall of 1992, I wandered through the crowd talking to folks about the art. I had just one question. It was about emotional responses to the work. I asked, "What do you feel looking at Basquiat's paintings?" No one I talked with answered the question. People went off on tangents, said what they liked about Basquiat, recalled meetings, talked generally about the show, but something seemed to stand in the way, preventing them from spontaneously articulating the feelings the work evoked. If art moves us—touches our spirit—it is not easily forgotten. Images will reappear in our heads against our will. I often think that many of the works that are canonically labeled "great" are simply those that lingered longest in individual memory. And that they lingered because, while looking at them, someone was moved, touched, taken to another place, momentarily born again.

Those folks who are not moved by Basquiat's work are usually unable to think of it as "great" or even "good" art. Certainly this response seems to characterize much of what mainstream art critics think about Basquiat. Unmoved, they are unable to speak meaningfully about the work. Often with no subtlety or tact, they "diss" the work by obsessively focusing on Basquiat's life or the development of his career, all the while insisting that they are in the best possible position to judge the work's value and significance. A stellar example of this tendency is Adam Gopnik's piece in the *New Yorker*.[1] Undoubtedly it is a difficult task to determine the worth and value of a painter's life and work if one cannot get close enough to feel anything, if indeed one can only stand at a distance.

Ironically, though Basquiat spent much of his short adult life trying to get close to significant white folks in the established art world, he consciously produced art that was a *vattier*, a wall between him and that world. Like a secret chamber that can be opened and entered only by those who can decipher hidden codes, Basquiat's painting challenges folks

who think that by merely looking they can "see." Calling attention to this aspect of Basquiat's style, Robert Storr has written, "Everything about his work is knowing, and much is *about* knowing."[2] Yet the work resists "knowing," offers none of the loose and generous hospitality Basquiat was willing to freely give as a person.

Designed to be a closed door, Basquiat's work holds no warm welcome for those who approach it with a narrow Eurocentric gaze. That gaze which can recognize Basquiat only if he is in the company of Warhol or some other highly visible white figure. That gaze which can value Basquiat only if he can be seen as part of a continuum of contemporary American art with a genealogy traced through white males: Pollock, de Kooning, Rauschenberg, Twombly, and on to Andy. Rarely does anyone connect Basquiat's work to traditions of African-American art history. While it is obvious that Basquiat was influenced and inspired by the work of established white male artists, the content of his work does not neatly converge with theirs. Even when Basquiat can be placed stylistically in the exclusive white-male art club that denies entry to most black artists, his subject matter—his content—always separates him once again, and defamiliarizes him.

It is the content of Basquiat's work that serves as a barrier, challenging the Eurocentric gaze that commodifies, appropriates, and celebrates. In keeping with the codes of that street culture he loved so much, Basquiat's work is in-your-face. It confronts different eyes in different ways. Looking at the work from a Eurocentric perspective, one sees and values only those aspects that mimic familiar white Western artistic traditions. Looking at the work from a more inclusive standpoint, we are all better able to see the dynamism springing from the convergence, contact, and conflict of varied traditions. Many artistic black folks I know, including myself, celebrate this inclusive dimension of Basquiat, a dimension emphasized in an insightful discussion of his life and work by his close friend, the artist and rapper Fred Braithwaite (a.k.a. Fab 5 Freddy). Braithwaite acknowledges the sweetness of their artistic bonding, and says that it had to do with their shared openness to any influence, the pleasure they took in talking to one another "about other painters as well as about the guys painting on the trains."[3]

Basquiat was in no way secretive about the fact that he was influenced and inspired by the work of white artists. It is the multiple other sources of inspiration and influence that are submerged, lost, when critics are obsessed with seeing him as connected solely to a white Western artistic continuum. These other elements are lost precisely because they are often not seen, or, if seen, not understood. When the art critic Thomas McEvilley suggests that "this black artist was doing exactly what classical-Modernist white artists such as Picasso and Georges Braque had done: deliberately echoing a primitive style," he erases all of Basquiat's distinct connections to a cultural and ancestral memory that linked him directly to "primitive" traditions.[4] This then allows McEvilley to make the absurd suggestion that Basquiat was "behaving like white men who think they are behaving like black men," rather than understand that Basquiat was grappling with both the pull of a genealogy that is fundamentally "black" (rooted in African diasporic "primitive" and "high art" traditions) and a fascination with white Western traditions. Articulating the distance separating traditional Eurocentric art from his own history and destiny and from the collective fate of diasporic black artists and black people, Basquiat's paintings testify.

To bear witness in his work, Basquiat struggled to utter the unspeakable. Prophetically called, he engaged in an extended artistic elaboration of a politics of dehumanization. In

his work, colonization of the black body and mind is marked by the anguish of abandon-
ment, estrangement, dismemberment, and death. Red paint drips like blood on his unti-
tled painting of a black female, identified by a sign that reads "Detail of Maid from
'Olympia.'" A dual critique is occurring here. First, the critique of Western imperialism,
and, then, the critique of the way in which imperialism makes itself heard, the way it is
reproduced in culture and art. This image is ugly and grotesque. That is exactly how it
should be. For what Basquiat unmasks is the ugliness of those traditions. He takes the
Eurocentric valuation of the great and beautiful and demands that we acknowledge the
brutal reality it masks.

The "ugliness" conveyed in Basquiat's paintings is not solely the horror of colonizing
whiteness; it is the tragedy of black complicity and betrayal. Works such as *Irony of a Negro
Policeman* (1981; color plate 19) and *Quality Meats for the Public* (1982) document this
stance. The images are nakedly violent. They speak of dread, of terror, of being torn apart,
ravished. Commodified, appropriated, made to "serve" the interests of white masters, the
black body as Basquiat shows it is incomplete, not fulfilled, never a full image. And even
when he is "calling out" the work of black stars—sports figures, entertainers—there is still
the portrayal of incompleteness, and the message that complicity negates. These works sug-
gest that assimilation and participation in a bourgeois white paradigm can lead to a process
of self-objectification that is just as dehumanizing as any racist assault by white culture.
Content to be only what the oppressors want, this black image can never be fully self-actu-
alized. It must always be represented as fragmented. Expressing a firsthand knowledge of
the way assimilation and objectification lead to isolation, Basquiat's black male figures
stand alone and apart. They are not whole people.

It is much too simplistic a reading to see works such as *Jack Johnson* (1982), *Untitled
(Sugar Ray Robinson)* (1982), and the like, as solely celebrating black culture. Appearing
always in these paintings as half-formed or somehow mutilated, the black male body
becomes, iconographically, a sign of lack and absence. This image of incompleteness mir-
rors those in works that more explicitly critique white imperialism. The painting *Native
Carrying Some Guns, Bibles, Amorites on Safari* (1982) graphically evokes images of incom-
plete blackness. With wicked wit, Basquiat states in the lower right-hand corner of the
work, "I won't even mention gold, (oro)," as though he needed to remind onlookers of a
conscious interrogating strategy behind the skeletal, cartoonlike images.

In Basquiat's work, flesh on the black body is almost always falling away. Like skeletal fig-
ures in the Australian aboriginal bark painting described by Robert Edward (X-ray paintings,
in which the artist depicts external features as well as the internal organs of animals, humans,
and spirits, in order to emphasize "that there is more to a living thing than external appear-
ances"[5]), these figures have been worked down to the bone. To do justice to this work, then,
our gaze must do more than register surface appearances. Daring us to probe the heart of dark-
ness, to move our eyes beyond the colonizing gaze, the paintings ask that we hold in our mem-
ory the bones of the dead while we consider the world of the black immediate, the familiar.

To see and understand these paintings, one must be willing to accept the tragic dimen-
sions of black life. In *The Fire Next Time*, James Baldwin declared that "for the horrors" of
black life "there has been almost no language." He insisted that it was the privacy of black
experience that needed "to be recognized in language." Basquiat's work gives that private
anguish artistic expression.

Stripping away surfaces, Basquiat confronts us with the naked black image. There is no "fleshy" black body to exploit in his work, for that body is diminished, vanishing. Those who long to be seduced by that black body must look elsewhere. It is fitting that the skeletal figures displayed again and again in Basquiat's work resemble the shoe depicted in Gillies Turle's book *The Art of the Maasai*.[6] For both Maasai art and Basquiat's work delineate the violent erasure of a people, their culture and traditions. This erasure is rendered all the more problematic when artifacts of that "vanishing culture" are commodified to enhance the aesthetics of those perpetrating the erasure.

The world of Maasai art is a world of bones. Choosing not to work with pigments when making paintings or decorative art, the Maasai use bones from hunting animals in their art to give expression to their relationship with nature and with their ancestors. Maasai artists believe that bones speak—tell all the necessary cultural information, take the place of history books. Bones become the repository of personal and political history. Maasai art survives as a living memory of the distinctiveness of a black culture that flourished most vigorously when it was undiscovered by the white man. It is this privacy that white imperialism violates and destroys. Turle emphasizes that while the bones are "intense focus points to prime minds into a deeper receptive state," this communicative power is lost on those who are unable to hear bones speak.

Even though socially Basquiat did not "diss" those white folks who could not move beyond surface appearances (stereotypes of entertaining darkies, pet Negroes, and the like), in his work he serves notice on that liberal white public. Calling out their inability to let the notion of racial superiority go, even though it limits and restricts their vision, he mockingly deconstructs their investment in traditions and canons, exposing a collective gaze that is wedded to an aesthetic of white supremacy. The painting *Obnoxious Liberals* (1982) shows us a ruptured history by depicting a mutilated black Samson in chains and then a more contemporary black figure no longer naked but fully clothed in formal attire, who wears on his body a sign that boldly states "Not For Sale." That sign is worn to ward off the overture of the large, almost overbearing white figure in the painting. Despite the incredible energy Basquiat displayed playing the how-to-be-a-famous-artist-in-the-shortest-amount-of-time game—courting the right crowd, making connections, networking his way into high "white" art places—he chose to make his work a space where that process of commodification is critiqued, particularly as it pertains to the black body and soul. Unimpressed by white exoticization of the "Negro," he mocks this process in works that announce an "undiscovered genius of the Mississippi delta," forcing us to question who makes such discoveries and for what reason.

Throughout his work, Basquiat links imperialism to patriarchy, to a phallocentric view of the universe where male egos become attached to a myth of heroism. The image of the crown, a recurring symbol in his work, calls to and mocks the Western obsession with being on top, the ruler. The art historian Robert Farris Thompson suggests that the icon of the crown reflects Basquiat's ongoing fascination with the subject matter of "royalty, heroism, and the streets."[7] McEvilley interprets the crown similarly, seeing it as representative of a "sense of double identity, a royal selfhood somehow lost but dimly remembered."[8] He explains that "in Basquiat's oeuvre, the theme of divine or royal exile was brought down to earth or historicized by the concrete reality of the African diaspora. The king that he once was in another world (and that he would be again when he returned there) could be imagined concretely as a Watusi warrior or Egyptian pharaoh."[9]

There is no doubt that Basquiat was personally obsessed with the idea of glory and fame, but this obsession is also the subject of intense self-interrogation in his paintings. Both Thompson and McEvilley fail to recognize Basquiat's mocking, bitter critique of his own longing for fame. In Basquiat's work the crown is not an unambiguous image. While it may positively speak of the longing for glory and power, it connects that desire to dehumanization, to the general willingness on the part of males globally to commit an unjust act that will lead them to the top. In the painting *Crowns (Peso Neto)* (1981), black figures wear crowns but are sharply contrasted with the lone white figure wearing a crown, for it is that figure that looms large, overseeing a shadowy world, as well as the world of black glory.

In much of Basquiat's work the struggle for cultural hegemony in the West is depicted as a struggle between men. Racialized, it is a struggle between black men and white men over who will dominate. In *Charles the First* (1982), we are told, "Most Young Kings Get Their [*sic*] Head Cut Off." Evoking a political and sexual metaphor that fuses the fear of castration with the longing to assert dominance, Basquiat makes it clear that black masculinity is irrevocably linked to white masculinity by virtue of a shared obsession with conquest, both sexual and political.

Historically, competition between black and white males has been highlighted in the sports arena. Basquiat extends that field of competition into the realm of the cultural (the poster of him and Andy Warhol duking it out in boxing attire is not as innocent and playful as it appears to be), and the territory is music—in particular, jazz. Basquiat's work calls attention to the innovative power of black male jazz musicians, whom he reveres as creative father figures. Their presence and work embody for him a spirit of triumph. He sees their creativity exceeding that of their white counterparts. They enable him not only to give birth to himself as black genius but also to accept the wisdom of an inclusive standpoint.

Braithwaite affirms that Basquiat felt there was a cultural fusion and synthesis in the work of black male jazz musicians that mirrored his own aspirations. This connection is misunderstood and belittled by Gopnik in his essay "Madison Avenue Primitive" (note the derision the title conveys) when he arrogantly voices his indignation at Basquiat's work being linked with that of great black jazz musicians. With the graciousness and high-handedness of an old-world paternalistic colonizer, Gopnik declares that he can accept that the curator of the Basquiat show attempted to place the artist in a high-art tradition: "No harm, perhaps, is done by this, or by the endless comparisons in the catalogue of Basquiat to Goya, Picasso, and other big names." But, Gopnik fumes, "What *is* unforgivable is the endless comparisons in the catalogue essays of Basquiat to the masters of American jazz."[10]

Gopnik speaks about Basquiat's own attempts to play jazz and then proceeds to tell us what a lousy musician Basquiat "really" was. He misses the point. Basquiat never assumed that his musical talent was the same as that of jazz greats. His attempt to link his work to black jazz musicians was not an assertion of his own musical or artistic ability. It was a declaration of respect for the creative genius of jazz. He was awed by all the avant-garde dimensions of the music that affirm fusion, mixing, improvisation. And he felt a strong affinity with jazz artists in the shared will to push against the boundaries of conventional (white) artistic tastes. Celebrating that sense of connection in his work, Basquiat creates a black artistic community that can include him. In reality, he did not live long enough to search out such a community and claim a space of belonging. The only space he could claim was that of shared fame.

Fame, symbolized by the crown, is offered as the only possible path to subjectivity for the black male artist. To be unfamous is to be rendered invisible. Therefore, one is without choice. You either enter the phallocentric battlefield of representation and play the game or you are doomed to exist outside history. Basquiat wanted a place in history, and he played the game. In trying to make a place for himself—for blackness—in the established art world, he assumed the role of employer/colonizer. Wanting to make an intervention with his life and work, he inverted the image of the white colonizer.

Basquiat journeyed into the heart of whiteness. White territory he named as a savage and brutal place. The journey is embarked upon with no certainty of return. Nor is there any way to know what you will find or who you will be at journey's end. Braithwaite declares, "The unfortunate thing was, once one did figure out how to get into the art world, it was like, Well, shit, where am I? You've pulled off this amazing feat, you've waltzed your way right into the thick of it, and probably faster than anybody in history, but once you got in you were standing around wondering where you were. And then, Who's here with me?"[11] Recognizing art-world fame to be a male game, one that he could play, working the stereotypical darky image, playing the trickster, Basquiat understood that he was risking his life—that his journey was all about sacrifice.

What must be sacrificed in relation to oneself is that which has no place in whiteness. To be seen by the white art world, to be known, Basquiat had to remake himself, to create from the perspective of the white imagination. He had to become both native and nonnative at the same time—to assume the blackness defined by the white imagination and the blackness that is not unlike whiteness. As the anthropologist A. David Napier explains, "Strangers within our midst are indeed the strangest of all—not because they are so alien, but because they are so close to us. And so many legends of 'wildmen,' wandering Jews, and feral children remind us, strangers must be like us but different. They cannot be completely exotic, for, were they so, we could not recognize them."[12]

For the white art world to recognize Basquiat, he had to sacrifice those parts of himself they would not be interested in or fascinated by. Black but assimilated, Basquiat claimed the space of the exotic as though it were a new frontier, waiting only to be colonized. He made of that cultural space within whiteness (the land of the exotic) a location where he would be remembered in history even as he simultaneously created art that unsparingly interrogates such mutilation and self-distortion. As the cultural critic Greg Tate asserts in "Nobody Loves a Genius Child," for Basquiat "making it . . . meant going down in history, ranked beside the Great White Fathers of Western painting in the eyes of the major critics, museum curators and art historians who ultimately determine such things."[13]

Willingly making the sacrifice in no way freed Basquiat from the pain of that sacrifice. The pain erupts in the private space of his work. It is amazing that so few critics discuss configurations of pain in Basquiat's work, emphasizing instead its playfulness, its celebratory qualities. This reduces his painting to spectacles, making the work a mere extension of the minstrel show that Basquiat frequently turned his life into. Private pain could be explored in art because he knew that a certain world "caught" looking would not see it, would not even expect to find it there. Francesco Pellizzi begins to speak about this pain in his essay "Black and White All Over: Poetry and Desolation Painting," when he identifies Basquiat's offerings as "self-immolations, Sacrifices of the Self" that do not emerge "from

desire, but from the desert of hope."[14] Rituals of sacrifice stem from the inner workings of spirit that inform the outer manifestation.

Basquiat's paintings bear witness, mirror this almost spiritual understanding. They expose and speak of the anguish of sacrifice. A text of absence and loss, they echo the sorrow of what has been given over and given up. McEvilley's insight that "in its spiritual aspect, [Basquiat's] subject matter is orphic—that is, it relates to the ancient myth of the soul as a deity lost, wandering from its true home, and temporarily imprisoned in a degradingly limited body," appropriately characterizes that anguish.[15] What limits the body in Basquiat's work is the construction of maleness as lack. To be male, caught up in the endless cycle of conquest, is to lose out in the realm of fulfillment.

Significantly, there are few references in Basquiat's work that connect him with a world of blackness that is female or to a world of influences and inspirations that are female. That Basquiat, for the most part, disavows a connection to the female in his work is a profound and revealing gap that illuminates and expands our vision of him and his work. Simplistic pseudo-psychoanalytic readings of his life and work lead critics to suggest that Basquiat was a perpetual boy always in search of the father. In an essay included in the Whitney catalogue the critic Rene Ricard insists, "Andy represented to Jean the 'Good White Father' Jean had been searching for since his teenage years. Jean's mother has always been a mystery to me. I never met her. She lives in a hospital, emerging infrequently, to my knowledge. Andy did her portrait. She and Andy were the most important people in Jean's life."[16]

Since Basquiat was attached to his natural father, Gerard, as well as surrounded by other male mentor figures, it seems unlikely that the significant "lack" in his life was an absent father. Perhaps it was the presence of too many fathers—paternalistic cannibals who overshadowed and demanded repression of attention for and memory of the mother or any feminine/female principle—that led Basquiat to be seduced by the metaphoric ritual sacrifice of his fathers, a sort of phallic murder that led to a death of the soul.

The loss of his mother, a shadowy figure trapped in a world of madness that caused her to be shut away, symbolically abandoned and abandoning, may have been the psychic trauma that shaped Basquiat's work. Andy Warhol's portrait of Matilde Basquiat shows us the smiling image of a black Puerto Rican woman. It was this individual, playfully identified by her son as "bruja" (witch), who first saw in Jean-Michel the workings of artistic genius and possibility. His father remembers, "His mother got imperialism started and she pushed him. She was actually a very good artist."[17] Jean-Michel also gave testimony: "I'd say my mother gave me all the primary things. The art came from her."[18] Yet this individual who gave him the lived texts of ancestral knowledge as well as that of the white West is an absent figure in the personal scrapbook of Basquiat as successful artist. It is as if his inability to reconcile the force and power of femaleness with phallocentrism led to the erasure of female presence in his work.

Conflicted in his own sexuality, Basquiat is nevertheless represented in the Whitney catalogue and elsewhere as the stereotypical black stud randomly fucking white women. No importance is attached by critics to the sexual ambiguity that was so central to the Basquiat diva persona. Even while struggling to come to grips with himself as a subject rather than an object, he consistently relied on old patriarchal notions of male identity despite the fact

that he critically associated maleness with imperialism, conquest, greed, endless appetite, and, ultimately, death.

To be in touch with senses and emotions beyond conquest is to enter the realm of the mysterious. This is the oppositional location Basquiat longed for yet could not reach. This is the feared location, associated not with meaningful resistance but with madness, loss, and invisibility. Basquiat's paintings evoke a sense of dread. But the terror there is not for the world as it is, the decentered, disintegrating West, that familiar terrain of death. No, the dread is for that unimagined space, that location where one can live without the "same old shit."

Confined within a process of naming, of documenting violence against the black male self, Basquiat was not able to chart the journey of escape. Napier asserts that "in naming, we relieve ourselves of the burden of actually considering the implication of how a different way of thinking can completely transform the conditions that make for meaningful social relations."[19] A master deconstructivist, Basquiat was not then able to imagine a concrete world of collective solidarities that could alter in any way the status quo. McEvilley sees Basquiat's work as an "iconographic celebration of the idea of the end of the world, or of a certain paradigm of it."[20] While the work clearly calls out this disintegration, the mood of celebration is never sustained. Although Basquiat graphically portrays the disintegration of the West, he mourns the impact of this collapse when it signals doom in black life. Carnivalesque, humorous, playful representations of death and decay merely mask the magic, cover it with a thin veneer of celebration. Clinging to this veneer, folks deny that a reality exists beyond and beneath the mask.

The black gay filmmaker Marlon Riggs recently suggested that many black folks "have striven to maintain secret enclosed spaces within our histories, within our lives, within our psyches about those things which disrupt our sense of self."[21] Despite an addiction to masking/masquerading in his personal life, Basquiat used painting to disintegrate the public image of himself that he created and helped sustain. It is no wonder, then, that his work is subjected to an ongoing critique that questions its "authenticity and value." Failing to accurately represent Basquiat to that white art world that remains confident it "knew" him, critics claim and colonize the work within a theoretical apparatus of appropriation that can diffuse its power by making it always and only spectacle. That sense of "horrific" spectacle is advertised by the paintings chosen to don the covers of every publication on his work, including the Whitney catalogue.

In the conclusion to *The Art of the Maasai*, Turle asserts: "When a continent has had its people enslaved, its resources removed, and its land colonized, the perpetrators of these actions can never agree with contemporary criticism or they would have to condemn themselves."[22] Refusal to confront the necessity of potential self-condemnation makes those who are least moved by Basquiat's work insist that they know it best. Understanding this, Braithwaite articulates the hope that Basquiat's work will be critically reconsidered, that the exhibition at the Whitney will finally compel people to "look at what he did."

But before this can happen, Braithwaite cautions, the established white art world (and, I would add, the Eurocentric, multiethnic viewing public) must first "look at themselves." With insight, Braithwaite insists: "They have to try to erase, if possible, all the racism from their hearts and minds. And then when they look at the paintings they can see the art."[23] Calling for a process of decolonization that is certainly not happening (judging from the

growing number of negative responses to the show), Braithwaite articulates the only possible cultural shift in perspective that could lay the groundwork for a comprehensive critical appreciation of Basquiat's work.

The work by Basquiat that haunts my imagination, that lingers in my memory, is *Riding with Death* (1988). Evoking images of possession, of riding and being ridden in the Haitian *voudoun* sense—as a process of exorcism, one that makes revelation, renewal, and transformation possible—this work subverts the sense of dread provoked by so much of Basquiat's work. In place of dread is the possibility that the black-and-brown figure riding the skeletal white bones is indeed "possessed." Napier invites us to consider possession as "truly an avant-garde activity, in that those in trance are empowered to go to the periphery of what is and can be known, to explore the boundaries, and to return unharmed."[24] No such spirit of possession guarded Jean-Michel Basquiat in his life. Napier reports that "people in trance do not—as performance artists in the West sometimes do—leave wounded bodies in the human world."[25] Basquiat must go down in history as one of the wounded. Yet his art will stand as the testimony that declares with a vengeance: We are more than our pain. That is why I am most moved by the one Basquiat painting that juxtaposes the paradigm of ritual sacrifice with that of ritual recovery and return.

Notes

1. Adam Gopnik, "Madison Avenue Primitive," *New Yorker*, Nov. 9, 1992, pp. 137–139.

2. Robert Storr, "Two Hundred Beats per Minute," in John Cheim, ed., *Basquiat Drawings*, New York, Robert Miller Gallery, 1990.

3. Fred Braithwaite, "Jean-Michel Basquiat," *Interview*, Oct. 1992, p. 119.

4. Thomas McEvilley, "Royal Slumming: Jean-Michel Basquiat Here Below," *Artforum*, Nov. 1992, p. 95.

5. Robert Edward, *Aboriginal Bark Painting*, Adelaide, Rigby Limited, 1959.

6. Gillies Turle, *The Art of the Maasai*, New York, Knopf, 1992.

7. Robert Farris Thompson, "Royalty, Heroism, and the Streets: The Art of Jean-Michel Basquiat," in Richard Marshall, ed., *Jean-Michel Basquiat*, New York, Whitney Museum of American Art, 1992.

8. Thomas McEvilley, "Royal Slumming," p. 96.

9. Ibid.

10. Gopnik, "Madison Avenue Primitive," p. 139.

11. Braithwaite, "Jean-Michel Basquiat," p. 123.

12. A. David Napier, "Culture as Self: The Stranger Within," in *Foreign Bodies: Performance, Art, and Symbolic Anthropology*, Berkeley, University of California Press, 1992, p. 147.

13. Greg Tate, "Nobody Loves a Genius Child," *Village Voice*, Nov. 14, 1989, p. 33.

14. Francesco Pellizzi, "Black and White All Over: Poetry and Desolation Painting," *Jean-Michel Basquiat*, New York, Vrej Baghoomian Gallery, 1989.

15. McEvilley, "Royal Slumming," p. 96.

16. Rene Ricard, "World Crown ©: Bodhisattva with Clenched Mudra," in Marshall, ed., *Jean-Michel Basquiat*, p. 49.

17. Gerard Basquiat, quoted in Marshall, ed., *Jean-Michel Basquiat*, p. 233.

18. Jean-Michel Basquiat, quoted in *Jean-Michel Basquiat*, p. 233.

19. Napier, *Foreign Bodies*, p. 51.

20. McEvilley, "Royal Slumming," p. 97.

21. Kalamu ya Salaam, "Interview with Marlon Riggs," *Black Film Review* 7, no. 3 (fall 1992), p. 8.

22. Turle, *The Art of the Maasai*.

23. Braithwaite, "Jean-Michel Basquiat," p. 140.

24. Napier, *Foreign Bodies*, p. 69.

25. Ibid.

RACE-ing Us

White, Beige, Brown, and Black
in the Twentieth Century

19

International Abstraction in a National Context

Abstract Painting in Korea, 1910–1965

Jae-Ryung Roe

The development of modern abstract painting in Korea is closely connected to the political and social history of the country. The old kingdom of Korea, dubbed the "Hermit Kingdom," had attempted to close its borders to foreign influences. However, by the mid-nineteenth century, Korea became increasingly exposed to the international community and was confronted with forces of integration such as pressure to conduct overseas commerce, military aggressions from foreign empires, religious missions, and tourism. Along with the onslaught of such forces came cultural forms from the West, including a novel mode of painting using new materials, techniques, and aesthetics called *suh'yang hwa* (Western-style painting). Introduced to Korea via Japan, *suh'yang hwa* soon gained followers and secured footing in the art community, making it necessary to define traditional painting in terms of its differences from Western-style painting. The designations *suh'yang hwa* and *dong'yang hwa* (Korean-style painting) came to denote two separate painting cultures, perpetuating the notion that Korean painting was bound to tradition and conventions while Western-style painting was novel and modern.[1]

In 1910 Japan formally annexed Korea and assumed rule of the country. Japanese Army troops shut down local newspapers and political organizations and took control of the educational system. Under colonialism Koreans were required to adopt the Japanese language, the Shinto religion, and Japanese names. A communist movement began in 1921 to regain Korean independence through solidarity among the proletariat.[2] Communism became popular among the cultural elites, and they formed the Korean Artists Proletariat Federation (KAPF) in 1925.[3] Through its national networking and publications, KAPF expanded into a full-fledged cultural movement but failed to expand into a widespread grassroots movement. It did, however, generate genuine debates about art and created an interest in realism and the social function of art.

Despair and anger about a nation under the shackles of colonialism motivated one artist, Chu Kyung (1905–1976), to create pioneering works of abstraction in the *suh'yang hwa* style as early as 1923 (color plate 20). In describing the motive behind his abstract paintings in the 1920s and 1930s, Chu stated, "It was a time when I didn't even understand what being avant-garde was . . . regardless, the paintings came about naturally from my

intentions to organize the dark recesses of my emotions into a structured composition. I found release of my sorrows in my work."[4] Chu's paintings were not the outcome of aesthetic investigation of the fundamental properties in painting, as was the case with the various modes of abstraction in Europe, but instead were expressions of his feelings about the current political situation.

The defeat of Japan and the end of World War II in 1945 marked the end of colonialism. Korean nationalists split between "rightists," those who looked to Western Europe and the United States as models for the liberated nation, and "leftists," those who saw the Soviet Union as the means of national salvation. The Allied forces occupied South Korea for an interim period of 1945 to 1948 and the Soviet Union occupied the North. The U.S. position was to support the rightist faction and enforce its agenda by massive arrests of leftists and by closing down presses.[5] With the Left suffering a major setback, artists of the politically neutral and Right who were previously marginalized came to dominate the art scene.

It was during these postwar years that a number of artists came together to form the *Shin sashil pa* (New Realism Group) in 1947. These artists were trained in Japan, where they had familiarized themselves with the new ideas and modes of painting from the West. Two leading figures of the group were Kim Whanki (1913–1974) and You Young Kuk (b. 1916). Both graduates of Tokyo University, they were associated with noted Japanese modernists such as Sabro Hasegawa and Murai Masmagodo.[6] After studying in Japan, Kim lived in Paris during the 1950s and later moved to New York, where he spent the last ten years of his life. In the late 1930s he began painting abstractions. *Rondo* (1938, fig. 19.1), which was exhibited in a group show in Japan, is an important example of his early assimilation of synthetic Cubism. His work is generally characterized by a brevity of line, bright colors, and repeated forms. As an avid collector of Korean artifacts, he was especially drawn to celadon ware and stated that the imagery of moon, mountains, women, or birds, as well as the colors of these ceramics, gave inspiration to his own works.[7]

Like Kim, You Young Kuk became interested in abstraction in the 1930s. He actively participated in the avant-garde circles in Japan and his work during this time shows a great deal of experimentation. Using collage, photomontage, and assemblage, You investigated the conceptual and physical properties of different materials and the basic properties of painting. He also developed an increasing interest in pure Constructivist and Minimalist abstraction. In the 1950s You began a process of simplifying and rendering into archetypal forms the shapes found in nature such as mountains, the sky, the sea, rocks, the sun, fish, and birds. This was not nature observed but iconographical and conceptual imagery—an abstraction of landscape into a composite of lines, colors, and shapes (color plate 21). In reference to painting, You said that "the basic act of creation is to explore the many diverse forms in nature through the process of composition." Nature served not so much as subject matter but as a means to pursue the painterly in abstraction.

The oeuvres of Kim Whanki and You Young Kuk constitute an important phase in the history of modern painting in Korea. Their abstract paintings set them apart from the academic and realist styles that were prevalent in the mid-twentieth century. The advanced level of abstraction in their work cannot be viewed as an extension of a native school of abstraction, since there was none to speak of, but as an isolated phenomenon and a result of their training and experiences in Japan.

Figure 19.1 Kim Whanki, *Rondo*, 1938, oil on canvas, 60.5 cm × 72.5 cm. © Copyright 1992 Whanki Museum, Seoul. Courtesy National Museum of Contemporary Art, Korea.

The art community in Korea in the 1950s was dominated by conservative academicism and trite figurative painting that had become institutionalized through the *Daehan Min'kuk Misul Dae'jun* (Korean Art Exhibition inaugurated in 1949 by the then Ministry of Culture and Education, referred to in its abbreviated form, *Kuk'jun*). Art historians have surmised that the *Kuk'jun* was a means to police the art community and that it provided a system for official sanction of rightist artists who had been overwhelmed by the activities of the left-ists. For some time the *Kuk'jun* was the only major venue for artists to show work and to receive publicity and recognition. The exhibition was touted as a major national cultural event each year and received extensive press coverage and throngs of viewers who gathered at the exhibition venue as if on an annual pilgrimage.

Founded with the intention to "encourage the development and growth of art in Korea," the power brokerage institution continued its annual exhibition for the next thirty years, finally terminating in 1979, no doubt the longest surviving art institution in modern Korean art history. Only briefly interrupted by the Korean War (1950–53), the *Kuk'jun* per-sisted in South Korea despite military coups d'état, political upheavals, and changes in

administration. It was operated on a mammoth scale; the categories included *dong'yang hwa, suh'yang hwa*, sculpture, crafts, and calligraphy. Submissions to each category were screened by a panel of jurors. This format imitated the *Sun'jun*, the annual exhibition inaugurated in 1922 by the governor-general of Japan in Korea as a mechanism of intervention and surveillance. The conservative academicism and figurative painting that were favored by *Kuk'jun* came to dominate the mainstream, and *Kuk'jun* became a notorious breeding ground for sectarianism and cronyism.

The new administration that came to power in 1963 proclaimed sweeping changes to reorganize *Kuk'jun* under the banner to "unite all artists," and the structure of the exhibition was expanded to incorporate such categories as "figuration," "semiabstraction," an "abstraction." This brought about the participation of mid-career painters working with abstraction who were previously marginalized by the *Kuk'jun* system. That year, for the first time, an abstract painting received the grand prize in the *suh'yang hwa* category. This sudden change was, predictably, perceived as a threat by the *Kuk'jun* establishment artists and they reacted with immediate and fierce resistance and lobbying.

Despite the predominance of the *Kuk'jun*, Korean artists were able to maintain a continuous flow of information about the international art community either via Japan or directly from Europe and the United States. Abstract painting was practiced by a comparatively small number of artists, however, as there was not yet a widespread school or organized group. The progress of modern art in Korea was made possible only by those few individual artists who worked outside of the *Kuk'jun* system, striving to formulate a mode of painting that engaged contemporary art in the international arena and was expressive of the sensibilities and lived experiences of the younger generation. These artists eventually formed groups in order to differentiate their art from that of the establishment.

The *Hyundai milsul hyup'hoe* (Modern Art Association) was founded in 1957. Its members were mostly in their twenties, of the generation that had experienced colonialism, liberation coupled with the ideological battle between Left and Right, and the Korean War. They were also the first generation to have been trained not in Japan but in art colleges in Korea. This group was the leading force behind the first major abstract art movement in Korea, known as *Informel*, that remained strong until 1965. The artists associated with *Informel* regularly held group exhibitions that presented mural-scale nonrepresentational paintings encrusted with thick layers of paint that were applied with sweeping and vigorous brushstrokes. A central artist to this movement, Park Seo-Bo, previously had been painting monochromatic black canvases of distorted human figures which developed into a series that he titled *Primordialis* (color plate 22). Begun after Park's return from a year's visit to Paris in 1961, the *Primordialis* series consists of mostly black backgrounds from which shapes appear, built up with thick layers of encrusted paint that the artist leveled with the palette knife and scraped with a fine-toothed comb. The coarse paint surface was sometimes further emphasized by the addition of hempcloth or the creation of craterlike holes that punctuate the picture surface. During his stay in Paris, Park was impressed by the art of Jean Dubuffet and Antoni Tàpies, whose works also depicted deformed human figures with a vigorous energy and primitivism. Human fate, original sin, and primordial humanity became central tenets of the *Informel* group.

Park Seo-Bo recalls that the elimination of imagery and the transition to large-scale gestural painting came as a sudden revelation one evening. He found the traces of the very act of

painting, the simple yet basic factor of painting a true liberation. Park thereby dismisses any notion of *Informel* as being simply derivative of European and American schools of painting. Such rhetoric about the autonomy and independence of *Informel* painting from foreign influences derives from the desire to construct nativist and nationalist art histories and can create a distorted picture of what actually happened. Rather, art historians have evaluated this mode of painting as the synthesis between the national and international or foreign. The *Informel* movement has therefore been of most significance in the history of modern art in Korea as it was a phenomenon that was not directly influenced by the art scene in Japan, predicated on a postcolonial relationship, but rather was born from the national context—an autonomous movement that was still a part of the international art scene.

Informel by the mid-1960s had become a mannerism onto itself and had lost its vigor and excitement. However, the movement bore many followers, and artists assimilated and quoted the traits of *Informel* painting in their work. The artists of the *Informel* movement were no longer the renegade young generation that defied the establishment but instead had become highly visible artists and represented Korea in such international venues as the Paris Biennale and the São Paulo Biennale. Thus, *Informel* of the 1950s, which had been to some extent dependent on its Western predecessors, was followed by a mode of abstraction that engaged ideas about native traditional aesthetics, as well as by the assimilation of geometrical abstraction and variations of Op art. Expansion and ruptures of boundaries within the art community continued into the 1970s as the number of art institutions grew and as artists experimented with assemblage and conceptual art, happenings, and performance art.

Notes

1. This distinction in painting styles is similar to the Japanese designations of *yoga* (Western-style painting) and *nihonga* (traditional Japanese painting).

2. Donald Clark, *Korea Briefing, 1993* (New York: The Asia Society, 1993), 205.

3. Young Taek Park, "Shik'minji Shidae Saheo Guchoui Misul Un-dongui Sung-gwawa Han-gae" (Socialist Art Movement During Colonialism), in *Gundae Misul Non-chong* (Anthology on Modern Korean Art) (Seoul: Hakgojac, 1992).

4. Sung Rok Suh, *Han'gukui Hyundai Misul* (Contemporary Art in Korea) (Seoul: Moonyae Chool pan'sa, 1994), 18.

5. Clark, 205.

6. Suh, 33.

7. Beom Mo Yoon, *Han'guk Kundai Misului Hyung sung* (The Formation of Modern Art in Korea) (Seoul: Mijin'sa, 1988), 342.

20

The Other Immigrant

The Experiences and Achievements of Afro-Asian Artists in the Metropolis

Rasheed Araeen

The main aim of my essay is to highlight the struggle of what we may call, for the sake of this conference, the "black immigrant artist," and in so doing I will draw your attention to its socio-historical as well as ideological importance for postwar British society. I use the word "immigrant" instead of "migrant" because of the special constraints and restrictions which black or Afro-Asian artists in particular face in their freedom of movement in the West. However, a word of caution would be useful before we proceed further. Under consideration here is not what some people call "black art"—a term which, in my view, should only apply to works produced by black artists which specifically reflect their social experiences vis-à-vis racism. I'm not suggesting that the experience of racism has been confined to some artists and that others escaped from it. But only some artists, particularly of a younger generation who were born in Britain, and who experienced racism while growing up, allowed this experience to be *explicitly* part of their work. If I use the term "black" or "Afro-Asian," it is only to emphasize the racial divisions that still exist in our society today, and which continue to define the role and status of the non-white artist. I use these terms contingently, and without invoking any essential ethnic or racial differences, and I look forward to the day when there will be no need to make distinctions between white and black artists.

It is also important to locate this struggle in postcoloniality, a terrain in which the colonial other struggles to become a historical subject. Paradoxically the journey begins at the moment of the traveler's freedom from colonial bondage, a "slave" liberated to become a "free" traveler in the unending journey of diasporic existence. This may sound like a postmodern cliché, but how else can we describe an experience of the world which cannot easily be located and legitimized in national narratives?

Migration breaks boundaries, whether they are geographical, cultural, or ideological, and provides a space for an adventurous exploration into a new world, into a different future. The idea of adventure may appear preposterous to those who believe that migration only creates painful diaspora, which may inhibit such an exploration. Of course, people also leave their countries through poverty or political oppression, and many of them may find themselves in an extremely unhappy situation abroad. This is a situation which a

new immigrant can face in any country, but the fact of being in a "foreign" land can also be an advantage, particularly for the ambitious artist. Being away from home and somewhat excluded from the social life of the adopted country, the immigrant artist can challenge those ideas which are tied up with the notion of stability, conformity, and loyality to a particular order or entrenched nationalism. It was, in fact, this challenge which played a fundamental role in the modernism of twentieth-century art.

Twentieth-century art represents a great achievement of the immigrant artist, and I'm glad that this conference recognizes the role of migration in shaping our modern social and cultural environment. The continuing challenge of the immigrant artist to the old order has given us a new perception of the world, which may still be Eurocentric but is nevertheless no longer confined to the centrality of the classical European tradition from which the sensibilities of other cultures were excluded. It may perhaps be unnecessary to cite the names of Picasso, Mondrian, Kandinsky, Brancusi, among many others, whose great achievements are, in my view, an homage to the idea of migration, and which in fact inspired hundreds of artists all over the world to migrate to the metropolis of our modern world.

However, it may be premature to declare this century "the Century of the Immigrant" (as mentioned in an earlier announcement of the conference); this century may represent a beginning rather than the end of an era, in which migration, particularly Afro-Asian, will, I believe, play a central role in shaping the future of multicultural Europe. Who can tell what will happen in the next century, given the precariousness of the world today? Perhaps a frightening prospect for those who still believe in the idea of nation-states with singular, homogeneous cultures.

The artistic ambition of the "black immigrant artist" was, in my view, no different from that of earlier artists. I do not therefore make a distinction between the movements of European artists from one country to another in Europe and the arrival in postwar Europe of artists from Asia, Africa, or the Caribbean. But, at the same time, we cannot deny a distinction which Europe (or the West) makes in its treatment of the "others." Unlike the earlier generation of immigrant artists, who were all white European, Afro-Asian artists are seen as outsiders, and their work is considered to be outside the mainstream of twentieth-century art. It is seen to be outside the mainstream not because their contemporaneity is not recognized, but because this contemporaneity is somehow always either specified in relation to "other" cultures, or located within the so-called inauthentic space of "borrowed" experiences. Whatever these artists do, the status and value of their work is already predetermined. The obvious result of this is that we have failed to understand the true nature of their contribution to our modern culture. In Britain, we have only recently recognized the presence of these artists, but their achievement has yet to be acknowledged by the mainstream or enter the annals of art history.

The obvious question which comes to mind now is: why are black or Afro-Asian artists generally invisible or/and excluded from modern discourse or art history, even when the cultural plurality of our society is recognized?

My immediate response to this question would be to raise the issue of racism. But because racism is often confused with racial bigotry, it would distract us from confronting what is intrinsically woven into the institutional fabric of European society and its ethnocentricity. Let us therefore proceed differently.

It is often assumed that the predicament of the so-called ethnic minorities in Europe is due to their inability to come to terms with the cultures of their newly adopted countries, and this inability is attributed to their cultural differences. This view, to some extent, highlights the socioeconomic and cultural problems of the newcomers in general, but it fails to recognize the fact that postwar immigration to Europe comprised many social classes and professions with different aspirations and ambitions. It is often forgotten that most of the artists I refer to came from already Westernized middle classes, and the ambition behind their migration had been to establish themselves as professional artists in the metropolis and within the context of contemporary art practice; and the problem they faced *as artists* had very little to do with the problems of so-called ethnic minority cultures. But, since it is assumed that they are part of their communities—and only their communities whose problems are seen to be intrinsic to their specific cultures, Afro-Asian artists are pushed into communal and essentialist cultural frameworks. After being reduced to "ethnic minority" artists, and being thus denied their own *individual* aspirations, perceptions, and experiences, black or Afro-Asian artists are removed from the authentic space or experiences of the modern age. As a result, all signs of modernity in their work become *in*-authentic representations, making it almost impossible to understand the real significance of their work in their broad social and historical contexts.

I have already dealt, elsewhere, with what underlies the notion of "ethnic minority arts" and its conflation with so-called "primitivism."[1] However, it needs to be pointed out here that "ethnic minority arts" is a form of cultural bantustan which has been imposed upon the Afro-Asian minority in Europe in order to deny its presence and innovative roles within modernism.

This brings me again to the issue of racism, without the discussion of which we cannot talk about the distinction between the white and non-white artists. But in Britain, it is almost impossible to discuss racism at any rational level, for it is only accepted when it is confined to a rhetorical *appeal* to white liberal conscience or benevolence. In fact, whenever the question of institutional racism is raised, the response from the art establishment always comes in the form of either an evasion or some new maneuver to dislodge the whole question altogether. It's still a taboo to talk about or discuss this question within the art world, unlike other spheres of British life where racism is now debated quite openly.

If the story of Afro-Asian artists in Britain is a story of important achievement, it is also a story of failure. It is a story of the failure of this society to understand this achievement. It is a sad story of paternalism, indifference, complacency, and cynicism on the part of those who think themselves to be enlightened, and who think their decisions should never be questioned even when it can be shown that their attitudes and views have been flawed, if not prejudiced, and that they have miserably failed to fulfill their responsibility to a multiracial and multicultural society.

The most obvious consequence of recent immigration in Europe is that postwar Europe is no longer an exclusively white society. It would be a truism to say that in Europe there now live peoples who have brought with them their own cultural traditions and values which are different from those of Europe's Judeo-Christian traditions. It has thus transformed Europe's cultural map. However, it is important to recognize that the ambitions and aspirations of the new immigrants, despite their cultural differences, are no different from the

native population. They may continue to carry with them their own old traditions, but why should this prevent them from demanding their full human rights and becoming active participants in modern Europe? After all, what is pluralism if not the coexistence of many cultures within the same space, and having equal functions?

It is true that postwar immigration has not only altered the demographic map of Europe but has also created many social problems. What is perhaps not fully recognized is that it has also enriched Europe's culture, and has provided it with an opportunity to come to terms with a world which is no longer its empire. But it seems this enrichment has put extra demands on the normal functioning of the European body. Not everyone can digest enriched food, particularly when it tends to appear in the everyday menu. A metaphor of food may not be right here, given the tremendous success of curry and tandoori houses in Britain, but it at least demonstrates that people in general are more open to changes than the few in positions of power who would do anything to maintain the old status quo.

However, the intellectual demand that postwar immigration has put on European culture is something entirely different. It not only invokes what is fundamental to European culture—its universal humanism, enlightenment, and freedom—but also unmasks and challenges that which lies behind these universal aspirations. Confronted by "others," how is it that European culture is unable to recognize, cope with, or understand, in a rational manner, what is a normal demand for human equality? Why is this demand often *confused* with cultural differences? What is remarkable is a peculiar behavior of European intellectuals, who, whenever they are concerned with the "other" world, only see there "primitive" societies. The result is nothing but a fetishization of "premodern" traditions of other cultures and a mere celebration of their differences. Are we here witnessing a collapse of the universal ambition of Western culture (global modernism) or its inability to face its consequences? As I have already said elsewhere, I do not question the necessity of recognizing the importance of all cultural traditions, old and new, but I do worry when other cultures are reduced to stereotypical functions (myth and magic) and are prevented from entering and *critically* functioning within modern discourses. Is there any function for other cultures in Europe (or in the modern world, for that matter) beyond merely offering exotic entertainments?

It is obvious that what we face is an extremely difficult problem, and to reduce it to the common anti-racist rhetoric would not help us understand the ideological complexity of racism in art. However, this rhetoric is not solely responsible for the confusion regarding "black arts" in Britain, in which every Afro-Asian artist is seen to be a "black" artist producing "black art"— another stereotype (which even Anish Kapoor has failed to avoid). If the demand of Afro-Asian artists for their artistic freedom, and for the recognition of their work without being categorized separately, sometimes takes up a rhetorical language, then this demand is answered by a language which is full of assumptions, anomalies, and discrepancies. In fact, the discourse of prevailing art scholarship begins to collapse into trivialities when faced with the work of black or Afro-Asian artists. It is an extraordinary phenomenon, and I think we ought to pay serious attention to it.

But before I illustrate this phenomenon, I must point out that the picture I have painted so far is not as gloomy as it may appear. It is not my aim to suggest that no Afro-Asian artist has been successful, but the question of success at the marketplace is not central to my essay. The role of the art market is, of course, essential in the recognition of the artist,

and in the present system there is no alternative. But the art market only provides an entry into the system, which operates at many different levels. It does not necessarily always provide a full Right/Rite of Passage, by which I mean both the Right and Ritual of the journey from financial success to the value system which guarantees an artist's place in history. It would be naive to suggest that market forces do not affect or control institutional legitimation. But if we leave everything to market forces, would this not be a recipe for an impoverished intellectual life, impinging upon the very objectivity of those liberal scholarships which are fundamental to this legitimation?

There have been, in fact, many successful black or Afro-Asian artists, particularly in the early '60s, in terms not only of financial success but also of considerable critical acclaim. They did not make flower or animal paintings, the kind of work one sees in the backwaters of Bond Street. Their work was firmly located in their experiences of modernism: it was not only about their individual encounters with modernism but also about their experiences of living in postwar British society, and they expressed this in a variety of ways and positions. Some artists also took up avant-garde positions, and *pioneered* some of the ideas which are today very much part of modern history. But what is amazing is that none of these artists managed to enter the history of British art—leaving aside the recent case of Anish Kapoor about whose real position it would be premature to speculate now.

My concern is, therefore, not just about success at the marketplace, or whether black artists are receiving their share of the multicultural funding pie or not. At the end of the day, we are talking about a society which claims to be democratic, and in which all its citizens are supposed to have equal rights: not just economic rights but also the *individual* right to participate culturally. It should be the responsibility of the country to recognize the important contribution of *all* its citizens without categorizing them separately on the basis of ethnicity or race. Being a "foreigner" or an "immigrant" should not matter in a modern pluralist society.

The history of art in Europe in this century shows that there was nothing which particularly restricted the artistic rights of the "immigrant," nor was his or her status defined separately from the native artist. This was also true in the case of Britain.[2] Here are some examples: Henri Gaudier-Brzeska, a French citizen, lived in England for only four years. Naum Gabo, a Russian, arrived in England in 1935 and lived here for about 10 years before moving to America. Their work is part of British history, in spite of the fact that they were not British citizens. Jacob Epstein is regarded as an important *British* sculptor, although he was born in New York. Postwar examples include Anthony Caro and Eduardo Paolozzi, both second generation Italian immigrants; and, of course, we all know that R. B. Kitaj, who lives in London, is recognized as a British artist while being an American citizen.[3]

The point is that it does not *normally* matter who you are and where you come from. The immigrant artist is seen to be part of our global culture: not an outsider, but a nomad whose movement from one country to another is recognized to be important in the spread of ideas. But how is it that this *normality* begins to collapse when faced with what I described in the beginning as the "black immigrant artist"?

How do we explain this anomaly? It's a difficult question to deal with here in its full complexity. However, the quality argument, which has often been used to rubbish and devalue the work of black or Afro-Asian artists, as I will show you later, holds no water. This argument is often no more than the gibberish of those whose task is to defend the

established order at any cost, even if it leads to a total collapse of their intellectual and moral integrity.

Quality in art is not something which can be fully determined by opinions or personal tastes, unless they are informed by an art discourse and represent rational criteria. I hope to show here that rational criteria are seldom used in the case of the black or Afro-Asian artist.

I must also clarify that I have never argued for the acceptance of works of Afro-Asian artists regardless of their artistic or aesthetic merits. In fact I got into trouble with some black artists, not included in "The Other Story" exhibition, who accused me of using white/Western standards. I admit that my tastes and preferences have been informed and formed by the modernism of twentieth-century art, to which Afro-Asians have made an important contribution in Britain, and I make no apologies for not falling into the facile rhetoric of much of the so-called "black art" debate.

What is artistic quality? How is it determined and recognized? Art is a commodity subject to exchange value, but is it a commodity like carrots or potatoes whose exchange value is use value of the kind which is universally recognized? What is the use value of art? Can we quantify it? It's a kind of question whose complexity can drag one into an unending debate. To simplify the matter, it can be said that the exchange value of cultural products (particularly art, for its object-based uniqueness) is determined by the complexity of their cultural functions. In other words, the exchange value of art represents the recognition of its role and place, both material and ideological, in the culture as a whole. It is therefore not just the selling and buying of a work of art that determines its *full* value and status, but its complex institutional function in relation to the ideology or worldview of the society in which art is produced and to which it is attributed at its creation.

It seems that the anomaly faced by black or Afro-Asian artists is the ideology of Western culture, or modernism, which separates its historical formation from that of what it considers to be its racial Others. In so doing, it marginalizes the "others" by relegating them to past histories.

This bring me to "The Other Story" exhibition, which took me more than ten years to realize. It was a difficult struggle, and at times I almost gave up in desperation. But I'm now glad that the exhibition has taken place, whatever its merit, and ultimately it should be the responsibility of this society to respond to it in a manner which can uphold its humanist claims and intellectual integrity.

The main objectives of the exhibition were to give material evidence of the contribution of Afro-Asian artists to mainstream British culture in its postwar period; and to celebrate this achievement in a big way, not at the margins but within a major institution of this country. It was hoped that this would surprise those who are concerned with art and inform those who seek knowledge, and would also help to generate a debate in the light of new information provided by the exhibition about the nature of postwar British art and what has been repressed by its official art history. But what actually happened, as far as any debate was concerned, can only be described as pathetic.

While about twenty-five thousand people visited the Hayward Gallery, and showed tremendous enthusiasm and admiration for what they saw in the exhibition, the media had a field day in renouncing and denouncing it. In one way this was seen to be good, because the controversy created some publicity; but beyond that it was the same old story.

There would have been no need for such an exclusive exhibition if it was not for the intransigence of those who still believe that British art is the exclusive domain of *white* artists. The exhibition clearly demonstrated that this was not so. Afro-Asian artists have been participating within, and in relation to, the mainstream, and also have been bringing to it something which was otherwise missing from it: the black immigrant's experience of the metropolis and its modernity. As for the artistic or aesthetic merits of the works, these were open to critical scrutiny. In fact, we made no extraordinary claims, except that what was being presented was a part of this society's postwar transformational processes, and therefore it belonged to its history. We did not expect our claim to be taken for granted or accepted without being subjected to the critical processes by which all artistic or aesthetic qualities are evaluated. What was perhaps unusual about the works in "The Other Story," in addition to their modernism and avant-gardism, was their representation of the social experiences specific to Afro-Asian immigrants. That this society had not previously confronted such experiences and their representations in art, perhaps accounts for their difficulty of being accepted, but it is a difficulty which could be overcome if there is an intellectual inclination or will to do so; if there is a recognition that critical criteria are not fixed entities but change with time and with a society's social changes. If, for instance, we were to apply nineteenth-century critical approaches to twentieth-century art, most of it would then end up on the rubbish heap of art history.

I'm not suggesting that it was possible to evaluate *fully* this exhibition within the prevailing framework of art criticism or/and art history. But, even if we had applied the prevailing framework with some objectivity and rationality, there would have been a different situation. Instead, there was a total lack of critical and rational response, and an unprecedented hysteria and pettiness, not from the general public, but from those who have a highly respectable place in the art world. Is this an indication of a bankruptcy of the established framework, or of something more serious? The irrational and outright dismissal of the exhibition by the critics was quite common, but I will take up only two examples.

Let us begin with Peter Fuller. The late editor of *Modern Painters* was no ordinary person. I don't have to tell you that he had a highly respectable place in the establishment. In spite of his eccentric and chauvinistic views, which were thought to be controversial, no one dismissed him as a crank.

Writing in *The Sunday Telegraph* Peter Fuller presented himself as a typical white liberal who is progressive and is thus against racism:

A few weeks ago, the national newspaper editors got together and agreed . . . never to mention an individual's color, except where this was deemed to be relevant. Those of a progressive disposition thought this to be "a good thing."

But only last week considerable publicity was given to an exhibition, called *The Other Story* . . . [which] is the first exhibition of contemporary British art held in a major public institution of which the criteria for inclusion are explicitly and exclusively racial. How can this be a good thing?[5]

He then goes on to dismiss the exhibition: " . . . much of the work Araeen has reinstated is quite simply of little, if any, aesthetic or artistic value."[6]

Mr. Fuller criticized the exhibition on the assumption that it was our own choice to have a racially exclusive exhibition,[7] without giving any consideration to what had been happening in Britain over the last forty or so years. On no occasion in the past had Mr. Fuller wondered about, or criticized, those exhibitions which were exclusively white, knowing full well that there were non-European artists around. His suggestion of inverted racism is, therefore, not only an example of hypocrisy but a clever attempt to blame the "victims."

Mr. Fuller had every right to express his opinion. But as a critic writing for a major newspaper, it was expected that he would show some respect to the ethics of his profession. These ethics demand that one acknowledge historical facts, and that one's opinion be determined by the objective framework of what is known as art criticism. I would have, in fact, no hesitation in respecting his judgment if Mr. Fuller had shown some respect for these ethics and not paraded his petty gibberish as art criticism. Listen to this:

> It is not difficult to see why Araeen prefers racial explanations. He trained as an engineer, came to England from Pakistan . . . , and decided to become an avant-garde sculptor. He began by imitating Anthony Caro's work in Industrial Steel I-Beams; but unlike Caro, he had no sculptural imagination, and chose simply to pile up his prefabricated elements in regular stacks.[8]

In trying to demolish me, Mr. Fuller had in fact demolished the very significance of Caro's work by suggesting that his work had something to do with "a pile of prefabricated elements in regular stacks." I don't know if Caro has read this, but I'm sure he would be shocked to know about this reference to his work.

Anyone who has some knowledge and understanding of the sculptural developments in the '60s would know that "a pile of prefabricated elements in regular stacks" cannot be an imitation of the compositional sculpture of Caro. I cannot imagine any serious art critic or historian suggesting that Sol Lewitt's work was an imitation of David Smith. If anybody did, it would be considered an act of extreme ignorance and idiocy. I know Mr. Fuller did not like Minimalism, but why did he not say so? He couldn't, because that would have required him to recognize, unwittingly, something which has been repressed by official art history. It was also possible that Minimalism was, for Mr. Fuller, something "foreign," and it could not therefore fit into his perception of "what's British art?" But then, that exactly was the point of "The Other Story," to question the entrenched white nationalism of British art.

Peter Fuller goes further to demonstrate his ability to twist historical facts by deliberately confusing cause and effect:

> In the '60s the fashion changed to events, performance art, and so forth—so did Araeen. In the '70s, the avant-garde art world went stridently political—so did Araeen. After a visit to Pakistan, he announced that he had joined the Black Panthers; and thenceforth devoted much time to hysterical polemics.[9]

This fits neatly into what is a common Western view about "other": they cannot produce anything original but only follow and imitate the West. However, not many people know that Mr. Fuller had in fact started his campaign to discredit me as soon as he heard that the Hayward Gallery was going to hold this exhibition. I draw your attention to the right-

hand bottom corner of page 61 of *Modern Painters* (No. 2, Summer 1988), where he refers to me as a "Pakki Piss-Artist." This remark was made in the context of an article[10] criticizing the idea of "The Other Story" exhibition long before it was held. One expects this kind of racist abuse in the tabloids of the British press or fascist leaflets. But *Modern Painters* is a respected art journal with a large respectable readership. What was depressing was not that an individual such as Mr. Fuller could fall to such vile tactics, but that there was no single protest from the art world against such abusive language. Silence is the British trick!

It is perhaps unethical to take to task an individual who is no longer living. But I'm not concerned at all with Mr. Fuller as a person, but with the attitudes and views he represents. These attitudes and views may not always be expressed so explicitly, but I have experienced them again and again during my 27 years in Britain; and they have been openly expressed recently as a response to "The Other Story."

Most critics dismissed the exhibition on the basis that it represented mediocre, second-rate, or derivative works, and that they were not surprised that these artists were not recognized, blah, blah, blah. . . . Some also used the success of Anish Kapoor to confuse the issue. It is difficult to mention every critic, but the general attitude was summed up by Brian Sewell whom I would like to quote here at some length. Writing in *The Sunday Times Magazine,* he begins by asking a question: "Why have Afro-Asian artists failed to achieve critical notice and establish a London market for their work?" He then answers it himself: " . . . they are not good enough. They borrow all and contribute nothing." He then continues to conclude:

> The dilemma for the Afro-Asian artist is whether to cling to a native tradition that is either imaginary, long moribund, or from which he is parted by generations and geography, or to throw his lot with an ancient tradition of white western art, from which he borrows, but with which he has scant intellectual or emotional sympathy. Whichever he chooses, he must not require praise, not demand a prime place in the history of art, simply because he is not white. For the moment, the work of Afro-Asian artists in the West is no more than a curiosity, not yet worth even a footnote in any history of twentieth-century western art.[11]

What do you make of it? I don't have to tell you again what underlies this kind of attitude. It's clear that Mr. Sewell was unable to understand or to come to terms with what he saw. I have been told that I should not pay much attention to him, even though he was "Critic of the Year," because he had an eccentric right-wing position. I take the point, but I have yet to encounter a debate in the mainstream art press which would contest Mr. Sewell's views or put forward a sympathetic or different understanding of the exhibition.

Most critics used the word "derivative" to define the works in the exhibition. But what do we mean by this word? Aren't new ideas "derived" from old ones? Don't ideas travel from one place to another, from one individual to another, from one culture to another, to achieve their historical transformations? The word "derive" is not the word I would use, and I have therefore put it in quotation marks. What I'm really concerned with are inspirations and influences. There is nothing unusual or wrong in artists being inspired and influenced by others. When Anthony Caro visited America in 1959 he was inspired by the work of David Smith, and what he did on his return to London was influenced by this visit. Do

we dismiss Caro's work on this basis? Even Peter Fuller, with his hatred of foreign influences and of internationalism, recognized the importance of Caro.

Anthony Caro is indeed a major British sculptor. He singlehandedly changed the direction of British sculpture in the early '60s; he not only influenced his own generation, but also inspired a counter movement among his young students at St. Martins School of Art, such as Richard Long, Barry Flanagan, Bruce McLean, and so on.

Why is this common and recognized phenomenon not accepted or acceptable in the case of black or Afro-Asian artists? Why is it so difficult to accept that those artists who are not European or white could have also been inspired and influenced by modern movements, and in turn could have produced original works of art? What is it that makes the British art world so blind that it is unable to recognize its own important achievement?

The simple answer to all this would perhaps be that British society has not yet accepted Afro-Asian peoples as its equal citizens, and it then ignores their contributions on one pretext or another, because their achievement goes beyond the "ethnic" framework which this society has constructed to contain them as Others. Many Afro-Asian artists have defined this framework, and it seems that this is seen as a threat to the established order.

I have already pointed out elsewhere, that the colonial experience of artists in the so-called Third World countries was part of the modern experience, which created desires and aspirations that led to postcolonial migration. With the physical collapse of the wall between the colonial metropolis and its colonies, there was nothing to prevent the colonized other from traveling to the metropolis and claiming his or her historical subjecthood. But it seems that this confronts the basic ideology of modernism, which, being entangled or conflated with Western national narratives, separates the historical role of the Self and the Other. I don't have to remind you of Hegel, and many others, who seem to suggest that "others" are still trapped in their inescapable collective consciousness.

It seems that we can only enter British (or Western) space through its liberal benevolence, keeping a respectable distance between the "guest" and the "host." We should not claim or demand an active or critical role within it and a place in its history. We should not confront or change its fundamental values, which may be the legacies of its imperial past—which may still be playing an important part in its worldview today.

I'm not suggesting that there have been Afro-Asian geniuses (whatever that means), who have been victims of a deliberate conspiracy or racial bigotry, and thus have been kept out of the history books. But I cannot help asking, again, the questions: why should the history of twentieth-century art only represent *white* European artists and their experiences of the world; why shouldn't the modern experiences of other people be part of this history? These are not easy questions and I'm not looking for easy answers. It is just that we have not yet begun to ask such questions. Only when we begin to think that there might be something which has been repressed, when we recognize that the official history of postwar British art might be incomplete, that we will begin to have a change in our attitude.

This re-thinking would involve a critical examination of the dominant culture, its international and global ambitions. I'm not suggesting that this is not being done. There are many postmodern texts which point to the present crises of modern culture. But my concern is specifically with the prevailing state of radical art scholarship, which recognizes these crises but is still somehow removed from the reality of the "others," as Stuart Hall has put it.

. . . those who are doing formal deconstruction of the most elegant, mannered kind are perfectly in touch with the advanced frontiers of theoretical work, yet their contribution to the resolution of the cultural crises I have just named is nonexistent. . . . It is perfectly possible to write elegant treatises on the "other" without ever having encountered what "otherness" is really like for some people actually to live. It is perfectly possible to invoke the postmodernist paradigm and not understand how easily postmodernism can become a kind of lament for one's own departure from the centre of the world.[12]

The problem with postmodernist texts on art is that they suffer not only from the ignorance of actual facts, but also from the very same Eurocentric assumption which sees "others" outside modernism. It is assumed that modernism was a total disaster for other peoples and their cultures, and that the only alternative now for them is to forget or bypass that historical period. They are thus now being offered a new space, a celebration of premodernity, in such a way that the *problematic relationship* of other cultures to modernism is swept aside as irrelevant. The dominant view is therefore trapped in a kind of pluralism that denies a historical and critical space for others and only encourages celebration of cultural differences.

It is important therefore to locate the crises of modernism within the context of those mainstream discourses specific to art and art scholarship. If the present system of aesthetic interpretation and evaluation is incapable of crossing racial boundries, and/or is inadequate for accounting for the social changes that have taken place in postwar British society (or in the world), then this system must change. In other words, there must occur a radical change in art criticism and art history. But this can only happen when there is a general change in the attitudes of people who are concerned with art, when there is an openness with which one can debate or discuss all sorts of ideas, and without the fear of being ostracized by the art establishment.

Notes

1. Rasheed Araeen, "From Primitivism to Ethnic Arts," *Third Text*, No. 1, Autumn 1987.

2. My aim here is not to contradict Monica Bolun-Duchen's position. Although Jewish artists are now assimilated into the mainstream of Western culture, this does not necessarily resolve the question of anti-Semitism.

3. I could have also mentioned here the names of Mary Kelly and Susan Hiller, both Americans, who have lived in London since early '70s, whose contributions to British art are important, and their positions are also somewhat recognized. But, being women, they do not have the kind of status which is given to their white male contemporaries. And therefore their inscription in the text would have not helped my argument.

4. *The Other Story: Afro-Asian Artists in Post-war Britain*, Hayward Gallery, London, 29 Nov. 1989 to 4 Feb. 1990. The exhibition was initiated, researched, and curated by Rasheed Aracen, and organized by The South Bank Centre, London.

5. Peter Fuller, "Black Artists: Don't Forget Europe," *The Sunday Telegraph*, Dec. 10, 1989.

6. Ibid.

7. My own choice would have been to curate an exhibition of postwar British art which would include both white and black artists, and showed their comparison, but I doubt if I would have received support or funding for such a project.

8. Fuller, op. cit.

9. Ibid.

10. Peter Donner, "The Voice of Redemption: Mr. Rasheed Araeen and Race," *Modern Painters*, Vol. 1, No. 2, Summer 1988, p. 60.

11. Brian Sewell, "Pride or Prejudice?" *The Sunday Times Magazine*, 26 Nov. 1989.

12. Stuart Hall, "The Emergence of Cultural Studies and the Crisis of the Humanities," *OCTOBER*, No. 53, Summer 1990, pp. 22–23.

21

Reframing the Black Subject

Ideology and Fantasy in Contemporary South African Representation

Okwui Enwezor

I

In the house next door to mine in a suburb of Johannesburg, my Afrikaner neighbor makes it a duty every weekend and on public holidays to hoist on his flag pole the blue, white, and orange colors of the old South African nation. Like all symbols of nationalistic identification, this flag raises extreme emotions—either of mortification or nostalgia. It has become rare to find a South African of any race who is not either a staunch supporter of the African National Congress or an anti-apartheid activist, and my new neighbors have made it very clear on which side of the ideological plane their allegiances lie. It seems nothing has changed for these people and thousands of others like them, who still persistently dream of the return of the old nation. Nostalgia, cleansed of poisonous memories, endures, and is thus justified in its almost fatalistic clinging to a relic of racism. In many ways, this defiant use of an old nationalist symbol, with its undisguised, terrifying history, is nothing new or unique. It has companions in the recent Fascist revivalism that has engulfed Europe in the aftermath of the Cold War, with the return of swastika and Nazi symbolism, and in the more enduring history of the Confederacy flag in the southern United States.

Reading this image in the uneasy light that illuminates South Africa's return to the ranks of the modern nations, the flag display reveals, and at the same time masks, certain anxieties around the transition from apartheid to a representative, tolerant, liberal democracy. As I write this, I am listening to the wind snap the stiff cloth and colors of the fading flag. I am fascinated by that sound, by the rituality of my South African companion's forlorn hope. The flag is an ideological prop of longing, the lost dream of a fallen nation whose haunted past is very much part of the present, a sentinel that echoes the ambivalence and the desires of both the new South African nation, and the fantasy of a time fading fast with the bleached tricolor of the old flag. However optimistic one may sound in articulating the new South Africa, we must constantly remind ourselves that while nations may disappear, the ideologies that feed and sustain them, and which form the foundational basis of their creation, are more difficult to eradicate. For they are imaginatively

reconstituted through the use of the surplus resources of their enduring myth as banners to rally adherents.

Thus in late 1996, two years after the legal fall of apartheid, it is hardly revealing to observe the racism and racial suspicion endure as rampant realities of the new South African state. We can hear it in the resplendent, undisguised accent of those anxious voices who still await the return of the owl of Minerva, bearing the news that the experiment was a failure: the "natives" are simply ill-prepared to run a functioning, well-oiled state. In pointing out the above, I am less interested in the fraught political context out of which these issues arise than I am in using the questions they raise to examine issues of representation in a culture that has lived for generations with racist stereotypes as a prevailing attitude. To sketch out the image fully, I want to begin with two analogous depictions that run synchronously through the histories of both the United States of America and of South Africa: *baas* and *massa*; *kaffir* and *nigger*; the Hottentot and the auction block; Jim Crow and apartheid.

The uncanny resemblance of these characterizations is not an accident. For they are both founded on blackness as anathema to the discourse of whiteness; whiteness as a resource out of which the trope of nationality and citizenship is constructed, and everything else that is prior is negated, defaced, marginalized, colonized. By thinking analogously of the two systems of whiteness as official policy, and as a mechanism of bureaucratic normality, I want to extrapolate from the cultural text of the United States a commentary on the fascinating usage in post-apartheid representation of the African body as subject and prop in both the political and cultural expressions of the "New South Africa."

This retrieval of the black figure from the debased image-bank of the former apartheid state is not surprising. Nor is it necessarily new; it is parceled in the experience of a "nation" emerging from one of the most traumatic events of the twentieth century: the long, terrible, insomniac night of apartheid. Dialectically, what one encounters within this scripted and representational presence is a nation seeking a new identity, and thus new images, new geographies, boundaries with which to ballast its strategic and mythological unity as what has come to be known as the "Rainbow Nation," a term coined by Desmond Tutu to describe the multicultural population of South Africa. To put it bluntly, such a search is clearly related to how whiteness and its privileges are presently conceived, interpreted, translated, and used to access the code of a disturbed sense of South African nationality. Thus to examine the charged descriptive detail of what strikes at the mortal heart of the "New South Africa"—multilingual, and hopefully, multivocal—is to keen one's ears to the new uses and revindication of whiteness (in subdued and barely registered forms) as an idiom of cultural identity, that is, as a renewed and authoritative presence in the country's iconographic text.

II

Although today the word "identity" has lost discursive currency, especially as multicultural and postcolonial discourse come under persistent academic attack, it would seem that South Africa has arrived belatedly at such contestations. This belatedness could be attributed to its rearguard position vis-à-vis identity, which up until recently, had been bound to the archaic formulation of whiteness as a nationalistic desire.

To be WHITE is in many senses an ideological fantasy. In discursive terms, it is a fantasy framed in the old mode of nationalist address (pursued with brutal efficiency by old apartheid ideologues); it is the arena in which all kinds of ideological longings converge, and are recovered in terms of a specific sociopolitical agenda and historical formation. Such an agenda and formation have often been replayed in the charged territory of racial pathologies, the kind that Benedict Anderson in *Imagined Communities* described as the magic to turn chance into destiny.[1] This in turn is invested with symbolic signs and positive values of origin, space, and a sense of who occupies that space, who owns it, who lords over it, and for whose benefit it is worked. In the specific example of South Africa, as in the American model, the identity of whiteness binds itself to the exclusionary politics of national discourse. Who is included or excluded from that body politic and on what grounds is their admittance or exclusion ratified?

Until recently in South Africa, as with Germany's *jus sanguinis* ethnic policy, citizenship (nationality) was a special animus that carried the Calvinist symbol of whiteness. For it not only declaimed belonging from the position of exclusion, it effectively rendered millions of the indigenous population *persona non grata*. Under such definition, to challenge the sanctity of whiteness, to represent it adversely, either in writing or image-making, to question the Calvinist ethic of racial purity on which it is founded, is to court terrible reprisals (brutal beatings, ban orders, jail, solitary confinement, exile, death) or to be cast out of the inner sanctum of the *broederbond*. And nowhere is the ideology of this racial fundamentalism in the shaping of national identity more potently manifested than in the arena of sports and visual arts. These are modes of culture that, according to Edward Said, occupy the realm of pleasure and leisure, coarsened by brutal exclusion and primitive racial determinism.[2]

For years, because they were neither citizens nor persons with a national affiliation, black South Africans were not offered the opportunity to participate in the corporate body of national sports, let alone to represent such a body or speak on its behalf. Sports had simply become a purified zone, the hallowed ground upon which white supremacist impulse traded its currency. In art, the museums of South Africa, in their attempt to redress the imbalances of the past, are paying the price for their past neglect of work by African artists, excluded from their collections. Because of this neglect, a process of gobbling up any work of art made by "black" artists has intensified within both public and private institutions in the last ten years. But since the pragmatic value of everything that defines the old South Africa was derived from the interregnum of white nationalism and black resistance—in terms of popular iconography, art, literature, language, and religion—it goes without saying that the birthright of utterances that spoke authentically about the nation, rendered the exactitude of its character, probed its borders and alleviated its insecurity, drew it into the light through all kinds of signifying devices (which included speaking on behalf of the "native"), ultimately belonged to the white interlocutor.

III

But what is it, exactly, that makes whiteness such an exorbitant space of subjectivity, as the unimpeachable and irrefutable testimony of the knowledge of the colonized native? One could hazard—though this might imply an essentialist projection or even a prejudicial

marking—that the tropes of whiteness can be related to what Claire Kahane, following psychoanalytic theory, has called object relations theory. She writes that object relations theory assumes that from birth, the infant engages in formative relationship with objects—entities perceived as separate from the self, either those persons or parts of the body, either existing in the external world or internalized as mental representations.[3]

Is this, then, how the Other is invented and assigned his place on the margins of the nations in the wilderness of incommensurability? The Hottentot Venus, whose supposed horrendous looking vagina is now preserved in formaldehyde in a museum in France, and the black man on the auction block, as objects of denigration, become props of this ideological fantasy, the degenerative sketch from which whiteness stages its purity. These two historical scenes in which the black body has been tendered as display, reproduce the abject as a sign of black identification. Thus, the Hottentot Venus and the black man on the auction block signal a kind of black-genitalia abjection, products of a white masochist enjoyment of black sexuality in its most debased form.

Although today these are thought of as things of the past in reality they remain perversely lodged in popular culture, films, novels, and art in films, the fantasy is of the meaning black criminal or prostitute. In contemporary art, we have Robert Mapplethorpe to thank for furthering the illusion of the black body as an object of enjoyment and spectacle, in short for helping restore it to an aesthetic state of grace.

Olu Oguibe has noted that the introduction of digitalization in our time has sanitized and transformed it into a messless act, and the object of the obliterative act now disappears together with the evidence of its own excision, making erasure an act without trace.[4] These obliterative acts are constantly played out in the resurgence of the black subject as a popular image in all forms of representation in contemporary South Africa.

In the post-apartheid moment of national reconciliation, reconstruction, and unification, we have heard much of the militant black subject who wants to change everything and remake the nation in the illusory image of black identity. Conversely, another enduring popular image has emerged of the sulking white subject who harbors fantasies of an ethnic white *volkstaat* and failing that, either emigrates to Australia or stays behind to complain bitterly about how things have changed. These images represent the polar axes around which the terms of transition are being negotiated. But they are both founded on the basis that notions of whiteness have constituted the terms of national identity and citizenship, and must now either be amended or attenuated and deconstructed in order to reconstitute the new image of the nation as something neither white nor black, but "a rainbow of multiple reflections". Hence, to speak through the territory of both the old and new South African nation and the intersection of black and white subjectivity within their iconographic lexicon, might it be possible to begin with the question of the abject, so as to delineate what binds the subject of the nation to both its object of desire, its internal unity, its frame of stability and to that which disturbs it, calls it into question, sets it adrift?

As part of the experience of apartheid, the primal symptom of whiteness was always in relation to that broad category in which large groups of people were reproduced in the image of the abject, defined by Julia Kristeva as that which "disturbs identity, system, order does not respect borders, positions, rules."[5] Frantz Fanon relates this to that moment when a white child shrinks in horror into her mother's arms, pointing to a black man in a public space as some kind of defilement, a mark of excess, an abscess sprung fresh in the temporal

imagination. "Look a Negro," screamed the child.[6] Here, the Negro becomes an object of fetishistic fascination and disturbance to both the spatial and temporal order. There is a demand both for the repression of his presence and for his objectification, so as to mark out the divide that separates his polluting presence from the stable environment of whiteness: the enclosed suburbia in which he is forever a stranger, a visitor. Within South Africa, the Pass Laws, Separate Amenities Act, Bantu Education Act, Group Areas Act, and so forth, were the mechanisms employed to cleanse territories, coveted by whites, of the scourge of blackness. This schematic trace of the abject as a transgressor of borders and rules is especially disturbing because the abject seems so wholly reproduced in the image of the criminal, the fugitive, the trespasser. This point was necessary in the construction of South African identity, regimented as it was in a color-coded system of appreciation, value, and worth, of which the ideological fantasy of whiteness becomes the marker against which everything is measured, whether as resistance or aspiration.

The racism that instituted and structured apartheid can be said to have been first accommodated by what Edward Said has described in his elaborate study of Orientalism as an ontological and epistemological distinction between the settler population and the indigenous populations.[7] These distinctions, which lie at the root of the colonial project, worked on the premise of two inventions: one, the ontological description of the native as devoid of history, and two, the epistemological description of the native as devoid of knowledge and subjectivity. On each account, the colonial territory grows more expansive as the imaginary map, drawn from the two distinctions, opens further a corporate body of interests in which the native now exists in direct competition for resources—material, history, representation—which culminates in resistance and sets in motion the process of decolonization.

But for this sense of competition to grow into an ideological struggle, it must first be imagined as imperiling either the profitable position of the settler or putting at even greater risk the interests and benefits that accrue from his superiority—that is to say, his race, language, culture, knowledge, history, or the authority with which he narrates history—in short, whiteness. This is the crucial point at which African subjectivity and white interests seem to intersect in the contest of the meaning of identity in post-apartheid South Africa. It appears that the struggle for this meaning hinges on who controls the representational intentionality of the body politic, especially its archive of images, both symbolic and literal.

IV

The colonized man is an envious man. And this the settler knows very well; when their glances meet he ascertains bitterly, always on the defensive, "They want to take our place." It is true, for there is no native who does not dream at least once a day of setting himself up in the settler's place.[8]

Fanon's astute observation of the Manichean universe inhabited by the opposing factions of black and white, and the competing narratives of the native and settler, bears some unadorned truths and demands attention, if at least cursorily. Surely the black South African is envious of the position of the white South African, who has always deigned, and regarded it as natural, to speak on his behalf, for his presence, history, sociopolitical position, and

place within South Africa. Surely the colonized man is an envious man. For he wants to write his own history, to retrieve his own body from the distortive proclivities of white representation. Even though on this account, he is no less willing to succumb to certain ideals of ethnicity, to ideological fantasies of blackness in order to tell his story.

It doesn't matter under which guise it is told (whether it is in the recuperation of the mythological essence of the omnipotent King Shaka as a noble warrior fighting colonial incursions on territories that belong rightfully to Africans) as long as it connects with some atavistic sense of destiny. In other words, he wants to take the place of the settler. And he is no more willing to give up that dream than the settler is willing to concede that key ideological position. For in their historical relationship, the settler always feigns to know his native better than the native knows himself. It is this crucial position that the white South African, which has always been in control of how the eyes perceive the African, is not yet ready to give up. Hence, in recent South African representation, the ideological battle seems to be over the control of the black body, its frame of analysis, the projection site in which its image is refreshed with the new insight of a suddenly untroubled social relation. But according to Fanon the two zones are opposed.

V

If, as Stuart Hall suggested, "identities are the names we give to the different ways we are positioned by, and position ourselves in, the narratives of the past," what happens when suddenly the "narratives of white representation of Africans are challenged by a black counter-narrative? It is no secret that in the aftermath of emancipation it is precisely the terrain of the narratives of the past" that is the most fiercely contested. As we all know, during half a millennium of European presence in South Africa, the specters, the haunted and historic memory, the glow, the consciousness, the metaphorical speech of European identity has stood solidly on a nationalism of white supremacist ideology. In the faded glory of the fallen apartheid republic, workaday speech signals a desire still unfulfilled, a speech currently being unlearned in the space of representation, and within the transitional haze of political and social transformation. If no articulate voices have been heard in this din, it should not be surprising, particularly if one listens within earshot of the contrapuntal narrative of the "native's" agitation to be heard, and the hardened habit of the settler not to listen. At present an impasse exists.

Two years after the official demise of apartheid, Nelson Mandela and the majority of South Africans—black and white—have tried to achieve nothing less than the reinvention of their once-divided country, a new South African identity attempting to shed the wool of its racist past. The drive is for the emergence of a new nation, from one that lived in isolation and mutual suspicion, in competition and as adversaries, to one today described as the last miracle of the twentieth century. Part of the formidable repertoire of images with which the nation has attempted to heal itself is framed in the iconographic technicolor of the "Rainbow Nation." One's understanding of the "Rainbow Nation" has less to do with its mythic dimensions, the uneasy air of ambivalence that visits its every invocation, than with the pragmatic politics of reconstruction that it seeks to articulate: a reborn nationalism. But no one in full honesty believes the "Rainbow Nation to be a long-term

project. Rather, it is a project of accommodation, of armistice, in the absence of which, competition between the various members could again erupt into civil strife. Along this thinking, Rob Nixon has noted that much the strongest current of nationalism in South Africa—that represented by the ANC—is inclusive, nonracial, and premised on a conciliatory unity, not an enforced ethnic homogeneity."[10] But the critics of the "Rainbow Nation" easily ignore this fact.[11] In this regard, one casts an uneasy glance in the direction of KwaZulu Natal, where the cauldron of Zulu nationalism bubbles.

On this note, I want to suggest that nationalism—whether framed in the sectional rhetoric of Zulu nationalism, in the *volkstaat* of Afrikaner nationalism, in the settler colony belief in generic whiteness as an essential way of being, or in blackness as a revolutionary discourse of decolonization—has always been an inextricable reality that frames South African identity. There is no better way to acknowledge this sense of factionalism than in the different responses to the concept of the "Rainbow Nation," particularly that of a white community that suddenly finds itself a minority, and potentially, the underling of its former African vassals. And nowhere has this recent resistance been more fierce than in a representational terrain still dominated by highly literate, but nonetheless unreflexive white cultural practitioners, unblinkingly intent on representing black subjectivity at the margins of cultural and aesthetic discourse. Unmoored from what they have always known—that is, the unquestioned privilege of whiteness from which everything is refracted—the Rainbow now seems a motley reflection of images alien to the old sensibility. Very simply, the Rainbow either opposes or seems antagonistic to whiteness. The Rainbow is what "disturbs identity, system, order. What does not respect borders, positions, rules" has made artistic practice a volatile and transgressive act of realpolitik, for it has suddenly made South Africans clearly aware of how different, culturally, ethnically, and linguistically they are as a "nation." No longer tenable is that hardened position of binaries—black/white, settler/native, colonizer/colonized.

VI

This calls into question what images in a decolonizing South Africa should look like, who has the right to use them, and what the authorizing narrative ought to be. If decolonization is, as Fanon noted, "the meeting of two forces opposed to each other by their very nature"[12]—and one might add, linked by mutual suspicion—is it possible to suggest that the recent conference among Afrikaner intellectuals in Stellenbosch, Western Cape, in a bid to form an organization that will promote Afrikaans language and culture, could be linked to an opposition to the "Rainbow Nation"? Some of their derisive, perhaps even naive, mockery of the "Rainbow Nation," on the level of an ideological promotion of a wounded whiteness, could be seen as separatism in disguise. At least, it seems to suggest that. Judging from the recent convulsive events around the world, this kind of nationalism has persistently made its bid by invoking a certain particularity, by investing its images with a sense of uniqueness, a manifest destiny without which the desire and destiny of the national entity withers. To be potent, the object of nationalist discourse has to see itself as endangered, on the brink of extinction, in need of special protection and reparation.

This is what some of my black South African colleagues found so disturbing about the Stellenbosch conference. Not least because some of its most prominent advocates, such as

the writer Breyten Breytenbach, have strong liberal credentials in the Leftist politics of South Africa, and were staunch anti-apartheid activists. Even so, the Stellenbosch conference was not a display of unanimity on the meaning of what ostensibly may be perceived as Afrikaner chauvinism rearing its ugly head again. Some of the attendees of the conference, such as the poet Antjie Krog—who has writen brilliantly and movingly in the *Weekly Mail & Guardian* about the harrowing testimonies to the Truth and Reconciliation Committee, chronicling past human rights abuses during the political struggle against apartheid—were uneasy about the implications of such a gathering, and made an attempt to distance themselves from any suggestion of reviving Afrikaner nationalism.

To encounter this debate as it unfolds in the disjunctive, uneasy peace of the "New South Africa" is to admit the unfinished business of the transformation of the apartheid state and the huge task of decolonization. It is also to acknowledge the fragility of the post-apartheid nation. For here, the question that could be asked of the Stellenbosch colloquium is: what exactly is it about the "Rainbow Nation" barely two years into reunification that makes Afrikaners so uneasy in terms of their prospects as an ethnic minority in South Africa? Is this response—the inability of a once-dominant white culture to deal with its diminished role and sense of superior entitlement in the cultural and political life of the nation—a preamble to a resurgent Afrikaner nationalism, caught so well in the shadow of the Voortrekker monument in Pretoria? Can one assume that such a colloquium, however well-meaning, is not a pretext for the rallying of the troops below from above?[13]

I want to return to how today this fantasy of whiteness again images the black subject in the old, warped frame of the apartheid era as lacking, at the liminal point of defeat: That is, his story, as spoken through the transitional identity of post-apartheid contemporary representations, is narrated in the past tense, as if the narrators want to stop history; as if everything about the black subject resides only in his pre-linguistic period, in the residue of his diminished state as subject, prior to his act of speech, fixed in his eternal silence. Of course these narratives are cleverly couched in a manner that appears to recover the essence of a black subjectivity suppressed during apartheid.

While the Stellenbosch conferees measure, within listening distance of the nation, the mythological space of the "Rainbow Nation," the site from which Mandela's daydream takes its *fait accompli* attempts to steer a different course, a course in which all ethnicities are recognized as "equal" perforce of the recently ratified constitution. Could one even suggest that in participating in what is seen as a chest-thumping projection of the robust characteristics of Afrikaner speech and subjectivity during a difficult period of reconciliation, the conference was not only ill-advised, but arrogant? And in the face of testimonies of horrible apartheid crimes made to the Truth and Reconciliation Committee that was set up to investigate the murderous policy of the old regime, does this portend a larger lack of sensitivity and accountability to victims of Afrikaner domination? In mounting a drive to promote Afrikaans in such a short space of time, in a volatile period of reconciliation, could these intellectuals be accused of lapsing into a form of amnesia and disavowal of historical memory, characteristic of the Holocaust deniers in post-Nazi Germany? And finally, could this drive for the promotion of Afrikaans as special and endangered be seen as a need to shore up and maintain the dominance of a minority Afrikaner culture? Are some of these progressive white intellectuals still clinging to that old image of the "native" entrapped in muteness?

VII

Perhaps there is a difference between what the colloquium staged, and what the artist attempts when employing the image of the African subject in order to come to terms with South Africa's past, present, and future. But why am I unconvinced by the remonstrative gestures of those artists who sentimentalize African images, who persist with those images that are devoid of conflict, depicting the quietly suffering but still noble African? Since he can't speak for himself, he is spoken for. I want to believe in the sincerity of these gestures, to think that the whiteness of the artists is beside the point.

And, even more strongly, I want to believe that there is no continuation of that old business, which nevertheless still persists, of serving up African culture as spectacle and source of reassuring, harmless entertainment. But my faith is forbiddingly racked by doubt. We easily deceive ourselves, believing that the dividing line of racial discourse is not as baited as it once was. Today, the spectacles of yesterday have returned. The most resourceful and formidable examples of this kind of representation have recently made their appearance in the booming South African tourist industry. In what are described as "Cultural Villages" throughout South Africa, so-called old African customs are being staged for mostly white audiences, in exclusive holiday resorts. In Lesedi Cultural Village in Guateng Province, tourists have their choice of which African fantasy they may sample. Depending on your taste, you might choose Zulu dancing, in which pot-bellied, ferocious-looking men in leopard skins prance and stamp around a bright, burning fire, in a performative, ethnographic Surrealism. Or you can partake in an authentic Xhosa, Pedi, or Sotho domestic scene, replete with the visible iconographical marks of those cultures. In this retrieval of African customs from a besmirched ethnographic cupboard, only those aspects of African culture that entertain are presented. Such are the images of Africans that are beginning to enter the archival bank of the new South African nation.

Of all such cultural villages, Kagga Gamma, a space that does double duty as a game park in the Western Cape, is perhaps the most primitive. At Kagga Gamma, the so-called endangered Bushman has been reinvested as entertainment and put on display. His brief? To put in a performance daily, which could live up to, or approximate, colonial fantasies of his nomadic hunter-gatherer past. For a little more than a subsistence wage, he is given a leather loin cloth, bows and arrows and in full view of the paying guests at Kagga Gamma, performs the task that defines that aspect of his "authentic" past.

A headline in a *New York Times* article in early 1996, which reported on Kagga Gamma, captured the tragedy of this form of representation. It read: "Endangered Bushman Finds Refuge in a Game Park."

VIII

Even after the fall of apartheid, the temptation to retrieve the "native" in his full ethnic regalia remains, evidenced in representations that attempt to address the notion of difference and otherness in these images. While the primary intention of these works may be as critique, the irony is that the artists who embark on them often end up uncritically seduced

by their fascination for the abject and docile bodies of African men, women, and children. Homi Bhabha captures this well when he writes that:

> An important feature of colonial discourse is its dependence on the concept of "fixity" in the ideological construction of otherness. Fixity, as the sign of cultural/historical/racial difference in the discourse of colonialism, is a paradoxical mode of representation: it connotes rigidity and an unchanging order as well as disorder, degeneracy, and demonic repetition. Likewise, the stereotype, which is its major discursive strategy, is a form of knowledge and identification that vacillates between what is always "in place," already known, and something that must be anxiously repeated.[14]

This anxious repetition finds itself inscribed again and again in the almost obsessive usage of old photographic images of Africans or in the ethnographic tourist postcards depicting near-naked African women in a state of colonial arrest. The resulting work is redolent of a time past, if not one quite vanished. But it is the overfamiliarity, and brazen usage of the photographs, many of which were undoubtedly found in curio shops, that attracts one's attention. The subjects, it seems, are attractive because of their anonymity and existence at the margins of history. They have no names, thus they pose the least emotional or ethical threat, and the distance between them and the artist offers a gratifying contextual license to do with the images as one chooses.

Thus Penny Siopis turns the ubiquitous ethnographic postcard of "native" women into large Cibachrome prints, then paints over them and drapes them with assorted paraphernalia, syringes, medical catheters, etc. The surfaces of the large photographs have been worked on for effect, some parts highlighting and other parts covering or erasing certain tell-tale and problematic areas, an effect that recalls what Olu Oguibe has called "the scarred page."[15] By sentimentalizing her images, Siopis turns them into over-aestheticized vessels for pleasurable consumption, untroubled and available. The images are rendered as banal texts, sources of art. A turn-of-the-century photograph of a doleful-looking boy in a suit and hat carrying an ostrich egg is one such image, which appears in Siopis' extensive incursions into this arena of racialized representation. The image has been recolored blue and decorated with vertical borders of baby shoes. It is pure visual candy. The work says very little about the photograph, or who the little boy is, or about the artist's relationship to the image. Instead, what we are given is an aesthetic that reveals a curious ambivalence towards its subject as a social being, and towards the historical impediments that frame his reception within this strategic restaging of African identity through the ghostly outline of his faded form.

Along the same lines, Wayne Barker puts such images on display at the Johannesburg Art Gallery as indigenes, foils to the young artist Piet Pienaar's more revealing critique of identity, stereotype and essentialism. Gunther Herbst appropriates them as kitsch ethnographic symbols of the "native's" Western desire.

On the obverse side of this discourse is photographer Santu Mofokeng's ongoing project *Black Photo Album/Look at Me: 1890–1950s* (1995; fig. 21.1), a meditation on black desire and what it means to be black under colonial domination. Rather than making aesthetic interventions on the images to prove a point as author, he has instead, except for restoring the images, left them as they were. In this sensitive recovery of the private history of black

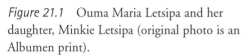

Figure 21.1　Ouma Maria Letsipa and her daughter, Minkie Letsipa (original photo is an Albumen print).

Maria was born to a family of "inboekselings" in Lindley, Orange River Colony now called Orange Free State. Inboekseling loosely translated means forced juvenile apprenticeship in agriculture. Her family became prosperous livestock and grain farmers at the turn of the century. This information was supplied by Emma Mothibe. The image is used courtesy of the Ramela family of Orlando east. Photo: Scholtz Studio, Lindley, Orange River Colony c. 1900s.

families during the colonial period and that leading up to the early stages of apartheid, Mofokeng has ostensibly upset the apple cart, in turn redeploying the archival images of black identity for the recovery of historical memory. By emphasizing the historicity of the subjects who occupy the site of his exhaustive study, Mofokeng has painstakingly searched out the often elusive biographies of the sitters and their families. Their names form part of the larger task in what these images suggest for future usage. Perhaps it is best to use Mofokeng's own words:

> These are images that urban black working and middle-class families in South Africa had commissioned, requested or tacitly sanctioned. They have been left behind by dead relatives, where they sometimes hang on obscure parlor walls in the townships. In some families they are coveted as treasures, displacing totems in discursive narratives about identity, lineage, and personality. And because, to some people, photographs contain the "shadow" of the subject, they are carefully guarded from the ill-will of witches and enemies. . . . If the images are not unique, the individuals in them are. . . . When we look at them we believe them, for they tell us a little about how these people imagined themselves. We see these images in terms determined by the subjects themselves, for they have them as their own.[16]

What is evident is Mofokeng's insistence that the subject be seen as a person possessing a history, identity, and desire. However, it must be understood that far from drawing a positivist sketch of noble Africans, Mofokeng is attempting to tease out an often elusive sense

of black complexity in racialized discourse. Cast neither in the splintered light of deformity, nor in the pathos of a curative nostalgia, his project provides us with at least one of the ways in which an ethical sense of African agency can be used imaginatively.

Willie Bester's multimedia constructions carry the liminal images of the fight against apartheid with a brutal realism that situates the black body in the realm of political struggle and social resistance. He fashions a critique in which the black subject is able to speak, to threaten, to be angry, unbowed within the temporal and spatial history of South Africa. On the other hand, Lien Botha memorializes that body's absence by fragmenting it. In her installation, *Krotoa's Room* (1996), she squares it into a close-up of Krotoa's sad eyes and mouth: simply an "authentic" image of suffering. Botha lights votive candles to the eternalization of the object position of black people in South African history, signing her images, perhaps unknowingly, with the pure mark of the mute African, on whose behalf the metaphoricity, rather than the commensurability of the African subjectivity, is pleaded for by another, by a surrogate voice. Botha's use of the black image recasts another stereotype, of the eternally grateful, eternally noble native, who, despite the most horrendous deprivation and dehumanization, is incapable of hurting a fly.

To represent the black subject as Bester does, in the midst of his violent struggle for emancipation from servitude and denigration, is to pick up another slur, which is his enduring image as the uppity nigger, the smart-alecky *kaffir*, the rebellious native, the runaway, the maroon, the terrorist. It is this sense of radicality that made the preacher in Ralph Ellison's first novel *Invisible Man* defiantly declare, "Black is . . . black ain't." The dominant trope and discursive address of the black subject by these artists is predicated on their overdetermined sense of familiarity with African identity—a sense of themselves thoroughly evoked by Susan Vogel when, to her eternal damnation, she referred to European curators and ethnographers as "intimate outsiders."[17] The black subject, however, continues to elude the primary task of such discourse, which seeks the normalization of the power role of whiteness through the historicizing of black desire.

IX

Such a position of power was evident in the much-discussed exhibition "Miscast: Negotiating the Presence of the Bushmen," curated by the artist Pipa Skotness at the National Gallery of South Africa in Cape Town in April 1996. The show, according to Skotness, was mounted to reveal the horrors suffered by the "Bushmen" in southern Africa at the hands of white settlers and Africans alike. Skotness assigned herself the role of historian, perhaps even custodian, of "Bushman" history. Not one African was invited to join more than fifteen white contributors to the catalogue, to comment on a history in which Africans themselves are implicated. And neither was there a section in which the "Bushman" was called upon to testify on his own behalf. Instead, we heard his "voice" only through the anecdotal voiceover of the white anthropologists commissioned to carry out the research, which Skotness believed to be great material for exhibition in an art museum. As James Clifford has observed, one increasingly common way to manifest the collaborative production of ethnographic knowledge is to quote regularly and at length from informants. . . . Quotations are always staged by the quoter and tend to serve merely as examples or confirming testimonies."[18]

It is not, however, the paternalistic framing of the "Bushman" as a gentle, misunderstood creature hunted to extinction, in a commentary embellished by what Clifford calls "redemptive modes of textualization", that disturbs. It is Skotness' attempt to make out of this history an artistic project.

Accompanying this creative exercise in curatorship was an attempt to stage authenticity through the metonymic presence of objects. Skotness ransacked various ethnographic storerooms, coming up with musical instruments, bows and arrows, bits of ethnic paraphernalia such as bead work, old colonial photographs, and ancient cameras (placed all around the room, surveillance style), anthropological documents, dissecting instruments in illuminated glass cabinets, and numerous shelves bearing cardboard boxes of concealed information on ethnographic expeditions (at least that's what the captions on the boxes suggested). She even had molds of the dismembered body parts of the "Bushmen" cast in wax and displayed on pedestals.

Along two huge walls, she constructed a gridded mural of photo-collages of the "Bushmen," in which she had interspersed and juxtaposed the photographs of various white people. Perhaps the most interesting aspect of this was the disjunction it created between the white subjects and the "Bushmen." Many of the photographs of the "Bushmen" gave one the eerie feeling of looking at police mugshots of criminals or condemned people. But what staged this disjunction so dramatically was the contrast between the totally at ease white faces and the forbiddingly morbid black ones. This did not so much blur the line between the hunter and hunted, between the colonizer and colonized, as it highlighted it, with quite surprising perversity.

Unaware, perhaps, of this perversity, Skotness was escorted by these images into the charnel house of an entirely submerged social history of photographic representation, the archive as a signpost pointing to how difference and otherness are constructed through photographic practice. For what we were confronted with in the panels were two socially constructed positions of knowledge in pitched battle: the white man and the "Bushman." But Skotness' exhibition "contains subordinate, territorialized archives: archives whose semantic interdependence is normally obscured by the 'coherence' and 'mutual exclusivity' of the social groups registered within each."[19] As one wandered through the rooms, bludgeoned by a didactic relativism that at times seemed an act of ironic self-mockery, I was forced to ask what this exhibition was all about. What was the exhibition actually saying, and to whom was it addressing its message? Certainty not to the "Bushmen" who, to the surprise of the curator and the institution, upset the cart by rejecting the message of the exhibition.

Part of the reason for this rejection was their refusal to recognize the body cast as forming any kind of knowledge of their history or world. But most especially it was the linoleum flooring, which Skotness had commissioned, embossed with photographic likenesses of their images invited as special guests to the exhibition opening, the "Bushmen" were horrified at the sight of their images embossed on the linoleum carpet and refused to walk on it. That we as viewers were invited—and in some cases acquiesced—literally to trample the abject figure of the "Bushman" was most disturbing. But it was the "Bushmen's" complete rejection of the carpet that was the most memorable and damning event of the exhibition, effectively vitiating Skotness' attempt to serve as the sympathetic interlocutor of their history, indeed as their historian.

If we hold on to this critique, we will observe how Skotness as curator of this postmodern ethnography took the role of a dilettante, neither ethnographer nor historian, neither of the clan nor confidante, nor "intimate outsider." In her obsessive attempt to raise emotional hackles (as if all we need do is think about the "Bushman" with our hearts rather than our heads), she neglected to take into account that her voice as the authority of history might indeed be contested by the very people she was attempting to recuperate. It is indicative of the ethical blinkers familiar to all redemptive colonial errands that her allegedly exhaustive consultation with the "Bushman" community failed to alert her to the potential violation they may feel in the face of her work. For in reproducing this diapositive image of blackness, in which the historical memory of the "Bushman" was desacralized and appropriated for a kind of colonialist exegesis, Skotness repeated the act of arrest of the native subject at the moment of his fall.

The refusal by the "Bushmen" to assist in the production of a distorted view of their history indicates certain stances of oppositionality that are sometimes enacted by repressed groups in the face of misrepresentation. To bell hooks, the African American experience of repression under slavery had produced "an overwhelming longing to look, a rebellious desire, an appositional gaze. By courageously looking [they] defiantly declared: 'Not only will I stare, I want my look to change reality.' Even in the worst circumstances of domination, the ability to manipulate one's gaze in the face of structures of domination that would contain it, opens up the possibility of agency."[20] It was this failure to contain the gaze of the "Bushman" that caused the discomfort still reverberating in the halls of the South African National Gallery.

It would seem that Skotness, as is often the case with white representations of African history, had assumed that as spectators we all see the same thing, and thus believe that our gazes are constituted and therefore affirmed and defined by the same regime of looking. Such an assumption is not only simplistic, but reductive as well. As Manthia Diawara has suggested, under such a position, "the dominant reading compels the Black spectator to identify with racist inscription of Black character."[21] Difficulty and anxiety arise when the gaze of the black spectator is accounted for, and ends up challenging representations that the white community might have deemed irrefutably conclusive. Therefore, when looking at white representations of African identity, we must allow that positions of spectatorship be recognized, particularly in a racist society, as always conditioned by the economy of racialized interpretation, as well as desire.

It is the non-recognition of the place of the black spectator as an affirmed and enabled participant in the act of looking that burdens the work of the young artist Candice Breitz in her "Rainbow Series" (1995), a body of work reminiscent of Hannah Hoch's photomontages, particularly the ethnography series from around 1919. Breitz explores the tension that exists in the discursive territory of the "Rainbow Nation," as rendered in the pornographic depiction of white women and the doubly coded depiction of the black female body, framed by both pornographic and ethnographic desire (color plate 23).

Breitz stages this *mise-en-scène* through that most inimitable form of hybridity—collage—the errant pastiche of irresolvable miscegenation. She began by pulling images of white women from the pages of porn magazines. These she cut, ripped, and collaged with stereotypical images of barebreasted and barefooted black South African women in "ethnic" garb (Ndebele blankets, beaded aprons and jewelry, and brass leg ornaments), taken from

those tourist postcards familiar to safari trippers. These crude joinings, some of which conflate the bodies of prepubescent black children with those of leering, sexually exposed white women, are meant to enact an analogy of equal relationship and compatibility at the site of representation: the equation of colonial ethnographic capture of the black body with the pornographic capture of white women. For example, the body of a young smiling girl, with barely sprouting breasts, carrying a large pumpkin on her head was collaged on the faceless body of a squatting white woman wearing nothing but white shoes and socks and baring her vagina.

Another particularly striking image is a photograph of a ghostly, pale Breitz reclining, odalisque-style, like Manet's Olympia, holding a cardboard cut-out of a black woman's face, which partially frames and conceals her face. It is interesting that Breitz is represented full figured, while the black woman is rendered as a mask, a simulacrum to white feminine subjectivity. What are we to make of this degenerate form of African womanhood—without body, without name, the image of an image—except to see it as an object with which white femininity acquires its fullest enjoyment as subject? And what is it that Breitz is saying here that is of real interest to the African woman? Is she saying that this woman lives in the same temporal zone as the white woman? That they are both on the same level, as naive victims of masculine violence?

The props of Breitz' argument begin to wobble exactly on this level. She simply cannot tell us just what makes these images congruent, as forms of a charged and cohesive discourse of race, femininity, ethnography, pornography, the "Rainbow Nation," and the complex web of entanglements that further undermine her thesis. A discursive absurdity, the images are often spliced and scanned through the computer to produce large, seductive Cibachrome photographic prints. It seems that she is just too much in a hurry to show both her unimpeachable feminist credentials and her equally enlightened liberal sympathy towards the much-abused African woman. Despite her effort to prove irrefutably that the bodies she uses for her misguided narrative do indeed cohere, and do indeed accuse and reproach Mandela's "Rainbow Nation," the black body speaking through Fanon's ghost arrives with a jarring retort: "You came too late, much too late. There will always be a world—a white world—between you and us."[22]

While such a Manichean scheme might irritate, what Fanon seems to be saying—either missed or ignored by Breitz—is the fact that not even gender could so suddenly bind together black and white women's bodies as equal partners against patriarchy in post-apartheid South Africa. For white women must first recognize their own complicity in constructing the African subject. The vehement responses to this work by African women in South Africa and in the United States bear this out. The measure of this opposition to an all-knowing, non-complicit whiteness in South Africa is written within the dialectic of an empowered black feminine presence in the "New South Africa." What white representation disavows or disallows, through what Toni Morrison has called "the stressed absence," black women aim to reify through a questioning and empowered voice. Perhaps to some ears the ring of hostility in the obliterative act (whiting out, ghosting, decapitation, etc.), the unwelcome overfamiliarity, bordering on ownership of the black body, the smug lecturing of those who have severely borne the sentence of these kinds of titillating attentions, might seem too harsh.

The "Rainbow Series" has been critically praised by the white establishment, dismissing the protestations of African viewers as reactionary, childish, and hysterical. Such praise,

however, blissfully ignores that in Breitz' need to valorize and shift emphasis to the recognition of difference as the most plausible counteractive force to the homogenization of South African identity by the "Rainbow Nation" ideology, her work neglects the fact that, under apartheid, white women fought against African women. These critics fail to address the vast chasm that still separates black women from white women in South Africa, socially, economically, and in access to educational opportunities. They have either looked askance at, or peremptorily dismissed, the objections of African women and the traumatic experiences of violation that images such as Breitz' series re-enacts for them, and which has been tendered for public display and consumption in the plush living rooms of white collectors. Perhaps one should neglect, as not being of critical importance, the comment of a black South African woman friend, who commented, rather ruefully at Breitz' exhibition, "Is this the way they still see us?" To understand this comment, it is important to note that white women metaphorically sodomized and pornographicized black women by using their bodies as functional objects of labor, as domestic workers, as maids and nannies and wet nurses.

However, in issuing this injunction against Breitz' questionable representation of black women, one must not dismiss it merely by casting it in the ethical swamp of colonial mimicry, nor simply damn it as another form of racist stereotype masquerading as liberal civilizing mission. Bhabha provides a cogent example of how one may think of work of this nature:

> To judge the stereotyped image on the basis of a prior normativity is to dismiss it, not to displace it, which is only possible by engaging with its effectivity, with the repertoire of positions of power and resistance, domination and dependence that constructs colonial identification subject (both colonizer and colonized).[23]

Is it possible to read this situation as a glaring lapse, or is Breitz constructing a strategic discourse of whiteness? Surely one must allow that the subjectivity and desire of white women is attached and close to white patriarchy and its desubjectivization of both black men and women. Even in her submissive position, the white woman still does colonial errands that denigrate black men and women, partly as a member of the tribe, partly to make the white fathers of the broederbond happy.

My mind is called to attention here by an anecdote from bell hooks that encapsulates the sense of a narrative in which the black subject remains vividly etched on the margin, and is made secondary to white female desire. She relates an account that appeared in the newspaper *USA Today*, which reads: "The Jefferson County Commission voted not to remove a courthouse mural of a white female plantation owner, looming over black men picking cotton."[24] She notes that the subject of the mural relates to how white femininity performs within white patriarchy to further marginalize the black subject in an act of incestuous impulse: "No doubt the white woman in this mural is . . . doing it for daddy; performing an act of domination [of the black body] that she hopes will win his approval and love."

This act of "doing it for daddy," which hooks also refers to as the search by white women within patriarchy "to find ultimate pleasure, satisfaction, and fulfilment in the act of performance and submission,"[25] is a crucial disjunctive element not at all accounted for in Breitz' work. Read in the shadow of this discourse, Freud's question, "What does woman want?" and Fanon's archly patriarchal counter, "What does the black man want?" loom large. For in each instance, it is the black woman that is disavowed, lodged in the lowest

register of articulation. This aspect fascinates me, for the intersection of Freud and Fanon's questions as a description of the black woman's utter otherness could be transferred to the kind of attention devoted to bisecting, coloring, whiting, ghosting out, morphing, collaging of the black figure within the field of representation. These acts seem to have the common desire of enacting fantasies of whiteness, in which the black figure again returns for mediation as an anathema, as a hollow presence: seen and unseen.

<div align="center">X</div>

Despite the sincerity of the artists who have brazenly maintained a relationship in their work with the black body, there is a certain overdetermination that accompanies their gestures. They seem to neglect the fact that the black form is as much a grotesque bearer of traumatized experiences as it is the abject vessel of race as a point of differentiation. More than alerting us to how the stereotype fixes its objects of desire in that freeze-frame of realism, as prior knowledge, the work of these artists exacerbates the stereotype by replaying it, perhaps unconsciously, as if it had always been factual. The problem with this kind of work is that it is so fixed on the body that it neglects to account for the more crucial psychic split that positions black and white bodies in polarities of worth and value. By seeking to merge them, albeit forcibly, and taking as license the fact of their whiteness, they repeat that act of surrogacy that emphasizes the subject's muteness and silence, while embellishing their own positions as the voices of reality, as the vocal integers of truth.

While this attention, which has grown out of the need to sate white liberal conscience in a fragile post-apartheid culture, persists, African artists have conversely adopted a contrary attitude towards the same body. There is very little usage of that figure in their work. Instead, we encounter it as a suppressed presence, abstracted and exorbitantly coded with the semiotic speech of *détournement*, a kind of shift of emphasis from its representational "realness" to a metaphorical search for its lost form.

But in pointing out some of these problems, are we not fetishizing identity as something that wholly belongs to and can be used only by a particular group? And am I not again reiterating that postcolonial litany of the wounded black subject, caught in the mesh of white, European displacement, who must again be either protected or spoken for? The fact that I am an African does not in itself absolve me from this quandary. Despite such dilemmas, what will be the implication of remaining silent on the matter? In proposing a re-examination of certain facts lodged in the iconographical heart of South Africa, in a delimited forum of whiteness as a nation unto itself, should we not also admit that it is the reappropriation of blackness by Africans as a nationalistic emblem, as a fantasy of the coherence of African identity, that has set up the appositional measures against the "Rainbow Nation"?

I remain skeptical of there being a possible resolution to the problems raised by these issues. I question the wisdom of enacting any kind of representational corrective through a recourse to "positive" images of blackness. For identity must never be turned into a copyright; an antinomy in which ethnicity through group reckoning stages its authenticities and retains exclusive user rights to its images. To do so would be to fetishize identity, to render it into a totem, a token of mythology, an ideological fantasy. Moreover, we would

miss the vital lessons that inform the complex motives of usage and the reasons why we resist such use of images. The predicament into which one is thrown, then, is how to imagine identity in the present tense of South Africa's transitional reshaping and reconstitution of its reality; between authenticity and stereotype. For everything seems haunted by this paradoxical affirmation of origin and disavowal of past histories. Within all that, what needs interrogation is usage of any fixed meaning of blackness as an ideology of authenticity, or whiteness as a surplus enjoyment of superiority. Whatever the orientation, whatever the signifying strategies of usage, either to mask whiteness or to valorize falsely an atrophied and immobile black identity, we would do well to heed Aimé Césaire's refusal to fix blackness in any stable meaning. Césaire, in his seminal epic poem *Cahier d'un retour au pays natal* (Notebook of a Return to My Native Land), wrote in some of its most moving lines:

> my negritude is neither tower nor cathedral
> it takes root in the red flesh of the soil
> it takes root in the ardent flesh of the sky

What Césaire is articulating here, far from being a fantasy of blackness, is a proposition of heterogeneity, in which he casts aside all those fantasies that fetishize blackness in such a way that it loses its human dimension. "My negritude is neither tower nor cathedral," "Black is . . . black ain't": are there any more succinct ways to begin the delimitation of those fantasies that mark the black subject as abject, than to start with these two ideas of unfixed blackness, burgeoning into the expansive site of heterogeneity? I want to end with this question, because the relationship of the white or black artist to the black body is indeed paradoxical. And the less anxiously repeated the image, the better the opportunity to find an ethical ground to use its index as a form of discursive address, for radical revision, as well as to unsettle the apparatus of power that employs it as a structurally codified narrative of dysfunction.

Notes

1. Benedict Anderson, *Imagined Communities* (London: Verso, 1991).

2. Edward Said, *Culture and Imperialism* (London: Vintage, 1994).

3. Claire Kahane, "Object Relations Theory," in *Feminism and Psychoanalysis: A Critical Dictionary* (Oxford: Basil Blackwell, 1992), p. 284, quoted by David Sibley in *Geographies of Exclusion: Society and Difference in the West* (London and New York: Routledge, 1996), p. 5.

4. Olu Oguibe, "Art, Identity, Boundaries," *Nka: Journal of Contemporary African Art*, Fall/Winter 1995, p 26.

5. Julia Kristeva, *Powers of Horror: An Essay on Abjection*, trans. Leon S. Roudiez (New York: Columbia University Press, 1982), p. 4.

6. Frantz Fanon, *Black Skin, White Masks*, trans. Charles Markmann (New York: Grove Press, 1967), p. 112.

7. Edward Said, *Orientalism* (London: Routledge and Kegan Paul Ltd, 1978).

8. Frantz Fanon, *The Wretched of the Earth*, trans. Constance Farrington (New York: Grove Press, 1963), p. 39.

9. Stuart Hall, "Cultural Identity and Cinematic Representation," *Framework*, no. 36 (1989), p. 70.

10. Rob Nixon, "Of Balkans and Bantustans," *Transition*, no. 60 (New York: Oxford University Press, 1993), p. 25.

11. While on the surface, the challenges to the "Rainbow Nation" as a unitary polity might seem like a defense of pluralism, difference, and heterogeneity, in reality they seem to recast a neo-conservative stance that echoes the divisive Bantustan policy of separate development of the apartheid regime. For what the critics fear and have failed to admit, at least explicity, are the prospects for whiteness in an overwhelmingly "black" South African country. Hence, the maintenance of ethnic, racial, and linguistic faultlines seems the best check against an encroaching Africanization of South Africa. In fact, the extreme right wing have seized on such arguments and fears of Africanization to demand an outright white Bantustan (homeland) for Afrikaners, and the Inkatha Freedom Party has adopted the neobiologism of Zulu ethnicity to make an appeal for what its leader Mangosuthu Buthelezi has dubbed the "Yugoslav option" or KwaZulu. See Rob Nixon's brilliant essay (ibid.) for a more in-depth study of these contestations.

12. Fanon, *Wretched of the Earth*, op. cit., p. 36.

13. This issue was echoed by Mahmood Mamdani, the Tanzania-born Chair of the Department of African Studies at the University of Cape Town. In the discussions that surrounded the conference, Mamdani asked whether the desire to form an organization to promote Afrikaans was not an attempt "by the privileged but displaced section to recruit foot soldiers from its less fortunate cultural cousin to strengthen a bid to retain some privileges and regain others?" Neville Alexander, one of the speakers, also placed himself at a distance from the nationalistic intonation carried by aspects of the conference by insisting that "if people want to form this kind movement to protect a specific language, they must accept the consequences." But the entire debate, as it relates to the concept of the "Rainbow Nation" with equal access for all cultures, was phrased most effectively by Antjie Kr'of, who stated that if this meant standing shoulder to shoulder with Afrikaners whose motives were anti-government, anti-ANC, anti-truth commission and anti-nation building, then she would have none of it. All quotes taken from Chris Barron, "Afrikaans Takes a Wary Step into the Future," *Sunday Times* (8 December 1996), p. 8.

14. Homi Bhabha, *Location of Culture* (New York and London: Routledge, 1994), p. 66.

15. Olu Oguibe, "Art, Identity, Boundaries," *Nka: Journal of Contemporary African Art*, Fall/Winter 1995, p. 26.

16. Santu Mofokeng, "Black Photo Album/Look at Me: 1890–1950s," *Nka: Journal of Contemporary African Art*, Spring 1996, p. 54.

17. Susan Vogel, *Africa Explores: 20th Century African Art*, exhibition catalogue (New York: The Center for African Art, 1991), p. 10.

18. James Clifford, *The Predicament of Culture: Twentieth Century Ethnography, Literature and Art* (Cambridge: Harvard University Press, 1988), p. 50.

19. Allan Sekula, "The Body and the Archive," in Richard Bolton (ed.), *The Contest of Meaning: Critical Histories of Photography* (Cambridge, MA: MIT Press, 1989), p. 347.

20. bell hooks, "The Oppositional Gaze: Black Female Spectators," in Manthia Diawara (ed.), *Black American Cinema* (London: Routledge, 1993), pp. 288–289.

21. Manthia Diawara, "Black-Spectatorship: Problems of Identification and Resistance," in ibid., p. 213.

22. Fanon, *The Wretched of the Earth*, op. cit.

23. Bhabha, op. cit.

24. bell hooks, "Doing it for Daddy," in Maurice Berger, Brian Wallis, and Simon Watson (eds.), *Constructing Masculinity* (New York: Routledge, 1996), p. 99.

25. Ibid.

22

Biraciality and Nationhood in Contemporary American Art [1]

Kymberly N. Pinder

"For when we swallow Tiger Woods, the yellow-black-red-white man, we swallow something much more significant than Jordan or Charles Barkley. We swallow hope in the American experiment, in the pell-mell jumbling of genes. We swallow the belief that the face of the future is not necessarily a bitter or bewildered face; that it might even, one day, be something like Tiger Woods' face: handsome and smiling and ready to kick all comers' asses"[2] (fig. 22.1). The hope in "the yellow-black-red-white man," reflected in the Tigermania that swept the U.S. in the mid-90s, is indicative of the racial crossroads at which we, as a nation, find ourselves at the close of the twentieth century. As Stanley Crouch describes, "We have been inside each other's bloodstreams, pockets, libraries, kitchens, schools, theaters, sports arenas, dance halls, and national boundaries for so long that our mixed-up and multi-ethnic identity extends from European colonial expansion and builds upon immigration."[3] Where are we as a nation regarding race when Woods can consider himself "Cabliasian" while some Southern states are still officially ending their "one-drop" rules and laws against mixed marriages? How can we address the concerns of those who see the demise of Affirmative Action and a multiracial category on the 2000 census equally devastating to racial equality? There is a (melting) pot boiling here as we transverse a millennium and the suspense is killing all of us.

Some contemporary artists in the U.S. have been hashing out these issues in the 1980s and '90s. Lorraine O' Grady is one of them. She originally titled her photomontage diptych *The Clearing* in 1991; however, later, she lengthened the title to *The Clearing: or Cortez and La Malinche, Thomas Jefferson and Sally Hemings, N. and Me* to clarify the historical and personal relevance of the work (fig. 22.2). The left half of the piece presents the relationship between the black woman and white man as loving while the right as malevolent. The skeletal face of the man and the gun on the pile of clothing provide elements of violence and death. Yet O'Grady says, "It isn't a 'before/after' piece; it's a 'both/and' piece. This couple is on the wall in the simultaneous extremes of ecstasy *and* exploitation."[4] The

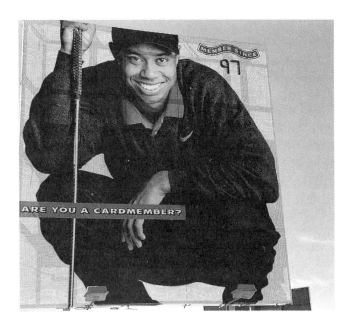

Figure 22.1 Tiger Woods
Billboard, 1999, photo by
Michelle Tomszewski.

complex relationship between exploitation and defiance for such women of color as La
Malinche and Sally Hemings has become a trope of American hybridity and assimilation.

Though anthropologists have established the mixed-race heritage of all humans with the
discovery of "missing link" hominids in Central and South Africa, racial purity, mixing and
conflict are still hotly debated issues in American society. I am not contesting any scientific
definitions of race and human origins in this essay, but I will focus on representations of
multiraciality and their socio-political currency in American society, specifically contempo-
rary popular culture. Throughout this essay, I will use the terms biracial, mixed-race, multi-
racial, multiethnic, racial hybridity, and multicultural with the understanding that such
terms are socially constructed and based on perceptions, either of oneself or by others in our
society. These terms and their instability reflect the challenge we face to meaningfully dis-
cuss the reality of racial mixing, as well as to create the very language needed to do so.

Of course, the reality of a nation of immigrants, the legacy of slavery, and the genocide
of native populations prevents issues of race and difference from being resolved in the U.S.
In the last decade or so, as the collapse of Affirmative Action initiatives and the rise of
white supremacy groups attest, racial divides seem to be widening rather than narrowing.
Some race scholars such as Crouch think otherwise and see the increased mixing of the
races in the U.S. as the "end of race":

> The international flow of images and information will continue to make for a greater and
> greater swirl of influences. It will increasingly change life on the globe and also change
> our American sense of race. . . . In that future, definition by racial, ethnic and sexual
> groups will most probably have ceased to be the foundation of special-interest power. . . .
> Americans of the future will find themselves surrounded in every direction by people
> who are part Asian, part Latin, part African, part European, part Indian.[5]

Figure 22.2 Lorraine O'Grady, *The Clearing: or Cortez and La Malinche, Thomas Jefferson and Sally Hemings, N. and Me*, 1991, Collection of the Artist.

As panaceas or true saviors, historical figures, like Hemings, and contemporary celebrities, like Woods, have become national touchstones for unity. These biracial or multiracial individuals who were once outcast traces of taboo sexual transgressions, the stereotypical "tragic mulattos," are now signifiers of a future of racial harmony. In February 1995, *Newsweek* devoted an entire issue to the "New Race" in America and though its surveys showed some significant pessimism among blacks and whites regarding our nation's race relations, the magazine presented the nation's growing mixed-race population as a future remedy for current racial conflicts.[6] As one biracial writer responded, the magazine declared "it hip to be mixed."[7] Another article, with a markedly flippant tone, in *Harper's Magazine* in 1993, even recommended a more practical "need" for racial mixing: melanin-rich skin for the survival of future generations as our ozone layer erodes.[8] Popular movies such as *Bulworth* (1998), written and directed by Warren Beattie, present a jaded white politician who, after living a few days with a black family in South Central L.A., makes "procreative, racial deconstruction" his political platform, his remedy for racial discrimination and the economic disparities it has caused in this country.

Historical figures who loved transracially, such as La Malinche and Pocahontas, have also gained political significance as they offer hopeful moments of cross-cultural cooperation in our racially divided pasts. For example, the 1995 Disney film about the latter presents the saga as a love story in which Pocahontas risks her own life to save that of John Smith. This narrative, based upon Smith's account and revised for a young audience, excludes Matoaka's (Pocahontas' real name) later kidnapping and forced conversion. Many applauded Disney's politically correct inclusion of Native American history into its repertoire; however, the effects of the distortion of "Distory"[9] on our children's understanding of national history and race relations are questionable. The scale of this type of nationalistic desire for harmony, past and present, through these icons, is summed up in the words of Woods' father, Earl, "Tiger will do more than any other man in history to change the course of humanity. . . . Because he's qualified through his ethnicity to accomplish miracles. He's a bridge between

East and West. There is no limit because he has the guidance. . . . He is the Chosen One. He'll have the power to impact nations. Not people. Nations."[10]

O'Grady's photomontage parallels the relationships of La Malinche and Sally Hemings which did impact nations and bridge cultures in the past. La Malinche's facility at languages made her translator for the Spanish conqueror Hernan Cortez; then she gave birth to a racial bridge, their son, the original mestizo. La Malinche's other name was La Lengua, the language, and the transformation from "race traitor," La Malinche, a slur in some Mexican dialects, to the status of the great communicator and reconciler, as she has been recently reclaimed, namely by feminists, is a leitmotif in the biographies of such historical figures. No matter her intentions, La Lengua brought together Europeans and Indians; Hemings united, inside and outside of herself, Africans and Europeans; and Woods, "the yellow-red-black-white man" brings together *all* of the "primary races" in one body. As his mother Tida says, "Tiger has Thai, African, Chinese, American Indian, and European blood; he can hold everyone together; he is the Universal Child."[11]

The artist, O'Grady, considers this mixing to be a great strength of multiethnic people. She uses the diptych format symbolically in *The Clearing*, and in other works, such as *The Miscegenated Family Album Series* (1994), which explores her own family history and, most recently, in *Studies for Flowers of Evil and Good* (1996), which addresses the relationship between Charles Baudelaire and his black, common-law wife, Jeanne Duval. O'Grady feels that the diptych reflects her "cultural situation" as an artist of bicultural identity (the artist's family was originally from the Caribbean and is of mixed-race ancestry). These works explore interracial relationships both personally and historically. I quote extensively from her:

> I think that the biggest problem that those of us have who are bi- or even tricultural and are trying to interpolate our positions with those of the west . . . the way in which, both philosophically and practically, the west divides its ability to comprehend good/evil and black/white, the way in which it makes oppositions of everything. Not just simple oppositions, but hierarchical, superior/inferior oppositions, so that male/female, black/white, good/evil, body/mind, nature/culture are not just different, one is always better than. . . ."[12]

In *The Clearing*, O'Grady addresses this dualism in a number of ways. Besides the diptych format that presents a "good"/"bad" dichotomy, she presents compelling details such as the lush landscape and happy children on the left in opposition to the specter of death on the right. This figure on the right wears armor (chain mail) which, juxtaposed with his actions, rape, subverts all ideas of European chivalry. This photomontage is also a montage of ideas concerning the complexity of cross-racial unions, either through love or violence.

In earlier American representations of the "bicultural condition," we can find little of this nuanced treatment. Thomas Noble's *The Price of Blood* (1867) shows a white slave owner selling his own biracial son who stands sullenly in the background. This representation of the "tragic mulatto" continued almost unchanged into the middle of the twentieth century.[13] The African American painter Archibald Motley, Jr. created a series of portraits of mixed-race women in the 1920s whose solemn faces against dark backgrounds also convey some of these tragic qualities. Motley considered this series to be both an artistic and scientific experiment. Writing about one of the portraits, he commented, "In this painting

I have tried to show that delicate one-eighth strain of Negro blood. Therefore, I would say that this painting was not only an artistic venture but also a scientific problem."[14]

Such writers as Frantz Fanon have articulated the social, political, and economic power of the visibility of race, "the racial epidermal schema"of non-whiteness in a post-colonial world.[15] Motley's interest in pigment as a painter resonates in the recent work of a number of contemporary artists. The Korean American artist Byron Kim's "skin" paintings are abstract musings on the visual reality of a multicultural society. Some of these pigment paintings, such as *Cosmetic Portrait Series* (1992), are rows of flesh-toned ovals reminiscent of cosmetic products. Usually, Kim arranges groups of them in grids that suggest a pseudo-scientific project similar to Motley's. In *Synechdoche* (1991), for example, the key on the work's label identifies each panel as the skin tone of a family member or friend which makes these panels function as racial indices (color plate 24). As Kim alludes to cosmetics, Gabrielle Varella uses paint color sample strips as her referent to address the loaded function of skin tone in our society in her *Untitled Series (1999)* (color plate 25) In these fragile, mundane gradations of beiges and browns that run the spectrum from cafe au lait to deep mahogany, Varella has printed phrases, such as "The color of my skin makes you think I can't be lucky" or "My name is not Mexican enough for you to know what I am." These "skin samples" address a multiracial audience with the visual realities regarding the daily assessments and assumptions that are made and internalized about race. Each one of us is embraced, dismissed, respected, or ignored in every encounter. In a series of altered photographs by Paul Solomon entitled *Biracial Portraits* (1997), his sitters appear to be literally half one race and half another. The literal halving of an individual questions the validity and potential absurdity of racial labels if indeed these racial markers were so clearly visible on each biracial body. Returning to the often ignored issue of race in Latin American cultures, the painter Bibiana Suárez presents a retablo of two self-portraits from 1991–92: in one, *Y tu abuela a donde está?* (What color is your grandmother?) (color plate 26 and 27), Suárez celebrates the Afro-Antillean aspects of her Puerto Rican heritage, something that many Puerto Ricans deny. The title of the work is taken from the poem "Y tu agüela, a'onde ejitá?" (1942) by Fortunato Vizcarrondo in which he confronts these racial biases in his culture. In the accompanying portrait, *La Blanquita* (The White One), Suárez paints herself more as she is, fair-skinned, with an emphasis on her whiteness. In the same way in which the conceptual artist Adrian Piper has explored the social and personal ramifications of her being a light-skinned African American, Suárez forces her audience to acknowledge the reality of Puerto Rico's *mestizo* legacy *and* how much American racism has affected this legacy. As she writes, "The colloquial expression 'blanquita' (or *blanquito* for a male) in Puerto Rico signifies more than just the color of one's skin. It conveys the common perception in Puerto Rico that a light skin person is better, revealing a colonial mentality that values its own racial heritage only so far as it compares to the dominant U.S. culture." The way in which she presents her two selves in dress and demeanor speak to these biases since one can interpret the head wrap and ill-fitting t-shirt of the *black* Suárez versus the neatly coiffed blonde hair and embellished title banner of *La Blanquita* as communicating a value hierarchy. She does not neglect to suggest class distinction as part and parcel of the history of racial bias in Puerto Rico and elsewhere.

Robert Colescott, who has made a career out of confronting racism and racial taboos in his art, approaches the same themes of racial labels and self-identification in *Lightning Lipstick*

(1994) (color plate 28). Like Varella and Suarez, Colescott addresses the conflict for dark-skinned Latinos who are Latino-identified, meaning, they derive their identity from their specific geographical roots, i.e., Mexico or Puerto Rico, but they are seen as black, "negrito", by others, especially North Americans. In *Grandma and the Frenchman: Identity Crisis* (1991) the "tragic mulatto" rears her misshapen head. Not only does this woman have all of the colors of many races, but all of their hair, eyes, mouths, and noses! Colescott says this work is "all about identity—this woman cannot have just a two-faced Picasso head, she must be even more fragmented because her identity is so screwed up. Mixed-race people are all around us, we all are and have been for centuries." Standing in stark contrast to the happy, mixed-race children in O'Grady's *The Clearing* who offer hope for the future, Colescott's image speaks to both white and non-white fears of racial mixing and the hegemonic collapse it signals. One could see the distorted head as a metaphor for the social and political morass that occurs when the physicality of racial marking is obscured. For the dominant, European power structure, this ambiguity subverts exclusion, the bedrock of its oppression, and for the non-Europeans it oppresses, it betrays any solidarity against this very exclusion.

Though recently the horrific events in Rwanda and Bosnia have proven that intraracial oppression and annihilation are alive and well, these genocidal projects are complicated by this very issue of the physicality of difference and its intersection with personal relationships, such as intermarriage. Michael Lind addressed the statistical reality of this breakdown in the U.S. in his essay, "The Beige and The Black." He interrogated the many statistical predictions regarding racial demographics for the next century and noted that interracial unions are not included in these projections, therefore, skewing the numbers *and* our ideas of our multiracial future. The most compelling observation he makes, which simultaneously dampens and bolsters the optimistic rhetoric regarding this future of racial blurring and erasure, is that blacks are intermarrying at a fraction of the rate of Asians, Native Americans, and Latinos:

> In the twenty-first century, then, the U.S. population is not likely to be crisply divided among whites, blacks, Hispanics, Asians, and American Indians. Nor is it likely to be split two ways, between whites and nonwhites. Rather, we are most likely to see something more complicated: a white-Asian-Hispanic melting-pot majority—a hard-to-differentiate group of beige Americans—offset by a minority consisting of blacks who have been left out of the melting pot once again.[16]

Lind goes on to articulate the socioeconomic fallout of this shift in the racial power structure, which would, on one hand end balkanization, but, on the other, would significantly weaken what few political alliances that current "rainbow coalitions" have against discriminatory treatment. The dissolution of identity politics will also affect representation.

Another artist from the first half of this century helps us frame these contemporary issues. William H. Johnson's painting of 1941 entitled *Mom and Dad* shows his mother with a photograph of his father on the back wall. Johnson sometimes said his father was Native American and other times, white. This father's powerful presence of absence, if you will, in the hanging portrait reflected the importance of Johnson's mixed heritage to his identity as both a black man and an artist in the 1930s and '40s. He considered himself

"both a cultured painter and a primitive man."[17] He frequently used his ambiguous racial lineage as proof of his natural artistic hybridity that made him an "authentic" modern primitive, the fusion of European and "primitive," that was by blood. Like Woods who "can bring everyone together," Johnson too felt his heritage made him superior to the "purer" races—*and* to such wannabe primitives as Pablo Picasso and Paul Gauguin.

In Johnson's case, we see the colonial catch-22 of racial purity. Johnson was essentially defining himself within a discourse created by others. Like all non-white "primitives," he was trying to a win in a game whose rules are ever shifting. It is similar to the uneasy alliances such political leaders as Marcus Garvey and Malcolm X made with segregationists and other whites against racial mixing. As O'Grady expands on this slippery slope:

> My own feeling is that the only thing that will ultimately work is if we can somehow find a way to use the "mixed product" to negate not just the idea of "purity" but the idea of "superiority" itself. In racial code, "purity" is a cover for what is really meant, "superiority/inferiority." Those who espoused it certainly didn't mean that pure blackness was superior. . . . Seducing blacks into accepting that form of discourse was a way of gaining their collaboration in the maintenance of their own inferiority, under the false guise of preserving their own purity.[18]

Yet, the rhetoric of "the new and improved" prevails in some sectors and I would suggest, *rules* at the current time. Racial hybrids become evolutionary cultural products. Their strength lies in their ability to genetically unify two or more oppositional forces. Johnson became the perfect Modernist while La Malinche and Hemings have become the perfect postcolonial beings—and feminists. The subversive nature of their acts of racial and cultural mixing transcends their victimization. Though artists like O'Grady and Colescott question this transcendence, they would agree that though these interracial unions are exploitative, their very existence and their resulting offspring weaken the very hegemonic structure that enables such exploitation. A not-so-"sub" subtext of this entire discussion about the representation of racial mixing has been the visibility *or* more accurately, the erasure of whiteness.

The pop success of the actor Vin Diesel in such films as *Pitch Black* (2000), *The Boiler Room* (2000), and *The Fast and the Furious* (2001) at the turn of this current century also attests to the new appeal of racial ambiguity. Diesel's refusal to answer any questions regarding his race and its link to his success is something he himself foreshadowed in an independent film he made titled *Multifacial* (1995) in which an actor of unclear ethnicity rises to stardom because he can play anything from an Italian to an African American. He becomes whatever part is needed. It is interesting to note that in these Hollywood films, Diesel has become a perennial villain. His racial ambiguity helps make him a suspicious and dangerous outsider in each film, yet his sexual appeal and physical and mental superiority are also highlighted as aspects of this "bad boy" aura. Diesel's characters are always experts at being devious. In each film, lead characters seek, often reluctantly, his help and advice for survival, be it against deadly alien creatures (*Pitch Black*) or in a crucial business teleconference (*The Boiler Room*). His talents surpass those of all other characters, black and white.

O'Grady has said, "Interracial sex, and the fear surrounding it, seems to me to be at the nexus of the country's social forces."[19] Hence, the creation of elaborate miscegenation laws

to control the potential of interracial sex to degrade the white, European, capitalist patriarchal social structures in the Americas and elsewhere. As the controversy over the descendants of Thomas Jefferson and Hemings attests, much can be at stake when these biracial offspring are allowed to be heard. Can whites transcend their race? Does not the mirror of difference always help construct, or reconstruct in some cases, the self? The critique of race in the academy has recently turned to examinations of whiteness and notions of white ethnicity with such works as David R. Roediger's *The Wages of Whiteness: Race and the Making of the American Working Class* (1991), Theodore W. Allen's *The Invention of the White Race* (1997), Matthew Frye Jacobson's *Whiteness of a Different Color. European Immigrants and the Alchemy of Race* (1998), Karen Bodkin's *How Jews Became White Folks and What that Says about Race in America* (1998). In the movie *Bulworth*, the love affair between Halle Berry's "ghetto girl" and Warren Beattie's racist politician is such a bridging of disparate sectors of the American population that it is presented as socially, politically, and personally altering; here, the interracial relationship serves as a moral corrective of sorts for the white oppressor who empathizes so much with blacks that Berry even refers to Beattie as "my nigger." The Jefferson-Hemings union is the best example of this type of nationalistic racial "spin" placed on such relationships. Some of those who have acknowledged their relationship and its longevity have reread Jefferson's more tempered statements regarding blacks as a reflection of the humanity he witnessed in his relationship with Hemings. As many have been quick to point out, however, he still allowed politics to silence his abolitionist feelings *and* no matter how much he may or may not have cared for Hemings, he still owned her until his death.

However, post-colonial theorists have continued to argue that the very core of white, European identity was indeed shaped by such transgressions, especially those of the late-nineteenth and twentieth centuries. In *The Empire Writes Back: Theory and Practice in Post-Colonial Literatures*, Bill Ashcroft, Gareth Griffiths, and Helen Tiffin point out that,

> Africa is the source for the most significant and catalytic images of the first two decades of the twentieth century. In one very significant way the "discovery" of Africa was the dominant paradigm for the self-discovery of the twentieth-century European world in all its self-contradiction, self-doubt, and self-destruction, for the European journey out of the light of Reason into the Heart of Darkness. As such, the more extreme forms of the self-critical and anarchic ushered in can be seen to depend on the existence of a post-colonial Other which provides its condition of formation.[20]

In this next millennium, the cultural syncretisms of European encounters with not only Africa but Asia and Latin America will redefine, and possibly extinguish, European hegemony in some parts of the world where it exists. The numbers tell the future. Within a few decades, people of non-European ancestry or mixed ancestry will dominate certain populations in America and Europe.

Christian Walker alludes to the sexual dimension of these encounters in his *Miscegenation Series* (1985–88). It consists of sepia photographs which depict close-up views of interacting body parts whose blurred and grainy surface simultaneously allude to old daguerreotypes and contemporary pornography. The nudity and overlapping suggest sexual encounters, yet gender is often unclear. The murkiness of the sepia tone forces the viewer

to stare and probe for more information. Walker makes us conscious of the act of looking. This consciousness makes the viewer aware of the exotic and *verboten* aspects of the social attitudes towards interracial sex. Adrian Piper's *Vanilla Nightmare Series* (1986–87) also uses ambiguity to address societal fears of racial mixing and conflict beneath the surface of everyday life. She literally brings these hidden terrors to the surface in her drawings of blacks, some sexually menacing to whites, over pages of the *New York Times*. Similarly, her video installation, *Cornered* of 1988 presents a personal view of being a light-skinned black woman whose very existence, poignantly documented with her father's "conflicting" birth certificates: one declaring him white, the other "colored," makes whites and blacks confront the distorted race relations of the U.S.

The frenzy over Tiger Woods and the anticipation of Colin Powell's bid for the presidency in the mid '90s were desperate, national scrambles for racial reconciliation. Both a recent advertisement for a clothing company called NuSouth and the work of Kara Walker struggle to simultaneously confront and market slavery's past, one source of the nation's racial woes. Yet, is the nation ready to "sell" slavery? The Africanized, red, black, and green Confederate flag is NuSouth's logo and the ad's text identifies its buyers as the sons and daughters of former slaves and former slave owners, a line lifted from Martin Luther King's "I Have A Dream" speech. A final line presents the sportswear as conciliatory: "Threads that connect us. Words that free us." The controversy over Walker's representations of our slave past, such as *Cotton* (1997) whose blending of humor, brutality, and racial stereotypes are considered by some to be offensive and dangerous, *and* the dismal failure of Oprah Winfrey's project, the movie *Beloved* may indicate that we are not quite ready to confront this history only 140 years later.[21]

Are multiracial icons the answer to national harmony? Can they really transcend centuries of conflict as revisions of the past and hopes for the future? Despite his symbolism, Tiger Woods was never announced as the first multiracial person to win this or that PGA tournament. In the U.S. blacks claim him and in Asia, Asians. And despite the multiracial rhetoric, his proclivity towards telling racist jokes about big black penises has been disappointing to some and dampened many multiracialist hopes. A "multiracial" choice on the 2000 census will not erase the "us/them"(and now more often, "us/them/them and them") mentalities that the artists discussed in this essay are critiquing. What has motivated me to write on these artists is that their reflections on these multicultural realities resist current trends in the mainstream media to simplify our increasingly complex populations through a nationalistic lens. O'Grady, Kim, and others encourage us to scrutinize and problematize the idea of a "raceless," "colorblind" world. As O'Grady honestly writes, "With the diptych [both real and symbolic], there's no being saved, no before and after, no either/or; it's both/and, at the same time. With no resolution, you just have to stand there and deal."[22] These artists present the complexities of our society. The coexistence of beauty, horror, love, death, happiness, and rape does not shy away from the history that shapes our present. Historical figures like La Malinche and Sally Hemings *did* build nations with their European lovers.

And it is this burden of history that prevents a multiracial person to be devoid of race; widespread ethnic "cancellations" will not "end race" as writers like Crouch predict. It will be the challenge for us and following generations to cope, articulate, and understand the conundrum of a multiethnic nation, the polyptych of cultures in which we live. I am not

arguing for ignoring our post-colonial hybridity, for, as Ashcroft and his colleagues so elo-quently note,

> it is arguable that to move towards a genuine affirmation of multiple forms of native
> "difference," we must recognize that this hybridity will inevitably continue . . . [and
> through it] a genuinely transformative and interventionist criticism of contemporary
> post-colonial reality can be achieved.[23]

Through creating new critical linguistic, socio-political and economic models that are inclusive and not dismissive of the lingering effects of our new societies' historical founda-tions, we can address all of the complexities and challenges of our multiracial "conditions." We must follow the example of our historical, transracial icons like La Malinche and Hem-ings who, according to O'Grady's eloquent statement, "met the future with forgiveness and a lack of fear."[24]

Works Cited

Cottingham, Laura. "Lorraine O'Grady. Artist and Art Critic. An Interview" in *Art Influences* 1996, vol. XV. Ed. James V. Hatch, et al. New York: Hatch-Billops Collection, Inc., 1996.

Crouch, Stanley. *The All-American Skin Game; Or, The Decoy of Race* (New York: Vintage, 1995).

Crouch, Stanley. "Race Is Over. Black, White, Red, Yellow—Same Difference" in *New York Times Magazine*, September 29, 1996, 29–30.

Davis, Theo. "Artist as Critic. An Interview with Conceptualist Lorraine O'Grady," in *Sojourner: The Women's Forum*, November 1996.

Greenhouse, Wendy and Joyntyle Robinson. *The Art and Life of Archibald Motley, Jr.* Chicago: Chicago Historical Society, 1991.

Smith, Gary. "Sportsman of the Year: The Chosen One" in *Sports Illustrated*, vol. 85:26 (December 23, 1996), 28–55.

Notes

1. A version of this essay was presented during the panel, "La Malinche as Metaphor" at the College Art Association Annual Conference on February 13, 1999 and yet another appeared in *Third Text*, vol. 53 (Winter 2000–01).

2. Smith, Gary, "Sportsman of the Year: The Chosen One" in *Sports Illustrated*, vol. 85:26 (December 23, 1996), 55.

3. *The All-American Skin Game; Or, The Decoy of Race* (Vintage Books, 1997), 244.

4. Cottingham, Laura. "Lorraine O'Grady. Artist and Art Critic. An Interview" in *Art Influ-ences* 1996, vol. XV. Ed. James V. Hatch, et al. New York: Hatch-Billops Collection, Inc., 1996, 214.

5. Crouch, Stanley. "Race Is Over. Black, White, Red, Yellow—Same Difference" in *New York Times Magazine*, September 29, 1996, 29.

6. *Newsweek*, vol. 125:7 (February 13, 1995). *Newsweek* revisited this issue as a cover story in Fall of 2000.

7. Senna, Danzy, "Passing and the Problematic of Multiracial Pride" in *Black Renaissance/ Renaissance Noire*, vol. 2:1 (Fall/Winter 1998), 76.

8. Bush, David A., "Ozone Anxiety: It's a White Thing" in *Harper's*, vol. 287:1723 (December 1993), 28. Bush actually recommends the government encourage racial mixing. In reading through the popular press and its take on the new multiethnic nation, I found it to be overwhelmingly contradictory with much statistical manipulation. The races and ethnicities that were considered also varied. A survey of this literature is evidence enough that we are plunging ahead in our analyses yet incredibly bereft of the tools to do so.

9. Stephen M. Fjellan coined this phrase in his *Vinyl Leaves. Walt Disney World and America* (Oxford: Westview Press, 1992), 59.

10. Smith, 33.

11. Smith, 36.

12. Davis, Theo. "Artist as Critic. An Interview with Conceptualist Lorraine O'Grady," in *Sojourner: The Women's Forum*, November 1996, 28.

13. For more on nineteenth-century images of miscegenation, see Judith Wilson's seminal article, "Optical Illusions. Images of Miscegenation in Nineteenth- and Twentieth-Century American Art," in *American Art* , vol. 5:3 (Summer 1991), 88-1-7. I am indebted to this essay and subsequent discussions with Professor Wilson. It is my hope that my essay successfully continues the dialogue she began in 1991.

14. Greenhouse, Wendy and Joyntyle Robinson. *The Art and Life of Archibald Motley, Jr.*, Chicago: Chicago Historical Society, 1991, 9.

15. *Black Skin, White Masks* (New York: Grove, 1967 (1952)), 112.

16. *New York Times Magazine*, August 16, 1998, 39.

17. Powell, Richard J., *The Homecoming: The Art of William H. Johnson* (Washington, DC: Smithsonian, 1991), 69.

18. E-mail letter to author, February 5, 1999.

19. Quoted in Laura Cottingham, "Lorraine O'Grady. Artist and Art Critic. An Interview" in *Art Influences* 1996, vol. XV. Ed. James V. Hatch, et al. New York: Hatch-Billops Collection, Inc., 1996, 213.

20. New York: Routledge, 1989, 160.

21. For more on the Walker controversy see *International Review of African-American Art* (December 1997).

22. Quoted in "The Diptych vs. the Triptych: An Excerpt from a Conversation between Lorraine O'Grady and a Studio Visitor" (unpublished, undated, and unpaginated), courtesy of the artist.

23. *Empire Writes Back*, 180.

24. E-mail letter to author, February 5, 1999.

List of Contributors

Rasheed Araeen is an artist and one of the founding editors of *Third Text*, an art journal which focuses on contemporary global art. His own work has been exhibited all over the world and he speaks and writes frequently on issues regarding culture and developing countries.

Albert Boime is Professor of Art History at the University of California, Los Angeles. He has published widely on nineteenth-century art with his most recent books including *The Art of Exclusion: Representing Black People in the Nineteenth Century* (Smithsonian Institution Press, 1990), *Manifest Destiny and the Magisterial Gaze in Nineteenth-Century American Painting* (Smithsonian Institution Press, 1991), *The Art of the Macchia and the Risorgimento: Representing Culture and Nationalism in Nineteenth-Century Italy* (University of Chicago Press, 1993), and *Art and the French Commune, Imaging Paris After War and Revolution* (Princeton University Press, 1995).

Anna C. Chave is Professor of Contemporary Art and Theory and twentieth-century European and American Art the Graduate Center at CUNY. She is the author of *Constantin Brancusi: Shifting the Bases of Art* (Yale University Press, 1994) and many articles on Agnes Martin, Eva Hesse, and Georgia O'Keeffe.

John R. Clarke is Annie Laurie Howard Regents Professor of Fine Arts at University of Texas at Austin. His most recent books are *Looking at Lovemaking* (1998) and *Art in the Lives of Ordinary Romans* (2002), both published by the University of California Press.

James Clifford is Professor of the History of Consciousness at the University of California, Santa Cruz. Trained in social and intellectual history, he is co-editor of *Writing Culture: the Poetics and Politics of Ethnography* (University of California Press, 1986) and author of *The Predicament of Culture: Twentieth-Century Ethnography, Literature, and Art* (Harvard University Press, 1988), and *Routes: Travel and Translation in the Late 20th Century* (Harvard University Press, 1997).

Jean Devisse is a former Professor of the History of Africa at the University of Paris and the University of Dakar and was President of the Société française d'outre-mer.

Okwui Enwezor is a critic, independent curator, and adjunct curator of Contemporary Art at the Art Institute of Chicago. He has served as artistic director for the Johannesburg Biennale and Kassel Documenta. He is Publisher and Founding Editor of *Nka: Journal of Contemporary African Art*. He most recently co-edited *Reading the Contemporary: African Art from Theory to the Marketplace* (MIT Press, 2000) and curated "The Short Century: Independence and Liberation Movements in Africa, 1945–1994" in Berlin and Chicago.

Jean Fisher is Research Associate in the Department of Visual Culture and Media at Middlesex University, London. An artist and former editor of *Third Text*, she has written extensively on issues of contemporary art practice and the multicultural debate. She edited the selected writings of Jimmie Durham and Lee Ufan, as well as the two anthologies *Global Visions: Towards a New Internationalism in the Visual Arts* (Kala Press in association with the Institute of International Visual Arts, 1994) and *Reverberations: Tactics of Resistance, Forms of Agency in Trans/cultural Practices* (Jan van Eyck Akademie, 2000).

Sander Gilman is Distinguished Professor of the Liberal Arts and Medicine at the University of Illinois in Chicago and Director of the Humanities Laboratory. A cultural and literary historian, he is the author or editor of over sixty books, including *Picturing Health and Illness: Images of Identity and Difference* (Johns Hopkins University Press, 1995) and *The Fortunes of the Humanities: Thoughts for After the Year 2000* (Stanford University Press, 2000), his most recent monograph.

Michael Hatt is Visiting Instructor of Visual Culture at the University of Nottingham. He has published widely on the body, race, and empire, and more recently on critical theory and art historical method. His most recent publications include *The Politics of Muscle. An Introduction to the Male Nude 1800–2000* and the forthcoming *Approaches to Art History: From Hegel to Post-Colonialism*.

bell hooks is Distinguished Professor of English at City College in New York. A literary and cultural historian, she has published many books on race, feminism, writing, and cultural politics, such as *Teaching to Transgress: Education as the Practice of Freedom* (Routledge, 1994), *Talking Back: Thinking Feminist, Thinking Black* (South End Press, 1989), *Black Looks: Race and Representation* (South End Press, 1992), and *Outlaw Culture: Resisting Representations* (Routledge, 1994).

Patricia Leighten is Professor of Art History at Duke University. She is the author of *Re-Ordering the Universe: Picasso and Anarchism, 1897–1914* (Princeton University Press, 1989) and *The Politics of Form: Art, Anarchism and Audience in Avant-Guerre Paris*.

Reina Lewis is Senior Lecturer at the undergraduate Literature program at MA Cultural Studies at the University of East London. She is the author of *Gendering Orientalism: Race,*

Femininity and Representation (Routledge, 1996) and coeditor of *Outlooks: Lesbian and Gay Visual Cultures* (Routledge, 1996).

Robert Linsley is Life Drawing Instructor at Vancouver Institute of Media Arts. He has participated in several solo and group exhibitions in Canada and abroad, with numerous articles and exhibition reviews published.

Linda Nochlin is the Lila Acheson Wallace Professor of Modern Art at New York University Institute of Fine Arts. Among her many publications are *Realism and Tradition in Art, 1848–1900: Sources and Documents* (Prentice-Hall, 1966) and *Women, Art, and Power and Other Essays* (Harper & Row, 1988).

Kymberly N. Pinder is Associate Professor of Art History, Theory, and Criticism at the School of the Art Institute of Chicago. She has published on race and American Art in the *Art Bulletin* and *Third Text*. Her most recent work appears in *Dox Thrash: An African American Master Printmaker Rediscovered* (Philadephia Museum of Art, 2001). She is currently preparing the manuscript *Framing Color: Reading Race in the History of Western Art*.

Jae-Ryung Roe is a former curator at the National Museum of Contemporary Art in Korea and is currently Director at Kukje Gallery. She has written extensively about Korean contemporary art for *ArtForum, Art,* and *Asia Pacific* and exhibition catalogues. Her most recent publication is *Contemporary Korean Art* (Craftman House, 2001).

Abigail Solomon-Godeau is Professor of Art History at University of California at Santa Barbara. Her publications include *Male Trouble: A Crisis in Representation* (Thames and Hudson, 1997) and *Photography at the Dock: Essays on Photographic History, Institutions and Practices* (University of Minnesota Press, 1994).

J. Gray Sweeney is Associate Professor of Art History at the Arizona State University. His publications include *The Columbus of the Woods: Daniel Boone and the Typology of Manifest Destiny* (Washington University Gallery of Art, 1992) and essays in *Drawing the Borderline: Artist-Explorers and the US-Mexico Boundary Survey* (Albuquerque Museum, 1996) and *Inventing Arcadia: Artists and Tourists at Mount Desert Island* (Farnsworth Art Museum [distributed by the University Press of New England], 1999).

Cornel West is the Alphonse Fletcher, Jr. University Professor at Harvard University teaching in Afro-American Studies and Philosophy of Religion. His many publications on race and culture include *The Cornel West Reader* (Basic Civitas Books, 1999), *Beyond Eurocentrism and Multiculturalism* (Common Courage Press, 1993), and *Race Matters* (Beacon Press, 1993).

Judith Wilson is Assistant Professor of African American Studies and Art History at the University of California, Irvine. Her publications include articles in *Art in America, Art Journal,* and *Third Text*, among others. She is currently completing a collection of her own essays, *Optical Illusions: Race and Gender in American Art*.

Diane Wolfthal is Associate Professor of Art History at the Arizona State University. She has written *The Beginnings of Netherlandish Canvas Painting* (Cambridge University Press, 1989, 2nd printing 1990) and *Images of Rape: The "Heroic" Tradition and Its Alternatives* (Cambridge University Press, 1999, paperback edition 2000), and edited *Peace and Negotiation: Strategies for Peaceful Coexistence in the Middle Ages and Renaissance* (Brepols, 2000). She is currently completing a book entitled *Jewish Romance, Ritual, and Remembrance: Images in Early Yiddish Books.*

Permissions

Twenty-one chapters in this book are reprinted with permission from the following sources: Clarke, John R. "'Just Like Us': Cultural Constructions of Sexuality and Race in Roman Art," *Art Bulletin* (Dec. 1996): 599–603. "Imaging the Self: Identity and Gender in Representations in a Yiddish Book of Customs." © 2001 Diane Wolfthal. Jean Devisse, "Sanctified Black: Maurice," in *The Image of the Black in Western Art*, vol. 2, part 1, *From the Demonic Threat to the Incarnation of Sainthood*, pp. 149–208. Translated by William Granger Ryan. © 1979 Menil Foundation, Inc. Houston. "The Imaginary Orient" by Linda Nochlin. Originally published in *Art in America*, Brant Publications, Inc., May 1983. Lewis, Reina. "'Only Women Should Go to Turkey': Henriette Browne & the Orientalist Female Gaze." In *Gendering Orientalisms, Race, Feminism & Representation*, 127–143, 162–185. London: Routledge. "The Hottentot and the Prostitute: Toward an Iconography of Female Sexuality." Reprinted from Sander L. Gilman: *Difference and Pathology: Stereotypes of Sexuality, Race, and Madness*. © 1985 by Cornell University. Used by permission of the publisher, Cornell University Press. "Going Native" by Abigail Solomon-Godeau. Originally published in *Art in America*, Brant Publications, Inc., July 1989. Sweeney, J. Gray. "Racism, Nationalism, and Nostalgia in Cowboy Art," *Oxford Art Journal* (1992): 67–80. Boime, Albert. "Blacks in Shark-Infested Waters," *Smithsonian Studies in American Art* (Winter 1989): 14–47. Hatt, Michael. "Making a Man of Him: Masculinity and the Black Body in Mid-Nineteenth-Century American Sculpture," *Oxford Art Journal* (1992): 21–35. "Histories of the Tribal and the Modern" by James Clifford. Originally published in *Art in America*, Brant Publications, Inc., April 1985. Leighten, Patricia. "The White Peril and L'art Nègre: Picasso, Primitivism, and Anticolonialism," *Art Bulletin* (Dec. 1990): 609–630. Chave, Anna C. "New Encounters with 'Les Demoiselles d'Avignon': Gender, Race and the Origins of Cubism." *Art Bulletin* 76, 4 (Dec. 1994): 596–611. © Anna C. Chave. Linsley, Robert. "Wilfredo Lam: Painter of Negritude," *Art History* (1988): 527–544. © Association of Art Historians. Wilson, Judith. "Sargent Johnson: Afro-Californian Modernist." In *Sargent Johnson: African-American Modernist*, exhibition catalogue organized by Lizetta LeFalle-Collins, 27–40 (1998). San Francisco: San Francisco Museum of Modern Art. "Horace Pippin's Challenge to Art Criticism" by Cornel West. © 1993 from *Keeping the Faith* by

Index